The Painter 11 Wow! Book

BOOK

Cher Threinen-Pendarvis

Peachpit Press

The Painter 11 Wow! Book

Cher Threinen-Pendarvis

Peachpit Press
1249 Eighth Street
Berkeley, CA 94710
(510) 524-2178
(510) 524-2221 (fax)

Find us on the Web at: www.peachpit.com
To report errors, please send a note to errata@peachpit.com.

Peachpit Press is a division of Pearson Education.

Series Editor: Linnea Dayton
Peachpit Press Editor: Karyn Johnson
Cover design: Mimi Heft
Cover illustration: Cher Threinen-Pendarvis
Book design: Jill Davis
Art direction and layout: Cher Threinen-Pendarvis
Editors: Carol Benioff, Jennifer Lynn, Beth Prince
Proofreader: Linda Seifert
Indexer: Joy Dean Lee
Peachpit Press Production Editor: Hilal Sala
Production and Prepress Manager: Jonathan Parker

This book was set using the Stone Serif and Stone Sans families. It was written and composed in InDesign CS3. Final output was computer to plate at CDS, Medford, Oregon.

ISBN-13: 978-0-321-68579-7
ISBN-10: 0-321-68579-2

0 9 8 7 6 5 4 3 2 1
Printed and bound in the United States of America.

CREDITS

Cher Threinen-Pendarvis is the originator of *The Painter Wow! Books*. In addition to being the author of this book, she is a fine artist, designer, educator and author of *The Photoshop and Painter Artist Tablet Book: Creative Techniques in Digital Painting* and co-author of *Beyond Digital Photography: Creating Fine Art with Photoshop and Painter* (with Donal Jolley). A California native, she lives near the coast with her husband, Steve, who is an innovative surfboard designer.

Exercising her passion for Painter's artist tools, Cher has worked as a consultant and demo-artist for the developers of Painter. Her artwork has been exhibited worldwide and her articles and art have been published in many books and periodicals. Cher holds a BFA with Highest Honors and Distinction in Art specializing in painting and printmaking, and she is a member of the San Diego Museum of Art Artist Guild. She has taught Painter and Photoshop workshops around the world, and is principal of the consulting firm Cher Threinen Design. To learn more about Cher, please visit her Web site at www.pendarvis-studios.com.

Carol Benioff helped to develop and illustrate techniques for Chapters 3, 4, 6, 8 and 12, and she edited portions of Chapters 4, 8, 10, 11, and 12. A native San Franciscan, she is an award-winning artist and illustrator currently living in Oakland, California. Carol loves combining Painter with her printmaking, drawing and painting tools, which is an ongoing experiment that she uses in all her work. When she puts down her brush, she loves to garden, accompanied by her cats, and take long walks in the woods with her companion, Heinz. You can see more of Carol's art and illustrations on her Web site, www.carolbenioff.com.

Please see the Acknowledgments for a more thorough listing of the *Painter Wow!* team contributors.

To my husband, Steven,
for his friendship,
encouragement and understanding;
and to our Creator
from whom all inspiration comes...

— Cher Threinen-Pendarvis

John Derry, co-creator of Painter

FOREWORD

The Painter Wow! Book is now in its ninth edition. The world of digital art has changed a lot since the first edition was published in 1995. The Web, digital photography, and affordable large-format archival inkjet printing were all in their infancy. Very few artists had a Wacom drawing tablet, let alone knew what it was. Today, these technologies are ubiquitous and it is hard to imagine the world without them.

Looking through the editions of the *Painter Wow!* books is like digging down through the geologic layers of digital art: The original edition's contributing artist appendix listed the artists' mailing addresses—how Twentieth Century. Now everyone has a Web site and email address.

Back then, any photographic source art was captured via scanner. Now, film is dead and everyone has a digital camera.

Output of artwork was either via inkjet prints that quickly faded in sunlight or expensively printed on high-end Iris printers. Today, the majority of artwork is displayed via the Web on flat panel displays, or printed with high-quality archival inks and substrates by the artists themselves.

Painter-created images now appear routinely in a broad range of high-end publishing, whereas it was a creation tool used by a much smaller group of artists in the early years.

The upshot of this technologic evolution illustrates how the *Painter Wow!* series has kept apace with these advancements. What hasn't changed are the basics of how good, well thought out art is created. Throughout *Painter 11 Wow!*, Cher provides her patented high-quality instruction; you don't just learn about the tools, but how to express yourself through them.

John Derry created HHT Abstract 1 *using the Artists' Oils and his own custom Image Hose brushes.*

Dundee Morn *is a photo-painting that John Derry created using a variety of Digital Watercolor brushes.*

Combining newfangled technologies in concert with tried-and-true art and design fundamentals is quite the juggling act and Cher does it with aplomb. Art is not a way point but a journey. As the technology of digital art has evolved, so has Cher's inclusion of it within *Painter Wow!*. Whether you're new- or old-school, there is a wealth of valuable information compressed between the covers of this book.

I've been privileged to write the forewords for Cher's entire series of *Painter Wow! Books*. Something tells me this won't be the last one . . .

John Derry
Omaha, Nebraska
February 2010

Brachs Fall *is a packaging illustration created by Michael Bast.*

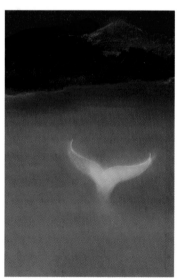

Kathy Hammon painted The Whale *using the Chalk, Pastels, Oil Pastels, Sumi-e and Blenders brushes.*

PREFACE

No matter how familiar you are with Painter, and no matter what type of art you want to create, you will find no better companion than *The Painter Wow! Book*.

Each *Painter Wow! Book* in the series has been an invaluable learning resource, as well as a source of inspiration thanks to amazing artwork from countless artists. *The Painter 11 Wow! Book* continues this tradition, offering the insight and expertise that only Cher can provide through her years of experience with Painter. Equipped with her knowledge of the nuances of the various tools and brushes offered by Painter, Cher provides countless tips, tricks, and techniques that help you get the most out of virtually every aspect of the program.

When I first saw Cher's *The Painter Wow! Book* (for Painter 8), I was immediately struck by Cher's depth of knowledge on Painter, and I took the opportunity to learn many of the program's inner workings. As I've continued my journey with Painter, I've always held Cher in the highest regard. When contemplating and developing new features for Painter, I've counted Cher among my closest advisors. And when designing new brushes, I've depended on Cher for her understanding of how the Painter brush engine

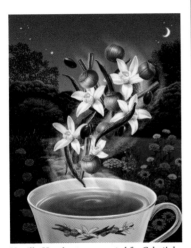

Vanilla Hazelnut *was created for Celestial Seasonings teas by Delro Rosco. Rosco used a variety of Watercolor brushes to paint the illustration.*

works, and for her artist's perspective on how brushes should look and function.

Whether you are new to Painter or a long-time user of the program, you'll find that *The Painter 11 Wow!* Book can help you express your vision in no time. And with a little extra effort, you, too, can master Painter.

Steve Szoczei
User Experience Designer, Corel Painter
March 2010

Mark Zimmer created the original Paint Can *image for the Painter 1.0 program.*

John Derry created the Burning Ice Cube *for the Painter 2 poster.*

ACKNOWLEDGMENTS

The Painter 11 Wow! Book would not have been possible without a great deal of help from some extraordinary people and sources.

First of all, I am grateful to each of the talented Painter artists who contributed their work and techniques; their names are listed in Appendix D in the back of the book.

Heartfelt thanks go to my friend and colleague Carol Benioff for collaborating with me to create new art and for helping to edit chapters. Warmest thanks go to Linnea Dayton, our *Wow!* Series Editor and a longtime friend and colleague. During all nine editions, her inspiration, wisdom and encouragement were invaluable. Special thanks go to Jill Davis for her brilliant book design, to Beth Prince for her enthusiastic technical editing, to Jennifer Lynn for her helpful copy-editing, to Linda Seifert for her careful proofreading, to Joy Dean Lee for her expert indexing, and to longtime friend and colleague Jonathan Parker, for his careful attention to the production issues. Jonathan's calm assurance during the deadlines of all nine editions of this book was much appreciated!

Sincere thanks go to my friends at Peachpit Press, especially Ted Nace for his inspiration, Nancy Ruenzel for guidance, Karyn Johnson for her advice, Hilal Sala for her production advice, Eric Geoffroy for his work on the CD-ROM, Mimi Heft for the beautiful cover design, and the rest of the Peachpit publishing team for their support. Thank you, Peachpit, for giving me the opportunity to write this book.

A big "thank you" goes to the creators of Painter: Mark Zimmer, Tom Hedges and John Derry, for creating such a *Wow!* program with which we artists can enjoy limitless creativity. Sincere thanks go to my longtime friend John Derry, for his inspiration and

Pouring it on with Painter *was created for the Painter 3 poster by John Derry.*

John Derry created this illustration for the Painter 5 poster.

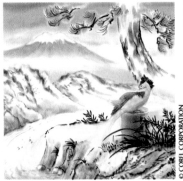

Phoenix and Painter at Mount Fuji *was created for the Painter 7 poster by Cher Threinen-Pendarvis.*

encouragement, which have been motivating factors during all editions of *The Painter Wow! Book*.

My warmest thanks go to Rob MacDonald and Steve Szoczei, the Product Manager and User Experience Designer for Painter products, for their support. I'm also grateful to the Painter 11 development team: Project Manager Heather Anderson, Vladimir Makarov, Aliaksandr Piashko, Caroline Sauvé, Christopher Tremblay, Daniel Jetté, Pascal Becheraz, Philippe Casgrain, and the QA folks—Rina Fougere, Ruby Panoch and Wendy Cook.

I'd also like to thank the companies who supplied the *Wow!* book team with supporting software and hardware during the development of the book. I'm grateful to Adobe Systems for supplying me with Photoshop, so that I could demonstrate how nicely the program works with Painter.

Thanks to Wacom for their great pressure-sensitive tablets and Cintiq pressure-sensitive LCD, and to Epson for color printers for the testing of printmaking techniques.

Thanks to Corbis Images, PhotoDisc and PhotoSpin for their support during all editions of the book; these "stock on CD-ROM and Web" companies allowed us to use their photos for demonstration purposes in the book. I am also grateful to the other companies who provided images or video clips for *The Painter 11 Wow!* CD-ROM; they are listed in Appendix A in the back of the book.

My warm thanks go to Carol Benioff for sharing her expertise in traditional and digital printmaking and Steven Gordon for his experience with terrain maps. Special thanks go to Dorothy Krause, Bonny Lhotka and Karin Schminke for sharing their knowledge of experimental printmaking; Jon Lee and Geoff Hull of Fox Television for sharing their experience in designing for broadcast television; Cindy and Dewey Reid of Reid Creative, and John and Joyce Ryan of Dagnabit! for sharing their expertise in animation and film.

A heartfelt thank you to these special "co-workers": to my husband, Steve, for his encouragement, humor, healthy meals and reminders to take surfing breaks and morning walks together during the project; and to our cats, Pearl, Sable and Marika, the close companions who entertain us and keep me company in the office and studio. Warm thanks go to dear friends Lisa Baker, Susan Bugbee, Elaine Chadwick, Rick Geist, Julie Klein, Michele Jacquin, Donal Jolley, Beth Meyer, Janine Packett and Ian O'Roarty, who shared sincere encouragement and prayers. Thanks for checking in with me while I worked!

Finally, I would like to thank all the other family, friends and colleagues who have been so patient and understanding during the development of nine editions of this book.

— Cher Threinen-Pendarvis

CONTENTS

WELCOME TO *PAINTER 11 WOW!*

SOME PEOPLE EMPHASIZE THE DIFFERENCES between traditional and digital art tools—almost as if "real" art and the computer are not compatible. But during the early development of this book, we discovered many working artists who had bought computers specifically because they were thrilled by the promise of Painter. It seemed logical that *The Painter Wow! Book* should become a bridge connecting conventional tools and techniques with their electronic counterparts. Early chapters of the book, in particular, touch on color theory, art history and conventional media, and explain how to translate foundational art theory using Painter's tools.

This book addresses the needs of a wide variety of creative professionals: artists making the transition from traditional to digital media; photographers looking to expand their visual vocabulary; screen or print graphic designers hunting for special effects to apply to type and graphics; even creative explorers out for some fun. For those of you with a long history in a traditional art form and a short history with computers, we've done our best to guide you through Painter's interface, making it as simple as possible for you to achieve the results you want. And if you've spent more time with a keyboard and mouse than you have with an artist's palette and paintbrush, you may learn a lot about conventional art terms and techniques as you read the book.

The creative team that invented Painter—Mark Zimmer, John Derry and Tom Hedges—are famous for their creativity. The exciting new natural-media tools such as the responsive Hard Media brushes—including the Pencils and Markers—simulate the performance of their traditional counterparts more than ever before. Corel has made significant changes to the interface that make Painter more streamlined and efficient to use—for instance, brushes perform as much as 30% faster than before.

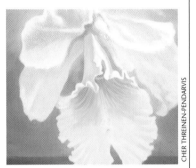

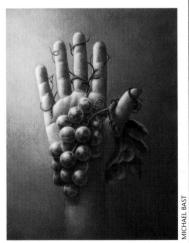

Carol Benioff used Acrylics brushes with RealBristle qualities—including the Real Wet Brush—to create Portrait of Nana, *a detail of which is shown here.*

Floating Orchid 2, *a detail of which is shown here, was created using various Hard Media brushes including the Real Hard Chalk and Real Soft Chalk.*

Michael Bast used the Art Pen Brushes, Sponges variants and the Wacom 6D Art Pen to create to create Vine and Hand.

WHAT'S NEW IN PAINTER 11?

To make *The Painter 11 Wow! Book* complete and up-to-date for Painter 11, we've revised every page. And we've added brand-new techniques, new real-world tips, and galleries that specifically profile features added in version 11. Here's a quick overview of some of Painter's exciting new features and a description of where in this book you can find information about them.

Among the changes that make Painter easier to use are these: Painter 11 features **enhanced speed and stability**. You will notice dramatic performance improvements, especially when painting with brushes and when opening and saving files.

Painter 11 boasts exciting new natural-media features, including the **Hard Media** brushes, with dozens of new brushes scattered throughout existing brush categories, including the Chalk, Pastels, Pencils and Pens. As with traditional chalk and pencils, you can use the tip for drawing and the side of the tool for shading. Painter 11 also boasts a new brush category with Hard Media capabilities— the **Markers**, with which you can paint a continuous shade or a buildup of color. See "A Painter Hard Media Primer" on page 72 and "Painting with the Hard Media Brushes" on page 75 for information about using these new tools in a creative way.

With Painter 11, the **Transformation** capabilities are combined into a centralized **Transform tool**, improving the ease and efficiency of transforming image elements. The new Transform tool offers easy-to-use buttons on the Property Bar that allow artists to quickly switch between the Move, Scale, Rotate, Skew, Distort, and Perspective Distortion modes, "Commit the transformation" and more. See "A New Transform Tool" on page 205 for information about using this new tool.

The updated **Colors** palette and **Mixer** palettes have been redesigned with Painter 11 so they can be resized, allowing for more accurate color choices. The Colors palette can be enlarged as much as 800% for a more detailed view when choosing colors. When scaling the Mixer palette more swatches appear to make color mixing easier. After choosing and mixing colors, the Colors and Mixer palettes can be reduced to their normal size. To learn more about the updated Colors palette and Mixer, see pages 24–25.

The improved **Color Management** system in Painter 11 includes individual color profiles for each document and better color recognition for imported files, and more, so fewer corrections need to be made and our workflow is more efficient. For information about the updated Color Management system, see Chapter 12 "Output and Printing Options" on page 376.

Painter 11 features **enhanced support** for the new Wacom **Intuos4** tablets and the **Cintiq pressure-sensitive LCD**, which when combined with the amazing new Hard Media brushes allow you to express an unprecedented range of natural hand movements.

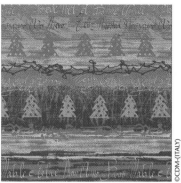

Athos Boncompagni used Painter's Chalk, Pastels, Oils and Pens brushes in creating this wrapping paper design.

1

You'll learn real applications for Painter's tools in the Basics sections of each chapter.

2

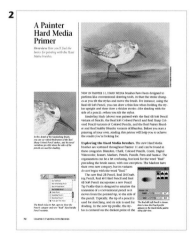

The Primers include detailed information about Painter's more complex media.

DO YOU USE MAC OR WINDOWS?

Painter works similarly on Macintosh and PC/Windows platforms. We've taken the path of least resistance by using screen shots primarily from the Macintosh OS X systems we work with. (Just to make sure of our techniques, though, we've tested them under Windows Vista and XP, and we've included key commands for both Windows and Mac users.) The few differences between running Painter on Mac and on PC are covered in Chapter 1.

ARE YOU A BEGINNER OR A POWER USER?

If you're new to Painter, welcome! We've worked very hard to make this edition of *Painter Wow!* friendly to beginners by adding many cross-references and by including complete, unabbreviated directions to the techniques in the book. We've also added more basics to the chapter introductions. For intermediate and advanced users, we've included new power-user tips throughout and added many new techniques and inspiring galleries.

We've assumed that you're familiar with the basic Mac or Windows mouse functions and that you know how to open and save files, copy items to the clipboard and navigate through the Mac's hierarchical file system or through Windows directories. We suggest reading Chapter 1, "Getting To Know Painter," right away, and reading the beginning pages of Chapter 5, "Selections, Shapes and Masks," and Chapter 6, "Using Layers," before jumping into the techniques that include layers and masking. It's also a good idea, though it isn't essential, to have looked through the documentation that comes with the program.

HOW TO USE THIS BOOK

In Chapters 2 through 12 and the appendixes, the information we're presenting generally progresses from simple to complex. We've organized these chapters into six types of material: "Basics" sections, "Primers," techniques, practical tips, galleries and appendixes.

1 The Basics sections teach how Painter's tools and functions work, with real-world applications. *The Painter 11 Wow! Book* wasn't designed to be a replacement for the *Painter Help* or the manual that comes with the program. We've focused on how to use the tools and functions that we think are most useful. In some cases we've further explained items addressed in the manual, and, where important, we've dug deeper to help you understand how the tools and functions work. In other cases, we've covered undocumented functions and practical applications, either shared by contributing artists or uncovered in our own research.

2 Several of Painter's media types (for instance the Artists' Oils, Hard Media, Impasto, Liquid Ink and Watercolor), are rich and complex, so we've written detailed, inspirational Primers to help you unlock their power.

3 SAMPLING PAINT

You can temporarily switch to the Dropper tool and sample colors by holding down the Alt/Option key while you're using many of Painter's other tools.

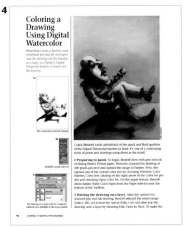

Each chapter includes step-by-step Technique sections.

Each chapter includes an inspiring gallery of professional work.

3 The Tips are easily identified by their gray title bar. We've placed them in the Basics and Technique sections where we thought they'd be the most helpful. But each tip is a self-contained tidbit of useful information, so you can learn a lot very quickly by taking a brisk walk through the book, reading only the tips.

4 Within each Technique section, you'll find step-by-step, real-world methods that give you enough information to re-create the process yourself. In the *Wow!* format, pictures illustrating the stages of the process are positioned alongside the appropriate step in the project. Browse the pictures in the art column within a technique for a quick overview of the development of an image. We've done our best to give you enough information so you won't have to refer to the manual to follow the steps.

5 The Galleries are there for inspiration, and one appears at the end of every chapter. With each gallery image, you'll find a short description of how the artwork was produced.

No book is an island, so in the Appendixes in the back of this one, we've included lists of other resources for your use. If you want to contact a vendor, an artist, or a fine-art print studio, or locate an art-related book or other publication, you'll find the information you need there.

The Painter 11 Wow! Book was created to share useful techniques and tips and to provide creative suggestions for using the program. We hope that you'll use it as inspiration and a point of departure for your own creative exploration. Above all, don't be overwhelmed by Painter's richness. Just dig in and enjoy it!

—Cher Threinen-Pendarvis

Cher Threinen-Pendarvis's web site: www.pendarvis-studios.com

GETTING TO KNOW PAINTER

John Derry's illustration, Brush Mandala, *was inspired by the artist Peter Max. Derry created it for the promotion of Painter using a variety of brushes and special effects such as Effects, Esoterica, Blobs and Apply Marbling. To create the mirrored group of paintbrushes, he used Painter's Kaleidoscope, available through the Dynamic Plug-ins menu at the bottom of the Layers palette. Derry also painted spontaneous brush strokes using the Smeary Flat variant of Oils and the Smooth Ink Pen variant of Pens.*

SIT RIGHT DOWN AND POWER UP! This chapter explores Painter's basic functions and unique strengths, as well as what's required to run the program. If you're new to Painter, you may want to use Painter 11 Help, available through the Help menu, to further explore topics that intrigue you.

PAINTER'S REQUIREMENTS FOR MAC AND PC

Here are Painter's *minimum* requirements: If you use a Macintosh you'll need at least a G5, 700 MHz or faster, running System OS X 10.4 (with latest version), 1 GB of application RAM. To run Painter on Windows Vista™, or Windows XP, you'll need a Pentium 4, 700 MHz or faster, with 1 GB MB of application RAM. For both platforms, a 1024 x 768 display with 24-bit color is recommended, and a hard disk with approximately 500 MB of free space is required to perform an installation.

When you open an image in Painter—for example, a 5 MB image—and begin working with it, Painter needs three to five times that file size in RAM in order to work at optimal speed—in our example, that would be 15 to 25 MB of RAM. Opening more than one image, adding layers or shapes, or increasing the number of Undos (under Edit, Preferences, Undo, in Windows, and under Corel Painter 11 on Mac OS X) adds further demands on RAM. When Painter runs out of RAM, it uses the hard disk chosen under Edit, Preferences, Memory & Scratch in Windows and under Corel Painter 11 on Mac OS X as a RAM substitute, "scratch disk." Since hard disks operate more

ABOUT LAYERS AND SHAPES

Layers and *shapes* are image elements that are "stacked" above the Painter image canvas. Both layers and shapes can be manipulated independently of the image canvas—allowing for exciting compositing possibilities.

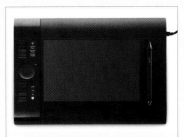

This Wacom Intuos4 pressure-sensitive tablet with stylus is versatile and easy to use. The Intuos4 tablets offer pressure-sensitivity, as well as tilt and bearing. Tablets with these capabilities allow you to paint more expressive strokes with Painter's brushes that can sense the pressure you apply, and the rotation of your hand, as you draw. You will find detailed information about using a tablet in The Photoshop and Painter Artist Tablet Book, published by Peachpit Press (www.peachpit.com/tabletbook).

slowly than RAM, performance suffers—even if you have a fast hard disk.

Ideally, to work with Painter, you would use a computer with a speedy processor; a large, fast hard disk; and lots of RAM. In addition, you'll want a large, 24-bit color monitor—probably no less than 17 inches—and perhaps a second monitor on which to store palettes. Also highly recommended—some would say *essential*—is a pressure-sensitive drawing tablet with a stylus. Not only is it a more natural drawing and painting tool than a mouse, but many of Painter's brushes have a lot more personality with a pressure-sensitive input device.

The Scratch Disk pop-up menu with a Volume chosen

Memory allocation. Painter users can set the maximum percentage of available RAM for Windows and Mac OS X that Painter will use. Windows users go to the Edit menu and then choose Preferences, Memory & Scratch. Mac OS X users go to the Corel Painter 11 menu and then choose Preferences, Memory & Scratch. You can specify more than the default 80% of available RAM for Painter, but this may or may not increase performance. The minimum that you can specify is 5%. If you type a number in the dialog box to change it, quit all applications, and then relaunch Painter.

FILE SIZE AND RESOLUTION

If you're new to the computer, here's important background information regarding file sizes: Painter is primarily a *pixel-based* program, also known as a *bitmap*, *painting* or *raster* program, not a *drawing* program, also known as an *object-oriented* or *vector* program. Drawing programs use mathematical expressions to describe the outline and fill attributes of objects in the drawing, while pixel-based programs describe things dot-by-dot. Since mathematical expressions are more "compact" than dot-by-dot descriptions, object-oriented files are generally smaller than pixel-based files. Also, because its components are mathematically described, object-oriented art can be resized or transformed with no loss of quality. Not so with Painter, Photoshop and other pixel-based programs. Increasing the size of most images in these programs means that additional pixels must be created to accommodate the larger size by filling in spaces as the existing pixels spread apart. As a result of these interpolated (manufactured) pixels, resized images can lose their crispness.

There are ways of working around this "soft image" dilemma. One solution is to do your early studies using a small file size (for instance, an 8 x 10-inch image at 75 pixels per inch), and then start

This scan of a photograph is a pixel-based image. Enlarging it to 1200% reveals the grid of pixels.

Using Painter's cool Sketch effect, you can generate a black-and-white sketch from a photo. Open an image with good contrast, and then choose Effects, Surface Control, Sketch. In the dialog box, move the Grain slider to the right to add more grain and leave the Sensitivity slider at a lower range if you'd like to pick up primarily the edges.

We increased the Sensitivity to 1.40 to pick up lines from the photo background. We set the Grain setting at 1.40 to add richer paper grain to the sketch.

The black-and-white "sketch" image

over with a large file to do final art at full size (for instance, an 8 x 10-inch file at 300 pixels per inch). Another approach is to block in the basic form and color in a small file, and then scale the image up to final size (using Canvas, Resize) and add texture and details (textures seem particularly vulnerable to softening when enlarged). You'll notice that many of the artists whose work is featured in this book use another efficient method: They create the components of a final piece of art in separate documents, and then copy and paste (or drag and drop) the components into a final "master" image. Painter offers yet another solution for working with large file sizes—composing with reference layers which are small "stand-in" versions of larger images. Because data for the larger images is not kept in the working file, performance improves. "Using Reference Layers" on page 208, tells more about this feature.

Painter's vector capabilities. Although the image canvas, masks and image layers—are pixel-based, the program does have some object-oriented features—type, of course, and shapes, shape paths and outline-based selections. Painter's shapes exist as layers above the image canvas; they are mathematically described outlines with stroke and fill attributes. And Painter's selections (areas of the image designated for work) are versatile; they can be used as pixel-based selections (similar to Photoshop's selections), or they can be transformed into outline-based selections or converted into shapes. Chapters 5 and 6 tell more about selections and shapes.

Pixels and resolution. There are two commonly used ways of describing file sizes: in terms of their pixel measurements, or in a unit of measure (such as inches) plus a resolution (pixels per unit of measure). An image is a fixed number of pixels wide and tall—like 1200 x 1500—or a measurement combined with a resolution—4 x 5 inches at 300 ppi (4 x 300=1200, and 5 x 300=1500). If you use pixels as a measurement for Width and Height in the New dialog box when you create a file, notice that changing the numbers you type into the Resolution box doesn't change the file size. But increasing or decreasing the number of pixels in the Width and Height fields in the New dialog box or the Canvas, Resize box will add (or reduce) pixel information in the picture.

Here are two ways to make quick copies without going through the clipboard and using valuable RAM. To make a copy of your entire document, use File, Clone. (This is also a quick way to make a "flat" copy with the layers in the document merged.) To quickly duplicate a layer, select the layer in the Layers palette, choose the Layer Adjuster tool, press the Alt/Option key and click in the image to make a copy in register, or drag off a copy into another area of the document.

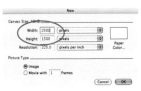

Expressing width and height in pixels in the New dialog box keeps the file size the same, regardless of how you change the resolution.

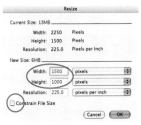

Whether the Constrain File Size check box in the Resize dialog box is checked or unchecked, if you're using pixels as the units, the file size stays the same, regardless of how you change the resolution.

In the File, Save dialog box, you can choose to have Painter append a file extension and embed the Color Space when you save the file. You can choose to preserve alpha channels when saving as well.

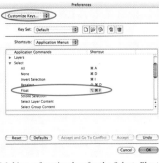

Click the Browse button in the Open dialog box to preview all the images in a folder. The watercolor studies in Mary Envall's "Lilies" folder are shown here. (Some files may not have a preview—for example, some PICT or JPEG files created by other programs.)

OPENING FILES

Images in Painter are 24-bit color, made up of RGB (red, green and blue) components consisting of 8 bits each of color information. Painter will recognize and open CMYK TIFF and grayscale TIFF images as well as layered Photoshop format files in CMYK, but it will convert both CMYK and grayscale files to Painter's own RGB mode. LAB format and other color formats will need to be converted to RGB in a program such as Adobe Photoshop or Equilibrium's Debabelizer before Painter can read them.

SAVING FILES

Painter offers numerous ways to save your image under File, Save or Save As. If you've created an image with a mask to hide some parts and reveal others (Chapter 5 discusses masks), some of the formats will allow you to preserve the mask (by checking the Save Alpha box in the Save or Save As dialog box), while others won't. Here's a list of the current formats that includes their "mask-friendliness" and other advantages and disadvantages:

USEFUL FUNCTION KEYS

You can set the F keys on your keyboard for your own favorite commands, making it easier to access the commands nested in Painter's menus and palettes. Choose Edit, Preferences, Customize Keys (Windows) or Corel Painter 11, Preferences, Customize Keys (Mac OS X). You can create your own custom set, or add new commands to Painter's default key set. To give the helpful Float command a shortcut, choose Application Menus from the Shortcuts pop-up menu, open the arrow to the left of Select and then click on the Float command. In the highlighted shortcut area, type Alt-Ctrl-F (Windows) or Option-⌘-F (Mac). The key command appears under the Shortcut list. Click OK to accept.

Making a function key for the Select, Float command using Customize Keys

RIFF. Thrifty (files are saved quite small) and robust (allows for multiple layers), RIFF (Raster Image File Format) is Painter's native format. If you're using elements unique to Painter, such as Watercolor layers, Liquid Ink layers, reference layers, dynamic layers, shapes, or mosaics, saving in RIFF will preserve them. (Watercolor layers, Liquid Ink layers, reference layers, dynamic layers and shapes are described in depth in Chapter 6; mosaics are described in Chapter 8.) If you have *lots* of free hard disk space, check the Uncompressed box in the Save dialog box when you're saving in RIFF: Files will become many times larger, but will save and open much more quickly. Few other programs recognize RIFF, so if you want to work with a Painter image in another program, save a copy in a different format.

You can preserve pixel-based layers in files by saving in either RIFF or Photoshop format. Rick Kirkman's 2025 x 2517-pixel image with 8 layers weighs in at 15.8 MB as a compressed RIFF, 119.3 MB as an uncompressed RIFF.

Photoshop format. Saving files in Photoshop format gives you nearly all the flexibility of RIFF, and is ideal if you frequently move data between Painter and Photoshop. When you use Photoshop to open a file saved in this format, Painter's layers become Photoshop layers (Chapter 10, "Using Painter with Photoshop," contains more information about working with Painter and Photoshop); Painter's masks (explained in depth in Chapter 5) become Photoshop channels; and Painter's Bézier paths translate perfectly into Photoshop's paths and subpaths, appearing in Photoshop's Paths palette.

TIFF. Probably the most popular and widely recognized of the bitmap file formats, TIFF allows you to save a mask with your image (check the Save Alpha check box). Unfortunately, unlike Photoshop, all your layers are dropped onto the background, and only the first of your User Masks will be visible in Painter. Also note, Painter's Save As dialog box gives you no option to compress the TIFF file—the Uncompressed check box is checked and grayed-out.

PICT. PICT is the format of choice for many Mac multimedia programs and other onscreen displays. Painter's PICT format lets you save a single mask (but not layers), and you can save a Painter movie as a sequence of numbered PICT files to export and animate in another program (described in Chapter 11, "Animation and Film with Painter"). Painter also opens PICT files very quickly.

JPEG. When you save a file in JPEG format, a dialog box will appear with four choices: Excellent, High, Good and Fair. You'll get the best-looking results by choosing Excellent. The advantage of saving a file in JPEG format is that you get superb space savings: A JPEG file is usually only one-tenth as large as a TIFF file of the same image if you choose Excellent, and only one-hundredth the size if you choose Fair. The drawbacks: no mask, layers or

WORKING WITH CMYK

Here are some hints for working with Painter in a CMYK production environment. If you're starting with scanned images, scan them in RGB instead of CMYK—RGB has a significantly broader color gamut. If possible, avoid importing your image into another program (like Photoshop) to convert it to CMYK until you're ready to print, since you lose colors when you convert from RGB to CMYK. And, it's a good idea to save a copy of the RGB image before converting in case you want to convert it again with different RGB-to-CMYK conversion settings.

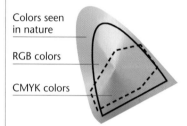

Colors seen in nature

RGB colors

CMYK colors

Relative sizes and extents of color gamuts

To create Zorro's Gone, Janet Martini used several of Painter's brushes and effects. She colored the birds white using the Graphic Paintbrush variant of F-X. To complete the image, she added a Woodcut look by choosing Effects, Surface Control, Woodcut.

paths are saved, and the compression is a lossy compression—which means that some data (color detail in the image) is lost in the compression process. While JPEG is a good way to archive images once they're finished (especially images that have no sharp edges), many artists prefer not to use JPEG because it alters pixels. Don't save a file in JPEG format more than once—you'll lose more data every time you do so.

JPEG is also useful for preparing 24-bit images with the tiny file sizes that are needed for graphics used on the World Wide Web.

A SAVING GRACE

Saving multiple versions of your art at various steps along the way makes good sense: It helps you remember how you created your art, and it could be your saving grace if a file gets corrupted.

GIF. GIF is the graphics format of choice for the majority of non-photographic images on the Web. Like saving in TIFF, PICT or JPEG, saving in GIF format combines layers with the background. It also reduces the number of colors to a maximum of 256, so remember to Save As in a different file format first if you want to be able to access the original image structure again. When you save in GIF, a dialog box appears that gives you a number of options for saving your file. Check the Preview window to see how your choices will affect your image.

EPS. Saving in this format drops layered elements into the background and ignores masks, so it's best to choose Save As in another format if you'll want to make changes to your document at a later time. Saving in EPS format also converts the file into a five-part DCS file: four separate files for the four-process printing colors, and a fifth file as a preview of the composite image. Check the Painter Online Help (Help, Help Topics) for a complete explanation of the EPS Options dialog box.

PC formats. BMP, PCX and Targa are formats commonly used on DOS and Windows platforms. BMP (short for "bitmap") is a Windows-based graphics file format, and PCX is the PC Paintbrush native format. Neither of these two formats supports shapes or masks. Targa is a popular format used for creating sophisticated 24-bit graphics. The Targa format is often used (in place of PICT) when preparing numbered files for import into Windows animation applications.

Movie formats. Movies in Painter (described in Chapter 11, "Animation and Film with Painter") are saved as frame stacks, but you can choose Save As to export the current frame of your movie, export the entire frame stack as a QuickTime or AVI (on the PC)

Save As GIF Options

Misc Options: ☐ Interlaced

Map Options: ☐ NCSA Map File
☐ CERN Map File
☐ Client Side Map File

Imaging Method: ⦿ Quantize to Nearest Color
☐ Dither Colors

Transparency: ☐ Output Transparency
⦿ Background is WWW Gray
☐ Background is BG Color
Threshold: ◄ ▢▢▢▢▢▢▢▢▢ ► 256

Preview

Number of Colors: ☐ 4 Colors
☐ 8 Colors
☐ 16 Colors
☐ 32 Colors
⦿ 64 Colors
☐ 128 Colors
☐ 256 Colors
☐ Color Set

(Cancel) (OK)

The Save As GIF Options dialog box includes GIF Animation Options.

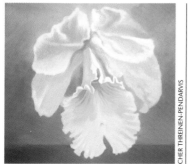

Floating Orchid 2, a detail of which is shown here, was painted with Painter's new brushes that feature Hard Media capabilities, including the Real Soft Chalk and Real Hard Chalk. The final painting appears on the front cover of this book.

movie or export the entire Frame Stack as numbered PICT files. See Chapter 11 for more about multimedia formats.

PAINTER BASICS

Here's a guide to some of Painter's basic operating procedures:

Navigating the Painter Workspace. The Painter 11 workspace is easy to use. Tools and functions are organized into menus, selectors and palettes, or are set in the frame of the document window (for instance, the Scale slider and the Drawing Mode icon). The Content Selectors in the Toolbox and the context-sensitive Property Bar allow you to choose art materials and change settings quickly. Painter's palettes (for instance, the Brush Controls, Color palettes and Library palettes) can be accessed from the Window menu.

Painter's Menus, Palettes and Document Window

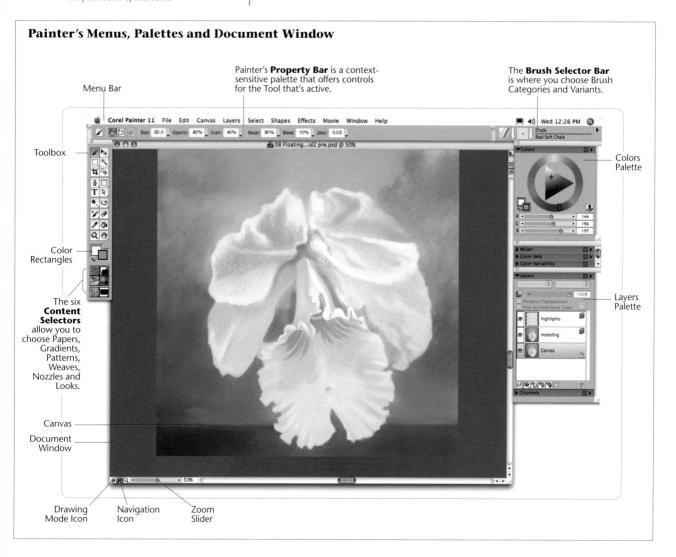

Menu Bar

Painter's **Property Bar** is a context-sensitive palette that offers controls for the Tool that's active.

The **Brush Selector Bar** is where you choose Brush Categories and Variants.

Toolbox

Colors Palette

Color Rectangles

The six **Content Selectors** allow you to choose Papers, Gradients, Patterns, Weaves, Nozzles and Looks.

Layers Palette

Canvas

Document Window

Drawing Mode Icon

Navigation Icon

Zoom Slider

You can change settings in the Property Bar for the Brush tool using your keyboard. Press **b** to navigate to the Brush tool, and then press **v** to paint straight lines; press **b** to toggle back to freehand operation.

*In this detail of the Property Bar, Freehand Strokes mode is chosen. To paint Straight Line Strokes, click the button to the right, or press **v** on your keyboard.*

Painter's Layer Adjuster tool is analogous to the Move tool in Adobe Photoshop. You can use the Ctrl/⌘ key to switch temporarily to the Layer Adjuster tool when you are using any of the following tools: the Magnifier, Rotate Page, Crop, Lasso, Magic Wand, Brush, Paint Bucket, Dropper, Rectangular Selection, Oval Selection, Selection Adjuster, Dodge, Burn, Eraser, Cloner, Rubber Stamp and Shape Selection.

Using the Toolbox. Painter's slick Toolbox features mark-making tools, and tools with which you can draw and edit shapes, view and navigate a document and make selections. In addition to the Color Rectangles, you'll also find the Content Selectors near the bottom of the Toolbox.

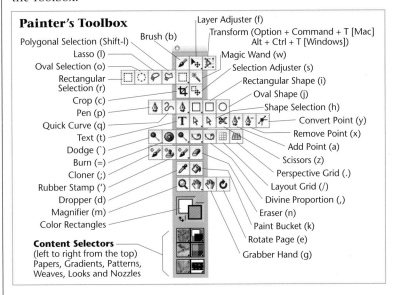

Painter's Toolbox

Layer Adjuster (f)
Transform (Option + Command + T [Mac] Alt + Ctrl + T [Windows])
Brush (b)
Polygonal Selection (Shift-l)
Magic Wand (w)
Lasso (l)
Selection Adjuster (s)
Oval Selection (o)
Rectangular Shape (i)
Rectangular Selection (r)
Oval Shape (j)
Crop (c)
Shape Selection (h)
Pen (p)
Convert Point (y)
Quick Curve (q)
Remove Point (x)
Text (t)
Add Point (a)
Dodge (`)
Scissors (z)
Burn (=)
Perspective Grid (.)
Cloner (;)
Layout Grid (/)
Rubber Stamp (')
Divine Proportion (,)
Dropper (d)
Eraser (n)
Magnifier (m)
Paint Bucket (k)
Color Rectangles
Rotate Page (e)
Grabber Hand (g)

Content Selectors
(left to right from the top)
Papers, Gradients, Patterns,
Weaves, Looks and Nozzles

Accessing art materials using the Content Selectors. Early versions of Painter used a drawer-like container to hold materials. In recent versions, swatches for Papers, Gradients, Patterns, Weaves, Looks (a combination of a brush and a paper, for instance) and Nozzles (images that are sprayed using the Image Hose) are easy to choose from the Toolbox. Each Content Selector has a triangle menu that pops out a menu with which you can access commands, like launching a full palette or loading an alternate library of materials.

Choosing Art Materials

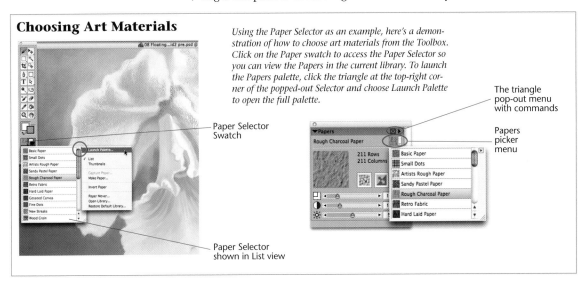

Using the Paper Selector as an example, here's a demonstration of how to choose art materials from the Toolbox. Click on the Paper swatch to access the Paper Selector so you can view the Papers in the current library. To launch the Papers palette, click the triangle at the top-right corner of the popped-out Selector and choose Launch Palette to open the full palette.

Paper Selector Swatch

The triangle pop-out menu with commands

Papers picker menu

Paper Selector shown in List view

Using the Brush Selector Bar. The Brush Selector Bar, which is located to the right of the Property Bar at the top of the Painter workspace, offers an open list of choices for both brush categories and their variants. (For more information about using the Brush Selector Bar, turn to the beginning of Chapter 3.)

The Brush Selector Bar

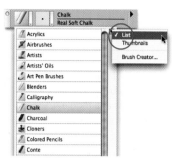 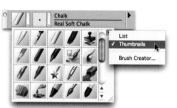 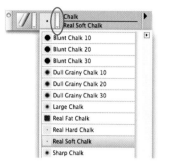

In the Brush Selector Bar, click the Brush Category icon to open the picker. Clicking on the tiny triangle to the far right of the Brush Category menu will open the pop-out menu, which will allow you to switch from List view (above left) to Thumbnail view. Click on a name or thumbnail to choose a new Brush Category.

Clicking on the Brush Variant icon in the Brush Selector Bar will open a pop-out menu, that allows you to choose a variant—in our case, the Real Soft Chalk variant of Chalk. The Brush Variant menu can be displayed using the List view (shown here) or Stroke view.

Menus

Many of Painter's menus include keyboard shortcuts.

Palettes

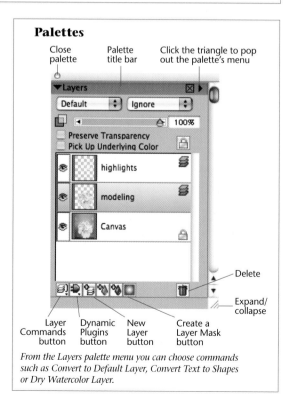

From the Layers palette menu you can choose commands such as Convert to Default Layer, Convert Text to Shapes or Dry Watercolor Layer.

By right-clicking a two-button mouse or by pressing the Control key and clicking on a one-button mouse, you can access helpful, context-sensitive menus like this one, which appears when a Brush is chosen.

Toggle Tracing Paper, Toggle Overlay, Toggle Color Correction and Toggle Impasto Effect icons reside at the top of Painter's vertical scroll bar.

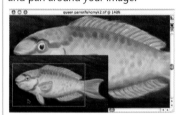

Clicking the Navigation icon (the binoculars) opens a window in which you can see the area you are viewing in relationship to the entire image.

Screen management shortcuts. Like other programs, Painter offers lots of shortcuts designed to cut down on your trips to the menus, palettes and scroll bars. To *scroll* around the page, press and hold the spacebar (a grabber hand appears), as you drag on your image. To *zoom in* on an area of your image at the next level of magnification, hold down Ctrl/⌘-spacebar (a magnifier tool appears) and click in your image. Add the Alt/Option key to *zoom out*. (You can also use Ctrl/⌘-plus to *zoom in* one magnification level and Ctrl/⌘-minus to *zoom out*.) These are the same zooming shortcuts used in Photoshop and Adobe Illustrator.

To *rotate the page* to better suit your drawing style, press spacebar-Alt (Windows) or spacebar-Option (Mac) until the Rotate Page icon (a pointing finger) appears, and click and drag in your image until the preview shows you the angle you want. (The Rotate Page command rotates the view of the image only, not the actual pixels.) Restore your rotated image to its original position by holding down spacebar-Alt or spacebar-Option and clicking once on the image.

Another frequently used screen-management shortcut is Ctrl/⌘-M (Window, Screen Mode Toggle), which replaces a window's scroll and title bars with a frame of gray (or toggles back to normal view).

Context-sensitive menus. Painter boasts context-sensitive menus that make it easier to change the settings for a brush for instance, or even quickly copy a selection to a layer. Context-sensitive menus are available for all of Painter's tools and for certain conditions, such as for an active selection when a Selection tool is chosen. To access a context-sensitive menu, right/Ctrl-click.

Helpful icon buttons. Just outside the Painter image window are two sets of helpful icon buttons. At the top right on the Painter Window scroll bar are four toggle buttons: the Toggle Tracing Paper icon (allowing you to turn Tracing Paper on and off), the Toggle Grid icon (which turns the Grid View on and off), the Toggle Color Correction icon (to toggle between the full-color RGB view and a preview of what your image will look like when printed) and the Toggle Impasto Effect icon (which you can click to hide or show the highlights and shadows on thick paint). For a step-by-step technique using Tracing Paper, see "Cloning, Tracing and Painting" on page 106; see page 15 for information about using Grid Overlay. Turn to Chapter 12, "Printing Options," for information about Painter's Output Preview; Impasto is covered in "A Painter Impasto Primer" on page 119.

Lennox Sunrise. *The Drawing Mode icons will pop up if you click the icon in the lower-left corner of the image window. They are, from left to right: Draw Anywhere, Draw Outside and Draw Inside. To read more about them, turn to page 183 in Chapter 5.*

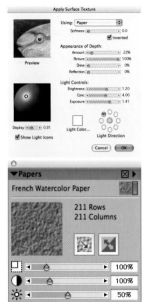

The Apply Surface Texture dialog box Preview window, shown here Using Paper (top), updates when a new choice is made in the Papers palette (bottom).

In the left corner of Painter's window frame is an icon that pops up the three Drawing Mode icons, which allow you to control where you paint—anywhere in the image, outside of a selection, or inside of a selection.

Interactive dialog boxes. Painter's interactive dialog box design encourages you to continue to make the choices you need. As an example, you can open a piece of artwork or a photo, and then choose Effects, Surface Control, Apply Surface Texture and click and drag in the Preview window until you see the part of the image that you went to view. If you then choose Paper in the Using pop-up menu you can go outside the dialog box to choose a different paper (even a paper in another library) from the Paper Selector in the Toolbox or from the Papers palette (Window, Library Palettes, Papers). You can even move the Scale, Contrast and Brightness sliders in the Papers palette and watch as the Preview image in the Apply Surface Texture dialog box updates to reflect your choice. When you've arrived at a result that you like, you can click OK in the Apply Surface Texture dialog box. The Effects, Surface Control, Color Overlay dialog box and the Effects, Surface Control, Dye Concentration dialog box behave in a similar way, allowing you to choose different papers. Or you can choose Uniform Color in the pop-up menu and test different colors from the Colors palette before you click OK. The Edit, Fill dialog box (Ctrl/⌘-F) is also interactive, giving you the ability to preview your image before it's filled with the current color, pattern, gradient or weave.

Measuring and positioning elements. The Ruler, Guides, Grid, Perspective Grids and Compositions (Divine Proportion and Layout Grid) can help you measure and position shapes and layers. The commands for these features reside in the Canvas menu. They are especially helpful for aligning text and selections.

ALIGNING SHAPES AND LAYERS AUTOMATICALLY

The Align dialog box (Effects, Objects, Align) is helpful for lining up shapes or layers (or a combination of the two). To align a series of items, start by selecting the Layer Adjuster tool, holding down the Shift key and clicking on each item's name in the Layers palette. When all the items are selected, go to the Effects menu and choose Objects, Align, and choose your settings. The dialog box preview will update to show you how your choice of Horizontal and Vertical options will affect alignment of the objects, and you can click OK to accept or cancel. The elements below in the center were aligned using Horizontal: Center and Vertical: None. The elements below on the right were aligned using their tops. The settings were Horizontal: None and Vertical: Top.

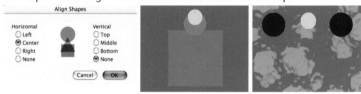

The Objects, Align dialog box with settings for the shapes in the center illustration above

Positioning the baseline of text with the help of the Ruler and a Horizontal Guide created by clicking the Vertical ruler. The circled items here are the Ruler Origin field (top) and a triangular guide marker (bottom).

SAVING CUSTOM GRIDS

Once you customize the divisions, size or guideline colors for the Layout Grid or Divine Proportions, you may want to save your custom grid for later use. You can save your grid as a preset by clicking the Add Preset button (the + near the top of the palette or in the Property Bar), naming the preset, and clicking OK. Whenever the Layout Grid or Divine Proportion is enabled, you can choose your preset by name from the Type menu at the top of the palette or in the Property Bar.

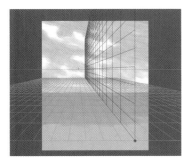

The Perspective Grid feature enables you to set up a one-point Perspective Grid, which can be useful as a guide for drawing.

To add a new guide, click on a Ruler. To set up a guide using precise measurements or to change the default guide color, double-click on a Ruler or a triangular marker to access the Guide Options, where you can change the options for an individual guide or for all guides at once. Delete guides by dragging their triangles off the document window or by pressing the Delete All Guides button in Guide Options.

To easily measure the exact *width* of an item, try moving the Ruler Origin. Press and drag it from the upper-left corner of the Ruler, where the horizontal and vertical measurements meet, to the top or the left end of the item you want to measure. Then see where the bottom or the right end falls on the ruler.

The Grid Overlay is useful for aligning items. Choose Canvas, Grid, Show Grid or click on the checkered Grid icon above the scroll bar. To change the grid's appearance (for example, to create a grid of only horizontal lines), choose Canvas, Grid, Grid Options and adjust the Grid type or other settings.

The Perspective Grid is useful both for aligning items and for drawing. Choose Canvas, Perspective Grids, Show Grid to display a grid. You can adjust the grid using the Perspective Grid tool from the Toolbox by dragging the vanishing point and horizon line or either forward edge of the grid. Choose Canvas, Perspective Grids, Grid Options to adjust the settings and to save your own presets.

The Layout Grid is helpful for planning compositions. For instance, you can divide your image into thirds or fifths, horizontally or vertically. Using the Layout Grid palette, you can configure the grid settings, such as the size, angle, color and opacity of the grid, as well as the number of divisions.

DOCKING THE PALETTES

Painter's resizable palettes are designed to snap together when one is dragged close to the side, top or bottom of another. This design helps to keep your desktop tidy, and there's a bonus: The palettes are designed not to overlap each other. If you dock a palette, and then open it, the palette will open but will not cover the palette below it, unless you drag the bottom corner to expand it.

UP AND DOWN A GROUP

To move up or down an open palette group:

- Drag up or down in any background area of a palette.
- Use any palette surface to scroll by pressing Alt/Option, and then dragging.
- Click or drag the interactive scroll bar on the right side of the palette.

CONTROLLING ALL PALETTES

To use a palette group efficiently:

- Click the left triangle on a palette title bar to open that palette.
- Press Shift and click the left triangle on one of the palette bars to close or open all of the palettes in a grouping at once.
- Click the name of a palette to open that palette and close all other palettes in the group.
- Click the right triangle on a palette title bar to open the palette's pop-up menu.

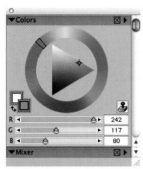

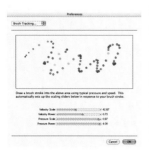

The Colors palette showing a custom grouping, including the Mixer

When you make a brushstroke in the Preferences, Brush Tracking dialog box, Painter adjusts the range of pressure sensitivity based on your stroke.

THE GHOST OF A BRUSH

To view Painter's brush footprint cursor, turn on Enable Brush Ghosting in the Preferences, General dialog box. To view the tilt, bearing, and rotation of the stylus, turn on the Enhanced Brush Ghost in the Preferences, General dialog box.

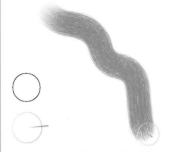

Painting a stroke with the Real Round variant of RealBristle with the Enhanced Brush Ghost turned on. The circle shows the size of the dab and the outer line indicates the tilt and bearing of the stylus. The dab with Brush Ghost enabled (top left) and with Enhanced Brush Ghost enabled (bottom left).

The Divine Proportion grid is helpful for planning a composition with classical proportions, and helps you decide where to locate the center of interest in your composition. For a step-by-step technique using this helpful feature see "Designing with Divine Proportion" on page 21.

CUSTOMIZING YOUR WORKSPACE

Painter makes it easy to customize your workspace. To move a palette grouping to another part of the screen, drag the blank bar at the top of the grouping. You can also move a palette up or down within a palette group, or remove or add palettes from a group to a group. To see this work easily, click on a blank area of a palette title bar and drag it up or down. For instance, we rearranged our Colors palettes in this order: Colors and Mixer closing the other palettes in the group by clicking the white "x" box near the right end of the title bar.

To save your palette layout permanently, choose Window, Arrange Palettes, Save Layout, and when the Save Layout dialog box appears, name your palette grouping and click OK. As your needs change, it's easy to rearrange the palette group. Then to restore a saved layout, choose Window, Arrange Palettes and choose the saved layout from the menu. To delete a layout, choose Window, Arrange Palettes, Delete Layout and choose the layout you want to remove from the list. To return to Painter's default palette arrangement, choose Window, Arrange Palettes, Default.

Using the useful new Workspace feature, Painter 11 allows you to customize your workspace by hiding palettes and art materials that you don't need for your workflow. Learn more about the Workspace functions in "Customizing a Workspace" on page 20.

SETTING PREFERENCES

Painter's Preferences (in the Edit menu in Windows or the Corel Painter 11 menu in Mac OS X) go a long way in helping you create an efficient workspace. Here are a few pointers:

Brush Tracking. Before you begin to draw, it's important to set up the Brush Tracking so you can customize how Painter interprets the input of your stylus, including parameters such as pressure and speed. Windows users choose Edit, Preferences, Brush Tracking. OS X users choose Corel Painter 11, Preferences, Brush Tracking. Make a brushstroke with your stylus using typical pressure and speed. Painter accepts this as the average stroke and adjusts to give you the maximum range or speed and pressure sensitivity based on your sample stroke. Previous versions of Painter did not remember Brush Tracking settings when you quit the program, but Painter 11 will remember your custom settings until you change them.

Multiple Undos. Painter lets you set the number of Undos you want under Edit, Preferences, Undo (in OS X it's Corel Painter 11, Preferences, Undo.) The default number of Undos is 32. It's

You can open alternate libraries for each of the six Content Selectors in the Toolbox. For instance, click the Paper Selector in the Toolbox and when it opens, click the right triangle to open the pop-out menu and choose Open Library.

The open Papers Selector showing Painter's default Paper Textures library, and the popped out menu where the Open Library command is chosen

The open Papers palette showing the popped out menu where Open Library is chosen

important to note that this option applies cumulatively across all open documents within Painter. For example, if the number of Undos is set to 5 and you have two documents open, if you use 2 Undos on the first document, you'll be able to perform 3 Undos on the second document. And, since a high setting for the number of Undos can burden your RAM and scratch disk—because information is saved to support each Undo—unless you have a good reason (such as working on a small sketch where you'll need to make many changes), it's a good idea to set the number of Undos at a low number, such as 5, and keep open only the documents you need.

Palette Preferences. You can choose which palettes are displayed by choosing their names from the Window menu, which makes it easy to configure Painter to save valuable screen real estate. The Preferences, Palettes and UI dialog box offers controls for Autoscroll (lets you automatically scroll through a palette that includes several elements), Snapping Behavior (how palettes in a group are laid out) and Snapping Tolerance (how close one palette needs to be to another before it's snapped into the group).

ORGANIZING WITH LIBRARIES AND MOVERS

Painter uses *libraries* and *movers* to help you manage the huge volume of custom textures, brushes and other items that the program can generate. Libraries are the "storage bins" for those items, and movers let you customize those bins by transferring items into or out of them.

How libraries work. Every palette that includes a resource list of materials has an Open Library (or Load Library) command. Let's use the Papers palette as an example. Choose Window, Show Papers. Click the right triangle on the palette title bar to access the pop-out menu, and choose Open Library to display a dialog box that lets you search through folders on any hard disk until you find the library you want; then double-click to open it. (**Caution:** It's not recommended to load libraries directly from a CD-ROM—like the Painter 11 CD-ROM or the *Painter 11 Wow!* CD-ROM—it's more reliable to copy the libraries from the CD-ROM into your Painter application folder.) Fortunately, Painter is smart enough to show only libraries that can be opened in the palette you're working from.

The General Preferences dialog box lets you specify default libraries, cursor type and orientation, Temp File Volume (location of the scratch disk) and Units, among other features.

Painter 11's General Preferences dialog box, with the Drawing Cursor set for our right hand and Brush Ghost enabled

number of Undos at a low number, such as 5, and keep open only the documents you need.

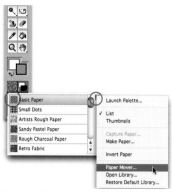

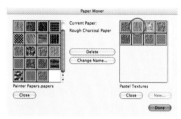

The open Papers Selector showing Painter's default Paper Textures library, and the path to the menu where the Paper Mover choice is located

Dragging an item from the default Paper Textures library into the newly created Pastel Paper Textures library

Using movers to customize your libraries. If you find that you're continually switching paper texture libraries, it's probably time to use the Paper Mover to compile several textures into a single custom library for your work. For instance, you can create a Paper texture library containing favorite textures that work well with Painter's grain-sensitive Chalk and Pastel brushes and the Wow! Chalk Brushes library on the *Painter 11 Wow!* CD-ROM—such as Basic Paper, Thick Handmade Paper and Rough Charcoal Paper (all from Painter's default Paper Textures library), plus Ribbed Deckle, Rough Grain and Light Sand (from the Drawing Paper Textures library) and Coarse Pavement (from the Relief Textures library). The Drawing Paper Textures and Relief Textures libraries can be found in the Paper Textures folder, on the Painter 11 CD-ROM.

Here's how to build a custom paper library: In the Toolbox, click the Papers Selector, and open its pop-up menu. Choose Paper Mover. (You can also access the Paper Mover via the pop-up menu on the Papers palette.) In the Paper Mover, create a new, empty Papers library by clicking on the New button on the right side of the mover, and then name your new Papers file and save it. (We named ours Pastel Paper Textures and saved it to into the Painter 11 application folder.) To copy a texture from the left side of the mover (your currently active library) into the new library, select a texture's icon on the left side of the mover, click its name in the center of the mover window and drag and drop the swatch into the new library on the right side.

Continue adding textures to the new library in this fashion. To add a texture from another library to your new library, click on the left Close button, and then click again when it changes to an Open

The Scripts library containing special effects "macros" that can be applied to images

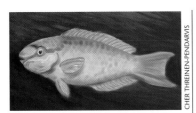

For this illustration of a Queen Parrotfish, we laid in color for an underpainting with the oil-painting brushes (including the Round Camelhair variant of Oils), and then we added texture to areas of the image by painting with grain-sensitive brushes (the Square Chalk variant of Chalk, for instance) over the Laid Pastel Paper loaded from our custom Pastel Paper Textures library.

button and open the next library that you want to draw from. (Don't forget the libraries on the *Painter 11 Wow!* and Painter 11 CD-ROMs!) When you've finished adding textures, click Quit. Now open your new library by choosing Open Library from the pop-up menu on the right side of the Papers Selector's list menu. Your custom paper library will remain loaded even after you quit the program.

All movers work in the same way, so you can follow the above procedure. For instance, you can use a mover to create a new Patterns library that contains the only five patterns that you ever use. (See "Creating a Seamless Pattern" on page 288 to read about building a pattern using the Pattern Mover.)

LOADING AN ALTERNATE BRUSH LIBRARY IN PAINTER 11

To load a different brush library in Painter 11, first copy it into the Brushes folder within the Painter application folder, and then click the triangle menu on the right side of the Brush Selector Bar and choose Load Brush Library. When the Brush Libraries dialog box appears, navigate to the brush library (use the Import button if needed) and click Open. (We chose the 11 Wow! Impasto.) When the Brush Libraries dialog box reappears, click the Load button. The new brushes will now be visible in the Brush Selector Bar.

The open Corel Painter 11 application folder (shown in Mac OS X), with the Brush Libraries organized in the Brushes folder; choosing Load Brush Library from the Brush Selector Bar pop-up menu; selecting the 11 Wow! Impasto library in the Brush Libraries dialog box, and then clicking the Load button. **Note:** *To be read as a brush library, the brush category folder and category JPEG must be inside a folder with the same name as the category.*

IMPORTING OLDER BRUSHES

In Painter 11 you can import favorite brushes that were created in earlier versions of Painter. These brushes must first be converted to the new brush model, and this is done by choosing Import Brush Library from the pop-up menu on the Brush Selector Bar. **Note:** Many early Watercolor brushes were not built to work with Painter 11's Watercolor layers or Digital Watercolor. They can be imported, but will not perform the same as in the earlier version because they were designed to work with the old Wet Paint layer on the Canvas.

The open Corel Painter 11 application folder (shown in Mac OS X), with the 6 Wow! New Chalks library (created in Painter 6) copied into the Brushes folder. After choosing Import Brush Library from the Brush Selector Bar's pop-up menu, we selected the 6 Wow! New Chalks library in the Select Brush Library dialog box and clicked the Open button, which converted and loaded the 6 Wow! Chalk brush library.

Customizing a Workspace

Overview *Create a new workspace; customize the new workspace by hiding and showing brushes and media variants.*

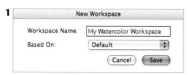

Saving a new workspace

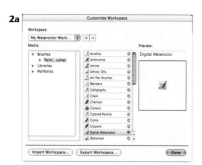

The Customize Workspace dialog box with the Painter Brushes library selected and some of the brush category eye icons closed

The Customize Workspace dialog box with the Patterns library selected and most of the pattern eye icons closed

THE CUSTOM WORKSPACE FEATURES in PAINTER allow you to set up Painter's palettes, brush libraries and other art materials to suit your workflow. You can create multiple workspaces with different art material and custom palettes and import and export them.

1 Making a new workspace. To make a new workspace, begin by choosing Window, Workspace, New Workspace. Give your new workspace a name in the New Workspace dialog box (we named ours "My Watercolor Workspace"). From the Based On pop-up menu, choose a workspace (we chose Default, which would save time by opening the Colors palettes and the Layers palette), and click the Save button. The screen will refresh and the new workspace will appear.

2 Customizing the new workspace. First, display the palettes that you need. If a palette is not open, choose it from under the Windows menu. Next, customize the media in your workspace: From the Window menu, choose Workspace, Customize Workspace, and make sure the workspace you saved is chosen from the list. In the Media list in the Customize Workspace window you will see the art materials: Brushes (Painter Brushes), Libraries (Papers, Patterns, Gradients, Weaves, Looks and Nozzles) and Portfolios (Images and Selections).

To build our custom Watercolor Workspace, begin by clicking on the Painter Brushes library in the Media list window. The list of brush categories will appear. You can hide or show each brush category by clicking the eye icon to the right of its name. (We hid all of the categories except Digital Watercolor and Watercolor.)

You can export a custom workspace and share it with others. So the file will be small, you can remove any unneeded variants in the art materials libraries. (The Papers, Patterns and Nozzles libraries especially can make an exported workspace file large.) However, even if you turn off the eye icons for all the materials in a library, Painter will retain one of them and all six Selectors will remain in the Toolbox. To export, choose Windows, Workspace, Export Workspace, name your workspace and click Save.

Designing With Divine Proportion

Overview *Open the Divine Proportion palette; set up the grid for your painting; sketch your composition.*

CHER THREINEN-PENDARVIS

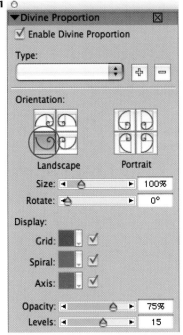

Settings in the Divine Proportion palette

IN PAINTER 11, DIVINE PROPORTION helps you design compositions with the classical proportions of the Golden Rectangle (an approximate 3:5 ratio of height to width) which has been recognized by artists for centuries as pleasing to the eye. *In the Barrel 2* was inspired by memories of surfing a favorite beach in San Diego. While sketching, we used a Divine Proportion grid to lay out a composition that would focus attention on the center of interest—the opening at the end of the barreling wave.

1 Opening palettes and applying a grid. Begin by opening a new file for your painting. Choose File, New. In the New dialog box, type your dimensions in the Width and Height fields. To apply a grid, choose Window, Divine Proportion and click Enable Divine Proportion. Next, choose an Orientation for your composition. (To arrange the focal point of the composition in the upper right of our sketch, we clicked the Landscape Top Left button.)

2 Sketching a composition. Now choose a brush and begin sketching your composition. We chose a Sketching Pencil variant of Pencils from the Brush Selector Bar. To view your image without the grid, turn off the Enable Divine Proportion button. To paint the wave, we used the Round Camelhair variant of Oils and customized Oils brushes. To blend and move paint, we used the Distorto variant of Distortion and the Grainy Water variant of Blenders.

Using the grid as a guide while sketching

DIVINE CROP

Painter's Divine Proportion can help in cropping a photo to make a pleasing composition. Open the Divine Proportion palette (Window, Show Divine Proportion) and also choose the Divine Proportion tool in the Toolbox. You can scale the Divine Proportion grid using the Size and Levels settings in the palette. To reposition the grid so the spiral originates on the area you want to be the "focal point" of the cropped photo, drag inside the grid. When the grid is set as you like it, choose the Crop tool in the Toolbox and drag from one corner of the grid to the diagonally opposite corner, and click inside the grid to crop.

■ **Tom Tilney** is a manufacturing jeweler and designer who specializes in designing with platinum and 18K gold. When Tilney is commissioned to create a new piece of jewelry for a client, he uses Painter to develop the design and to create a full-color presentation to show the client before he begins the manufacturing process. First, Tilney interviews the client to get a basic idea for the design, and for the stones and metals that are desired.

For the example in gold, Tilney wanted to make a setting that complemented the client's beautiful Tanzanite stone. After photographing the stone, he opened the photo in Painter. Then, he used the Pen tool to draw a shape for the border around the stone. (Later, during the manufacturing process, he would use the shape to cut a bezel to hold the stone in place.) Next, he drew the shapes that would become the yellow-gold outer portion of the pendant. To keep the shape perfectly symmetrical, he drew half of the form, duplicated it and flipped it horizontally. He moved the new segment so that the endpoints lined up with the original segment and then joined the end points. (For detailed information about working with shapes and layers, see Chapters 5 and 6.) For the diamonds along the top, Tilney used a photograph of a 10 mm stone from his Image Portfolio. He dragged the stone image from the Image Portfolio (Window, Show Image Portfolio) and dropped it into his working image, and then he scaled it using the Effects, Orientation, Free Transform function. Then, he duplicated it to create the diamonds around the top of the piece.

Next, Tilney converted the larger shape to a layer (Shapes, Convert to Layer), and then he filled it with a custom gold gradient. To achieve a shiny appearance, and to add dimension to the gold, he used Painter's versatile Effects, Surface Control, Apply Surface Texture effect to apply a custom gold environment map to the layer. (For information about making and applying environment maps, see Chapter 8.)

For the diamond and platinum pendant, Tilney used many of the same techniques. He used the Pen tool to draw intricate, curved shapes for the platinum and bevels. After converting the shapes to layers, he applied a custom platinum gradient to them. To achieve the look of shiny white metal, he used special environment maps that complemented the platinum-colored metal.

To complete both presentations, Tilney added artistic, textured backgrounds by choosing Effects, Surface Control, Apply Surface Texture, Using Paper and subtle settings. Then, he used the Create Drop Shadow effect to apply a soft offset shadow to each background.

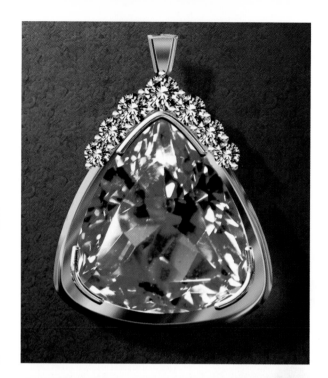

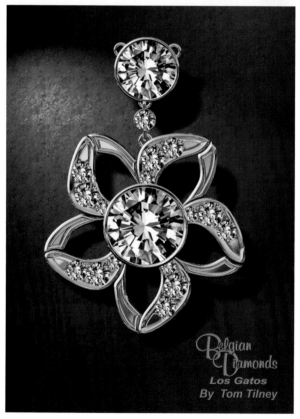

Belgian Diamonds
Los Gatos
By Tom Tilney

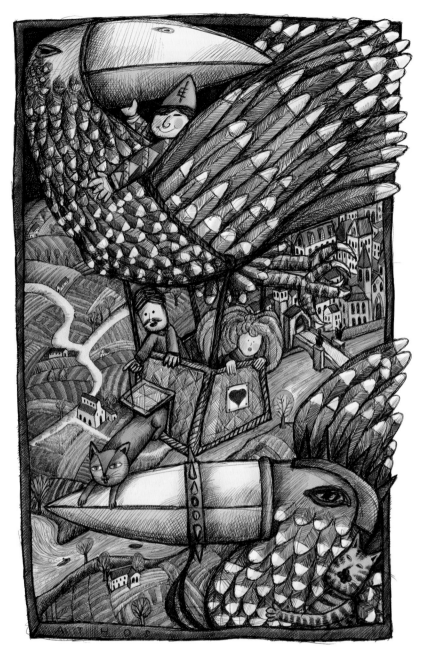

■ *Tavola* is a fantasy illustration created by Italian artist **Athos Boncompagni**. To begin the illustration, Boncompagni drew a detailed sketch with conventional pencil-and-paper. When the drawing was complete, he scanned it and opened the scan in Painter. So that he could hide and show the sketch as he worked, he put it on a layer. To cut the Canvas to a layer, he chose Select, All and then Select, Float. Then,

Boncompagni added a new transparent layer to his file by choosing Layers, New Layer, and he dragged the empty new layer to the top of the layer stack in the Layers palette. Working on the new layer, he used several Pens (including the Scratchboard Tool) to create a black-and-white ink drawing. When his drawing was complete, he hid the layer with the pencil sketch by clicking its eye icon shut in the Layers palette.

Next, Boncompagni began the coloring process. First, he applied smooth transparent washes to the Canvas using a variety of Digital Watercolor brushes, including the Simple Water brush. Then, he painted loose, textured color on the feathers using Chalk brushes. Finally, to add a few crosshatching details to the basket, he used a small Pastel Pencil variant of Pastels.

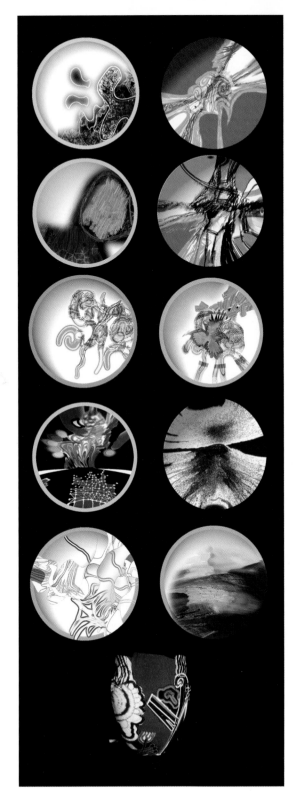

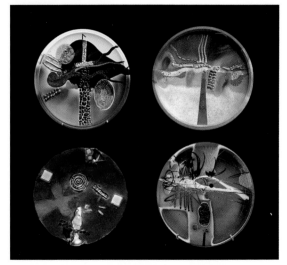

■ A longtime practicing potter and clay artist, **Brian Gartside** uses Painter as his sketchbook and to keep himself visually fit. During his career as an artist, he has moved from painting, woodcuts, etching and silkscreen before finding his current medium—clay. Gartside is internationally renowned for developing a unique system of ceramic glazes. "There is so much to know about color. To use it well is a real skill," says Gartside. Colors and shapes are the building blocks of his imagery, and he uses Painter to loosen up visually and to experiment with color. *Virtual Pots* (left), are examples of pots he has painted using Painter. The examples in the photograph above show his glazing technique and imagery on the actual clay pots. His abstract imagery is often inspired by the land and sky forms of his current home in New Zealand.

Since the very first version of the program, Gartside has used Painter to see and mix color combinations quickly and freely. *Seeing* color in this way and being able to make dramatic changes quickly gave Gartside a more profound understanding of color and composition. Gartside expanded his original color experiments with later versions of Painter and now finds the new creation and manipulation of shapes, use of transparency, layers and other improved tools give him new ways to visualize. As mentioned above, Gartside uses Painter to keep himself visually fit. With his Wacom tablet, pen and monitor, he does daily visual exercises, or warm-up exercises, and this results in a free-flowing, unrestricted feeling in all that he creates. There is no analysis, no thinking and no hesitation, but simply alertness of experience as he creates his imagery.

When Gartside approaches the surface of the clay, he maintains the same intuitive, open attitude. He works the clay and glaze with as much ease as possible, without trying to emulate his Painter sketches. However, he does keep the freedom and free-flowing hand movements he gained during the computer drawing experience when he paints with the ceramic glazes on the clay surface. He loves the contrast of the two mediums—Painter which is all light, and clay which is grounded in earth and fire. Gartside feels that the two mediums, Painter and clay, feed one another. Each activity reflects on the other, yet has its own inherent characteristics. The color and shapes he works with during the visual exercises in Painter provide him with a fresh visual dialog that keeps him working.

■ Created and written by **Drew Kampion** and illustrated by **Thomas Threinen**, the *Don Redondo* comic strip is published in *The Surfer's Path* magazine. The episode *Part 20, In which Careless meets Secos Sam* is shown here. After the team met to discuss the concept, Threinen drew each scene on vellum and then scanned them and assembled them in Painter, where he added the borders, type and color.

To begin the illustration, Threinen chose a sheet of vellum, using traditional marker brushes. He modeled the forms by brushing washes of soft, gray tones, and then he added deeper shading—the fine marks and dark strokes—with various sizes and weights of pencils. Then, he used a fine brush again, this time to deepen a few outlines and expressive strokes. He repeated this process for each panel. Finally, he scanned the panels saved them as TIFF files.

After opening the scanned drawings in Painter, Threinen assembled the scenes into the comic strip file by copying and pasting each scene into the working file. He then positioned the scenes with the Layer Adjuster. To adjust the tones of the scans, he used Effects, Tonal Control, Brightness/Contrast. When he was happy with the contrast and arrangement, he grouped the layers by Shift-selecting them in the Layers palette and choosing Layers, Group. Then, he merged the group into one layer by choosing Layers, Collapse Layers. To keep his layers organized, he named the layers as he worked; he named this first collapsed group layer Base Art.

After the Base Art layer was in place, Threinen added the borders and the type. To draw the borders, he chose the Rectangular Shape tool. In the Property Bar, he turned on the Stroke check box and turned off the Fill check box. He set the color he desired and drew the boxes. Next, Threinen set the type using the Text tool—for the dynamic headline style, he chose the Adventure typeface and for a whimsical handwritten look for the bubbles, he used the Notepad font. After he set the elements for the header and bubbles on Text layers, he arranged the headline elements into one group and the bubble text into a second group and then merged each group, naming them Heads and Text.

Next, Threinen used Painter's brushes to color elements, such as the sea, sky, car interior and characters on individual layers. To color the ocean, he added a new empty layer to his image by choosing Layers, New Layer and named this layer Sea. Using the Basic Round variant of Tinting and varied shades of blue, he brushed smooth washes onto the water, and he painted all of the water on this layer. In areas where he wanted to blend, he used the Blender variant of Tinting. For the cars, he added a new empty layer and painted colored tints as he did for the Sea layer. To complete the coloring, he added more layers and color; for example, for the sky, the hills and ground, the car interior and the characters Don Redondo, Careless Constipeda and Secos Sam.

THE POWER
OF COLOR

For Flying A, Susan LeVan used saturated colors in contrast with monochromatic values to communicate emotion. To see more of her work, turn to Chapter 5.

INTRODUCTION

"COLOR, THE FRUIT OF LIGHT, is the foundation of the painter's means of painting—and its language." Abstract painter Robert Delaunay's observation mirrors our own appreciation of color as an expressive and essential element of the visual arts. Getting the most out of Painter's powerful color tools is an important first step for those of us who work with "the fruit of light."

HUE, SATURATION AND VALUE

Exploring the Colors palette. Painter's interface for choosing color is built around a model that uses *hue, saturation* and *value* (HSV) as the three basic properties of color. The program is designed so that you'll typically first choose a hue, then alter it by changing its saturation or value. Painter's Colors palette is designed to work with these properties, but the program also allows you to work in RGB (red, green, blue) color space if you prefer. Clicking the triangle on the left end of the Colors palette bar (Window, Show/Hide Color Wheel) opens the Colors palette. Painter 11 combines the sliders from the Color Info palette with the Colors palette, and by default, the sliders display RGB colors. To view HSV values rather than RGB choose HSV Color by clicking the right triangle on the Colors section bar and choosing HSV. To display the Colors palette without the Color Info sliders, choose Hide Color Info from the pop-up menu on the right side of the Colors palette.

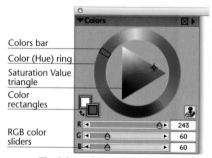

Colors bar
Color (Hue) ring
Saturation Value triangle
Color rectangles

RGB color sliders

The Colors palette with Hue ring, opened by expanding the Colors palette bar

Hue. The term *hue* refers to a predominant spectral color, such as red or blue-green. Hue indicates a color's position on the color wheel or spectrum, and also tells

QUICK SWITCH TO HSV
Click the triangle on the right side of the Colors palette section bar, and from the pop-up menu, choose display as HSV.

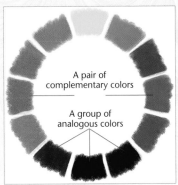

A pigment-based color wheel

A pair of
complementary colors

A group of
analogous colors

us the color's temperature. A red-orange hue is the warmest color; a blue-green hue is the coolest. (Keep in mind, though, that temperatures are relative. Blue-violet is a cool color, but it warms up when it's placed next to blue-green.)

In the traditional pigment-based color system, red, yellow and blue are *primary* hues—colors that cannot be obtained by mixing. *Secondary* hues—green, orange and violet—are those colors located midway between two primary colors on the color wheel. Yellow-green, blue-violet and red-orange are examples of *tertiary* hues, each found between a primary and a secondary color.

Analogous hues are adjacent to each other on the color wheel and have in common a shared component—for instance, blue-green, blue and blue-violet. *Complementary* hues sit opposite one another on the color wheel. Red and green are complements, as are blue and orange. (Painter's Hue ring and bar are based on the RGB components of the computer screen; they don't exactly match a traditional pigment-based color wheel.)

To change hues in Painter's Colors palette, drag the little circle on the Hue ring or click anywhere on the ring.

Saturation. Also known as *intensity* or *chroma*, *saturation* indicates a color's purity or strength. The most common way of changing a color's saturation is by adjusting the amount of its gray component. In the Color triangle, move the little circle to the left to desaturate a color, or to the right to saturate it. Fully or very saturated colors—those at or near the tip of the Color triangle—won't print the way they look on the screen. If you want to see colors closer to their printed equivalents while you paint, the Canvas, Color Management command can help. (See the "Color Management" tip on page 34 of this chapter and the *Painter 11 Help Menu.*)

Saturating a color

Desaturating a color

Creating a shade of a color

Creating a tint of a color

USING THE MIXER PALETTE

The Mixer allows you to mix color as an artist would mix paint on a palette. Begin by clicking on one of the Color Wells at the top of the palette (or choosing a color in the Colors palette), and dab the colored paint onto the Mixer Pad using the Brush tool in the Mixer palette. Add a second color and use either the Mix Color tool (selected in the illustration) or the Dirty Brush to mix the colors as we did here. The tools at the bottom of the Mixer are from left to right: the Dirty Brush (chosen), Apply Color, Mix Color (chosen), Sample Color, Sample Multiple Colors, Zoom, and Pan. Brushes with these dab types can paint with multiple colors that are picked up using the Sample Multiple Colors tool: Camel Hair, Flat, Bristle Spray, Blend Camel Hair and Blend Flat.

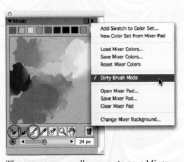

The pop-up menu allows you to save Mixer Colors, add them to a Color Set, and more.
Note: *New in Painter 11, the Mixer can be resized to allow more room for mixing colors and more accuracy when using them. To resize the Mixer, drag its bottom-right corner.*

As you can see in this detail of Decoys, *Richard Noble used saturated color and strong value contrast to paint a bright morning light on his subject. To see more of Noble's work, turn to the galleries at the end of this chapter and Chapter 3.*

CHER THREINEN-PENDARVIS

An example of atmospheric perspective. The illusion of distance is enhanced in Along Tomales Bay *because the distant hills are painted with reduced saturation and less value contrast.*

A study in value contrast, based on a drawing by Michelangelo

Value. A color's lightness or darkness is its *luminance* or *value*. To create a *tint* of a color (lightening it, or increasing its value), move the little circle higher in the Color triangle. To create a *shade* of a color (darkening it, or decreasing its value), move the little circle lower in the Color triangle.

PUTTING HSV TO WORK

Here are several practical suggestions and creative solutions for solving artistic problems using hue, saturation and value.

Reduce saturation and value to indicate distance. Artists have been creating *atmospheric* (or *aerial*) *perspective* in their work for thousands of years. The wall paintings of Pompeii in the first century B.C. show this technique. Hills we see in the distance have less intensity than nearer hills, and they also have less variation in value. This effect increases in hazy or foggy conditions. To depict this in your art, you can reduce the color saturation and value range as the landscape recedes from the foreground.

Use saturation to indicate time of day. At dawn or dusk, colors appear to be less saturated, and it becomes more difficult to distinguish colors. At noon on a bright sunny day, colors seem saturated and distinct.

Use color temperature to indicate distance. The eye puts warm colors in front of cool colors. For example, orange flowers in the foreground of a hedge appear closer than blue ones.

Create drama with light-to-dark value contrast. Baroque and Romantic period artists as diverse as Caravaggio, Zurbarán, Géricault and Rembrandt are known for their use of extreme light-to-dark contrast. They accomplished this by limiting their palette to only a few hues, which they either tinted with white or shaded by adding black. A close look at the shadows and highlights that these artists created reveals complex, modulated tone. Digital artists can use Painter's Apply Lighting feature (from Effects, Surface Control) to add a dramatic splash of contrast to an image and also to unify a painting's color scheme, although achieving genuine tonal complexity requires additional painting.

Use complementary colors to create shadows. The Impressionists, Monet, Renoir and Degas frequently avoided the use of black in the shadow areas of their paintings. They embraced a more subjective view of reality by layering complementary colors to create luminous shadows.

Neutralize with a complement or gray. One way to tone down a hue is to paint on top of it with a translucent form of its complement. El Greco painted his backgrounds in this manner to draw attention to more saturated foreground subjects. Try painting

To paint dramatic billowing clouds in Path to Water West, *we blended color by using the Smeary Palette Knife variant of Palette Knives, and the Grainy Water variant of the Blenders.*

Simultaneous contrast at work. Notice how the gold looks brighter next to the dark blue than it does next to pink.

A landscape with figures, based on Mahana no atua (The Day of the God) *by Paul Gauguin*

with a bright green hue, and then glaze over it with a reduced opacity of red. The result will be an earthy olive. You can also neutralize a hue using shades of gray, as did the French artist Ingres. Although he often limited his palette to red, blue, gold and flesh tones, he created the illusion of a larger palette by adding varying proportions of gray and white.

Blending, pulling and thinning colors. Subtle changes in hue and saturation take place when colors are blended in a painting. You can use the Just Add Water, Grainy Water or Smudge variant of the Blenders brush (from the Brush Selector Bar) to blend, for instance, two primary colors (red and blue) to get a secondary color (violet). For a more dramatic blending, you can pull one color into another by using the Smeary Palette Knife variant of the Palette Knives. Artists using traditional tools often thin paint by mixing it with an extender. In Painter, you get a similar effect by reducing a brush's Opacity in the Property Bar.

Draw attention with simultaneous contrast. If two complementary colors are placed next to one another, they intensify each other: Blue looks more blue next to orange, and white looks more white next to black. In the 1950s, Op artists used the principle of simultaneous contrast to baffle the eye. Advertising art directors understand the power of simultaneous contrast and use it to gain attention for their ads.

Use a family of colors to evoke an emotional response.

You can create a calm, restful mood by using an analogous color theme of blues and blue-greens. Or develop another family of hues using reds and red-oranges to express passion and intensity. You can also use a color family to unite the elements of a composition.

Create your own color world.

Post-Impressionist Paul Gauguin (among others) created a powerful, personal color language by combining several of the above techniques. He used warm, bright colors to bring a subject forward in his composition, and used cool, dark colors to convey distance and

COLOR FROM A CLONE SOURCE

In addition to choosing color from the Colors palette, you can sample color from an image by clicking with the Dropper tool, or, you can paint with color from another image (or clone source). To see how cloning color works, begin by making a clone. Open a file and choose File, Clone. In the Brush Selector Bar, choose the Impressionist Cloner variant of the Cloners. You can paint over the imagery, or you can delete the contents of the file and clone onto the blank canvas from the original. To read more about cloning, turn to "Coloring and Cloning" on page 108.

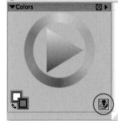

When the Clone Color box is selected, the Colors palette is disabled.

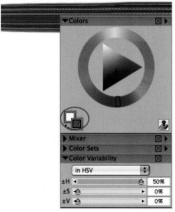

These brushstrokes were painted with the Round Camelhair variant of the Oils with the following settings in the Color Variability palette: top brushstroke, Hue slider only set to 50%; middle, Saturation slider only set to 50%; bottom, Value slider only set to 50%. The Color Variability palette shows the settings for the brushstroke painted with the Round Camelhair.

These brushstrokes were painted with the Diffuse Grainy Camel (top) and the Wash Bristle (bottom) variants of Watercolor with a Hue variability of 10%.

These brushstrokes were painted with the Scratchboard Rake variant of the Pens with an increased Hue variability of 10% (top) and 50% (bottom). Each "tine" of this Rake brush can carry a different color.

mystery. He also made the bright foreground colors seem brighter by surrounding them with darker, more subdued colors.

PAINTING WITH MULTIPLE COLORS

Painter's Brush Selector has several brushes that can paint with more than one color at a time if you use the settings in the Color Variability palette (Window, Color Palettes, Color Variability). Brushes with the Rake or Multi stroke type or the Bristle Spray, Camel Hair or Flat dab types have the capability to paint with multiple colors. The Van Gogh variant of the Artists brush and the Round Camelhair variant of the Oils are examples. See the Using the Mixer palette tip on page 27 to learn how to pick up multiple colors from the Mixer pad and apply them to your images.

Randomize colors with Color Variability. To see how multi-color works, open the Color Variability palette by clicking the triangle on the Color Variability bar. (Make sure that "in HSV" is chosen in the pop-up menu.) From the Brush Selector, choose the Round Camelhair variant of the Oils; its Camelhair dab type has the potential to carry a different color on each brush hair. Choose a color in the Colors palette and begin painting. Then experiment by adjusting the Hue (±H), Saturation (±S) or Value (±V) slider in the Color Variability palette and painting again.

For transparent Watercolor washes with variable color, try the Diffuse Grainy Camel and the Wash Bristle. Both of these brushes have the potential to carry a different color in each brush hair.

Also try the Scratchboard Rake variant of the Pens. The Scratchboard Rake incorporates the Rake stroke type; each "tine" of a Rake brush can paint with a different color. In the Color Variability palette, set Hue to 10% (for a subtle variation) or much higher (for a rainbow-like effect) and make brushstrokes on your image.

> **COLOR VARIABILITY CAUTION**
>
> Painter remembers the changes when you try out Color Variability, and this may cause confusing results later. After you've finished using Color Variability, set the Color Variability pop-up menu to "in HSV" and restore the Hue, Saturation and Value sliders to 0.

Use Color Variability based on a gradient. With Painter, you can paint with multiple colors from a gradient instead of using completely random Color Variability. To begin, set all the Color Variability sliders to 0; open the Colors palette and set up the colors for a two-point gradient by clicking on the front color rectangle and selecting a color, and then clicking on the back color rectangle and selecting a color. Open the Gradients palette by choosing Window, Library Palettes, Show Gradients. In the Gradients palette, choose Two-Point from the pop-up menu. From the Brushes Selector Bar, select the Oils category and the Opaque Bristle Spray variant. In the Color Variability palette, choose From Gradient from the pop-up menu, and then make brushstrokes on your image. If the brush

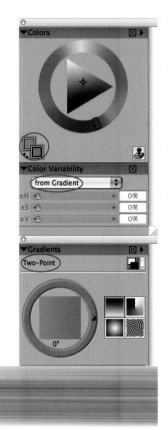

Brushstroke painted with the Opaque Bristle Spray variant of the Oils using Color Variability based on the current gradient

Brushstrokes painted with the Smeary Flat (above) and the Dry Ink (below) variants of the Oils using Color Variability based on the Color Set shown here

does not immediately paint using the Color Variability from the gradient, click the little circle in the Colors palette to help it to update.

Use Color Variability based on a color set. You can create a special Color Set containing a few colors and then use those colors when painting. Begin by opening the Color Variability palette (Window, Color Palettes, Color Variability); set Color Variability to "in HSV" and the ±H, ±S, and ±V sliders to 0. Open the Color Set palette (Window, Color Palettes, Show Color Sets) and choose the Library Access button (the one with the picture of the Grid). The Color Sets palette will now be empty; it's ready for you to begin adding colors. Choose a color in the Colors palette. Click on the Add Color to Color Set button (the "Plus") to add the chosen color to the Color Set. Continue to select and add more colors by using the Colors palette and clicking the "Plus" button. Choose the Smeary Flat variant of the Oils, and in the Color Variability palette, set Color Variability to "from Color Set." Paint brushstrokes on your image. To learn more about color sets, turn to "Keeping Colors in Color Sets," on page 35 and to "Capturing a Color Set," on page 40.

Change colors with stylus pressure. Use your pressure-sensitive stylus to paint in two colors. Start by choosing the Acrylics category and the Captured Bristle variant. In the Color Expression palette, choose Pressure from the Controller pop-up menu. In the Colors palette, click on the front color rectangle and choose a bright blue color. Click the back color rectangle and select a rose color. If you paint with a light touch, you'll be painting in rose. If you press heavily, the stroke turns blue. (If the balance between the two colors seems uneven, choose Corel Painter 11, Preferences, Brush Tracking. Make a typical brushstroke in the Scratch Pad area, click OK, and then try the graduated version of the Captured Bristle variant again.)

MORE COLOR VARIABILITY

Painter's Color Variability controls include RGB variability and variability based on the current Gradient or Color Set. These options are chosen from the pop-up menu in the Color Variability palette.

Choosing Color Variability from Gradient

MORE COLORFUL STROKES

To paint with two colors using criteria other than pressure, open the Color Expression palette (Window, Color Palettes, Show Color Expression) and move the Controller pop-up menu to Velocity. Once you get started, if you move slowly, you paint using the color in the front Color rectangle; speeding your strokes paints with the back color. Now change the Controller menu to Direction. Start drawing horizontal brushstrokes (front color) and then gradually turn the strokes vertical (back color).

Before and after: Sampling in the image with the Dropper to determine the color cast of a bright highlight on the aluminum foil reveals these values: Red: 236, Green: 239, and Blue 208 (left); the corrected image (right) with pure white highlights shows Red, Green and Blue values of 255.

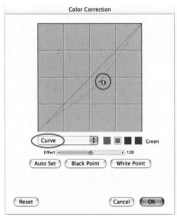

Pull the Green color curve in the Color Correction dialog box to lessen the green cast in the image above. Light colors are represented at the upper right and dark colors in the lower left. The biggest change in color occurs at the point where you pull the curve. If you pull the dot, the color you sampled will be affected most. The Effect slider controls how much of the curve will change when you pull on it. Move the slider to the right to affect a broad range of tones. Move the slider to the left to affect a narrower range of tones.

MAKING COLOR ADJUSTMENTS

Painter offers several ways to modify color in scanned photos or in your artwork *after* you have created it. To see the results of your choices in many of the dialog boxes that are involved in color adjustments, you'll need to click and drag in the Preview window.

Correct Colors. Do you see an unnatural color cast in your image? The Correct Colors, Curve feature can help you fix this problem. This feature is especially useful when working with scanned photos, for instance.

To adjust an image so that the brightest highlights are pure white, begin by analyzing the color cast. (To ensure that the front Color rectangle in the Colors palette will show the color you are about to sample, make sure that "in HSV" is chosen from the menu in the Color Variability palette.) Use the Dropper tool to sample a bright highlight in your image. In the Colors palette, click on the HSV values box to toggle to RGB val-

ues. Check the RGB values in the Colors palette. In our example (shown at the left), the color and numbers show that the unwanted color cast is green, because the G value is higher than the R and B values. A bright white should have R, G and B values of 255 in the Colors palette. Choose Effects, Tonal Control, Correct Colors and choose Curve from the pop-up menu in the Color Correction dialog box. Curve will allow you to adjust the individual RGB values. Click on the small square icon for the color that you want to adjust. (We clicked on the Green color icon—to constrain the adjustment to *only* the green values in the image.) Then, position the crosshair cursor over the diagonal line, and when you see the hand cursor appear, pull down and to the right. Pulling down (as shown) will decrease the selected color in the image. Click the Reset button to try out another adjustment without leaving the dialog box.

Adjust Colors. To change the hue, saturation or value of all of the colors in an image, choose Effects, Tonal Control, Adjust Colors. Experiment with the sliders and view the changes in the Preview window. Adjust Colors is also useful for quickly desaturating a full-color image—making it look black-and-white. To desaturate an image, move the Saturation slider all the way to the left.

Adjust Selected Colors. You may want to make color adjustments—in particular, color ranges of your image. Painter's Adjust Selected Colors feature lets you make dramatic changes (turning a

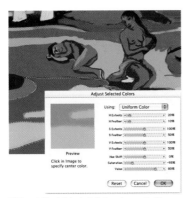

Using Adjust Selected Colors to neutralize a bright blue

blue sky yellow) or more subtle ones (removing the red cast from a subject's face). Choose Effects, Tonal Control, Adjust Selected Colors. When the dialog box opens, click in your image (*not* in the Preview window) on the color you want to change. Adjust the Hue Shift, Saturation and Value sliders at the bottom of the dialog box. When the targeted color is changed to the color you want, use low settings on the Extents sliders to limit the range of colors that are adjusted. Use the Feather sliders to adjust transitions between colors: 100% produces soft transition; 0% gives abrupt ones.

Color Overlay. Found under Effects, Surface Control, the Color Overlay dialog box lets you tint an image with a color using either a Dye Concentration model (which applies *transparent* color) or a Hiding Power model (which covers the image with the opaque color). With either model you can add texture by choosing Paper in the pop-up menu, as we did in the illustration at the left. When using the Dye Concentration model, adjust the Amount slider to control the density of the color from 0% for no effect to 100% or –100% for full transparent coverage. The Hiding Power model operates differently. You can add color using a plus value, or pull color out of an image using a minus value. Try this to see how it works: Open a new image and use the Rectangular Selection tool to make a selection. Choose a yellow-green in the Colors palette (approximately R 185, G 255, B 100). Fill the selection using Effects, Fill, Current Color. Choose yellow in the Colors palette (ours was R 247, G 246, B 100) and then choose Effects, Surface Control, Color Overlay, Using Uniform Color and Hiding Power. Move the Opacity slider to 100% to see the yellow completely cover the yellow-green. Finally, move the Opacity slider to 0% to the see the yellow disappear from the original green. A negative percentage (–50) will remove more yellow from the original green.

MATCHING PALETTES

The useful new Match Palette dialog box (Effects, Tonal Control, Match Palette) allows you to match color palettes between two open images, and apply the Color and Brightness from a source image to a destination image. For step-by-step instructions for using the Match Palette effect, turn to page 249 in Chapter 7.

LAYER COMPOSITE COLOR

With Painter's Composite Methods you can change how a layer interacts with the image underneath, affecting the color in your image. For more about layers and to see examples of how Painter's 21 Composite Methods affect color, turn to the beginning of Chapter 6, "Using Layers."

In this image, we applied the Darken composite method to the leaf layer.

Dye Concentration. With Effects, Surface Control, Dye Concentration you can add or remove pigment from your image. Setting the Maximum slider above 100% increases the density of the existing pigment. When you choose Paper in the Using menu, the Maximum slider controls the amount of dye on the peaks and the Minimum slider controls the amount of dye in the valleys of the texture.

PHOTO: PHOTODISC

We added colored texture to this photo with Color Overlay.

Susan LeVan used Effects, Tonal Control, Negative on the left side of the background of Guardians *as shown in this detail. After creating the negative side of the image, she drew over portions of the left side to make the character unique.*

Negative. Creating a negative of all or part of an image can have dramatic, artistic purposes—such as in the detail of Susan LeVan's illustration, at left. Choose Effects, Tonal Control, Negative to convert your image or a selected part of it.

Output Preview and Video Colors. Your monitor can display more colors than can be reproduced in the four-color printing process, and if you are creating images for video, some highly saturated colors will not make the transition from computer to video. It's a good idea to convert your out-of-gamut colors while you're in Painter so there won't be any surprises. Choose Canvas, Color Management or Effects, Tonal Control, Video Legal Colors, depending on whether your image is destined for paper or video. For more information about output for printing, turn to Chapter 12, "Printing Options."

Here is the Edit Gradient dialog box with Painter's Strange Neon gradient, and the Linear box is unchecked. When you click a square hue box above the Gradient, the Color hue pop-up menu appears. Here it's set to Hue Clockwise, resulting in a tiny spectrum below the square hue box.

MORE COLOR TOOLS

Adding color with Gradients. Painter's powerful Gradients palette lets you fill selected areas with preset gradations or ones that you've created. (See "Adding Color and Gradations to Line Art" later in this chapter.) You can also colorize an image with a gradation using Express in Image from the pop-up menu at the right side on the Gradients palette. To see an example of this technique, turn to "Creating a Sepia-Tone Photo" in Chapter 7.

The gradient editor is a powerful tool for creating custom color ramps. You can't use this tool to alter all of Painter's existing gradations. However, it is used primarily for creating new ones. Choose Window, Show Gradients to open the palette; then click the right triangle, and choose Edit Gradient from the pop-up menu to bring up the gradient editor. Select one of the triangular color control points and choose a color from the Colors palette. The color ramp will update to reflect your choice. Add new color control points by clicking directly in the color bar; the triangular control points are sliders that can be positioned anywhere along the ramp. To delete a control point, select it and press the Delete key; click on the

Click on a color control point triangle, and the Color Spread slider will appear. Adjust it to control the smoothness between the colors.

Linda Davick uses gradient fills to give her illustrations depth, as shown here in Mice. *Read about Davick's technique in "Adding Color and Gradations to Line Art" on page 36 of this chapter.*

gradient bar to add a new control point. Clicking on any of the squares above the gradient displays the Color menu; experiment with the options available there to get quick rainbow effects in the section of the gradient indicated by the square. To store the new gradient in the Gradients palette, choose Save Gradient from the pop-up menu on the right end of the Gradients palette.

Coloring images. You can color images or selected parts of images using either Effects, Fill (Ctrl/⌘-F) or the Paint Bucket tool. The Fill command lets you fill your image with a color, a gradient, a clone source (if one is available), a pattern (if no clone source is available) or a weave. The Paint Bucket gives you the same fill options. (The Paint Bucket options appear on the Property Bar when you select the Paint Bucket tool.) Cartoonists and others who fill line art with color will want to explore the Lock Out Color feature (to preserve black line art, for example) made available by double-clicking on the Paint Bucket tool icon in the Tools palette. For more information about Lock Out Color and Cartoon Cel fills, see the *Painter 11 Help Menu.*

Keeping colors in Color Sets. Painter can store your most frequently used colors in a Color Set. Painter Colors is the default set. Switch Color Sets by clicking on the Library Access button (the grid) in the Color Sets palette. You'll find more Color Sets (including several Pantone sets) in the Color Sets folder on the Painter 11 application folder. For more about Color Sets, turn to "Capturing a Color Set" on page 40.

For more about Color Sets, turn to "Capturing a Color Set" on page 40.

In H is for Hell-bent Haddocks *(shown here as a detail), Keith MacLelland used the Paint Bucket to create a background of filled squares. To see more of MacLelland's work, turn to the galleries in this chapter and Chapter 9.*

Adding Color and Gradations to Line Art

Overview *Draw line art with the 1-Pixel Pen variant; use the Paint Bucket to fill areas with flat color and gradations; add highlights with the Airbrushes.*

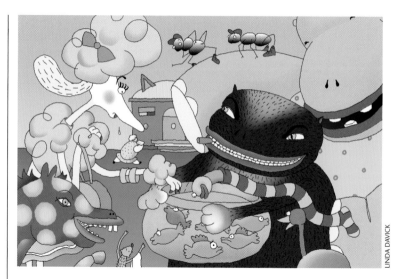

LINDA DAVICK

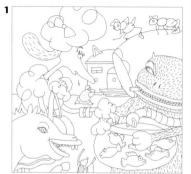

Line art created with the 1-Pixel variant of the Pens brush, shown here as a detail

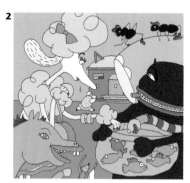

Filling the drawing with flat color

FILLING LINE ART WITH COLOR AND GRADATIONS is slick and efficient in Painter, using what children's book illustrator Linda Davick calls "the coloring-book technique." Davick employed the Paint Bucket tool when creating the illustration *Fish Fry* for Debbie Smith's *Beauty Blow-Up.*

1 Creating a black-and-white line drawing. From the Brush Selector Bar palette, choose the Pens, 1-Pixel variant. Choose Window, Brush Controls, Show General and in the General section of the Brush Controls choose the Flat Cover subcategory. Flat Cover lets you draw a solid-color line, creating the necessary barriers for this technique that fills all neighboring pixels of the same color. Choose black in the Colors palette and draw your line art, making sure all your shapes are completely enclosed with black lines. If you need to correct your work, switch the color to pure white in the Colors palette and erase.

2 Filling with flat color. To test color choices and tonal values, you can fill areas of your illustration with flat color. So the color is flat and not affected by settings in the Color Variability palette, choose Window, Color P, Color Variability to open the Color Variability palette, and choose "in HSV" from the pop-up menu. Set the ±H, ±S and ±V sliders to 0. Now choose the Paint Bucket tool, and in the Property Bar, click the Fill Image button and under the Fill menu, Current Color. Turn off Anti-Alias. Choose a color, and then click in the area of your drawing that you want to fill. Since the Paint Bucket fills all neighboring pixels of the same color, you can refill by choosing another color and clicking again. If you're filling small areas, it's important to know that the Paint Bucket's "hot spot" (where it fills from) is the tip of the red paint in the icon.

Setting up the Two-Point linear gradient for the sky behind Zuba

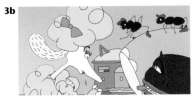

Filling the background with the gradient

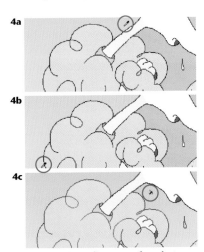

Sampling the gradient across from the top of the area to be filled (a); sampling across from the bottom of the area to be filled (b); filling the area with the gradation (c). Repeat this process for each flat color (negative) area to be filled.

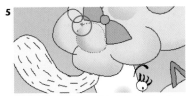

Adding dimension to Zuba's hair using the Digital Airbrush inside a selected area

Davick filled all areas except Zuba's (the pink poodle) face using this method.

3 Adding color ramps. To fill the background with a gradation, open the Gradients palette (Window, Library Palettes, Gradients). Choose Two-Point from the pop-up menu (top right of the palette) and click the Linear Gradient button (from the four Types buttons to the right of the direction ring), and set an angle for your fill by rotating the red ball around the direction ring. In the Colors palette, choose colors for both the front and back Color rectangles. (Click on the front Color rectangle and select a color; then click on the back Color rectangle and select a color.) With the Paint Bucket chosen, in the Property Bar, click the Fill Image button, and from the Fill menu, choose Gradient. Finally, to apply the gradation, click in the area that you want to fill. Davick filled the largest background sky area with a linear gradation.

4 Duplicating color ramps. To duplicate the large background gradation in each of the smaller background shapes—to the right of Zuba, and under the ants—Davick created a new gradation using color sampled from areas in the background gradation. She then filled the smaller background shapes with the new gradation. If you need to do this on the "negative" shapes in your image, first check the Colors palette to make sure that the Color rectangle that contains the starting color of your original gradation is selected. Choose the Dropper tool and position it over the gradation in your image at approximately the same height as the top of the negative area that you want to fill. Click in the gradation to sample the color. To sample the bottom portion of the gradation, select the other Color rectangle; then position and click the Dropper at about the same height as the bottom of the area to be filled. Click in the negative area using the Paint Bucket to fill with the new sampled gradation. (If you need to refill, undo the fill—Edit, Undo Paint Bucket Fill—before you fill again.)

5 Painting airbrush details. Davick finished the piece by painting with the Digital Airbrush variant of the Airbrushes within roughly circular selections to add details to Zuba's face and fur. You can make roughly circular selections using the Lasso tool by choosing the Lasso tool and dragging in your image. (To read more about selections, turn to the beginning of Chapter 5, "Selections, Shapes and Masks.") Now use the Digital Airbrush to add dimension. Paint along the edge of the animated selection marquee. Davick used the same Airbrush with unrestricted strokes to add other details in other areas, such as on the cat's face and paws.

A TOLERANT PAINT BUCKET

If you need to fill an area of modulated color with the Paint Bucket, use the Tolerance slider on the Property Bar to increase the amount of Tolerance. To sample a narrower color range, decrease the Tolerance setting.

Coloring a Woodcut

Overview *Create black-and-white art; float it and apply the Gel Composite Method; view the black-and-white art as you add colored brush work and texture to the original canvas layer.*

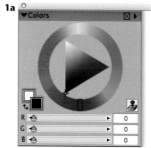

Black is chosen for the Main Color in the Colors palette

1b

Phillips's expressive use of the Scratchboard Tool can be seen in this detail.

1c

The completed black-and-white drawing

CHET PHILLIPS

HERE'S A CREATIVE WAY TO ADD COLOR to black-and-white art, a favorite technique of artist Chet Phillips. *Grasshopper* (above), is one of eighty illustrations that Phillips created for *The Bug Book*, written by entomologist Hugh Danks. The book showcases different nature environments and the insects that inhabit those spaces.

For *Grasshopper*, Phillips used the Gel Composite Method, which makes the white areas of a layer appear transparent. After drawing in black-and-white on the Canvas, he floated the drawing to a layer, and then added color on the canvas using a palette of vibrant greens and golds with accents of orange and brown.

1 Creating black-and-white art. Phillips is known for his expressive drawing with the Scratchboard Tool, a versatile brush that draws lines of variable thickness, based on the pressure applied to the brush. He created a black-and-white drawing in Painter by first filling the image with black color and then etching into the black fill with white color. To draw as Phillips did, start a new document with a white background. Choose black for the Main color (front color square) in the Colors palette, and then click on the Additional Color (back color square) and choose white. Select the black front color square by clicking on it, and then choose Edit, Fill (Ctrl/⌘-F), Fill with Current Color. Click OK. In the Colors palette, click the Color Swap icon (the arrows) to reverse the colors and choose White as the Main Color. Use white and the Scratchboard Tool variant of the Pens to "etch" into the black fill, with the look of a detailed woodcut in mind.

2 Making a layer with transparent white areas. Select All (Ctrl/⌘-A), choose the Layer Adjuster tool, and click once on the image. The image is now floating over a white background. In the Layers palette, choose Gel from the Composite Method pop-up

The Layers palette showing the line drawing floated to a layer. The active line drawing layer has the Composite Method set to Gel.

The Canvas is selected in the Layers palette.

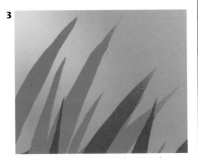

After painting the sky with the Digital Airbrush, Phillips used the Scratchboard Tool to paint the blades of grass.

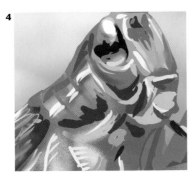

The linear details are drawn with a small Scratchboard Tool.

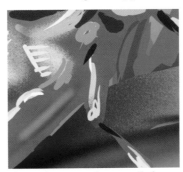

The pastel texture can be seen on the large leaf and on the shoulder of the insect.

menu. This method makes the white areas of the layer transparent, which allows any color you add to the background in steps 3 and 4 to completely show through without affecting the black in the layer.

3 Making freehand selections and laying in base colors. In preparation for painting the base colors, Phillips used the Lasso tool to draw freehand selections so he could isolate areas of his image, for instance the sky and the grasshopper. With the selection active, he used the Digital Airbrush variant of the Airbrushes to paint within the selection. Then, he made selections for the body of the grasshopper and laid in base colors of brown and gold. Next, he selected the large leaf and airbrushed shades of green.

To color his illustration, Phillips used a rich color palette. He used the Scratchboard Tool to paint the blades of grass, beginning with lighter greens and then progressing to darker greens directly behind the grasshopper. The darker greens would suggest shade and help to bring the lighter colored grasshopper forward in the composition. Then, Phillips used the Digital Airbrush to lay in color within selected areas on the grasshopper.

Before beginning to work on the background Canvas, click the Canvas layer's name in the Layers palette. Choose a color in the Colors palette. Use the Scratchboard Tool for loose, freehand-drawn lines, as in the blades of grass. You can hide and show Layer 1 as you work by clicking the eye icon in the Layers palette.

To paint color within a selected, or isolated area, choose the Lasso tool in the Toolbox (it's nested under the Rectangular Selection Tool), and drag to create an irregular selection boundary on your image. (You will find more detailed information about selections and masks in Chapter 5, "Selections, Shapes and Masks.") Then, for smooth airbrushed strokes, choose the Digital Airbrush variant of Airbrushes in the Brush Selector Bar.

4 Painting details and textured areas. For a fine-grained airbrush look, switch to the Fine Spray variant. You can see the smooth Digital Airbrush strokes on the large leaf under the grasshopper and Fine Spray strokes along the edge of the vignette. For the linear details on the grasshopper, use a small Scratchboard Tool.

Next, using the Artist Pastel Chalk variant of Pastels, take advantage of the brush's texture-sensitive capability to brush on grainy strokes in a few areas. Choose Basic Paper texture in the Paper Selector in the Toolbox, and the Artist Pastel Chalk variant of Pastels in the Brush Selector Bar. Next, choose a color, and then brush lightly using the Artist Pastel Chalk to reveal texture.

Capturing a Color Set

Overview *Capture color from a reference image using the Dropper; build and customize a Color Set; use the Color Set to paint a new image.*

CHER THREINEN-PENDARVIS

PHOTO: PHOTODISC

1a

The reference photograph

1b
The Color Variability palette showing ±H, ±S and ±V set to 0

1c

Using the Dropper to sample color from the image

2

Choosing New Empty Color Set in the Color Sets palette

IF YOU'RE PLANNING A SERIES OF ILLUSTRATIONS based on the same color theme, you'll find Painter's Color Sets invaluable. Use this technique of sampling color from a photo or painting to quickly build a selective palette of colors as we did here prior to creating the pastel painting *Tienda Verde*.

1 Sampling the color. Open the image that contains the color range you want. Before you begin to sample the color, open the Color Variability palette (Window, Color Palettes, Show Color Variability), choose "in HSV" from the pop-up menu and set the (±H), (±S) and (±V) sliders to 0. (This will ensure that the colors sampled will be pure color instead of variegated.) Now choose the Dropper tool and click it on a colored pixel in the image. The Colors palette will display the color. If the displayed color isn't the one you want, you can click or drag the Dropper around your image. The Colors palette will update to show the new color.

2 Creating a Color Set. Now click on the Color Sets section name to open the Color Sets palette, and click on the Library Access button (the Grid). From the pop-up menu choose New Empty Color Set. The Color Sets palette will now be empty. Click on the Add Color button (the "Plus" in the Color Set palette) to add the selected color to the Color Set. Continue to sample and add more colors by clicking the Dropper and the Plus button. To save your colors, click on the right triangle on the Color Sets palette bar and choose Save Color Set from the menu, navigate to the Painter 11 application folder, or wherever you want to store your set, name the set and click Save. To use the new Color Set it can be reopened by selecting it in the Painter application folder and clicking the Open button. We named ours "Autumn Color."

3 Arranging the Color Set display. You can change the layout of your colors in the Color Set to fit your drawing environment. To change the shape of the individual color squares, click on the right

3a

Entering the pixel size in the Customize dialog box

3b

The completed Autumn Color Set

4

Applying colored brushstrokes with the Square Chalk using the Autumn Color Set

triangle on the Color Sets bar and choose Swatch Size to display choices. If you don't see a size that you like, choose Customize. We built our Color Set of 32 x 24-pixel-wide squares.

4 Using your new colors.
To paint with the new Color Set, start a new file, click on a color in the set, choose a brush and begin painting. We drew a sketch using a dark blue-gray from our set with the Cover Pencil variant of Pencils, and added brushstrokes in other colors using the variants of the Chalk brush.

AUTOMATIC COLOR SET TOOLS

Painter offers four automatic color set building features: New Color Set from Image, New Color Set from Selection, New Color Set from Layer and New Color Set from Mixer. Using these tools, you can quickly build a color set by extracting every color from an image, selection, layer or the Mixer. (These features are useful if you want to sample every color, but they don't offer quite the same control as sampling individual colors with the Dropper.) To make a color set based on a selected area of your image, begin by opening the Color Sets palette by clicking the Color Sets palette bar name. Open an image, and make a selection (as we did here with the Rectangular Selection tool). In the Color Sets palette, click the Library Access button (the Grid) to display the pop-up menu and choose New Color Set from Selection. Painter will generate the color set. After our color set was made, we displayed the colors in dark-to-light order by clicking the right arrow on the Color Sets palette bar and choosing Sort Order from the pop-up menu, and then choosing LHS (Light, Hue and Saturation) from the menu. Automatically generated color sets often have several colors that are very similar. To remove a color, click on it in the working Color Set and then click the Delete Color from Color Set button (the "Minus") in the Color Sets palette. To save your colors, click on the right triangle on the Color Sets palette bar and choose Save Color Set from the menu, navigate to the Painter 11 application folder (or wherever you want to store your set), name the set and click Save. To use the new Color Set it can be reopened by navigating to where you saved it, and clicking the Open button.

CHER THREINEN-PENDARVIS

An active rectangular selection shown on Forked Path (top left). Choosing New Color Set from Selection in the Color Sets palette (top right); choosing LHS in the Sort Order menu; Show Grid is enabled in the pop-out menu; and the brightly colored color set (bottom left).

Coloring a Scanned Illustration

Overview *Scan a traditional black-and-white pen drawing; clean up the scanned line art; use the Paint Bucket to fill areas with flat color; create texture and energy with a variety of brushes.*

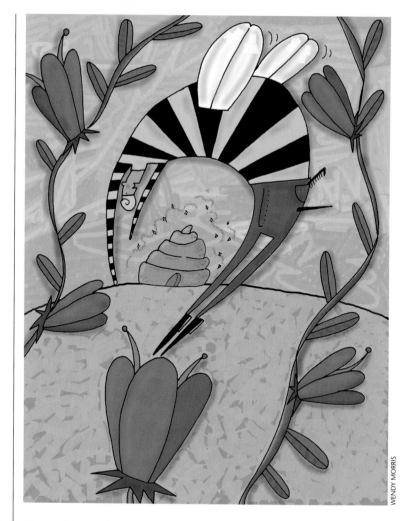

WENDY MORRIS

The raw scan of the Rapidograph pen drawing

WENDY MORRIS'S WHIMSICAL DRAWING STYLE appears to be a quick, spontaneous expression, but her illustrations begin by drawing carefully with traditional pen and ink. In Morris's *Beeman*, the sky is vibrant and charged with frenetic bee energy. *Beeman* was colored with Paint Bucket fills and a variety of brushes.

1 Creating a pen drawing and scanning. Morris chose a bright white recycled drawing paper with a smooth finish and created a black-and-white line drawing using a conventional Rapidograph pen. She intended to use the *Beeman* illustration for a 6 x 8-inch greeting card design that would be printed with offset lithography so she scanned the line drawing using grayscale mode at 100% magnification with a resolution of 300ppi. She saved the scan as a TIFF file and opened it in Painter, which automatically converted the grayscale art to RGB. To learn more about scanning and resolution, see Chapter 1, "Getting to Know Painter" and Chapter 12, "Printing Options."

2a

Adjusting the Brightness and Contrast to "beef up" the line work

2b

Cleaning up specks of black on the scan

3a

The Layers palette with Layer 1 chosen and its Composite Method set to Multiply.

3b

Image canvas showing the flat color fills with "halos"

Image with Layer 1 in Multiply mode and with its visibility turned on

2 Cleaning up the scan. Morris adjusted the contrast of the scanned line work using Brightness/Contrast. To make the adjustment on your scan, choose Effects, Tonal Control, Brightness/Contrast. When the dialog box appears, you can thicken or thin the line work by moving the Brightness slider (the bottom one of the two) to the left or to the right, respectively. Then, to get rid of any fuzziness along the edge that resulted from the Brightness change, increase the Contrast by moving the top slider to the right. (Keep in mind that moving it too far to the right can create a pixelated edge rather than a smooth one.) Each time you move one of the sliders, you can see the tonal adjustment on your image.

Then Morris cleaned up the specks of black on the scan by choosing white in the Colors palette, and touching up areas with the Flat Color variant of the Pens. She switched to black color, and used the pen to repair any breaks in the black lines. (The lines must be completely solid, to "trap" the edges of the Paint Bucket fills that follow in step 3.)

3 Trapping fills using a transparent layer. Morris used the Fill Cell method on the Canvas in an earlier version of Painter. (You can learn about the Fill Cell method using the *Painter 11 Help*. In Painter 11, the updated layers make it quicker and easier to do flat color fills when working with line art. The method of coloring line art described here uses a transparent layer that contains the line art alone to "trap," or hide the edges of, the fills on the image canvas below.

Select the black line art by choosing Select, Auto Select, Using Image Luminance. When the selection marquee appears, hold down Alt/Option (to copy) and choose Select, Float to make a transparent layer containing only the line art. (Layer 1 will appear in the Layers palette.) In the Layers palette, turn off the visibility of Layer 1 by clicking its eye icon off; then target the Canvas layer by clicking on its name. Make the lines thinner on the canvas by choosing Effects, Tonal Control, Brightness/Contrast, and moving both sliders to the right enough to thin the lines but not enough to make breaks in them (you may have to experiment with settings, depending on the thickness of your lines).

Now choose the Paint Bucket tool, and in the Property Bar, click the Image button and from the Fill menu choose Current Color. In the Colors palette, choose a new color; then click the Paint Bucket in a white area of the canvas. To complete the "trap" on your fill, toggle Layer 1's visibility back on by clicking its eye icon, choose the layer and then choose Multiply in the pop-up Composite Method menu at the top of the Layers palette. You can inspect the result with the Magnifier tool. (To read more about Layers, turn to Chapter 6, "Using Layers.")

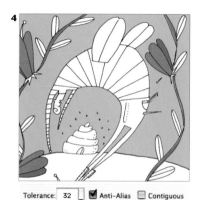

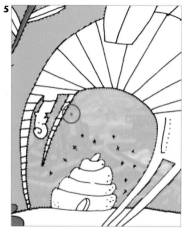

Tolerance: 32 | ☑ Anti-Alias ☐ Contiguous

Using the Magic Wand to select the sky. This detail of the Property Bar shows the Contiguous box unchecked.

Painting on the sky with free brushstrokes

Morris airbrushed soft shadows along edges of the foliage.

4 Making a selection with the Magic Wand. In preparation for the next step, when she planned to paint lively brushstrokes across the sky, Morris isolated the entire sky area (based on its color) by making a selection using the Magic Wand. To select all of the blue sky areas at once, she chose the Magic Wand in the Toolbox, unchecked the Contiguous check box on the Property Bar, and clicked on a blue sky area in her image. To read more about the Magic Wand and selections, turn to the beginning of Chapter 5, "Selections, Shapes and Masks."

5 Painting with brushes. Morris used the Dropper tool to sample sky color in her image; then she used the Variable Flat variant of the Oils to paint "helter-skelter style" brushstrokes across the sky. The Variable Flat incorporates enhanced Color Variability, which allowed the value of the color to change subtly as she painted. For more subtle brushstrokes, she lowered the opacity using the Opacity slider on the Property Bar.

6 Adding texture and details. After completing the flat color fills and the brushwork in the sky, Morris used the Dirty Marker variant of the Felt Pens to modulate color in the plant stems; then she used a low-opacity Digital Airbrush variant of the Airbrushes to paint soft shadows on the leaves and stems. To add texture to the ground, she used the Scratchboard Rake variant of the Pens.

Next, Morris added movement and energy to the bee swarm and the beeman's stinger. She chose black in the Colors palette and used the Pixel Dust variant of the Pens to paint spiraling strokes behind the bee's stinger and above the hive. (The Pixel Dust pen is located in the Painter 5 Brushes library, within the Extras, Brushes folder, on the Painter 11 CD-ROM.)

Morris finished the piece using the Digital Airbrush to add more highlights and shadows to the bee, plants and flowers. She air-

The image with fills and brushwork texture, prior to adding Pixel Dust to the bee swarm

brushed a soft drop shadow along some of the edges on the beeman and the flowers. For more subtle brushstrokes, she lowered the opacity of all of the brushes (except the Pixel Dust pen), using the Opacity slider on the Property Bar. The completed illustration can be seen at the top of page 42. 🖌

■ *I Wish I Was a Cowboy* is one in a series of thirteen illustrations featuring a cowboy theme created by **Keith MacLelland**. "By using cowboy and western iconography in the form of a visual voice, I have enabled myself to assume a persona or virtual costume within the art itself. While peering through the facial cutout, this piece suggests a mirror-like experience where a viewer might imagine themselves to be the heroic cowboy seen riding in the distance," says MacLelland.

By using a playful color palette of complementary colors accented by brighter oranges, golds, reds and turquoises, the cowboy is represented as a fictitious character, rather than a real person . . . the playfulness of the color palette has a lyrical, almost cartoon-like quality. By using the complementary colors, red and green,

juxtaposed against orange and blue, MacLelland created a definite foreground and background. MacLelland began the illustration by assembling a collection of elements—objects, sketches and photographs from his collection. The original drawing of the main cowboy was done on brown craft paper as a pencil sketch, and then scanned and opened in Painter.

The drawing of the main cowboy, shown here in triplicate, was duplicated to make two additional figures (hold down the Alt/ Option key and drag to make a copy). Next, MacLelland adjusted the placement using the Layer Adjuster tool, and then merged the three together by grouping the three layers (by Shift-selecting them in the Layers palette) and then choosing Group from the Layer Commands menu on the Layers palette. To merge the group,

he chose Collapse from the Layer Command pop-up menu on the Layers palette.

Working on an additional layer, he used the Scratchboard Tool variant of Pens to loosely draw in red over the drawing of the three cowboys. Then, he added another new layer and quickly painted the accent colors. For instance, to paint the mint green color on the collar, he used the Grainy Dry Brush variant of the Artists' Oils.

To achieve the cut-out tin sign look, MacLelland used the Bevel World Dynamic Plug-ins feature. Then, to finish, he added a drop shadow by choosing Effects, Objects, Create Drop Shadow. (To learn more about using selections and masks, see the introduction to Chapter 5, "Selections, Shapes and Masks," and for more detailed information about Layers, see Chapter 6, "Using Layers".)

■ **Richard Noble** depicted the bright, almost directly overhead light—of midday—in *Geese*. He painted most of the work with the Broad Water Brush variant of Digital Watercolor using one of his digital photographs for reference. After opening the photo, he chose File, Quick Clone to create a clone copy of the photo, but with a blank canvas and Tracing Paper turned on in the clone image. Noble planned to use elements from the photo and to create a more simplified, elegant image. After choosing the Broad Water Brush, he enabled Clone Color in the Colors palette so that he could pick up color from the photo while he made the first loose, broad brushstrokes. As he painted, he toggled the Clone Color button off when he wanted

to paint with a color he mixed using the Colors palette and on when he wanted to use color from the reference. He used the Digital Watercolor brushes for smoother wash areas and the Watercolor brushes on Watercolor layers for more textured brush work. The textured brush strokes are most noticeable in the warm-colored reflections near the geese.

When Noble had the overall image blocked in, he added the lighter colors and details using the Gouache brushes. To marry the look and texture of the gouache strokes with the background watercolor strokes, he used the Confusion brush variant of the F-X brush. Noble refined the important detail areas, while leaving the larger areas rough.

■ For *Monet's Oat Fields,* **Dennis Orlando** used a luminous color palette, and he painted using grainy pastel strokes.

Orlando began the painting by making a sketch with the Thick and Thin variant of Pencils. Then, he loosely laid in broad strokes of color using the Artist Pastel Chalk variant of Pastels. To establish the mood, he used a brighter palette with deep shadow colors and more saturated highlights. To achieve activity in the color, Orlando increased the Color Variability for the Artist Pastel Chalk, and then he laid in more

brush strokes. He pulled and blended colors into one another using the Grainy Water variant of the Blenders.

For the look of wet paint, he used his favorite modified Round Camelhair variant and the Smeary variants of Oils, which allowed him to add color and blend as he painted. To finish the painting, he added a few grainy strokes using the Artists Pastel Chalk. This brushwork is most noticeable on the right of the painting, in the foreground grass and on the trees.

■ **Ad Van Bokhoven** is an artist based in Holland who works both traditionally and digitally. To create a series of paintings featuring the Toledo Cathedral in Toledo, Spain, he used Painter to emulate the brush work and color that he achieves with traditional oil paints. Van Bokhoven appreciates the realistic effects that can be achieved with the Acrylics, Oils, Impasto and Blenders brushes in Painter.

When on location, he was inspired by the warm, luminous light in the church. For *The Toledo Cathedral 03*, Van Bokhoven began by taking photographs to use for reference. Back at his studio, he opened a new file, and then he used Oils brushes

to block in a compelling color theme that included light golds, oranges, pinks and lavenders, as well as cool grays and blues. He worked directly on the Canvas, without the use of layers, to take advantage of being able to apply paint and blend it more fluidly as he worked. To mix and pull color, he used custom Blenders, based on the Round Blender Brush and the Grainy Blender variant of Blenders.

As he worked, Van Bokhoven focused on preserving the color theme and the soft play of the colors and values against one another—the subtle golds against the cool grays, blues and lavenders. Intuitively, he added accents of cool and warm greens.

He kept his brush work loose and dynamic as he painted. He did not paint a lot of detail, but instead massed large areas of color for impact.

To achieve the subtle layering of color on the walls and floor, he sampled color from his image and used the Colors palette to subtly change the color, which he then applied using a lower opacity brush.

As a final touch, Van Bokhoven added a subtle canvas texture to the painting. He chose a canvas texture in the Paper Selector and then chose Effects, Surface Control, Apply Surface Texture, Using Paper with subtle settings.

■ Inspired by the warm lighting and the perspective in the architecture, **Ad Van Bokhoven** began *The Toledo Cathedral 8* by shooting photographs for reference. Later, back at his studio, he opened a new file in Painter and used large Oils brushes—such as the Smeary Bristle Spray, Tapered Round Oils and Flat Oils variants of the Oils to lay down broad areas of color and value. To blend and move paint, he used Palette Knives and Blenders. So he could blend colors more fluidly as he worked, he worked directly on the Canvas, without the use of layers.

As he painted, Van Bokhoven focused on keeping his brushwork loose and dynamic, without worrying about details. He skillfully massed large areas of color and value. Intuitively, he played cool colors against warm ones. Looking at the composition, you can see it is diagonally divided into mostly warm sunlit areas on the right and cool areas of shadow on the left.

Van Bokhoven wanted to achieve a subtle layering of color on the masonry and floor, so he sampled color from his image and changed the color slightly in the Colors palette, and then applied it using lower opacity Oils brushes. This brushwork is most noticeable in the wall on the right and on the floor and in the shadows in the foreground. You can see more of Van Bokhoven's work in the gallery at the end of Chapter 7, "Enhancing Photos, Montage and Collage."

■ **Fiona Hawthorne** creates wild and imaginative illustrations with a strong graphic feel and vibrant, saturated color.

Shots magazine commissioned Hawthorne to create **Breaking China** (left) and **Advertising in Korea** (below) for articles that focused on creativity moving forward with technology. She began the illustrations by sketching with the Pens, Pencils and Oils variants. Then, she added graphic details.

Keeping in mind the theme of the article (China finding a new creative foundation in a very fast-moving economy), Hawthorne created the bold, expressive illustration *Breaking China*. For the bright-colored strokes on the buildings, she used the Retro Dots variant of the Graphic Design brushes (loaded from the Extras, Brushes folder on the Painter 11 CD-ROM). Then, to add more texture, she pasted in a few bits of images (for instance, for the image on the TV sets, she scanned her own Deng Xiaoping watch and photos of a TV). She selected the watch element layer and increased its saturation using Effects, Tonal Control, Adjust Colors, and then she duplicated it several times. Finally, she drew over the scanned elements with the Thick and Thin variant of Pencils so that they matched the brushwork in the illustration.

For *Advertising in Korea*, Hawthorne was inspired by the fact that broadband Internet access at home, the latest mobile phones and 15-second TV commercials are mainstream in South Korea. She created an image that suggested a link to the new products, ideas and the freedom of youth. She used a large Scratchboard Tool (Pens) to lay in the face, and then she sketched a few loose brushstrokes using the Retro Dots variant to suggest the hair and chest. Next, she used the Pen tool to draw shapes for the stars, which she duplicated and scaled. Then, she downloaded a picture of the Korean flag to use as a graphic in the necklace. She copied and pasted the flag image into her file as a layer and duplicated it, and then positioned the flags using the Layer Adjuster tool.

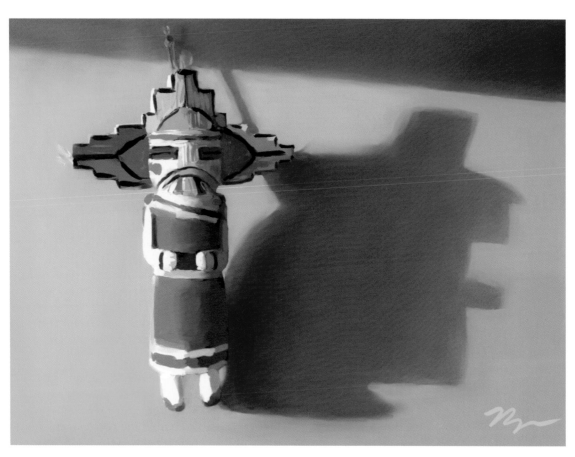

■ Artist and teacher **Steve Rys** began *Katchina* by sketching from life. When he was happy with his drawing, he created a monochromatic study to work out the values.

Rys established a palette of five values ranging from white to black. If the study works in five values, it gives him the confidence to build color within the values. Working with a cover brush (similar to the Opaque Round variant of Oils), he laid in a medium gray value and then began to mass the light and dark values using the values on either side of the medium value.

When he was satisfied with the value study, Rys worked out interesting shapes by making a hard-edged study with mid-value orange (warm) and blue (cool) colors. The warm-cool study established the pattern of light and shadow. At this point, he saved the file.

Working over the top of a copy of his warm-cool study, Rys began painting local colors onto the subject. He usually left the cool colors at mid-value and darker and the warm colors at mid-value and lighter. When the colors were blocked in, he blended some of the edges with the Just Add Water variant of Blenders. When he was satisfied with the small color study, he developed the final painting using his value and color studies for reference.

Rys is currently experimenting with a limited palette, based on the palette that he uses with conventional acrylic paints, to create a more unified color appearance without a formula or routine. All of the color and blending is done from a limited palette. "For me, working within boundaries is freeing. Instead of looking at millions of colored pixels, I am working with eight and blending them," says Rys.

3

PAINTING
WITH
BRUSHES

This detailed illustration for the Gray Fossil Museum in Gray, Tennessee shows Karen Carr's refined digital oil painting technique, achieved by using Charcoal, Blenders and Oils variants. See more of Carr's work in the gallery at the end of this chapter.

Brush Category icon

Arrow to open Brush Category menu

The Brush Selector Bar with the Brush Category menu open

Brush Variant icon

Arrow to open Brush Variant menu

The Brush Selector Bar with the Brush Variant menu open

INTRODUCTION

PAINTER'S BRUSHES ARE THE PROGRAM'S HEART: Without them, Painter would be a lot like other image editors. What sets Painter apart is the way it puts pen to paper and paint to canvas—the way its brushes interact with the surface below them and with the paint that you've already applied. Here's a primer on getting the most from Painter's brushes.

Getting started with painting. If you're new to Painter, follow these steps to jump right in and begin trying out Painter's brushes. Create a new file (File, New). In the New dialog box, under picture type, choose Image, choose Pixels from the pop-up menus, and then type 1000 in the width and height fields. If the Brush Selector Bar is not open, choose Window, Show Brush Selector Bar to open it, or double-click the Brush tool in the Toolbox. (For more brush choices, you can click the small arrow to the right of the Brush Category icon to choose a new brush from the pop-up menu.) Choose Pastels—a texture-sensitive brush—from the Brush Category pop-up menu, and then choose the Square Hard Pastel. Then to select a color, choose Window, Show Colors. Click in the Colors palette's Hue ring or bar and in its triangle to choose a color for your painting (we chose a blue). When you launched Painter, Basic Paper, a versatile medium-grained texture, was automatically loaded. (For information about changing paper textures, see "Switching papers" on page 54.)

For the feel of real painting, use a pressure-sensitive tablet and stylus. With your stylus in hand, sketch loose circles to get the feel of the brush. This simple exercise will help you get to know the Painter brushes and become more comfortable with your tablet and stylus. Experiment by trying out more brushes—for instance, the Flat Oils and Round Camelhair variants of Oils, and the Grainy Variable Pencil and Sketching Pencil variants of Pencils. You can

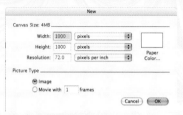

Setting up the New dialog box for a new image to try out the brushes

Pens: Strokes drawn with the Smooth Ink Pen (left) and the Coit Pen (right)

Pastels: Strokes drawn with the Square Hard Pastel (left) and the Tapered Pastel (right)

Oils: Strokes painted with the Flat Oils (left) and the Round Camelhair (right)

Pencils: Strokes drawn with the Grainy Variable Pencil (left) and the Sketching Pencil (right)

find information about drawing and painting with a tablet and stylus and Painter on page 5 in Chapter 1, "Getting to Know Painter." (*The Photoshop and Painter Artist Tablet Book: Creative Techniques in Digital Painting*, published by Peachpit Press treats this topic in detail.)

In addition to painting on the Canvas, it's also possible to paint on a layer or mask. Painting on masks is covered in Chapter 5, "Selections, Shapes and Masks," and painting on layers is covered in Chapter 6, "Using Layers."

Brush basics. Located in the Brush Selector Bar, Painter's brushes are organized into *categories* and *variants*. Brush categories are at the top level of organization for mark-making tools in Painter; they are like the *containers* or *drawers* that hold the individual brushes, pens, pencils, pastels and other painting and drawing implements. Every brush *category* has its own *variants* or varieties, so every time you choose a different brush category, the list of variants changes. To demonstrate, in the Brush Selector Bar, click on the small arrow to the right of the brush and choose the Pens category. Then choose the Smooth Ink Pen variant of the Pens. Click the small arrow to the right of the dab, to open the variant pop-up menu, and choose the Smooth Ink Pen. For detailed information about other

SAVING AND RESTORING VARIANTS

Many artists are content to use just a few of the many brush variants that come standard with the Painter, but others like to create their own. In-depth information for creating your own brushes can be found in Chapter 4, "Building Brushes," on page 138. When you make modifications to a brush, Painter remembers your custom settings. Still, it's a good idea to preserve Painter's default brushes and to save your custom brushes under their own names.

If you've made changes to a brush variant and you'd like to store it in the Brush Selector Bar, choose Save Variant from the pop-up menu on the Brush Selector Bar, name the variant and click OK. The variant that you made changes to will still be selected. Now choose Restore Default Variant, and then click on the new brush variant name that you saved. The original default brush will be restored, but your new variant will stay there until you remove it by selecting it and then choosing Delete Variant from the pop-up menu. Custom variants that you save are also stored in the Application Support folder, (described in "A Word of Caution," below), along with Painter's standard brushes. If you've changed settings and want to switch back to the default, choose Restore Default Variant from the pop-up menu at the right side of the Brush Selector Bar. (To restore all brushes to their default settings, choose Restore All Default Variants from the pop-up menu.) To *replace* a default brush with your custom settings, choose Set Default Variant from the triangle menu. **A word of caution:** After this choice, to restore Painter's original default variant, you will need to remove the variant you saved and relaunch Painter. To navigate to where your custom variants are stored, look for Users, User Name, Library, Application Support, Corel, Corel Painter 11, Brushes, Painter Brushes and remove the variant you saved (as described next) from the category folder you used when you chose Set Default Variant. After relaunching Painter, you will have the original, default brush.

Athos Boncompagni added interest to Casa 1 *—maximizing the interaction between brush and virtual texture in Painter—by exaggerating the size of the texture. Before painting with Chalk variants, he adjusted the Paper Scale slider in the Papers palette.*

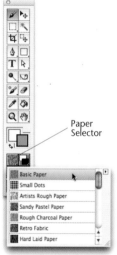

Paper Selector

The pop-up menu in the Paper Selector

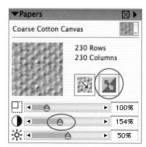

Controls on the Papers palette allow for the adjustment of Paper Scale, Paper Contrast and Paper Brightness. There are also buttons for toggling Directional Grain and Invert Paper on and off. (Paper Contrast is adjusted here, and the Invert paper box is circled.)

aspects of brushes, including creating your own custom brushes, see Chapter 4, "Building Brushes."

Paper interaction. When you draw with a texture-sensitive brush (such as the Grainy Variable Pencil variant of Pencils or the Square Hard Pastel variant of Pastels), the paper texture will be revealed in the stroke as you draw. When you launched Painter, Basic Paper was loaded automatically. Not all brushes are sensitive to the paper texture in the Papers palette. For instance, many of the default Acrylics, Gouache and Oils variants paint beautiful strokes that have bristle marks but do not show paper textures. Although these default brushes do not interact with the paper textures, they can create interesting textures of their own.

Switching papers. Here's how to switch paper textures. Click the Paper Selector icon near the bottom of the Toolbox. (It's the top-left button in the group of six buttons at the bottom of the Toolbox.) Now, click the Papers icon to open the Papers list and click a new paper swatch (such as Rough Charcoal Paper) to change the texture from Painter's default. Experiment by choosing different textures and making brushstrokes using a grain-sensitive brush such as one of the Chalk or Pastels brushes.

GRAIN PENETRATION

For almost all of Painter's grain-sensitive brushes (such as the Chalk and Pastel brushes), the lower the Grain setting, the "grainier" your strokes will look. That's because the Grain setting actually describes *grain penetration.* A lower Grain setting means that less of the color will penetrate into the valleys of the grain. The paint is hitting only the "peaks" of the paper surface. However, with Digital Watercolor, the controls are reversed. A higher setting will reveal more Grain.

The Grain setting and pop-up slider are visible in the Property Bar when the Brush tool is selected in the Toolbox.

INVERTING THE GRAIN

Painter allows you to paint on both the "peaks" and the "valleys" of paper textures. To demonstrate this, choose the Fine Dots texture in the Papers Selector. Open the Papers palette by clicking the tiny arrow on the top right of the Paper Selector and choose Launch Palette. Now choose the Square Chalk variant of Chalk in the Brush Selector Bar and a blue color in the Colors palette. Use the Square Chalk to brush over the "peaks" of the texture. To paint in the "valleys" of the texture, turn on the Invert Paper check box in the Papers palette and brush lightly to apply a gold color.

New in Painter 11, the "Real" Hard Media brushes are scattered through out Painter, and can be found in these categories: Blenders, Chalk, Colored Pencils, Conté, Digital Watercolor, Erasers, Markers, Pastel, Pencils, Pens and Sumi-e—look for "Real" preceding the name. Hard Media brush variants have been designed to perform like traditional drawing tools, in that the stroke changes as you move the brush and tilt the stylus. See "A Painter Hard Media Primer" on page 72.

Using the Real 6B Soft Pencil, when holding the stylus at a tilt, you can draw a thicker stroke—like shading with the side of a pencil.

These quick sketches of Little Doll were drawn using the Cover Pencil variant on Italian Watercolor Paper with a Wacom pressure-sensitive tablet and stylus and a laptop.

Painter's Tracker palette remembers the most recent brushes that you've used, and it's also useful for keeping your favorite brushes close at hand while you're working. To open the Tracker palette, choose Window, Show Tracker. To choose a brush from the palette, click on it. The Tracker palette can store up to 25 variants after the document is closed and in-between work sessions. To clear a brush variant, select the brush and then choose Clear Selected from the palette menu. To save a brush variant with the Tracker, select the brush variant that you want to save and then choose Save Variant from the palette menu. Give the variant a name and click OK. The variant will appear in the Tracker palette, and it will also appear in the variant list under the current brush category on the Brush Selector Bar. If you have a few brushes that you regularly use, you can lock them on to the Tracker palette, so that they will appear at the top of the Tracker every time you launch Painter. To lock a brush, click on it and then choose Lock Variant from the Tracker palette menu. The locked brush will appear at the top of the list. To unlock it, select it and choose Unlock Variant from the palette menu. You can also click the Lock button at the bottom of the palette to lock and unlock brushes.

EMULATING TRADITIONAL TECHNIQUES

Here's a brief description of favorite traditional art techniques and how to re-create them in Painter. One or two techniques for each medium are outlined as a starting point for your own experimentation, but there are a number of ways to obtain similar results.

Pencil. Pencil sketches using traditional materials are typically created on location. Tools include soft-leaded graphite pencils (HB to 6B), various erasers and white paper with a smooth to medium grain. To create a pencil sketch in Painter, select an even-grained paper texture such as Basic Paper and choose the Pencils category, 2B Pencil variant. Select a black or dark gray and begin sketching. To paint a light color over dark—for instance, to add highlights— choose a white color and draw with the Cover Pencil variant. For more about working in pencil, see "Sketching with Pencils" on page 66.

Colored pencil. Conventional colored pencils are highly sensitive to the surface used. Layering strokes with light pressure on a smooth board will create a shiny look, whereas a rougher surface creates more of a "broken color" effect (strokes that don't completely cover the existing art). To closely match the grainy, opaque strokes of a soft Prismacolor pencil on cold-pressed illustration board with Painter, select a fine- or medium-grained paper such as Plain Grain (found in the Drawing Paper Textures library in the Paper Textures folder on the Painter 11 CD-ROM). Choose

The Artist Pastel Chalk variant of Pastels and the Large Chalk variant of Chalk were used on a rough texture to paint Coastal Meadow.

For this Harp Shell study, a Conté variant was used to draw on custom-made Laid Pastel Paper.

This charcoal study inspired by Raphael Sanzio was drawn with the Hard Charcoal and Soft Charcoal variants (Charcoal), and then blended with the Smudge and Just Add Water variants (Blenders).

the Colored Pencil variant of Colored Pencils. Open the General section of Brush Controls and switch the Method from Buildup to Cover and then change the Subcategory to Grainy Edge Flat Cover. See "Drawing with Colored Pencils" later in this chapter for a full description of this technique.

Pastel. Pastels encourage a bold, direct style. Edgar Degas preferred pastels for his striking compositions because they simultaneously yield tone, line and color. A great variety of hard and soft pastels are used on soft- or rough-grain papers. Pastel artists often use a colored paper stock to unify a composition.

Use Painter's Chalk, Pastels and Oil Pastels brushes to mimic traditional hard or soft pastels, and if you want to use a colored paper, click on the Paper Color box (in the New dialog box) as you open a new document and choose a color. The Chalk and Pastels variants are among Painter's most popular. For a step-by-step technique, turn to "Blending and Feathering with Pastels" later in this chapter.

Conté crayon. Popular in Europe since the 1600s and used today for life drawing and landscapes, Conté crayons have a higher oil content than conventional chalk or pastel; as a result, they work successfully on a greater variety of surfaces.

To get a realistic Conté crayon look in Painter, choose the Conté category and the Tapered Conté variant. Reveal more paper grain in the brush work by moving the Grain slider in the Property Bar to 8%. Begin drawing. This Conté variant works well over the Hard Laid Pastel Paper. To blend color while revealing the paper texture, choose the Smudge variant of the Blenders brush.

Charcoal. One of the oldest drawing tools, charcoal is ideal for life drawing and portraiture in *chiaroscuro* (high-value contrast) style. Renaissance masters frequently chose charcoal because images created with it could be transferred from paper (where corrections could be made easily) to canvas or walls in preparation for painting. To create a charcoal drawing in Painter, select a rough paper (such as Charcoal Paper) and a Hard Charcoal Pencil variant of Charcoal. Create a gestural drawing and then blend the strokes—as you would traditionally with a tortillion, a tissue or your fingers—with the Smudge variant of the Blenders. Finish by adding more strokes using the Gritty Charcoal variant of Charcoal.

Pen and ink. Many artists use Painter's Pens variants to draw editorial and spot illustrations. To create a black-and-white pen-and-ink drawing in Painter, choose the Fine Point variant of the Pens and choose 100% black in the Colors palette. Sketch your composition. To draw with lines that are expressively thick and thin based on the pressure you apply to your stylus, switch to the Smooth Ink Pen. To etch white lines and texture into black areas of your drawing, select pure white in the Colors palette and draw with the Fine Point or

To draw Crab, *a spot illustration, Mary Envall used the Smooth Ink Pen and Scratchboard Tool variants of the Pens. Both of these Pens use Painter's rendered dabs.*

Kathleen Blavatt created Heart *using Painter's Liquid Ink brushes.*

In Tiger Kitty, *Chet Phillips used the Scratchboard Tool variant of the Pens.*

Smooth Ink Pen. For a sense of spontaneous energy try drawing with the Nervous Pen. The Real Fine Point Pen, incorporates Hard Media capabilities (new in Painter 11), allowing you to draw a thin line with the stylus upright and a thicker line with the stylus tilted.

Thick ink and resists. When you start to paint with Painter's Liquid Ink, a special Liquid Ink layer is created. With Liquid Ink you can use the thick, viscous ink to paint graphic, flat-color art or to paint thick, impasto-like brushstrokes. For smooth-edged strokes try the Smooth Camel variant. To paint textured brushstrokes, experiment with the Sparse Bristle and Coarse Camel variants. To erode Liquid Ink you've already laid down, choose a Resist variant, such as the Graphic Camel Resist. Brush over the area of ink you want to erode. You can also apply a resist and then paint over it. The resist will repel brushstrokes made with a regular Liquid Ink variant, until repeated strokes scrub the resist away. To see how to add volume to a Liquid Ink drawing, click on the Liquid Ink layer in the Layers palette (Window, Show Layers) and press the Enter key. Move the Amount slider to 50%, and click OK. For more information about using Liquid Ink, turn to "A Painter Liquid Ink Primer" later in this chapter.

Scratchboard illustration. Scratching white illustrations out of a dark (usually black) background surface became popular in the late 1800s. Illustrations created in this manner often contained subtle, detailed tone effects, making them a useful alternative to photographic halftones in the publications of that era. Modern scratchboard artists use knives and gougers on a variety of surfaces, including white board painted with India ink. To duplicate this look in Painter, start with the Flat Color variant of the Pens and increase its size in the Property Bar. Choose black from the Colors palette and rough out the basic shape for your illustration. To "scratch" the image out of the shape with hatch marks, switch to white and change to the Scratchboard Tool variant. Use the Scratchboard Rake to draw several lines at once. Turn to "Coloring a Woodcut" on page 38 and the Chapter 6 gallery to see more work by Chet Phillips.

Calligraphy. With the exception of "rolling the nib" and a few other maneuvers, you can imitate nearly all conventional calligraphic strokes in Painter. (If you

BRUSH RESIZE SHORTCUT

To resize your brush on the fly, press Ctrl-Alt (Windows) or ⌘-Option (Mac). You will see the cursor change to a crosshair. Drag to create a circle the size of the brush you want.

Brushstrokes made using the Opaque Acrylic 30 variant of Acrylics. In the upper left, its default size; upper right, the resized brush "ghost" cursor; lower right, a stroke made with the resized brush.

Script drawn with a pressure-sensitive stylus using the Calligraphy variant of Calligraphy

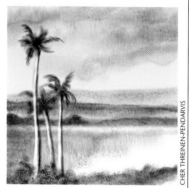

CHER THREINEN-PENDARVIS

Cloudy Day on Kauai was painted with the Runny Wash Bristle, Wash Camel, Fine Camel and Diffuse Camel variants of Watercolor. On the trees, highlights were brought out using the Eraser Dry variant, and foreground texture was added with the Eraser Salt.

CHER THREINEN-PENDARVIS

Glazing techniques were used for this watercolor portrait of Sabina Gaross.

have a Wacom 6D Art Pen you can emulate those as well. See page 64 for more information about the 6D Art Pen and the Art Pen Brushes.) To create hand lettering similar to the example on the left, choose the Calligraphy variant of Calligraphy and begin your brush work. To make guides for your calligraphy, select Canvas, Rulers, Show Rulers and drag guides out from the rulers, or use Painter's Grid overlay (choose Canvas, Grid, Show Grid). If you want a rougher edge to your strokes, try switching to the Thin Grainy Pen 10 variant of Calligraphy, which has a flatter "nib."

Watercolor. Landscape artists such as Turner and Constable helped popularize watercolors in the nineteenth century. The medium's portability lends itself nicely to painting on location. Traditional watercolor uses transparent pigment suspended in water, and the paper is often moistened and stretched prior to painting.

Painter lets you achieve many traditional watercolor effects—without paper-stretching! There are *two* watercolor mediums in Painter: Watercolor and Digital Watercolor. Painters who have worked with traditional watercolors may find themselves more at home with Watercolor, even though it's a bit more challenging to use. In contrast to Digital Watercolor, Watercolor employs a special Watercolor media layer. Here, the pigments can realistically blend, drip and run. To paint with Watercolor, choose the Wash Bristle variant of Watercolor, a rough paper (such as French Watercolor Paper) and a light-to-medium color and then begin painting. (If the color painted is too intense, reduce the Opacity in the Property Bar.) To remove only the color painted with Watercolor variants, use the Eraser Dry variant of Watercolor. For more about Watercolor, turn to "A Painter Watercolor Primer" on page 82.

Digital Watercolor. Digital Watercolor operates like most of Painter's other painting tools—you can choose a brush and begin to paint on a standard layer or on the canvas. (Users of Painter 6 and previous versions will recognize similarities between the earlier watercolor and the new Digital Watercolor.) Many beautiful transparent painting effects can be achieved with Digital Watercolor, which is easier to use and correct than Watercolor. Choose the New Simple Water variant of Digital Watercolor and make brushstrokes on your image. To blend color, stroke over the area with a

Study of a Nude after Rembrandt van Rijn. We sketched with the Fine Point variant of Pens, and then added washes using the Wash Brush variant of Digital Watercolor.

To paint Porcelain Morning Glory, *Kathleen Blavatt used several Airbrushes.*

This detail of Nancy Stahl's Sappi Portrait *shows her gouache technique. To read about her illustration, turn to "Painting with Gouache and Impasto," later in this chapter.*

low opacity New Simple Water brush. For strokes that reveal bristle marks, try the Coarse Dry Brush or the Coarse Mop Brush. Turn to pages 82 and 90 for step-by-step techniques using Digital Watercolor.

Pen and wash. Tinted, translucent washes over pen work has been a medium of choice of Asian painting masters for many centuries. Painter's Digital Watercolor lets you add a wash to any drawn (or scanned) image without smearing or hiding the original image. Choose the Dry Brush or Wash Brush variant of Digital Watercolor and pick a color (it works best to build up color beginning with very light-colored washes). Choose an even, medium-textured paper (such as Basic Paper) and begin painting on top of line work.

Airbrush. The trademark of most traditional airbrush work is a slick, super-realistic look; photo retouching is a more subtle use of the tool. A traditional airbrush is a miniature spray gun with a hollow nozzle and a tapered needle. Pigments include finely ground gouache, acrylic, watercolor and colored dyes, and a typical support surface is a smooth illustration board. Airbrush artists protect areas of their work from overspraying with pieces of masking film or flexible friskets cut from plastic.

In Painter, choose one of the Airbrushes variants and begin sketching or retouching. To get the most from the tool, make selections with the Lasso tool and use them to limit the paint, just as you would with traditional airbrush friskets.

Several of Painter's Airbrushes (such as the Fine Spray, Pixel Spray and Graffiti variants) spray paint onto the image Canvas differently from earlier Airbrushes such as the Digital Airbrush. These Airbrushes take advantage of input technology available from tablet-and-stylus manufacturers such as Wacom. They respond to angle (tilt) and bearing (direction). For instance, as you paint, particles of color land on the image Canvas, reflecting the way the artist tilts the stylus. And with Painter's Fine Wheel Airbrush variant, you can adjust the flow of paint by adjusting the wheel on a special Airbrush stylus. For those accustomed to the Airbrushes in earlier versions of Painter, the Digital Airbrush variant is most similar to these.

HIGH-RESOLUTION PAINTING

If you are working with large, high-resolution files, consider increasing your brush size and scaling up paper textures. Choose a brush, and in the Property Bar adjust the Size slider, or type in a new value. To scale up a paper texture, use the Paper Scale slider in the Papers palette or type in a new percentage.

Gouache. Rouault, Vlaminck, Klee and Miró were a few of the modern artists who experimented with this opaque watercolor, used most frequently in paintings that call for large areas of flat color. Gouache contains a blend of the same type of pigment used in transparent watercolor, a chalk that makes the medium opaque and

This detail from Amaryllis *was painted with the Opaque Bristle Spray and Smeary Bristle Spray variants of Oils, and then blended with the Smudge variant of Blenders.*

"REAL" AND HARD MEDIA

Painter X featured the amazing Real-Bristle Brushes that are, for the most part, contained in the RealBristle Brush category. And now Painter 11 debuts exciting new "Real" brushes that incorporate Hard Media capabilities, for instance, the Real 6B Soft Pencil variant of Pencils and the Real Fine Point Pen variant of Pens. Brushes with Hard Media performance are scattered throughout Painter 11. Brushes in the new Marker category also incorporate Hard Media capabilities, but its variants do not have the word "Real" included in their name.

Coast by Richard Noble is an example of the artist's digital acrylic technique.

an extender that allows it to flow more easily. For an expressive, opaque color painting brush, try the new Flat Opaque Gouache variants; for a more subtle semi-transparent look, use the Wet Gouache Round variants.

USING SETTINGS IN THE PROPERTY BAR

You can quickly check settings for the current brush variant by using the Property Bar (Window, Show Property Bar). Settings for the Tapered Flat Oils variant of the Oils category are displayed below. To change brush settings (such as Size) without opening the Brush Controls or the Brush Creator, click on the tiny arrow to the right of the field to access the setting pop-up and then drag the slider to the right to increase the setting or drag to the left to decrease it.

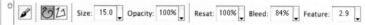

The default settings for the Tapered Flat Oils variant of Oils

Oil paint and acrylic. These opaque media are "standards" for traditional easel painting. Both can be applied in a thick impasto with a palette knife or stiff brush. (Impasto is a technique of applying paint thickly.) They can also be *extended* (thinned) with a solvent or gel and applied as transparent glazes. They are typically applied to canvas that has been primed with paint or gesso. Try the following methods to get the look of acrylic in Painter.

For a technique that incorporates the texture of brush striations and a palette knife, begin by choosing the Gessoed Canvas paper texture from the Paper Selector (located near the bottom of the Toolbox) and an Opaque Acrylic variant of the Acrylics, and then start painting. Blend colors using short strokes with a Round Blender Brush variant of Blenders. To subtly bring out the Gessoed Canvas texture, try blending with the Grainy Water variant of Blenders. To scrape back or move large areas of color on the image canvas, use a Smeary Palette Knife variant of the Palette Knives. When working on smaller areas of your image, adjust the size of the Palette Knife variant using the Size slider on the Property Bar.

For a painting method that emphasizes the texture of canvas, begin by choosing the Coarse Cotton Canvas texture from the Paper Selector. Now choose the Opaque Bristle Spray variant of the Oils and lay color into your image. To smear existing paint as you add more color, switch to the Smeary Bristle Spray variant. To reveal the texture of the image canvas, while you blend colors, switch to the Smudge variant of Blenders. For yet another digital oil method,

REALBRISTLE EXPRESSION

The RealBristle Brushes give you the joy of more realism and expression. RealBristle Brushes simulate the feel and the movement of a conventional brush in your hand, as well as the interaction of the brush with the canvas. RealBristle Brushes are ideal for simulating the look of oils and acrylics. Learn more about the RealBristle Brushes in "A Painter RealBristle Primer" on page 102 and "Painting with RealBristle Brushes," on page 105.

This detail from Agaves on the Edge, Summer *was painted with the Artists' Oils brushes. See the entire image on page 95.*

CHER THREINEN-PENDARVIS

This detail from Dawn Peace *was painted with the RealBristle Brushes. See the entire image on page 102.*

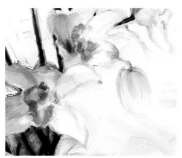

Chelsea Sammel used Impasto brushes to add thick paint to Dying Orchids, *a detail of which is shown here. To see the entire image and read about her painting process, turn to page 173.*

see Dennis Orlando's version of a traditional oil look in "Painting with Pastel and Oils," in Chapter 4; to see more examples of Richard Noble's digital acrylic paintings, turn to the gallery at the end of this chapter.

To get textured brushstrokes (a "3D paint" look) with any of these methods when you're finished, choose Effects, Surface Control, Apply Surface Texture. Choose Image Luminance from the pop-up menu and an Amount setting of 20%–30%. If you want to mimic the look of acrylic paint extended with a glossy gel medium, drag the Shine slider to 100%. To get a semi-matte finish, move the Shine slider to between 20% and 30%.

Painting with wet Artists' Oils paint. The Artists' Oils medium feels just like viscous, wet oil paint. With the Artists' Oils, you can apply paint and blend paint to your heart's content. The brushes are also exciting to use for loose gestural work and for working over photographs. For more information about the Artists' Oils see "A Painter Artists' Oils Primer" on page 92, and "Painting with the Artists' Oils" on page 95.

Painting with realistic Impasto. Impasto gives you the power to show the texture of brushmark striations and the thickness of paint itself with realistic highlights and shadows

IMPASTO COMPOSITE DEPTH

You can paint Impasto on layers and then set Composite Depth on each layer (in the Layers palette) to raise or excavate the paint, as described in "A Painter Impasto Primer" on pages 114–115. (The Composite Depth option will have no effect if you've used Impasto on the Canvas instead of on added layers.)

We painted each rust brushstroke on a separate layer with the Opaque Round variant of Impasto. Then, we used Composite Depth controls, Subtract (left) and Add (right), to excavate the left stroke and raise the right stroke.

as you paint. Impasto brings thick paint to the tip of your stylus! When you choose a variant of the Impasto brush (such as the Thick Wet Round) in the Brush Selector Bar, the Impasto effect is automatically enabled. You can use Impasto on the image Canvas or on added layers.

Here's an Impasto primer: Create a new, blank file (File, New). To activate Impasto, choose an Impasto brush (such as the Thick Wet Round variant) from the Brush Selector Bar. Make brushstrokes on the image canvas. To toggle the Impasto effect on and off, you can click the small paint splat icon in the upper-right corner of Painter's scroll bar. (This toggle does not affect the dimensionality created with the Apply Surface Texture command described on the "Oil paint and acrylic" section above.) To read more about painting with Impasto, turn to "A Painter Impasto Primer," "Brushing Washes Over 'Live' Canvas" and "Working with Thick Paint," later in this chapter.

In Three Trees, *Chelsea Sammel mixed media while painting. As shown in this detail, she used modified Chalks and Oils brushes: the Smeary Bristle Spray; Blenders, the Coarse Smear; and finally the Oil Pastels and a modified Sharp Chalk variant (Chalk) to define details.*

To complete Speedy Persimmon, *Janet Martini mixed media using the Calligraphy variant of the Calligraphy on top of Watercolor variants and Oil Pastel strokes.*

For Zinnias, *we painted over a photo with Pastel variants, completely covering it with colored strokes. Then, we used Distortion and Blender variants to distort the flowers, add texture and emphasize the focal point.*

Mixed media. You can create media combinations in Painter that would be impossible (or at least very messy!) in traditional media. Try adding strokes with a Watercolor or Pencils variant atop Oils, or use a Pens variant on a base you've painted using the Chalk or Gouache variants. See how artists Chelsea Sammel and Janet Martini combined media in the two paintings at the left.

Mixed media painting with a liquid feel. Painter offers several brushes that are reminiscent of wet paint on canvas—for instance, the Sargent Brush variant of the Artists brush, which can both lay down color and smear it, and the Palette Knives variants, which can move large areas of color. Painting with these brushes is a very tactile experience.

In the *Paths to Water 4* study shown on page 63, we sketched in color with the Square Chalk (Chalk) and a Round Soft Pastel (Pastels) on a rough paper. Then, we switched to the Sargent Brush variant of the Artists brushes to apply more painterly strokes. To blend areas of the foreground and midground, we used the Grainy Water variant of Blenders, and then we used the Smeary Palette Knife and Subtle Palette Knife variants of the Palette Knives to expressively pull color in the sky. To paint and blend using these brushes, choose the Sargent Brush and a color, and begin painting. When you are ready to pull and blend paint, switch to the Palette Knife. Try reducing its Opacity in the Property Bar for a more subdued effect.

The Blenders and Distortion variants are also helpful blending tools. To create *Zinnias*, we used the Bulge variant of the Distortion category to enlarge the pink flowers, and the Coarse Smear variant of Blenders to pull pixels and add diffused texture to the edges. Then we used the Marbling Rake variant of Distortion to add linear texture and to pull pixels up and around the image to create a sense of movement.

Erasing techniques. Painter provides several ways to simulate traditional erasing and scratch-out techniques. *Lighten* an area of an image by using the Bleach variant of the Erasers, lowering the Opacity slider in the Property Bar to 5% for improved control. (You can also use the Dodge variant of the Photo brush to lighten color.) Use the Thin Grainy Pen 10 variant of the Calligraphy brush and white (or a light color) to *scratch out* pigment from a pastel or oil painting; to create strokes with more subtle texture, switch to the Thin Smooth Pen 10 variant of Calligraphy. Use the Eraser Dry variant of the Watercolor brush to pull up pigment from a "wet" painting done with Watercolor variants (similar to *sponging up* a traditional watercolor). For a more subtle result, lower the Opacity slider (in the Property Bar) to 40%. Try the Bleach Runny

LIQUID BRUSH STRENGTH

To control the strength of the Bulge, Pinch, Smear and Turbulence variants of the Distortion brush, adjust the Strength (or Opacity) slider in the Property Bar.

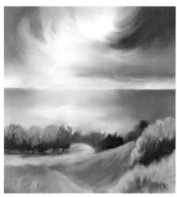

In this detail from a study for Paths to Water 4, Palette Knife *variants were used to pull and spread color in the clouds and sky.*

Brian Moose used the Glow brush variant of the F/X brush to make the brush tips burn in his painting Creative Journey, *a detail of which is shown here.*

variant of Watercolor to leach color from an area, while creating a drippy texture. To pull color out of areas when using Digital Watercolor, use the Wet Eraser, and for picking color out of smaller areas, try the Pointed Wet Eraser variant of Digital Watercolor.

Painting with texture. The Add Grain variant of the Photo brush is just as useful for painting as it is for photo manipulation, because it literally puts texture on the tip of your brush. You can switch textures at any time during the painting process by changing the selection in the Papers palette. For best results, use very light pressure on the stylus. Make a few marks in the document to preview the effect. For a more subtle look, try lowering the Strength and Grain settings in the Property Bar.

Painting with special effects. Painter offers intriguing special-effects brushes that allow you to paint with fire, glows, fur, sparkly fairy dust, hair spray, neon, striped strokes, shattered glass and more! In the detail of *Creative Journey* shown on the left, Brian Moose used the Glow variant of the F-X brush to make the paintbrush tips in his image smolder with a fiery glow.

Painting with the Fire and Glow variants works best on a dark area of your image. To paint semi-transparent flames, choose the Fire brush variant of the F-X brush. For a subdued fire effect that you can build up gradually, with a light pressure on the stylus, choose a very dark orange color with a value (V) of 10%–15% in the Colors palette. Make short strokes in the direction you want the flames to go. For realism, vary the size of the brushstrokes. Change

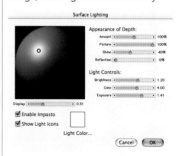

The Surface Lighting dialog box allows you to dynamically set Appearance of Depth and Light Controls for Impasto brushstrokes in the entire image.

Calligraphy drawn with the 6D Art Pen and the Thin Smooth Calligraphy pen from the Art Pen Brushes

Expressive brush strokes painted with the 6D Art Pen and the Soft Flat Oils brush from the Art Pen Brushes

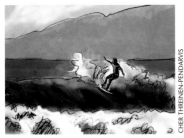

To paint this study for Cutting Back at Rincon, *we used the Pens, Gouache and Airbrushes variants to paint on transparent layers. After drawing the line sketch on its own layer, we created a second layer for the color work. Using low-opacity color, we painted on the "color" layer to build up brushstrokes without altering the image canvas or the layer with the line sketch. We finished by dragging the line sketch layer to the top of the Layers palette, placing it on top of the color layer.*

CHER THREINEN-PENDARVIS

the size of the brush by using the Size slider in the Property Bar; then paint more brushstrokes by using a light pressure on the stylus.

USING THE EXPRESSIVE ART PEN BRUSHES

Painter 11 and the Wacom 6D Art Pen support rotation, which, prior to the 6D Art Pen, was a missing dimension for artists using a Wacom tablet. The Painter Art Pen Brushes were designed by Cher Threinen-Pendarvis to work with the Wacom 6D Art Pen and to allow you to tap into more expression in Painter. The brushes are as follows: Thin Smooth Calligraphy, a broad pen that changes stroke thickness and character as you rotate the pen; Grainy Calligraphy, a tapered pen that responds by changing the character of the stroke as you rotate your hand; the Soft Flat Oils, a flat brush whose soft bristles respond subtly as you move your hand in a natural way while painting; the Tapered Gouache, a round brush whose bristles also respond as you rotate your hand and the stroke thickness also changes as you apply pressure to the stylus; and the Square Grainy Pastel, a brush that is similar to a hard square pastel that shows a lot of paper grain. Its strokes also change as you move your hand in a natural rotation while drawing.

PAINTING ON LAYERS

Painter lets you paint (and erase) not only on the program's Canvas but on transparent layers above it. A transparent layer is similar to a piece of clear acetate that hovers above the image canvas. When you paint on a transparent layer with a brush, in the clear areas you can see the Canvas underneath, as well as color on other layers that you may have stacked up. You can also change the stacking order of the acetate sheets. If you work with Adobe Photoshop, you'll find Painter's transparent layers familiar.

PICKING UP COLOR

To bring color from underlying layers into an upper layer that you're painting on (and mix color on the active layer), turn on Pick Up Underlying Color in the Layers section.

To add a new layer to an existing file, open the Layers palette (Windows, Show Layers) or click the left triangle on the Layers section bar to open this section. Click the right triangle on the section bar to access the Layers palette's pop-up menu and choose New Layer. To paint on the new layer, choose any brush except a Watercolor or Liquid Ink variant, target the layer in the Layers palette and begin painting.

Layers offer great flexibility to digital illustrators. Some artists prefer to draw each item in an image on its own layer, which isolates the item so that it can be repositioned or painted on as an individual element. Transparent layers are also useful when creating *glazes*—thin, clear layers of color applied over existing color. (Turn to Chapter 6, "Using Layers" to read more about painting and compositing techniques.)

Align Brush to Path:
Tolerance: 20
☐ Paint hidden shapes

Cancel OK

The default Shapes Preference settings for the Align Brush to Path

Size: 40.0

The Align to Path button in the Property Bar

Selecting the Canvas layer, with the Oval shape layer visible

Painting on the Canvas with an Artists' Oils brush using Snap to Path function. The Oval Shape layer is visible.

PAINTING ALONG A PATH

When you want to paint a precise curve or shape, the Snap to Path Painting feature in Painter saves you time. Using Snap to Path, you can constrain a brushstroke to a path by clicking the Align to Path button on the Property Bar. The brush stroke will reflect the sensitivity that Painter brushes are famous for, such as pressure, tilt and bearing.

To use the Snap to Path feature, begin by choosing the Oval shape tool in the Toolbox. In the Property Bar, enable Stroke and disable Fill, and then choose a color in the Colors palette. From the Shapes menu, choose Set Shape Attributes and set the Width of your stroke to 2. As you draw the shape, constrain the oval to a circle by holding down the Shift key. With the Oval shape layer visible, click on the Canvas layer in the Layers palette to select it. Choose a brush in the Brush Selector Bar. In the Property Bar click on the Align to Path button to activate the Snap to Path function. (Note: In Preferences, Shapes you can set the Align Brush to Path tolerance and enable Paint hidden shapes. For this example, we used the default preference settings of 20 for Tolerance with Paint hidden shapes unchecked.)

As you paint, your strokes will follow the path of the circle. To create concentric circles, select the Layer Adjuster tool, and then Shift-drag one of the corner handles of the shape to proportionally reduce the size of the circle. Now, move the smaller circle shape inside of one of your painted circles and paint with Snap to Path active around the smaller circle. Experiment by trying out more brushes with the Snap to Path feature. To read about how Carol Benioff uses the Snap to Path feature turn to "Illustrating with the Artists' Oils" on page 99 later in this chapter.

THE LOOKS YOU LIKE

If you like the look of a particular brush-and-paper combination (for instance, a Square Soft Pastel variant of Pastels on Rough Charcoal Paper), save the combo as a *Brush Look* so that you can quickly call it up when you want to use it again. Before you can save a new Look, in Painter it's necessary to select an area of an image that can be used as an icon for the Brush Look. In the Toolbox, choose the Rectangular Marquee tool and drag in the image to make a selection. Select the texture from the Paper Selector (near the bottom of the Toolbox) and the brush variant from the Brush Selector Bar. In the Toolbox, click the Looks Selector and choose New Look from the triangle pop-up menu. Naming your New Look saves it to the current Brush Look library, which is located in the Look Selector in the Tools palette. Open the Look Selector by clicking the Look icon. To paint with your new Brush Look, select it from the pop-up menu.

A brushstroke painted with the Pattern Pen brush, Pattern Pen Masked variant (over a blue background) using the Jungle Vines pattern as the Source. This look can be accessed by clicking the Looks Selector (near the bottom of the Toolbox) and choosing Jungle Vine Pen.

Sketching with Pencils

Overview *Draw a loose sketch with Pencils variants; scribble and crosshatch to develop tones; brighten highlights with an Eraser.*

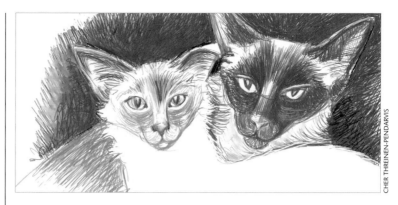

LOOSE, EXPRESSIVE SKETCHES CAN BE DRAWN with the Painter's Pencils variants, with a look that's similar to traditional tools, as shown in this drawing of Soshi and Pearl.

1 Setting Brush Tracking. Pencil sketching often involves rapid, gestural movements with the stylus so it's important to set up Brush Tracking before you begin to sketch. With Brush Tracking you can customize how Painter interprets the input of your stylus, including parameters such as pressure and how quickly you make a brushstroke. Choose Edit, Preferences/Corel Painter 11, Preferences, Brush Tracking and make a representative brushstroke in the window.

2 Beginning to sketch. Create a new image file (File, New). (Ours measured 1100 x 600 pixels.) Click OK. Click on the Paper Selector icon in the Toolbox and select an even-textured paper such as Basic Paper and then select the Pencils category, 2B Pencil variant in the Brush Selector Bar. The default 2B Pencil uses the Buildup method, which means that color you draw is semitransparent and will darken to black, just like when you draw with a conventional 2B graphite pencil. Select a dark gray in the Colors palette and draw a line sketch that will establish the negative and positive shapes in your composition.

3 Building tones and modeling form. To bring the subjects forward in the picture frame, add dark values behind them. Make crosshatched strokes with the 2B Pencil to create the darker tones. Keep your strokes loose and gestural. Lively stroke patterns will add texture interest to your drawing. To model the faces and bodies of the cats, we used the Oily Variable Pencil, which smeared the pencil slightly as we scribbled and crosshatched. The Oily Variable Pencil incorporates the Cover method, which means that the color you draw is opaque; a lighter color will paint over a darker color.

For highlights, choose white in the Colors palette and switch to the Cover Pencil variant in the Brush Selector Bar. The Cover Pencil is ideal for adding highlights because it covers previous strokes without smearing. To clean up areas, choose the Eraser variant (Erasers). A tiny Eraser also works well for brightening highlights.

Making a stroke in the Brush Tracking window

The loose composition sketch

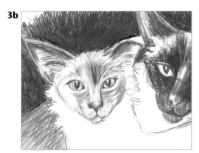

Adding tones to the background and values to the faces

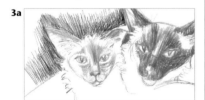

Darker tones and more texture have been added to the background and the faces.

Drawing with Colored Pencils

***Overview** Create a sketch with the Sharp Colored Pencil variant; use the Cover Colored Pencil to further develop the drawing; adjust Color Variability settings for a more active color effect.*

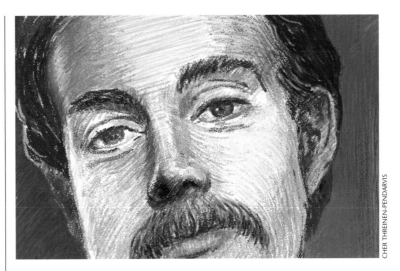

CHER THREINEN-PENDARVIS

The line sketch drawn with Colored Pencils

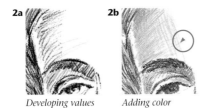

Developing values *Adding color*

Building dimension using increased settings in the Color Variability palette, and strokes that follow the form

YOU CAN MODIFY THE COLORED PENCIL variant and get a broken color effect (where the color only partially covers the background or underdrawing) by brushing lightly across a textured surface.

1 Starting with a sketch. To work at the same size we did, open a new 883-pixel-wide file with a white background. Click the Paper Selector near the bottom of the Toolbox, choose Basic texture and select a dark brown color in the Colors palette. From the Brush Selector Bar, choose the Colored Pencils category and the Sharp Colored Pencil variant, and then draw a portrait sketch.

2 Developing value and adding color. Now choose the Cover Colored Pencil 5 variant of Colored Pencils from the Brush Selector Bar. Use this brush and a lighter brown to develop values throughout the sketch. Choose a skin color (we chose a tan for this portrait of Steve Pendarvis) and apply strokes with a light touch to partially cover some of the brown sketch. Follow the form with your strokes, switching colors and brush sizes as you draw.

3 Building dimension. To give a shimmery look to the color as it's applied, choose Window, Color Palettes, Color Variability, and drag the Hue (±H) and Value (±V) sliders in the Color Variability palette to 3%. Using a light touch to allow the underpainting to show through, apply fresh strokes in the areas of strongest color (in our drawing, the forehead, nose shadows and the hair).

COLORED PENCIL WASHES

If you're using Colored Pencils on rough paper, you can create a wash effect. Choose the Grainy Water variant of the Blenders, reducing Opacity and Grain penetration in the Property Bar to 40% or less. Stroke over your pencil work to blend colors while maintaining texture on the "peaks" of the paper grain.

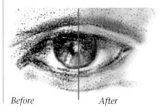

Before *After*

Making Sketchbook Studies Using Pens

Overview *Start with gestural drawing; build the forms with crosshatching; clean up with an Eraser.*

Drawing the first gestural lines with the Croquil Pen variant

CAROL BENIOFF

Adding defining lines to the gesture drawing and removing some of the lines with an Eraser variant

USING THESE SIX DIFFERENT PEN VARIANTS, it's easy to create quick studies with a variety of looks. The Pens resemble their traditional counterparts, but unlike the conventional pens they emulate, Painter's Pens do not spatter, and you can erase their ink. Carol Benioff used the Pens to draw these black-and-white studies.

Studies from Leonardo da Vinci. Benioff began by finding good reproductions of Leonardo da Vinci's drawings to use as a reference. Then she created a new 7 x 9-inch image in Painter at 300 pixels-per-inch.

1 Making a gesture drawing. She chose the Croquil Pen 5 and she sketched a gestural drawing, mapping out the shape of the hand.

2 Defining lines. Benioff drew over the gesture drawing with more definitive lines. She removed lines that she no longer needed using

3

Completing the study with crosshatch and gestural strokes

4

Study of a hand drawn with a Smooth Round Pen in short curving strokes

5

Hand drawn with the Thick n Thin Pen

6

Study of a foot using the medium weight line of the Ball Point Pen 1.5

a Pointed Eraser variant of Erasers. Next, she built up the tones and form with short, quick strokes.

3 Completing the study. Using a combination of crosshatching and curving lines, she created the highlights and shadows that gave the hand its definition. The study had the scratchy feel of the traditional croquil pen without the splatters.

4 Using the Smooth Round Pen. Turning to another drawing by Leonardo to use as her model, Benioff then selected the Smooth Round Pen 1.5 variant of Pens. It had the delicate quality that she wanted to create thin expressive lines. She drew this study using long gestural strokes.

5 Using the Thick n Thin Pen. For her fifth study, Benioff selected the Thick n Thin Pen 3. The bold quality of line the pen produces helped to create a clean and simple drawing. She added a suggestion of shading, which she sketched using short squiggles and a bit of crosshatching.

6 Using the Ball Point Pen. For this study of a foot, Benioff chose a Ball Point Pen variant. This gave her an even-weighted medium line. She built up the form using overlapping scribbles and crosshatching.

7

The beginning gesture drawing and the completed sketch of a foot using the Reed pen variants

8

The first gestures and the finished sketch of two feet, using the Bamboo Pen 10 resized to about 5 pixels using the Size slider on the Property Bar

7 Using the Reed Pen. In this drawing of a foot Benioff selected the Reed Pen 5 for its strong, thick-to-thin lines. First she drew a quick gestural outline. Then she used long, smooth strokes to define the contours. Sizing the pen nib down to 3.7 from 7 pixels in the Property Bar, she continued to draw short, curving strokes to indicate the form and shadow.

8 Using a Bamboo Pen. For a strong, clear line Benioff chose the Bamboo Pen 10, sizing it down to about 3 pixels. Again she started with a simple gestural outline, and then used short, smooth lines to add the contours. She finished the sketch with short straight lines to add definition to the form and to indicate shadows.

Expressive Drawing with Pens

Overview *Create a line sketch using a Thick n Thin Pen; modify the Leaky Pen for more expression; add spotted and linear accents.*

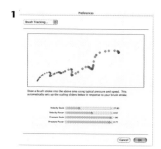

Setting up Brush Tracking

Drawing the line sketch with the Thick n Thin Pen 5 variant of Pens

PAINTER IS THE ULTIMATE DIGITAL ART STUDIO, with literally hundreds of brushes to choose from. For *Today's Suit,* a fashion illustration sketch, we drew with several expressive Pens variants in Painter, including the Thick n Thin Pen, the Coit Pen and the Leaky Pen. Additionally, we modified the Leaky Pen so that it would paint even more random spots.

1 Setting Brush Tracking. For the most responsive strokes during your work session, it's important to set up Brush Tracking. Brush Tracking allows you to customize how Painter interprets the input of your stylus, including parameters such as pressure and speed. From the Edit/Corel Painter 11 menu, choose Preferences, Brush Tracking and make a representative brushstroke in the window. For instance, if you plan to use both light and heavy pressure while sketching slowly and then quickly, make a brushstroke that includes these factors.

2b

Drawing a few squiggly accents on the line sketch with the Thick n Thin Pen

3a

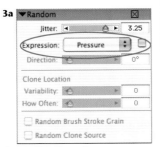

Changing the Jitter Expression pop-up menu to Pressure

3b

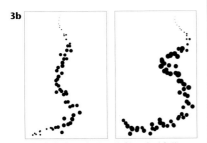

The default Leaky Pen (left) and with Jitter Expression set to Pressure (right)

4a

Leaky Pen spots on the hat and jacket

2 Creating a line sketch. Open a new file that is 1500 x 2000 pixels. In the Brush Selector Bar, choose the Pens category from the Brush Category pop-up menu; then choose the Thick n Thin Pen 5 variant from the Brush Variant pop-up menu. It's a good idea to make some practice marks with the pen. Choose black in the Colors palette and press lightly on your stylus to sketch a thinner line and press more heavily to draw a thicker line. When you've finished practicing, delete your practice strokes by choosing Select, All and then pressing the Delete/Backspace key.

For this illustration, we chose to sketch the basic shapes using the Thick n Thin Pen because it allows you to draw smoothly, while varying the thickness of the lines. To sketch a graceful, tall model, use your stylus to make sweeping, curved vertical strokes, which will suggest the outline of the model and emphasize her height. As you sketch, keep in mind the motion of her walk and the sweeping curves of her clothing. Then, add a few details and accents with shorter, squiggly strokes.

3 Adding more expression to the Leaky Pen. In preparation for adding texture with the Leaky Pen, we modified its settings to make it even more expressive. Choose Window, Brush Controls, Show Random and set the Jitter Expression pop-up menu to Pressure. Save your variant by choosing Save Variant from the pop-up menu on the Brush Selector Bar and give it a name. For good Painter housekeeping, restore the default variant to its original settings by choosing Restore Default Variant from the same menu.

4 Adding texture with unusual Pens. Next, we added whimsical texture to the line work using two unusual Pens variants. To add interesting textured spots, we used both the default Leaky Pen and the custom Leaky Pen from step 3. Choose your modified Leaky Pen. Make a practice stroke using light pressure to begin the stroke, and then gradually apply heavier pressure at the end of the stroke.

4b

Detail showing the Coit Pen strokes on the jacket and skirt

You'll notice that the spots will become larger and more random with heavier pressure. Now, draw a few textured accent strokes on your model using the modified Leaky Pen. We loosely drew in a few accents.

Next, we used the Coit Pen to draw textured line accents. When you have the spotty texture as you like it, switch to the Coit Pen variant of Pens and draw a few gently curved linear accents, as we did here along the sides of the jacket and skirt in the illustration.

A Painter Hard Media Primer

Overview *Here you'll find the basics for painting with the Hard Media brushes.*

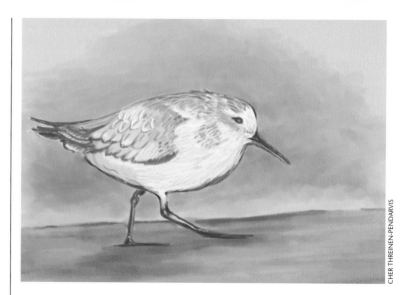

CHER THREINEN-PENDARVIS

In this detail of the Sanderling Study, *you can see varied thicknesses of the Real Sharp Colored Pencil strokes, and the tonal variations possible when the sides of the pencils are used for shading.*

NEW IN PAINTER 11, HARD MEDIA brushes have been designed to perform like conventional drawing tools, in that the stroke changes as you tilt the stylus and move the brush. For instance, using the Real 6B Soft Pencil, you can draw a thin line when holding the stylus upright and then draw a thicker stroke—like shading with the side of a pencil—when you tilt the stylus.

Sanderling Study (above) was painted with the Real 6B Soft Pencil variant of Pencils, the Real Soft Colored Pencil and Real Sharp Colored Pencil variants of Colored Pencils, and the Real Pointy Blender and Real Stubby Blender variants of Blenders. Before you start a painting of your own, reading this primer will help you to achieve the results you're looking for.

Exploring the Hard Media brushes. The new Hard Media brushes are scattered throughout Painter 11 and can be found in these categories: Blenders, Chalk, Colored Pencils, Conté, Digital Watercolor, Erasers, Markers, Pastels, Pencils, Pens and Sumi-e. The organization can be a bit confusing, but look for the word "Real" preceding the brush name, with one exception: The Markers have their own new category, but its variants do not begin with the word "Real."

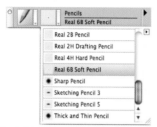

The Brush Selector Bar, open to show the Pencils category and new "Real" Hard Media Pencil variants.

The new Real 2B Pencil, Real 2H Drafting Pencil, Real 4H Hard Pencil and Real 6B Soft Pencil incorporate a new Pencil Tip Profile that is designed to emulate the transition of a conventional pencil as it moves from the pointed tip, to the side of the pencil. Typically, the tip of a pencil is used for sketching, and its side is used for shading. In the new tip profile, the stylus is centered on the darkest point of the

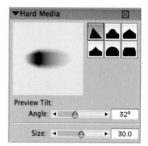

The Real 6B Soft Pencil is chosen. Here is how the Pencil profile appears in the Hard Media palette using dab view.

The Real 6B Soft Pencil variant of Pencils offers versatile thin and thick brushstrokes depending on the angle of the stylus. The top stroke was drawn with the stylus held erect, and the bottom stroke with the stylus tilted.

Brushstrokes painted using the Real Soft Chalk variant of Chalk

Strokes drawn using the Real Sharp Colored Pencil (top) and the Real Soft Colored Pencil (bottom) variants of Colored Pencils

These overlapping strokes were painted using the Real Soft Pastel (left) and the Real Hard Pastel (right) variants of Pastels.

Stroke drawn using the Real Drippy Pen (top), hatched strokes using the Real Fine Point Pen (middle) and stroke drawn with the Real Variable Width Pen (bottom)

SET BRUSH TRACKING

Brushes using the Hard Media capabilities are very sensitive to *Brush Tracking*. With Brush Tracking you can customize how Painter interprets the input of your stylus, including parameters such as pressure and speed. Choose Edit (Win) or Corel Painter 11 (Mac), Preferences, Brush Tracking, make a representative brushstroke in the window and then click OK.

dab, and the edge is feathered from black to gray to allow for a soft edge on the stroke.

When using the Hard Media brushes, you can work directly on the Canvas or you can paint on a layer—we worked on the Canvas. To try out the Hard Media pencils, go to the Brush Selector Bar and from the category menu, choose Pencils. Create a new file by choosing File, New. (Our file for trying out the brushes measures 600 x 600 pixels and has a white background.) The new pencils are based on the performance of conventional pencils, both in the softness/hardness and how they interact with texture on the Canvas: Real 2B Pencil, Real 2H Drafting Pencil, Real 4H Hard Pencil and Real 6B Soft Pencil. In the Paper Selector (Toolbox), choose a coarse, natural texture for trying out the brushes (we chose Charcoal paper). To draw with the fine point, hold your stylus upright at about a 20° to 30° angle from vertical and practice drawing a curved, looping stroke. Next, transition to a wider stroke as if you were shading with the side of the pencil by tilting the stylus to about 40°–60° degrees from vertical. Draw another curved looping line, this time emulating drawing with the side of the pencil.

Next, try out the Real Sharp Colored Pencil and Real Soft Colored Pencil variants of Colored Pencils. These versatile tools are great for sketching in color and for drawing both thin and thick lines.

Next, let's explore brushes that apply grainy strokes and looks, for instance the Chalk and Pastels. Choose the Real Soft Chalk variant of Chalk from the Brush Selector Bar—the Real Soft Chalk paints broad strokes when used on its side and is good for blocking in large areas quickly. Paint a slightly curved horizontal stroke by slightly tilting your stylus, and then experiment with tilting it more as you rotate your hand. Next, use the Real Soft Chalk to paint a circular stroke, while moving your hand naturally. Now, try out the Real Soft Pastel variant of Pastels. This brush has a softer feel, and is also good for shading and laying broad areas of color. Using this brush, make several angular, overlapping brushstrokes, while tilting your stylus. Next, choose the Real Hard Pastel, which simulates a harder pastel and paints grainier strokes. Using this brush, paint angular strokes so that you can see how this brush interacts with the chosen texture. (For a technique using the Real Pastels and Blenders, see "Blending and Feathering with Pastels" on page 78.)

Located in the Pens category, you will find the Real Drippy Pen, Real Fine Point Pen and the Real Variable Width Pen. Choose the Real Fine Point Pen and sketch some hatched strokes as we did here. Follow up with more practice strokes with the other new pens.

Painting a continuous overlapping stroke with the Flat Rendering Marker (top) and painting two strokes (bottom). Notice the buildup of the orange on the pink in the lower strokes.

Painting transparent color using the Markers. An exciting new brush category and media type, the Markers incorporate the new Hard Media capabilities for tip profile control, and they also offer transparent wet media that has similarities to Digital Watercolor. Using the Markers, you can lay down color using one continuous stroke without buildup of the color, until you lift the stylus and touch the tablet again, to paint a new stroke. Similar to Digital Watercolor, the Markers work on a Gel layer, allowing for beautiful transparency effects. See "Drawing with Real Pencils and Markers" on page 80 for a creative technique featuring the Markers.

Customizing the Hard Media brushes. When making your own "Real" Hard Media brushes, you can start with any Captured Dab, Circular and Eraser dab type brush, for example, the existing Pencils, Chalk and Pastels variants. Following is an overview of the settings in the new Hard Media section of Brush Controls.

Within the Preview Window, you can toggle between the dab and size previews by clicking in the Preview Window. Six Tip Profiles are available, with the new Pencil profile is in the upper left. In the Preview Tilt area, the Angle slider is tied to the Mouse Angle control and when the Angle slider is adjusted, it updates on the Mouse section of Brush Controls. The range of the slider is 0° to 90°, with 0° being the tip of the pencil for thin lines (as if the stylus was upright) and the other extreme, 90°, as if the stylus was tilted, shading with the side of the pencil. The Size slider adjusts the Size of the brush, and this control is tied to the Size slider on the Size section of Brush Controls. Squeeze determines the roundness or elliptical shape of the brush. In the Squeeze section, the V Min and V Max sliders denote the minimum and maximum squeeze on the vertical axis. The H Min and H Max controls the set amount of Squeeze applied to the dab on the horizontal axis. The Stepping slider sets the number of variations for the dabs for the angle adjustment; the lower number will take longer to render the dab matrix, but will create a smoother transition from small-to-larger-size dabs. The Transition Range allows the user to set the start and finish points for the transition between a fine point to a larger shading dab.

The Dab Type pop-up menu in the General section of Brush Controls. The Circular, Captured and Eraser dab types are compatible with the Hard Media controls.

The Preview Tilt area of the Hard Media section shows the Brush Dab Preview Window, the Tip Profiles and the Angle and Size sliders. The Brush Dab Preview is shown in Size view. Click in the window to toggle between views.

The Hard Media section of Brush Controls contains Brush Tip Profiles, as well as Preview Tilt, Squeeze and Transition Range settings.

Painting with the Hard Media Brushes

Overview *Design a still life; set Brush Tracking and make practice strokes with Hard Media brushes; build a color palette using the Mixer; draw a sketch; lay in colors and model forms; add details.*

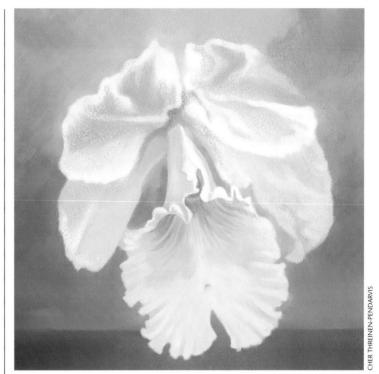

CHER THREINEN-PENDARVIS

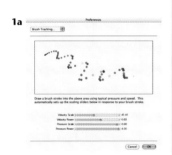

Making a brushstroke in the Brush Tracking window using light to heavy pressure

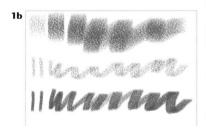

Practice strokes drawn with the Real Fat Chalk (top), Real Hard Chalk (middle) and Real Soft Chalk (bottom)

FLOATING ORCHID 2 IS ONE IN a series of surrealist paintings of flowers hovering over land and sea. The flower was painted from life, while the simple seascape was painted from a memory of beautifully lit clouds over the sea in the early morning.

This project uses Chalk and Blenders brushes that incorporate Hard Media capabilities, which means the brushes are very sensitive to the nuances of your hand, for instance, whether the stylus is held upright or at a tilt while drawing. We love painting with the Chalk brushes because they interact with Painter's textures in such a unique and natural way!

1 Setting up and making practice strokes. The first step is to set up the still life. We placed the blooming orchid under a full spectrum light on the desk. Then we planned a composition with plenty of space around the flower because we planned to paint a seascape behind it.

It's important to set Brush Tracking before you work with the sensitive Hard Media brushes. Brush Tracking allows you to customize how Painter interprets the input of your stylus, including parameters such as pressure and speed. Choose Edit, Preferences, Brush Tracking (Mac OS X users, choose Corel Painter 11, Preferences, Brush Tracking) and then make a typical brushstroke in the window. For a broader range of sensitivity, we recommend making a stroke in the Preview window that reflects using light and heavy pressure while painting quickly and then slowly.

The Mix Color tool is chosen in the Mixer, and the Dirty Brush mode is turned off.

Loosely sketching with the sensitive Real Soft Chalk variant of Chalk

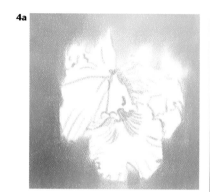

Blocking in the sky behind the orchid using the Real Fat Chalk variant of Chalk

It's a good idea to get acquainted with the brushes by making some practice strokes. In this project you will use the Real Fat Chalk, Real Hard Chalk and Real Soft Chalk variant of Chalk and the Real Stubby Blender and Real Pointy Blender variants of Blenders.

2 Planning a color palette using the Mixer. We used the Mixer palette to build basic colors for the painting. If the Mixer is not visible, choose Window, Color Palettes, Mixer. It's a good idea to have both the Colors palette and the Mixer open while you work. Apply color to the Mixer with the Apply Color tool (at the bottom of the Mixer Pad, second from left). The Dirty Brush mode is active by default. Deselect the Dirty Brush by clicking on it. The Dirty Brush mode retains color that was previously used. For this painting, we preferred to apply puddles of pure, clean color to the Mixer and then mix them using the Mix Color tool (third from left).

3 Sketching with Chalk. Now, it's time to sketch. To create a file for your painting, choose File, New and set up a file that measures 10 x 12 inches at 150 ppi. In the Paper Selector located in the Toolbox, choose a natural texture (we chose Basic Paper). In the Colors palette, choose a color that will complement the colors you plan to use in your painting. We created a drawing in Painter from direct observation, by sketching with one of our favorite Hard Media brushes, the Real Soft Chalk using a blue-gray color over Basic Paper. For this sketch, you can work directly on the Canvas. While drawing, carefully observe the shapes of the forms in your subject and pay careful attention to the lighting on the forms.

4 Building an underpainting. We envisioned a background sky with soft cloud shapes. The darker values behind the white orchid will help the background to recede and allow the flower to come forward in the composition. The Real Fat Chalk is a sensitive, grainy, Hard Media brush that is ideal for laying in large areas quickly. Choose the Real Fat Chalk variant of Chalk. Use the Sample Color tool from the Mixer to pick up color and then lay color onto the clouds and sky. Notice how the width of the stroke changes with the tilt of the stylus. When you are ready to add color to the center of interest, switch to the Real Soft Chalk. Be loose and expressive with your brush work. While carefully observing the forms and lighting, we blocked in the shapes and values, resizing the brush as we worked.

5 Sculpting forms and modulating color. Now that the basic colors are established, begin to layer chalk strokes that will build color complexity. As you work, continue to use the Mixer palette as a paint palette to pick up color and the Real Soft Chalk to apply paint to the Canvas. Directional brushstrokes will add dynamic energy to the image. Layer color over color, and let your strokes follow the direction of the forms. Next, use a wider range of values to further establish the light on the forms. We also added brighter

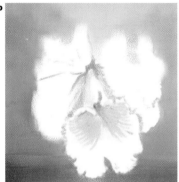

4b

Using a Real Soft Chalk to lay in base colors for the flower and to add more varied colors to the background

5a

Modeling forms on the interior of the flower with a small Real Soft Chalk

5b

Using the Real Pointy Blender to smooth the shadow edge on the flower petal

colors to the sky and then blended large areas of color with the Real Stubby Blender.

Now that your painting is nearly completed, zoom in to 100% and take a careful look at your composition. In our painting, the center of interest needed brighter highlights and deeper shadows. The petals in the center of the flower needed to be brightened and refined. To paint crisper edges and brighter color on these petals, we used a small Real Soft Chalk, and to add textured details to shadowed areas on the petals, we used a small Real Hard Chalk. Then, to blend small areas, we reduced the size of the Real Pointy Blender to about 7–10 pixels and brushed carefully, allowing the strokes to follow the forms. Next, to layer more texture onto the sky, we sampled color from the image using the Dropper tool, switched to the Real Fat Chalk and then loosely brushed back and forth over the cloud shapes, sampling a different color with every few strokes.

6 Refining and adding details. As with the modeling and sculpting work in step 5, when painting the smaller details, keep in mind the shapes of the forms, and apply the strokes in the direction of the forms. To add final touches to the center of the flower, we used a small Real Soft Chalk (try 7–10 pixels). First, we added strokes of varied gold, orange and brown onto the center of the flower. Then we added deeper tones to the interior to help bring the overlapping lip forward. The final brushwork can be seen in the completed illustration on page 75. 🖌

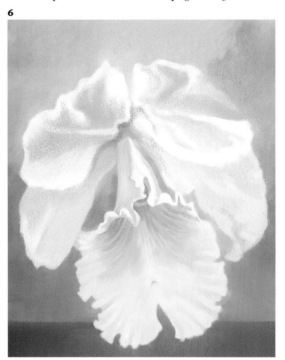

6

The nearly completed painting. Details in the center of interest are finessed and blended, and texture is preserved on supporting areas.

Blending and Feathering with Pastels

Overview *Set up a still life; sketch from life with pastels; build color and form; blend the painting; add feathered brushstrokes to finish.*

Choosing a paper color

The Real Soft Pastel variant of Pastels incorporates Hard Media capabilities

Loosely sketching with the Real Soft Pastel variant of Pastels

FEATHERING—THIN, PARALLEL STROKES over a blended underpainting—is a traditional pastel technique that yields texture and freshness. Because the feathered finishing strokes remain unblended on the painting's surface, the viewer's eye must work to blend the colors. Here is an example of optical color blending. For more sensitivity and expressive strokes, we used new Pastels brushes that incorporate Hard Media capabilities.

1 Starting with a sketch on colored paper. We set up a still life next to a window, arranging the subject so that the shadow would help to lead the eye into the composition and give the painting more depth. In this painting we designed a complementary color scheme, using a varied purple background that would set off the yellow and green pears.

When we were happy with the still life design, we opened a new file (File, New: 4 x 4 inches x 300 ppi) with a dull purple-colored background. To set the Paper Color, click the Paper Color preview in the New window and choose a color in the Colors dialog box. To select a new hue or adjust its saturation, click or drag in the color wheel. To make the color darker or lighter, adjust the value slider on the right side of the window. When you have a color that you like, click OK. Now click the Paper Selector near the bottom of the Toolbox and select Sandy Pastel Paper texture. Pick a color to sketch with from the Colors palette (we began with a warm yellow). Select

1d

Blocking in base colors on the pears and foreground to begin the underpainting

2a

Sculpting the forms with curved and angled strokes of varied color.

2b

Adding hatched strokes to sculpt the form of the pears and build values

3

Blending with the Grainy Water and Real Pointy Blender variants of Blenders

the Real Soft Pastel variant of Pastels from the Brush Selector Bar. For a more sensitive response when using your stylus, choose Edit, Preferences/Corel Painter 11, Preferences, Brush Tracking, make a representative brushstroke in the window and click OK. The Real Soft Pastel incorporates Hard Media features that are new in Painter 11, and allows you to make thin strokes when the stylus is upright and broader strokes when the stylus is tilted. (See "A Painter Hard Media Primer" on page 72 for detailed information about Hard Media.) Make a few practice strokes to get a feeling for the brush. Now increase the size of the brush (we used 50–60 pixels), so you can block in the base colors easily. Using broad strokes, lay in the base colors on the pears and suggest a horizon line (in our case, an angled table top), choosing new colors as needed.

2 Sculpting the forms. Next, we roughly sculpted the shapes of the pears. Still working with Real Soft Pastel, lay in more color over your subject, allowing your strokes to follow the direction of the forms. We sized our brush to about 40–50 pixels to paint broad strokes of color and value.

Now, resize the Real Soft Pastel to about 30 pixels, and add smaller curved and angled strokes that follow the direction of the forms. To give the simple composition more interest, we used angled strokes to paint varied purple, cream and brown colors on the background and on the table.

3 Softening the brush work. Select the Grainy Water variant of Blenders, and blend areas of color, again following the direction of the forms. To blend detailed areas with a thin, tapered brush, try the Real Pointy Blender variant of Blenders. We smoothed larger areas on the pears with the Grainy Water, then switched to the Real Pointy Blender to blend the highlight details on the stems.

4 Adding feathered strokes and detail. To create thin, textured strokes on top of the blended forms, choose the Real Soft Pastel and reduce its size using the Size slider in the Property Bar (try 10 pixels). Stroke with this brush in the direction of the form. Here, feathering is most noticeable in the highlights near the top of the closest pear—in the varied yellow colors overlaid over the pears

Using feathered strokes to bring out highlights and color variations on the pear

more neutral colors. Finish the piece by using the Grainy Water variant to soften the feathering in the shadow areas. (To do the final blending touches, we lowered the Grainy Water variant's Opacity to 40% using the Opacity slider in the Property Bar.) Finally, we used a tiny Real Soft Pastel to add details to the stem on the foreground pear.

Drawing with Real Pencils and Markers

Overview *Set Brush Tracking and make practice strokes; draw a line sketch using the Real 2B Pencil; paint areas of flat color with the Chisel Tip Marker; add details with the Sharp Marker.*

CHER THREINEN-PENDARVIS

Practice strokes drawn with the Real 2B Pencil variant of Pencils

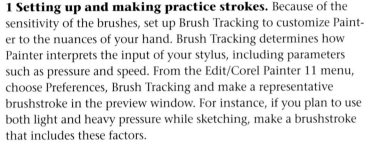

Left: Practice strokes drawn with the Chisel Tip Marker (top), the Sharp Marker (center) and the Flat Rendering Marker (bottom.) Right: The purple stroke and gold stroke drawn over the top in the example show the ability to multiply color when separate strokes are drawn.

NEW IN PAINTER 11, THE REAL PENCILS AND THE MARKERS incorporate the sensitivity of the Hard Media features. With Hard Media tools, the width of the brushstroke changes as you hold the stylus upright and then tilt the stylus at an angle—a more dramatic angle produces a wider line. The Markers offer transparency similar to Digital Watercolor. Because of their transparency, the Markers are an excellent choice for quickly painting solid areas of color and for building up colored washes similar to watercolor. For *Chasing the Blue Bird*, we sketched with the Real 2B Pencil variant of Pencils and then colored the drawing with Markers, including the Chisel Tip Marker and Sharp Marker. This drawing is inspired by the beautiful children's book illustrations of Patricia Palacco.

1 Setting up and making practice strokes. Because of the sensitivity of the brushes, set up Brush Tracking to customize Painter to the nuances of your hand. Brush Tracking determines how Painter interprets the input of your stylus, including parameters such as pressure and speed. From the Edit/Corel Painter 11 menu, choose Preferences, Brush Tracking and make a representative brushstroke in the preview window. For instance, if you plan to use both light and heavy pressure while sketching, make a brushstroke that includes these factors.

Now, open a new file for your illustration that is 900 x 1150 pixels (File, New). Before you start your drawing, try out the brushes by

The line sketch is drawn with the Real 2B Pencil variant of Pencils.

The base colors for the little girl are painted with the Chisel Tip Marker.

The dots and stripes on the little girl's jumper are drawn with the Sharp Marker.

doodling with the Real 2B Pencil. Choose a dark color in the Colors palette and in the Brush Selector Bar, choose the Real 2B Pencil variant of Pencils. The Real 2B Pencil is sensitive to the tilt of the stylus and draws a thin line when the stylus is upright and a thicker line the more you tilt the stylus. Make curved and linear strokes while you vary the tilt of the stylus.

Next, in the Brush Selector Bar, choose the Markers category; then choose the Chisel Tip Marker. Using the Markers, a continuous stroke drawn without lifting the stylus from the tablet produces even color, and this is true even if areas of the stroke overlap. This quality makes the Markers very forgiving. Make a few practice strokes with all of the Markers variants. A new stroke layers color over existing paint and darkens it, similar to using the Multiply compositing method or painting on a Gel layer.

2 Creating a line sketch. Now that you're familiar with the brushes, use the Real 2B Pencil to draw your line sketch on the Canvas, using loose, natural strokes. If you want to clean up a line, you can do so quickly using the Eraser tool in the Toolbox.

3 Painting the base colors. When the sketch is as you like it, make a new layer for the base coloring. Click the New Layer button at the bottom of the Layers palette, and a layer titled Layer 1 will appear. Choose the Markers category from the Brush Category pop-up menu and then choose the Chisel Tip Marker from the Brush Variant pop-up menu. When you touch the Marker to Layer 1, the Composite Method for the layer automatically switches to Gel, a transparent layer mode. Use the Chisel Tip Marker to lay in the colors for the girl's clothing and skin on this layer. Color using a single continuous stroke where possible to keep the color even.

Next, choose a green-gold and paint the base color for the field. The Just Add Water variant of Blenders is a useful tool for smoothing areas if overlapping strokes look too uneven for your taste.

4 Adding the details. After the base colors are established, add a second layer for the details. Paint decorative patterns on the clothing and draw the grass and other details using the Sharp Marker variant of Markers and using contrasting colors. For the stripes, reduce the size of the Sharp Marker to 7–10 pixels using the Size slider in the Property Bar and then carefully draw vertical stripes on the jumper.

The grass blades and shading are in progress in this detail.

Use this same small Sharp Marker to loosely paint the random blades of grass. For the light brown shading on the rabbits, reduce the opacity of the Chisel Tip Marker to about 10%, using the Opacity slider in the Property Bar, and brush lightly.

A Painter Watercolor Primer

Overview *Here you'll find the basics for painting with Painter's Watercolor brushes and layers.*

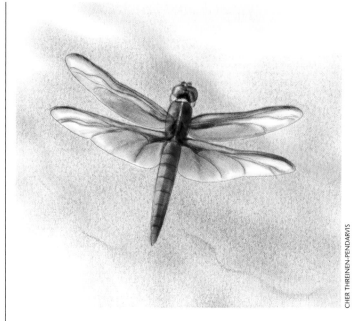

CHER THREINEN-PENDARVIS

PAINTER FEATURES TWO KINDS OF WATERCOLOR: Watercolor layers and Digital Watercolor. This primer covers Watercolor Layers. Digital Watercolor, which is simpler to use and doesn't require a special layer, is covered on pages 90–91.

Watercolor media layers provide artists with an experience that's surprisingly like traditional watercolor. The Watercolor Layer is a simulation of a transparent wet medium containing suspended pigment. This makes it possible to create smooth, transparent washes and then diffuse color into existing wet paint to blend, as a traditional watercolorist would.

Dragonfly (above), is one of a series of insect studies painted using a technique similar to the one presented step-by-step in "Wet-into-Wet Watercolor" on page 86. But before you start using Watercolor, reading these four pages will help you to understand how to achieve the results you desire.

Controlling Watercolor. With Painter, you can control the wetness, drying time, direction in which your wash will run and many other techniques that you're able to achieve using conventional watercolor tools. The most important settings for Watercolor are in the Brush Controls (the General, Size and Water sections— these windows are also located in the Stroke Designer tab of the Brush Creator); the Papers palette and the Layers palette. When you make a brushstroke with a Watercolor brush, a Watercolor Layer is automatically generated in

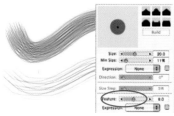

These two brushstrokes were painted with the Dry Bristle brush. The top stroke uses the default brush settings. For the bottom stroke, the Feature size was increased to 8.0 in the Size section of the Brush Controls, which resulted in a brushstroke with fewer brush hairs.

The Water section of the Brush Stroke Designer (Brush Controls) contains controls for modifying Watercolor brushes.

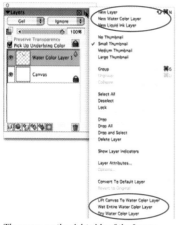

The menu on the right side of the Layers palette bar offers useful options for working with Watercolor layers: New Watercolor Layer, Lift Canvas to Watercolor Layer, Wet Entire Watercolor Layer and Dry Watercolor Layer.

the Layers palette. Watercolor Layers can be targeted in the Layers palette and edited like other layers. Chapter 6 tells about working with layers.

In the General section of Brush Controls, the Watercolor dab types are displayed in the Dab Type pop-up menu. A dab type determines the shape of the brush—for instance, Watercolor Flat and Watercolor Camel Hair (round). Most of the Watercolor brushes use continuous-stroke technology, which means that brushstrokes are painted using brush hairs that are a set of anti-aliased 1-pixel lines. You'll find more information about dab types in Chapter 4, "Building Brushes."

In the Size section of Brush Controls, you'll find the Feature slider, which determines the density of the brush hairs in the continuous-stroke brushes. **Note:** A very low Feature setting (producing more densely packed brush hairs) takes greater computing power, which can slow down the performance of a Watercolor brush.

In the Water section of the Brush Controls, *Wetness* works with Evaporation Threshold to control the amount and spread of the *water* and *dye*. A low Evaporation Threshold will allow more spread; higher values will cause less spread. A high Wetness setting will blur the individual bristle marks and (with a high Diffusion Amount setting) increase the spread of the stroke, but it may make the performance of the brush lag. *Pickup* controls the amount of existing paint that gets moved when a new brushstroke paints over existing pigment. High Pickup rates cause wet edges or puddles, which can be desirable. The *Dry Rate* controls the length of time the water and pigment take to settle. A high Dry Rate will keep a brush with high Diffusion Amount settings from spreading as far, because the stroke will dry before it has had time to diffuse. A low Dry Rate value will allow more time for spread. *Evaporation Threshold* controls the amount of *water* that can diffuse. (In traditional watercolor, evaporation is the rate in which liquid is sublimated into the atmosphere.) *Diffuse Amount* controls the amount of *pigment* that can diffuse.

With Accurate Diffusion off in the Water section, larger cells are visible when a brushstroke is made. Accurate Diffusion allows finer detail and a more natural-looking diffusion of pigment into the Watercolor Layer. But it may cause a slight decline in brush responsiveness.

Two brushstrokes painted with the Diffuse Camel variant of Watercolor (brushstrokes shown at 200%). Accurate Diffusion was turned off when the top stroke was painted and turned on for the bottom stroke.

A smooth wash (top), and thick and thin flower petal shapes (bottom), painted with the Wash Camel variant of Watercolor

A smooth stroke painted the Wash Bristle (top) and diffused strokes with wet edges, painted with the Wet Bristle (bottom). The variation in color is caused by pigment buildup.

These soft-edged washes and brushstrokes were painted with the Diffuse Flat.

These crisper, expressive strokes were painted with the Wash Pointed Flat.

Capillary Factor and *Grain Soak-In* affect the amount of pigment that settles in the valleys of the paper grain. Setting both of these controls to 0 will minimize grain effects. Also, very low Capillary Factor and Grain Soak-In settings will allow a runny wash to spread more smoothly. A high Capillary Factor (with a low Grain Soak-In setting) will create a "stringy" drip texture in the runny wash.

GETTING TO KNOW THE WATERCOLOR BRUSHES

Here are some suggestions for how to paint traditional-looking brush work using Painter's Watercolor brushes. Even if you're familiar with using a stylus and Painter's other brushes, try these exercises and experiment with all of the Watercolor brushes. You may enjoy discovering a new kind of expressive brushstroke!

Versatility with Camel brushes. The most versatile of all the Watercolor brushes, the Camel brushes, are round. In addition to painting various kinds of washes, most Camel brushes allow you to paint brushstrokes that can be thick and thin, depending on the pressure applied to the stylus. Other Camel brushes allow you to apply drippy washes (Runny Wash Camel and Runny Wet Camel), while the Diffuse Camel paints strokes that have soft, feathery edges.

Choose the Wash Camel variant and paint a smooth wash area. Apply even pressure to your stylus, and make a horizontal stroke; then carefully paint a second horizontal stroke below it, just slightly overlapping the first stroke. The diffusion in the stroke edge will help make a smooth transition between the strokes. Before painting thick to thin strokes, choose Edit, Preferences/Corel Painter 11, Preferences, Brush Tracking, make a representative brushstroke in the window and click OK. Using the Wash Camel, press harder to paint the thicker area of the shape; then gradually reduce pressure on the stylus, finally lifting your stylus as you complete the stroke.

Expressive brush work with Bristle brushes. These Watercolor brushes paint just like brushes with real bristles because they're sensitive to tilt and rotation of the stylus. As you tilt your stylus, the bristles of the brush spread or splay out as you rotate your hand through the stroke. To paint a wash that has the texture of soft bristle marks, try the Wash Bristle brush. For a wet-into-wet effect with subtle bristle marks and pools at the stroke edges, experiment with the Wet Bristle.

Thick and thin strokes with the Flat brushes. Look for brushes with the word Flat in their name; the Diffuse Flat and Wash Pointed Flat are examples. With Flat-tipped brushes, you can paint wide or narrow strokes, depending on the way you hold the stylus and how much pressure you apply. When trying the strokes that follow, position your stylus with the button facing up (away from you). To paint a fuzzy wash with the Diffuse Flat (as in the image on the left), pull the brush straight across your image using even

The Fine variants are useful when painting expressive, linear brushstrokes, as in the sketches of the eye and grasses shown here.

We painted this cloud study using the Runny Wash Bristle and Runny Wet Camel to paint the clouds, the Wash Camel and Fine Camel variants to paint the water and the Diffuse Camel to soften a few edges.

For this foliage study we created texture in the foreground with a small Splatter Water brush.

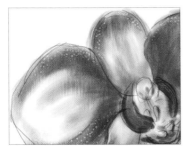

As a final touch to Pink Orchid, we used the Eraser Salt variant of Watercolor to sprinkle light speckles on the tops of the petals.

pressure. To make the thin lines, pull down. To make a curved, thin-to-thick wavy line, use light pressure on your stylus for the thin top areas, and more pressure as you sweep down and rotate the brush.

For flat brushstrokes with crisper edges and more thin-to-thick control, try the Wash Pointed Flat. For a thin-to-thick sweeping curved stroke, begin the thin portion with very light pressure on your stylus, and as you sweep downward rotate your stylus slightly (changing the button orientation) and apply more pressure. To make a thick, even stroke, pull the stylus sideways relative to the button, using even pressure. For the thin lines, apply even pressure and pull in a direction toward or away from the button.

Adding detail with the Fine brushes. The Fine variants of the Watercolor brush are good for painting details, and for calligraphic line work. The Fine Bristle and Fine Camel are similar to "rigger" or "line" brushes, which are used to paint expressive line work in traditional watercolor.

Painting runny washes using the Runny brushes. The *Runny* variants (the Runny Wash Bristle and the Runny Wash Camel, for instance), are useful for painting drippy wet-into-wet washes, where the colors run together and blend, but they don't displace the underlying color. The *Runny Wet* variants, however, will run and move existing color as the new pigment travels. The Runny Wet brushes are useful if you want to add a darker wet-looking edge to the bottom of a cloud, for instance.

For all of the Runny Wash and Runny Wet brushes, the Wind Direction and Force settings determine the direction of the run and how far a wash will run, much like tipping your watercolor board when working in the field. To paint a Watercolor Runny wash that moves only a little, lower the Force setting.

While painting the clouds in the illustration on the left, we laid varied sky colors in using the Runny Wash Bristle and Runny Wet Camel. To soften some of the runny edges, we dotted in more color using the Diffuse Camel, applying color with short dabbing strokes. Then we painted the water with the Wash Camel and Fine Camel variants, again softening areas with the Diffuse Camel.

Adding spatter effects. With the Splatter Water variant, you can add dots of diffused color to your paintings. This is especially effective when painting foliage. Paint some wash areas using the Wash Camel or Wash Flat, and varied colors of green. Now choose the Splatter Water variant and a slightly different color. Paint a few dots of color; then change the color slightly in the Colors palette and add a few more diffused color dots, changing the size of the brush as you work.

Also, you can add varied, light speckles to your images (as we did in the image on the left), with the Eraser Salt variant of Watercolor. To follow a step-by-step technique similar to the one used for painting the orchid, turn to "Wet-into-Wet Watercolor" on page 86.

Wet-into-Wet Watercolor

Overview *Make a "pencil sketch"; loosely paint smooth washes with Watercolor brushes to build up varied color; add subtle wet-into-wet bristle marks; add details to the image and create a speckled texture using Salt.*

CHER THREINEN-PENDARVIS

Starting a new file for the African Violet painting

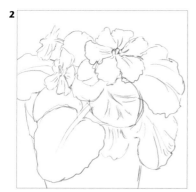

The pencil sketch drawn in Painter using the Grainy Cover Pencil variant of Pencils

AFRICAN VIOLET, A LOOSE WATERCOLOR STUDY, was painted from life using Painter and a Wacom Intuos pressure-sensitive tablet and stylus. Watercolor wet-into-wet techniques were used; then details and texture were added. *Wet-into-wet* is a traditional technique that can be simulated using Painter's Watercolor layers. Wet-into-wet is the most fluid way to apply color, as it involves keeping the paper wet while new color is applied, so that new colors blend with existing moist paint. With Watercolor layers, you can paint with Watercolor brushes that apply pigment that percolates and diffuses into the paper grain and paint washes that actually run and blend into existing wet paint, and you can paint transparent glazes. More texture effects are possible with Watercolor layers than with Digital Watercolor, which is described on pages 90–91.

1 Setting up and opening a new file. Begin by creating a new file with a white background (File, New). In the New dialog box, click the Image button. For a square format, set the Width and Height at 1500 x 1500 pixels. Click OK. (The brush sizes that you'll use will depend on the pixel size of the document.)

2 Making a pencil sketch on a new layer. Select a natural-looking grain (such as French Watercolor) by clicking the Paper Selector near the bottom of the Toolbox and choosing from the menu. Choose a dark gray color in the Colors palette and select the Grainy Cover Pencil variant of Pencils (in the Brush Selector Bar) to

3a

Painting smooth washes using the Wash Camel variant

It's a good idea to set up Brush Tracking before you begin a Watercolor session because it will increase expressiveness in Painter's brushes and make smoother strokes. With Brush Tracking you can customize how Painter interprets the input of your stylus, including parameters such as pressure and how quickly you make a brushstroke. You'll notice the more sensitive control of the Watercolor brushes, especially with brushes such as the Diffuse Camel and Fine Camel variants. From the Choose Edit (Win) or Corel Painter 11 (Mac), Preferences, Brush Tracking, make a representative brushstroke in the window and then click OK.

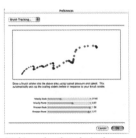

Making a brushstroke in the Brush Tracking window

3b

An active Watercolor layer shown in the Layers palette. The sketch layer is also visible.

draw your line sketch. Make a new layer by clicking the New Layer button on the Layers palette. Drawing your sketch on a new layer will give you the flexibility to adjust its opacity and composite method. We set up our blooming violet plant next to the computer and sketched from life.

3 Painting the first washes. The brush work in the *African Violet* study is fresh and loose. As you prepare to begin adding color, make a few practice brushstrokes. (You can always undo the brushstrokes by pressing Ctrl/⌘-Z, or you can delete your practice Watercolor layer by selecting it in the Layers palette and clicking the Delete button on the palette.)

Plan to work from light to dark as you add color washes to your painting. Choose a light color in the Colors palette (we chose a warm light green). In the Brush Selector Bar, choose the Wash Camel variant of Watercolor. (When you select a Watercolor brush and make a brushstroke on your image, Painter automatically creates a new Watercolor layer in the image.) When you apply a light, even pressure on your stylus, the Wash Camel allows you to lay in the wash areas smoothly. The slight bit of diffusion built into the brush will help the brushstrokes to blend subtly as you paint. When you make a new stroke, place it next to the previous stroke so that it barely overlaps. Try not to scrub with the brush or paint over areas too many times, unless you want to darken the area. Painter's Watercolor operates like traditional transparent Watercolor. Paint with strokes that follow the direction of the forms in your subject. Complete the lighter wash areas, leaving some of the "white of the paper" showing through for the highlights. If the paint seems to build up too fast, reduce the opacity of the brush using the Opacity slider in the Property Bar. (We used opacities between 10%–20% for the light washes on the flowers and leaves.)

3c

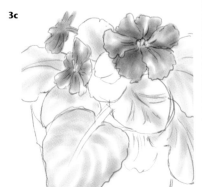

Adding light, varied washes of color using the Wash Camel and Diffuse Camel variants

Don't feel like you have to cover every inch of your image with color. Leaving strategic areas of white will add to the beauty and give your painting a feeling of dappled light.

4 Building up the midtones. Using medium-value colors, begin to develop your midtones, painting lighter colors first and then adding darker tones to continue to develop the form. Keep your light

4a

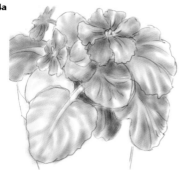

The violet study in progress showing the light and midtone washes

4b

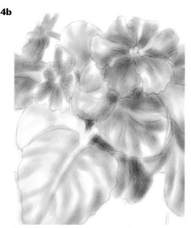

Painting darker greens on the leaves to help focus more attention on the flowers. The sketch layer is viewed at 50% opacity in this example.

5

The soft runny washes on the leaves were painted with the Runny Wash variants of Watercolor. The sketch layer is hidden in this example.

source in mind and let your strokes follow the direction of the forms. To resize the brush or change its Opacity as you work, use the sliders on the Property Bar. We gradually built up deeper golden-yellows and greens, while keeping the brush work loose.

As we completed the mid-tones stage, we switched to the Dry Camel variant of Watercolor, which allowed us to add a little more brushstroke texture over some of the wash areas and at the ends of the strokes, while still allowing the new strokes to blend as wet-into-wet.

5 Painting wet-into-wet runny washes. Painter offers dynamic brushes that allow you to emulate various traditional Watercolor *run* effects. For a smooth, runny wash that will not displace the underlying color, use one of the Runny Wash variants. Choose a slightly different color in the Colors palette and dab the new color onto areas with existing color. Using the Runny Wash Camel and Runny Wash Bristle, we applied brighter orange, pink and magenta colors (using short dabbing strokes) on the deeper colored areas of the flower lip. Then, we added deeper green colors to the leaves. The Runny Wash variants allowed the new color to mix with existing color without moving the existing color.

6 Painting the background. Using the Diffuse Grainy Camel variant to paint short, dabbed strokes of varied color, we added a soft, modulated background with darker values that would

Painter X and later feature faster Watercolor performance. The Watercolor medium is based on traditional watercolor painting. With traditional watercolor, an artist anticipates time for the paint to diffuse, run and dry, and this time is often used to analyze and improve the composition of the painting. Painter's updated Watercolor technology allows you to enable Delay Diffusion, so that the pigment will diffuse and settle on the image after a brushstroke is painted.

RUNNY VERSUS WET WASHES

The *Runny* variants of Watercolor (the Runny Wash Bristle and the Runny Wash Camel, for instance) are useful for painting *wash runs*, where colors run together and blend, but don't displace the underlying color. This is similar to a glazing effect. The *Runny Wet* variants, however, will run and displace existing color on the image as the new pigment travels. Often, the Runny Wet brushes will leave a lighter area because the Wet variants cause leaching of the existing pigment. The Runny Wet brushes are useful if you want to add darker wet-looking edges to foliage or when painting a sky with rain clouds.

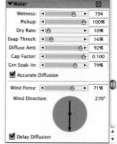

The default Runny Wet Bristle variant of Watercolor paints strokes that run vertically down the image and move existing color. The Dry Rate is set at 10%, allowing lots of time for the pant to run; the Wind Direction is set to 270°, and the Wind Force setting (71%) makes the washes drip a long way. The high Pickup rate allows the brushstrokes to move existing color. Notice that the Delay Diffusion check box is enabled for better performance.

6

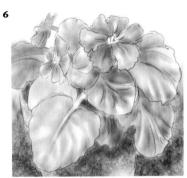

Painting a soft, modulated background using the Diffuse Grainy Camel variant

7

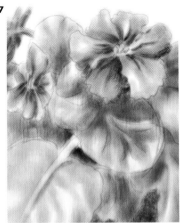

The crisp detail on flower stamens painted with the Fine Camel variant, and the softened shadows on the petals painted with the Diffuse Camel variant

8

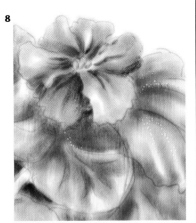

Sprinkling a little "salt" on the leaves and flower using the Eraser Salt variant of Watercolor

help to bring the subject forward in the composition.

7 Adding details. If you want very crisp details, it's a good idea to paint detail work on a separate layer, but in this case we stayed on the same Watercolor layer because we wanted to preserve the softer wet-into-wet look. Add crisper edges to areas that need definition by using a small Fine Camel variant (6–8 pixels). To reduce the Size of the Fine Camel variant, use the Size slider in the Property Bar. If the Fine Camel seems too saturated for your taste, lower the Opacity to about 20%, using the Opacity slider in the Property Bar. If you'd like softer edges, experiment with the Wash Camel and the Diffuse Camel variants, using a small size (about 6–8 pixels). For expressive strokes, vary the pressure on the stylus. To paint details, we used the Fine Camel variant to add curved brush strokes and to paint small areas of color on the interior of the flowers. We also added a little more color to the shaded areas under the flowers using the Runny Wash Camel. To break up some of the crisper strokes, we chose a light color in the Colors palette and then used the Diffuse Camel variant to dab and pull color out from the linear strokes that we had painted using the Fine Camel.

It's not possible to use a variant of the Erasers brush on a Watercolor layer, and you can't use a Watercolor Eraser or Bleach variant on the Canvas, or on an image layer. To softly remove color on a Watercolor layer, choose the Eraser Dry variant of Watercolor and choose white in the Colors palette. In the Layers palette, click on the name of the Watercolor layer you wish to edit and brush over the area you'd like to lighten. We used the Eraser Dry variant to brighten the highlights on the flower petals and the stamen.

8 Adding speckled texture. Finally, we added a light speckled texture using the Eraser Salt variant of Watercolor, in various sizes. To add bleached speckles on your image, choose the Eraser Salt variant and scrub the brush over the area you want to add speckles to. To keep a spontaneous hand-finished look, we retained the lower opacity version of the original sketch drawn with the Grainy Cover Pencil in the image. 🖌

Coloring a Drawing Using Digital Watercolor

Overview *Create a drawing using traditional pen and ink and paper; scan the drawing; put the drawing on a layer; use Painter's Digital Watercolor brushes to hand-color the drawing.*

1a

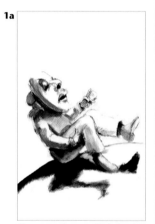

The scanned pen and ink drawing

1b

Benioff's custom color set

2

The drawing on a layer with its Composite Method set to Multiply in the Layers palette

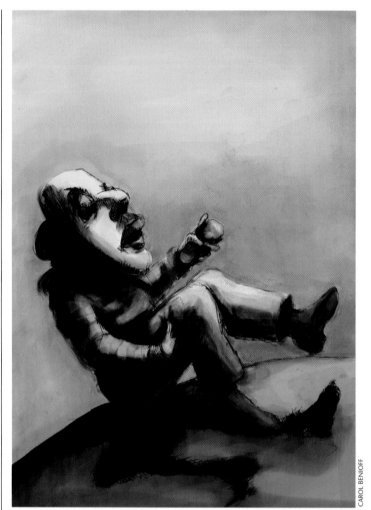

CAROL BENIOFF TAKES ADVANTAGE of the quick and fluid qualities of the Digital Watercolor brushes in *Study #3*, one of a continuing series of prints and drawings using shoes as the motif.

1 Preparing to paint. To begin, Benioff drew with pen and ink on Rising Bristol Vellum paper. Then she scanned the drawing at 300 pixels-per-inch and opened the image in Painter. Next, she opened one of her custom color sets by choosing Window, Color Palettes, Color Sets, clicking on the right arrow of the Color Set palette and choosing Open Color Set. For the paper texture, Benioff chose Italian Water Color Paper from the Paper Selector near the bottom of the Toolbox.

2 Putting the drawing on a layer. After she opened her scanned pen and ink drawing, Benioff selected the entire image (Select, All), cut it from the canvas (Edit, Cut) and then put the drawing onto a layer by choosing Edit, Paste In Place. To make the

For painting the sky and foreground, Benioff used the Wash Brush, Soft Broad Brush, Soft Round Blender and the Pure Water Brush variant of Digital Watercolor.

Using long, fluid strokes, Benioff painted the figure using the Real Filbert Watercolor brush. Then, she painted details with the Real Tapered Watercolor brush.

Benioff mixed colors in the Mixer palette.

white areas of the drawing appear transparent in the next step, she set the Composite Method for the layer to Multiply in the Layers palette. Then she clicked on the Canvas in the Layers palette to make it active so she could begin her painting.

3 Painting the sky and the foreground. To add the first washes of color, she chose the Brush tool in the Toolbox and chose the Wash Brush variant of Digital Watercolor in the Brush Selector Bar. Using large sweeping strokes, she began painting the sky, resizing the brush from 50 to 90 pixels in the Property Bar as she worked. She also used the Soft Broad Brush variant sized to 40 pixels, the Soft Round Blender with its Wet Fringe set to 0% in the Property Bar (with its Size ranging from 40 to 70 pixels) and the Pure Water Brush sized to 40 pixels. These combinations of brushes gave her the smooth translucent look that she wanted.

4 Painting the figure. For the figure, Benioff chose the Real Filbert Watercolor for textured brushstrokes that would blend and bleed. She painted with long strokes that followed the contours of the drawing, decreasing the opacity for more translucent colors (with the brush size ranging from 20 to 50 pixels). For more detail in the image, Benioff used the Real Tapered Watercolor, reducing the size of the brush as needed. To blend large areas of the wash, she chose Pure Water Bristle with diffusion set to 7 (with its size ranging from 20–220 pixels).

5 Mixing colors. When Benioff's color set did not have the color she wanted, she switched over to the Mixer palette (Window, Color Palettes, Mixer). She chose the Apply Color tool in the Mixer palette, painted a stroke in the Mixer, and then clicked on another color from her custom Color Set and mixed it into the colors on the

The final watercolor image without the pen and ink drawing layer

palette. Using the Sample Color tool in the Mixer palette, she then could select a new color from her mix.

6 The final touches. So she could paint glazes without mixing them with the underlying colors, Benioff dried the first Digital Watercolor washes by choosing Dry Digital Watercolor from the pop-up menu on the right side of the Layers palette. Then she painted glazes on the sky and foreground using the Wash Brush (with its size ranging from 23 to 87 pixels), the Opacity reduced to 2% and Diffusion set to 10.

A Painter Artists' Oils Primer

Overview *Here you'll find the basics for painting with the Artists' Oils medium and brushes.*

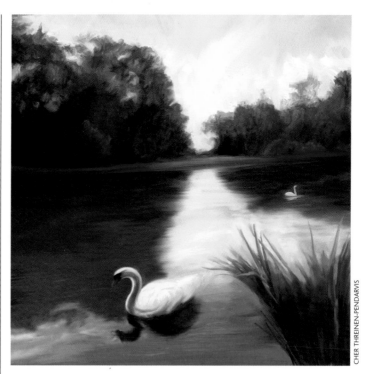

CHER THREINEN-PENDARVIS

The fluid blending of wet Artists' Oils paint can be seen in this detail of the in-progress trees and sky.

The Mixer palette with the Sample Multiple Colors tool chosen, ready to pick up paint and apply it to an image

WITH THE REVOLUTIONARY ARTISTS' OILS medium and brushes in Painter, you can paint expressive, gestural strokes. Like traditional oils, Artists' Oils paint is malleable and viscous. As you paint, the brush will run out of pigment just like a traditional brush. When you paint a new stroke, you can mix the new paint with the existing paint on the canvas just as you can with conventional media.

Quiet Moment at Schwetzingen (above) was painted with the Dry Brush, Blender Brush and Blender Palette Knife variants of Artists' Oils. Before you start an Artists' Oils painting of your own, reading this Primer will help you to achieve the results you desire.

The Artists' Oils and the universal Mixer palette. The Artists' Oils work in conjunction with the Mixer (Window, Color Palettes, Mixer). You can load a brush (the Dry Brush, for instance) with colors from the Mixer and paint with them. You can blend colors in the Mixer palette and apply the multi-colored mix directly to your painting. The Sample Multiple Colors tool allows you to sample a color mix, load your brush and then apply the mix to your image. (Updated for Painter 11, the Mixer now works with all continuous-stroke Painter brushes.) To learn more, see the "Using the Mixer palette" tip on page 27.

Controlling the Artists' Oils. When you choose an Artists' Oils brush, the Canvas is filled with oil, making it very easy to lay down color and blend. You can choose the amount of paint and oil that you load into a brush, and how the new paint interacts with the

The six new Artists' Oils Brush Tip profiles are located in the Size window. The top three work best with the Artists' Oils brushes; the bottom three work best with the Artists' Oils Palette Knife variants.

Strokes painted using the Tapered Oils variant of Artists' Oils. This variant uses the Pointed Rake Brush Tip Profile. Leaning the stylus paints a more pointed stroke.

The Artists' Oils section of Brush Controls

existing paint. The most important settings for the Artists' Oils are in the Property Bar and in the Brush Controls. They are the General, Size and Artists' Oils sections. (You will find these same controls in the Stroke Designer window of the Brush Creator.)

In the General section of the Brush Controls, the Artists' Oils dab type is displayed in the Dab Type pop-up menu. A dab type determines the character of the brush. You'll find more information about dab types in Chapter 4, "Building Brushes," on page 139.

In the Size section of the Brush Controls, you'll find the six new *Artists' Oils Brush Tip Profiles* that were designed specifically to work with the Artists' Oils. The Soft Round, Pointed Rake Profile and Flat Rake Profile work best with the brushes (the Dry Brush and Impasto Oil, for instance), and the Flat Profile, Chisel Profile and Wedge Profile were built for the Artists' Oils palette knives (such as Blender Palette Knife and Dry Palette Knife). Depending on how you hold the stylus, the beginning of a stroke will change. Hold the stylus vertically and the start of the stroke will be flatter. Hold the stylus at an angle, and the start of the stroke will reflect the brush tip profile. The effect is subtle.

The Artists' Oils window in Brush Controls is organized into the Paint, Brush and Canvas areas. The seven sliders in the Artists' Oils section work in conjunction with each other to create the character of the oily brushstrokes. These controls are complex and interdependent. Dig in and try out the Artists' Oils variants, while keeping an eye on the controls in the Artists' Oils section.

In the Paint area, the *Amount* slider controls the amount of oil that is loaded when you make each new stroke. The *Viscosity* slider allows you to control the flow of the paint through the brush and how fast the brush will run out of paint. The *Blend* slider controls how easily new strokes will mix with the existing paint.

In the Brush area, the *Bristling* slider allows you to design how subtle or prominent the bristles look. This pertains to both the head and tail of the stroke. The *Clumpiness* slider allows you to adjust the randomness of the

You can use the Artists' Oils medium on the Canvas or on default layers. You can also combine Artists' Oils paint with other Painter media. For instance, you can soften strokes by using the Blenders variants such as the Just Add Water brush. You also can add strokes with Chalk, Pencils or Acrylics brushes, for example, and work this new media into your painting.

ARTISTS' OILS AND GRAIN

Artists' Oils brushstrokes can be smooth or grainy. Choose the Artists' Canvas in the Paper Selector and the Grainy Dry Brush in the Brush Selector Bar. Make a stroke. You'll notice the grain in the trail of the stroke. Switch to the Grainy Blender brush, which is useful for blending and enhancing grain. Lightly brush over the paint you applied and then pull out from the paint to reveal more grain. Experiment with the Grain slider in the Property Bar to adjust the graininess. Move the slider to the left to reveal more grain and to the right to cover more grain.

Strokes painted with the Dry Brush (top) and custom Smooth Dry Brush (bottom)

Strokes painted with the Clumpy Brush (top). For more subtle striations (bottom), adjust the Clumpiness and Blend sliders.

Strokes painted with the Oily Bristle and blended with the Grainy Blender

Thick strokes painted with the Wet Oily Impasto. Notice the excavated paint.

Strokes painted with the Dry Clumpy Impasto brush. Notice the graininess in the brush trails.

brush hairs and to make them fine or coarse. For a good example of a clumpy brush, check out the Dry Clumpy Impasto variant. With the *Trail-off* slider, you can adjust the length of the brush trail.

In the Canvas area, you'll see the *Wetness* slider. With the Wetness slider, you can adjust the Wetness of the paint on the Canvas (or layer) and how this paint interacts with new strokes that you apply.

The *Dirty Mode* allows you to intermix colors as you pick them up from the Mixer and apply them to your image. When you choose a new color, you'll notice that some of the previous color remains in the brush.

WORKING WITH THE ARTISTS' OILS BRUSHES

Here are some suggestions for how to paint using the Artists' Oils brushes. Even if you're familiar with Painter's other brushes, try out these ideas and experiment with all of the Artists' Oils variants.

Making smooth strokes. Brushes with low Bristling and Clumpiness settings will allow you to paint strokes with smooth, soft beginnings, with less striated tones. Sample a single color from the Mixer using the Sample Color tool (not the Sample Multiple Colors tool) and paint a stroke with the Dry Brush variant. To make it smoother, in the Artists' Oils window, reduce the Bristling to 0 and the Clumpiness to 0.

Painting striated strokes. Brushes with a high Clumpiness setting will paint strokes with variation in color and value. Experiment with the Clumpy Brush. For more subtle striations, decrease the Clumpiness setting to 20% and reduce the Blend setting to 10%.

Mixing color with blender brushes. Any Artists' Oils variant with Blender in its name will allow you to blend as you lay down new paint, just like a brush loaded with very wet paint. Choose the Grainy Blender and use light pressure on your stylus to make strokes that pull color up, blending while revealing the grain.

Artists' Oils thick paint. The Artists' Oils Impasto brushes paint strokes of thick paint with realistic highlights and shadows. Choose the Wet Oily Impasto brush. Using a light pressure on your stylus, and lay down several strokes on top of one another to build up thick paint. Then use heavy pressure to dig into the existing paint. You can adjust the lighting in the Canvas, Surface Lighting menu. To adjust Impasto settings, use the Impasto section of Brush Controls. (To learn more about working with Impasto, see "A Painter Impasto Primer" on page 114.)

Painting with the Artists' Oils

Overview *Plan a composition; build a color palette using the Mixer; use the Artists' Oils to create a colorful underpainting; sculpt forms; paint glazes to build richer color and values; paint details.*

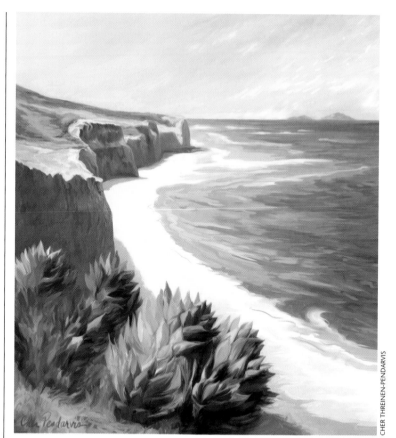

CHER THREINEN-PENDARVIS

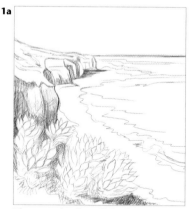

The conventional pencil sketch

The sketch on a layer, with the Composite Method set to Multiply

AGAVES ON THE EDGE, Summer is one in a series of seascapes of the spectacular cliffs in San Diego, California. The inspiration for this painting was a bright sunny morning on a day when there was a brisk wind. To begin the painting, we made conventional sketches on location in a sketchbook. Back at the studio, we assembled the sketches and used them for reference as we developed the painting by using the Artists' Oils medium in Painter.

1 Sketching and planning the composition. Observe your subject and decide where your focal point will be. After choosing the viewpoint, we made composition sketches of the landforms and lighting in pencil and pastel. We also made a more detailed drawing of a few of the plants in our sketchbook.

Back at the studio, we scanned the composition pencil sketch at full size, at 300 ppi and saved it as a TIFF file. (The scan of the composition sketch measured 2500 x 2700 pixels.)

Open your sketch in Painter, and for added flexibility, cut it to a layer by choosing Select, All and Select, Float. To make the white areas of the layer appear transparent, set the Composite Method to Multiply in the Layers palette. Then, to stay organized, name your layers (we named our layer "sketch"). It's a good idea to save your working file in RIFF format under a new name so that your

The Mixer palette with the basic colors. The Brush tool is chosen.

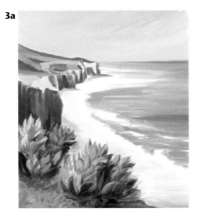

Using large brushes to lay in the basic shapes and structure. The sketch layer is hidden in the example.

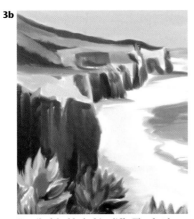

Detail of the blocked-in cliffs. The sketch layer is hidden in the image.

original sketch is not accidentally replaced. RIFF format preserves media that is native to Painter—such as the Artists' Oils—which you'll be using later in the development of your painting.

2 Mixing the base colors. For the painting, we used the Mixer palette to create a color palette based on the colors in nature, but more saturated.

If the Mixer is not open, choose Window, Color Palettes, Show Mixer. Apply color with the Add Color tool (the brush) at the bottom of the Mixer. You can blend between colors using the Mix Color tool (the palette knife). Just like an artist's palette, you can pick up color from the Mixer Pad with the Sample Color tool (eyedropper in the Mixer palette) and then use the color and brushes to apply the paint to your image.

3 Making an underpainting. We used large brushes to create an underpainting to work out the basic values and colors in the composition. While referring to location sketches, we blocked in simple colored shapes, just as we would when painting on location using watercolor, acrylics or oil paint.

Working on layers will allow you to enjoy added flexibility as you develop your painting. To add a new layer, click the New Layer button on the bottom of the Layers palette. With the new layer selected, begin by blocking in the darker values using broad brushstrokes. Don't focus on the details at this stage. Use your sketch as a guide, but develop the shapes in your scene expressively, without worrying about staying within the lines of your drawing.

The Mixer palette works in conjunction with the Artists' Oils. With the Artists' Oils, you can load your brush with multiple colors from the Mixer and apply them to your image. If the Mixer is not open, choose Window, Color Palettes, Show Mixer. To apply color to the Mixer, you can choose a color from the Colors palette or from the color wells at the top of the Mixer, or you can sample color from an image using the Dropper tool from the Mixer. Apply color using the Add Color tool (the brush, second from the left at the bottom of the Mixer Pad). You can blend between colors using the Mix Color tool (the palette knife). Just like an artist's palette, you can pick up color from the Mixer using the Sample Color tool (eyedropper in the Mixer) and then use brushes to apply the paint to your image.

The Sample Multiple Colors tool (the eyedropper in a circle) works in conjunction with Artists' Oils (but not with other brushes at this time) to allow you to load your brush with more than one color and then apply it to your image.

Using the Sample Multiple Colors tool

3c

Establishing the light on the forms

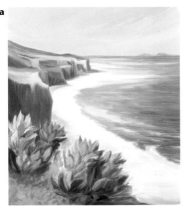

4a

Adding more color to the foreground

4b

Pulling color on the cliff face using the Wet Oily Palette Knife

5a

Dabbing with short strokes to sculpt the cliffs

As we began to apply color on the new layer using the Oily Bristle variant of the Artists' Oils, we focused on the design of the landscape and the natural light. We laid in the darker values first to establish the light on the forms—the purple-gray shadows at the base of the cliffs and the darker browns on the cliff faces. Then, we roughed in the foliage by using loose strokes of warm greens, golds, oranges and browns. For the ocean, we painted cool turquoise blues, and we used warmer blues in the sky.

When your composition is established, delete the sketch layer from the file by selecting it and pressing the Delete (trash can) button on the Layers palette. When your underpainting is complete, save the file.

4 Refining the color study. Next, we added more complex color areas on another new layer. This way, we could adjust the opacity or the Composite Method if we chose to, or remove the information on the layer and start over without harming the underpainting below.

Click the New Layer button to add a new layer to your image and enable the Pick Up Underlying Color button on the Layers palette. This will allow you to pick up color from the underlying layer when you work with brushes such as the Blender Brush or Oily Blender Brush, that blend and smear color. Switching between the Blender Brush and the Oily Bristle variants, we painted, pulled and blended colors, rendering the forms using expressive strokes.

When you want to move and blend paint without applying more color, switch to the Wet Oily Palette Knife variant of Artists Oils. To move small areas of paint, we reduced the size of the Wet Oily Palette Knife to about 9–12 pixels. The palette knife work is most visible on the broad cliff faces. When you are happy with your color study, save your file—including its layers—in RIFF format.

5 Sculpting forms and building more complex color. At this point, we wanted to take advantage of the oilier feel of the Artists' Oils medium on the Canvas, so we dropped all of the layers to the Canvas and then saved a new version of the file with a new name. To drop your layers to the Canvas, choose Drop All from the Layers palette menu. As we sculpted and refined the forms of the landscape, we worked new color into existing color.

For the foreground grass, we used the Sample Multiple Colors tool to pick up mixtures of green and gold colors from the Mixer palette and loosely painted the grass using short, curved strokes.

ARTISTS' OILS AND LAYERS

When you choose an Artists' Oils brush (such as the Oily Bristle) and begin to paint on the Canvas layer, the Canvas will be loaded with the Artists' Oil medium, and you will notice an oily feel that allows you to effortlessly blend paint. The brush will run out of paint if you attempt to paint a long stroke. For best results, paint using short strokes to keep the brush loaded with paint. If you paint on a layer, the oil will exist only where you have applied Artists' Oil brushstrokes. Additionally, when painting on a layer, it will take longer for a brush to run out of paint.

Refining the foreground cliff forms

Painting the crevices in the foreground cliffs and finessing the highlights and shadows

Details of the loosely painted foreground plants and grass, and the reflected light painted on the lower cliff face

6 Finessing the foreground. Then, we added more color interest and light to the cliffs using lighter reddish browns and purples that were based on the colors from the Mixer. To bring the foreground cliff into clearer focus, we used a tiny Wet Oily Palette Knife to sharpen some of the edges on the cliff tops and define the smaller crevices on the cliffs. To help the distant cliffs recede, we mixed a light blue-gray and used a low-opacity Oily Bristle brush to apply a glaze of the lighter colored paint.

To refine the agave plant forms, we defined the exterior shapes of the leaves, and then we used tints and shades of the same color to model the highlights and shadows. We also used the Dry Bristle variant of Artists' Oils to add accent color to the leaf edges. Next, we switched to the Wet Oily Palette Knife and pulled and blended color, making sure to let our strokes follow the forms of the leaves.

7 Painting glazes and final details. We wanted to paint the choppy, active ocean that we remembered on the windy day. So when adding more color to the water, we chose the Wet Oily Bristle. Starting with a medium value blue that had a little green in it for the turquoise water, we painted short, curved strokes. Then, we added white to mix lighter tints and added darker blues to create shades of the color, and again painted short, curved strokes.

If you want to paint a calmer sea, use the Wet Oily Bristle to paint longer brushstrokes and blend them to create a smoother surface, still varying the color for interest. To smooth the transitions between the colors in the water, use the Blender Brush or the Wet Oily Palette Knife.

As a last step, we zoomed in to 100% and took a closer look at the brush work. Then, we used the Dry Bristle brush to add small areas of warmer color to the foreground water and beach. 🖌

The glazes of paint on the water and the subtle color transitions on the beach

Illustrating with the Artists' Oils

Overview *Scan a rough pencil sketch for the template; fill the canvas with a colored ground; build color and form with the Artists' Oils brushes; use the Snap-to-Path feature when painting the frame; add paper texture and lighting.*

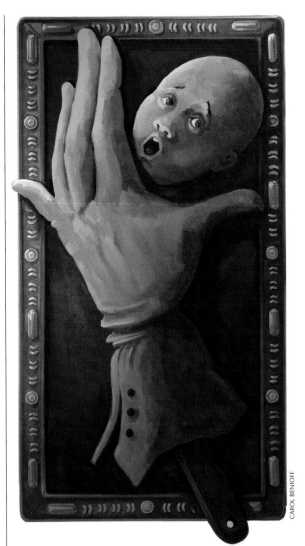

CAROL BENIOFF

The scan of the rough sketch that Benioff used as a template

Benioff filled the canvas by using the Rectangle Selection tool and the Paint Bucket.

WHEN DEVELOPING AN IMAGE for her ongoing series *The Price of Silence*, Carol Benioff maximized the fluid capabilities of the Artists' Oils. Because she planned to combine the image with an intaglio print or use it as part of another illustration, she kept her Painter composition simple and the background open. (To read about Benioff's creative printmaking process, turn to "Making a Color Managed Art Print" in Chapter 12.)

1 Setting up. To begin, Benioff scanned a rough sketch of her image and opened it in Painter. She selected the image (Select, All), cut it from the canvas (Edit, Cut), pasted the cut image, which is now on its own layer, and set the Composite Method to Multiply in the Layers palette. Next, she created a custom color set from a scan of one of her paintings. (See "Capturing a Color Set" on page 40 for how to create a Color Set.) Click on the Canvas layer in the Layers

3a

Roughly painting the colors of the face with the Dry Brush

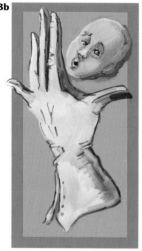

3b

Blocking out the lights and darks in the glove with neutral tones

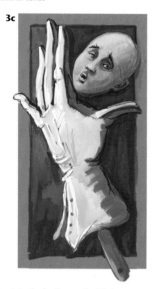

3c

Painting into the background with deep purples and oranges

palette to select it. To save time while building the colored frame, Benioff used the Paint Bucket tool and selections. To make the outer frame, select the Rectangle Selection tool (Toolbox) and draw a rectangle selection. Select the Paint Bucket tool, choose Fill with Current Color in the Property Bar, select a color in the Colors palette and then click inside the selection to fill it with color. Repeat the process to build the inside of the frame, but this time use a smaller rectangular selection and a yellow-ochre color. Leave the area outside the larger frame white.

2 Picking brushes. When working with the Artists' Oils, Benioff was drawn to these brushes: Dry Brush, Dry Bristle, Wet Brush, Wet Oily Brush, Tapered Oils and Grainy Blender. To extend the possibilities within this group of variants, she made subtle changes to a few of the brushes. Benioff's Soft Tapered Brush (described in the tip on this page) has soft bristles that are filled with paint that easily blends with the underlying colors. (See "A Painter Artists' Oils Primer" on page 92 for information about the Artists' Oils brush settings. To learn more about making your own custom brushes, see Chapter 4, "Building Brushes" on page 138.)

3 Working with Artists' Oils. Benioff kept the Sketch layer visible to use as her template, but painted on the active Canvas layer. (Click on Canvas in the Layers palette to select it.) Working with a light hand and short strokes, quickly rough out the values and tones in your image using the Dry Brush. Pick a mix of cool and warm colors to build rich hues. When you'd like to soften transitions, use the Grainy Blender variant to smooth the strokes that wrap around the forms. Continue to add layers of paint to the image using a mix of cool and warm colors.

Benioff painted neutral tones for the lights and darks of the glove using the Tapered Oils, Dry Brush, Dry Bristle and Wet Oily brushes. With short, curved overlapping strokes of dark purples and oranges, she began to paint the background area. She continued painting, adding depth and color to the face and glove. She did not paint over the frame at this stage.

Painting with Artists' Oils required Benioff to work with slower, shorter strokes and a lighter hand than usual. She found that by adjusting her technique, she maximized the fluidity and gestural capabilities of these brushes.

Painting a highlight on the cheek using the Dry Bristle brush variant

Painting with her Skinny Tapered brush on the Canvas with the Oval shape layer visible using the Snap to Path function

Detail of the completed decorative pattern that was painted using Snap to Path

Detail of the final image before Benioff applied texture using the Dye Concentration effect (top) and afterward (bottom)

4 Adding color, details and highlights. Benioff used the Wet Oily and Dry Bristle brushes to paint a variety of ochres and greens (from her color set) onto the glove. She continued to move around the image, pushing and pulling the paint to refine the forms. She used a small version of the Tapered Brush to add gestural lines and detail. To punch out the highlights, choose the Dry Bristle brush from the Brush Selector Bar. Pick a warm white color in the Colors palette. To paint as Benioff did, use a light touch to let the bristles of each stroke show at the start and end of each stroke. To smooth and blend the colors, keep the brush down while lightly brushing between multiple swaths of color.

5 Painting the frame using Snap to Path. To paint the decorations and the edges of the frame, Benioff used the Snap to Path function, which constrains your brushstrokes to the path of a visible shape, making it easy to paint concentric circles and straight edges. (See "Painting Along a Path" on page 65 for more information about using Snap to Path.) First, she drew shapes with the Pen, Oval Shape and Rectangular Shape tools. (For information about working with Shapes, see Chapter 6.) She selected the small Tapered Brush, clicked on the Align to Path button in the Property Bar, and then clicked on the Canvas Layer in the Layers palette to make it active. As she painted multiple strokes of light and dark yellow, the strokes were automatically constrained to the visible path. With the Layer Adjuster tool active, Benioff moved, rotated and scaled the shapes as needed while she painted along the transformed shapes to complete her decorative border. When it was complete, Benioff disabled the Align to Path button in the Property Bar and painted the details and shadows of the decorations by using small versions of the Tapered Brush and Dry Brush.

6 Adding texture. Benioff wanted to add a subtle texture to the image. To apply the effect that she used on the painted areas only, select the Magic Wand tool, click in the white area around the image, choose Select, Invert and then Select, Save Selection. To open the Paper palette, choose Window, Library Palettes, Show Paper and select French Watercolor Paper. Increase the Paper Scale to 140% and increase the Paper Brightness to 65%. Now, choose Effects, Surface Control, Dye Concentration, Using Paper and set the Maximum to 162% and the Minimum to 15%. Click OK.

7 Applying lighting for drama. Finally, Benioff added drama to her image using a custom lighting effect. She lit the face and top of the glove with a custom yellow and pink Soft Globe light, dropping the rest of the image into shadow. She loaded the selection from step 6 (Select, Load Selection), and then she chose Effects, Surface Control, Apply Lighting and applied the light. (The Warm Globe light will give a similar effect.) See "Adding Dimension with Lighting" on page 282 for more information about the Apply Lighting feature.

A Painter RealBristle Primer

Overview *Here you'll find the basics for painting with the RealBristle painting system.*

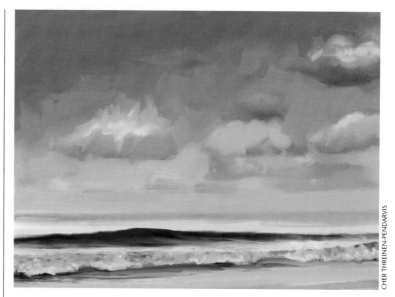

CHER THREINEN-PENDARVIS

The RealBristle Brushes allow incredible sensitivity and realistic brushstrokes as you can see in this detail of the in-progress clouds and sky.

THE REALBRISTLE BRUSHES HAVE BEEN DESIGNED to feel like conventional brushes as they move over the canvas. And the resulting brushstrokes are amazingly real.

Dawn Peace (above) was painted with RealBristle Brushes, including the Real Flat, Real Round and Real Blender Flat variants. Before you start a RealBristle painting of your own, reading this primer will help you to achieve the results you desire.

Painting with RealBristle Brushes. The RealBristle category contains a wide variety of brush variants. To choose the RealBristle category, go to the Brush Selector Bar, and from the category menu, choose RealBristle. Create a new file by choosing File, New. (Our file for trying out the brushes measures 500 x 500 pixels and has a white background.) The RealBristle Brushes category is organized into

The Brush Selector bar, open to show the RealBristle variants

USING THE BRUSH GHOST AND ENHANCED BRUSH GHOST

The Brush Ghost and Enhanced Brush Ghost give you helpful visual feedback on the brush cursor while painting, especially when you use the RealBristle Brushes or the Art Pen Brushes. Choose Edit (Win) or Corel Painter 11 (Mac), Preferences, General, and check to make sure that the Enable Brush Ghost, and Enhanced Brush Ghost options are turned on. Enable Brush Ghosting gives you important visual information about the size and shape of your brushes. The Enhanced Brush Ghost shows not only the size of the brush, but also other important parameters, if your tablet and stylus are equipped with these features: tilt and bearing, and the rotation of your stylus as you paint.

Painting a brushstroke with the Soft Flat Oils variant of the Art Pen Brushes. The ring on the Enhanced Brush Ghost shows the brush size, and the line indicates the tilt and bearing of the stylus. If you are using a 6D Art Pen (the flat Wacom pen that supports 360 degree rotation), a dot will appear to indicate the degree of the stylus rotation, as shown above.

The RealBristle Brushes are very sensitive to *Brush Tracking*. With Brush Tracking you can customize how Painter interprets the input of your stylus, including parameters such as pressure and speed. From the Choose Edit (Win) or Corel Painter 11 (Mac), Preferences, Brush Tracking, make a representative brushstroke in the window and then click OK.

Brushstrokes painted using the Real Flat Opaque brush variants.

Brushstrokes painted using the Real Flat and Real Oils Short brushes.

Brushstrokes painted with the Real Round Bristle using two sizes and two colors.

We painted the wavy blue stroke with the Real Round Bristle. Then we painted the angled tan stroke using the Real Blender Round, while tilting the stylus toward the right. Notice how the Real Blender Round moves the left edge of existing blue paint, just like a conventional brush!

several types of variants, based on their performance and brush-stroke characteristics: Real Blenders, Real Fan brushes, Real Flats, Real Oils, Real Round brushes and Real Tapered brushes. In the Paper Selector (Toolbox), choose a coarse, natural texture for trying out the brushes. (We chose Coarse Cotton Canvas paper). To try out the brushes, you can work directly on the Canvas or you can paint on a layer—we worked directly on the Canvas.

Let's begin with brushes that apply paint with various brush shapes and feels. Choose the Real Flat Opaque variant from the Brush Selector Bar—the Real Flat Opaque is a good brush for laying in color quickly. Paint a slightly curved horizontal stroke by applying medium pressure on your stylus, and then lighter pressure, while slightly rotating your hand. Use the Real Flat Opaque brush to paint a circular stroke using moderate pressure.

Now try out the Real Flat. This brush has a softer feel, and is also good for laying in base colors on your paintings. Using this brush, make several overlapping horizontal brushstrokes, while varying the pressure on your stylus. Next choose the Real Oils Short. This brush is somewhat flat, has a stiffer feel, is a little drier, and it allows you to move existing paint on the canvas. Using this brush and a different color, paint angular strokes that overlap some of the existing paint, so that you can see how this brush interacts with paint that you've already applied.

Try out the Real Round Bristle. This versatile brush is useful for applying a good amount of paint, and you'll notice subtle bleed of pigment when brushstrokes are applied over existing paint.

Mixing color with blenders. Any RealBristle brush variant with Blender in its name will allow you to blend as you lay down new paint, just like a brush loaded with very wet paint. Choose the Real Blender Round and use light pressure on your stylus to make strokes that blend and move the existing paint.

Customizing RealBristle Brushes. The most important settings for the Real-Bristle Brushes are located in the Property Bar and the RealBristle section of Brush Controls; additional settings are located in the Well, General, and Artists' Oils sections of the Brush Controls. (You can also access all of these same controls in the Stroke Designer window of the Brush Creator.)

In addition to modifying the default RealBristle Brushes, you can enable the RealBristle functionality for other brushes within Painter. We recommend trying out the RealBristle painting capabilities

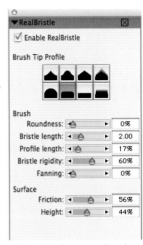

The RealBristle section of Brush Controls contains Brush Tip Profiles, as well as Brush and Surface settings.

The context-sensitive Property Bar contains settings that are important to the RealBristle Brushes.

The Resat slider located in the Property Bar can also be found in the Well section of Brush Controls. For several RealBristle variants, the Resaturation Expression pop-up menu is set to pressure.

The Artists' Oils section of Brush Controls contains settings that affect many of the RealBristle Brushes.

The General section of Brush Controls contains the Dab Type pop-up menu, along with Opacity and Grain settings.

with brushes such as the Acrylics, Oils and Gouache brush categories that incorporate a Camel Hair or Flat dab type.

To enable the RealBristle characteristics for a brush, choose the brush category and variant in the Brush Selector Bar. (We chose Acrylics and Thick Acrylic Round.) In the RealBristle section of Brush Controls, enable the RealBristle option. You can adjust the other settings in the RealBristle dialog box and the sliders in the context-sensitive Property Bar: the *Resat, Bleed, and Feature* sliders. The *Resat* slider controls the amount of paint flowing from the brush; the *Bleed* slider controls how much the new paint moves the existing paint; the *Feature* slider controls the tightness of the brush hairs. In addition, if a brush uses the Blend Camel Hair or Blend Flat dab type, all of the controls in the Artists' Oils section will affect its performance and the *Blend* slider will be available in the Property Bar. The *Blend* slider controls how new paint blends with existing paint. The Blend Flat or the Blend Camel Hair, displayed in the Dab Type pop-up menu of the General section of Brush Controls, will give you an oiler feel. For more information on the Artists' Oils controls, see "A Painter Artists' Oils Primer" on page 92.

In the RealBristle section of the Brush Controls, you'll find the six *Brush Tip Profiles* that work best with the RealBristle Brushes: the Pointed Profile, Medium Profile, Linear Profile, Pointed Rake Profile, Dull Profile, Soft Round Profile, Flat Profile, and Flat Rake Profile. (These tip profiles are among those visible in the Size section of the Brush Controls palette.) Under the *Brush* area of the RealBristle controls, the *Roundness* slider allows you to control the overall shape of the brush, and the rounding across the width of the brush. A lower setting creates a flatter brush. With the *Bristle Length* slider you can control the length of the bristles, from the tip of the brush to its base. The *Profile Length* slider lets you set the length of the Brush Tip Profile in relation to the overall length of the bristles. *Bristle Rigidity* controls how flexible the bristles are. Lower values build a more flexible brush and higher values build a stiffer brush. Next, the *Fanning* slider controls the spread of the bristles; a lower value will build a more compact tip, while a higher Fanning value will create a wider tip, with the bristles more spread out.

In the *Surface* section, you'll find the Friction and Height sliders. With *Friction* you can control whether the bristles move across the canvas smoothly, or whether they drag. A higher setting will reveal more texture. The *Height* slider allows you to paint with just the tip of the brush, or enjoy the feeling of pressing your brush onto the canvas. A lower setting will allow the bristles to splay or compress when you apply more or less pressure. When customizing brushes, if you want an oilier feel, try using one of the two new dab types. You'll find more information about dab types, and customizing RealBristle Brushes in Chapter 4, "Building Brushes," on page 138.

Painting with the RealBristle Brushes

Overview *Set Brush Tracking; sketch a composition; build a color theme using the Mixer; create a painting using RealBristle Brushes; blend color and add final details.*

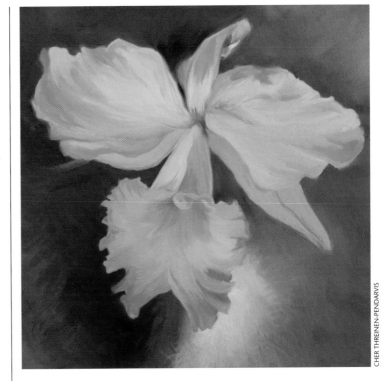

CHER THREINEN-PENDARVIS

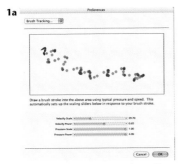

Making a brushstroke in the Brush Tracking window using light to heavy pressure

Sketching the orchid using the Pastel Pencil variant of Pastels

LIGHT AND SHADOW PLAY IS ONE IN A SERIES of paintings of flowers that were painted by hand from direct observation using the Real-Bristle Brushes. The inspiration for this painting was the soft afternoon light shining on and through the petals of the live blooming orchid.

1 Setting Brush Tracking. The RealBristle Brushes are more sensitive to the movement and pressure of your hand than other brushes. For this reason, it is very important to set Brush Tracking before you use them. Brush Tracking allows you to customize how Painter interprets the input of your stylus, including parameters such as pressure and speed. Choose Edit, Preferences, Brush Tracking (Mac OS X users, choose Corel Painter 11, Preferences, Brush Tracking) and then make a representative brushstroke in the window. For instance, if you plan to use both light and heavy pressure while painting quickly and then slowly, try to make a brushstroke in the window that includes all of these factors.

2 Planning the composition and sketching. The first task was to set up the still life. To begin, we placed the blooming orchid plant in soft diffused light near a window. We planned an asymmetrical composition with interesting negative space around the flower, dynamic curves and subtle diagonals, and we arranged the still life so that there was no busy background to distract attention while painting. Then, we created a detailed drawing in Painter

The Dirty Brush mode and the Sample Multiple Colors tools are chosen in the Mixer.

4a

Establishing the light on the forms with the Real Oils Short variant.

4b

The underpainting in progress with color blended with the Real Tapered Flat variant.

from direct observation. If you prefer, you can scan a conventional drawing and open it in Painter. If you'd like to sketch in Painter for this project, we recommend using a quick, responsive brush—for instance, a Pastel Pencil or Soft Pastel Pencil variant of Pastels, or a Chalk brush. In the Paper Selector (Toolbox), choose a coarse, natural texture and in the Colors palette, choose a dark color that will blend with the colors of your painting to come. (We sketched with a Soft Pastel Pencil over Coarse Cotton Canvas paper using a dark reddish brown color). For this study, you can work directly onto the Canvas, or paint on layers. As we sketched, we observed the forms in the flower and paid careful attention to the lighting.

3 Building a color theme for the painting. Next, we used the Mixer palette to mix colors for the painting based on more saturated versions of the colors in the still life. With the Mixer palette, Painter gives the you the experience of dipping your brush in mixed colors and then applying the variegated paint to your image. If the Mixer is not visible, choose Window, Color Palettes, Mixer. It's helpful at this stage to have both the Colors palette and Mixer open. You can choose a color from the Colors palette, or from the color wells at the top of the Mixer palette, or you can sample color from an image using the Dropper in the Toolbox (or the Brush with Alt/Option). Apply color with the Add Color tool, second from the left) at the bottom of the Mixer Pad. The *Dirty Brush* mode is active by default. The Dirty Brush mode allows you to mix new colors easily with color you have previously applied to the Mixer pad. You can pick up multiple colors from the Mixer pad with the Sample Multiple Colors tool (the eyedropper with the circle at the bottom of the Mixer) and then use the RealBristle Brushes and Dirty Brush mode to apply the multi-colored paint to your image.

4 Building an underpainting. When painting from life with watercolor, acrylics or oil, we usually begin with large brushes, and we work quickly, because natural light changes as we work. Choose the Real Oils Short variant of RealBristle from the Brush Selector Bar. The Real Oils Short is a good brush for quickly laying in color for the underpainting. Begin painting the background areas using broad brushstrokes. If you'd like to lay in paint and blend as you work, try the Real Tapered Wet Flat variant of RealBristle. Don't focus on details at this stage. Carefully observing the subject, and focusing on the composition, the forms and the natural light, we blocked in the flower shapes and base values, resizing the brush as we worked.

Then we began to use a wider range of values to establish the light on the forms. We expressively painted the shapes of the orchid, flower pot and background without restricting the brushwork to staying within the lines of the tight sketch. As we worked, we continued to use the Mixer palette as our paint

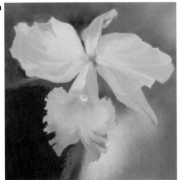

5a

The background is partially blended.

5b

Adding and blending color on the petals

5c

Painting crisper edges on the petals with the Real Oils Short

6

The highlight is too strong on the pistil

palette to pick up color and the two RealBristle Brushes to apply the paint to the Canvas.

5 Modulating color and sculpting forms. When the basic color areas are established, begin to layer strokes to build more complex color areas. The direction of the brushstrokes helps to establish the forms and to add dynamic energy to the image. We layered color over color, creating striations in the colored paint (to suggest the folds in the flower petals), and to sculpt the forms.

We blended color as we painted using the Real Blender Flat variant of the RealBristle category. This brush allowed us to move and blend paint without applying much new paint. The Real Blender Flat is similar to a conventional oil brush with a small amount of wet oil paint. If you keep the brush pressed to the Canvas, and brush back and forth over an area, you can build smooth, blended transitions between colors. If you pick up your brush and touch the Canvas, you will apply a small amount of new color. Switching between the Real Blender Flat and the Real Oils Short variants of RealBristle, we painted, pulled and blended colors, rendering the forms using expressive strokes. We continued to loosely focus on the structure of the flower petals, using various size brushes and colors. The Real Blender Flat brushwork is most visible on the background, flower pot and in a few areas of the flower petals.

6 Refining and adding details. Now, zoom in to 100% and take a closer look at your brushwork. What areas need refinement? To move small areas of paint, we reduced the size of the Real Blender Flat brush to about 9–12 pixels. To paint crisper edges on some of the petals, we used a small version of the Real Oils Short. To add accents of brighter opaque color to a few of the petal edges, we used a small version of the Real Flat Opaque. For richer brush textures on the background, we sampled color from the image using the Dropper tool, and then switched to the Real Fan Short variant of RealBristle. Using the Real Fan Short, we loosely brushed back and forth in a soft cross-hatch pattern. We sampled a different color every few strokes. To add final touches to the center of the flower, we used the Real Tapered Wet Flat. First, we painted subtle translucent strokes of orange and peach colors onto the interior. The highlights on the pistil were too strong, so we sampled a gray-gold color from the shadow on the pistil and brushed lightly over the brightest areas to subdue them. We used gentle, curved strokes that followed the direction of the forms. You can see this final brushwork in the two detail illustrations that show the center of the orchid.

The subtle brushwork on the orchid pistil.

Coloring and Cloning

Overview *Scan a pencil sketch; clone it, tint it and add texture; restore from the original by cloning; add color with the Airbrush, Chalk and Watercolor brushes.*

PHILIP HOWE

1

The original pencil illustration, scanned

2

Adding a tint and a texture to the clone

3

Using a Cloning method brush to partially restore the gray tones of the original

MUCH OF THE BEAUTY of illustrator Philip Howe's work lies in his seamless, creative blending of the traditional with the digital. In a spread for *Trailblazer* magazine—a detail of which is shown here— Howe combined hand-drawn calligraphy, a photo of two slides, a photo of a watercolor block (for the background), and his own pencil sketches, colored to simulate traditional watercolor.

1 Starting with a sketch. Howe began by sketching the various birds in pencil on watercolor paper. He scanned the images on a flatbed scanner, saving them as grayscale files in TIFF format. Each bird image was 4 to 5 inches square and 300 ppi.

2 Modifying a clone. Open a grayscale scan in Painter. Choose File, Clone to clone your scan, giving you an "original" and a clone. Keep the original open—you'll want to pull from it later. Howe added a color tint and a texture to the clone of the scanned bird. To add a tint, choose a color in the Colors palette (Howe chose a reddish brown); then choose Effects, Surface Control, Color Overlay. Select Uniform Color from the Using pop-up menu, set Opacity to 30%, click the Dye Concentration button and click OK. To add texture, select a paper texture (Howe chose Basic Paper) from the Paper Selector near the bottom of the Toolbox, and choose Effects, Surface Control, Apply Surface Texture. Select Paper from the Using menu, set Amount to 50% and set Shine to 0%. Click OK.

3 Restoring from the original. Howe used Painter's cloning capabilities to replace most of the tint and texture in the bird's body with the light gray tones of the original. In the Brush Selector Bar, choose the Cloners category, and the Soft Cloner variant. In the Property Bar, try lowering this cloning brush's Opacity for more sensitivity. (The Soft Cloner sprays soft color, similar to an airbrush.) Once you've arrived at the opacity you like, paint on the portion of your image that you want to restore. The original will automatically be revealed in the area covered by your strokes.

4 Adding color tints with an Airbrush. To achieve the effect of traditional airbrushing with transparent dyes or watercolor pigments, Howe used two versions of the Digital Airbrush variant of

4

Applying color tints with the Digital Airbrush in Buildup method

5

Using a Large Chalk variant to add color to the background

6

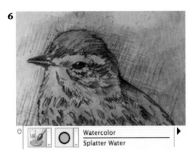

Applying watercolor accents with the Splatter Water variant

Another spot illustration from the Trailblazer *spread. Howe used the same brushes and technique for all illustrations.*

Airbrushes. The first Digital Airbrush (using the default Cover method) allowed a light color to cover a darker one. In the Property Bar, he reduced the Opacity setting to between 5% and 10%. He used this low-opacity brush to carefully lay in the golden brown tones on the bird's back. Howe's second airbrush used the Buildup method, which applied color transparently. The Buildup method allowed him to use a slightly higher Opacity (between 10% and 20%) to achieve richer color while preserving the intensity of the pencil sketch. To make a "transparent" airbrush similar to Howe's, choose the Digital Airbrush variant of Airbrushes in the Brush Selector Bar. To change its method from Cover to the Buildup Method, open the Brush Controls. (Choose Window, Brush Controls, Show General.) In the General section, change the Method pop-up menu to Buildup, and the subcategory pop-up menu to Soft Buildup.

5 Cloning again and brushing with Chalk. Howe uses the Clone feature like a flexible "Save As" command. When he's ready to move on to the next phase of an illustration, he often makes a clone and uses the original as "source material." Here, when he had colored the bird to his satisfaction, he chose File, Clone. If he overworked an area in the new clone, he restored it by cloning in imagery from the previous version by opening that version and designating it as the "source" by choosing File, Clone Source. Then he painted with a cloning brush to restore the area.

Howe switched to the Large Chalk variant of Chalk and began to paint loose, gestural strokes on the image background around the bird using two similar green hues. He changed the size of the brush as he worked by making adjustments in the Property Bar.

6 Adding tints and texture. To add a finishing touch without muddying his existing color work, Howe used transparent washes to add more depth to the color on the bird's head and other areas. To paint washes, use the Wash Camel variant of Watercolor. (As you paint, a Watercolor layer will be generated in the Layers palette, keeping these brushstrokes separate from the Canvas.) Now, sample color from the bird and background using the Dropper tool, switch to the Splatter Water variant and paint a "water drop" effect on the background. To combine the selected Watercolor layer with the Canvas, click the Layer Commands button at the bottom of the Layers palette and choose Drop.

Merging the files. Using the Lasso, Howe drew a loose selection around the bird; then he chose Select, Feather and feathered it 30 pixels. Then he opened the 17 x 11-inch main image and used the Layer Adjuster tool to drag and drop the bird into the main image. To blend the bird layer with the background, he set its Composite Method in the Layers palette to Multiply.

Combining Oil Pastels, Texture and Blending

Overview *Start from a pencil sketch; build a drawing using Oil Pastels variants combined with different paper textures; blend them with Blenders variants.*

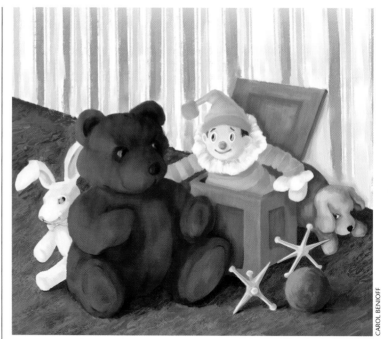

CAROL BENIOFF

The scan of the pencil sketch

Drawing with the Chunky Oil Pastel on Pebbled Leather texture for the stuffed dog

Benioff clicked the Invert Paper button in the Papers palette, and then she painted the texture for the flooring.

THE OIL PASTELS ARE A VERY VERSATILE set of tools—their strokes, blending capability and responsiveness to paper textures all add to the tactile feel of this illustration of toys painted by artist Carol Benioff. She also used Blenders variants, to smear, ripple, add texture and blend the drawing.

1 Starting with a pencil sketch. Benioff started by drawing a simple composition of toys with traditional pencils and paper. Then, she scanned the drawing at 300 pixels per inch and opened it in Painter. To load a new paper library, open the Paper palette (Windows, Library Palettes, Show Papers), and in the pop-up menu, select Open Library. (The message "Loading a new Paper Texture will overwrite your current Paper Textures, and any changes that you have made will be lost" will appear. If you have saved custom paper textures in the default Paper Textures library, choose Cancel and then use the Paper Mover to create a new library for them before you open a new library. For information about libraries and movers, see Chapter 1.) Next, navigate to the Painter 11 application folder, Extras, Paper Textures and select Painter 8 Textures.

2 Picking different papers. Benioff began sketching the stuffed dog. She selected the Pebbled Leather texture from the Painter 8 Textures library that she had loaded in the Papers palette. The paper emulates the dog's nubby blue fabric. Using the Chunky Oil Pastel variant of Oil Pastels, she drew colored strokes, which revealed the pebbly paper and blended with the underlying colors. For the floor, she switched to the Simulated Wood Grain texture and a Soft Oil Pastel variant. To reveal more texture, she adjusted the Grain slider

She drew the jacks on Smooth Handmade Paper and the ball on Coarse Cotton Canvas.

Benioff used Oil Pastels variants and 1954 Graphic Fabric texture to paint the jack-in-the-box and the wallpaper.

Drawing the bear with the Chunky Oil Pastel on Corrugated Paper, with the paper texture inverted and lighter colors

Using the Grainy Water variant of Blenders on the stuffed bunny

to 10% in the Property Bar. Then, she painted dark blue color. To reverse the value of the paper, Benioff clicked on the Invert Paper button in the Papers palette and then she selected a light blue and again drew on the floor with quick strokes. With the inverted paper texture, you can now draw into the recesses of the paper with the lighter color. Vary the pressure on the stylus as you paint to control how much of the paper texture is revealed or covered by the pigment. The Soft Oil Pastel is built so the amount of resaturation and bleed are controlled by the amount of pressure you apply.

3 Using smooth and coarse textures. To achieve the dull metal sheen on the jacks, Benioff chose the Oil Pastel 10 variant, reduced its size to 4 pixels and then she chose the Smooth Handmade Paper for a more subtle paper texture effect. To paint the ball and simulate the rough-textured rubber, she picked the Coarse Cotton Canvas texture in the Paper Selector, and then she switched to the Chunky Pastel, which reveals the paper texture as well as blends with the colors underneath.

Next, Benioff chose the 1954 Graphic Fabric texture for the box, the jack-in-the-box's clothing and the striped wallpaper. For the wallpaper and the jack-in-the-box's clothing, Benioff used the Variable Oil Pastel brush in a variety of sizes. Before drawing the straight lines for the wallpaper, she clicked the Straight line strokes button on the Property Bar. Then, she painted the box with the Round Oil Pastel.

4 Using inverted texture. To paint the stuffed bear's well-worn fur, she used a Chunky Oil Pastel over Corrugated Paper texture. First, she mapped out the lights and darks of the forms. Then, she clicked on the Invert Paper button in the Papers palette and selected lighter shades of browns to draw into the recesses of the paper. By varying the colors, pressure and strokes, she was able to paint mottled textures on the bear.

5 Blending and smearing color. To complete the study, Benioff used a variety of the Blenders brushes on different areas of her drawing as follows: For the dog, she chose an Oily Blender, and pushed and pulled the existing color. For the ball, she switched to a Coarse Oily Blender, with the Coarse Cotton Canvas paper selected. This pushed and pulled the paint and blended the strokes, while still revealing subtle paper texture. For the jacks, she used a Detail Blender, which maintained their dull metallic shine. For the jack-in-the-box's clothing, she used a Coarse Smear Blender. She used Just Add Water to bleed and blur the rough-edged strokes on the box. To soften the transitions from light to dark while keeping the texture on the bear and rabbit, she used a Grainy Blender and the same paper texture that she had used with the oil pastels. Finally, Benioff used the Runny variant of Blenders to create a rippling effect on the floor.

Applying Paper Textures

Overview *Scan textured paper and fabric; open the file in Painter and capture the texture; use grain-sensitive brushes and Painter's special effects to paint and apply texture.*

Scanned lace texture (left) and Japanese paper (right)

Capturing a selected area of the lace scan

Saving and naming the new paper texture

Selecting Make Paper in the Papers palette

Using the Triangle Pattern in the Make Paper dialog box to build the Quilted Paper

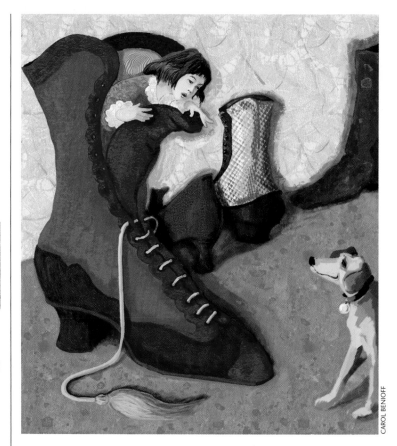

CAROL BENIOFF

WHILE PAINTER OFFERS A LARGE ASSORTMENT of ready-made paper grains, it also offers many ways to create your own unique surfaces. You can capture textures from video grabs, scanned photos, texture collections on CD-ROM, scans of paper, patterns, natural objects (leaves, flowers, wood grains) or images drawn in Painter. The Make Paper and Make Fractal Pattern features in Painter provide another way to generate custom paper textures. With *Parked Boot*, Carol Benioff took full advantage of Painter's capability to apply paper textures with effects and brushes as she painted with variants of the Chalk and Oil Pastels.

1 Scanning and capturing paper textures. Benioff scanned decorative papers, cork, lace and flowers on her flatbed scanner at 300 ppi in grayscale mode. If you are scanning a translucent sheet, or lace, like Benioff used for this piece, you may want to place a black sheet behind it to create greater contrast. For maximum flexibility when applying the texture, make sure the scan has good contrast and a broad tonal range.

Use the Rectangular Selection tool to isolate an area of your image. The repetition of your paper pattern may be too obvious if you select an area that is smaller than 200 x 200 pixels. Open the Papers palette (Window, Library Palettes, Papers). Choose Capture

3

Detail of textures applied with the Color Overlay effect to the background surfaces

4a

Detail of Quilted Paper texture painted onto the top portion of the brown boot

4b

Benioff used Painter's Pebble Board texture with Oil Pastels to paint the dark brown leather of the boots.

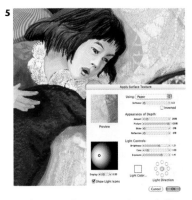

5

Applying a Surface Texture using Benioff's captured Japanese Paper texture

Paper from the pop-up menu on the Papers palette. For the smoothest results, use a Cross-fade setting between 16–30. Name your paper and click OK. A picture of the texture will appear in your current Paper library.

2 Making papers. To build the Quilted Paper, Benioff opened the Make Paper dialog box. (To choose Make Paper, click on the right triangle of the Papers palette and choose Make Paper.) In the Patterns pop-up menu, Benioff selected Triangle, adjusted the spacing and angle and then named her paper and clicked OK.

3 Filling selections with textured color. Benioff built broad areas of color and texture by selecting portions of her drawing with the Magic Wand and Lasso tools, and then filling the selections with color and texture using the Color Overlay effect. To paint as Benioff did, choose a color in the Colors palette and a paper in the Papers palette. Then choose Effects, Surface Control, Color Overlay. In the Using pop-up menu, select Paper. Next, set your desired Opacity and click the Dye Concentration button for a transparent tint *or* the Hiding Power button for a semi-opaque look. On the background wall, Benioff applied the Japanese Paper texture and the Lace texture using Color Overlay. For more depth, she applied the Lace texture again using the Dye Concentration effect.

4 Applying paper grain with brushes. Benioff brushed the Quilted Paper texture on the ankle-high boot using the Square Chalk variant of Chalk and a yellow ochre color. Then, for the shadow areas, she reversed the Quilted Paper by checking the Invert Paper box in the Papers palette and painted dark brown strokes. (See "Inverting the Grain" on page 54 to learn more about inverted textures.) Next, she used the Pebble Board texture in Painter 11 and the Oil Pastels to create the leather grain on the red boot. She painted reds and browns. As she worked, she adjusted the Grain slider on the Property Bar to vary the amount of texture revealed in the strokes. Choose Pebble Board texture in the Papers palette and the Soft Oil Pastel variant of Oil Pastels. Using gentle pressure on your stylus, brush textured strokes onto your image using the Soft Oil Pastel.

5 Applying paper grain with effects. For more warmth and depth on the background wall, Benioff overlaid more texture and a warm yellow light. She began by selecting the captured Japanese Paper texture in the Papers palette. Then she chose Effects, Surface Control, Apply Surface Texture and used these settings: Using, Paper; Amount, 25%; Shine, 0%. Benioff adjusted the Brightness, Exposure and Color of the Light, and then she clicked OK.

EXCITING TEXTURED EFFECTS

Here's how selected special effects apply paper textures to your images with exciting results. *Surface Texture* applies texture by simulating a paper surface with lighting and shadows, *Color Overlay* applies texture as a transparent or semi-opaque tint and *Dye Concentration* applies texture by darkening (or lightening) pixels in the image that fall in recesses of the paper grain.

A Painter Impasto Primer

Overview *Here you'll find the basics for painting with the Impasto medium and brushes.*

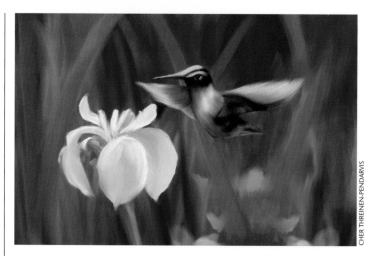

CHER THREINEN-PENDARVIS

The Toggle Impasto Effect button in the image window

Brushstrokes made with the Thick Tapered Flat variant of Impasto

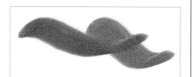

The Impasto section of Brush Controls, with the Draw To pop-up menu set to Color and Depth

WITH IMPASTO, LUSCIOUS THICK PAINT is available at the tip of your digital brush. Painter's Impasto brushes and Impasto depth layer give you the ability to paint with exciting, realistic, three-dimensional brushstrokes that leave bristle marks and paint texture on the surface of the image. Impasto brushes are found in the Impasto category and in other categories in the Painter Brushes library such as the Acrylics, Gouache, Oils and Cloners. Look for brushes with the word *Thick* in their name, such as the Thick Opaque Acrylic variant of Acrylics and the Thick Wet Camel variants of Oils. A few brushes in the Cloners category include Impasto settings; the Oil Brush Cloner and the Thick Camel Cloner variants of Cloners are examples.

Impasto properties. Impasto has two properties: the *color* of the paint and the *depth* of the paint. The Impasto depth medium is a grayscale bump map that is part of the Painter image Canvas. It is similar to a layer, but it does not appear in the Layers palette. Choose the Thick Tapered Flat variant of Impasto and make a brushstroke. You will see a brushstroke with the realistic highlights and shadows of thick paint. To view your Impasto brushstrokes with their color only (without the depth), use the Toggle Impasto Effect button to turn the depth on and off. The Toggle Impasto Effect button is the paint splat icon located in the upper right of the Painter image window.

Controlling Impasto. There are two types of controls for Impasto. The first affects the appearance of individual Impasto brushstrokes and is located in the Impasto section of Brush Controls. Choose Window, Brush Controls, Show Impasto to open the Impasto section. (The Impasto section is also located in the Stroke Designer section of the Brush Creator.) The Impasto section controls affect the performance of the Impasto brushes and the depth of individual brushstrokes as you paint them. In the Draw To menu, Color applies only color; Depth applies three-dimensional highlights and shadows but with no color; Color and Depth applies both color and

The choices in the Draw To pop-up menu in the Impasto section

The Surface Lighting dialog box settings apply to the entire image.

The Composite Depth is set to Subtract.

For On Golden Hill, we painted Impasto brushstrokes on layers so that we could use the Composite Depth for more complexity in the overlapping, thick brushstrokes.

three-dimensional highlights and shadows of thick paint. Depth applies the depth layer only. (For an example of an Impasto brush that uses Draw To Depth, try out the Thick Clear Varnish.) The Depth slider controls the amount of depth the brush will apply; Smoothing allows you to adjust the texture of the strokes and Plow controls how much a new stroke will displace existing paint. Under the Depth Method menu, Uniform applies depth evenly; Erase removes depth and Paper applies depth using the current paper texture. (For *Humming-bird* on page 114, we used the Paper Depth Method to achieve the grainy strokes.) Original Luminance applies depth based on a Clone Source, and Weaving Luminance applies depth using the current weave.

The second way you can control Impasto is by adjusting lighting that shines onto the brushstrokes. Surface Lighting, which is located under the Canvas menu, is a global control, which means that it affects the entire document, including all of its layers. Surface Lighting is dynamic, which means that you can continue to adjust the appearance of the Impasto brushstrokes, until you're satisfied with the look.

Building up, or excavating paint. The Thick Tapered Flat and Thick Round are examples of brushes that will build up thick Impasto paint. To excavate, or dig into the paint, use the Palette Knife variant of Impasto. You can also customize a brush to dig into existing Impasto paint. Choose the Thick Round variant of Impasto, and in the Impasto section, enable the Negative Depth box.

Impasto, layers and Composite Depth. When creating *On Golden Hill*, we painted Impasto on layers so that we could adjust the Composite Method and the Composite Depth. We built up paint and excavated paint. The Composite Depth settings on the Layers palette allowed for interesting paint interaction. We painted brushstrokes on two layers with the Thick Acrylic Round variant of Acrylics. Then, we used the Composite Depth controls, Subtract (to excavate) and Add (to raise) the brushstrokes. For more Impasto painting tips and techniques, see "Brushing Washes over 'Live' Canvas" on page 116 and "Painting with Gouache and Impasto" on page 118.

If you save your file in RIFF format to preserve the "live" Impasto qualities, you can use Canvas, Surface Lighting to change the light direction, or to increase or decrease the depth of the Impasto paint, even after you open and close the image.

If you're not satisfied with the look of the relief after you've applied depth, you can erase Impasto with one of these two methods. To erase the entire depth effect, choose Canvas, Clear Impasto. To use a brush to decrease depth from an area, choose the Depth Equalizer variant of Impasto and brush over the area you want to smooth. To completely erase a portion of the depth layer, use the Depth Eraser. However, use the Depth Eraser with care, as it can make an indentation in the depth layer.

Brushing Washes over "Live" Canvas

Overview *Open a new file and use an Impasto brush to emboss texture into the image canvas; paint color washes over the canvas with brushes.*

STANLEY VEALÉ

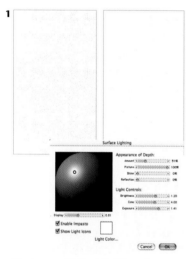

The canvas with the default Impasto Lighting settings (left) and with the reduced Amount and Shine (right), as set in the Impasto Lighting dialog box.

2a

Choosing the Wet Bristle variant of Impasto in the Brush Selector Bar

ON TRADITIONAL CANVAS YOU CAN USE OIL PAINT mixed with linseed oil and turpentine to brush washes over the surface without obliterating the canvas grain. With Painter's Impasto feature you can do something very similar, with the added advantage of being able to emphasize or de-emphasize the grain by changing the angle or intensity of lighting on the canvas. Using the Impasto feature to "emboss" the canvas will keep the grain "live" and changeable throughout the painting process. To paint *Ashanti,* a still-life study of an African wood carving, artist and designer Stanley Vealé used a unique method that allows the canvas texture to always show through the brushstrokes.

1 Embossing the canvas. Begin by creating a new file the size and resolution you need. (Vealé's file was 800 pixels square.) In the Papers Selector, choose the Coarse Cotton Canvas texture. (Considering the 800-pixel file size, Vealé left the Scale of the Coarse Cotton Canvas texture at 100% in the Papers palette.)

Vealé used the Grain Emboss variant of Impasto to "emboss" the Raw Silk texture values into the image canvas without adding color. Select the Grain Emboss variant of Impasto and paint wide strokes all over the image so that the paper texture is embossed into the image. You can reduce or increase the effect of the texture by choosing Canvas, Surface Lighting, and adjusting the Amount slider to your liking. Because the default Impasto Lighting settings seemed too coarse and shiny, Vealé reduced the Amount to 51%, and for a matte finish on the canvas, he set the Shine at 0.

2 Customizing a brush. Vealé likes the Wet Bristle variant of Impasto because of its bristle marks and how it scrubs existing paint when you apply pressure on the stylus. However, if he

2b

Changing the Impasto settings in the Stroke Designer tab of the Brush Creator for the Wet Bristle variant copy

3

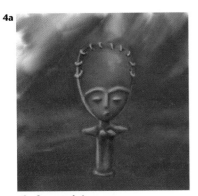

Applying glazes to the image canvas

4a

The figure study in progress

4b

Vealé painted reflected light on the face of the Ashanti figure.

used the default Impasto Wet Bristle, the brush would paint with depth as well as color, eventually covering the embossed texture applied in step 1. So he modified a copy of the Wet Bristle so that it would apply only color to his image, as follows: Select the Wet Bristle variant of Impasto and copy it to the Oils category by choosing Copy Variant from the triangle pop-up menu on the right side of the Brush Selector Bar. When the Copy Variant dialog box appears, choose the Oils category from the pop-up menu and click OK. Now choose the Wet Bristle copy from the Oils category. Open the Brush Creator (Ctrl/⌘-B), and its Stroke Designer tab. In the Impasto section, change the Draw To pop-up menu to Color. Then choose Set Default Variant from the Variant menu in the Brush Creator to make the change permanent for the new Wet Bristle variant.

3 Painting colored washes. Using a light touch on the stylus, and the new Wet Bristle brush, Vealé freely brushed loose washes of color over the image canvas, suggesting a subtle horizon line and a glowing campfire in the background.

Choose your new Wet Bristle variant and paint brushstrokes on the image. The brush applies paint when you press lightly, but scrubs underlying paint when you press hard. (You can also achieve good washes with other brushes, such as the Smeary Round and the Variable Flat variants of the Oils.)

4 Setting up a still life and painting the figure. Vealé set up a conventional light to shine from behind the figure that served as his model and another to reflect light onto its face. Then he carefully studied the Ashanti figure's form, and painted it directly on the image canvas with a smaller version of the Wet Bristle variant. He built up values slowly, gradually adding more saturated, darker tones to the still life study. Vealé brought out orange tones that were reminiscent of firelight in the background. He added deeper red and brown colors to the sky, and brighter colors and more detail to the bonfire in the background. Then he added stronger highlights and cast shadows to the foreground and to the carving. Finally, to relieve some of the rigidity of the centered composition, he repainted areas of the background to move the horizon up.

Variations. A slightly different effect (shown at right) can be achieved if you choose the new Wet Bristle, and in the General section of the Stroke Designer (Brush Creator), reduce the Opacity of the brush to between 20%–40% and set the Opacity Expression pop-up menu to Pressure.

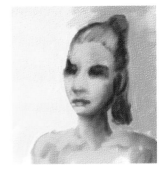

Figure study by Stanley Vealé

Painting with Gouache and Impasto

Overview *Create a finely grained surface; begin with a scanned sketch; sculpt highlights and details using Oils, Gouache and Impasto variants; pull color with a Palette Knife.*

Scaling the Fine Hard Grain texture to 50%

Stahl's sketch drawn with the Smooth Ink Pen variant

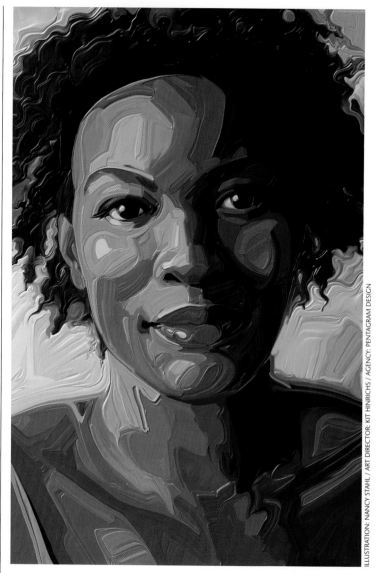

ILLUSTRATION: NANCY STAHL / ART DIRECTOR: KIT HINRICHS / AGENCY: PENTAGRAM DESIGN

ARTIST NANCY STAHL HAS WORKED WITH TRADITIONAL gouache on illustration board since 1976. When she began to work with the computer, her clients would accept her digital art only if the quality matched her conventional style. After much experimentation with Painter's brushes and surfaces, she has been able to fully re-create the effects in her traditional work, evident in *Sappi Portrait,* above.

1 Emulating a traditional gouache surface. Stahl's favorite traditional gouache support is a Strathmore kid finish illustration board. The kid finish is soft and allows for a smooth application of paint. To create a surface for gouache similar to Stahl's, begin by choosing Window, Library Palettes, Papers to open the Papers palette. Choose the Fine Hard Grain texture. To make the surface

3a

Sculpting the forms of the eye and brow area using the Camelhair Medium

3b

The completed color study

4

The Impasto painting of the eye and brow area is shown in this example

5

Using a tiny Palette Knife (Impasto) to pull color in the hair and background

6

Using the Palette Knife (Impasto) to add linear accents and paint texture on the lips and chin

even smoother, scale it to 50%. This finely textured surface is most noticeable when used for painting the hair in step 3.

2 Beginning with sketches. Stahl began by using traditional pencils and paper to draw a black-and-white study to establish the composition and work out values.

In Painter, she created a new file that measured approximately 1200 x 1900 pixels. Stahl drew an expressive sketch with the Smooth Ink Pen variant of Pens. Begin by creating a new file similar to the size of Stahl's, select the Smooth Ink Pen variant and set the Size to 4.0 in the Property Bar. Choose a dark color and begin sketching.

3 Painting teardrop shapes. For the color study, Stahl used two brushes, a fast, sensitive brush with grainy edges to rough in color (the Broad Cover Brush 40 variant of Gouache sized to 25 pixels) and a modified Round Camelhair variant, to paint teardrop shapes suggesting highlights in the hair and to sculpt the facial features. The controls needed to build Stahl's modified Round Camelhair brush are located in the Property Bar.

In the Brush Selector Bar, choose the Round Camelhair variant, and in the Property Bar, set Feature to 1.3. (Lowering the Feature setting "tightens" the bristles in the brush, giving the strokes a smoother, crisper edge with fewer bristle marks, similar to using a soft traditional brush loaded with paint on a smooth surface.) In the Property Bar, set Resat to 65% and Bleed to 8% (increasing the Resat setting allows the brush to paint with more of the current color, with less mixing of colors on the image canvas). From the Brush Selector Bar's triangle pop-up menu, choose Save Variant, name your variant (Stahl named hers Camelhair Medium) and click OK. Stahl varied the size of her brush while she worked.

4 Building up thick paint. For the look of thicker paint, Stahl used Impasto brushes. To quickly make a copy of her color study, she chose File, Clone. She saved the clone image using a new name, to preserve the color study, then she painted directly over the copy of the color study using various Impasto brushes, including the Opaque Flat and Round Camelhair. When she wanted to reveal bristle marks, she used the Opaque Bristle Spray (Impasto). To pull color with a flat-sided tool that would give the features a sculpted look, she used a small Palette Knife variant (Impasto).

5 Pulling and blending. Stahl used varying sizes of the Palette Knife variant of Impasto to blend and pull colors in the background and on the shoulders. To paint curls in the hair and achieve an oily look, she used the Distorto variant of Impasto.

6 Finishing touches. To finish, Stahl added linear accents on the model's eyes, lips, nose and chin using a small Palette Knife (Impasto) and she painted a few thick bristle marks on the background and hair using Opaque Bristle Spray (Impasto). 🖌

A Painter Liquid Ink Primer

Overview *Here you'll find the basics for painting with the Liquid Ink brushes and layers in Painter.*

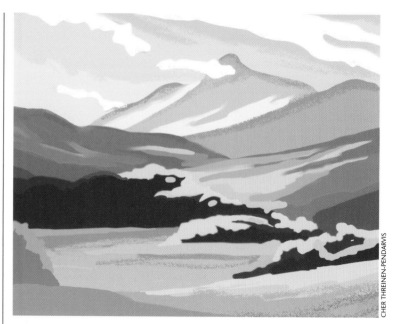

CHER THREINEN-PENDARVIS

JOHN DERRY

After drawing black line work using the Fine Point variant, John Derry created a new Liquid Ink layer and dragged it below the line work layer in the Layers palette. Working on the new layer, he used the Smooth Knife variant to paint broad areas of color onto the background. He created interesting texture by eroding paint with the Coarse Airbrush Resist. For the smooth-edged highlights on the stool, he painted with the Smooth Camel variant.

WITH THE LIQUID INK BRUSHES AND MEDIA LAYERS in Painter, you can paint bold, graphic brushstrokes of flat color, and then erode ink with resist brushes or build up thick ink that has three-dimensional highlights and shadows. Like traditional viscous media (printer's ink or the enamel used in jewelry making, for example), Liquid Ink is sticky.

Hillside Lake, Wales (above), is one in a series of landscape studies created with the Graphic Camel and Graphic Camel Resist variants on Liquid Ink layers. Using the Soften Edges and Color variant, we blended the top edge of the purple hill in the midground. Before you start a Liquid Ink painting of your own, reading the next five pages will help you to understand how to achieve the results you are looking for.

Controlling Liquid Ink. The most important settings for Liquid Ink are in the Property Bar and in several sections of the Brush Creator's Stroke Designer window: the General, Size and Liquid Ink sections of the Stroke Designer; the Layers palette; and the Surface Lighting dialog box, found under the Canvas menu. Painting with a Liquid Ink brush automatically generates a Liquid Ink Layer, which is then listed in the Layers palette. Liquid Ink layers can be targeted in the Layers palette and edited like other layers. (Chapter 6 tells more about working with layers.)

The brush settings described below in the General, Size and Liquid Ink sections can also found under Window, Brush Controls. In the General section of the Stroke Designer (Brush Creator), the

> **RESOLUTION-INDEPENDENT INK**
>
> A graphic medium, Liquid Ink is resolution-independent. It's possible to create a Liquid Ink illustration at half size, and then double the resolution of the file and retain the crisp edges on the brush work.

In this example, the "e" was drawn after the "S," and the new Liquid Ink stroke melted into the existing ink. The lettering was drawn using the Smooth Flat variant of Liquid Ink. The rough strokes were added using the Graphic Camel.

The Volume settings in the Liquid Ink section of the Stroke Designer allow you to specify which factor controls the Volume of a stroke.

The Liquid Ink section, showing the Ink Type pop-up menu

The Liquid Ink section, showing the default settings for the Graphic Camel

Liquid Ink dab types are displayed in the Dab Type pop-up menu. A dab type determines the shape of the brush tip—for instance, Liquid Ink Flat and Liquid Ink Camelhair (Camel brush tips are round). The Liquid Ink brushes use continuous-stroke technology, which means that brushstrokes are painted using brush hairs that form a set of antialiased 1-pixel lines. You'll find more information about dab types in Chapter 4, "Building Brushes" on page 138.

In the Property Bar (and in the Size section of the Stroke Designer, and in the Size section of Brush Controls), you'll find the Feature slider, which determines the density of the brush hairs in the continuous-stroke brushes. **Note:** A very low Feature setting (producing more densely packed brush hairs) takes greater computing power, and this can slow down the performance of a Liquid Ink brush.

In the Liquid Ink section of Stroke Designer (Brush Creator), if the Volume Expression controller is set to Pressure, the height of the brushstroke will increase as pressure is applied to the stylus.

Liquid Ink has two basic components: Ink and Color. *Ink* consists of the shape and dimension of the Liquid Ink, giving the medium its sticky, plastic quality and form. The *Color* component is independent of the ink form. In the Liquid Ink section of the Stroke Designer (Brush Creator), the Ink Type pop-up menu includes nine important Color-and-Ink options that dramatically affect the performance of the Liquid Ink brushes. The Ink Type settings themselves are complex and are also affected by slider settings in the Liquid Ink section (described below). A brush of the *Ink Plus Color* type adds new ink using the current color in the Colors palette. While the *Ink Only* type affects only the shape of the brushstroke, the *Color Only* type affects only the color component. *Soften Ink Plus Color* alters existing brushstrokes so that the ink changes shape and the colors blend into one another. The *Soften Ink Only* reshapes the ink without changing its color, and *Soften Color Only* blends the Color without reshaping.

Painting with a *Resist* type brush will cause brushstrokes applied over the resist to be repelled. (Scrubbing with a non-resist brush can erode the resist until it is eventually removed.) Using the *Erase* type will remove existing ink and color. *Presoftened Ink Plus Color* works in conjunction with the Volume control settings to build up height as additional brushstrokes are applied.

Liquid Ink has two basic components: Ink and Color. *Ink* controls the shape and dimensionality of the strokes and gives the medium its sticky, plastic quality. *Color* controls color without affecting the shape.

Many of the various settings that control Liquid Ink interact with one another in complex ways. This is what produces the magic of this medium, but mastering the complexity can present quite a challenge. It's a good idea to experiment with the different brushes and types until you get a feel for how Liquid Ink performs.

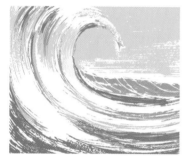

An active Liquid Ink layer as it appears in the Layers palette. To create a new Liquid Ink layer, click the right triangle on the Layers palette bar and choose New Liquid Ink Layer or click the Create New Liquid Ink Layer button at the bottom of the Layers palette.

For Ocean Waves, the Coarse Bristle variant of Liquid Ink was used to draw curved strokes with a thick, bristly texture. We used the Coarse Airbrush Resist to add a foamy texture to the water and to suggest atmosphere in the sky.

Sumo Ink Man. We drew this study using a Wacom pressure-sensitive tablet and stylus on a laptop (while watching Sumo wrestlers on TV), with the Graphic Camel and Graphic Bristle variants of Liquid Ink.

The eight sliders in the Liquid Ink section work in conjunction with each other to create many kinds of Liquid Ink brushstrokes. Because these controls are very complex and interdependent, they're difficult to clearly define. Experiment—dig in and try out the Liquid Ink variants, while keeping an eye on the Liquid Ink section controls. The *Smoothness* slider controls how sticky the ink is. Lower values will create coarser brushstrokes with less self-adhesion. A high Smoothness setting will help to hide the individual bristle marks and will increase adhesion, but it may make the performance of the brush lag. *Volume* controls the height of the brushstroke. Use this setting in conjunction with the Volume Expression in the Liquid Ink section to add height to brushstrokes. (**Note:** To view volume on your image, the Amount setting must be adjusted in the Liquid Ink Layer Attributes dialog box. See the "Turning on 3D Highlights and Shadows" tip below.) The *Min Volume* controls the amount that the volume can vary. (This slider is used in conjunction with the Volume Expression in the Liquid Ink section.) *Rand Vol* controls the randomness of the volume in a stroke. A low value will create a smoother, less variable stroke. *Random Size* controls randomness of brush hair size within the stroke; again, a lower value will help to create a smoother stroke. *Bristle Frac* controls the density of the bristles. *Rand Bristle Vol* controls the variation in volume of ink laid down by individual bristles, and a low value will make the bristle marks a more even thickness. *Rand Bristle Size* controls variation in the widths of individual bristles. A very low setting will make the bristles more similar in width.

TURNING ON 3D HIGHLIGHTS AND SHADOWS

To view Liquid Ink brush work with three-dimensional highlights and shadows, double-click the name of the Liquid Ink Layer in the Layers palette and increase the Amount (thickness) setting. Click OK. The Liquid Ink medium has no thickness limit. After you have increased the Amount setting, you can use your stylus to paint more Liquid Ink onto the layer, continuing to build up the pile of ink. You can adjust the thickness at any time using the Amount slider in the Liquid Ink Layer Attributes dialog box. (There is no preview in this dialog box. You have to adjust the slider and click OK, and then observe the effect on the image.) To change the direction, intensity or other properties of the lighting, choose Canvas, Surface Lighting and adjust the settings in the Surface Lighting dialog box.

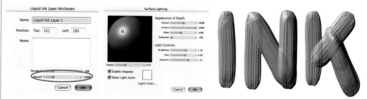

Increasing the Amount setting (left) increased the thickness of the brushstrokes (right). We left the settings in the Surface Lighting dialog box at their defaults.

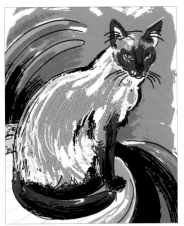

We began this Liquid Ink study of Little Doll *by creating a black line drawing with the Fine Point variant of Liquid Ink on a Liquid Ink layer. Then we added a new layer (by choosing New Liquid Ink Layer from the Layers palette menu), dragged it below the sketch layer in the Layers palette and added color to the table and background with the Graphic Camel variant. For the cat's fur we created another new layer between the two we already had, and painted using gold and tan colors. For the look of thicker paint on the layer with the fur, we double-clicked the layer's name in the Layers palette and adjusted the Amount slider in the Liquid Ink Layer Attributes dialog box. Then we painted with the Coarse Camel Resist to erode some of the colored ink.*

Brushstrokes painted with the Smooth Flat variant of Liquid Ink

Thin-to-thick sweeping curved strokes painted with the Pointed Flat variant of Liquid Ink

WORKING WITH THE LIQUID INK BRUSHES

Here are some suggestions for how to paint using the Liquid Ink brushes in Painter. Even if you're familiar with Painter's other brushes, try out these ideas and experiment with all of the Liquid Ink variants.

Painting coarsely textured brushstrokes. To paint brushstrokes with a coarse, bristly texture, choose the Coarse Bristle variant. You can control the paint coverage by applying more or less pressure to the stylus—a lighter pressure will create a stroke with less paint. The Graphic variants also paint coarsely textured brushstrokes and with better performance, for more spontaneous painting. The Graphic Camel is one of our favorites because it paints expressive, thin-to-thick strokes, with finer texture on the edges of the brushstrokes.

Blended color with smooth brushes. Any Liquid Ink variant with Smooth in its name has a high smoothness setting and will paint just like a brush loaded with very thick, sticky ink or paint. The Smooth Bristle variant's bristles will spread or splay out as you rotate your hand through the stroke, while the Smooth Camel performs like a big, round brush with longer bristles. As you press harder on the stylus, the Smooth Camel will paint a broader stroke. As you paint a new color over existing ink with a Smooth brush, the edges of the colors will subtly blend.

Thick and thin strokes with the Flat brushes. Look for brushes with the word Flat in their name; the Coarse Flat and Pointed Flat are examples. With Flat-tipped brushes, you can paint wide or narrow strokes, depending on how you hold the stylus relative to the stroke direction and how much pressure you apply. When trying the strokes below, position your stylus with the button facing up (away from you). To paint a broad flat area of color with the Smooth Flat (as in the example on the left), pull the brush straight across your image using even pressure. To make the thin lines, pull down. To make a curved, thin-to-thick wavy line, use light pressure on your stylus for the thin top areas, and more pressure as you sweep down and rotate the brush. For flat brushstrokes with sensitive thin-to-thick control, try the Pointed Flat. With this brush, bristle marks will be more visible when heavy pressure is applied to the stylus. For a thin-to-thick sweeping curved stroke, begin the thin portion with very light pressure on your stylus, and as you sweep downward rotate your stylus slightly and apply more pressure.

> **MOUSE ALERT!**
>
> Liquid Ink brushes are very responsive to the pressure applied to a stylus. Because of the importance of pressure, many of the brushes do not perform as described here when a mouse is used. For instance, the brushes will not paint the expressive thick-to-thin brushstrokes that are possible with a pressure-sensitive tablet and stylus. Also, the Volume settings that are enhanced by pressure will not perform identically.

We drew the sketch for Yellow Pitcher *using the Velocity Sketcher variant.*

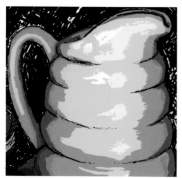

The Graphic Camel Resist variant was used to erode ink and create highlights in Yellow Pitcher. *A detail is shown here.*

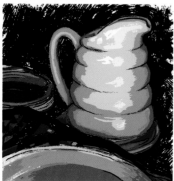

The completed Yellow Pitcher *painting.*

To make a thick, even stroke, pull the stylus sideways relative to the button, using even pressure. For the thin lines, apply even pressure and pull in a direction toward or away from the button.

Sketching and line work. You can also sketch or draw line work with Liquid Ink. Quick performance makes the Velocity Sketcher ideal for spontaneous sketching. On the edges of the brushstrokes, you'll notice grainy texture.

The *Fine* variants of Liquid Ink are good for painting details and for calligraphic line work. The Fine Point draws like a steel pen with a pointed nib, and the Fine Point Eraser is ideal for cleaning up edges and for removing small patches of ink.

Painting resists. A *resist* is a substance that can be painted onto a Liquid Ink layer with a Liquid Ink Resist-type brush. A resist is capable of repelling ink when the area is painted over by a standard Liquid Ink brush. You can also "scrub away" existing Liquid Ink using a Resist type brush. The Coarse Bristle Resist and the Graphic Camel Resist, for instance, are useful for painting coarse, eroded areas on a Liquid Ink painting. For a smoother resist, try the Smooth Bristle Resist, Smooth Camel Resist or Smooth Flat Resist variant. To erode existing ink and create an interesting speckled texture, use the Coarse Airbrush Resist.

ADJUSTING LIQUID INK EDGES

You can nondestructively make Liquid Ink brushstrokes appear to expand or contract by adjusting the Threshold slider in the Liquid Ink Layer Attributes dialog box. To see how Threshold works, in the Layers palette, target the layer that you'd like to change and access the Liquid Ink Layer Attributes dialog box by double-clicking the layer's name in the Layers palette (or press the Enter key). To thicken the appearance of the brushstrokes, lower the Threshold value by moving the slider to the left. To give the ink a thinner appearance, raise the Threshold value by moving the slider to the right.

Adjusting the Threshold slider very low (to −49%) thickened the blue ink.

Adjusting the Threshold very high (to 160%) dramatically thinned the blue ink on the sugar bowl.

Encaustic Painting with Liquid Ink

Overview *Use a Liquid Ink brush to paint textured color on a layer; duplicate the layer; make a custom coloring brush; recolor the layer and erode areas; add more layers with new color and texture.*

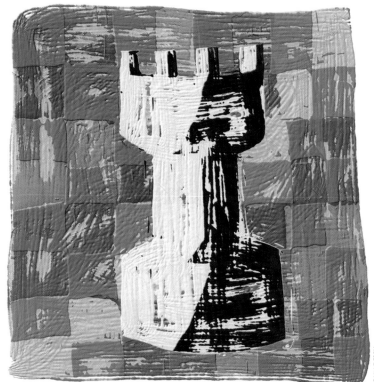

JOHN DERRY

1a

Painting the yellow square with the Sparse Camel variant of Liquid Ink

1b

The new active Liquid Ink layer shown in the Layers palette

ENCAUSTIC PAINTING INCORPORATES PIGMENTS suspended in wax. It was used by the ancient Greeks who painted the brightly colored statues in the Acropolis and by the Romans for wall murals in Pompeii. Traditional encaustic technique involves heating the wax-based medium and then painting quickly while the wax is still malleable. Delicate layering of transparent color as well as heavy Impasto techniques are possible. In Painter, you can create the look of encaustic painting with the new Liquid Ink brushes and media layers.

To create *Chess*, John Derry used Liquid Ink brushes and media layers to emulate encaustic painting. He painted bright colors on Liquid Ink layers, and then eroded and scratched out areas to reveal the color and textured brush work on the underlying layers. For the look of thick encaustic paint, he added subtle three-dimensional highlights and shadows to the layers.

1 Creating textured brush work. Begin your Liquid Ink painting by opening a new file with a white background (File, New). To work at the scale of this painting, set the Width and Height at 800 x 800 pixels and click OK.

To paint a background consisting of large, textured strokes, choose the Sparse Camel variant of Liquid Ink in the Brush Selector Bar and choose a bright yellow color in the Colors palette. When you've chosen a Liquid Ink brush and you touch your stylus to the

2

The completed first layer, showing the highlights and shadows on the brush work and the settings in the Liquid Ink Layer Attributes dialog box

3

The active, duplicate layer in the Layers palette

4

Choosing Color Only for the Type setting in the Liquid Ink section of the Stroke Designer

5

The square reddish areas added to the image on the duplicate layer, and then partially eroded using a resist brush; shown with both layers visible (left) and with the yellow layer hidden (right)

tablet, a Liquid Ink layer will automatically be generated and will be listed in the Layers palette. Loosely block in a square shape using the Sparse Camel. Derry purposely painted an irregular edge and left part of the white background as an informal border, which would add to the textural contrast in his image.

2 Turning on thick paint. To add realistic highlights and shadows to the brush work on the yellow layer, double-click its name in the Layers palette. When the Liquid Ink Layer Attributes dialog box appears, increase the Amount setting to about 20% and click OK.

3 Duplicating a Liquid Ink layer. Derry wanted to add different colors while keeping the brushstroke pattern that he had already created. So he duplicated the active yellow layer by choosing the Layer Adjuster tool in the Toolbox, pressing the Alt/Option key and clicking once on the layer in the image. (To read more about working with layers, turn to Chapter 6, "Using Layers.") Once you've duplicated the layer, choose the Brush again in the Toolbox.

4 Making a custom brush for coloring. With some Liquid Ink brushes, you can recolor elements without disturbing the ink (shape, volume and lighting) component that you've painted on a layer. After the layer duplicate was created, Derry modified the Sparse Camel brush so that it would change the color without changing the shape and thickness of the existing strokes. To modify the Sparse Camel as Derry did, open the Brush Creator palette by choosing Window, Show Brush Creator, or by pressing Ctrl/⌘-B. Click the Stroke Designer tab, and open the Liquid Ink section by clicking on the Liquid Ink section bar. (The Liquid Ink section can also be found in the Brush Controls.) In the section's Ink Type popup menu, choose Color Only. To save this custom Sparse Camel brush, choose Save Variant from the Variant menu in the Brush Creator, name the new brush and click OK to save it. In addition to saving your new brush, Painter will remember the changes that you've made to the default Sparse Camel brush, so it's a good idea to restore it to its default settings. To return the original Sparse Camel variant to its default, choose Restore Default Variant from the Variant menu in the Brush Creator.

5 Coloring and eroding the duplicated layer. With the duplicate layer active in the Layers palette, choose a new color (Derry chose a bright reddish-pink) and paint over the areas that you want to recolor. To scrape away areas of the layer so that the color from the underlying layer will show through, you can use a Resist-type variant or an Eraser-type variant

ERASING LIQUID INK

To completely remove Liquid Ink from a Liquid Ink layer, choose the Eraser or Fine Point Eraser variant of Liquid Ink. Click on the name of the layer you wish to edit in the Layers palette and brush over the area that you'd like to remove. If you have a thick buildup of Liquid Ink on the layer, you may have to scrub over the area a few times to completely remove all of the ink.

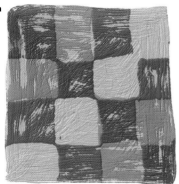

6a

The smaller blue squares are added to the image, breaking each of the original four squares into four.

6b

The small green squares are added, so that now each of the four original squares has 16 parts.

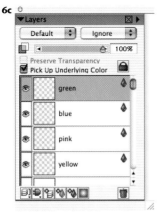

6c

The Layers palette showing the renamed Liquid Ink layers

of Liquid Ink. Because he likes the texture it creates, Derry scrubbed with the Sparse Camel Resist variant to scrape away the pink upper-right and lower-left areas to reveal the yellow. Then, to add an eroded texture into areas within the pink squares that he planned to keep, he brushed lightly over them using the Sparse Camel Resist variant.

6 Adding the blue and green squares. To add the blue and green colors to his image, Derry repeated the duplicating, revealing and eroding process in steps 2 and 3. The blue squares were smaller, so the effect was to break each pink square into four. The green squares were even smaller; the effect was to break up each original square into 16.

7 Painting the chess piece. So the castle would look as if it were thicker paint sitting on top of the painted chess board, Derry wanted the direction of the brushstrokes to be different. He created a new Liquid Ink layer by clicking the New Liquid Ink Layer at the bottom of the Layers palette bar. On the new layer, he blocked in the basic shape of the chess piece with the default Sparse Camel using white color, and then used the Sparse Camel Resist to erode some of the white paint. For the black areas on the chess piece, Derry duplicated the white layer as he had done for the yellow in step 3. Then he chose his custom Sparse Camel brush (which used Color Only) and painted black onto the right half of the castle. To finish, he used the Sparse Camel Resist to erode areas of the black layer to expose the white underneath. 🖌

7a

The white shape was painted on a new Liquid Ink layer.

7b

The black brush work shown in this detail was painted on a duplicate of the white layer.

■ "I approach painting in Painter the same way I paint conventionally," says **Karen Carr**, an accomplished, award-winning illustrator who often creates natural history illustrations for educational publishers. Carr was commissioned by the Smithsonian National Museum of Natural History to create the illustration *Smithsonian Burgess Shale Community* for the museum.

The Burgess Shale is famous for the exceptional preservation of the fossils found within it, in which the soft parts are preserved. A Cambrian black shale formation, it crops out in the Canadian Rockies of Brit-ish Columbia, Canada. Carr's illustration portrays extinct marine animals and plants, including Pikia, Marrella, Anomalocaris, Yohoia and Opabinia.

Carr began by sketching with modified Charcoal variants to block in basic col-or. She used the Just Add Water variant of Blenders to smoothly blend and sculpt the figures. Using Digital Watercolor brushes, she painted glazes of color for her under-painting. She worked back and forth, add-ing color and blending as she refined the volume of the animals' forms. When she wanted to smudge the paint and reveal texture, she used the Coarse Smear and Smudge variants of Blenders. To bring out highlights in areas—for instance, the sun-light on the foreground forms—she used the Dodge variant of the Photo brushes. In Painter X and later, the Dodge tool is available in the Toolbox and yields a simi-lar result.

■ **Karen Carr** was commissioned by the
Virginia Museum of Natural History to
paint this illustration of *Mecistotrachelos
Apeoros*, a winged gliding reptile. Mecis-
totrachelos apeoros is a fascinating diapsid
reptile found fossilized along the Virginia
and North Carolina border. The glider was
found in a series of fossilized formations
identified as having been a marshy swamp
area during the Upper Triassic.

"I particularly enjoy the interrelationship
between the subjects and light," Carr says,
and her love of light is evident here in

her treatment of the delicate, translucent
wings of the glider in the foreground.

To begin, Carr chose a blue-gray color in
the Colors palette and then chose Effects,
Surface Control, Color Overlay, Using Uni-
form Color to establish the color theme
for the painting. Then, using Charcoal
variants, she sketched the composition.
Because she likes the tactile feel of moving
paint around on the Canvas, she kept the
use of layers to a minimum. To paint trans-
parent glazes, she used the Digital Water-
color brushes and a variety of textures.

So that she could merge the washes with
underlying brushwork she had laid down
with the Charcoal brushes, she dried the
Digital Watercolor by choosing Dry Digital
Watercolor from the pop-up menu on the
Layers palette. To lighten areas, she used
the Dodge variant of the Photo brushes. As
Carr began to refine elements in the scene,
she used the Just Add Water (and other
Blenders variants) to blend and model the
forms. This detailed brushwork is most evi-
dent in the lizard in the foreground and in
the background.

■ **Andrew Jones** is the founder of Massive Black, a video game and film concept design studio whose clients include Nintendo and Industrial Light and Magic.

Jones' inspiration for *Aya* was the divine mother archetype of mankind. To begin the painting, he opened a new file in Painter and used the Paint Bucket to fill the background with dark brown. Then he drew a composition sketch. In preparation for adding color, he used the Lasso tool to select the shapes of the figures. Then, he applied light brown colors to the selected areas using the Paint Bucket. He proceeded to select and fill other areas with flat base colors.

Using Airbrushes and Colored Pencils, Jones modeled the forms on the figures. He varied the size and opacity of the brushes as he worked. To paint the textured strokes on the birds and plants, Jones used a modified Loaded Palette Knife variant of Palette Knives that included an increased Feature setting in the Property Bar. With this brush he was able to apply color and achieve the optical color mixing and textures he wanted. He also used a small Loaded Palette Knife to paint expressive details on the characters and skeletal elements in the bottom areas of the image.

To complete the modeling of Aya's skin, Jones used a low-opacity version of an Airbrushes variant. Then he added detail to

her hair using the Loaded Palette Knife. To finesse the feathers on the doves and to paint the calligraphic details on the decorations in the upper corners, Jones also used the Loaded Palette Knife, changing the size of the brush as he worked.

Using various brushes and choices from the Effects menu, Jones applied several of his own paper textures to the painting—for instance, the texture around the veil and on the halo on the woman's shoulders. As a final touch, Jones painted with the Glow variant of F-X to enhance the glow on Aya's halo, and to intensify the highlights in her eyes. You can see more of Jones' work in "Mixed Media Painting" on page 160 or on his web site, androidjones.com.

■ Artist **Nancy Stahl** has created award-winning illustrations using gouache and other traditional materials since 1976. Using Painter's brushes and surfaces, she's been able to re-create the effects she achieved in her traditional work, as shown here in *Sax* (above). To learn more about her painting techniques, turn to "Painting with Gouache and Impasto," on page 118.

Stahl began *Sax* by roughing in a cream-colored background using a modified Broad Cover Brush variant (Gouache). Using a darker color, she sketched the forms of the sax using the Smooth Ink Pen variant of the Pens.

Using custom-made brushes she had built to imitate her favorite gouache brushes, Stahl added color and began to render the forms of the musical instrument. For the look of thicker paint on her study, Stahl used the Opaque Flat and Round Camel-hair variants of Impasto to paint expressive linear strokes on the instrument and behind it. To move the paint around while carving into the existing thick paint, she switched to a small Palette Knife variant of Impasto. To finish, she chose the Opaque Bristle Spray (Impasto) and brightened the highlights in a few areas.

■ An accomplished traditional painter and designer for many years, **Richard Noble** now paints most of his fine artwork in Painter, using techniques that simulate traditional acrylic painting. He typically begins a painting by shooting reference photographs and sketching on location.

"I have always tried to keep a feeling of freshness in my work and to stay away from the 'overworked syndrome.' In the traditional world of watercolor and acrylics, that means laying in large areas quickly and getting them right, and then following up by working in the detail areas and leaving the large areas alone. This gives the eye the detail it seeks while retaining a fresh, immediate look," says Noble.

For *Dry Dock*, Noble was inspired by finding a row boat incongruously located in a dry area on a ranch in the high country desert of Idaho. The boat was completely rotted, with plants growing through what was left of the hull. He shot reference photos and made sketches on location.

Back at the studio, Noble used a color palette inspired by the desert—predominantly oranges and purples as the basis for the color scheme. Noble roughed in color using Pastels variants, for instance, the Artist Pastel Chalk variant of Pastels, changing the size of the brushes as he worked. He used these large and small pastels to create the look of a color drawing, layering colored strokes over the top of one another. "It also allowed me to capture the movement of the grasses, which lead the eye around the canvas, and keep the painting from becoming 'blocky' and static," Says Noble.

For the sky and distant hills, Noble painted transparent washes of blues, violets and an earthy deep pink using several Digital Watercolor variants, including the Simple Water and Broad Water Brush variants of Digital Watercolor.

When the composition structure was complete, he began to push and pull detail and contrast by using smaller and smaller Artist Pastel Chalk, and Digital Watercolor variants to draw back into the painting. For instance, to subtly emphasize shadows on the building, he used transparent washes of Digital Watercolor.

For the finer details, Noble used a small Artist Pastel Chalk to draw fine, textured strokes. This brushwork is most noticeable on the foreground grasses and in the details of the woodgrain on the boat. Finally, to soften a few areas of the detail drawing, he used the Just Add Water variant of the Blenders.

■ **Ad Van Bokhoven** is an artist based in Holland, who works both traditionally and digitally. To create *Toledo 4*, he used Painter to produce brushstrokes and a style similar to what he achieves with traditional acrylics and oils.

Van Bokhoven began the painting by sketching on location and shooting reference photographs. Later, back at his studio, he opened a new file in Painter, and used Oils and Acrylics brushes to lay in

broad areas of color and value to establish the composition. So that he could apply paint and blend it as he worked, he worked directly on the Canvas, without the use of layers. To mix and pull color, he used Blenders, including the Round Blender Brush and the Grainy Blender variants of Blenders. He worked quickly and expressively, using large brushes, skillfully massing large areas of color for impact.

As Van Bokhoven worked, he focused on keeping his brushwork loose and dynamic, without worrying about details. Intuitively, he played light values against darks, painting accents of warm gold and brown. This brushwork is most noticeable in the foreground furniture and in the warm highlights on the ceiling. You can see more of Van Bokhoven's work in the galleries at the end of Chapter 2 and Chapter 7.

■ **Carol Benioff** works with both conventional materials and digital tools for her fine art and when she creates illustrations for children's books.

For the study *Stalemate,* Benioff used the RealBristle Brushes in Painter, developing the study by painting on both the canvas and transparent layers. To add a layer to her image for the black and white drawing, she clicked the New Layer button on the Layers palette. Then she sketched her composition using the Real Tapered Round variant of RealBristle Brushes and black paint. To arrive at her final composition, Benioff selected and repositioned the figures and the background (upper left). To read about working with layers, see Chapter 6, "Using Layers."

To begin the color work, Benioff added another new layer to her image. Then,

working with one of her custom color sets, Benioff painted over the sketch with the Real Flat Opaque and Real Oils Short variants of RealBristle Brushes. Both of these brushes laid down a lot of smooth wet paint and she used the Real Oils Short to blend the transitions between the shapes and colors.

To add texture and a painterly feeling to the shoes and figures, Benioff used the Real Tapered Bristle and Real Tapered Round. For the detailed areas in the figures and the grass, she built a custom version of the Real Flat variant. She reduced the brush size to 5, reduced the Blend setting to 9%, and saved her custom brush as Real Flat Detail.

After she built up the color and form of the two figures, she dropped the layers by choosing Drop from the Layers palette menu, so that she could enjoy real-

istic paint interaction as she worked overall her image on the image canvas. Painting with the Real Tapered Bristle and the Real Oils Short brushes gave Benioff the feeling of pushing and pulling conventional oil paint. To paint the smooth transitions in the pavement and shadows she switched to the Real Round variant of Real-Bristle. Benioff wanted to glaze certain areas of the image to deepen the shadows and increase contrast, so she added a new layer to the image and set its Composite Method to Multiply. With the new layer active, she painted large, smooth strokes using the Real Oils Short variant with its opacity reduced to 4%. Then using white color, she gently blended and smoothed out the edges of her glazing (center left). She dropped this layer and saved her final image (see the detail in the bottom right).

■ An accomplished illustrator who specializes in book illustration, **Don Stewart** used to work on gessoed illustration board with airbrush and colored pencils before he began using Painter. Today he draws on the computer using Painter's tools and brushes that match his traditional materials.

Planters Foundation Books commissioned Stewart to create *When Feathers Fly* for a children's story poster, *Baskim's Lesson*. Stewart began by choosing a fine-textured paper and drawing a detailed sketch in Painter using Pencils variants. To isolate areas of the image (such as the crow and fox), he made freehand selections using the Lasso tool and then saved the selections as a channel in the Channels palette (Window, Channels), in case he needed to use them later. He blocked in basic color using Watercolor brushes, and then he dropped the Watercolor layer to the Canvas so he could paint on it with other brushes. To build up values, he used the Digital Airbrush variant of Airbrushes and the Smeary variants of the Oils. Then he added highlights, deeper shadows and fine detail using the Colored Pencil variant of Colored Pencils. Stewart sprayed texture on the wood using the Coarse Spray variant of Airbrushes. To paint the texture on the grass in the foreground, he used the Chalk variants and the Coarse Spray and Variable Splatter Airbrushes.

■ An award-winning illustrator who specializes in animation and book illustration, **John Ryan** works with both traditional and digital tools.

Ryan created the illustrations on these two pages for *Daddy Answers*, a children's book that shows kids asking their dads a simple question like, "Can Penguins Fly?" followed by Dad's imaginative answer.

Ryan began the illustrations using conventional pencil and ink on paper. Then, he painted a unique background for each piece using conventional watercolor paint. When the paint was dry, he scanned the drawings and the watercolor wash backgrounds, so he could open them in Painter and add color and textures.

Working in Painter, Ryan opened a background image and copied and pasted the sketch on top. He usually flattens the image before he begins painting because it's more natural to paint on a single surface. Ryan loves the Watercolor brushes and Watercolor layers in Painter. Using the Soft Camel and Wash Camel variants of Watercolor, he sculpts forms and then he uses various brushes, such as the Runny Wash Camel and Runny Wash Bristle, to get bristle and texture effects throughout the piece.

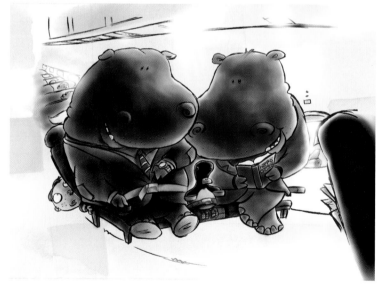

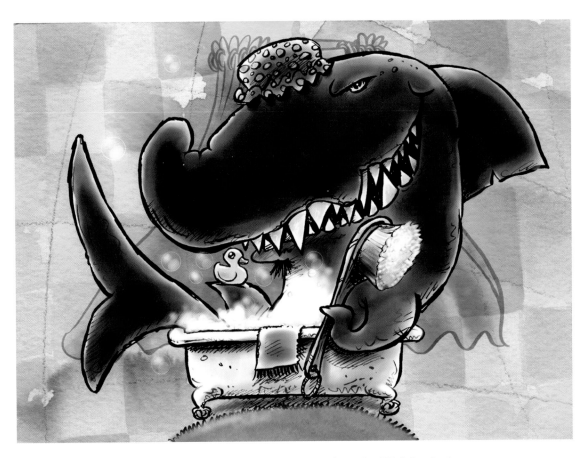

For *Shark,* **John Ryan** began by using conventional pencil and pen-and-ink on drawing paper to sketch the shark in the bathtub. Then he chose a piece of watercolor paper and laid down washes on the paper to paint a pastel background. Next, he scanned both the drawing and watercolor into Painter. He copied and pasted the sketch onto the scan of the watercolor background and positioned it using the Layer Adjuster tool. Because it's more natural to paint on a single surface, Ryan merged the sketch with the background by choosing Drop from the pop-up menu on the Layers palette. Ryan likes the versatility and texture of the Watercolor brushes and Watercolor layers in Painter. (Touch a Watercolor brush to the image and a new Watercolor layer appears.) Ryan used the Soft Camel and Wash Camel variants of Watercolor to model the forms and to define the edges. To build up bristle and texture effects throughout the piece, he employed a variety of brushes to paint transparent washes, such as the Runny Wash Camel, Runny Wash Bristle, Smooth Runny Camel, and Wet Bristle. When the watercolor washes were complete, he dropped the Watercolor layer to the Canvas by choosing Drop from the pop-up menu on the Layers palette. Finally, to complete the illustration, Ryan added additional brushwork with dry media, and other paint media, for instance, the Oil Pastels and the Palette Knives. This brushwork can be seen in the opaque white soap bubbles floating above the shark.

BUILDING
BRUSHES

Dying Orchids *by Chelsea Sammel, shown here as a detail, was painted using custom Impasto brushes. See the complete image in the gallery on page 173.*

Switch methods to make dramatic changes in brush characteristics. Here we've applied the Waxy Crayons variant of Crayons over a gradient using the default Buildup method (top), Cover method (center) and Eraser method (bottom).

INTRODUCTION

IF YOU ARE AN ARTIST who does not rest until you get exactly the brush stroke that you want, then this chapter is for you.

Painter offers many features for customizing brushes, including the Brush Creator's Stroke Designer (described on pages 144–145) and the Transposer and Randomizer functions (described on pages 146–147). The Stroke Designer is where the individual controls for building unique custom brushes reside. The Transposer allows you to blend components of two existing Painter brushes and choose which blend you want. With the Randomizer you can choose a brush and have Painter create 12 variations.

If you like trying new brushes but don't want to build them, check out the Brush libraries on the *Painter 11 Wow!* CD-ROM in the back of this book—you'll find the brushes shown on these pages and more. But if you enjoy creating your own brushes, read on.

METHODS

Methods are the backbone of many brush variants, including brushes that users of earlier versions of Painter know and love. A brush variant's Method setting controls how the paint will interact with the background and with other paint. For instance, by default the Felt Pens variants use the Buildup method, meaning that overlapping strokes will darken. The Chalk variants use the Cover method by default, which means that strokes—even light-colored ones—will cover other strokes. You can, however, switch the method for the variant that you design. For example, you can save a Cover method variant of the Felt Pens. To see the method for a specific brush variant, such as a Square Soft Pastel, open the Brush Controls palette's General section by choosing Window, Brush Controls, Show General.

The Gritty Charcoal variant of Charcoal was applied using various Subcategory settings: the anti-aliased default Grainy Hard Cover (top); the pixelated Grainy Edge Flat Cover (middle); and the soft-edged Soft Cover (bottom).

Strokes painted with a default Square Hard Pastel that uses a Grain setting of 10% (left), and with the grain reduced to 6% (right).

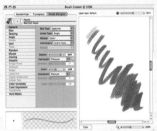

You will find the Dab Type, Stroke Type, Method, and Subcategory in the General section of the Stroke Designer in the Brush Creator (and in the General section of the Brush Controls).

SUBCATEGORIES

While each method gives a radically different effect to a brush, the *subcategories*, or submethods, make more subtle changes, affecting the edges of brush strokes. Subcategories that include the word *Flat* produce hard, aliased strokes with pixelated edges. Those that include the word *Hard* give smoother strokes. Strokes made using *Soft* subcategories appear with feathered edges. Strokes with the word *Grainy* in their subcategory setting will be affected by the active paper texture. Strokes that contain the word *Edge* give a thicker, stickier look; *Variable* refers to strokes that are affected by tilt and direction.

Paper textures. "Grainy" brush methods will reveal the paper texture you've selected in the Paper Selector. Adjust the Grain slider on the Property Bar to vary the intensity of the grain revealed by your brushstrokes. For most of Painter's brushes, a lower Grain setting means that *less of the color will penetrate the grain*, so your strokes will look grainier.

DAB TYPES

In Painter, brushstrokes are built from *dabs*. Painter has 27 dab types (all located in the Dab Type menu); however, they fall into two general classifications: *dab-based* brushes (such as the brushes in earlier versions of Painter) and brushes created with *continuous-stroke* dab types. The main difference lies in how brushstrokes are created from the dabs as described in "Dab-Based Brushes" and "Continuous-Stroke Brushes" on page 140. You can switch dab types by opening the Brush Creator (Ctrl/⌘-B), selecting the Stroke Designer, and in its General section, selecting a new dab from the Dab Type pop-up menu.

THE BRUSH CREATOR

When building new brushes, you'll spend most of your time using the Stroke Designer tab of the Brush Creator (described on pages 144–145). The Brush Creator offers useful features for customizing brushes, including the Transposer and Randomizer functions (described on pages 146–147).

BRUSH CONTROLS

The Painter 11 Brush Controls mirror the functions in the Stroke Designer section of the Brush Creator. To open it, choose Window, Brush Controls, General. Click a section name to open that section.

▶ General ⊠
▶ Size ⊠
▶ Spacing ⊠
▶ Angle ⊠
▶ Bristle ⊠
▶ Well ⊠
▶ Rake ⊠
▶ Random ⊠
▶ Mouse ⊠
▶ Cloning ⊠
▶ Impasto ⊠
▶ Image Hose ⊠
▶ Airbrush ⊠
▶ Water ⊠
▶ Liquid Ink ⊠
▶ Digital Watercolor ⊠
▶ Artists' Oils ⊠
▶ RealBristle ⊠
▶ Hard Media ⊠

The Brush Controls palette with sections closed

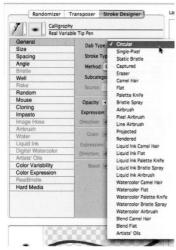

Choosing the Circular dab type in the General section of the Stroke Designer within the Brush Creator

Four examples of dab-based brushes. Top, from left to right: Round Soft Pastel 40 variant of Pastels (Circular), Square Hard Pastel 40 variant of Pastels (Captured). Bottom, from left to right: Spatter Water variant of Digital Watercolor (Circular) and Dry Ink variant of Sumi-e (Static Bristle).

Four examples of continuous-stroke-based brushes. Top, from left to right: Flat Oils 40 variant of Oils (Flat), Smeary Bristle Spray variant of Oils (Bristle Spray). Bottom, left to right: Texturizer-Variable variant of Impasto (Airbrush) and Pixel Spray variant of Airbrushes (Pixel Airbrush).

You can also access the Dab Type menu using the Brush Controls by choosing Window, Brush Controls, General.

DAB-BASED BRUSHES

For brushes that are *dab-based,* you can think of the dab as the footprint for the brush—a cross-section of its shape. The brush lays down a series of dabs of color to make a stroke. If the spacing is set tight, the stroke will appear to be a continuous mark. If the spacing is loose, the stroke will be a series of footprints with space between them. Here are some dab types useful for building brushes:

Circular. Many of Painter's brushes use this round dab type. Don't be fooled by the term *Circular*; even if you change a brush's Squeeze setting in the Angle section of the Brush Controls palette so that its footprint looks elliptical, it's still a Circular brush.

Single-Pixel. Just as it sounds, this is a 1-pixel-wide brush.

Static Bristle. Because Static Bristle brushes are made up of several "hairs," they have a rich potential. You can make adjustments in Bristle Thickness, Clumpiness and other settings in the Bristle section of the Stroke Designer tab in the Brush Creator.

Captured. You can capture any area of a document to act as the footprint for a Captured brush. Use the Rectangular Selection tool and draw a marquee (press the Shift key if you want to constrain the selection to a perfect square) around a mark or group of markings. With the Brush Creator open, choose Brush, Capture Dab; the brush footprint will appear in the Size section of the Brush Creator's Stroke Designer tab.

CONTINUOUS-STROKE BRUSHES

Brushes using *continuous-stroke* dab types produce smoother-edged, more responsive brushstrokes because these brushes render brushstrokes using a bundle of continuous, anti-aliased one-pixel lines. Because the stroke is composed of continuous lines instead of overlapping dabs, the brushes can produce smoother, more realistic brushstrokes than dab-based brushes can. Additionally, each brush hair has the capability to carry its own well of color. When a painter uses a traditional brush, the bristles often get contaminated by the colors of wet paint on the canvas. When the brush touches a neighboring color, it affects the paint along the edges of the new brushstroke.

Camel Hair. With Camel Hair dabs, you can build round brushes that paint brushstrokes with obvious bristle marks. Brushes using the Camel Hair dab type

Click on the brush footprint in the Size section's Preview window to switch the view between "hard" (showing the maximum and minimum sizes) and "soft" (showing bristles).

The Size section of the Stroke Designer (Brush Creator) palette showing a "soft" view of a Static Bristle dab used to create the Feathering Brush described on page 145. You can also preview the dab by choosing Window, Brush Controls, Size.

When you paint a stoke with a brush that has an airbrush-like conical spray (Airbrush, Pixel Airbrush or Line Airbrush dab type), you can tilt the stylus to apply paint more densely along the edge closest to the stylus. To switch the direction of the spray without changing the tilt of the stylus, hold down the Control-Alt/Option keys as you paint.

The Fine Spray variant of the Airbrushes is sensitive to the amount of tilt and to the bearing (which direction the stylus is leaning) and sprays conic sections—similar to a beam of light projected onto the canvas—just like a traditional airbrush. Holding the stylus upright sprays a smaller, denser area of color (top right). Tilting the stylus sprays color wider and farther (top left). And holding down Control-Alt/Option redirects the spray (bottom).

(the Round Camelhair variant of Oils, for example) are capable of painting very smoothly, and they can carry a different color on each brush hair.

Flat. Just as it sounds, a flat dab is used to create a flat-tipped brush. With brushes using the Flat dab type, you can paint wide or narrow strokes, depending on the way you hold and move the stylus. The Opaque Flat variant of Oils is an example.

Palette Knife. With Resaturation set low in the Well section of the Stroke Designer (Brush Creator), you can use brushes with Palette Knife dabs to scrape paint or move it around on the canvas. The Loaded Palette Knife and Smeary Palette Knife variants (Palette Knives) are examples.

Bristle Spray. With many brushes that use Bristle Spray dabs (such as the Opaque Bristle Spray variant of Oils), the bristles will spread out on one side of the brushstroke as you tilt the stylus.

Airbrush. Like Bristle Spray, Pixel Airbrush and Line Airbrush dab types, Airbrush dabs spray conic sections, and they "understand" Bearing (which direction the stylus is leaning) and Angle (amount of tilt). (See "Redirecting the Spray" on the left.)

Pixel Airbrush. Brushes using this dab type work like brushes using the Airbrush dab type. With the Pixel Airbrush dab type, however, the individual droplets *cannot* be adjusted using the Feature slider.

Line Airbrush. Brushes using the Line Airbrush dab type (for instance, the Furry Brush variant of F/X) spray a "fur" of lines instead of droplets.

Projected. The Projected dab-type brushes spray conic sections, similar to the Airbrush dab type, but without the responsiveness. For now, we recommend constructing brushes with the Airbrush and Pixel Airbrush dab types rather than a Projected dab type.

For brushes with Airbrush dab types, you can use the Feature slider in the Property Bar to control the size of droplets. With a higher Feature setting, Airbrush dabs spray larger droplets, like those shown on the right.

Several of Painter's Airbrushes—the Coarse Spray, the Fine Spray and the Graffiti variants, for example—allow media to pool when the stylus (or mouse) is held down in one position. In contrast, the Digital Airbrush and Inverted Pressure variants must be moved before they apply color to the image. To enable these two variants to apply color at the first touch, turn on Continuous Time Deposition in the Spacing section of the Stroke Designer (Window, Show Brush Creator), or the Brush Controls palette (Window, Brush Controls, Spacing).

We painted this Portrait Study *from life using the Grainy Wash Bristle, Runny Wash Bristle and Fine Camel variants of Watercolor.*

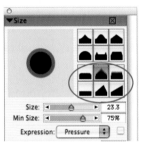

The six new Artists' Oils Brush Tip Profiles allow for expressive strokes, depending on how you hold your stylus.

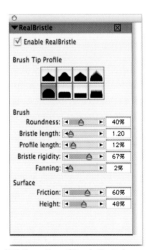

The RealBristle section of Brush Controls includes Tip Profiles and other settings that are useful for building RealBristle Brushes.

Rendered. In addition to painting with color, brushes built using Rendered dabs can contain a pattern or gradation as a Source. The Graphic Paintbrush variant of F/X is an example. To change the Source used by a Rendered dab brush, use the Source pop-up menu in the General section of Brush Controls (or Brush Creator).

Watercolor dab types. The five Watercolor dab types were created for painting on Watercolor media layers. These dabs are based on several of the rendered dab types discussed earlier—the Camel Hair, Flat, Palette Knife, Bristle Spray and Airbrush. For more information about working with Watercolor, turn to "A Painter Watercolor Primer" on page 82.

Liquid Ink dab types. Designed for painting on Liquid Ink media layers, there are five Liquid Ink dab types. They're based on several of the rendered dab types: the Camel Hair, Flat, Bristle Spray, Palette Knife and Airbrush. To read more about Liquid Ink, turn to "A Painter Liquid Ink Primer" on page 120.

Artists' Oils dab type. The Artists' Oils dab type is unique in that it's designed only for painting with the Artists' Oils medium. This dab type works in conjunction with the six new Artists' Oils Brush Tip Profiles (in the Size section) and Bearing (tilt direction) that is applied to the stylus, to vary the appearance of a stroke. To read more about the Artists' Oils, turn to "A Painter Artists' Oils Primer" and "Painting with the Artists' Oils" on pages 92–98.

Blend dab types. The two new Blend dab types, the Blend Camel Hair and Blend Flat, have a sensuous oily feel and allow you to incorporate Artists' Oils qualities into your custom brushes. The Blend dab types are used in many of the new RealBristle Brushes. To read more about the Blend dab types and the RealBristle Brushes, turn to "A Painter RealBristle Primer" and "Painting with the Real-Bristle Brushes" on pages 102–107.

STROKE TYPES

The *stroke* is the way a dab is applied over a distance. You can switch Stroke Types using the pop-up menu in the General section of the Stroke Designer (Brush Creator) or Brush Controls.

BRUSHES THAT SMEAR

Do you want a brush to pull and smear color? A low Resaturation and a high Bleed setting (in the Property Bar or the Well section of Brush Controls) will work with Brush Loading to allow the brush to smear pigment while applying it. Choose the Variable Flat variant of the Oils, and in the Well section, set Resat at 5% and Bleed at 80%. To see the colors mix, choose a new color in the Colors palette and drag the brush through existing color on your image.

SCRUBBING EXISTING COLOR

To make a brush that applies color when you use a light touch and scrubs underlying color when you use heavier pressure, choose the Fine Camel variant of Oils. Go to the Well section of the Stroke Designer, and set Resat low. Also, next to the Resaturation Expression pop-up menu, turn on the Invert box.

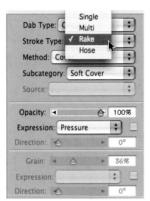

Choosing the Rake stroke type in the General section of the Stroke Designer (Brush Creator)

QUICKER CUSTOM BRUSHES

When you want to design and capture a brush, start by opening a variant that's close to the effect you want. That way you'll have fewer adjustments to make.

AN ANGLE ON CALLIGRAPHY

If you'd like to adjust the orientation of a Calligraphy pen for right- or left-handed work, open the Angle pane of the Stroke Designer within the Brush Creator. Drag the Angle slider to set the angle you want, and make a test stroke in the Preview window.

BRUSHSTROKES WITH DEPTH

Using Impasto, you can add brushstrokes that have 3D texture but that don't alter the color in the image—like painting with thick, clear varnish. Select any Impasto variant and in the Draw To pop-up menu in the Impasto section of the Stroke Designer tab of the Brush Creator, select Depth, or in the Brush Controls palette (Window, Brush Controls, Impasto).

Single. Just as it sounds, Single stroke-type brushes have only one stroke path. Because of this, they're fast. If you use a Static Bristle, a Camel Hair or a Flat dab type, you can create a fast Single stroke-type brush with a lot of complexity. Most Painter brushes incorporate the Single stroke type.

Multi. Painter's power-hungry Multi stroke-type brushes can paint sensitive multicolored strokes, but are the least spontaneous of the program's brushes. (The Continuous-Stroke brushes on pages 140–142 provide a much more responsive way to paint with multiple colors.) Try drawing a line with the Gloopy variant of the Impasto. Instead of a stroke, you'll see a dotted "preview" line that shows its path; the stroke appears a moment later. Multi brushes are built from several randomly distributed dabs that may or may not overlap. The Gloopy variant of Impasto is an example of a Multi-stroke brush in the Painter default brush library. But lovely, variable strokes can be made using custom Multi brushes. To spread the strokes of a Multi-stroke brush, increase the Jitter setting in the Random section of the Brush Creator's Stroke Designer tab.

Rake. The Rake stroke type is like a garden rake; each of the evenly spaced tines is a bristle of the brush. Painter gives you control over the bristles; for instance, you can make them overlap, which makes it possible to create wonderfully complex, functional brushes. And you can change the number of Bristles (keeping in mind that fewer bristles make faster brushes). In the Rake section of the Stroke Designer, you can also adjust the way the bristles interact. To try out an existing Rake brush, paint with the Van Gogh variant of the Artists brush.

Hose. The Hose stroke type sprays a variety of images when you paint each stroke. To read about painting with the Image Hose, turn to "Creating a Color-Adjustable Leaf Brush" on page 306.

BRUSH LOADING

Brush Loading enables a brush to carry a unique color in each brush hair. Many of Painter's brushes have this capability already built in to them—for instance, the Variable Round variant of the Oils. (When Brush Loading is built in to a brush, the Brush Loading check box is grayed out in the Well section of the Brush Controls.) To allow a static bristle brush (such as an Opaque Acrylic variant of the Acrylics) or a dab-based brush from an earlier version of Painter to use Brush Loading, open the Well section of the Brush Controls and turn on Brush Loading. With Static Bristle and earlier dab types, Brush Loading works in conjunction with the Resaturation and Bleed sliders in the Well section to allow the brush to paint with multiple colors.

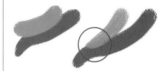

Overlaying paint with the Opaque Acrylic without Brush Loading (left) and with Brush Loading (right)

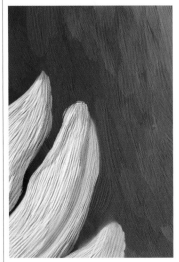

Painting thick Impasto brushstrokes with the custom Impasto brush

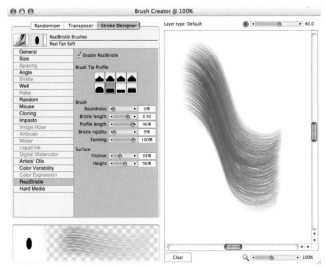

The Stroke Designer window of the Brush Creator. The RealBristle Brushes section is shown.

MAKING BRUSHES USING THE STROKE DESIGNER

For the custom brushes that follow, we used the Stroke Designer window of the Brush Creator. Open it by choosing Window, Show Brush Creator, or by pressing Ctrl/⌘-B and clicking the Stroke Designer tab.

For each of the custom brushes, we started with an existing Painter brush and radically modified it by making adjustments that affect brush behavior. After you've created the brush (and perhaps made further modifications on your own), you can save your variant. From the Brush Creator's Variant menu at the top of your screen, choose Save Variant to save the variant under a new name into the current palette. After saving your variant, restore the default settings for the Painter brush by selecting the variant you began with and choosing Restore Default Variant from the menu.

Try these brushes on images of 1000 pixels square or less. If you work with larger files, you'll want to proportionally increase the Size slider settings that we list here. When a Circular or Static Bristle dab type is used, you'll also want to optimize the Spacing and Min Spacing in the Stroke Designer's Spacing section to accommodate the larger size. If you have trouble setting exact numbers with the sliders, try typing the number into the field to the right of the slider. Press the Enter key to accept the number you've typed. And don't worry if nothing happens for a while when you try to paint: Painter is working away, building a very complex brush.

To make room for more brushes, we've shortened our descriptions of how to make the brushes. For instance, "*Well:* Resat, 80%" means, "In the Stroke Designer's Well section set Resaturation to 80% but leave all other sliders at their default settings." The palette sections you will use are found in the Stroke Designer. For a full description of the functions of the controls in each of the sections,

Brushstrokes made with the Wow Real Oils

Selecting a painted dab with the Rectangular Selection tool so that it can be captured

Brushstrokes made with the Soft Captured Oils Brush

Brushstrokes made with the Feathering Brush

Using the Camelhair Blender Brush to blend strokes made with the Captured Oils Brush

Brushstrokes made with the Wow Real Water brush

you can refer to Painter's *Online Help*, although painting with the brush after you make each adjustment will teach you a lot, too. **Caution:** Before starting a brush recipe, restore the default settings for the starting brush by choosing Variant, Restore Default Variant from the main menu above the Brush Creator.

Wow Real Oils. This RealBristle brush uses the Blend Camel Hair dab type. Its settings in the Artists' Oils section make it feel like a traditional round brush with soft, oily bristles.

Start with the default Real Oils Soft Wet variant of the RealBristle Brushes. *General:* Opacity Expression, Pressure. *Artists' Oils:* Amount, 76%; Viscosity, 68%; Blend, 20%; Clumpiness, 60%; Wetness, 100%. *RealBristle:* Friction, 31%.

Soft Captured Oils Brush. This captured dab type brush is built to feel like a soft brush with fine bristles. Begin by choosing the Coarse Spray variant of Airbrushes and black paint; then click once in your image to paint a dab. Choose the Captured Bristle variant of the Acrylics. *(Although this default brush is titled Captured Bristle, it has a Static Bristle dab type.)* Capture the painted dab by making an unconstrained selection using the Rectangular Selection tool and then choosing Capture Dab from the pop-up menu on the Brush Selector Bar and using the following settings. *Size:* Size, 38.0; Min Size, 30%; Size Expression, Pressure. *General:* Opacity, 26. *Spacing:* Spacing, 30; Min Spacing, 1.5. *Well:* Resaturation, 79; Bleed, 30. *Color Variability:* ±V, 3.

Feathering Brush. Created for feathering over existing color to add interest and texture, this Single-stroke, Bristle brush paints tapered strokes quickly. Increase pressure to widen the stroke.

Start with the default Captured Bristle variant of the Acrylics. *Size:* Size, 23.0; Min Size, 30%. *Size:* Size Expression, Pressure. *General:* Opacity, 9. *Spacing:* Spacing, 9. *Well:* Resaturation and Dryout, maximum; Bleed, 0. *Bristle:* Thickness, 40; Clumpiness, 0 (for smooth strokes); Hair Scale, 515%. *Color Variability:* ±H, 1; ±V, 2.

Camelhair Blender Brush. The *Well* section settings for this Single-stroke, Camelhair brush let you pick up existing color and blend with it. The brush hairs spread with more pressure, because Feature is set to Pressure in the Expression section.

Start with the default Round Camelhair variant of the Oils. *Size:* Size, 23; Min Size, 37%; Feature, 4.1; Feature Expression, Pressure. *Well:* Resaturation, 4%; Bleed, 96%.

Wow Real Water. This elliptical Watercolor brush has RealBristle performance and a watery feel. Its responsive bristles paint tapered strokes when you tilt your stylus.

Start with the default Wash Camel variant of Watercolor. *Water:* Wetness, 1000. Turn on Accurate Diffusion. *RealBristle:* Turn on Enable RealBristle; Brush Tip Profile, Pointed; Roundness, 31%; Bristle Length, 4.08.

To create a custom brush category icon from scratch, first select a square area of an image using the Rectangular Selection tool. From the Brush Selector Bar choose Capture Brush Category. Name your brush category and click OK. You'll see your selection appear in the Brush Selector Bar along with the variant that was active at the time you captured the category. You've just created an empty "variant holder," ready to be filled with your own custom variants.

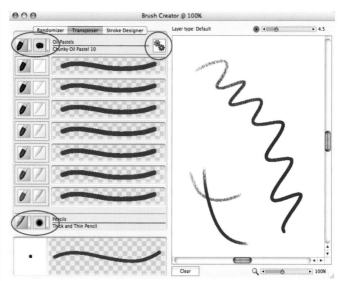

The Transposer window of the Brush Creator allows you to blend the components of two existing Painter brushes. Settings for the Oil Pastel Pencil are shown.

Brushstrokes made with the Oil Pastel Pencil

Brushstrokes made with the Grainy Charcoal

MAKING BRUSHES USING THE TRANSPOSER

The Transposer allows you to create a set of variations based on two brush variants that you choose. The Transposer has two Brush Selector bars, one at the top and one at the bottom of the window. In the illustration above, the Chunky Oil Pastel 10 is chosen in the *From* Brush Selector (top), and the Thick and Thin Pencil is chosen in the *To* Brush Selector (bottom). Painter will calculate new brush variations based on these two brushes when you click the Transpose Current Selection button (the Gears button). The variations that are nearest to the Chunky Oil Pastel 10 will be most like this original, and as you move down toward the Thick and Thin Pencil, the variations will begin to resemble the pencil. If you want a 50% blend between the two variants, click the center choice.

You can also continue to transpose variants by clicking on a brushstroke sample in the transposer window. This choice will be the next variant that will be transposed. For the three custom brushes that follow, we used the Transposer window of the Brush Creator. Open it by clicking the Transposer tab.

Oil Pastel Pencil. This pencil allows you to sketch while smearing color and revealing grain. In the Transposer's top category pop-up menu choose Oil Pastels, and in the variant pop-up menu choose Chunky Oil Pastel 10. In the Transposer's bottom category pop-up menu choose Pencils, and choose Thick and Thin Pencil as the variant. Next, click the Transpose Current Selection button (the Gears button) and then click the center choice. Save the variant by choosing Variant, Save Variant in the Brush Creator's menu at the top of the screen.

Grainy Charcoal. This charcoal allows you to softly sketch with Charcoal while revealing more grain. In the Transposer's top category

Brushstrokes made with the Wet Bristle Oils

Brushstrokes made with the Calligraphy 10 (top), and with one of the choices from the Randomizer (bottom)

pop-up menu choose Charcoal and also choose Charcoal for the variant. In the Transposer's bottom category pop-up menu choose Chalk, and choose Blunt Chalk 10 as the variant. Next, click the Transpose Current Selection button (the Gears button) and then click the center choice. Save the variant.

Wet Bristle Oils. This brush allows you to paint while subtly smearing color. In the Transposer's top category pop-up menu choose Acrylics, and choose Wet Soft Acrylic 20 as the variant. In the Transposer's bottom category pop-up menu choose Oils, and choose Bristle Oils 20 as the variant. Next, click the Transpose Current Selection button (the Gears button), and then click the center choice. Save the variant.

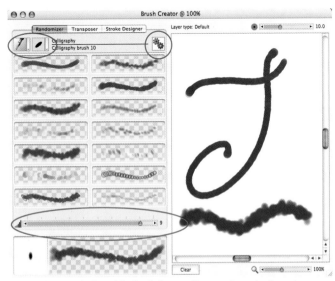

The Randomizer window of the Brush Creator allows you to randomly create variations of a brush. Variations of the Calligraphy Brush 10 are shown here.

MAKING BRUSHES USING THE RANDOMIZER

While it doesn't offer the control of the Stroke Designer or Transposer, the Randomizer is fun to use. It allows you to choose a brush (such as the Calligraphy brush 10 shown here) and have Painter randomly create 12 variations of the brush for you to choose from. To create your own randomization, click on the Randomizer tab of the Brush Creator, choose a brush and variant in its Brush Selector Bar and click on the Randomize Current Selection button (the Gears button on the right side of the Brush Selector bar). Painter automatically generates variations for the brush you have chosen. You can adjust the Amount of Randomization slider below the choices to make the randomizations more alike (lower settings) or more varied. If you want to create another set of variations, adjust the Amount of Randomization slider or choose another brush from the Brush Selector bar at the top of the window; then click the Randomize Current Selection button (the Gears button). 🖌

Painting in Pastel Using Custom Brushes

Overview *Build a palette of colors; make a drawing; add layers of color with custom Pastels; blend colors with custom Blenders brushes; add "scumbling" for texture and details to finish.*

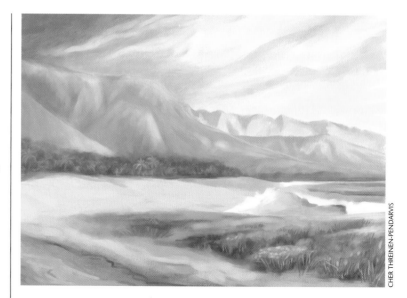

CHER THREINEN-PENDARVIS

Using the Mixer to create a palette of colors. The Mix Color tool is chosen.

Sketching in color with the Soft Pastel Pencil 3 variant of Pastels

INSPIRED BY THE SOFT LIGHT on a late afternoon, *Nani Waianae*, a pastel study of a favorite location on the west side of the island of Oahu in Hawaii, was painted using custom Pastels and Blenders variants. For inspiration, we referred to colored pencil sketches drawn on location. To achieve the soft atmosphere, we painted layers of color with modified Pastels variants, blended color using our Blenders brushes, and then added details and broken color to finish the painting.

1 Setting up. Choose a photo or a landscape sketch to use for reference. Open a new file. We started with a 14 x 10-inch file at 300 ppi. Set Brush Tracking for a more sensitive response when using your stylus. Choose Corel Painter 11, Preferences, Brush Tracking, make a representative brushstroke in the window, and click OK.

Next, use the Colors palette and Mixer (Window, Color Palettes) to create a palette of colors for your painting. We chose a range of earthy greens, browns and oranges, including a few more saturated hues of green, turquoise and purple. The Waianae Coast is on the leeward (western) shore of Oahu, and has a drier climate than some other areas of the island, hence the earthy palette. To apply paint to the Mixer, use the Brush tool in the Mixer to apply colors to the Mixer Pad. To blend colors, use the Mix Color tool. (Turn to page 27 in Chapter 2 for more information about using the Mixer.)

2 Making a drawing. Next, choose a color from the Colors palette or your Mixer palette. Click the Paper Selector icon (near the bottom of the Toolbox) and choose a medium-grained paper, such as Charcoal Paper. Select the Pastels category in the Brush Selector Bar, choose the Soft Pastel Pencil variant and begin sketching. To keep the freshness and energy of your sketch while you draw, don't get bogged down with details.

The Well section of Brush Controls with the settings for the Soft Smeary Pastel

Strokes painted with the Soft Smeary Pastel

Blocking in the sky using the custom Soft Smeary Pastel variant. Blending the clouds with the Grainy Water (Blenders).

The General section of Brush Controls with the settings for the Grainier Water

Blending the top of a pastel stroke using the new Grainier Water variant

3 Building a custom Pastel variant. When you've finished sketching your composition and you're ready to layer color in the underpainting, create a soft Pastel variant that will allow you to apply color and smear it as you vary pressure on your stylus. (So that you begin with the same settings discussed here, before beginning to build the brushes, choose Restore All Default Variants from the pop-up menu on the Brush Selector Bar.) Now, choose the Square Soft Pastel 30 variant of Pastels. In the Property Bar, lower its Opacity to 70%. Open the Well section of the Brush Controls (Window, Brush Controls, Well). Set Resaturation to 30%, Bleed to 75% and then check the Invert box next to the Expression pop-up menu. (Make sure that the Expression menu is set to Pressure.) A lower Resaturation setting, coupled with a high Bleed setting, allows you to blend color as you apply it. Enabling the Invert check box to the right of the Expression pop-up menu allows you to apply more color with lighter pressure and blend more with medium pressure. A lower opacity will allow you to build up color slowly, with more sensitivity. To save this custom brush, choose Save Variant from the pop-up menu on the right side of the Brush Selector Bar. Name your variant and click OK. (We named ours *Soft Smeary Pastel*.) The new name will appear in the Brush Selector Bar under the Pastels category. For good Painter housekeeping, it's a good idea to restore the original Square Soft Pastel to its default settings: Choose Restore Variant from the pop-up menu on the Brush Selector Bar while the Square Soft Pastel is chosen.

4 Blocking in color for an underpainting. With your custom pastel in hand, choose a color and begin laying in broad areas of color over your entire painting. At this point, don't focus on details, but paint larger shapes to establish values and the general color scheme. We adjusted our new variant's size and opacity as we worked, switching to a 50% opacity, for instance, when layering color or to show the warm light shining onto the hills.

Blending colors. To achieve a smooth look with traditional pastels, you rub them with precise blending tools such as a tortillion or a blending stump. Use the Just Add Water, Grainy Water and Smudge variants of the Blenders brush to mimic these traditional tools. A few hints about these blenders: The Just Add Water uses the Soft Cover subcategory and blends smoothly without texture; Grainy Water uses Grainy Flat Cover and blends showing a hint of texture; Smudge uses Grainy Hard Cover and reveals more texture as it blends color. Begin blending, and experiment with these brushes and various brush sizes while you work.

5 Building a custom Grainier Blender. We layered color using our new custom Pastel and other Pastels variants, and blended using the Grainy Water and Just Add Water variants of Blenders. We also wanted to blend while revealing more texture in certain areas than the default variants would allow, so we built a new

6a

The basic colors are blocked in over the entire painting to create a soft atmosphere.

6b

Defining the subtle shadows on the distant hills using the Artist Pastel Chalk

6c

Softening edges on the distant hills using the custom Grainier Water

7a

Brush strokes painted using the default Square Hard Pastel (left) and the custom Square Grainy Pastel (right)

custom blender based on the Grainy Water 30 variant. To build the new blender, choose the Grainy Water 30 variant of Blenders. Open the General section of Brush Controls and set the Subcategory pop-up menu to Grainy Edge Flat Cover, and then move the Grain slider to 15% (for less paint penetration). Save your new blender by choosing Variant, Save Variant from the pop-up menu on the Brush Selector Bar. Name your variant and click OK. (We named ours *Grainier Water*.) The new name will appear in the Brush Selector Bar under the Blenders category. To restore the Grainy Water 30 to its default settings, choose Restore Default Variant from the pop-up menu on the Brush Selector Bar.

6 Achieving a soft atmosphere. Select the Soft Smeary Pastel variant you created in step 3. Imagine soft afternoon light shining over your landscape, and apply light strokes over the hills in your painting. For aerial perspective (where the hills seem to recede into the distance), use lower contrast values and less saturated colors in the more distant areas. We added gold, warm green and blue strokes to the midground hills and lighter blues, soft purples and grays to the more distant hills. We alternated between using our new Soft Smeary Pastel and a default Square Soft Pastel, and covered most of the coastal hills with soft brushstrokes. We also used the Artist Pastel Chalk variant of Pastels to strengthen values in a few areas and to define edges in the midground and faraway hills. To soften a few of the edges on the most distant hills (where the hills met the sky), we used the new custom Grainier Water brush.

7 Making a Grainier Pastel for "scumbling." Artists using traditional media will often add more texture to a painting by brushing the side of the pastel lightly along the peaks of the rough art paper. This technique, called *scumbling*, causes colors to blend optically and adds texture. A few Pastel variants that ship with Painter are useful for scumbling: for instance, the Square Hard Pastels and the Round Hard Pastels. However, we wanted a new brush that would not penetrate into the paper grain, but instead would paint color only onto the peaks of the paper surface. To build this special grainy Pastel variant, begin with the Square Hard Pastel 40 variant of Pastels. In the Property Bar, set the Grain slider to 6% (to reduce grain penetration) and set Opacity to 100%. Save your new pastel by choosing Save Variant from the pop-up menu on the Brush Selector Bar, and name your variant. (We named ours *Square Grainy Pastel*.) The new name will appear under the Pastels category. To restore the original Hard Square Pastel 40 to its default settings, choose Restore Variant from the pop-up menu on the Brush Selector Bar.

To scumble electronically, select your new Square Grainy Pastel variant from the Brush Selector Bar and brush lightly using a contrasting color. We scumbled to add texture interest to the sky and to suggest sunlight on the hills, beach and path.

7b

Scumbling on the hills and sky using the custom Square Grainy Pastel variant

8

Adding definition to the palm trees and other foliage using the Artist Pastel Chalk and the Tapered Pastel brushes

9

The loosely painted foreground foliage and the scumbling on the path

8 Defining the midground. After scumbling, we added important details to the midground: for instance, we added more definition to the palm trees and other foliage, and defined the edges and shadows on the closer hills using the Artist Pastel Chalk. In keeping with our color palette, we painted with warm greens and browns and cooler blues. Then, we softened areas using a Grainy Water variant or our custom Grainier Water brush, depending on the amount of texture that was needed.

9 Painting final details and adding more texture. During the painting process, we had created an underpainting by blocking color over the entire image (step 4). Then, as we defined areas, we worked mostly from the background to the foreground. Before we began to paint the foreground, we chose the Tapered Pastel 10, and opened the Color Variability palette (Window, Color Palettes, Color Variability) and adjusted the Value (±V) to 5% so that the color would vary slightly as we painted. To sketch the foreground plants, we used an Artist Pastel Chalk and greenish-gold and rusty colors. Then we painted thin, slightly curved strokes for the grass using a Tapered Pastel. To enhance the path, we scumbled and painted brighter highlights onto the areas that were catching the sunlight by using our custom Square Grainy Pastel, and then we blended using the custom Grainier Water.

As a last step, we strengthened the small cliff on the nearest hilltop that towered above the trees. So that the hill would stand out more in the composition, we also painted deeper color onto the sky above the hill and repainted some areas of the clouds. 🖌

A CUSTOM PASTEL PAINTING PALETTE

So that you can have easy access to your new Pastel brushes, favorite default Pastels, Blenders and textures, it's a good idea to make a custom palette for them. Begin by choosing a Pastel variant in the Brush Selector Bar. Click on the variant thumbnail and drag it out of the Brush Selector Bar and onto your desktop. A new custom palette will appear. To enlarge it, grab its lower-right corner and drag it into a horizontal shape. Continue to choose variants, and drag and drop them into your new palette. To reposition an icon, press the Shift key and drag it to a new position. We organized our palette with larger pastels on the left and smaller variants in the center with a space in-between so that we could grab them quickly. To make our palette complete, we added favorite Blenders and paper textures. To add a texture, select it in the Paper Selector in the Toolbox and drag and drop it into your palette. To name your custom palette, choose Window, Custom Palette, Organizer, select its default name (Custom 1, etc.) and then click on Rename. Give your palette a name and click OK.

The custom Pastel painting palette with Pastels, Blenders and favorite paper textures. To view the name of an art material using Tool Tips, hover the cursor over its icon. To enlarge the palette drag the lower-right corner.

Digital Watercolor with Custom Brushes

Overview *Quick Clone a scan of a rough pencil sketch; refine the sketch with the 2B Pencil; build custom Digital Watercolor brushes; apply color washes using default and custom Digital Watercolor brushes.*

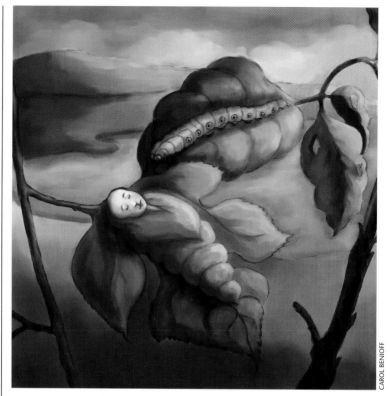

CAROL BENIOFF

1a

The final drawing that Benioff used as a guide for her Digital Watercolor painting

1b

Selecting New Color Set from Image in the Color Set palette pop-up menu

THE DIGITAL WATERCOLOR MEDIUM IN PAINTER ALLOWED Carol Benioff to build up rich tones and luminous colors in her illustration, *Pupa*. Benioff created six custom brushes that were based on the variants that ship with Painter. As she painted, she alternated between painting color washes with wet-into-wet paint and drying the wet paint. Then, she added more washes without disturbing the dried color underneath, just like glazing in conventional watercolor. Digital Watercolor offers the richness of watercolor, with more flexibility.

1 Preparing to work. Benioff began by scanning a rough pencil sketch, opening the scan in Painter and making a Quick Clone. (Quick Clone allows you to see the rough sketch underneath, like drawing on a light table.) To sketch as Benioff did, open a scanned drawing, choose File, Quick Clone and leave the original file open. Select the 2B Pencil variant of Pencils. Using the rough sketch as a guide, draw cleaner lines and reshape the forms in your drawing. Then, save the Quick Clone file with a new name in the RIFF format, which will preserve the Digital Watercolor wet paint that you will use in future stages.

After cleaning up her drawing, Benioff created a custom color set based on one of her conventional watercolor images. She opened a scan of the watercolor image; then she clicked on the right triangle on the Color Set palette to access the pop-up menu and chose

2a

Brush stroke samples of Benioff's custom Dry Grainy Brush variant

2b

Painting with the Dry Grainy Brush to build up the shadows on the face

3a

Strokes painted with the Glaze Brush. The circles show the overlapping areas.

3b

Detail of the Pupa face prior to applying a wash with her Glaze Brush

3c

Detail of the Pupa face after applying a wash with her Glaze Brush

New Color Set from Image. She chose Save Color Set from the palette menu, named her set and saved it in the same location as her new Painter file.

2 Building a Dry Grainy Brush. Next, Benioff built six custom brushes that were based on the default Digital Watercolor variants that ship with Painter. Two of them are described in detail here; four more are described in the tip that follows this story. (So that you begin with the same settings that Benioff did, before beginning to build the brushes, choose Restore All Default Variants from the pop-up menu on the Brush Selector Bar.)

Benioff built a brush that she named *Dry Grainy Brush*. She liked the softness of Soft Broad Brush, but wanted a thicker, bristly brush that would lay down a bit more paint and bleed into the underlying colors. Her Dry Grainy Brush puts down soft grainy washes of color with the bristle marks visible at the end of each stroke. To build the Dry Grainy Brush, choose the Soft Broad Brush variant of Digital Watercolor in the Brush Selector Bar and open the Brush Controls palette by choosing Window, Brush Controls, General. In the General section, change the Dab Type from Circular to Static Bristle (for the bristle look) and increase the Opacity from 4% to 39%. To make the brush look dry, decrease the amount of Grain to about 25%. The lower the percentage of Grain, the less the paint will penetrate the paper, revealing more paper texture. In the Size section of the Brush Control palette, increase the Size to 26. To keep the brush size constant, set the Expression pop-up menu to None. In the Digital Watercolor section of Brush Controls, set the Wet Fringe to 20% to help the color to pool at the edges of each stroke. (When using a brush with Wet Fringe settings, the preview of the wet paint strokes can change temporarily until you switch to a brush with a Wet Fringe setting below 10%.) In the Well section of the Brush Controls, reduce the Resaturation from 40% to 32% and in the Expression pop-up menu choose Pressure (leaving the Invert box disabled) so that the pressure you apply will affect how much color the brush applies. Next, increase the Bleed from 21% to 80% and set the Expression pop-up menu to Pressure. This will ensure that the brush will blend with the underlying color, depending on the pressure that you apply with each stroke. Save the variant by choosing Save Variant from the pop-up menu on the Brush Selector Bar.

3 Building a brush for glazing. Benioff frequently uses a custom *Glaze Brush* in her work, which is based on the Simple Water variant. She wanted a soft, even brush that painted smooth translucent washes, without grain. To build this brush, begin by choosing the Simple Water variant of Digital Watercolor in the Brush Selector Bar. In the Brush Controls, General section, reduce the Opacity to 1% and the Grain to 0. In the Size section, increase the Size to 32.2. The Spacing will need to be adjusted to accommodate the larger size. In the Spacing section of the Brush Controls, reduce the

4

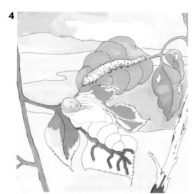

Blocking in the basic colors on the canvas

5a

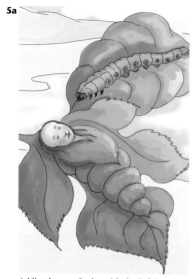

Adding layers of color with the Soft Broad Brush and Dry Grainy Brush

5b

Before Benioff blended the pencil lines (left) and after she blended the pencil lines with the Just Add Water brush (right)

Spacing to 13% and set the Minimum Spacing to 0.1. The tighter spacing will create a smoother stroke with no circular dab artifacts. In the Well section of Brush Controls, reduce the Resaturation to 5%. To ensure that this brush will *not* pick up any of the existing color, set the Bleed to 0%. Save the variant. Benioff continued to build the four other custom brush variants that she used in the piece. With all her brushes in hand, she was ready to paint.

4 Blocking in colors. For each new Painter session, you have to select the paper you have been using because Painter does not remember this setting. To paint as Benioff did, choose the French Watercolor Paper from Paper Selector in the Toolbox. Begin by painting broad, loose strokes that quickly cover the canvas. She used her new custom variants, the Dry Grainy Brush, Soft Wash Brush, Extra Fine Tip Water and the default variants Fine Tip Water and Gentle Wet Eraser to paint the first washes. (The Soft Wash Brush and Extra Fine Tip Water are described in the tip on page 155.) When you have completed your first washes, choose Dry Digital Watercolor from the Layers palette menu to prevent the subsequent layers of Digital Watercolor from mixing with the first washes.

5 Adding layers of color and tone. Benioff built up the color and tonalities of the pupa and caterpillar by painting washes using the Soft Broad Brush. Then, she used the Dry Grainy Brush to build up the shadow tones. Benioff painted the smaller details with the Extra Fine Tip Water brush. Then she dried the wet paint by choosing Dry Digital Watercolor from the Layers palette menu. To add more depth and richness to the shadows, Benioff painted thin washes of complementary colors using her Glaze Brush. Again, she dried the wet paint.

Benioff continued to build up the richness of her colors by painting smooth wash strokes with the Soft Broad Brush on the leaves and stems. When her brush strokes overlapped onto the dried paint on the pupa or caterpillar, Benioff used the Gentle Wet Eraser to remove the unwanted wet Digital Watercolor. She could easily erase the wet Digital Watercolor strokes with any of the *wet* erasers without disturbing the previously dried Digital Watercolor strokes. She painted with her custom variants Thick Clumpy Dry Brush and the Dry Grainy Brush in various sizes to deepen the tones and color of the leaf. She dried the paint on the leaf and then added thin washes using her Glaze Brush. Once again, she dried the watercolor to protect it from the next wet washes of paint. When the first leaf was completed and dried, Benioff repeated the same steps for the remaining leaves and stems. She continued this process until she was pleased with the varied tonalities and colors of the foreground. Then, she dried the entire image. At this point, Benioff felt that the pencil lines were too prominent, so to soften some of the lines and to integrate them into the image, she used the Just Add Water

5c

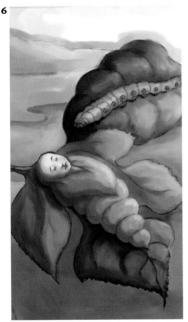

The painting on the foreground completed

6

Adding colored washes to the background

7

Detail of the pupa face and the caterpillar in the completed image

and the Grainy Water variants of the Blenders. She used soft, short strokes to blend the lines into the existing color.

6 Painting deeper color and tones on the background.

With the foreground completed and dried, Benioff started building up the color and tones on the background. She painted wide strokes with the Soft Broad Brush. Then, she continued to apply color with her Dry Grainy Brush, and Thick Clumpy Dry Brush. To clean up overlapping brush strokes on the completed dried foreground elements, she used the Gentle Wet Eraser. For the large areas of the water and sky, she used her Soft Wash Brush. To add color and depth to areas of the water, she painted washes with her Dry Grainy Brush with the Wet Fringe setting reduced to zero. This softened the edge of the stroke. To soften the edges in the background, Benioff used her Fine Tip Blender brush (which is described in the tip below). She dried the background wet layer, and then she added thin washes of complementary color using her Glaze Brush. When she was happy with the colors, she dried the entire image.

7 Glazing to add depth. In order to achieve the level of richness that she wanted, Benioff added thin washes of complementary color. As a last step, she added details with the Tapered Artist Chalk variant of Chalk: for instance, she painted a few small highlights on the caterpillar and the pupa.

MORE CUSTOM DIGITAL WATERCOLOR BRUSHES

For the four other custom brushes used in her *Pupa* illustration, Carol Benioff used the Brush Controls (Window, Brush Controls) to make changes to default Digital Watercolor brushes in Painter 11. Beginning with the Dry Brush variant of Digital Watercolor, she built the *Thick Clumpy Dry Brush (1)*, the

Brush strokes from the four custom brushes: 1. Thick Clumpy Dry Brush, 2. Soft Wash Brush, 3. Fine Tip Blender, 4. Extra Fine Tip

small size brush that is full of color, and shows both bristle marks and grain. The altered settings are as follows: General section: Expression, Pressure; Grain, 20%; Size section: Size, 23.6, Minimum Size, 58%; Bristle section: Thickness, 40%, Clumpiness, 65%; and Hair Scale; 468%. Next, Benioff created the *Soft Wash Brush (2),* which was based on the Broad Water Brush. A painting and blending brush that paints short broad strokes, the Soft Wash Brush will easily pick up the underlying wet colors. The setting changes for this brush are as follows: Size section: Minimum Size, 28%; Expression, Pressure; Digital Watercolor section: Diffusion, 5, Wet Fringe, 0; Well section: Resaturation, 20%; Spacing section: Spacing, 15%; and Minimum Spacing, 1.5. From the Fine Tip Water brush, Benioff built two custom brushes. She built the *Fine Tip Blender (3)* to paint long, thick-to-thin strokes (with grain) that easily blend with the underlying wet paint. The changed settings are General section: Grain, 79%; Size section: Size, 11.1; Well section: Resaturation, 8%; and Bleed, 90%. She built the *Extra Fine Tip Water (4)* to be a smaller and stiffer version of the Fine Tip Water brush. The changed settings are Size section: Size, 3.5, Minimum Size, 34%.

Sculpting a Portrait

Overview *Make a sketch; block in color with Chalk variants; build a custom Distortion brush; blend and sculpt the forms; refine the composition.*

RICHARD BIEVER

1

The sketch on a warm-toned paper color

2

Loosely blocking in mid-tone color

3

Sculpting the facial features

RICHARD BIEVER LOVES THE EXPRESSIVE FREEDOM he enjoys while working with Painter and a pressure-sensitive tablet and stylus—the natural brushstrokes, the sensitivity, the happy accidents of two colors blending together or a bit of canvas showing through. Biever's painting *The Parable,* a portrait of Jesus Christ, was painted using Painter's Chalk and custom Distortion variants.

1 Sketching on a colored ground. To begin the portrait with a warm tone, Biever began a new file (about 3000 x 3500 pixels) with a sand-colored paper color. He chose the Sharp Chalk variant of Chalk in the Brush Selector Bar, a dark neutral color in the Colors palette and Basic Paper in the Paper Selector. Using the Sharp Chalk, he sketched loosely, indicating the general position of the facial features and shape of the head.

2 Blocking in color and blending. Next, Biever blocked in the base tones using the Square Chalk variant (Chalk). Using the Size slider on the Property Bar, he enlarged the Square Chalk to make thicker strokes. Using broad strokes of color, he established the planes of the face and set the general tone of the painting and the angle and color of light on the face. (Biever wanted the feeling of natural sunlight, outdoors.) He worked from dark to light, roughing in general shapes using mid-toned color to sculpt the facial structure, letting his brushstrokes follow the direction of the forms. (He planned to add the highlights last.)

3 Blending and sculpting with a custom brush. Biever built a custom brush that is based on the Marbling Rake. This custom Marbling Rake gives an illusion of oil paint texture. To build his

4a

Roughing in the left hand

4b

The left hand and more canvas added

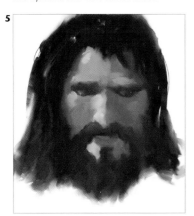

5

The completed face after the contrast was adjusted

brush, which paints a smoother stroke than the default Marbling Rake, reduce the Size and Opacity of the brush using the sliders in the Property Bar. For more smear, lower the Resaturation using the slider in the Well section of Brush Controls. Next, in the Rake section (Brush Controls), reduce the Brush Scale to between 75%–100%. Save your new variant and give it a name. You can lose the paper texture with the Rake, but through careful stroking Biever left bits and pieces of the canvas showing through. He continued to refine the face using the Large Chalk variant of Chalk, while mixing and pulling color with his custom Marbling Rake.

USING PAPER COLOR

Painter lets you specify Paper Color in the New dialog box (File, New) by clicking the Paper Color icon and choosing a color in the Colors window. You can change it midway through the painting process by selecting a color in the Colors palette and then choosing Canvas, Set Paper Color to apply the color. The color of the existing background doesn't change, but if you make a selection and delete an area of the image or choose an Erasers variant (Bleaches don't work) and erase an area of the image, the new color appears.

4 Painting the hands and emphasizing the face. To emphasize the telling of a story, Biever roughed in the hand on the left. To balance the composition and give the picture more room, he added to the canvas using Canvas, Canvas Size. After he had rendered the right hand also, he selected them using the Lasso tool, floated them (Select, Float) and repositioned them using the Layer Adjuster tool. Then, he dropped the layer by choosing Drop from the Layer Commands menu on the bottom of the Layers palette. (To learn about using selections and layers, turn to Chapters 5 and 6.)

Using lighter colors, Biever brought out highlights in the face and hands using small Chalk variants. To emphasize the face even more, he painted over the tunic with the Large Chalk and lighter color, again blending with the Marbling Rake.

5 Adding final details and more texture. To enhance the highlights and shadows in the portrait, Biever increased the contrast using Effects, Tonal Control, Brightness/Contrast.

Then for *more* atmosphere, he added a papyrus texture from an Art Beats CD-ROM, copying and pasting the texture into the file as a layer. Using the pop-up menu on the Layers palette, he set the Compositing Method to Soft Light. He blended the texture into the hair and beard, creating a dusty feel. To blend a texture into your painting, target the texture layer in the Layers palette; then click on the Layer Mask button. The new Layer Mask will appear in the Channels palette. Choose the Digital Airbrush (Airbrushes) and black color. Spray over the area of the image that you want to hide. (To read more about working with masks and layers, see Chapters 5 and 6.)

Painting with Acrylics

Overview *Use a sketch for a template and add base color; build custom brushes; model forms on a separate layer; enrich colors with glazing.*

The scan of rough sketch used as template.

Using a custom Color Set and Mixer palette to define the color palette

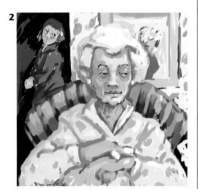

To block out the painting, Benioff used the Real Dry Flat and Real Wet Brush variants of Acrylics.

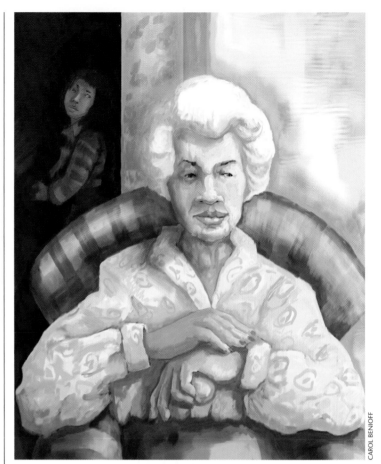

CAROL BENIOFF USED THE NEW REAL Acrylic brushes to quickly build form and color in her *Study of Nana.*

1 Setting up for the painting. Benioff began by drawing a rough pen-and-ink sketch and scanning it at 300 ppi. She opened the scan in Painter and copied and pasted it onto a new layer. Next, she created another new layer to hold her paint. (To add a layer to your image, choose Layers, New Layer.) Benioff named the layer Painting and set its Composite Method to Multiply in the Layers palette. Next, she opened one of her custom color sets. To open a color set, choose Window, Color Palettes, Color Set, Open Color Set; click on the right arrow of the Color Sets palette and choose Open Color Set.

2 Using the Real Acrylic brushes. Benioff started painting the figure with the Real Dry Flat variant of Acrylics. Using the sliders in the Property Bar, she varied Resaturation from 17% to 40% and the size of the brush from 3 to 25 pixels. To build up the background forms, Benioff used the Real Wet Brush variant of Acrylics varying the size from 5 to 30 pixels. As she painted, she picked up new

3

Beginning with the Real Dry Flat to make a custom brush that scumbles

4

Defining the form of the background figure using the Wet Detail Brush 5 and the Real Dry Flat Acrylic Brush.

mixtures of color from the image on the fly. (Press the Alt/Option key to switch from the brush to the Dropper tool.)

3 Customizing brushes. Benioff continued to work with a combination of Real Dry Flat and Real Wet Acrylics brush variants. To add small linear strokes, she used the Wet Detail Brush 5, reducing the brush size as needed. Benioff wanted a brush that could *scumble* (add more texture to a painting by brushing lightly along the peaks of the rough paper or canvas) and blend with short strokes, similar to the Real Dry Flat brush. Start with the Real Dry Flat brush and in the Property Bar, change the Opacity to 32%, Resaturation to 2%, and Bleed to 80%. Next, open the RealBristle palette (Window, Brush Controls, RealBristle) and use these settings: Bristle length, 2.08; Bristle rigidity, 100%; Fanning, 58%; Friction, 75% and Height, 38%. To save this variation, in the Brush Selector palette, click on the triangle on the top right and select Save Variant in the pop-up menu. Benioff named this brush variant Real Scumble Flat.

4 Defining the form of the background figure. Switching between the Real Dry Flat and her custom Real Scumble Flat and the Wet Detail Brush 5, Benioff built up the form with contrasting colors both in the highlights and shadows. She kept the painting lively with the push and pull of contrasting colors, strong lights and darks, and loosely painted strokes.

5 Glazing to add richness and depth. Benioff loves the depth and richness that happens with laying thin washes of translucent color over an existing painting. This technique, called *glazing,* is one that she has used in traditional mediums and in most of the work that she creates with Painter. The Acrylics brush category comes with its own built-in glazing variants called Glazing Acrylic. She used these variants in varying sizes up to 60 to glaze in the shadows, adding richness to the color and helping the shadows recede.

5a

The final painting before the translucent glazes of color were added

5b

The faces before Benioff began glazing the medium-toned and shadow areas.

5c

The multiple glazes of browns and blues can be seen in this detail.

Mixed Media Painting

Overview *Lay in background colors; build a custom Felt Pen; draw a sketch; create form and dimension with Felt Pens and the Artists' Oils; refine details with Felt Pens and Palette Knives.*

ANDREW JONES

The background is established.

Sketching the skull using a custom Felt Pen

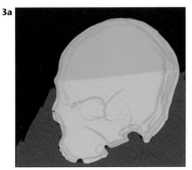

The base color for the skull is laid in.

WHEN PAINTING *SKULL*, ANDREW JONES PAINTED from direct observation. Working in Painter, he used a variety of tools, including Felt Pens, Artists' Oils brushes and Palette Knives.

Jones is passionate about drawing from observation and imagination. He has worked for Industrial Light and Magic, Black Isle Studios and is the Senior Concept Artist at Retro Studios. Jones created the concepts for Nintendo's Metroid Prime games.

1 Roughing in the background. Because Jones designs for the screen, he usually works with small file sizes, under 1500 pixels. Jones opened a new image. He chose a warm red and a cool green that would reflect interesting lighting onto the subject as he worked. Then he began to block in warm and cool background colors. He filled the Canvas with a dark green using the Paint Bucket. Next, he used the Lasso tool to quickly make a selection for the tabletop, and then he used the Paint Bucket to fill it with a rich rust color. (See Chapter 5, "Selections, Shapes and Masks" to read about selections.)

2 Sketching the skull with a custom Felt Pen. Next, Jones used a custom Felt Pen (that incorporated the Cover method) to sketch the outline of the skull and to suggest a few of its basic forms, including the eye sockets and cheek bones. To build his custom Felt Pen, he chose the Felt Pens category and the Medium Tip Felt Pens variant in the Brush Selector Bar. Choose Window, Brush Controls, General and change the Method to Cover and the Subcategory to Soft Cover. Now, open the Size section of Brush Controls,

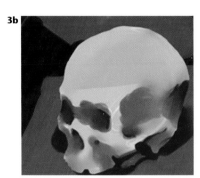
Roughing in the shadows

3b

Adding warmer color

4a

Beginning to refine the forms

4b

Painting deeper shadows and brighter highlights

4c

and in the Brush Tip Profile area, click on the Linear Profile, and then save your new variant by choosing Save Variant from the pop-up menu on the Brush Selector Bar. Give it a name such as Felt Pen Cover. To stay organized, it's a good idea to return the default Medium Tip Felt Pens to its original settings by choosing Restore Default Variant from the pop-up menu on the Brush Selector Bar.

Carefully observe your subject and use the Felt Pen Cover to sketch the basic shapes and forms. Jones drew around the outside of the skull loosely from one direction, and then he sketched again, this time starting from the other direction and drawing over his original lines. "It's like getting a second opinion of the forms," says Jones.

3 Laying in color and shadows. At this point, Jones added a new layer by clicking the New Layer button on the Layers palette. He set the layer to the Screen Compositing Method. Then, he chose a cream color in the Colors palette. He made a Lasso selection of the shape of the skull and laid a cream color into the area using the Paint Bucket. Then, he dropped the layer to the Canvas by choosing Drop from the pop-up menu on the Layers palette.

Next, Jones increased the Size and lowered the Opacity of the Felt Pen Cover to about 50%, using the sliders in the Property Bar. Using a medium umber-ochre color, he laid in the big shadow masses on his subject. When they were in place, he added lighter colors to the areas that were catching more light.

To apply glazes, Jones added a new layer. He set this layer to Multiply, and then, using a lower opacity Felt Pen, he gradually painted glazes of light and dark umber colors to build the dimension of the forms. Then he dropped the layer. At this point, he switched to the Artists' Oils category and used a variety of the Artists' Oils brushes (including the Wet Oily Palette Knife) to move and blend areas of paint and to add more color and tone. When you use an Artists' Oils brush, the entire Canvas is covered with oil, and this makes the paint on the Canvas very malleable. Jones used the blending capabilities of the Artists' Oils brushes to smooth and refine areas.

4 Refining the forms and adding details. Jones chose a darker value of the umber-ochre and, using a varied pressure on his stylus, he developed the deeper shadow areas using the Artists' Oils and his custom Felt Pen. Then, using a light cream color, he added the brightest highlights to the top of the skull, its brow and a few other areas. Jones also refined the reflected light that was bouncing from the table and wall onto the subject.

As a last step, Jones refined the details on the skull (for instance, the crevices above the brow and the indentations in the top of the head) using the Felt Marker Cover. To achieve harder edges (such as along the top of the brow), he switched to the Loaded Palette Knife variant of Palette Knives, and then he applied more color and tightened up edges.

Painting Rich Textures with Custom Brushes

Overview *Scan a traditional pencil sketch; modify brushes to include enhanced grain settings; paint rich color with varied textures using the Digital Watercolor and Chalk brushes.*

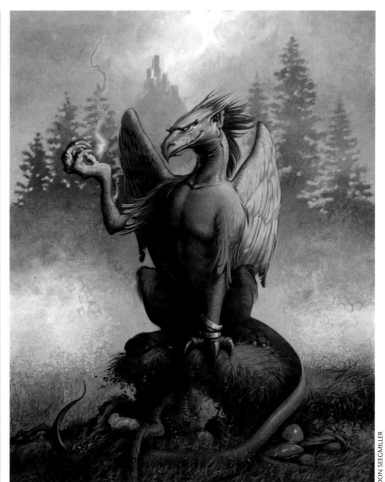

DON SEEGMILLER

1

The scanned pencil sketch

1b

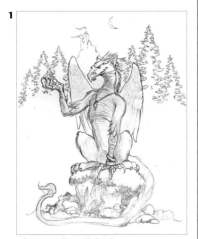

Using Equalize to give the sketch more contrast. The sliders are adjusted.

BY SKILLFULLY USING COLOR WHILE PAINTING with several brushes and textures, Don Seegmiller created a mysterious atmosphere for *Griffin,* which began as a book cover sketch that he had developed for *The Oathbound Wizard.* He developed a rich layering of textures, which he applied, using brushes that included enhanced grain settings.

Seegmiller, whose traditional oil paintings can be found in both private and public collections, has worked as an art director for innovative gaming development companies. He also teaches illustration at Brigham Young University.

1 Sketching, scanning and equalizing. Seegmiller began by sketching with conventional pencil on paper. He scanned the pencil drawing at 300 ppi, a resolution suitable for offset printing. Because he likes working with a high-contrast version of the sketch, he removed the grays from the scan. To increase the contrast in your sketch, as Seegmiller did, choose Effects, Tonal Control, Equalize. When the Equalize dialog box appears, move the black point marker

Opacity: 48% Grain: 100% Diffusion: 0

A close up of the texture that is revealed when using the New Simple Water brush and the Grain setting in the Property Bar

2b

The first washes are laid in on the background. Starting to brush color onto the figure.

3a

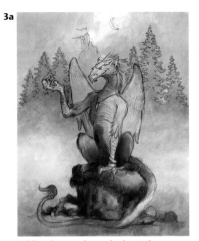

Adding deeper value and color to the illustration by applying thin glazes

and the white point marker under the histogram closer together to eliminate the gray tones. Move them right or left to affect the line thickness and quality. You'll be able to preview the adjustment in your image before you click OK to accept.

CHALK, DIGITAL WATERCOLOR AND PAPER GRAIN

The Grain setting in the Property Bar describes *grain penetration*. With most of Painter's grain-sensitive brushes (such as the Chalk brushes), the lower the Grain setting, the "grainier" your strokes will look. A lower Grain setting allows less of the color to penetrate into the valleys of the grain, and the paint hits only the "peaks" of the paper surface. However, with Digital Watercolor, the controls are reversed. A *higher* setting will reveal more Grain.

2 Painting the first washes. Prior to painting with color, Seegmiller made a quick duplicate of his sketch to preserve the original. Choose Select, All, and then copy and paste the sketch back into your file. Now change the composite method of the newly pasted layer to Gel, so that all of the white in the image becomes transparent, leaving the drawing to use as a guide later, if you need it. Seegmiller used a custom texture that is similar to the Pavement texture from the Painter 6 library in the Extras, Paper Textures folder on the Painter 11 CD-ROM. Copy the Painter 6 Textures library to the Painter application folder on your computer. To load the Pavement texture, open the Papers palette (Windows, Library Palettes, Papers) in the pop-up menu, select Open Library, navigate to the Painter 11 application folder and select Painter 6 Textures.

Next, he used the New Simple Water variant of Digital Watercolor to lay in light washes onto the background. Seegmiller likes the New Simple Water brush because of the way that it interacts with the paper texture. To paint as Seegmiller did, from the Brush Selector Bar choose the New Simple Water variant of Digital Watercolor and a light color in the Colors palette. Begin by painting light values of color on the background. When the background is as you like it, dry the wet Digital Watercolor paint so that subsequent strokes do not mix with the existing paint on the Canvas. Choose Dry Digital Watercolor from the pop-up menu on the Layers palette.

When the background was laid in, Seegmiller began to add color to his character. As he worked, he varied the look of the textures by changing the scale using the Paper Scale slider in the Papers palette. To open the Papers palette, choose Window, Library Palettes, Show Papers. He continued to build up thin layers of color over the entire image. Part of the beauty of using Digital Watercolor is its capability to slowly build up rich areas of color with great textural effects.

3 Building up thin glazes of color. Seegmiller gradually painted three glaze layers of Digital Watercolor and dried the washes between each application of paint. The washes are subtle applications of digital paint, similar to the glazes that you would apply with traditional watercolor.

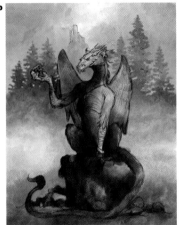

3b

Applying final Digital Watercolor washes

4

The trees with sketch and Digital Watercolor (left) and with the Variable Chalk brush work (right)

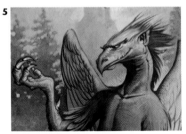

5

Defining the Griffin's forms

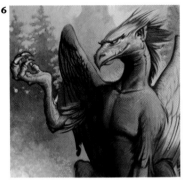

6

The darker wing on the Griffin helps to bring the hand forward

As Seegmiller finished his last Digital Watercolor washes, he added richer, darker colors where he wanted more contrast. Notice that there is still a lot of texture visible throughout the image. When the washes were complete, again, he dried this final watercolor glaze. He painted the next stage using a different brush.

4 Painting with a grainy chalk. At this point, Seegmiller wanted to cover areas of the original sketch and achieve a more painterly feeling—so he switched to a favorite brush—the Variable Chalk variant of Chalk and he chose Basic Paper in the Paper Selector in the Toolbox. Now, set the Grain very low in the Property Bar: Move the Grain slider to about 8% to allow the Chalk to reveal more grain. (Seegmiller used varied Grain settings between 9%–17% when using the Chalk.) To keep your chalk strokes separate from your Digital Watercolor, make a new layer by clicking the New Layer button on the Layers palette and begin to paint with the Variable Chalk. Seegmiller painted over the background trees, leaving only hints of the sketch. Then, he began to develop the foreground texture and details using the Variable Chalk, changing the size and opacity of the brush as he worked.

5 Adding definition with a custom brush. Next, to add more definition and form to the Griffin, Seegmiller switched brushes again, this time to *Don's Brush*, a custom variant that he had created. He worked from dark to light and, for the most part, across the form. His brush has a fairly low opacity setting of about 30%.

For information about building a brush that is similar to Seegmiller's, see the custom Soft Captured Oil Brush that is described on page 151. Seegmiller's brush has some similar qualities, but he uses the Grainy Soft Cover or the Grainy Hard Cover Subcategory in the General section of Brush Controls. *Don's Brush* can be found on the *Painter 11 Wow!* CD-ROM in the Don Seegmiller folder.

6 Darkening the shaded wing. The shadow side of the character's right wing was too light, so he wanted to darken it by duplicating a portion of the chalk layer. To use his method, select the area of the layer that you want using the Lasso tool, copy the selection and then paste the selection back over the same areas using Edit, Paste in Place (Shift-Ctrl/⌘-V). Then change the Composite Method to Multiply in the Layers palette. The Multiply method can make the area very dark,

The grass blades and toadstools are added.

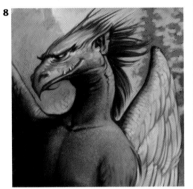

The reptile skin texture on the chest

Painting rich textures on the foliage and midground

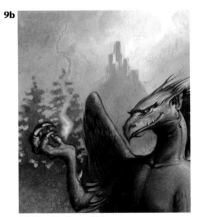

Making the flame flicker

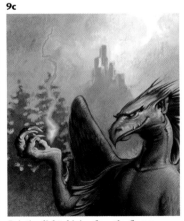

Painting light shining from the flame

but you can adjust the Opacity slider to get the effect that you want. Next, Seegmiller cleaned up the edges of this new layer with an Eraser variant. He saved his image and combined the two layers into one. To merge the layers, Shift-select their names in the Layers palette, group the two layers (Ctrl/⌘-G) and then collapse them together by choosing Collapse from the Layer Commands menu on the Layers palette. After collapsing the layers, he saved a new version of his image using Iterative Save. It is not uncommon for Seegmiller to have as many as 50 saved versions when a project is complete.

7 Adding elements to the character and foreground. He continued to work on the foreground. Although it's not a good idea to try to paint every blade of grass, sometimes there is no other way to get a realistic look. Using your stylus and *Don's Brush*, quickly paint a number of blades of grass in the foreground. Vary the direction of the blades of grass to create a random, natural look. At this point, Seegmiller also painted the red toadstools.

8 Painting the reptile skin on a layer. Next, he added another new layer so that he could work freely as he painted the skin. This method is more flexible than carefully painting textured strokes around elements, such as the feathers on the arms, because he could easily touch up areas or erase on the layer without disturbing the underlying paint. Switching to a custom paper texture that he had created to imitate reptile skin, he used the Variable Chalk to add texture to the torso and legs of the Griffin on the new layer. When the skin textures were laid in, they looked too harsh, so he softened them slightly by applying Effects, Focus, Soften to the layer, using subtle settings.

9 Painting details, texture and the flame. Next, Seegmiller added small bits of texture to the foreground foliage. He continued to work from dark to light as he refined the highlights on the grassy areas. He also used the Variable Chalk to paint a subtle crescent moon in the lightest sky area. Seegmiller added another new layer and painted the flame above his character's paw. Then, he used the Turbulence variant of the Distortion brush to add a flickering look to the flame. He painted the lighting on the paw of the figure, and he added light to the deep shadow areas that were catching the light from the flame. He added all of his final detail work on the new layer to make the corrections easy. 🖌

Painting with Pastel and Oils

Overview *Create a sketch with a custom Pencils variant; block in color using a custom Artist Pastel Chalk; blend and pull color with the New Totally Oils Brush from the* Painter 11 Wow! *CD-ROM.*

1

Orlando's pencil drawing

2a

Creating color activity while painting the water

DENNIS ORLANDO

INSPIRED BY NATURE'S DESIGN—spectacular driftwood on a beach with a restless tropical sea—artist Dennis Orlando created a dynamic composition. In *Barbados Driftwood*, the strong intersecting diagonal and vertical thrusts lead the viewer's eye to follow the composition around the image. Orlando's sensitivity to light and shadow all combine to give the composition its power.

1 Sketching with a custom Pencil. Orlando set up a new 11 x 15-inch document with a resolution of 300 ppi and a white Paper Color. He modified a Pencils variant and used it to create a drawing. To create his custom variant, select the Thick and Thin Pencil variant of Pencils. (So that you begin with the same settings that Orlando used, choose Restore All Default Variants from the pop-up menu on the Brush Selector Bar before beginning to build the brushes.) Next, open the Brush Controls (Window, Brush Controls). In the General section, change Method to Cover and Subcategory to Grainy Soft Cover. Save your new variant by choosing Save

2b

Laying in color using the Pastel variant

3

The in-progress pastel image

4

Brush Libraries

11 Wow! Oils
Painter Brushes

[Import...] [Cancel] [Load]

Choosing the 11 Wow! Oils library from the Brush Libraries dialog box

5a

Blending and pulling paint using the New Totally Oils brush

Variant from the pop-up menu on the Brush Selector Bar, and give it a descriptive name, such as *Soft Cover Pencil*. After saving your custom variant, return the original Thick and Thin Pencil to its default setting by choosing Restore Default Variant from the pop-up menu on the Brush Selector Bar. Switch back to your new Soft Cover Pencil and select the Artists' Canvas texture in the Papers Selector. Choose a color in the Colors palette (Orlando started with a dark gray) and begin sketching.

2 Underpainting with a custom Pastel. To define the shapes in his composition, Orlando roughed in the water and beach with a favorite custom Pastel. Select the Artist Pastel Chalk variant of the Pastels brush. To build his Pastel, change the Subcategory in the General section to Grainy Soft Cover—this gives softer brushstrokes than Grainy Hard Cover. Save the custom Soft Grainy Pastel by choosing Save Variant from the menu on the Brush Selector Bar.

One of Orlando's trademarks is activity in the color, achieved by adjusting the Color Variability settings for certain brushes. To re-create the active color look in the water, start with the same Pastels brush that you created for the beach. Choose a blue-green and then open the Color Variability section by choosing Window, Color Palettes, Color Variability. Adjust the Color Variability sliders as follows: set Hue (±H) to 13%, Saturation (±S) to 3% and Value (±V) to 6%. On the Brush Selector Bar, choose Variant, Save Variant, enter a descriptive name and click OK. Begin painting. Orlando painted a creamy tan on larger areas of the beach and around the edges of the wood. He changed to a smaller brush size when working close to the driftwood to preserve its shapes.

3 Establishing values and adding details. Use a smaller version of the same Pastel brush to rough in color and value details on the driftwood. Keep the same Color Variability settings. Orlando used blue-gray colors to paint the dark, recessed areas inside the driftwood, and he used lighter values of a warm, creamy color to paint the sunlit areas on the wood.

4 Loading a new brush library. To get a look similar to pushing conventional oils around on a canvas, Orlando used the *New Totally Oils Brush* from the 11 Wow! Oils library located on the *Painter 11 Wow!* CD-ROM. (This brush was inspired by a brush that shipped with an early version of Painter, the Total Oils.) To load the brushes, locate the 11 Wow! Oils folder. The folder contains a category folder and a category JPEG. Copy the folder with its contents to the Brushes folder within the Painter application folder. From the pop-up menu on the Brush Selector Bar, choose Load Brush Library. The new library will appear in the Brush Selector Bar.

5 Simulating traditional oils. Choose the New Totally Oils Brush. **A word of caution:** The New Totally Oils Brush incorporates the Drip method (in the General section of Brush Controls),

5b

Finessing the highlights and shadows on the wood

5c

Painting the reflected light on the wood using the New Totally Oils Brush

which allows the moving of paint. As of this writing, brushes that employ the Liquid method work best on the Canvas and may have problems when painting on layers. Orlando created his entire painting on the Canvas without the use of layers, as he might have done with traditional materials. As he painted, he varied his brush size slightly. With the Dropper tool, sample a color from the area you want to paint, or hold down the Alt/Option key while using a brush to temporarily switch to the Dropper tool.

To maintain the modulated color of the underpainting, give the New Totally Oils Brush the same Color Variability settings that were described in step 3. Save this variant by choosing Save Variant from the Brush Selector Bar, giving it a descriptive name.

Use this brush and short strokes to pull color from one area of your painting into another. Orlando switched between this brush and his custom Pastel (described in step 2) to work over the entire surface of the painting, including the shadow areas on the sand and the modeling on the wood. He painted the reflected light on the wood by sampling color from the water and painting into some of the mid-tone areas using the New Totally Oils Brush.

6 Defining the details. So that the arms of the driftwood stood out from the sky and water, Orlando used a small default Artist Pastel Chalk to define the surface edges on the driftwood and to add more color details to the wood and to the beach.

7 Softening the horizon and water. The Grainy Water variant of the Blenders brush is useful for blending and softening areas if you want to preserve some of the paper texture as you blend. Orlando used the brush to soften the horizon, making it appear to recede into the distance. He dabbed this brush on the water, using short, curved strokes to suggest a stormy, restless sea. He was careful to preserve the modulated color in the water as he worked. 🖌

6

7

Defining a few edges on the driftwood using a small default Artist Pastel Chalk

Softening the horizon and water with the Grainy Water variant of Blenders. The delicate shading and reflected light is also visible in this detail.

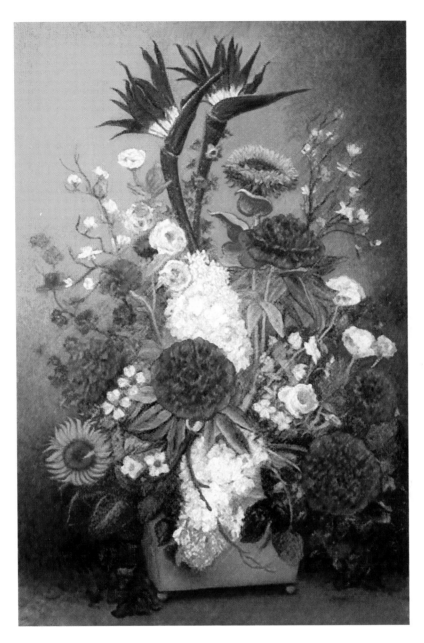

■ **Dennis Orlando** is well known for his Impressionist-style landscape and still-life paintings. To create the vibrant look of pastel in *Flowers Pastel*, he layered color using the Artist Pastel Chalk variant of Pastels.

Orlando chose the Artists Canvas texture from the Paper Selector in the Toolbox. Using a palette of luminous colors, he roughed out a study for the composition using Chalk and Pastels variants, and then

he layered more color. Switching back and forth between the Artist Pastel Chalk and the Grainy Water variant of Blenders, he continued to add color and smudge it. To help to modulate color, Orlando increased Color Variability for the Artist Pastel Chalk variant, moving the ±H (hue) slider to about 10% in the Color Variability palette. His use of enhanced Color Variability is most easily seen in the foreground tabletop

and on the vase. To build rich texture, he used a Large Chalk variant of Chalk and a light pressure on the stylus. This scumbled texture is most noticeable in the foreground and on the upper portion of the bird-of-paradise flowers. Finally, Orlando used a tiny Grainy Water variant of Blenders to blend and finesse the highlights on the flowers and leaves.

■ An award-winning cartoonist whose work has been published in *Newsweek, The New York Times, The Washington Post, USA Today, The Chicago Tribune* and the *Houston Chronicle*, **Nick Anderson** is the recipient of the 2005 Pulitzer Prize for editorial cartooning.

Anderson began the cartoons on these pages by drawing a rough sketch on traditional tracing paper. Then, working in Photoshop and using a Cintiq display, he sketched the black-and-white line drawings. After completing the drawings, he saved each one for opening in Painter and then used a variety of Painter brushes to add color and texture. Anderson isolates elements in his images by creating selections that he saves as alpha channel masks.

For more information about his masking process, see page 200.

Anderson describes his primary inspirations for *Mortgage Rescue:* "After months on end of bad news about the rising foreclosure rates and their potential threat to the economy, our leaders in Washington, D.C. finally resolved to do something about it. Unfortunately, a lot of damage to the economy and to real families had already occurred. I set out to come up with a visual representation of emergency workers arriving late to the scene." For most of the coloring of the *Mortgage Rescue* cartoon, Anderson used a custom version of the Flat Water Blender variant of Digital Watercolor that included a decreased Diffusion setting and an increased Wet Fringe setting in

the Property Bar. For example, he set Diffusion to 0 and Wet Fringe to 60. Anderson worked, carefully building the color and values from light to dark. He used a variety of papers and changed them on the fly as he worked, using the Paper Selector in the Toolbox. After laying in the basic colors, Anderson added random textures using the Variable Spatter Airbrush variant of Airbrushes. To complete his cartoon, he used the Spatter Water variant of Digital Watercolor to paint the larger spatters. For crisper edges on the spatter droplets, he increased the brush's Wet Fringe by using the slider in the Property Bar. Then, to achieve looser splatters, he opened the Brush Controls by choosing Window, Brush Controls, Random, and in the Random section, he increased the Jitter setting to his taste.

■ For the editorial cartoon **Credit Boarding**, **Nick Anderson** was inspired by current events. "Banks get consumers to sign up for credit cards, and then change the terms to more punishing interest rates and exorbitant late fees. Since the controversy over the United States' interrogating terror suspects with waterboarding was also in the news at the time, I did a topical 'mashup' of images to represent the 'torturous' credit card terms unwitting consumers were subjected to," says Anderson.

For most of the coloring of *Credit Boarding*, Anderson used a custom version of the Flat Water Blender variant of Digital Watercolor that included reduced Diffusion and increased Wet Fringe. Anderson likes the versatility of the Flat Water Blender and appreciates the ease of adjusting its basic settings in the Property Bar.

In the Property Bar, he set Diffusion to 0 and Wet Fringe to 100%. After adjusting the brush, he built the color and values from light to dark, also varying the Opacity and Grain settings in the Property Bar as he worked. When he wanted a softer edge to the strokes, he reduced the Wet Fringe 0–10%. After laying in the basic colors, Anderson added a new layer and used the Square Chalk variant of Chalk to paint highlights over the painted color. To add more depth to the colored background, he used the Dry Camel variant of Watercolor, adding this new paint on a separate Watercolor layer, so he that could easily erase anything that overlapped and then reduce its opacity, if necessary. Finally, Anderson used a small Square Chalk to add a few white highlights on the credit card and the background.

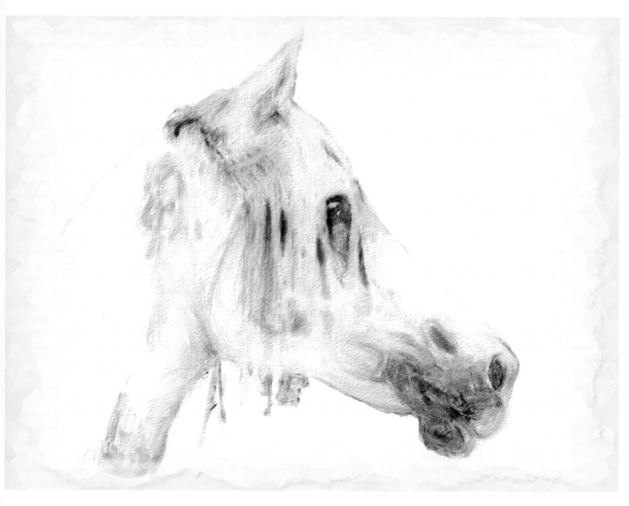

■ Artist **Terrie LaBarbera** painted *Nimbus Portrait.* Her painting was inspired by a photograph of the Arabian mare Nimbus that was taken by Lark Baum. LaBarbera began the painting by choosing Italian Watercolor Paper in the Paper Selector. She opened the photo in Painter and created a clone copy (File, Quick Clone). Then, she added a new layer for her sketch by clicking the New Layer button on the Layers palette, and drew a tight black-and-white sketch using a custom Cover Pencil variant with soft edges.

LaBarbera built several custom Digital Watercolor brushes that she used as cloning brushes so that she could paint using color from the photograph. Her *DWC*

Wet Soft and *DWC Wet Large* brushes are described here. To build the DWC Wet Soft brush, LaBarbera began by choosing the Simple Water variant of Digital Watercolor in the Brush Selector Bar. To begin, she enabled the Clone Color button on the Colors palette. In the General section, she changed the Dab Type pop-up menu from Circular to Static Bristle, and then reduced the Opacity to 5%. In the Size section of Brush Controls, she set Size to 20 and Min Size to 23%. In the Bristle section, she set Thickness to 50%, Clumpiness to 50% (for a smooth look), Hair Scale to 200% (for finer bristles) and Scale/Size to 0%. In the Well section, she set Resaturation to 100% and Bleed to 90%. Then, she saved the

variant. Next, she built the DWC Wet Large brush, a variation of the DWC Wet Soft. In the General section, she set the Opacity to 52%; in the Well section, she set Resaturation to 25%, leaving Bleed at 90% and then saved her new variant.

LaBarbera added another new layer to hold the first washes of colored paint. Then, she used the DWC Wet Soft brush to paint light washes over the entire image. For the detail on the horse's mane, jaw and lower face, she added another new layer, and then painted with the DWC Wet Large brush. She changed the sizes and opacity of her brushes as she worked.

■ When painting *Dying Orchids,* **Chelsea Sammel** used custom Impasto brushes to add the texture of brush marks with realistic highlights and shadows to her color study. She began by sketching in black-and white with the Colored Pencil variant of the Colored Pencils, over Basic Paper.

Next, she laid warm autumn colors—browns, burnt sienna, golds—and other rich hues directly over the sketch using the Round Camelhair variant of the Oils. Then Sammel added more interest and activity to the composition by adding textured brushstrokes that did not necessarily follow the lines of the colored paint. She modified the Loaded Palette Knife variant of Impasto so that it would paint with negative depth, but not color, and she made it smaller. In the Impasto section, she set the Draw To menu to Depth and the Depth slider to 35%, leaving other settings at their defaults: Smoothing at 77% and Plow at 100%. Then she saved the variant by choosing Save Variant from the Brush Creator's Variant menu, giving it a new name. Then, to preserve the original variant, she chose the original Loaded Palette Knife and restored its default settings by choosing Variant, Restore Default Variant.

When she wanted the new palette knife to paint with both color and depth, she modified it to pick up and smear underlying colors. To make this modification, she selected the new palette knife, and in the Impasto section of the Brush Controls, she set the Draw To menu back to Color and Depth. To pick up and mix underlying colors more, she clicked on the Well section bar to open the Well section and set Resat to 20%. She saved and named the new variant; then reselected the first modified palette knife.

Sammel used a small Loaded Palette Knife (Impasto) to drag color through the image (especially in the vase); then she added more colored paint using the Dry Ink variant of Sumi-e. To allow the Dry Ink to mix and pull colors on the canvas, she made changes to the Well controls using the Property Bar. She lowered the Resat (to about 20%) and raised the Bleed setting (to about 80%). Finally, she added spattery Impasto texture to the image foreground with the Texturizer-Fine variant of Impasto. Then Sammel brushed over areas that were too "impastoed" using the Depth Equalizer variant (Impasto) at a low opacity. She lowered the opacity using the Opacity slider in the Property Bar. Finally, she reduced the overall effect of the Impasto by choosing Canvas, Surface Lighting. To finish with a more subtle Impasto look, she reduced the Amount to 75%.

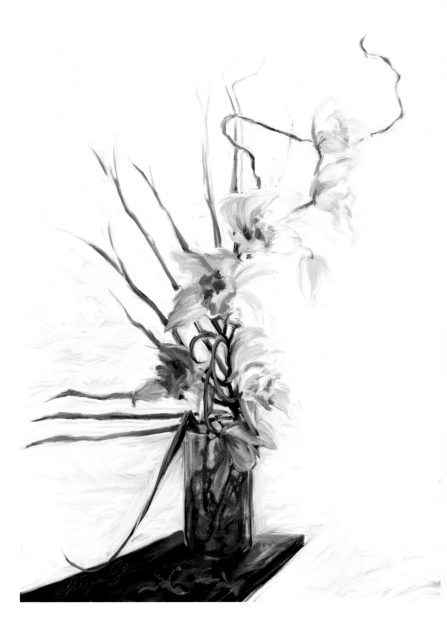

SELECTIONS, SHAPES AND MASKS

Artist Don Stewart painted Bus *for the Content Areas Readers Series published by Oxford University Press. He began the image by making a tight sketch in Painter using the Sharp Pencil variant of Pencils on Fine Hard Grain paper. Next, so that he could protect areas while he painted, he isolated the important elements in his sketch by making selections with the Lasso (for example, the girl's skin, hair and window), and saved them as masks in the Channels palette. To read more about Stewart's work, see "Using Hand-Drawn Selections" on page 189 and the gallery at the end of this chapter.*

INTRODUCTION

TO GET THE MOST FROM PAINTER, you need to invest some time in understanding how the program isolates portions of images so you can paint them, apply special effects, or otherwise change them without affecting the rest of the image. Much of the program's power is tucked into the complex area of *selections*, *shapes* and *masks*.

WHAT IS A SELECTION?

A *selection* is an area of the image that has been isolated so changes can be made to the contents only, or so the area can be protected from change. There are two kinds of selections in Painter: outline-based and pixel-based. Like a cookie cutter, an *outline-based* selection sharply defines the area it surrounds. But unlike cookie cutters in the real world, an outline-based selection border in Painter can be freely scaled or reshaped. Outline-based selections can be made by dragging with the Lasso tool (for free-hand selecting), the Rectangular Selection tool or the Oval Selection tool.

If Painter's outline-based selections are like the outlines produced by cookie cutters, then *pixel-based* selections are more like painted resists. Pixel-based selections make the selected areas fully or *partially* available for change or copying, with the degree of availability determined by the nature and "thickness" of the "resist material." Pixel-based selections can be made by selecting based on the color or tone of pixels, rather than by an outline you draw. The Magic Wand tool makes pixel-based selections; they can also be made with the Auto Select and Color Select commands from the Select menu.

The perimeter of either kind of selection is indicated by an animated border, the selection marquee. A selection is temporary.

The selection tools are located near the top of the Toolbox. Some tools share a space in the Toolbox with other tools, as shown here in pop-out view. (The Rectangular Selection, Oval Selection, Lasso and Polygonal Selection Tool are shown popped out on the left; the Magic Wand is shown on the right.)

The shape-drawing tools are the Pen and Quick Curve (left), which share a Toolbox space, and the Rectangular Shape and Oval Shape (right), which also share a space.

If you choose Select, None (Ctrl/⌘-D) or accidentally click outside the selection marquee, the selection will be lost, unless you have stored it in the Selection Portfolio palette or saved it as a mask in the Channels palette or converted it to a shape. (The Selection Portfolio is described on page 177, the Channels palette is covered on page 185 and shapes are described next.)

WHAT IS A SHAPE?

A *shape* is similar in construction to an outline-based selection, but it has stroke and fill characteristics. (This chapter tells about how to draw shapes and how they are related to selections. The stroke and fill attributes of shapes, their layering capabilities and their relationship to layers, are covered in Chapter 6.) Shapes can be created with the Rectangular Shape, Oval Shape, Pen or Quick Curve tool. As soon as a shape is drawn, it is automatically stored in the Layers palette. (The Layers palette can be used to control how shapes are used in the image, as described in Chapter 6.)

Shapes can be used as independent elements in an illustration, or a shape can be converted to a selection and then used to isolate an area of the image. When you convert a shape to a selection (Shapes, Convert to Selection), its name disappears from the Layers palette and an animated selection marquee appears on the image. **Beware:** If you convert a shape to a selection, it will be permanently lost if you deselect it before you either convert it back to a shape, store the selection you made from it, or choose Edit, Undo (Ctrl/⌘-Z) or Select, Reselect (Ctrl/⌘-Shift-D).

WHAT IS A MASK?

Unlike a shape, which is stored *outline* information, a *mask* is stored *pixel-based* information. Masks can store 8-bit grayscale information, which means that complex image information such as a painting, a photo or a graphic can be saved and then loaded as a selection. Painter's 8-bit masks allow 256 levels of opacity. When a mask is

The Property Bar for each of the selection-drawing tools has buttons for access to the other selection-drawing tools. It also has a button for converting the current selection to a shape.

The Property Bar for each of the shape-drawing tools has buttons for access to the other shape-drawing tools. It also has a button for transforming the current shape to an outline-based selection. This button will work only if the shape is closed—that is, if it has no gaps.

This shape has been selected with the Shape Selection tool (shown chosen in the Toolbox) and shows its control points and handles.

loaded as a selection, in areas where the mask is black, the selection completely protects the pixels of the image from change; where the mask is white, the pixels are fully selected and exposed to brush-strokes; gray areas of the mask result in partially selected pixels. The protective mask can be "thinned" or even completely removed pix-el by pixel. Masks allow complex image information to be used as a selection. Another way to use a mask, besides loading it as a selec-tion, is to choose it when applying the functions in the Effects menu, such as Tonal Control, Adjust Colors and Surface Control, Apply Surface Texture. Masks also provide a way of permanent-ly storing selection information until you need to use it. The Chan-nels palette not only stores masks but also controls operations such as turning them on and off so they can be used as selections. (The Channels palette is described on page 183.)

CREATING OUTLINE-BASED SELECTIONS AND SHAPES

You can make an outline-based selection or a shape in a number of ways. One way, as mentioned earlier and described in more detail here, is to draw it with one of the selection or shape tools:

Rectangular and Oval Selection tools. Drag to make selec-tions with these tools. To constrain the Oval or Rectangular Selec-tion tools so they select perfect squares or circles, begin dragging and then hold down the Shift key to complete the drag.

Lasso tool. The Lasso tool is good for making quick, freehand selections. Choose the Lasso and carefully drag around the area that you want to isolate.

Polygonal Selection tool. The Polygonal Selection tool is helpful for quickly selecting an area by clicking at different points on the image to anchor straight line segments.

Rectangular and Oval Shape tools. Drag with these tools to create rectangular and elliptical shape layers. Hold down the Shift key and drag with the tool to draw a perfect square or circle shape.

Pen tool. Choose the Pen tool for precise drawing using a combi-nation of straight lines and curves. Click from point to point to cre-ate straight line segments; to draw curves, press to create a curve point and drag to pull out handles that control the curves. To com-plete an outline drawn by the Pen, close the shape by connecting to the origin point or by pressing the Close Shape button on the Prop-erty Bar.

Quick Curve tool. Drag with the Quick Curve tool to draw free-hand shapes. Like the Pen, the Quick Curve has a Close Shape but-ton on its Property Bar.

If you're drawing shapes and you find that the stroke and fill obscure your view and make it hard to see the outline, simply uncheck the Fill and Stroke boxes in the Property Bar.

In addition to drawing them by hand, here are some other ways of making an outline-based selection or a shape:

Transforming a pixel-based selection. Change a pixel-based selection to an outline-based selection by choosing Select, Transform Selection. (See pages 182–183 for information about making soft-edged pixel-based selections and converting them.)

Using the Selection Portfolio. Drag a stored selection from the Selection Portfolio palette into your image. (If you use a lot of custom paths in your work, you may want to create custom libraries as described in the "Libraries and Movers" section of Chapter 1.)

Converting text. Convert a text layer to shapes by choosing Convert Text to Shapes from the Layers palette's pop-out menu. (For more information about type, turn to Chapter 9, "Working with Type in Painter.")

Importing PostScript art. Import EPS paths as shapes from a PostScript drawing program. Painter supports two ways to import shapes such as preexisting EPS clip art or type set on a curve and converted to outlines in a PostScript drawing program. The first option (File, Acquire, Adobe Illustrator File) creates a new file, importing the EPS outlines—with their strokes and fills—into Painter as shapes. To add a shape to an existing Painter file, you can then click it with the Layer Adjuster tool and copy and paste it from the new file into your working composition.

The second option allows you to copy outlines with strokes and fills from a PostScript program to the clipboard and paste them into your Painter file. The outlines will be imported into your document as shapes and will appear in the Layers palette. Objects such as the converted letters "O" and "A" that have a counter, or hole, in them will come into Painter as compound shapes, preserving the holes.

WHERE'S THE PATH?

If you switch from the Pen to another tool (such as the Brush), and your paths seem to disappear, you can bring them back into view by choosing the Pen, the Quick Curve tool, the Shape Selection tool or a shape-editing tool (Scissors, Add Point, Remove Point or Convert Point).

Choosing a heart-shaped path in Painter's Selection Portfolio palette, opened by choosing Window, Selection Portfolio

MOVING SELECTIONS AND SHAPES

For both pixel-based and outline-based selections, you can move the selection boundary without moving the pixels it surrounds. This gives you a great deal of flexibility in positioning the selection boundary before you use it to change the image. To move a selection boundary without moving any pixels, choose the Selection Adjuster tool and put its cursor inside the animated selection boundary; dragging will move the selection boundary. This works for both pixel-based and outline-based selections. To move the selection's contents, drag with the Layer Adjuster tool instead of the

AI IMPORTING ALERT!

There may be problems with importing Illustrator files created in early versions of FreeHand and Illustrator (prior to version 7 of the programs). So if you have an older file you want to use, open it in version 7 or later and resave it for version 7 compatibility. When working in Illustrator 10 or higher, for best results, save the file in AI format with Illustrator 7 or 8 compatibility.

Use the arrow keys on your keyboard to move selections or shapes by one screen pixel at a time. (Before attempting to move a selection, choose the Selection Adjuster tool; prior to moving a shape, choose the Layer Adjuster tool.) Since the distance moved is a screen pixel and not a fixed distance, zoom out from the selection or shape if you want to make coarse adjustments and zoom in for fine adjustments. Or hold the Shift key to move 10 screen pixels at a time. Arrow-key nudging is especially useful for kerning type that has been converted to shapes.

Alt/Option-dragging a selection to make a copy *Dragging a side handle to scale horizontally*

Shift-dragging one of the corner handles to scale proportionally *Using a corner handle and the Ctrl/⌘ key to rotate*

When you Alt/Option-duplicate a selection and then reshape it, only the new part is affected. To reshape the original as well, Shift-click it with the Selection Adjuster tool and then reshape.

Selection Adjuster; this turns the selected area into a new layer. The Layer Adjuster can also be used to move shapes: Click the name of the shape in the Layers palette and then use the Layer Adjuster tool to drag the shape.

RESHAPING SELECTIONS

Painter allows an outline-based selection border or a shape to be transformed—scaled, skewed or rotated—without altering the image. It can also be expanded, contracted, smoothed, or made into a selection of its border area only. Selections made with the Lasso or Rectangular or Oval Selection tools, as well as selections converted from shapes, are automatically outline-based and thus can be transformed. Selections made with the Magic Wand or loaded from masks must be converted to outline-based information before they can be scaled, skewed or rotated. To convert a pixel-based selection to an outline-based selection, choose Select, Transform Selection. To convert a selection stored as a mask in the Channels palette to an outline-based selection, load the selection (Select, Load Selection) and then transform it.

Whether it was outline-based from the beginning or it was made by transforming, a selection needs to display its bounding box handles in order to be transformed. To display the handles for the currently working selection, the Selection Adjuster tool has to be chosen. Once the bounding box handles are visible, you can move the selection, or scale, skew, or rotate its outline, or change it using commands under the Select, Modify menu to widen, contract or smooth it, or make a selection around its border.

Since outline-based selections are based on mathematical information, they can undergo all of the following transformations, carried out with the Selection Adjuster tool, with no loss of edge quality. (These transformations don't work on pixel-based selections; a pixel-based selection has to be converted to an outline-based selection first, as described above.) Display the eight bounding box handles as described above and then:

To duplicate, hold down Alt/Option (a tiny "plus" will appear next to the cursor); drag and release to add a copy to the selection.

To scale, position the tool over one of the corner handles; when the cursor changes, drag the handle. To *scale proportionally*, hold down the Shift key as you drag. If you want to *resize only horizontally or vertically*, drag on the center handle of the top, the bottom or a side.

To rotate, use a corner handle, adding the Ctrl/⌘ key as you position the cursor. Be sure you see the curved arrow cursor around the handle before dragging to rotate. **Be careful:** Don't start dragging until you see the curved arrow cursor, because the Ctrl/⌘ key is also used to temporarily turn the Selection Adjuster tool into the Layer

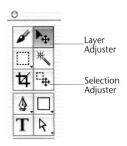

Layer Adjuster

Selection Adjuster

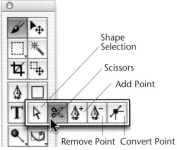

Shape Selection

Scissors

Add Point

Remove Point Convert Point

The Layer Adjuster and Selection Adjuster tools can move, rotate, scale and skew shapes and outline-based selections, respectively. The shape-editing tools that share a space on the Toolbox are used for reshaping shapes in a more detailed way.

This path has handles showing and is ready to be manipulated with the Shape Selection tool.

PATH MANIPULATION

To manipulate a path while drawing it, press the Ctrl/⌘ key to temporarily switch from the Pen to the Shape Selection tool so you can adjust the anchor points and control handles.

Adjuster tool—the pointing-finger cursor. If you're trying to rotate the selection boundary, don't drag with the arrow cursor! If you do so accidentally, the contents of the selection will be moved, but you can recover by pressing Ctrl/⌘-Z.

To skew, press Ctrl/⌘ while positioning the cursor over a center handle on the side, top or bottom and then drag. **Be careful:** Don't start dragging until you see the slanted arrow cursor across the handle. If you don't get the results you desire, you can recover by pressing Ctrl/⌘-Z.

RESHAPING SHAPES

The Layer Adjuster tool can scale, rotate and skew shapes in much the same way the Selection Adjuster works with outline-based selections. In addition, shapes can be modified in more detail with the shape-editing tools, which share a space in the Toolbox. The Shape Selection tool (hollow arrow) and the other shape-editing tools allow you to adjust individual anchor points and control handles to modify shapes.

The Shape Selection tool works much like its counterpart in Adobe Illustrator, by clicking the outline of a shape to show its control points, then dragging a point or path segment to change its position. You can also use it to click on an individual point so it will show its handles, and then drag a handle to adjust the curve.

The Scissors, Add Point, Remove Point and Convert Point tools will also be familiar to Illustrator users. For instance, the Scissors tool allows you to cut a path segment. To add a new anchor point, click with the Add Point tool. To delete an anchor point, click on it with the Remove Point tool.

Because it's so easy to convert an outline-based selection to a shape and vice versa (see pages 182–183), you can easily modify an outline-based selection by converting it to a shape, editing it with the shape-editing tools and then converting it back to a selection.

SELECTING AND MASKING BY COLOR

In addition to the selection-outlining tools described on pages 176–177, Painter also offers useful tools and procedures for making selections and masks based on the color in your image rather than on an outline you draw.

Magic Wand. Painter's easy-to-use Magic Wand is a real production time-saver. The Magic Wand lets you select an area of your image based on color similarities of contiguous (touching) or noncontiguous pixels. This is especially useful for selecting a uniformly colored element in an image, without having to draw around the area with the Lasso or Pen tool. To select a wider range of color, increase the Tolerance number in the Property Bar before you use the Wand. To make a smooth-edged selection, make sure the Anti-Alias box is checked before you make the selection.

The Property Bar for the Magic Wand lets you set the Tolerance, or size of the color range, you want the Wand to select. You can also choose whether to select only those pixels that are connected as a continuous patch of color that touches the pixel you click; for this option, Contiguous should be turned on (checked in the Property Bar). To select all pixels within the color range, both touching and not touching, turn off the Contiguous option.

Our goal was to generate a selection for the sky in this photo. We chose Select, Color Select and clicked in the image to sample the color we wanted to isolate. We adjusted the H, S and V sliders until the red mask covered only the sampled color in the preview window, and then clicked OK to activate the selection. Alternatively, you can use New From Color Range (from the pop-out menu of the Channels palette) to accomplish the same thing, except as a mask rather than a selection; the mask is automatically stored in the Channels palette.

To add areas of similar adjacent color to the selection, reset the Tolerance higher; then hold down the Shift key and click inside the existing selection. To shrink your selection by reducing the range of the colors it's based on, Alt/Option-click within the selection on the color you want to eliminate (you may want to set the Tolerance lower first). To remove a range of colors from a selection, Alt/Option-drag in the area. To add areas of similar color that are not adjacent (like Select, Similar in Photoshop), turn off the Contiguous check box in the Property Bar, and continue adding areas of non-contiguous color by Shift-clicking on other areas of the image. To turn off the nonadjacent mode, turn on Contiguous again.

Once the Magic Wand has produced the pixel-based selection you want, you can store it as a mask by choosing Select, Save Selection or by clicking the Save Selection as Channel button at the bottom of the Channels palette.

Color Select. Painter also offers an automated procedure for isolating parts of images based on color. It does something similar to the Magic Wand in non-Contiguous mode. In one way you have more control than with the Magic Wand because "Tolerance" is separated into three components (hue, saturation and value) and you can choose to partially select colors outside the range. The difficulty with this selection method is that it's hard to control the smoothness of the edges, and they tend to be somewhat rougher than an antialiased Magic Wand selection. To generate a rough-edged pixel-based selection based on a range of color, choose Select, Color Select. When the Color Select dialog box opens, click in the image on the color that you want the range to center around. In the Color Select dialog box adjust the H (Hue), S (Saturation) and V (Value) Extents sliders to control the range of each of these properties sampled in the image. Experiment with adjusting the Feather sliders to "soften" the edges of the selection. To reverse the mask to a "negative," enable the Inverted check box. Click OK to complete the selection.

To save your Color Select selection, you can use Select, Save Selection or click the button in the Channels palette as described above for the Magic Wand. But the Channels palette also provides a way to make and store a color-based mask directly, as described in the New from Color Range, below.

New From Color Range. In the Channels palette's pop-out menu, choose New From Color Range. In the Color dialog box (which works the same as the Color Select box described above), you can then make the same Extents, Feather and Invert choices.

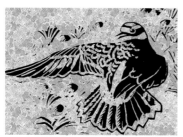

Killdeer *by Mary Envall. To create this wildlife illustration—featuring a black-and-white ink drawing floating on top of colored, textured paper—Envall began by making a black-and-white scratchboard drawing in Painter. To drop the white background out behind the drawing she made an automatic selection, choosing Select, Auto Select, using Image Luminance. She floated the active selection by clicking on it with the Layer Adjuster. Next she chose the background (the Canvas) by clicking its name in the Layers palette and filled it with a colored texture, using Effects, Surface Control, Color Overlay using Paper and Dye Concentration.*

Susan LeVan used Painter's New From, Current Color feature to make rough-edged masks for brushstrokes shown in this illustration Covering Home, *created for* Becoming Family *magazine.*

OTHER PIXEL-BASED SELECTING AND MASKING OPTIONS

Two powerful functions—Auto Select and New From (short for "New Channel From")—create a selection or mask based on color or on tonality (brightness values, or shades of light and dark). When you choose Select, Auto Select or choose New From from the Channels palette's pop-out menu, a dialog box opens that gives you a choice of Paper, which bases the selection or mask on the tonality of the currently selected Paper texture; 3D Brush Strokes, which is useful when you are "cloning" a painting from an image; Original Selection, which can be used to copy a selection from one file to another; Image Luminance, which bases the selection or mask on the lights and darks in the current image; Original Luminance, which is useful for importing an image into a channel so it can serve as a mask; or Current Color, which creates a selection or mask based on the current Main Color. The dialog boxes for Auto Select and New From are identical, with the exception that Auto Select creates a pixel-based *selection,* whereas New From creates and stores a *mask.* Both have an Invert check box for reversing the selection or mask, as described in the "Doing the Opposite" tip below.

To practice generating a mask based on the brightness values in an image, try this: Create a new file (Ctrl/⌘-N) with white as the Paper Color. Double-click the Main (forward) Color square in the Toolbox and when the Colors palette opens, choose black. From the Brush Selector Bar (opened by choosing Window, Show Brush Selector Bar), choose the Scratchboard Tool variant of the Pens. Make a sketch, and then generate a mask for your sketch by choosing New From (Ctrl/⌘-Shift-M) using Image Luminance; click OK. The mask will appear in the Channels palette, targeted and with its eye icon turned on, and you will see the mask as a red overlay. You can edit it by painting on it with a brush. Current Color is the only option for Auto Select or New From that produces a completely jagged selection or mask, with no edge-smoothing or antialiasing at all. For an

PHOTO: CORBIS IMAGES

To vignette this photo, we began by making an Oval selection. We scaled the selection using the Selection Adjuster tool, and then applied a feather of 15 pixels (Select, Feather) to soften the edge. Next, we reversed the selection by choosing Select, Invert Selection. We chose Edit, Clear to delete the background, leaving the vignetted edge against the white Canvas below it.

MIDDLE OF THE ROAD

When you use the Select, Transform Selection command on a soft-edged selection, Painter draws an outline-based selection using the 50%-transparency boundary. For instance, if you make a hard-edged selection with the Rectangular Selection tool, then feather it (Select, Feather) and transform it (Select, Transform Selection), the result will be a hard-edged selection, but with rounded corners.

To show the difference between a hard-edged and a feathered selection, the original rectangular selection was filled with blue, then feathered 20 pixels and filled with a rose color (left). Then the selection was transformed to an outline-based selection and filled with yellow, revealing the new rounded hard edge (right).

example of Auto-Selecting using Current Color, turn to "Selecting, Layering and Collaging" on page 191.

FEATHERING

Feathering a selection softens its edge. This is useful for vignetting an image or for blending a selected area into a background. To see feathering at work, drag a selection from the Selection Portfolio into your image. Choose Select, Feather, and type 20 into the field to define the extent of the feather; click OK. Now choose Edit, Fill, then select one of the options and click OK. Note the soft edges of the filled selection. The feather is always built both inward and outward from the selection boundary. Applying the Select, Feather command to an outline-based selection changes it to a pixel-based selection.

CONVERTING SELECTIONS, SHAPES AND MASKS

Outline-based and pixel-based selections have entirely different origins, but there is some degree of interchangeability.

To convert a pixel-based selection into an outline-based selection so you can transform the outline (scale, skew or rotate) using the Selection Adjuster tool, choose Select, Transform Selection. To convert a mask into an outline-based selection so you can transform it, first load the mask as a selection: In the Channels palette, click the Load Channel as Selection button at the bottom of the palette. In the Load Selection dialog box, choose the appropriate mask, make sure the Replace Selection button is chosen and click OK. This turns the mask into an active selection. Then you can choose Select, Transform Selection. (When a selection is loaded from a mask and transformed, the mask in the Channels palette remains unmodified unless you replace it using the Select, Save Selection, Replace Mask command.)

To convert an outline-based selection into a mask and save it in the Channels palette as pixel-based information instead of outline information, choose Select, Save Selection or click the Save Selection as Channel button at the bottom of the Channels palette. (You might want to make this kind of conversion in order to edit the mask by painting on it, and then load the modified mask as a selection again.)

To convert a shape to a selection so can you use it to isolate an area of the image canvas, select the shape by clicking its name in the Layers palette, and choose Shapes, Convert to Selection. (The tools that draw and edit shapes and selections have a Convert to Selection button on the Property Bar, allowing quick conversion of a shape you make or edit with one of these tools.) **Remember:** If you convert a shape to a selection, the shape is no longer stored in the Layers palette, and it will be lost when you deselect—unless

We set this Adobe Woodtype Ornament using the Text tool. We Alt/Option-dragged with the Layer Adjuster tool to make a copy of the text ornament. To convert it to shapes, we chose Convert Text to Shapes at the bottom of the Layers palette's pop-out menu. Next, we converted the copy into an active selection (Shapes, Convert to Selection) for treating the image canvas. To add the colored texture, we clicked the Paper swatch in the Toolbox and chose Worn Pavement texture, and then chose Effects, Surface Control, Color Overlay, Using Paper, Hiding Power.

A QUICK INVERT

When you want to *paint* inside or outside of a selection, you can use the Drawing icons in the bottom-left corner of the document window to quickly invert the selection without forcing the whole image to redraw every time you switch. However, *to invert the selection if you are applying a special effect*, you must use Select, Invert, which forces a complete screen redraw.

you have stored it in the Selection Portfolio (described in "Saving Selection Outlines" below) or in the Channels palette as a mask (as described earlier in this section), or unless you convert it back to a shape (as described next).

To convert the current selection into a shape so you can store it in the Layers palette, or edit its outline (using shape-editing tools on the anchor points and control handles), or fill and stroke it (using the Shapes, Set Shape Attributes dialog box), choose Select, Convert to Shape. Alternatively, all of the selection tools have a Convert to Shape button on the Property Bar for quick conversion when one of these tools is active.

SAVING SELECTION OUTLINES

Use the Selection Adjuster tool to drag outline-based selections to the Selection Portfolio to store them. If you want to save shapes into this library, first convert them to selections (Shapes, Convert to Selection) and then drag them to the Selection Portfolio. If you're very organized, you might create multiple selection libraries for different jobs. To swap outlines between libraries or to set up a new, empty palette, you can use the Selection Mover, accessed by clicking the triangle in the top-right corner of the Selection Portfolio palette to open the palette's pop-out menu.

Use File, Export, Adobe Illustrator File to export shapes to PostScript drawing programs. We successfully exported simple shape objects as well as more complex objects that included blends and compounds, opening them in Illustrator.

SELECTIONS AT WORK

Once you've made or loaded a selection, you can choose to draw outside of it instead of inside, or use it to isolate areas of the image canvas or a layer when applying special-effects procedures found in the Effects menu.

Inverting a selection. If you want to apply a fill or effect to the *outside* of your active selection, use Select, Invert Selection beforehand. This procedure reverses the current selection. It's often useful to save a selection as a mask in the Channels palette, and then save the inverse of it; for instance, save an element, and then save the background, also as a mask. This inverting process can also be used for painting outside a selection, but there's a more efficient way to control painting, described next.

Using the Drawing icons. The Drawing icons are found in the bottom-left corner of an active document's window. Take the name "Drawing icons" literally; they affect *drawing and painting actions only*, not fills or other effects. A fill or effect is always constrained to the inside of an active selection, regardless of which Drawing icon you choose. Several of the techniques in this chapter demonstrate

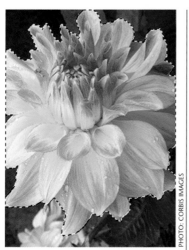

To make a selection isolating the large dahlia in this photo, we used Select, Color Select, and then used the Lasso to "clean up" the selection border—pressing the Alt/Option key to subtract from the selection—to exclude the smaller flower.

PHOTO: CORBIS IMAGES

how these icons work, and you can refer to "Selecting a Drawing Mode" in the Selections section of Painter's online help for a concise explanation.

Stroking a selection. In Painter, you can use any brush variant *to stroke an outline-based selection.* Begin by making an outline-based selection, either with one of the outline-based selection tools described earlier in this chapter or by transforming a pixel-based selection to outline-based (see page 182). The effect is more fun to observe if you choose one of Painter's grain-sensitive brushes. In the Brush Selector Bar, choose the Large Chalk variant of Chalk. Next, choose a texture from the Paper Selector in the Toolbox. With the selection still active, press the Drawing icon in the bottom-left corner of the image window and choose from the three options: You can choose to have your stroke inside the selection border (Draw Inside), outside of it (Draw Outside), or centered directly on top of it (Draw Anywhere); then go to the Select menu and choose Stroke Selection.

TRANSFORM FIRST . . .

If you'd like to stroke the outline of a pixel-based selection, use Select, Transform Selection to convert it to an outline-based selection before attempting to use the Select, Stroke Selection command.

EDITING SELECTIONS

Painter offers methods for finessing outline-based and pixel-based selections that will be familiar to Photoshop users. (To read about editing masks, see "Using the Channels Palette," on the facing page.)

Adding to a selection. To add to an existing selection marquee, choose a selection tool, and then click the Add to Selection button in the Property Bar and click or drag beyond or outside of the existing marquee. (A keyboard shortcut for using the button is to hold down the Shift key as you click or drag.) The Add to Selection operation is also useful.

Subtracting from a selection. To remove a portion of a selection, press the Subtract from Selection button in the Property Bar (or hold down the Alt/Option key) and drag with a selection tool. The Subtract from Selection and Intersect operations are also useful.

The Modify menu. Four commands under the Select, Modify menu—Widen, Contract, Smooth and Border—allow you to change outline-based selections. Widen and Contract allow you to change the size of a selection by a specified number of pixels on all edges. The Smooth command is useful for rounding corners and softening jaggedness in a selection. The Border function selects a border area (based on a specified number of pixels) outside the existing marquee, as shown at the left.

PHOTO: CORBIS IMAGES

To create a light-valued border for an image, make a rectangular selection where you want the inner edge of your border; then choose Select, Modify, Border and set the width for the border large enough so it reaches all the way to the edge of the image. Then choose Effects, Tonal Control, Adjust Colors and move the Value slider to the right to lighten the border area.

Multiple applications of the Smooth function can turn a perfectly good typeface (Stone Sans, left) into a trendy, avant-garde one. Set type with the Text tool, convert the characters to shapes (choose Convert Text to Shapes at the bottom of the pop-up menu of the Layers palette), convert the shapes to selections (Shapes, Convert to Selection), apply the Smooth operation (Select, Modify, Smooth) and fill them with a color (Edit, Fill; when you convert shapes to a selection, the Canvas becomes the active layer, so you may want to add a new layer to receive the fill). If the characters aren't "smooth" enough yet, undo the fill (Ctrl/⌘-Z), smooth again, and fill again.

The Channels palette. Several useful commands are found in the pop-out menu.

Five buttons at the bottom of the Channels palette offer shortcuts to important commands: From left to right, Load Channel as Selection, Save Selection as Channel, Invert Channel, New Mask and Delete.

MASKS

You can create masks in Painter in several ways: by making a selection and saving it in the Channels palette, by painting directly onto a new blank channel with brushes, by generating masks with procedures such as New From or New From Color Range in the Channels palette's pop-out menu, or by using Boolean operations to calculate new masks from existing ones. To read about New from Color Range, turn to "Selecting and Masking by Color" on page 179, and for more information about calculating masks, turn to "Calculating and Operating" on page 186.

USING THE CHANNELS PALETTE

The Channels palette lists all the masks you've made and stored. A Painter file can contain a maximum of 32 of these stored masks. If you'll be doing a lot of work with masks, it's a good idea to get on friendly terms with this palette. Here are some basics:

To view a mask as an overlay on top of the RGB image, click to open the eye icon to the far left of the mask's name.

To view a mask as an opaque overlay, click its name to choose it (the mask's name with then be highlighted) and choose Channel Attributes from the pull-down menu of the Channels palette, and move the Opacity slider to 100%. Viewing a mask as an opaque overlay can often help you see defects in the mask, and it may be less confusing than using partial opacity. Adjusting the Opacity slider changes the overlay's *onscreen appearance only*; it does not affect the actual density of the mask.

To hide a mask, click its eye icon shut.

To view a mask alone in black and white, without the RGB Canvas, open the mask's eye icon and close the RGB eye icon.

To edit a mask, click the mask's name to activate it and open its eye icon. You can edit the mask by painting on it with any brush except a Watercolor brush or a plug-in brush (Blenders, Digital Watercolor, Distortion, FX, Liquid Ink, Palette Knives, Photo, Watercolor or Liquid Ink).

To apply a paper grain to a mask, click the mask's name to activate it and use Effects, Surface Control, Express Texture, Using Paper. Watch the Preview as you experiment with the Gray Threshold, Grain and Contrast sliders.

TARGETING A MASK

In the Channels palette, make sure to click on the mask's *name*—not the eye icon—to target it.

INVERT CHANNEL BUTTON

The Invert Channel button at the bottom of the Channels palette makes a negative of a mask or a part of the mask that you select. To use this function, target a mask in the Channels palette and click the Invert button. If you want to invert only part of the mask, make a selection of that part before clicking the Invert button.

To change the mask overlay to a color easier to see while making a mask for an orange Garibaldi fish, we changed the overlay color from the default red to yellow by choosing Channel Attributes from the Channels palette's pop-out menu and clicking the Color swatch in the Channel Attributes dialog box.

THE HELPFUL TRANSFORM TOOL

New in Painter 11, the Transform tool (nested under the Layer Adjuster in the Toolbox) can transform the contents of a selection or an entire layer. See "A New Transform Tool" on page 205 in Chapter 6, "Using Layers," for more information about using the new Transform tool.

PAINTER AND PHOTOSHOP

To save Painter masks and use them in Photoshop, save a Painter file in Photoshop format. When you open the file in Photoshop, the named masks will automatically appear in the Channels palette. To learn more about using Painter masks and paths with Photoshop (and vice versa) turn to Chapter 10, "Using Painter with Photoshop."

To blur a mask so that loading it as a selection will produce a feathered selection, click on the mask's name to activate it, choose Feather from the Channels palette's pop-out menu, type a number in the field and click OK.

CALCULATING AND OPERATING

Painter offers Boolean operations, useful functions that help generate new masks that fit perfectly against existing ones. Skillful use of these techniques will save time and effort.

To edit a mask using a selection, create a selection marquee, and choose Select, Save Selection or click the Save Selection as Channel button at the bottom of the Channels palette. In the Save Selection dialog box, choose the mask you wish to edit from the Save To pop-up menu, and choose the operation you wish to perform.

To replace a mask with the active selection, in the Save Selection dialog box, from the Save To menu, choose the mask you wish to replace, and then click the Replace Mask button. This choice "throws away" the original mask.

To edit a selection using a mask, create a selection marquee and choose Select, Load Selection, or click the Load Channel as Selection button at the bottom of the Channels palette. In the Load Selection dialog box, choose the mask you want to use and click a button to add, subtract or intersect; then click OK. The Intersect with Selection button makes a new selection from the intersection of the existing selection and the mask, selecting only the area where the two overlap.

USING INTERSECT WITH SELECTION

We used Intersect with Selection to create the filled half-circle (below right). To repeat what we did, begin by making a square selection with the Rectangular Selection tool (it shares a Toolbox space with the Lasso) and Shift key and save it by choosing Select, Save Selection, or clicking the Save Selection as Channel button at the bottom of the Channels palette. You can view the mask as an overlay (below left) by clicking its eye icon open in the Channels palette, along with the eye for RGB (at the top of the palette). Click the RGB name to target the image canvas, and make a new selection partially overlapping the square with the Oval Selection tool. With this oval selection active, click the Load Channel as Selection button at the bottom of the Channels palette. In the Load From Selection dialog box, choose the square mask, click the Intersect With Selection button and click OK. Now you can fill the selection (choose Edit, Fill).

Viewing the mask as an overlay (left) and the filled circle area created by using the Intersect With Selection command (right).

Working with Bézier Paths and Selections

Overview Use the Pen tool to create paths of straight and curved lines; convert the paths to selections; use a custom pencil to draw inside and outside of the selections.

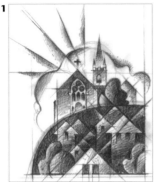
The logo sketch, including a rough grid

As this diagram shows, pulling a handle from an anchor point and then pressing and dragging creates a curve.

Dragging on a control handle changes the shape of a path.

CHANGING DIRECTION

While drawing with the Pen, click a second time on an anchor point to create a *cusp* and establish a new direction for the next curve. A cusp is a corner point between two curved line segments, such as the "dent" at the top of a heart shape.

JOHN FRETZ

TO DESIGN A LOGO FOR THE 100-YEAR-OLD Bethany Church in Seattle, John Fretz used a custom pencil to draw inside and outside of hard-edged selections to create a look similar to his colored-pencil illustration style.

1 Sketching the logo. Fretz created a 4 x 4-inch pencil drawing of the logo that included a rough grid aligning the roofs of the houses. He scanned the sketch at 300 ppi and opened it in Painter to use as a template.

2 Creating a path with Bézier curves. The most efficient way to create a combination of curve and straight-line path segments is with the Pen tool. You can set up shape attributes (with no fill or stroke) to produce only a skeletal line that will help you see precise lines and curves while you draw: Choose the Pen tool from the Toolbox. In the Property Bar, make sure the Stroke and Fill boxes are *not* checked. Now click to place anchor points for straight-line segments, and press, hold and drag to create anchor points with handles that control curve segments. When you want to close a path, place the cursor over the starting anchor point, and then click when you see a small circle, or press the Close Shape button in the Property Bar.

3 Changing the path shape. You can use the Shape Selection tool to fine-tune a path. First, if the anchor points are not showing, click the shape with the Shape Selection tool to show them; to show the control handles for an anchor point, click the point. Move the Shape Selection tool over an anchor point, a control handle, or a curve segment and drag to reposition it. (You can temporarily change from the Pen tool to the Shape Selection tool by pressing the Ctrl/⌘ key.)

4 Changing the path to a selection. Paths must be turned into selections before you can use them to control where paint is applied on the image. You can convert a closed path drawn with the Pen or Quick Curve tool to a selection immediately after drawing it (or

4a

Click on the Convert to Selection button to change the shape into a selection.

4b

Selections stored as masks in the Channels palette

5

Scaling the Basic Paper texture

6a

Painting outside of the cloud selection using the custom black pencil

6b

Painting inside of the cloud selection

7

The subtracted selection of the windows protected those areas, keeping them black when Fretz filled the house with white. He used his custom pencil to add black texture over the white fill.

after selecting it with the Shape Selection tool) by pressing the Convert to Selection button in the Property Bar. You can also change a path into a selection by selecting the shape in the Layers palette and choosing Shapes, Convert to Selection. In your image, the Bézier curves will turn into a selection marquee. To save and name the selection as a mask in the Channels palette for future use, choose Select, Save Selection. Type into the Name field and click OK. If necessary, click on RGB in the Channels palette to return to the image.

5 Creating the pencil and surface. To re-create the graduated effect he gets with conventional pencils on rough illustration board, Fretz built a heavy, grainy pencil. To build a grainy pencil similar to the one Fretz used, choose Window, Brush Controls, General and then choose the Pencils and the 2B Pencil variant in the Brush Selector Bar. In the General section of the Brush Controls palette, modify the variant by switching to the Cover method and Grainy Edge Flat Cover subcategory, and change the Grain setting to 10%. In the Size section, increase the Size to roughly 200 pixels. In the Spacing section, set the Spacing slider at 25% (so the dabs created by the larger pencil will overlap and paint continuous strokes). Now choose black in the Colors palette (Window, Color Palettes, Colors). Fretz clicked the Paper Selector in the Toolbox and chose Basic Paper because of its even texture, scaling it to 300% using the Scale slider.

6 Drawing in and out of selections. Fretz used the Drawing Modes, three icons located in the bottom-left corner of the image window, to paint inside and outside of selections. Begin by loading a selection (Select, Load Selection) and choosing the Brush tool in the Toolbox. For a clean surface to work on, add a new layer (by clicking the New Layer button on the Layers palette) and fill it with white (choose white in the Colors palette and then choose Edit, Fill, Using Current Color); to see through the layer to the scanned drawing below, adjust the Opacity control in the Layers palette. To protect the area inside an active selection, click on the middle Drawing button; to protect the area outside the selection, click on the far right Drawing button. Fretz switched back and forth between these two options as he rendered a graduated, even texture using his custom pencil. (You can also use the Select, Invert command, or Ctrl/⌘-I, to invert an active selection.)

7 Subtracting from a selection. To fill each house with white and leave the windows black, Fretz loaded each house selection and subtracted the window selection from it: Choose Load Selection again and in the Load Selection dialog box, choose a selection and click the Subtract From Selection button to subtract it from the original selected area. Fretz filled the resulting selection with white; then he added black texture to the house with his custom pencil. He continued to add white fill and black texture, until he completed the logo, and then restored the painted layer to full opacity. 🖌

Using Hand-Drawn Selections

Overview *Create a drawing; select areas of the image using the Lasso; use selections to limit brushstrokes painted with various brushes.*

1

Stewart drew a brown line drawing using the Sharp Pencil variant of Pencils.

2a 2b

Adding to a selected area

Subtracting from a selected area

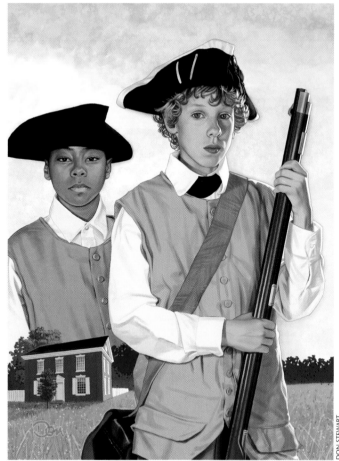

DON STEWART

TO CREATE *GUNS AT THE GUILFORD COURTHOUSE* for Tudor Publishers, Don Stewart began by making a drawing in Painter while referring to photo references. In preparation for painting, he drew freehand selections using the Lasso tool (just as he would use friskets with conventional airbrush) so that he could isolate portions of the image as he painted.

1 Developing the composition. After discussing the assignment with the art director, Stewart drew a rough thumbnail sketch in Painter. Upon approval of the thumbnail sketch, he shot photos for reference. Then he created a new Painter file that measured 5.5 x 7.5 inches at 300 ppi. With a dark brown color chosen in the Colors palette, he used the Sharp Pencil variant of Pencils to draw a detailed brown pencil sketch on top of Fine Hard Grain texture.

2 Creating selections. To isolate areas of his image, Stewart built a selection for each element in his drawing. To select with the Lasso tool, press L to choose the Lasso and drag carefully around the area you want to select, ending at your origin point. (You may find it helpful to zoom in on your image to make

2c

The masks stored in the Channels palette. The Canvas is selected.

3

Painting inside the selection for the face

4

The in-progress underpainting painted with the Digital Airbrush (Airbrushes) and Simple Water variant of Digital Watercolor

5

Adding deeper color and details to the face and clothing and texture to the sky

detailed freehand selections. Press M to switch to the Magnifier tool and click to zoom in; pressing Alt/Option and clicking will zoom out. (You can also zoom in and out of your image by using the Scale slider in the lower-left corner of the image window.)

Painter's Lasso tool lets you add to or subtract from the currently active selection. To add to the currently selected area, click the Add to Selection button on the Property Bar or hold down the Shift key and then drag with the Lasso. To subtract from the currently selected area, use the Subtract from Selection button on the Property Bar or hold down the Alt/Option key and then drag to cut away part of the active selection. Saving the completed selection as a mask will store it permanently with your image in the Channels palette. To save a selection, choose Select, Save Selection or click the Save Selection as Channel button at the bottom of the Channels palette. For straight line selections, such as the house, Stewart used the Pen tool and then converted the shapes to selections. For information about this method, see "Working with Bézier Paths and Selections" on page 187.

3 Painting inside selections. With the selections and masks built, Stewart was ready to start painting. He chose Painter's Big Canvas texture (copied from the Paper Textures 2 library in the Paper Textures folder, Extras folder on the Painter 11 CD-ROM). After loading the selection for the area he wanted to isolate and paint (Select, Load Selection), he used the Wash Camel variant of Watercolor to brush on color.

4 Painting richer color and texture. After he finished the underpainting for the image, Stewart loaded selections to isolate each area again, one at a time. This time he used the Digital Airbrush variant of Airbrushes to add richer color and to smooth areas. To build up deeper shadows within the isolated areas, he used the Simple Water variant of Digital Watercolor.

5 Adding details. Using the pop-up menu on the Paper Selector (Toolbox), Stewart switched back to the Fine Hard Grain texture that he used for his drawing. Then he used both the Sharp Chalk (Chalk) and Round Camelhair (Oils) to add details to the image; for instance, on the foreground boy's sunlit hair and shirt. Next, Stewart added more texture interest by spraying a subtle splattered paint look on the foreground grass and on the sky, by using a combination of the Pepper Spray and Coarse Spray Airbrushes. The final illustration can be seen on page 189.

The splattered paint on the grass and the subtle texture on the blue vest

Selecting, Layering and Collaging

Overview *Create a scanned collage background; create drawings; use Painter's Selection tools to isolate the drawing elements; copy the elements and paste them into the scanned collage background; paint into selected areas with brushes.*

1

The scan of the conventional collage

2

LeVan drew the girl, coyote and face on separate layers.

3a

The girl pasted into the brightly colored collage and selected

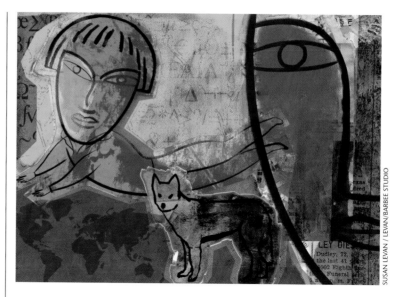

SUSAN LEVAN / LEVAN/BARBEE STUDIO

"WHAT I LIKE ABOUT USING the Current Color Auto Select feature with Chalk is the random residue of the original color that is left behind. This creates a natural, subtle texture within the masked areas of color," says Susan LeVan of LeVan/Barbee Studio. A collage artist with traditional media, LeVan brings her collage process into Painter. When she created *Floating Girl,* she used brushes to paint within selections she had made using the Current Color setting of the Auto Select command. This creates jaggy torn paper edges around the elements in her image, giving her piece texture, lightness and air. LeVan's collage technique also employs the use of other selection tools as well as painted and pasted layers.

1 Choosing a background for the collage. LeVan keeps a library of "grounds," traditional collages of paper and paint, that she often uses as background elements in her digital illustrations. She opened a scan of one of her traditional collages that she had built using newspaper, rag paper and conventional acrylic paint. The collage background measured 1200 x 857 pixels.

2 Drawing the foreground elements. LeVan opened a new image file that measured 1200 x 1248 pixels, with a white paper color. She sketched line drawings in black—a girl, a coyote and a face, each on its own separate transparent layer—using black color. She used the Sandy Pastel Paper texture throughout the entire image-building process. To sketch as LeVan did, from the Brush Selector Bar, choose the Dry Ink variant of Calligraphy, choose black in the Colors palette and choose Sandy Pastel Paper in the Paper Selector in the Toolbox. If the Layers palette is not open, choose Window, Show Layers. To create a new layer, click the New Layer button near the bottom of the Layers palette.

3b

The girl with "cut paper" edge

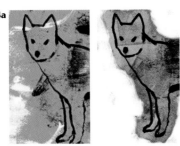

4a

The coyote pasted into the collage (left) and drawn around with the white chalk (right)

4b

This detail shows the "torn paper" edge achieved with the Auto Select, Using Current Color technique.

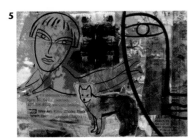

5

The "cut paper" girl, "torn paper" coyote, and line drawing of the face are pasted into the master collage file.

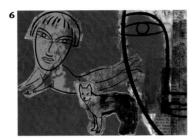

6

Painting brown and green colors on the background with the Square Chalk

3 Making the "cut paper" girl. Next, LeVan opened a scan of another collage from her library of scanned surfaces (this one composed of newspaper, torn paper and bright yellow and orange acrylic paint) to use with the line drawing. She clicked the thumbnail for the girl's layer in the Layers palette and copied the line drawing of the girl (Select, All; and then Edit, Copy) and pasted it into the brightly painted collage (Edit, Paste). Then she merged the line drawing layer with the collage by choosing Drop from the Layers palette menu.

To create a hard-edged cut-paper look around the girl, LeVan used the Pen tool to draw a loose Shape that also incorporated some of the collage background. She converted the Pen tool shape to a selection by clicking the Convert to Selection button on the Property Bar. Then she copied the selected area of the collage, and pasted it as a layer into the background file from step 1.

4 Building a "torn paper" coyote. She copied and pasted the coyote line drawing into a brown and black area of another copy of the original collage scan (to make a duplicate of your file, choose File, Clone) and she dropped this layer by choosing Drop from the Layers palette menu. Then, using the Square Chalk variant of Chalk and white paint, she drew loosely around the coyote. To create the torn-paper look, she selected the coyote by choosing Select, Auto Select Using Current Color, and enabling the Invert button. Then she copied and pasted the coyote area as a layer into the original background scan from step 1.

5 Adding the face and arranging the pasted elements. LeVan copied the face from the drawing made in step 2 and pasted it into the background scan from step 1. She used the Layer Adjuster tool to move the girl, coyote and face into position where she wanted them.

6 Creating texture and color variations. Next, LeVan focused more attention on the figures by painting over areas of the background. She used the Square Chalk variant of Chalk to paint rich brown and green strokes onto the Canvas, behind the layered girl, coyote and face elements.

7 Adding pattern elements to the background. LeVan built and added pattern elements to the background. First, she made a pattern from a light brown area of the background above the girl. (For information about building patterns, see "Creating a Seamless Pattern" in Chapter 8.) She cloned the working master collage file (File, Clone) and filled with it with the custom brown pattern. (Effects, Fill, Fill With Pattern). Then she chose a dark red in the Colors palette and chose the Text tool in the Toolbox. She clicked in the brown pattern file, and set type using the Symbol font. (For information on using Painter's text tools see Chapter 9, "Working

7a

The clone image filled with the type pattern

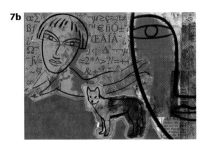

7b

Cloning the type pattern into the collage

8

Yellow and blue paint added

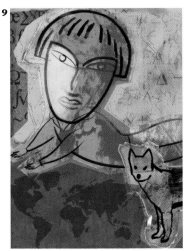

9

All of the elements are added to the collage.

With Type in Painter.") When the type was as she liked it, LeVan flattened the file by choosing Drop from the Layers palette menu. Then she used the Rectangular Selection tool to select an area of background with the type, and she captured it as a pattern into her current Patterns library.

To incorporate the type pattern into the master collage file, she filled the clone image with the type pattern by choosing Effects, Fill, Fill With Pattern. Then using the Lasso in her main collage file, she selected an area behind the girl. She chose File, Clone Source, and selected her pattern file as the Clone Source, and used the Effects, Fill, Fill With Clone Source to add the type pattern to the Canvas in the collage file.

8 Finessing the composition. LeVan felt the text area around the girl was too prominent, so she painted over the text pattern, adding a new layer by clicking the new Layer button on the Layers palette and using the Square Chalk to lightly brush textured yellow paint over the area.

She added new layers, moving them to various levels in the layer stack by dragging their thumbnails down in the Layers palette. She painted on the new layers and she changed the Composite Method of each layer to blend the colors. For instance, applying the Colorize Composite Method to a layer painted yellow will change any colors underneath but without affecting the black line work. On the other hand, painting in blue on a layer that's in Lighten Composite Method will color the black line work in the layers below without covering yellow, for example, since the blue paint is darker than the yellow. For more information about working with layers and Composite Methods, see Chapter 6, "Using Layers."

9 Adding the map and final brushwork. LeVan opened a small clip art image of a world map. She copied and pasted the map into the lower-left corner of her working collage file and then reduced the Opacity of the clip art map layer to 40% using the Opacity slider in the Layers palette. To complete her collage, LeVan added colored washes with the Simple Water variant of Digital Watercolor. The final image can be seen on page 191.

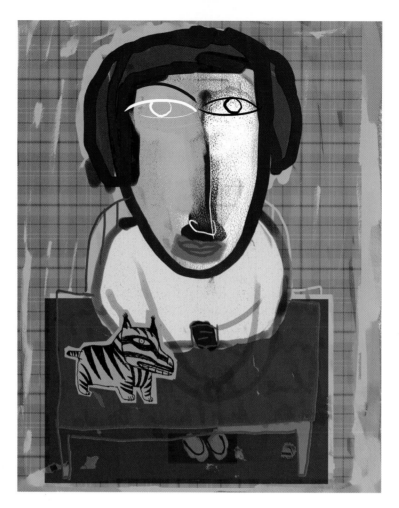

■ Using vivid color and loose illustrative strokes, collage artist **Susan LeVan** of LeVan/Barbee Studio creates a strong emotional quality in her work. When LeVan created the works shown on these pages, she used brushes to paint within selections.

For *Blue Woman*, LeVan repeatedly used the Select, Auto Select command using the Current Color setting and painted back into her image. To begin the work, she used the Scratchboard Tool and Round Pen variants of the Pens and black color to create a loose line drawing of the woman and table. She drew the pet in her conventional sketchbook with a black Sigma Micron pen and scanned it; then she opened the scan in Painter and copied and pasted the drawing into her working file. After positioning it with the Layer Adjuster, she merged it with the canvas by choosing Drop from the Layers palette menu. Next, LeVan made selections for the line drawing and animal by choosing Select, Auto Select, Using Current Color and painted grainy strokes within each selection using the Square Chalk variant of Chalk. Then she inverted the selection (Select, Invert Selection) and painted a light blur background behind the figure and table using the Square Chalk variant of Chalk.

For more color and texture interest in her composition, LeVan used a weave to create plaid wallpaper behind the woman. Using the Magic Wand, she selected the blue chalk background behind the woman and copied it to new layer, where she filled it with Bright Weave (Edit, Fill, Fill with Weave). Then she blended the Weave layer with the image using the Gel Composite Method, and reduced its opacity to 10% and moved it up and to the right. (To learn more about working with layers, see the introduction to Chapter 6, "Using Layers.")

The line making up her nose, face, hair and hands was painted with the black Chunky Oil Pastel 30. Finally, to add texture to the right side of the woman's face, LeVan brushed lightly with a large Square Chalk brush. For more depth and interest in the woman's eyes, LeVan painted transparent washes using the Simple Water variant of Digital Watercolor.

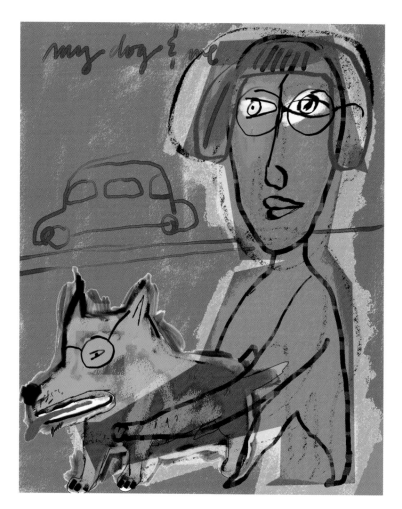

■ *My Dog and Me* is a member of a series of work by **Susan LeVan**, featuring men, women and their pets. "The long series of man or woman with a dog was originally inspired by a Picasso painting that I loved as a teenager, *Boy Leading a Horse*. I have continued to do variations on this theme for thirty years. Picasso remains an important influence on my work, especially his use of a stylized central figure on a flat, simple picture plane," says LeVan.

LeVan used a palette composed primarily of saturated colors, including warm reds, oranges and yellows, accented by greens and blues. To begin, LeVan filled the Canvas with a gray color and then brushed over the surface using the Square Chalk variant of Chalk and a reddish color, over Basic Paper texture. She added a new layer and drew the expressive woman's figure using the Calligraphy Pen variant of Calligraphy. For the dog, she scanned a

black-and-white line drawing from one of her sketchbooks and opened it in Painter. To select the line drawing of the dog, she used the Select, Color Select, Current Color feature and copied and the line drawing into her working image. Next, she targeted the Canvas and used the Felt Marker variant of Felt Pens and a bright green color to paint the background for the dog. For the background colors for the woman, she used the Square Chalk and a yellow color. She selected parts of both backgrounds with the Magic Wand and drew in the selection with a yellow Square Chalk.

For more texture interest, LeVan put a weave texture into the line drawing of the woman. She used the Select, Color Select, Current Color feature to select the black outline of the woman, and then she copied and pasted it onto another layer and filled it with the Bright Weave, chosen from the Weave Selector on the Toolbox (Edit, Fill,

Fill with Weave). Next, she used the Pen tool to draw the hard-edged form within the woman. With the Pen tool chosen, she disabled the stroke and fill check boxes in the Property Bar; then she drew the path. To convert the path to a selection, she clicked the Convert to Selection button on the Property Bar. With the selection active, she copied and pasted it into a new top layer and filled it with an orange color, and then composited it with the Colorize Composite Method.

She added more color and textured brush work using various brushes, including the Square Chalk and Chunky Oil Pastel variant of Oil Pastels. For the inscription "My Dog and Me," the road lines and the automobile, she used the Simple Water variant of Digital Watercolor. For more information on LeVan's collage painting technique, see "Selecting, Layering and Collaging" on page 191.

■ **Don Stewart** specializes in book illustration and commissioned portraits. For many years he worked on gessoed illustration board with airbrush and colored pencil. Today he draws on the computer, using Painter's tools and brushes that match his traditional ones.

Stewart began *Sisters* by sketching in Painter using the Sharp Pencil variant of Pencils on Fine Hard Grain paper texture. Then, he isolated areas of his image by making freehand selections with the Lasso (for example, the background, figures and clothing) so that he could limit the paint as he created an underpainting with the Wash Camel variant of Watercolor. For the background, Stewart painted, modulated and blended colors using a variety of Oils brushes, including the Round Camelhair variant of the Oils. For smoother areas (the skin, for instance), he painted with the Digital Airbrush variant of Airbrushes. To build up deeper values, Stewart painted transparent washes using the Simple Water (Digital Watercolor). To add final details, he applied highlights using a small Digital Airbrush, and the Sharp Chalk variant of Chalk. For subtle texture in a few areas on the clothing, he used the Large Chalk variant of Chalk.

■ **Don Stewart** was commissioned to paint the illustration *Rockwell* for a magazine ad for the law firm Crowell & Moring. Stewart began the image by making a tight drawing in Painter using the Sharp Pencil variant on Fine Hard Grain paper chosen from the Paper Selector in the Toolbox. Next, so that he could protect some areas while he painted others, he isolated the important elements in his sketch by making selections with the Lasso (for example, the table, the wall and window elements, the people's skin and the duck), and saved them as masks in the Channels palette (Select, Save Selection). For his texture while painting, he used Big Canvas from the Paper Textures 2 library, from the Extras folder on the Painter 11 CD-ROM. Stewart loaded a selection for an element (Select, Load Selection) and then laid in washes for the preliminary color scheme using the Wash Camel variant of Watercolor. Next, he loaded each selection again, and added richer color and values to each element with Digital Watercolor, for instance he used the Simple Water variant of Digital Watercolor to paint the texture on the table top. For finer, opaque details he used the Detail Oils Brush 5 variant of Oils (for highlights on the people's hair and faces, for instance). To paint deeper shadows and model the forms on the faces and clothing, he painted with the Simple Water variant of Digital Watercolor.

■ Award-winning illustrator **Michael Bast** has worked with conventional art tools for many years. Since 1990 he has painted digitally using Painter's brushes and art materials. Bast loves Painter because it allows him to capture the warmth and texture of his favorite conventional media.

To begin *Keebler Tray*, Bast assembled elements to use for reference. His client wanted him to use items that he had created for earlier illustrations, as well as draw new ones. He created a composition drawing that included all of the food items by using conventional pencils and paper; then he scanned the drawing.

Bast created selections, masks and vector shapes to make his work easier as he painted *Keebler Tray*. Working over his drawing, Bast built selections for each element in his illustration—the bowl rim, and the purple grapes and peppers, for instance. For safekeeping, he saved each selection as a mask in the Channels palette by choosing Select, Save Selection. For the geometric

shapes, such as the tray, he used the Pen tool and then saved the shapes into the Layers palette. He also converted a copy of the shapes to selections and then saved them into the Selection Portfolio. To store a selection in the Selection Portfolio as Bast did, choose Window, Selection Portfolio. Make a selection using one of the selection tools or load a selection by choosing Select, Load Selection. Then, use the Selection Adjuster tool to drag the active selection into the Selection Portfolio. When you want to use the selection on your image, use the Selection Adjuster to drag a stored selection from the Selection Portfolio palette into your image. (Read more about using the Selection Portfolio on page 177 in the beginning of this chapter.)

To paint, Bast primarily used the New Simple Water variant of Digital Watercolor to lay in colored washes within selected areas. Bast likes this brush because it is easy to build up areas of color. Using a process similar to glazing in conventional watercolor, he paints washes of color, dries them by

choosing Dry Digital Watercolor from the Layers palette menu, and then adds more color with the New Simple Water brush. (Read more about Digital Watercolor on pages 90 and 152.) When he wanted to pull color out from an area of wet paint, he used the Gentle Wet Eraser. To add opaque brush work, he used the Variable Flat variant of Oils. To add finer detail to areas, such as the strawberries, he used the Detail Opaque variant of Gouache. For the speckled texture on the crackers, he loaded a selection for the area and then used the Pepper Spray variant of the Airbrushes.

■ Artist **Martha Jane Bradford** has developed a technique for using masks to not only constrain paint, but to build tones in her paintings. For *Quarry Hill Afternoon* she wanted to create a very stylized image with flat tones that would have the look of an aquatint or hard-ground etching. The black-and-white and a color version are shown here.

Bradford began by working at the final size, a 2400 x 1600 pixel file, because masks can get fuzzy edges when resized. She put her reference photo on a layer to use as a guide. Bradford decided that the basic image would have 12 values from white through gray to black, using masks v2–v13

and six masks representing different facets of the sky, land and water, as shown in the Channels palette on the right. To make the first mask, she clicked the New Channel button on the Channels palette, filled it with black and then renamed it v2 (value two). So that she could get very sharp, clean edges, she customized the Flat Color variant of Pens to use the Grainy Edge Flat Cover Subcategory in the Brush Controls: General section. Next, she drew with white on the black mask wherever she wanted Value 2 (the white of the Canvas) to show. She carefully made masks for the remaining 11 values. To paint, she began by creating a layer for Value 2, which she left empty everywhere except for the highlight on the cloud. She loaded a selection using the Value 2 mask by choosing Select, Load Selection. Then, she used the Pixel Spray variant of Airbrushes on the sky to create a glow along the top of the cloud. Next, she created a layer for Value 3, where she used the Value 3 mask to lay in the lightest tones, drawing with a combination of large-sized Pixel Spray and Charcoal brushes on Synthetic Superfine Paper. She continued the process while painting values 4–12.

■ **Nick Anderson** is an editorial cartoonist at the *Houston Chronicle* in Houston, Texas. His award-winning cartoons have been published in *Newsweek, The New York Times, The Washington Post, USA Today*, and *The Chicago Tribune*. Anderson is the recipient of the 2005 Pulitzer Prize for editorial cartooning.

Anderson begins each cartoon by doing rough sketches on conventional tracing paper. When a concept is approved, he creates a black-and-white drawing working on a Wacom Cintiq display using Photoshop. Then, he saves his drawing as a TIFF file for import into Painter, where he uses a variety of Painter brushes to add color and texture. Anderson usually creates masks for the important elements in each cartoon. He paints directly on the alpha channel masks by using the Flat Color variant of Pens and black and white paint. To begin each mask, he created a new empty channel by clicking the New Channel button on the Channels palette. By default, this command creates a mask that

is filled with black, which can be viewed on the working image as a red overlay. With the red overlay in place over his drawing, Anderson paints directly onto the channel using white or black paint. Creating channels can be tedious, but when they are complete, they allow him to paint freely within isolated areas.

For *Health Care Rapids*, Anderson was inspired by stories about the national health care crisis. "It seemed to me that many of the opponents to reforming our health care system play on fears of change. But doing nothing while costs continue to rise dramatically and more people are pushed into the ranks of the uninsured seems crazier than doing nothing. So I came up with this visual to communicate what I consider to be the dangers of the status quo," says Anderson.

To begin, he opened his drawing in Painter and cut it to a layer by choosing Select All, and Select, Float. So that the white areas of the drawing would appear transparent, he set the Layer Composite Method to

Multiply in the Layers palette. Working on the Canvas, he used the Flat Water Blender variant of Digital Watercolor to lay down most of the base colors, changing the size of the brush as he worked. Then, he built up subtle, colored glazes, adding richness and depth to the image with a lower opacity version of the brush. To achieve the look of the rushing water, he painted thin, wavy strokes using a small Flat Water Blender that incorporated a high Wet Fringe setting in the Property Bar. For the highlights on the water, he used a tiny Wet Eraser (Digital Watercolor.) Anderson painted soft, wispy clouds with a large Flat Water Blender that incorporated a high Diffusion setting to achieve the look of clouds with soft edges. As a final touch, Anderson added spatters and bubbles on a new layer. He clicked the New Layer button on the Layers palette, and using the Spatter Water variant of Digital Watercolor, he painted a random spatter texture on to the rapids, and the sky, varying the opacities of the brush as he painted.

■ **Nick Anderson** discusses his inspiration for the cartoon *Compassionate Release*: "Eight years after being convicted of killing 243 passengers in Pan Am 103, the bomber was released by the Scottish Government on "compassionate grounds" because he was suffering from terminal cancer. This struck me as absolutely absurd. I'm not convinced there's an after life, but if there is, he'll receive his justice then," says Anderson.

For most of the coloring of *Compassionate Release,* Anderson used a custom version of the versatile Flat Water Blender variant of Digital Watercolor, that included reduced Diffusion and increased Wet Fringe settings in the Property Bar. While painting the base colors, he set the Diffusion at 0; and Wet Fringe at 100%. After laying in the underpainting, he built the color and values from light to dark varying the Opacity in the Property Bar as he painted. When

he wanted to reveal more or less grain, he adjusted the Grain setting in the Property Bar. After laying in the basic colors and modeling of the forms, Anderson added a new layer and used the Square Chalk variant of Chalk to paint opaque highlights over the underlying color. To clean up edges on this layer, he used a small Eraser. Next, to spray a granular texture on the foreground, Anderson used a small Spatter Water variant of Digital Watercolor. To build more depth and richness on the colored background, he again chose the Flat Water Blender, added a new layer and painted on this separate layer, so he that could easily make corrections with an Eraser and then reduce the opacity of the layer, if necessary. Finally, Anderson used a small Square Chalk to add a few white highlights on the large hand and on the running bomber.

USING
LAYERS

*Delro Rosco created the nostalgic scene,
Berry Orchard, as feature art on the
packaging for a new line of confections for
Liberty Orchard. This detail shows Delro
Rosco's refined painting technique, achieved
by using Digital Airbrushes and custom
Watercolor brushes on layers. See the
complete illustration in the gallery at the end
of this chapter.*

INTRODUCTION

LAYERS ARE ELEMENTS THAT HOVER above Painter's image Canvas,
or base layer, providing a great deal of flexibility in composing art-
work. You can move, paint on, or apply a special effect to a layer
without affecting other layers or the background canvas. So when
building images you can try several possibilities by manipulating or
repositioning the various elements. Then, when your layers are as
you like them, you can drop them onto the canvas, blending them
with the background.

In addition to *image* (or pixel-based) *layers,* Painter incorporates
other types of "layers": *floating objects, reference layers, shapes, dynam-
ic layers, text layers,* and two *media layers—Watercolor and Liquid Ink.*
The controls for naming, stacking, compositing and grouping all of
these kinds of layers are found in the Layers palette, as described in
"Organizing with the Layers Palette" on page 212. Each layer in a
layered file has a Composite Method that affects how it interacts (or
blends) with other layers and with the Canvas.

You can preserve layers by saving your file in RIFF format. Sav-
ing in most other formats requires *dropping,* or merging, the layers.

A TIFF-TO-RIFF LIFESAVER

If you save a layered file in TIFF format (a format in which Painter doesn't sup-
port layers and floating objects), Painter is smart enough not to automatically
drop the layers in your working image. A dialog box will appear, and when you
click OK, the program will save a closed copy of your document in TIFF format
with layers dropped, but the layers will stay alive in your open working image.
Make sure to save in RIFF format before closing the file, or quitting in order to
preserve the image layers, floating objects, reference layers, dynamic layers,
text layers, shapes, and Watercolor and Liquid Ink layers.

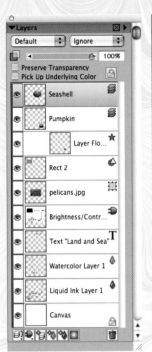

Recognizing items in the Layers palette: Image layers are designated by a stack of rectangles in the right corner, a layer floating object by a star, a shape by a circle and triangle, a reference layer by a dotted rectangle with handles, a dynamic layer by a plug icon, a Text layer by a capital "T," a Watercolor layer by a blue water drop and a Liquid Ink layer by a black drop of ink. In the Layers palette shown here, the Seashell layer is selected.

For this flower illustration, the Wash Bristle and Runny Wash Camel variants of Watercolor were used to paint washes on Watercolor layers.

However, if you'd like to be able to open a Painter image in Photoshop with layers intact, save the file in Photoshop format. All layers and shapes will be converted to Photoshop layers, with their names and stacking order intact. To read more about working with Photoshop, turn to Chapter 10, "Using Painter with Photoshop."

An *image layer* can hold pixels or transparency. When you add a new layer by clicking the New Layer button at the bottom of the Layers palette or by choosing New Layer from the palette's pop-up menu, it's completely transparent until you paint on it. See "Working with Image Layers," below.

A *layer floating object* is an area of an image layer that has been isolated and lifted from the layer, to create a kind of sublayer. Each layer can have only one floating object at a time. See "Working with Layer Floating Objects" on page 205.

Reference layers can be helpful for assembling large images from several separate source files. A reference layer is a 72 ppi screen proxy (or "stand-in") for an image layer in the current image, or for a placed image that's linked to an image file outside of the document. (See "Using Reference Layers" on page 206.)

Shapes are essentially a resolution-independent kind of layer that, unlike image layers, can be reshaped or resized without degradation. As described on page 207, shapes are outline-based elements with attributes such as stroke, fill and transparency. Shapes are PostScript-based objects. You can paint on a shape, adding pixel information, but you have to first convert the shape to an image layer.

Dynamic layers are special hovering devices that allow you to make adjustments to an existing image (by adding an Equalize layer or Brightness and Contrast layer, for example), or to create entirely new effects (for instance, a Liquid Metal layer). You can create a dynamic layer by clicking the Dynamic Plug-ins button at the bottom of the Layers palette and choosing a plug-in from the pop-up menu (see page 209).

Painter's *Text layers* are described on pages 330–333.

Media layers are special layers that allow startling, realistic painting effects. Read about Watercolor and Liquid Ink layers on page 211.

All layers take up extra disk space and RAM. You can minimize the need for extra space by floating only what's necessary, and by dropping and combining layers whenever it makes sense.

LAYER OR FLOATING OBJECT?
New *image layers* can be made by selecting an area of the *Canvas* and cutting or copying. But if you select and cut or copy *from an image layer rather than the Canvas*, you produce a *layer floating object* associated with the layer you used to make it.

WORKING WITH IMAGE LAYERS

You can make an image layer by activating the Canvas layer, selecting part of it, and then clicking on the selected area with the Layer Adjuster tool. This process cuts the selected area out of the Canvas

To make a new layer by copying an active selection on Painter's image Canvas, make or load a selection in your image, hold down the Alt/Option key, choose the Layer Adjuster tool, and click or drag inside the selected area. To *cut* from the image canvas and turn the selected area into a new layer, click or drag with the Layer Adjuster without pressing the Alt/Option key.

PHOTO: CORBIS IMAGES

If you don't hold down the Alt/Option key when you drag a selection with the Layer Adjuster, you'll leave a hole behind in the Canvas if you then move the newly created layer. Occasionally this is desirable, but most of the time you'll want to use the Alt/Option key!

USING DRAG-AND-DROP

Here's a quick way to copy a layer or shape from a source image into a composite file. Open both images. In the source image, select the layer or shape by clicking its name in the Layers palette and then drag the item from the source file into the composite image using the Layer Adjuster tool.

LAYERS AND SELECTIONS

In Painter there can be only one active selection at a time. You can use a selection to edit a portion of any image layer, reference layer, Watercolor layer or Liquid Ink layer listed in the Layers palette.

and turns it into the new layer, leaving behind a hole that you can see if you drag the new layer with the Layer Adjuster. Alt/Option-click to *copy* an active selection, even to duplicate the entire Canvas. This creates a new layer from the copy but also leaves the original pixels in place on the Canvas. The selection that defines the area to turn into the new layer can be made with any of the selection processes described in Chapter 5.

There are other ways to create an image layer. For instance, all elements pasted into a Painter document come in as image layers, and you can also drag an image layer from the Image Portfolio palette into your image.

An image layer automatically includes a *Transparency mask*; when the layer is active (clicked in the Layers palette) its Transparency mask is available to be loaded to select all the nontransparent areas of the layer (Select, Load Selection). An image layer can also include a *layer mask,* created by clicking the Create Layer Mask button at the bottom of the Layers palette. The layer mask determines what parts of the pixel information on the layer are shown or hidden. You can load the layer mask for the active layer as a selection (Select, Load Selection), just as you can the Transparency mask described above. In contrast to the transparency mask, the layer mask can be directly modified to hide or reveal parts of the layer or to blend layered images with exciting transparency effects.

Here's how to work with image layers once you've created or imported one:

To activate a layer, click its name in the Layers palette. Or choose the Layer Adjuster in the Toolbox, and then turn on Auto Select Layer in the Property Bar and click on a visible area of the layer. Either way, the name will be highlighted in the Layers palette to show that the layer is active.

To deactivate a layer, click on different layer. Or choose the Layer Adjuster tool, turn on Auto Select Layer in the Property Bar and click somewhere in the image where the current layer has no pixels.

To apply a special effect to a layer, make sure it's active (highlighted in the Layers palette, as described above). Then choose from the Effects menu. (Of course, an effect applied to a transparent layer with no pixels on it has no effect.)

To paint on a layer, make sure it's active (highlighted in the Layers palette, as described above). Choose any brush (except a Watercolor or Liquid Ink variant) and paint brushstrokes onto the layer. (Watercolor and Liquid Ink can paint only on appropriate media layers, which will automatically be created if you try to use these brushes on image layers.) For more information, turn to "Painting on Layers" on page 64 in Chapter 3.

To erase paint you have applied to a layer, making the area "clear" again, you can choose the Eraser tool in the Toolbox, and paint on the layer to "erase."

When creating Neural Pathway, *a detail of which is shown here, David Purnell used many layers and shapes. See another of Purnell's illustrations in the gallery at the end of this chapter.*

A QUICK CANVAS COPY

To quickly float a copy of the Canvas to a layer, choose Select, All (Ctrl/⌘-A); then hold down Alt (Windows) or ⌘-Option and click on the Canvas with the Layer Adjuster.

A NEW TRANSFORM TOOL

The Transform tool (nested under the Layer Adjuster in the Toolbox) can transform the contents of a selection or an entire layer. Click and hold the Layer Adjuster tool to reveal the Transform tool, and click it. The Property bar displays Transform tool modes: Move, Scale, Rotate, Skew, Distort and Perspective Distortion, as well as Reset Reference Point, Cancel Transformation and Commit Transformation.

RESTACKING LAYERS

When you create a new layer, it appears at the top of the layer stack. To reposition it in the stack, simply drag its name to the appropriate level in the Layers palette.

To hide part of a layer without permanently erasing it, begin by choosing black in the Colors palette. Click on the layer in the Layers palette. If the layer doesn't already have a layer mask, click the Create Layer Mask button at the bottom of the palette. Then click the mask thumbnail that will appear next to the image thumbnail for the layer; this activates the mask rather than the layer's image. Choose a brush (such as the Pens, Scratchboard Tool) and paint on the mask with black where you want to hide the layer. If you want to *reveal* parts of the image that you have hidden with the layer mask, paint the mask with white.

The most foolproof way to move a layer is to click the layer's name in the Layers palette to activate the layer, and then choose it with the Layer Adjuster tool (make sure the Auto Select Layer check box is turned off in the Property Bar), and drag anywhere in the image window. To adjust a layer's position a screen pixel at a time, activate the layer and use the arrow keys on your keyboard.

To merge a layer with the Canvas, activate the image layer in the Layers palette and click the Layer Commands button (far left at the bottom of the palette) and choose Drop from the pop-up menu, or click the triangle in the upper-right corner of the palette and choose Drop from that menu. If you want to merge all of your layers onto the Canvas—much like using Photoshop's Flatten Image command—simply choose Drop All from the menu in the upper-right corner (this command is not available through the Layer Commands button). Another option, if you want to keep a layered version but also create a "flattened" one, is to choose File, Clone; a duplicate of the image will appear with all layers merged.

To scale, rotate, distort or flip a layer, activate the layer and choose the appropriate command under Edit, Transform.

To change the opacity of a layer, click its name in the Layers palette and use the Opacity slider near the top of the palette.

WORKING WITH LAYER FLOATING OBJECTS

To reposition a portion of an image layer, Painter uses a layer floating object. Only an image layer can have a floating object, and each layer can have only one floating object at a time. Besides moving part of a layer, you can also use a layer floating object to isolate part of a layer for editing. The advantage of using a floating object (rather than simply selecting an area of the layer and changing it) is that a floating object can have its own layer mask, which you can use to hide or reveal part of the floating object.

To create a floating object that's cut out from a layer, make a selection, click on a layer's name in the Layers palette and choose Select, Float, or click inside the selection with the Layer Adjuster tool. The floating object will be listed below its parent layer in the Layers palette, indented to show the relationship. (If you turn

If you'll be making several transformations (such as rotations or scaling) to a single layer, like rotating it into place and then scaling it to fit your layout, you need to know that the quality of an image layer can be degraded with every transformation. Instead of using a series of individual transformation commands, consider converting the layer temporarily to a reference layer by selecting it and choosing Layers, Convert to Reference Layer. You can then rotate, scale and skew the reference layer as many times as you like. When you arrive at the result you want, choose Convert to Default Layer from the pop-up menu on the right side of the Layers palette. The effect is to transform the actual pixels only once and thus preserve quality.

A reference layer, ready to be transformed, has eight handles around it.

PHOTO: CORBIS IMAGES

You can merge several layers at once with the Canvas by Shift-selecting their names in the Layers palette before clicking the Layer Commands button and choosing Drop from the pop-up menu.

off visibility for the floating object by clicking its eye icon, you'll see the hole where it has been cut from the parent layer.)

To make a floating object copy of information on the parent layer (without cutting out), make a selection, press the Alt/Option key and then choose Select, Float, or Alt/Option-click with the Layer Adjuster tool. The floating object "copy" will be indented below its parent layer in the Layers palette.

To recombine a floating object with its parent layer, activate the floating object by clicking its name in the Layers palette, click the Layer Commands button (far left at the bottom of the palette), and choose Drop from the pop-up menu. The floating object will also recombine with its parent layer if you do any of the following: paint or make another selection while either the layer or its floating object is active, or paste into the document or drag an item from the Image Portfolio while the floating object is active.

To transform a floating object, activate the floating object by clicking its name in the Layers palette, choose the Transform tool (nested under the Layer Adjuster in the Toolbox) and position the cursor over a corner handle and drag to scale it. Using the Transform tool modes chosen in the Property bar, you can also rotate, skew, distort and apply perspective scaling to the Floating Object.

USING REFERENCE LAYERS

If you work with large files and your computer slows to a crawl when you try to reposition a big image layer, consider converting image layers to reference layers. Reference layers are 72 ppi proxies, or "stand-in" images. They let you manipulate high-resolution images faster, instead of dragging huge images around your screen. Because you are working with a proxy—and not the actual pixels—you can perform multiple rotations, scaling, skewing and repositioning very quickly. When you've finished all your manipulations, convert reference layers back to image layers; Painter will remember all the manipulations you've made and will carry them out as a single change, with much less loss of quality than if you had made them one by one on the high-resolution file.

To make a reference layer, select an image layer and choose Layers, Convert to Reference Layer. To get ready to operate on the layer, choose the Layer Adjuster.

To scale a reference layer proportionately, press the Shift key and drag on a corner handle with the Layer Adjuster tool to resize as many times as needed to get just the result you want.

If you're compositing large files, you may want to work with each component file separately, and then make a reference layer by importing the image (with its layer mask, if you like) into your composite file using File, Place. When the positioning and transformations of the imported layer are complete, convert the reference layer to an image layer by choosing Convert to Default Layer from the Layers palette menu.

Rick Kirkman created Postal Cat *by drawing shapes, and then converting them to image layers so that he could paint on them. Turn to page 215 to read about his technique step by step.*

Set Shape Attributes

Name: Oval 2

☐ Stroke

Opacity: ◄━━━━━━━━━━◯► 100%
Width: ◄◯━━━━━━━━━► 3.0

Miter limit: ◄━━━━━━━━◯► 7.0

☑ Fill

Opacity: ◄━━━━━━━◯━━► 75%

General:
Flatness: ◄◯━━━━━━━━► 1

[Set New Shape Attributes]

(Cancel) (OK)

The opacity of a shape's fill can be set in the Set Shape Attributes dialog box (Shapes, Set Shape Attributes).

WHOLE SHAPE SELECTION

To select an entire unfilled shape path, choose the Shape Selection tool (hollow arrow), press the Ctrl/⌘ key to put it in Whole Shape Selection mode and click on the shape's outline to select all of its anchor points at once, making it possible to move the shape to a new location, undistorted, by dragging anywhere on its outline.

To rotate a reference layer interactively, press the Ctrl/⌘ key and drag a corner handle with the Layer Adjuster.

To skew a reference layer interactively, press the Ctrl/⌘ key and drag one of the original four middle handles with the Layer Adjuster tool.

To turn a reference layer back into an image (pixel-based) layer, choose Convert to Default Layer from the pop-up menu on the right side of the Layers palette, switch the Transform tool, or paint or apply an effect to the reference layer, clicking the Commit button when prompted. If you drag a reference layer into the Image Portfolio palette, the full-resolution version is stored in the Portfolio.

WORKING WITH SHAPES

Shapes can be drawn with the Rectangular or Oval Shape tool, or the Pen or the Quick Curve tool. Or they can be made from a selection (converted from a selection using the Select, Convert to Shape command) or imported from a PostScript drawing program such as Adobe Illustrator (this process is described in Chapter 5).

Before modifying a shape, you need to make it active. You can activate a shape just as you would a layer—by clicking its name in the Layers palette, or by clicking it with the Layer Adjuster tool, with Auto Select Layer turned on in the Property Bar. Or use the Whole Shape Selection tool (solid arrow, the Shape Selection tool with the Ctrl/⌘ key held down) to select the entire shape so you can move it as a unit, without distorting it, by dragging anywhere on its outline.

To drag off a copy of a shape, you can select the shape with the Layer Adjuster tool, and then press Alt/Option and drag.

To scale a shape proportionately, click it with the Layer Adjuster, hold down the Shift key and drag a corner handle.

To rotate a shape, click it with the Layer Adjuster, press the Ctrl/⌘ key and drag a corner handle.

To skew a shape interactively, click it with the Layer Adjuster, press the Ctrl/⌘ key and drag a middle handle.

To scale, distort, rotate or flip a shape, select it in the Layers palette and use one of the choices from Edit, Transform.

To duplicate a shape and transform the copy, choose Shapes, Set Duplicate Transform. Set up specifications in the Set Duplicate Transform dialog box and click OK. Now choose Shapes, Duplicate, and the transformation and will be applied to the copy.

To modify the stroke and fill attributes of a shape, select it and open the Set Shape Attributes dialog box by choosing Shapes,

For this restaurant logo, we drew black calligraphy letters on the canvas using the Brush tool set to the Calligraphy variant of the Calligraphy brush in the Brush Selector Bar. We made a luminosity mask by choosing the New From command from the Channels palette's triangle pop-out menu and choosing Image Luminance in the New From dialog box. Then we loaded the selection (Select, Load Selection, Alpha 1), and converted the selection to shapes (Select, Convert to Shape). The client planned to use the logo in a variety of ways, so we appreciated that Painter automatically created compound shapes to make the counters transparent for the letter "O," the two descending "g" shapes and the "e." Seen here are the selected filled shapes (top), and the logo applied onto Koa wood texture (bottom) from an ArtBeats Wood and Paper CD-ROM. To read more about compound shapes, turn to "Making a compound," on the next page or to "Using Shapes," in the Painter 11 Help.

Set Shape Attributes or by double-clicking on the name of a shape in the Layers palette. To use the color wheel, *double*-click the Stroke or Fill color swatch in the Set Shape Attributes dialog box.) **A word of warning:** If you paint on, or apply an effect to, a shape—rather than simply changing its stroke and fill—Painter will automatically generate a new image layer above the shape. If you'd like to paint directly on a shape, first convert it to an image layer by choosing Shapes, Convert to Layer.

To convert several shapes into individual image layers, you can Shift-select multiple shapes in the Layers palette and convert the shapes to image layers all at once—as long as they are stroked or filled—using Shapes, Convert to Layer.

To make a single image layer from several shapes, first Shift-select the shapes, and then click the Layer Commands button on the left at the bottom of the Layers palette to access the pop-up menu, and choose Group. With the group closed (controlled by the arrow to the left of its name in the Layers palette), choose Shapes, Convert to Layer.

To duplicate, move or transform a group of shapes, you can select the group by clicking its name in the Layers palette and then move or transform it as you would a single shape. (See "Organizing with the Layers Palette" on page 212 to read more about groups.)

To move an individual shape within a group, expand the group by clicking the arrow to the left of the group's name in the Layers palette. Then click the name of the shape you want to move, choose the Layer Adjuster tool and drag the shape; or click it and move it using the arrow keys.

(See "Organizing with the Layers Palette" on page 212 to read more about groups.)

To automatically fill or stroke a shape with the Current Color chosen in the Colors palette as you draw it, set up your Shape preferences: Choose Preferences, Shapes from the Edit menu (for Windows) or from the Corel Painter 11 menu (for Mac OS X); check the appropriate check boxes and click OK.

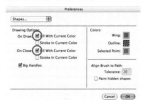

Setting up the Shape Preferences to automatically fill with the Current Color

You can rasterize PostScript art from Illustrator in Painter and at the same time save a mask for selecting that area later. Choose File, Acquire, Adobe Illustrator File to import the art as shape layers. Target each resulting shape in the Layers palette and convert it to an image layer using Shapes, Convert to Layer. To flatten the image and make a mask, target each layer by choosing its name in the Layers palette, use the Drop and Select command in the Layers palette's pop-out menu. To store the selection for use later, choose Select, Save Selection and save it as a mask in the Channels palette.

Viewing shape paths (top) and finished objects (bottom). For this filled compound outer object with blended interior object, we began by making a blend. To blend the blue circle with a very small white circle in its center, we selected both circles in the Layers palette, and then chose Shapes, Blend and specified 50 steps. To build the compound of the two outer shapes, we Shift-clicked in the Layers palette to target them both and chose Shapes, Make Compound. The Make Compound command cut a hole with the smaller eye shape, allowing only part of the fill of the outer shape to be visible.

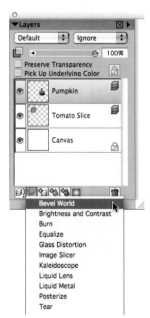

Clicking the "plug" icon on the Layers palette will reveal the Dynamic Plug-ins menu.

Blending between shapes. To create intermediate shapes between two shapes, Shift-select both shapes in the Layers palette and choose Shapes, Blend. Make choices in the dialog box and click OK. "Blending Shapes" in the Painter 11 Help contains a concise explanation.

Here's a useful application for Painter's Blend command: If you've imported an image created in Illustrator that has blends but they don't make the transition successfully into Painter, zoom in and count and then delete the interior objects inside the blend using the Shape Selection tool and Delete key. Shift-select the two remaining outside objects in the Layers palette, and then choose Shapes, Blend and specify the number of steps to regenerate the blend.

Making a compound. To cut a hole in a shape and reveal the underlying image, make a compound using two shapes: Move a small shape on top of a large one, Shift-select both of them in the Layers palette and choose Shapes, Make Compound. The top shape will cut a hole in the bottom shape to reveal the underlying image. Compounds are made automatically to create counters in letters when type is set or when type outlines are imported, and also when selections with holes are converted to shapes.

USING DYNAMIC LAYERS

Dynamic layers are special devices that allow you to create a variety of effects. To keep dynamic layers "live" (allowing changes to be made and previewed on the image without becoming permanent), the file can be saved only in RIFF format. Saving in Photoshop format converts the dynamic layers to image layers, freezing the effects in their current state.

Dynamic layers, which are indicated by a plug icon in the Layers palette, fall into three basic categories. The first kind is similar to an adjustment layer in Adobe Photoshop. It allows you to set up a procedure such as a brightness-and-contrast correction or a posterization of the underlying image, without permanently changing the pixels of the image itself. Image

AUTOMATIC DROP SHADOWS

To apply a drop shadow to a single shape, select the shape in the Layers palette and choose Effects, Objects, Create Drop Shadow. Enter your own specifications, or just click OK to accept Painter's defaults. When the Commit dialog box appears, asking if you'd like to commit the shape to an image layer, click Commit. Selecting a closed group of shapes and choosing Effects, Objects, Create Drop Shadow will apply an automatic drop shadow to each of the individual shapes in the group and will convert the shapes to image layers as well! To convert a group of shapes to a single image layer and make an automatic drop shadow for the new layer, begin by closing the group (click the arrow to the left of the group's name closed). Then select the group's name in the Layers palette, click the Layer Commands button to access the menu, choose Collapse Layers and click Commit All. Then choose Effects, Objects, Create Drop Shadow, and apply the shadow.

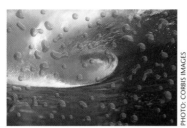

Cool Water Drops. To add a water droplet effect to this photo (simulating water drops on a camera lens), we used the Liquid Metal dynamic plug-in. First we made a clone of the image (File, Clone). Then we clicked the Dynamic Plug-ins button on the Layers palette and chose Liquid Metal from the menu. We chose the Clone Source Map type and a high Refraction setting to make the "water" translucent with a blue reflection. Then we clicked and dragged with the Circle tool from the Liquid Metal dialog box to place the drops. A drop can be extended simply by starting to drag with the Circle tool inside the edge of the existing drop.

Detail from Hot Beveled Metal. *Beginning with a text layer, we used a Bevel World Dynamic Plug-ins layer to commit the live text to an image layer and to create a 3D effect. Then we layered two more copies of the bevel—we painted on the first copy and we created the glow using the second copy. To learn more about type effects using Bevel World, turn to Chapter 9.*

correction tools such as Equalize, Brightness and Contrast, and Posterize, as well as special effects layers such as Glass Distortion, Kaleidoscope and Liquid Lens fall into this "adjustment" category. To generate a Posterize layer, for example, click the Dynamic Plug-ins button at the bottom of the Layers palette and choose Posterize from the pop-up menu. Click OK to apply it. The posterization will apply to all image layers, reference layers, shapes and dynamic layers listed below the Posterize dynamic layer in the Layers palette, so if you want it to apply to only certain layers, you can drag it down in the Layers palette. (To read more about Painter's image-correction layers, turn to Chapter 7. For information about creating special effects with this series of dynamic layers, refer to Chapter 8.)

For a second kind of dynamic layer, you choose an image layer and apply a special effect procedure to the selected image layer, the "source image layer," *turning it into* a dynamic layer. The dynamic layer is "live," so you can preview changes and then modify the effect and preview again, or even return the source image layer to its original condition if you choose. Three of the dynamic layers—Bevel World, Burn and Tear—require a source image layer to perform their magic. To make this kind of dynamic layer, activate a layer in the Layers palette and choose Bevel World, for instance, from the Dynamic Plug-ins menu. Make adjustments to the settings and click OK. (If you start with a selection on the image Canvas, clicking Apply will automatically generate a new dynamic layer from the selection.) Read more about these dynamic layers in Chapter 8.

The third type of dynamic layer allows you to build special-effects imagery on a new layer. Liquid Metal falls into this category. To read about exciting techniques using Liquid Metal, turn to Chapter 8, "Exploring Special Effects," and to "Painting with Ice" on pages 334–335 in Chapter 9.

To change a dynamic layer's appearance, double-click its name in the Layers palette, make changes to the settings in the dialog box and click OK.

To convert a dynamic layer to an image layer, so you can add a layer mask or convert the image layer into a reference layer (to scale it, for instance), click the triangle in the Layers palette's upper-right corner and choose Convert to Default Layer from the menu. The following actions will also convert a dynamic layer to an image layer: transforming using the Transform tool (to scale, rotate or distort); applying an effect from the Effects menu (such as Effects, Surface Control, Apply Surface Texture); painting on the layer; applying a dynamic layer special effect (such as applying the Tear special-effect layer to an active Burn layer) or merging a group that includes a dynamic layer.

Janet Smart used Watercolor brushes and their special layers and Digital Watercolor paint on layers to paint Pelican.

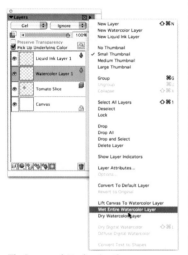

The Layers palette showing the pop-up menu that includes important commands for use with Liquid Ink and Watercolor layers.

John Derry created Capitola *using Liquid Ink layers.*

USING TEXT LAYERS

When you select the Text tool in the Toolbox and begin to set type on your image, the type is set on a new layer that appears in the Layers palette, designated by a "T" icon. Controls for specifying text settings are located in the Property Bar. For in-depth information about using Text layers, turn to Chapter 9, "Working with Type in Painter."

WORKING WITH MEDIA LAYERS

Painter includes two media layers, Watercolor and Liquid Ink. Special brushes must be used to paint on each kind of media layer. When the Canvas or an image layer is selected in the Layers palette and you attempt to paint with a Watercolor brush or Liquid Ink brush on any other kind of layer, a new Watercolor or Liquid Ink layer is automatically generated. Chapter 3 includes in-depth information about Watercolor and Liquid Ink, including "A Painter Watercolor Primer" and "A Painter Liquid Ink Primer" as well as step-by-step techniques for using both media.

Using Watercolor layers. Painter offers Watercolor layers and special Watercolor brushes, making it possible to add wet color on separate layers. Watercolor layers can be edited using selections to restrict the changes to the selected area. A Watercolor layer can also have a layer mask, which can be edited by clicking on the layer mask thumbnail in the Layers palette and targeting the mask in the Channels palette, and then editing the mask. (You'll have to choose a different brush to edit the mask, because Watercolor brushes don't work on masks.) For a step-by-step technique for using selections with Watercolor layers, turn to "Mixing Media on Layers" on page 226.

Using commands found in the triangle pop-out menu on the right side of the Layers palette, you can stop paint from diffusing on a Watercolor layer by choosing Dry Watercolor Layer, and you can re-wet a Watercolor layer by choosing Wet Entire Watercolor Layer. Or you can add the content of the Canvas to a Watercolor layer as wet paint, or create a new Watercolor layer if none is active, by choosing Lift Canvas to Watercolor Layer from the Layers palette menu.

Using Liquid Ink layers. Liquid Ink is a thick, viscous ink medium. A Liquid Ink layer is not pixel-based but resolution-independent. To paint on a Liquid Ink layer, you must use special Liquid Ink brushes found in the Brush Selector Bar. (Choosing a Liquid Ink brush and painting automatically creates a new Liquid Ink layer except when a Watercolor layer is active.) A Liquid Ink layer can have a layer mask. To constrain paint to a specific area, make a selection and then target the Liquid Ink layer before painting. For more information about Liquid Ink, see "A Painter Liquid Ink Primer" on page 120 in Chapter 3.

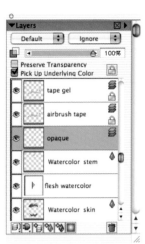

In the Layers palette (above), for Delro Rosco's Apple *illustration on page 224, he organized some layers in groups and locked other items so he wouldn't accidentally select them with the Layer Adjuster.*

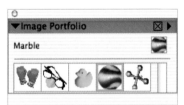

Create an empty image portfolio by opening the Image Portfolio palette (Window, Show Image Portfolio) and choosing Image Mover from the pull-down menu, opened by clicking the triangle on the right side of the Image Portfolio palette bar. In the Image Mover, click the New button to create an empty portfolio, name it and then save it into the Painter application folder. Drag items from the current Image Portfolio into your new Image Portfolio. (To learn more about using Painter's movers and libraries, turn to Chapter 1.)

ORGANIZING WITH THE LAYERS PALETTE

In the Layers palette, Painter assigns sequential names to layers and shapes (such as Layer 1, Layer 2 and so on) in the order they were created. Rename them by double-clicking on a name (or click on the name and press the Enter key) to bring up the appropriate dialog box. Enter the new name and click OK.

So that you can more easily work with underlying items, you can hide layers or shapes by clicking to close the eye icons next to their names. Click the eye open to show an item again.

To lock an item (making it impossible to select it in the image window, even with Auto Select Layer turned on), target the layer in the Layers palette and click the lock icon near the top of the palette. To unlock, click the lock icon again.

Using groups. Grouping layers or shapes is an ideal way to organize related elements in the Layers palette so the palette doesn't take up so much space on the screen. To group layers or shapes, Shift-select the elements in the Layers palette, and then click the Layer Commands button at the bottom of the Layers palette and choose Group, or press Ctrl/⌘-G. To ungroup, click the Layer Commands button and choose Ungroup, or press Ctrl/⌘-U. If you want to apply effects (other than Scale, Rotate, Flip or Create Drop Shadow) to a group of layers or shapes, you'll need to open the group, select individual items and then apply the effect. Like individual layers, groups can be hidden or made visible by clicking the eye icon, and they can also be locked.

Using the Image Portfolio. Open the Image Portfolio palette by choosing Window, Image Portfolio. To store a copy of an element for later use or for use in another file, hold down the Alt/Option key and use the Layer Adjuster tool to drag it from the image window into the Image Portfolio palette. (To remove the element from the current file as you store it in the Portfolio, use the Layer Adjuster without the Alt/Option key.)

PRESERVE TRANSPARENCY

By turning on the Preserve Transparency check box in the Layers palette, you can confine your painting and editing to those areas of an image layer that already contain pixels. Turn Preserve Transparency off if you'd like to paint or edit outside the existing pixels—for instance, to feather the edge by applying the Effects, Focus, Soften command, which would spread pixels outside of the original area. Preserve Transparency is not available for Liquid Ink, Text or Watercolor layers.

AUTO-SELECTING A LAYER

By choosing the Layer Adjuster tool and turning on Auto Select Layer in the Property Bar, you can click on the visible portion of any layer to select the layer and drag to move its contents.

If you've finished making changes to a group of image layers but you still want to keep the group separate from the Canvas, consider clicking the Layer Commands button at the bottom of the Layers palette and choosing Collapse. This feature merges an active closed group of image layers into a single pixel-based layer and can be a real memory-saver.

Africa 1 is one in a series of six paintings, Africa and Life, created by Michele Del Degan. To begin the works, she used conventional acrylics paint on canvas and watercolor on paper. Then she scanned the paintings to bring the imagery into Painter. She used layers, layer masks and the Multiply Composite Method to combine the elements. To unify the work and add details, she painted with the Soft Charcoal variant of Charcoal.

Caution: Using the Eraser tool (Toolbox) or the Eraser variant of the Erasers brush permanently removes the erased information from the layer. But adding a layer mask and editing it using black paint is much more flexible, because you can also restore the image by painting the layer mask with white. Use *black* on the mask to *hide* the layer, and use *white* on the mask to *restore* the layer's visibility. (For more information about layer masks, see "Melting Text Using Layer Masks" on page 224.)

LAYERS AND THEIR MASKS

Layer masks allow for transparent effects. You can edit layer masks using either brushes or special effect commands (such as Effects, Surface Control, Express Texture, with which you can apply a texture to a mask). To view a layer mask, target the layer in the Layers palette; then make sure the Layer Mask is also targeted in the Channels palette. For more information, see the "Dropping and Saving a Layer Visibility Mask" tip on this page.

Importing a source file with an alpha channel. Because it's faster to work with fewer layers, many artists assemble pieces of artwork in source files and then import the pieces into a final composite file. Consider preparing a mask in a smaller source file that you plan to import into a composite (using File, Place) and storing the mask in the Channels palette. When you import the file, in the Place dialog box, check the Retain Alpha check box, and click OK to place the source as a reference layer in your document. The imported layer will include the transparency created by the alpha channel mask. To turn the reference layer into an image layer, select it in the Layers palette and switch to the Transform tool in the Toolbox. (For more information, see "Using Reference Layers" on page 206.)

COMPOSITE CONTROLS

Painter's composite controls can give you nifty special effects with very little effort. With a layer selected in the Layers palette, choose from the Composite Method pop-up menu on the Layers palette. The options include many of the same blending modes found in Adobe Photoshop, which are listed below the ones that are unique to Painter. (Not included are Photoshop's Color Dodge, Linear Dodge, Color Burn, Linear Burn, Exclusion, Vivid Light, Linear Light and Pin Light.) "A Visual Display of the Composite Methods" on the next page shows these controls in action.

If you'd like to use a layer mask to make a selection on another layer or on the background Canvas to constrain paint or effects there, here's a way to trade masks back and forth: To copy a layer mask so it becomes a separate mask in the Channels palette, target the layer in the Layers palette, and then in the Channels, target the layer mask. Choose Duplicate from the Channels palette's pull-down menu. In the Duplicate Channel dialog box, choose "New" to create a new mask based on the layer mask, and click OK. Now you can activate any layer in the Layers palette and use Select, Load Selection to use the new mask on that layer.

To merge the visible part of an image layer so it becomes part of the image Canvas but at the same time store its transparency mask, choose Drop and Select from the Layers palette's pull-down menu. A selection will be made from the transparency mask, and you can save it as a mask in the Channels palette by choosing Select, Save Selection.

We applied one of Painter's Composite Methods to each of these marbles floating over a blue-and-white background. The top marble uses Gel and the bottom one uses Reverse-Out.

You'll find Painter's Composite Depth pop-up menu near the top of the Layers palette, to the right of the Composite Method menu. Painter's Composite Depth controls work only on impasto paint (see "A Painter Impasto Primer" on page 114 for more information about Impasto). The default Composite Depth method is *Add*. If you paint with an Impasto brush on a layer, *Add* raises the thick paint. *Ignore* turns off the thickness for the paint on the layer, and *Subtract* inverts the paint thickness on the layer, making brushstrokes on this layer excavated rather than raised on the surface. *Replace* changes the paint depth of Impasto on the underlying layer to the applied layer's depth wherever the layers overlap.

A VISUAL DISPLAY OF THE COMPOSITE METHODS

Painter's Composite Methods (from a menu at the top of the Layers palette) change how a layer interacts with the image underneath. Here a leaf floats over a two-part background. The Default and Normal methods give the same results, as do Shadow Map and Multiply. For complete descriptions of what the modes are doing, refer to Painter's Help.

 Default / Normal

 Gel

 Colorize

 Reverse-Out

 Shadow Map /Multiply

 Magic Combine

 Pseudocolor

 Dissolve (50%)

 Screen

 Overlay

 Soft Light

 Hard Light

 Darken

 Lighten

 Difference

 Hue

 Saturation

 Color

 Luminosity

Gel Cover

Working with Shapes and Layers

Overview *Draw Bézier shapes in Painter; fill and name the shapes; convert the shapes to layers; paint details on the layers with brushes; add and edit layer masks to achieve transparency; apply textured special effects with Color Overlay, Surface Texture and Glass Distortion.*

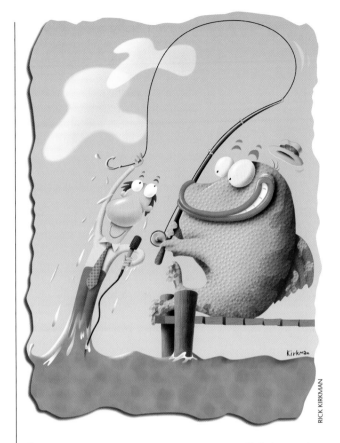

RICK KIRKMAN

1

Kirkman's scanned pencil sketch

2a

Setting the Shapes preferences

SHAPES BRING POWER AND VERSATILITY to Painter, saving many illustrators a trip to a drawing program to create Bézier paths for import. With Painter's Pen tool (now similar to Illustrator's) you can completely create and edit Bézier paths, add a stroke and fill, name them and organize them in the Layers palette. After you draw shapes, you can convert them to pixel-based layers and add paint and special effects.

1 Setting up a template. Kirkman began by scanning a pencil sketch, saving it as a TIFF file and opening the scan in Painter. The file measured 2374 x 3184 pixels.

2 Creating shapes. To create your outlines, you can work either in Painter or in a PostScript drawing program. If you plan to trace a template—as Kirkman did—set up shape attributes so that you can draw with a precise skeletal line. For Windows, choose Edit, Preferences, Shapes, or for Mac OS X choose Corel Painter 11, Preferences, Shapes, and choose these settings: Under "On Draw," uncheck the Fill and Stroke check boxes; under "On Close," uncheck the Stroke check box and check the Fill check box; click OK. Using the Pen tool to draw Bézier shape paths, Kirkman carefully traced his sketch. Before he started drawing each shape, Kirkman clicked the Fill swatch in the Property Bar and chose a color close to the color

2b

Choosing a color before drawing the "nose" shape with a flesh color

2c

Dragging with the Ctrl key held down to adjust a control handle on a path while drawing.

2d

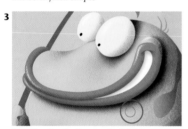

The color filled shapes

3

Painting the shadow on the fish's body using the Digital Airbrush variant

4

The layer mask for the "R piling" layer is targeted in the Layers palette. The heavy black border around the thumbnail shows that the mask, not the image, is targeted.

he would finally use, so the shape would fill with the color when he completed the path. To make adjustments on the fly while drawing a path with the Pen tool (like adjusting a control handle or anchor point), press the Ctrl/⌘ key to temporarily switch to the Shape Selection tool.

As soon as he had created each shape, he double-clicked its default name in the Layers palette and renamed it. As he worked, he adjusted the opacity of the shapes (using the Opacity slider near the top of the palette), so he could see the layers below more clearly. When his color-filled shapes were complete, Kirkman Shift-selected them in the Layers palette and chose Shapes, Convert to Layer.

3 Shading individual layers. To constrain your painting to stay within the edge of the element on a layer, turn on Preserve Transparency in the Layers palette. To paint on an individual layer, target it in the Layers palette. To create a grainy look (similar to colored pencil on kid-finish illustration board), Kirkman chose Basic Paper texture in the Paper Selector (Toolbox) and added shading to the clothing using the Brush tool with the Fine Spray variant of the Airbrushes. For a smoother look on the man's skin and eyes, he added strokes with the Digital Airbrush variant. Overlapping elements on the layers helped Kirkman create the cast shadows. For example, to paint the shadow under the fish's lips, he targeted the underlying body layer and then airbrushed the shadow directly on it.

4 Editing layer masks. Kirkman added and edited a layer mask on the layer he called "R piling" to achieve a transparent look. To achieve transparency—like Kirkman's—on your layer: Target the layer in the Layers palette, and then click the Create Layer Mask button at the bottom of the palette. Click on the new layer mask's thumbnail to target the mask. Next, choose black in the Colors palette, choose a the Digital Airbrush variant of Airbrushes and carefully paint into the mask to partially hide the layer. (See "Melting Text Using Layer Masks" on page 224 for a more detailed description of this technique.)

5 Adding details, texture and an irregular edge. Kirkman added the pattern to the tie using Effects, Surface Control, Color Overlay, Using Paper to apply the Op texture (Painter 11 application folder, Extras, Paper Textures, Crazy Textures). To add details to the water, he used Color Overlay to apply a colored texture using Globs from Wild Textures 2 (Painter 11 application folder, Extras,

NAMING AND FILLING SHAPES

To name and add a colored fill (or stroke) to a shape, with the Colors palette open (Window, Show Colors) double-click on the shape's name in the Layers palette. Rename the shape in the Set Shape Attributes dialog box and check the Fill (or Stroke) check box. With the Fill (or Stroke) color swatch active (outlined by a black and gold box), click in the Colors palette. (You can use the Color Sets palette instead of the Colors palette if you like.)

5a

Kirkman targeted the "fish body" layer in the Layers palette before choosing Apply Surface Texture to add texture to the fish's body.

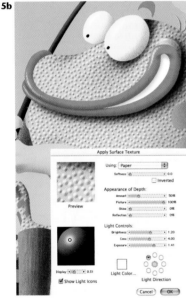

5b

Using Apply Surface Texture to add the 3D texture to the fish

5c

Adding dimension to the fish's teeth by airbrushing along a selection edge

Paper Textures), scaling it larger using the Scale slider on the Papers palette. To add more interest to the water, he added Effects, Focus, Glass Distortion, Using Paper with the Blobular texture from Molecular Textures (Painter 11 application folder, Extras, Paper Textures).

Using Effects, Surface Control, Apply Surface Texture, Using Paper, he applied a 3D texture to the fish with Random Bubbles (Molecular Textures). He used these approximate settings: Softness, 1.0; Amount, 50%; Shine, 0; leaving other settings at their default values.

The final embellishments he added were the man's mouth, the fish's teeth and the separation of the man's pant legs. To paint these details, Kirkman drew on his many years of experience as a traditional airbrush artist using a technique very similar to traditional airbrush friskets. Using the Pen tool, he drew a shape for each element and converted each shape to a selection by choosing Shapes, Convert to Selection. To save each selection as a mask in the Channels palette after he had converted it, he chose Select, Save Selection. When he wanted to use a selection as a frisket, he chose Select, Load Selection and then chose the appropriate mask from the Load From pop-up menu. When loaded, each active selection acted like a traditional airbrush frisket. For instance, to paint the fish's teeth, he targeted the layer containing the teeth, loaded a selection and then airbrushed along the edges of the selection, letting the selection create the hard edge where he needed it. He let the spray from the Airbrush fade out across the selected area. This technique added more dimension and created a rounded, cushiony effect.

Finally, Kirkman created an irregular edge for the background. He used the Lasso to make a loose, freehand selection on the background canvas and turned the selected area into a layer. (Drag with the Lasso to select and then click with the Layer Adjuster.) After the area was on its own layer, he targeted the canvas again (click on the Canvas name in the Layers palette) and turned it white (Ctrl/⌘-A, then Delete), to create a white border area. Then he clicked on the new layer he had made and dragged it to the bottom of the layer hierarchy just above the white Canvas to serve as a background element, and he renamed it Sky. To give the sky layer a smooth edge, he added a layer mask (using the process described in step 4) and feathered the mask 3 pixels by targeting the layer in the Layers palette, then targeting the layer mask in the Channels palette, and choosing Feather from the palette's pull-down menu (accessed by clicking the triangle in the top-right corner of the Channels palette). After he had feathered the edge, he added a drop shadow based on the Sky layer by choosing Effects, Objects, Create Drop Shadow. To flatten the image, he dropped all layers (choose Drop All from the Layers palette's pull-down menu). 🖑

Painting on Layers

Overview *Make practice sketches; set up a reference layer and build a canvas "ground"; sculpt the forms of the head on a layer using tone and color; add transitional tone and detail; apply a canvas texture to the painted layer.*

1

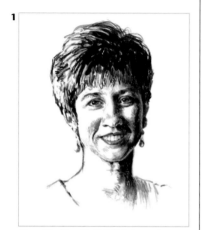

One of the "practice" digital charcoal sketches painted with the Charcoals variants

2a

The Layers palette with the reference layer active and at a lower opacity

2b

The reference layer at low opacity (left), and the sketch on "canvas" made with the Captured Bristle variant of Acrylics (right)

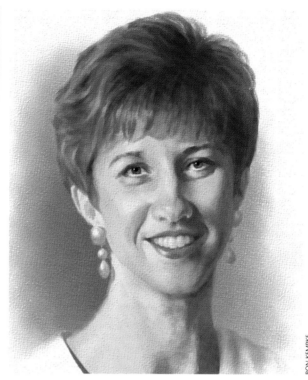

RON KEMPKE

YOU CAN USE PAINTER'S LAYERS, BRUSHES AND TEXTURES to create a realistic simulation of oil or acrylic paint. Ron Kempke produced *Portrait of Cindy* by painting on layers on top of a canvas "ground."

1 Assembling references and making practice sketches.
Kempke clamped a reference photo to his monitor, so he could easily refer to it when he needed to. He prefers not to clone or to do too much tracing because drawing by hand using the stylus keeps his brushstrokes freer and more expressive. Carefully studying his reference photo, Kempke drew several charcoal sketches in Painter just as a "warm up," working until he had achieved a good likeness of his subject.

2 Setting up layers and sketching. Kempke began his painting much as a portrait painter might do. But instead of projecting his painting onto a working canvas, he used a 1200 x 1400-pixel scan of his photo at reduced opacity in Painter. To set up your onscreen reference, open your scanned image and open the Layers palette (Window, Show Layers). To reduce the opacity of the photo, choose Select, All, and then Select, Float. This lifts the image to an image layer, leaving a white canvas underneath. By moving the Opacity slider near the top of the Layers palette, you can fade the reference photo.

Next, Kempke used a rough canvas texture to add the look of canvas before he started to paint. To build such a canvas "ground," target the Canvas in the Layers palette. Apply the canvas paper

3a

The shadow shapes are blocked in over the sketch.

3b

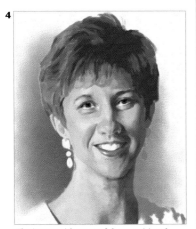

The shadow and midtone shapes are more developed in this example.

4

The image with most of the transitional tones and details added

texture to the image as follows: Open the Paper Selector by clicking the top-left square in the group of six at the bottom of the Toolbox and choose Coarse Cotton Canvas texture from the papers menu. Choose Effects, Surface Control, Apply Surface Texture, Using Paper. For a subtle canvas effect, reduce the Amount to approximately 20% and Shine to about 10% and leave the other settings at their defaults (Softness, 0; Picture, 100%; Reflection, 0; and Light Direction, 11:00).

Kempke created his painting on a layer above the reference so he could work without disturbing the reference. (To add a new layer, click the New Layer button at the bottom of the Layers palette.) He planned to apply surface texture to the brush work on the layer when he finished it, using settings to perfectly match the texture on the Canvas.

Kempke chose a neutral gray in the Colors palette and sketched using a modified version of the Captured Bristle variant of Acrylics. He mapped out the proportions of the head with perpendicular lines to locate the eyes, nose and mouth. He occasionally compared the proportions of his drawing with the reference photo on the layer below, toggling the visibility of the reference layer on and off as he worked by clicking the "eye" icon to the left of the layer name. After he was satisfied with the proportions, he deleted the reference layer by targeting it in the Layers palette and clicking the Delete button. (The photo clamped to his monitor was still available for reference if he needed it.)

3 Adding color and shadow. Kempke sculpted the solid form of the head with simplified shapes of the shadow colors using the Captured Bristle variant. He painted midtones, and then blocked in shadow colors in flat tones for the larger masses.

Next, he added transitional tones in the areas between light and shadow. He painted these in flat tones also, resisting the temptation to blend them with the shadow colors. These transitional tones are among the most intense colors in the portrait.

4 Refining the portrait and adding texture. Kempke added the highlight areas in the face and hair, using broad strokes of color to loosely indicate the features. To bring the head forward by suggesting the space behind it, he added a medium-dark background. Then he added depth and sheen to the hair and loosely suggested the teeth. In areas where he felt there was too much contrast, he added transitional tones and softened edges using a low-opacity brush. (Move the Opacity slider, popped out from the Property Bar, to the left to reduce brushstroke opacity.) Kempke also added brighter highlights to the eyes and nose. To complete the painting, he added "canvas" to the painted layer using the Apply Surface Texture process described in step 2.

Collage with Cloning and Brushes

Overview *Create a collage image from a variety of source photos; use point-to-point cloning with multiple brushes; painting portions of each source image on its own layer.*

CAROL BENIOFF

1

The source photographs and scans

2a

The photograph of the lily pond that is captured as a paper texture

2b

The Color Overlay dialog box and Benioff's Custom Color Set

FOR *WISH*, A NARRATIVE COLLAGE, Carol Benioff combined photographic elements by painting on layers using Cloners brushes and custom brushes that incorporate Clone Color.

1 Gathering elements. Benioff began by assembling digital photographs and scanned elements that touched on her childhood—her grandmother Nana at 18, the lily pond from the San Francisco Conservatory of Flowers near her childhood home and wishbones saved from family Thanksgiving dinners. After you have assembled your photos, open a new file (Benioff's measured 4 x 4 inches at 300 ppi). Save the image in RIFF format.

2 Capturing and applying a colored texture. Benioff wanted a monochrome lily pond image, so that it would sit behind the other collage elements and help to unify the elements. To accomplish this, she captured the pond photo as a paper texture that she could use in applying a monochromatic color effect. Choose a photo that you want to use as a texture, and then use the Crop tool to crop a square area of the image. Choose Canvas, Resize to resize it to the same size as your working composite file. Next, select the entire photo image (Select, All). Click the Papers Selector button in the Toolbox, and then click to open the palette's menu and choose Capture Paper. To get semi-transparent edges, Benioff left the Crossfade setting at the default of 16. (Crossfade is designed to blur the transition between the tiles of the paper texture.) Name your texture

2c

The captured paper texture applied as a Color Overlay to the image Canvas

3

The clone crosshair cursor visible on the clone source file (left) and the brush cursor visible on the target file (right)

4

The Glazing Acrylic 20 brush is transformed into a cloning brush by clicking on the Clone Color button (rubber stamp) in the Colors palette.

(Benioff named the paper texture *Lily Pond*). Select it from the list of papers in the Paper Selector. To apply the new paper texture to the Canvas of your image using transparent color, choose a Main Color in the Colors palette (Benioff applied a blue color from her custom Color Set), and choose Effects, Surface Control, Color Overlay. From the Using menu choose Paper, leave Opacity at 100% and click the Dye Concentration button. Then, to lift the image to a layer, choose Select, All and then chose Select, Float.

3 Cloning. With this technique, you select a starting point on your source file and on your target file. As you paint, with your brush on your target file, a crosshair cursor follows, pinpointing where you are painting from in your clone source file. First, create a new layer in your file by clicking on the New Layer button in the Layers palette. Benioff planned to create a layer for each new element in the collage. To keep track of the layers, give each layer a distinct name. Double-click on the layer in the Layers palette to open Layer Attributes, where you can type in a new layer Name. Next, Benioff opened a black-and-white scan of a portrait of herself that was taken when she was a child. To clone, select the Cloner tool in the Toolbox, and the Soft Cloner variant of Cloners in the Brush Selector Bar.) Arrange the two images on your monitor so both are visible, and at the same magnification. With the source image active, press the Alt/Option key and click in the area you want to clone in the source image. A green circle with a number 1 appears, indicating where Painter will start to clone information from in the source image. Next, make the target image active (choosing it from the Window menu). Click in the target file where you want to begin painting. As you paint on the target file, a crosshair cursor moves in sync on the source file. Benioff carefully watched the crosshair cursor to make sure that she picked up only the information she wanted from the source file. This allowed her to paint selectively from her clone source image to her target image *Wish*.

4 Changing an Acrylics brush to a cloning brush. Next, Benioff selected the Glazing Acrylic 20 variant of the Acrylics. To change it into a cloning brush, in the Colors palette, choose Clone Color by clicking on the rubber stamp button. With Clone Color enabled, the Colors palette will gray out. It's a good idea to save your new variant. Choose Save Variant from the pop-up menu on the Brush Selector Bar, name your variant (for instance Glazing Acrylic Cloner and click OK). Then restore the Glazing Acrylic 20 to its original settings by choosing Restore Default Variant from the same menu on the Brush Selector Bar.

5 Cloning images. Now choose the new Glazing Acrylic Cloner brush in the Brush Selector Bar, establish the cloning point on the source image, and then paint in your target image. Benioff used

5a

Cloning with the custom Glazing Acrylic Cloner brush

5b

Cloning with the Glazing Acrylic 20 brush and Soft Cloner brush

5c

Cloning with the Pencil Sketch Cloner brush

5d

Changing the Composite Method of the pond layer to Multiply

6

Detail of the image with the second wishbones layer in place

her Glazing Acrylic Cloner to create light, sweeping strokes that followed the contours and shapes of the clone source photo. To reestablish some of the detail from the clone source photograph, she used the Cloner tool, moving in a light circular motion. Then, she used the Iterative Save function (File, Iterative Save) to save the file in progression.

When you have your first image painted into your working file, close the first clone source and open your second source image. Benioff opened her next source photo, Nana, a photo of her grandmother. Repeat the processes in steps 3 and 5 to add your new image. Create a new layer in the target file. Use the same two cloning brushes, the Cloner tool and the Glazing Acrylic Cloner from step 4 to softly paint from the source photograph. As you paint, follow the contours and shapes of the forms. After you finish painting from one clone source, use the Iterative Save function, saving the file in sequential steps. Benioff created 14 iterative saves.

For the wishbones, Benioff created a new Wishbones layer. She opened her photograph of multiple wishbones on a painted background. This time, she chose the Cloner tool and the Pencil Sketch Cloner variant of the Cloners brushes. Benioff carefully drew with short strokes to paint one of the wishbones from the source file onto the new layer in her target file. Then, she switched to the Soft Cloner variant of the Cloners to add more detail from the wishbones photo.

Benioff envisioned the wishbones fading in and out of the two figures and the pond. To achieve this, in the Layers palette, she selected the Wishbones layer and dragged it below the Pond layer. The wishbone image was now hidden by the pond image. To "see through" the pond image without changing its opacity, in the Layers palette, she changed the Composite Method of the Pond layer to Multiply. Next, she selected the Layer Adjuster tool and with the Wishbones layer active, she repositioned it to overlap both of the figures.

6 Duplicating and arranging layers. To create a second wishbone, Benioff duplicated the Wishbone layer (Layers, Duplicate Layer), and then she named the layer *Wishbones 2*. She used the Layer Adjuster to reposition the second wishbone so that it overlapped the lower half of the woman's dress. Then she enlarged the second wishbone by to 115%, using the Edit, Transform, Scale dialog box.

USING ITERATIVE SAVE

The Iterative Save feature in Painter adds a sequential number after the filename and is useful when saving a file in stages. (Choose, File, Iterative Save.)

QUICK SWITCH TO CLONERS

Click the Cloner tool in the Toolbox to quickly switch to the Cloners brush category in the Brush Selector Bar. The last Cloners brush used will be chosen. To switch to another Cloners brush (for instance the Soft Cloner), choose it from the brush variant list.

7a

Drawing the outline of the orchid with the Sharp Pastel Pencil Cloner (top) and adding detail with the Soft Cloner (bottom)

7b

Rotating the orchid layer using the Free Transform feature

8a

Cloning using the Chalk Cloner variant of the Cloners

8b

The final layers palette for the Wish *image*

9

Two layers with the applied lighting effect

7 Transforming layers. To paint in the orchid blossom, she opened the photograph that contained the orchid. She chose the Sharp Pastel Pencil 3 variant of Pastels, enabled Clone Color on the Colors palette, and used it on a new layer at the top of the layer stack with the cloning technique to draw the outline of one of the blossoms. To paint the interior of the flower, she used the Soft Cloner.

To duplicate the orchid layer, Benioff repeated the same duplicating and arranging steps that she used for the layers in step 6. Then, she selected the Layer Adjuster to move the Orchid 1 layer to overlap the girl's neck. To make the orchid transparent, she set the opacity of the Orchid 1 layer to 90% in the Layers palette. Then, she duplicated the orchid layer (Layers, Duplicate Layer). She named the duplicate layer Orchid 2 and selected Edit, Free Transform, so that she could rotate and scale the image simultaneously.

The Free Transform function retains the quality of an image so that it does not degrade with the transformations. There are eight handles surrounding an image that is in Free Transform mode. To rotate the image, press the Ctrl/⌘ key. To constrain the aspect ratio when scaling the image, press the Shift key as you drag on a corner handle. When Benioff was happy with the size and angle of the Orchid 2 layer, she fixed the changes by selecting Edit, Transform, Commit Transformation. Then, she used the Layer Adjuster to position the second orchid into place on the woman's dress.

8 Adding the blue flower. For the final layer, Benioff opened the photograph of a blue flower. She chose the Chalk Cloner (Cloners), which would reveal the paper grain. For her paper texture, she selected Basic Paper from the Paper Selector. In the *Wish* file, she created a new layer. With both the source photo and the target file visible, she used cloning to draw in the flower. She painted with short, quick strokes and varied the brush size as she worked. If she picked up some of the photo background, she used an Erasers variant to clean up the edges. She used the Edit, Free Transform function to rotate and scale this final layer and then she used the Layer Adjuster to move the Blue Flower layer to the lower-right corner of her image.

9 Applying lighting for more depth. As a last step, Benioff used lighting to give her image more depth. She clicked on the Pond layer in the Layers palette and then chose Effects, Surface Control, Apply Lighting. In the Apply Lighting dialog box, she clicked on the Library button and loaded her custom lighting library. She chose a soft Globe light from the library and clicked OK. She applied the same light to the Blue Flower layer to complete her image *Wish*. 🖌

Melting Text Using Layer Masks

Overview *Use the Text tool to set type over a background; convert the text to selections; float two copies of the type, one to be used as a drop shadow; use feathering, Dye Concentration and a fill to add dimension to the type; add layer masks and paint on them to "melt" the bottoms of the letters.*

CHER THREINEN-PENDARVIS

Converting the Text layer to a default layer

Alt/Option-clicking with the Layer Adjuster on the selection to make the Text layer

Selecting the text Alpha 1 in the Channels palette

YOU CAN ACHIEVE A DRAMATIC TRANSLUCENT EFFECT using Painter's brushes to paint on a layer mask. In the image above, we used the Digital Airbrush variant of Airbrushes on the lower part of two layers—the type and the soft shadow behind it—to create the illusion of type melting into sky and water. You can get a similar result using other backgrounds such as stone or wood.

1 Setting text and converting it to selections. Open an image to use as a background; our photo was 1700 pixels wide. Choose the Text tool and select a bold font and a large point size in the Property Bar. We chose 200-point Arial Black. Open the Layers palette (Window, Layers); you'll be able to see the Text layer appear there when you type. Click the Text tool in the image to place the cursor and begin typing.

To achieve the result in the image above, using the text outlines to float portions of the background, it's necessary to convert the text to a default layer, then to selections. With the Layer Adjuster tool chosen and the Text layer targeted in the Layers palette, choose Convert to Default Layer from the pop-up menu on the right side of the Layers palette. Next, reduce the layer's opacity to 0% using the Opacity slider near the top of the Layers palette; the text will disappear from your image. Choose Drop and Select from the pop-up menu on the right side of the Layers palette; the type will reappear in your image as animated marquees.

To save your selection as a mask so you can use it later, choose Select, Save Selection. Open the Channels palette (Window, Channels) to see the new mask (named Alpha 1).

With the marquee still active (in preparation for making the soft shadow layer), choose Select, Feather; we used 30 pixels. Click OK. Now save this selection as a mask by choosing Select, Save Selection. This mask (named Alpha 2) will appear in the Channels palette.

2 Using selections to make layers. To make the two layers needed for this technique, begin with the active feathered shadow selection (if it's no longer active, you can load Alpha 2 by clicking the Load Channel as Selection button at the bottom of the

2c

The Layers palette after naming the layers

3a

Using Dye Concentration to lighten the text (left) and filling the Shadow layer with a dark blue (right)

3b

The Layers palette showing the Composite Method for the shadow layer set to Multiply

4

Using the Transform tool to skew the shadow

5a

The Text layer mask is selected in the Layers palette.

5b

Using the Digital Airbrush variant on the Text layer's mask (left) and the shadow layer's mask (with the Text layer hidden) to reveal the underlying image

Channels palette). Choose the Layer Adjuster tool, press the Alt/Option key and click on the active text selection to create Layer 1. (Holding the Alt/Option key makes a copy of the selected area, leaving the background intact.) Click on the Canvas to deselect Layer 1. Now load the text selection (Alpha 1) by choosing Select, Load Selection; when it appears, Alt/Option-click on it with the Layer Adjuster tool to create Layer 2. Double-click on the Layer 2 name and rename it "text" in the Layer Attributes dialog box. Do the same for Layer 1, naming it "shadow."

3 Distinguishing the layers. Next, you'll make the Text layer stand out from the background. In the Layers palette, click once on the Text layer to make it active. Now, change the color of the layer by choosing Effects, Surface Control, Dye Concentration, using Uniform Color; we dragged the Maximum slider to 53%. Click OK.

To create a soft, saturated shadow, click on the shadow layer in the Layers palette and enable Preserve Transparency (near the top of the palette). Using the Dropper tool, sample a dark color from your image and choose Edit, Fill, Current Color at 100% Opacity. Click OK. Set the Composite Method of the layer to Multiply.

4 Offsetting the shadow. In the Layers palette, move the shadow away from the bottom of the type by nudging the shadow up and to the right using the arrow keys on your keyboard. To make the type appear to stand at an angle to the background, as we did, skew the shadow: With the shadow layer selected, choose the Transform tool in the Toolbox (nested under the Layer Adjuster). Click the Skew button on the Property Bar and drag the top center handle of the bounding box down and to the right. When you are pleased with the skew of the shadow, click the Accept Transformation button (the check mark) on the Property Bar.

5 Painting into the layer masks. To "melt" the lower portions of the letters into the water, you can add layer masks to both text and shadow layers and use a brush to partially erase the layer masks.

To add each layer mask, target the layer in the Layers palette and click the Create Layer Mask button at the bottom of the palette. Choose the Brush tool with the Digital Airbrush variant of Airbrushes. For more sensitivity, set the Opacity in the Property Bar to 5–9%. Choose black in the Colors palette. Now, click the Text layer's mask in the Layers palette one or two times until a dark border appears around the mask thumbnail to show that it is selected. Brush along the bottom of the letters to make the lower part of the Text layer disappear. If you need to restore part of the text, switch to white paint. To complete the effect, target the shadow layer's mask in the Layers palette and brush black along its bottom. You may find it easier to work on the shadow layer if you hide the Text layer temporarily. In the Layers palette, click the Text layer's eye icon to close it; when you've finished working on the shadow, click the text's eye icon open again. 🐾

Mixing Media on Layers

Overview *Scan a pencil sketch; make masks to constrain paint; lay in color with Airbrushes; paint transparent Watercolor glazes on layers; add final details.*

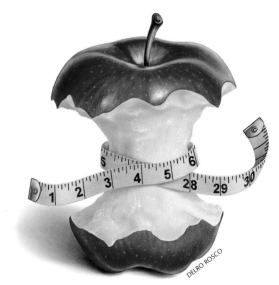

ILLUSTRATOR DELRO ROSCO WAS COMMISSIONED to create this book cover illustration for the *3 Apple-a-Day Plan*, published by Random House. Rosco's work has been honored by the Society of Illustrators of New York and Los Angeles, American Illustration, the National Watercolor Society, and *Print* magazine.

Rosco built selections and masks to limit the "paint" (just as he uses friskets with conventional airbrush) and then he airbrushed flat colored areas. Using the same mask add glazes and interesting paint texture, using the same masks, he painted diffused washes on Watercolor layers above the airbrushed paint. "The Watercolor layers make my work look more like my traditional wash and dry brush paintings, which are done using conventional watercolor on Arches hot press watercolor paper with very fine sable brushes," says Rosco.

1 Sketching and scanning. The art director gave Rosco a proposed layout to use as a starting point for the illustration. Rosco began by sketching with traditional pencil on tissue paper. He scanned the sketch at 100%, at 350 ppi, saved it as a TIFF file and then opened the scanned drawing in Painter.

Scan a sketch or create a drawing in Painter using the Brush tool with Pencils variants. When your drawing is complete, put it on a layer by choosing Select, All and then Select, Float. To keep your image organized, name the layer. Double-click its name in the Layers palette and when the Layer Attributes box appears, name the layer *Sketch*. So that he could use it as a guide while painting, Rosco lowered the opacity of the Sketch layer to about 30%.

2 Making selections and masks. Rosco built hand-drawn selections and masks for elements in his image. To use his technique, choose the Lasso tool (Toolbox) and use it to trace the outline of the drawing. When your selection marquee is complete, save it as a mask into the Channels palette (Select, Save Selection). For detailed information about freehand selections see "Using Hand-Drawn Selections"

1

The scanned pencil drawing

2

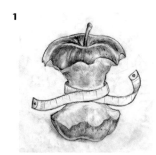

The apple masks in the Channels palette

3

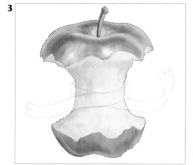

The airbrushed color within the active selection for the apple

4a

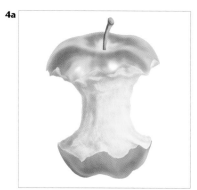

Watercolor washes on the apple's center

4b

Separate Watercolor washes were added on the skin within the active selection.

4c

The Watercolor skin layer selected in the Layers palette

5

The final details on the skin and stem

on page 189. With the mask chosen in the Channels palette, Rosco used the Scratchboard Tool (Pens) to refine the shape of the mask. He used the color white to add to from the mask and black to subtract from the mask. (See "Masks" on page 185 in the beginning of Chapter 5 for information about editing masks.) When he was satisfied with the mask, he named it *Apple Silo* and saved it. He repeated this process for various parts of the illustration.

| RUNNING OUTSIDE |

If the Wind Force is set high in the Water section of the Brush Controls (Window, Brush Controls, Show Water), a runny wash (painted with the Runny Wash Bristle, for instance) may creep outside a selection.

3 Airbrushing on layers. Rosco added a new layer to his image and then used Airbrushes to lay in base colors within selected areas. To make a new layer, click the New Layer button in the Layers palette. To load a selection based on your mask, choose Select, Load Selection and choose your mask. Using the Digital Airbrush variant of Airbrushes, lay in base colors, render the form and depth of your subject, and then save your image as a RIFF file.

4 Painting on Watercolor layers. When the airbrush layers were complete, Rosco built up more color, form and texture by using Watercolor layers. First, he moved the sketch to the top of the Layers palette and used the eye icon to toggle the sketch on as he worked. Load a selection for the area that you want to paint. To lay in soft, smooth washes, use the Wash Camel variant of Watercolor. Brush lightly, following the directions of the forms. For more textured brushstrokes, paint with the Diffuse Bristle, Dry Camel or Dry Bristle variant of Watercolor.

5 Adding final details. To paint over rough areas of color, and to add details and definition, Rosco added a new layer and used the Opaque Round variant of Oils. As he worked, he varied its size and opacity using the sliders on the Property Bar.

When the details were complete, he saved his working image as a RIFF file to preserve the wet Watercolor paint and layers. Then, he used the Digital Airbrush to paint a cast shadow. First, he saved a copy of the image (File, Save As) and dropped the layers (choose Drop All from the Layers palette menu). Then, he used the *Apple Silo* mask from Step 2 to limit paint as he created the drop shadow. Choose Select, Load Selection to load a selection based on the outline mask. The Drawing Modes enable you to paint outside the selection and save the time of creating another mask: In the lower left of the image window, click the Drawing Mode icon and choose Draw Outside, then paint the shadow. (For more information about using the Drawing Modes see page 187 in "Working with Bézier Paths and Selections.") Finally, for the tape measure, Rosco used the Text tool with the Curve Style option to set type on a path. Then, he converted the text to shapes and saved them as selections so that he would use them to limit paint.

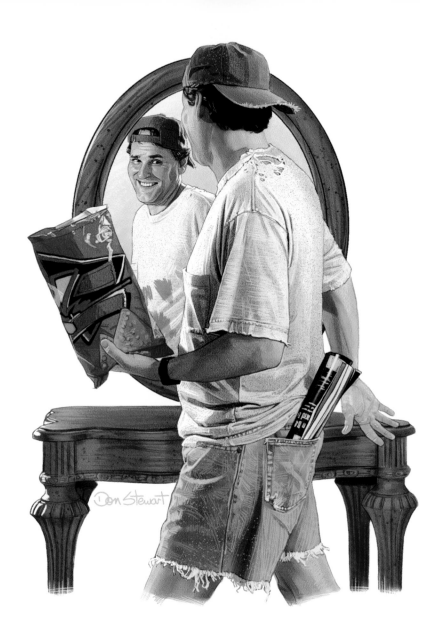

■ **Don Stewart** specializes in book illustration and commissioned portraits. He has extensive experience working with traditional airbrush and colored pencil. Today Don creates his illustrations on the computer, using tools and brushes in Painter that match his conventional tools.

Stewart began *Casual* by sketching in Painter using the Sharp Pencil variant of Pencils on Fine Hard Grain paper texture. Working over the sketch, he isolated areas of the image by making freehand

selections with the Lasso tool (for example, the character's skin and clothing) so that he could limit the paint as he built a monochromatic underpainting. For the underpainting, Stewart used the Wash Camel variant of Watercolor on a Watercolor layer above the Canvas. Stewart added a new layer by clicking the New Layer button on the Layers palette. Working on the new layer, he added more colored paint and blended areas using the Round Camelhair and the Smeary variants of the Oils,

including the Smeary Round brush. For smoother areas (the skin, for example), he painted with the Digital Airbrush variant of Airbrushes. To model forms and build up deeper values, Stewart painted transparent washes using the Simple Water variant of Digital Watercolor. To add final details, he applied highlights using a small Digital Airbrush and the Sharp Chalk variant of Chalk. For subtle texture in a few areas on the clothing, he used the Large Chalk variant of Chalk.

© 2009 *Purnell*

■ Medical illustrator **David Purnell** is the proprietor of the New York West Medical Illustration Studio in Minnesota. *Athero-matous Arterial Plaque* depicts a longitudinal section through an artery, in which there is an atheromatous plaque—a disease process named atherosclerosis, commonly known as hardening of the arteries. The plaque, or atheroma, thickens the wall of the artery and is comprised predominantly of fatty deposits.

To begin, Purnell used the Pen tool to draw vector shapes for every anatomical feature in the image, and then he filled them with flat colors so he could see them as he worked. After drawing them, he grouped them by Shift-selecting their names in the Layers palette and choosing Group from the Layer Commands menu on the Layers palette. Purnell likes to keep the original vector shapes as backups, so he can always return to them if needed during creation of the illustration. To make a copy of the Shapes group, he chose Layers, Duplicate Layer and then he renamed the new group Layers. Then, he hid the original Shapes group. Next, he opened the Layers group, selected each shape one-by-one and converted each one to a default layer by choosing Shapes, Convert to Layer.

For the muscle fibers layer on the artery wall, Purnell targeted the layer and enabled the Preserve Transparency check box on the Layers palette to constrain paint to areas of the layer that already contained pixels. He filled the layer with a dark red-brown base color. Then, he used a custom brush based on the Digital Airbrush variant of Airbrushes and a pink color to paint the muscle fibers. Purnell achieved the stringy muscle texture by using the Wheat String texture from the Wild Textures 2 paper texture library located in the Extras, Paper Textures folder on the Painter 11 CD-ROM. Purnell's airbrush employs the Grainy Soft Cover Subcategory in the General section of Brush Controls, which is sensitive to texture chosen in the Paper Selector.

To paint the yellow layer with small arteries and veins on the artery wall, Purnell filled the layer with a light ochre color. Then, using his custom Grainy Soft Cover airbrush, he painted darker orange textured strokes into the light ochre area. To achieve the look of fatty tissue, he used the Fatty texture from the Biological textures library, also located on the Painter 11 CD-ROM. Purnell painted the small vessels on a new layer (with Preserve Transparency disabled) using a custom Digital Airbrush with strokes of varied thickness. To paint the detailing and shading on the vessels, he used a tiny Digital Airbrush (with Preserve Transparency enabled). He painted the other elements in the illustration on their own individual layers, using various brushes, including the Digital Airbrush and Variable Splatter variants of Airbrushes.

For the guide wire resting in the artery, Purnell used the Pen tool to draw a shape with a black fill. Then, to create the highlight, he duplicated the black shape and changed the fill color of the new shape to white. Using the Layer Adjuster, he scaled the white shape to about half the width of the black shape. Then, he gave the white shape a soft edge by loading the layer transparency mask as a selection (Select, Load Selection) and then transforming it (Select, Transform Selection), contracting it 4 pixels (Select, Modify, Contract) and feathering it 3 pixels (Select, Feather). As a final touch, Purnell added a transparent cast shadow under the guide wire. He duplicated the guide wire layer, filled the duplicate with a gray color and then positioned it below the wire. To add transparency to the shadow layer, he set its Composite Method to Gel in the Layers palette.

■ In **Musical Pears**, artist **Richard Noble** incorporates the virtual world of Painter with the traditional world of old fashioned paper, pens and masking tape to create an intriguing collage. In his collage, Noble masterfully plays the smoothness of the pears against the scans of the rough papers in the background.

To begin his image-making process, Noble gathered a variety of art materials, including several kinds of paper, and masking tape, pastels, acrylics and pencils, as well as tracing paper that he would use to synchronize the various elements in the collage. Then he set up a still life with the pears in his studio and shot reference photographs.

To use as a guide for the still life portion of the work, he made a print of the chosen reference photo on 8½ x 11- inch paper. Then he attached the tracing paper to the print and traced the pears with pencil. Looking through the tracing paper, he positioned the individual sheets of art paper into a composition and taped them into place with masking tape. Then he painted and sketched on the papers with acrylics, pastels and pencils. Next, Noble scanned the painted paper, and the tracing paper sketch and sheet music. He opened the scan of the painted print in Painter and floated a copy of the scan to a layer. Then he copied and pasted the scans of the tracing paper sketch and sheet music with art papers into his working image, and used the Layer Adjuster

tool to arrange the elements into the composition. He blended the elements using layer masks and Composite Methods. When the composition was complete, he made a clone (File, Clone) to quickly create a flat copy of the image.

Working over the composition, Noble used Oils and Airbrushes variants to paint a soft surface on the pears to convey the smooth texture of their skin. To lay in broad strokes, he used the Round Camelhair variant of Oils. To paint details, he used the Round Camelhair (sized smaller) along with a very fine Digital Airbrush variant of the Airbrushes. The sketched detail lines on the skin painted with the tiny Airbrush and the modulated brushstrokes painted with the Oils give the pears their texture.

■ For nearly 20 years, artist **Delro Rosco** has created illustrations for product packaging and print advertising. His work has been honored by the Society of Illustrators of New York and Los Angeles, *American Illustration*, the National Watercolor Society and *Print* Magazine.

Rosco created *Berry Orchard* as feature art on the packaging for a new line of confections for Liberty Orchards. He was inspired to paint a nostalgic scene with golden light. Rosco began by drawing several sketches of the composition using conventional pencil on tissue paper.

When the final design was approved by the client, he scanned the sketch into Photoshop and saved it as a TIFF file. Opening the sketch in Painter, Rosco put the sketch on a layer by choosing Select,

All and then Select, Float. He lowered the opacity for the sketch layer using the slider on the Layers palette. Then, he laid in base colors using the Digital Airbrush variant of Airbrushes. To create more depth and interest, he varied the opacity of the airbrush as he worked, using the Opacity slider in the Property Bar.

When the general areas of color were established, Rosco used Painter's Watercolor layers and brushes to paint glazes and to build up natural-media textures that would enhance the scene. When creating the rows of berry bushes, Rosco found the copying, pasting and layer features helpful. For instance, he painted one small bush and then selected it, copied it and pasted it back into the image as a new layer. He positioned the layer and dropped

it by choosing Drop from the Layers palette menu. Then, he added more paint to blend the tree with the painting.

Rosco added final details to the painting using the Opaque Round variant of Oils, again varying the opacity to simulate transparent and opaque painting with conventional watercolor and gouache.

■ A beautiful terra cotta sculpture provided inspiration for *Woman of Colors* by artist **Joyce Ryan**. The image is a collage that incorporates a photograph of the sculpture with painted brush work, textures and special effects. Ryan began by photographing a life-sized sculpture that she had modeled in terra cotta clay. The sculpture had been fired, and a patina had been applied for a metallic finish.

Ryan likes using experimental color for emotional impact. She created a new file in Painter and drew rough sketches of the sculpture, playing with lines and then combining the drawings with textures. To build rich texture on the painting, she used the versatile Apply Surface Texture feature. She likes to create custom textures using Painter's Papers and Patterns functions. Ryan built complex textures and then applied them to layers in her composite file. (For

information about creating and applying custom paper textures, see "Applying Paper Textures" on page 112 in Chapter 3.)

To add a mysterious mood to her painting, she chose Effects, Surface Control, Apply Lighting and applied a custom lighting effect.

When she was happy with her painting, she opened the photograph of the sculpture. With her painting image active, she added a new layer. Then, she chose File, Clone Source and defined the sculpture photo as the Clone Source. Using Cloners brushes (including the Soft Cloner), she painted the photo image onto the new layer in her painting. To complete her image, Ryan used a variety of brushes to bring out the features. Finally, to enhance the depth of the image, she added a few accents by drawing over the painting with small brushes.

■ Artist **Andrew Jones,** who designs concepts for films and video games, created *Speaker Fist* for DJ Lorin (bassnectar.net).

Speaker Fist depicts the communications of people, sound and revolution in the underground movement. To begin the illustration, he opened a new file and clicked with the Paint Bucket tool to fill the background with a neutral gray color. Then he sketched the composition. When his sketch was complete, he used the Lasso tool to select elements in the composition. He applied light brown colors to the selected areas using the Paint Bucket. Then he proceeded to select and fill other areas with flat base colors. Using Airbrushes and

Colored Pencils, Jones modeled the forms on the figures. He varied the size and opacity of the brushes as he worked. To quickly work out perspective on the speakers and the upraised arms, Jones used the 3D modeling program ZBrush to build the elements. Then using these models for reference, Jones painted the forms on the large upraised fists using Airbrushes, varying the size of the brushes as he worked. He used a low-opacity version of the Airbrush to complete the smooth, detailed modeling on the upraised arms. For more textured strokes, he used variants of the Chalk brushes.

His client had requested that Jones use a particular photograph of a party scene.

To build the crowd element in the midground, Jones copied the photo of people and pasted the image into his drawing as a new layer. He added a layer mask to the layer and then used the Digital Airbrush (Airbrushes) and black paint to paint the layer mask so that it would hide parts of the layer, revealing the arms in front. To complete the noisy background and the tower of speakers, Jones applied several custom paper textures to his painting using the Square Chalk variant of Chalk—for instance, the client's logo in the upper left, the woven textures on the speakers and the electronic textures on the background.

■ Artist **Chet Phillips** created the painting *Extraterrestrial* for a personal gallery show. Phillips began by making a stylized drawing using the Scratchboard Tool variant of Pens and black color. Then, he floated the entire scratchboard drawing to a layer by choosing Select, All and clicking inside the active selection with the Layer Adjuster tool. Before deselecting the layer, he set the Composite Method to Gel in the Layers palette, so the white areas of the layer would appear transparent. Next, Phillips selected the Canvas in the Layers palette and used Chalk and Pastels variants in several sizes and opacities to paint the background and to create a richly textured look. He freely painted without using selections to constrain the paint. Using the Artists Pastel Chalk, he brushed varied colors onto his image. Phillips wanted to achieve a richly textured look, so he adjusted the randomness of the brushstroke grain. In the Random section of Brush Controls, he toggled the Random Brush Stroke Grain on and off as he worked. This technique is most noticeable in the foreground, in the transitions between the highlights and shadow areas, and on the edges of the clouds in the sky.

When the coloring was complete, Phillips merged the layers by clicking on the black-and-white drawing layer's name in the Layers palette and choosing Drop from the pop-up menu on the right side of the Layers palette. To see more of Chet Phillips's work, turn to "Coloring a Woodcut" in Chapter 2 and the gallery in Chapter 8.

 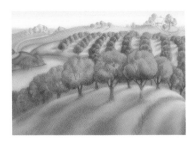 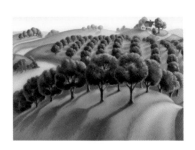

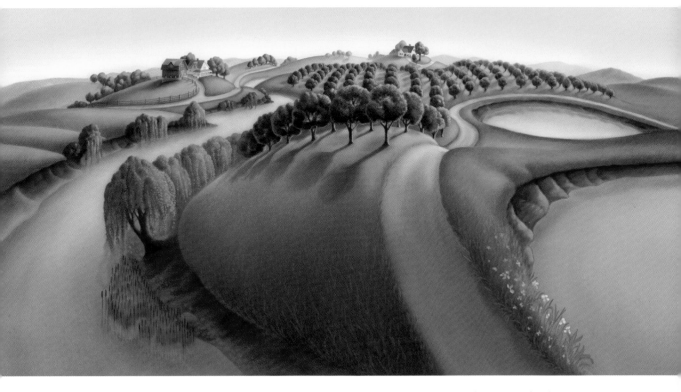

■ A commercial illustrator who has worked with traditional art tools for many years, **Michael Bast** has painted digitally using Painter's brushes since 1990. Bast loves Painter because it allows him to capture the warmth and texture of his favorite conventional media.

Bast creates illustrations for commercial products and packaging. To begin this ice cream package illustration *Pecan Farm Orchard*, Bast assembled elements to use for reference—inspiring images of the rolling hills in Texas, meandering waterways and pecan trees. He sketched the composition conventionally using pencils and paper, and then he scanned the drawing. Bast created selections and masks to make his work easier. (For detailed information about working with selections and masks, see Chapter 5.)

Before Bast began to paint the color underpainting, he added a new layer by clicking the New Layer button on the Layers palette. Bast used his Wacom 6D Art Pen for most of the brushwork in the painting. The pen allowed him to achieve more expressive strokes by rotating his brushes. He laid in color using the Worn Oil Pastel variant of the Art Pen Brushes. When the underpainting was complete, he dropped the layer to the Canvas by choosing Drop from the pop-up menu on the right side of the Layers palette.

Next, Bast added a new layer and used a variety of Digital Watercolor brushes, including the Simple Water brush, to add richer color and highlights and shadows to the scene. To model forms and paint translucent shadows, Bast used a process similar to glazing in conventional

watercolor. He painted washes using the New Simple Water variant of Digital Watercolor and then dried them by choosing Dry Digital Watercolor from the Layers palette menu. When Bast wanted to pull out color from an area of wet paint, he used the Gentle Wet Eraser variant of Digital Watercolor. Then, to add textured, opaque brushwork to the image, he painted with a modified version of the Smeary Bristle Spray variant of Oils. To add touches of opaque color and finer details in areas, such as the highlights on the trees and on the foreground plants, he used the Detail Opaque variant of Gouache.

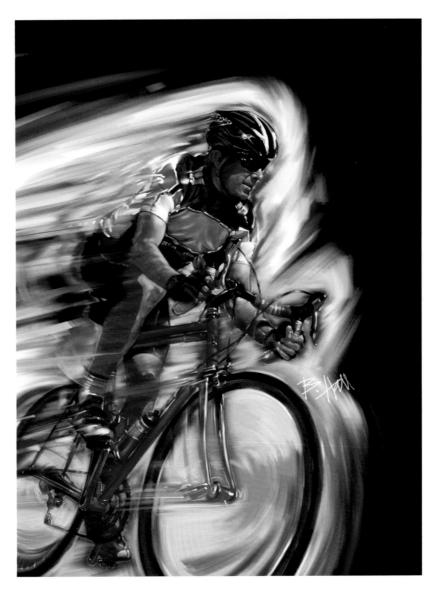

■ **Bill Hall** has completed paintings for sporting events that include the Special Olympics and the Cleveland Grand Prix. Prior to working in Painter, Hall created his illustrations with conventional oil paint. Painter's brushes and other natural media tools allow Hall to successfully re-create his conventional oil painting style.

To begin the illustration *Mike on Bike*, Hall shot reference photographs. Later, back at his studio, he opened a new file in Painter and clicked the New Layer button on the Layers palette to add a new transparent layer. He referred to the photographs as he sketched with the Pencils variants. When he was satisfied with the drawing, he added a new layer directly below the pencil

sketch so that the drawing would be visible when he added colored paint. Next, he used the Lasso tool to make loose, free-hand selections for the elements in his drawing. Then he used the Edit, Fill, Fill with Current Color feature to quickly fill each selection with a flat mid-tone color.

For the modeling of the forms, Hall added another new layer and positioned it above the Flat Color layer and below the Pencil layer. Working on the new layer, he used the Loaded Palette Knife variant of Palette Knives to model the forms, varying the size and opacity of the brush as he worked. When the modeling was as he liked it, he painted speed blurs on the rider and bicycle. He opened the Color Variability section

of the Colors palette and adjusted the Value slider to increase the streaky quality of the Loaded Palette Knife. So that he could pull color up from the layer below, he enabled Pick Up Underlying Color on the Layers palette. As he worked, he varied the opacity of the brush as needed.

To add more depth and richness to the rider and speed blurs, Hall painted transparent washes. He added another new layer and positioned it above the modeling layer and below the pencil sketch. He used various Digital Watercolor brushes, such as the Simple Water brush, to add deeper shadows to the modeling on the rider's face and his clothing.

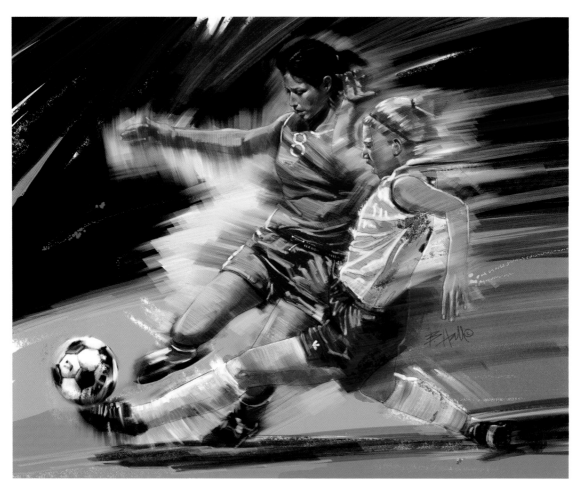

■ For *Girl's Soccer,* **Bill Hall** used Painter's brushes and Palette Knives to paint exciting color and dramatic motion that captured the action of the game. Hall created the image for a mural at a soccer park in Irving, Texas.

Hall began by taking photographs to use for reference. To design the composition, he opened a new file, added a transparent layer to his image and then sketched directly in Painter using Pencils variants. When the drawing was complete, he created a new layer below the pencil drawing so that he could view the pencil as he added colored paint. Next, he made hand-drawn selections with the Lasso tool, and then he

filled each selection on the layer with a flat mid-tone color by choosing Edit, Fill, Fill with Current Color (Ctrl/⌘-F).

Next, Hall added another new layer and positioned this layer below the Pencil layer and above the Flat Color layer. So that he could pull color from the Flat Color layer below, he enabled Pick Up Underlying Color in the Layers palette. Working on the layer, he used the Loaded Palette Knife variant of Palette Knives to model the forms. Hall painted brushstrokes that followed the forms and the direction of the motion that he wanted to express. To blend and pull paint without adding new color, he used the Palette Knife variant of Palette Knives.

When he was satisfied with the modeling, Hall added a new layer and painted blurs on the players to show movement and speed, and he also smudged paint in a few areas of the background. To increase the streaky quality of the Loaded Palette Knife, he adjusted the Value slider in the Color Variability section of the Colors palette. As he worked, he varied the size and opacity of the Loaded Palette Knife using the sliders in the Property Bar.

When Hall was satisfied with the way the painting looked, he selected the Pencil layer and used an Eraser variant to erase unnecessary lines, and he used a small Palette Knife to subtly blend other lines into the colored paint.

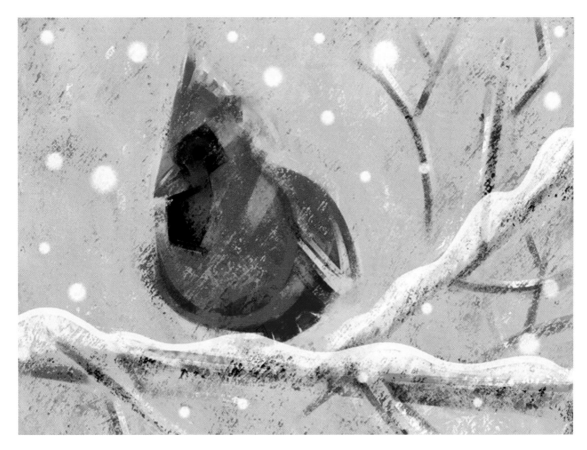

■ **Mike Reed** takes an approach to digital illustration that avoids the slick look sometimes seen in art created on the computer. To re-create the look of conventional pastel on rough paper, in the illustrations on these pages, he sensitively layered textured color with the Pastels and Chalk brushes on top of the Wood Shavings texture, from Wow! Textures on the *Painter 11 Wow!* CD-ROM, combined with a texture of his own, made by scanning an acrylic painting surface. Reed typically uses color sets to avoid the temptation of using too many colors, which can disturb the harmony of a painting.

Cardinal is a Christmas card illustration that Reed created for a mental health association. Reed began by drawing a colored sketch on the Canvas using the Square Chalk variant of Chalk over the Woodshavings texture. To reveal more grain while sketching, he set the Grain slider in the Property Bar to 18%. After the sketch was roughed in, he refined the image by

painting with the Square Chalk on successive layers. To add a new transparent layer, he clicked the New Layer button on the Layers palette. Reed often experiments on-the-fly with Composite Methods for the layers—a favorite is the Colorize Composite Method. When he is happy with the result, he drops the layer to the Canvas, by choosing Drop from the Layers palette menu.

To build the rich texture on the background, Reed added another new layer and brushed lightly with a large Square Chalk brush. He changed the scaling of the Woodshavings texture in the Papers palette. When Reed was satisfied with the layering of texture, he dropped the layer.

For the details and final color finessing, Reed added a new layer and used a small Square Chalk to add crisp strokes to the bird. As a last touch, Reed brightened the snow flakes and added brighter highlight details on the snow resting on the foreground branches.

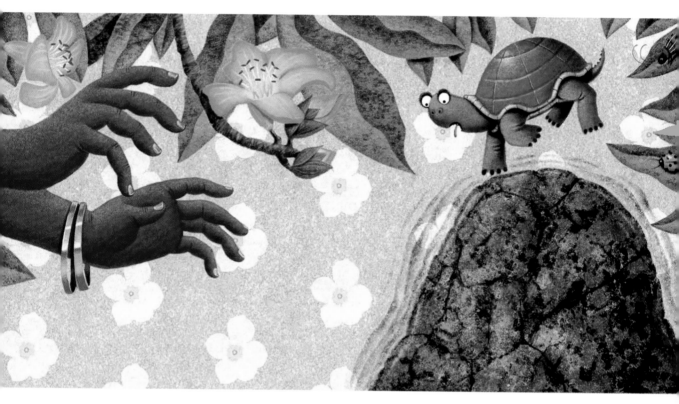

■ **Mike Reed** was commissioned to create this illustration for a children's book titled *Catching the Wild Waiyuuzee* for the publisher Simon and Schuster. To re-create the traditional look of pastel and paint on a richly textured surface, Reed sensitively layered textured color applied with the Chalk brushes on top of a captured paint texture and the Wood Shavings paper texture (loaded from Wow! Textures on the *Painter 11 Wow!* CD-ROM).

Reed began the composition by sketching with conventional pencil and paper, and then he scanned the pencil drawing and opened it in Painter.

To build a textured ground for the illustration, Reed painted with acrylic paint on illustration board, and then he scanned the painting and opened it in Painter. He captured the scan as a paper texture by selecting it (Select, All) and then clicking the

Paper Selector (Toolbox) and then choosing Capture Paper from the pop-up menu on the right side of the paper list menu.

Next, Reed clicked the New Layer button on the Layers palette to add a new transparent layer and applied rich layers of color to the layer using the Square Chalk variant of Chalk over his captured paper. Reed found the captured paper to be best for broader strokes, but when he wanted to paint precise details, he switched to the Wood Shavings paper.

When the underpainting was complete, Reed added a new layer for the shadows and then set its Composite Method to Gel in the Layers palette. Using the Square Chalk, he built up rich tones in the shadows. Next, he added another new layer and set it to Gel, and then he added more saturation and built up tonal complexity.

For the flowers, Reed created a flower on another layer by drawing it with a Flat Color or variant of Pens. After cleaning it up with the Eraser tool, he used the Magic Wand to select the colored area, and then he gave it a soft edge by feathering it (Select, Feather, about 6–10 pixels). For a more natural look, he roughened the edges by painting over the flowers again using the Square Chalk.

Reed created the texture for the rock by scanning a granola bar and converting it into a paper using the Capture Paper command in the Paper palette menu. To help the image look less digital, he used the Square Chalk to subtly apply a variety of other textures. Finally, Reed switched to the Wood Shavings paper and used the Square Chalk to apply highlights and a few brightly colored accents to the center of interest.

ENHANCING PHOTOS, MONTAGE AND COLLAGE

Helen Yancy was commissioned to create this lovely portrait of Sarah. With a watercolor interpretation in mind, Yancy began by shooting photographs of the child using a Canon 5D Mark II. After the shoot, she opened the chosen photo in Painter. Yancy began by using Quick Clone to make a clone copy of the photo with a white Canvas. Then she used Cloning brushes to lay in the basic image, leaving a white vignette border. She modeled the forms using the Captured Bristle variant of Acrylics and small Charcoal brushes, and blended areas with the Grainy Water variant of Blenders.

INTRODUCTION

ALTHOUGH PAINTER BEGAN as a painting program, the features that have been added over the years have turned it into a powerful image processor as well. Many tools are designed *just* for photographers—for instance, the Dodge and Burn tools in the Toolbox and the Scratch Remover and Saturation Add brushes found in the Photo brush category in the Brush Selector Bar. And dynamic layers allow you to adjust brightness, contrast, and color with complete freedom. Painter boasts color-reduction features that are useful for working with photos such as posterize (see page 245), woodcut (see page 262) and distressing (see page 261). And, of course, when it comes to achieving painterly effects with photos, Painter has no peer. If you're a photographer, an illustrator or a designer who works with photos, you'll want to pay attention to the following areas of the program.

Layers. Chapter 6 gives you an overall look at techniques using layers; this chapter focuses on using layers and masks for photo-compositing and other photo effects—for example, in "Selective Coloring" later in the chapter.

Dynamic layers. Painter offers three kinds of dynamic layers that are useful for making adjustments to photos. They are: Brightness and Contrast, Equalize, and Posterize. To find these tools, access the Dynamic Plug-ins pop-up menu by clicking the plug icon at the bottom of the Layers palette. Dynamic layers offer live previews in the document window as you adjust the settings in the dialog box. And because the adjustments are automatically made on a separate editable layer, you can easily change the settings later without degrading the original image by reworking the pixels. In the Layers palette, you simply double-click the layer name to reopen the dynamic layer dialog box.

An important component of the Auto-Painting system, the Underpainting palette allows you to adjust the tones and colors in an image, simplify photographic detail for a more painterly look, and create a variety of edge effects. To help bring out the sunset colors in our image, we chose Saturate from the Photo Enhance pop-up menu and we increased the Saturation to 74%. To subtly reduce detail, we set Smart Blur at 20%. For the irregular vignette, we chose Jagged Vignette from the Edge Effect pop-up menu, and set the Amount to 30%.

To enhance this portrait, we began by painting a mask to isolate the dancers. To create a shallow depth of field, we used Effects, Tonal Control, Adjust Colors to desaturate the background and Effects, Focus, Soften to blur it.

The Effects menu. Many of Painter's image-altering special effects can be found in the Effects menu. The features under the subheads Tonal Control, Surface Control and Focus are loaded with creative promise for the adventurous photographer.

Cloning. A powerful and versatile feature, cloning (File, Clone) lets you make multiple copies of an image, alter each copy and then recombine them in various ways while preserving access to the original. Several of the techniques described in this chapter use this menu choice or another kind of cloning method.

The Auto-Painting system. A powerful tool set, Auto-Painting allows you to transform photographs into paintings by applying automated strokes that incorporate stroke style, pressure and direction. You can use strokes supplied with Painter, or custom brushstrokes of your own. The Auto-Painting system includes three palettes: Underpainting, Auto-Painting and Restoration. For step-by-step techniques featuring the Auto-Painting system, turn to pages 265–267 later in this chapter.

Selections and masks. To alter only a portion of an image, you'll need to become acquainted with Painter's shapes and its selection and masking capabilities. If you're not familiar with the Pen and Lasso tools, you can learn about them in "Working with Bézier Paths and Selections" and "Working with Hand-Drawn Selections" in Chapter 5.

Painter's powerful masking features—located under the Select menu and in the Channels palette—give you a big jump on the process of creating masks to isolate parts of your image. And a bonus: Most of Painter's brushes can be used to paint directly on a mask. For information about combining Painter's automatic and painterly masks, turn to "Selections, Shapes and Masks" on page 174.

IMAGE-PROCESSING BASICS

With its strong focus on creative image manipulation, Painter has tools for adjusting brightness, contrast and color; for blurring or sharpening; and for photo retouching.

Adjusting brightness and contrast. Painter offers two main methods for changing image brightness and contrast—the Brightness/Contrast control and Equalize. When you click the plug icon at the bottom of the Layers palette to access the Dynamic Plug-ins menu and select **Brightness and Contrast**, the Brightness/Contrast dialog box will appear. Adjust the settings as you preview the corrections in your image. To read more about a Brightness-and-Contrast dynamic layer, see "Making a Selective Correction" on page 250.

An **Equalize** layer offers a dialog box with a histogram similar to Photoshop's Levels dialog, which allows you to adjust the tonal range in an image—the difference is that in Painter the image is automatically equalized (an effect similar to clicking on the Auto button in Photoshop's Levels). To make an Equalize layer, open

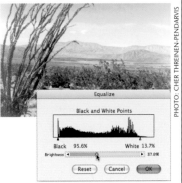

PHOTO: CHER THREINEN-PENDARVIS

Correcting the tonal range in an image using an Equalize dynamic layer. To lighten the image overall, we moved the Brightness slider to the left.

SMART STROKE PAINTING

The Smart Stroke Painting option in the Auto-Painting palette allows you to automatically apply strokes that follow the forms of a source image. Open a photo and choose File, Quick Clone to make a clone with an empty canvas. So you can see brushstrokes as they appear, toggle off Tracing Paper by pressing Ctrl/⌘-T. Choose Window, Show Auto-Painting to open the palette and turn on the Smart Stroke Painting and Smart Settings options. Choose a Smart Stroke Brush variant such as the Acrylics Captured Brush, Acrylics Dry Brush or Charcoal and click the Play button to paint the clone.

Illustrations created with the Acrylics Captured Brush (left) and the Charcoal (right) variants of the Smart Stroke Brushes.

an image and choose Equalize from the Dynamic Plug-ins pop-up menu at the bottom of the Layers palette. When the Equalize dialog box appears, watch the changes in the document window as you experiment. Move the triangular sliders toward the ends of the histogram to decrease the effect. Moving them all the way to the ends restores the "pre-Equalize" image; or simply click the Reset button.

Stripping color from an image. A quick way to turn a color image into a black-and-white is to desaturate the image using the Adjust Color dialog box. Choose Effects, Tonal Control, Adjust Colors and drag the Saturation slider all the way to the left.

Changing color. Also in the Adjust Color dialog box, you can use the Hue Shift slider to change the hue of all the colors in an image (or a layer or selection). You can get greater control in altering specific colors (turning blue eyes green, for instance) by using Effects, Tonal Control, Adjust Selected Colors. Click in the image to select a color; then drag the Hue Shift, Saturation and Value sliders at the bottom of the dialog box to make the changes. Use the various Extents sliders to expand or reduce the range of colors affected. Use the Feathers sliders to soften or sharpen the transitions between the changed and unchanged areas.

Matching palettes. The new Match Palette dialog box (Effects, Tonal Control, Match Palette) allows you to match color schemes between open images and apply the Color and Brightness from a source image to a destination image. For a step-by-step technique using the Match Palette effect, turn to page 249 later in this chapter.

REMOVING SCRATCHES

To repair a white scratch on this photo we used a two-step process, beginning with Painter's useful Scratch Remover brush (located in the Photo category, in the Brush Selector Bar). Open a photo you'd like to repair, and choose the Scratch Remover variant. For the best results, use a small brush size (we used a 1.7-pixel brush on this 350-pixel-wide image) and a low Opacity setting in the Property Bar (we used 9%). Zoom in to a magnification that lets you see the scratch in detail, and scrub along the scratch to blend it into the image. This first step is usually sufficient for images with even color. But the sky in our image was graduated and required more repair. Next, we used a Soft Cloner variant of the Cloners with a small brush size and a very low Opac-

ity, set in the Property Bar. Alt/Option-click to set the clone source to a point near the repair; then gently paint over the repaired area to bring back appropriate colors.

PHOTO: CORBIS IMAGES

The scratched image (left) and the repaired image (right)

Using the Saturation Add brush from the Photo brush library to "pop" the color on the red raincoat, umbrella and reflection

We applied Fine Hard Grain (chosen from the Papers Selector near the bottom of the Toolbox) to this photo with Effects, Surface Control, Dye Concentration Using Paper with the Maximum slider set to 200%.

The Add Grain variant of the Photo brush can paint texture for a special-effects treatment. Here we used the Dry Cracks texture (Window, Library Palettes, Show Papers) for a crackled look.

The 500 pixel wide image above (left) was sharpened to produce the result on the right using these settings: Amount, 2.15; Highlight, 90%; Shadow, 80%. A higher resolution image requires a higher Amount setting to get the same degree of sharpening.

Painting saturation with brushes. To "pop" the color in a specific area, use Painter's Saturation Add variant, located in the Photo brush category in the Brush Selector bar. For a subtler look, lower the Opacity to about 10%.

Adding film grain. To simulate film grain or a print on textured paper, open the Papers palette by choosing Window, Show Papers and choose an even-textured Paper grain, like Basic Paper or Fine Hard Grain. Next, choose Effects, Surface Control, Dye Concentration, Using Paper. Scale the texture in the Papers palette until the grain in the Preview window of the Adjust Dye Concentration dialog box is barely visible—try 50% as a starting point. Try minor adjustments to the Maximum and Minimum sliders.

Adding grain with a brush. If you use a pressure-sensitive tablet, Painter's Add Grain brush allows you to paint grain onto your images. To begin, choose the Photo brush category in the Brush Selector Bar and select the Add Grain variant. Choose a texture in the Paper Selector, scaling it if necessary, and brush lightly onto your image. For a more subtle effect, reduce the Strength of the brush in the Property Bar. (Without a pressure-sensitive tablet, changing the Strength has no effect, so the brush is not useful.) The Grain Emboss variant of Impasto is good for adding a textured, embossed look to an image.

Creating a shallow depth of field. By softening the background of an image, you can simulate the shallow depth of field that you'd get by setting your camera at a low f-stop. Select the area you want to soften and feather the selection by choosing Select, Feather to avoid an artificial-looking edge. Then choose Effects, Focus, Soften.

Smearing, smudging and blurring with brushes. To smoothly smear pixels in the image (for instance, to retouch skin), choose the Just Add Water variant of Blenders in the Brush Selector Bar; vary the Opacity in the Property Bar between 70% and 100%. To softly blur an area of an image while retouching, use the Blur variant of the Photo brush set to a low Opacity (about 20%). To smudge the image (for a more textured, painted look) while bringing out the texture chosen in the Paper Selector, choose the Smudge variant of Blenders. For a "wet oil" effect similar to conventional oil painting, try the Distorto variant of Distortion.

Sharpening. Painter's Sharpen feature (Effect, Focus, Sharpen) gives you control equivalent to unsharp masking on a drum scanner. (Unsharp masking sharpens the edges of elements in an image without sharpening small differences such as film grain or digital noise.) Use it to give definition to a selected area of interest, or to an entire image as a final step in preparing for output. The Sharpen variant of the Photo brush puts sharpening (very similar to the Effects, Focus, Sharpen command) on the tip of a brush so you can direct it exactly where you want it.

To add a mysterious gold spotlight to this woman's portrait, we used Effects, Surface Control, Apply Lighting. We modified the Center Spot by changing the Light Color from white to gold. To make the spotlight softer, we decreased the Exposure from 1.00 to .85.

Retouching. New tools in Painter's Toolbox allow easy access to powerful retouching brushes: The Cloner tool allows you to quickly access the last Cloners brush that you used, and the Rubber Stamp tool gives you quick access to the Straight Cloner variant (Cloners). The Straight Cloner and Soft Cloner variants of the Cloners work like Photoshop's Clone Stamp tool (with the Aligned function turned on) to reproduce imagery; use the Alt/Option key to sample an area (even in another image); then reproduce that image (centered at the point of sampling) wherever you paint. The Straight Cloner variant reproduces imagery without changing it; to clone imagery with a soft edge and low opacity (like an Airbrush) use the Soft Cloner.

ADVANCED TECHNIQUES

Here's a short guide for using Painter to re-create traditional photographic techniques, starting with simpler, in-camera ones and progressing to more complex darkroom procedures.

Motion blur. You can use the camera to blur a moving subject by using a slower shutter speed or by jittering (shaking) your hands while you hold the camera, or you can blur the background by panning with the subject. To create the look of "camera jitter," just as if you had accidentally moved the camera while taking a picture, choose Effects, Focus, Camera Motion Blur. When the dialog box appears, drag in the image (not the Preview) to specify the camera's direction and distance of movement. Dragging farther in the image will create a wider blur. To move the origin of the movement along the path of motion, adjust the Bias slider. (See "Simulating Motion" on page 246 to read about a versatile motion-blur technique that involves using an additional layer.)

Lens filters and special film. To re-create in-camera tinting effects achieved with special films or colored filters, use Effects, Surface Control, Color Overlay Using Uniform Color. If you want to mimic the effect of a graduated or spot lens attachment (partially colored filters), add a new layer, choose a gradation and fill the layer (Effects, Fill) with the gradation at a reduced opacity. In the Layers palette, adjust the Opacity and Composite Method of the layer (try Color, Hue or Overlay, for instance) to get the type of tint you want.

To get the effect of a line conversion, a straight-line screen was applied to a photo with Effects, Surface Control, Express Texture Using Paper and a Line texture set to an angle of 40 degrees. (For directions for setting up a Line texture, see "Line Screen" on the next page.)

Shooting through glass. With Painter's Glass Distortion effect or Glass Distortion dynamic layer you can superimpose glass relief effects (using a paper texture or any other image) on your photo. A small amount of this feature adds texture to an image; larger amounts can produce more extreme distortion. To make a Glass Distortion dynamic layer for your image, click the plug icon at the bottom of the Layers palette to open the pop-up menu, and then choose Glass Distortion. (For the basics of how to work with dynamic layers such as Glass Distortion, turn to pages 209–210.) The Effects, Focus, Glass Distortion command is harder to preview and

For this graphic effect, we applied Painter's Woodcut feature to a photo. See "Creating a Woodcut from a Photo" on page 262 for a step-by-step demonstration of this feature.

PHOTO: CORBIS IMAGES

We posterized this Craig McClain photo using a custom Color Set of "desert" colors and the Effects, Tonal Control, Posterize Using Color Set command.

PHOTO: CRAIG MCCLAIN

The original photo of a kelp frond had strong contrast, contributing good detail for this embossed image.

PHOTO: PHOTODISC

change than the dynamic layer, but it gives you more options for controlling the character of the glass. (See also Phil Howe's work with Glass Distortion in the gallery at the end of Chapter 8.)

Lighting effects. Use Painter's Apply Lighting feature (under Effects, Surface Control) to add subtle or dramatic lighting to a scene, as shown on page 244. You can learn more about creative uses of the Apply Lighting effect in the introduction to Chapter 8.

Multiple exposures. Double exposures used to be created in camera (by underexposing and shooting twice before advancing the film) or in the darkroom (by "sandwiching" negatives or exposing two images on a single sheet of paper). Now it's easy to reproduce the effect of multiple exposures by using layers or clones in Painter.

Line screen. Instead of developing your image in the darkroom onto high-contrast "line" or "lith" paper, try getting a similar effect in Painter. Open the Papers palette by choosing Window, Show Papers, click the right arrow on the Papers palette to access the pop-up menu, and choose Make Paper. In the Make Paper dialog box, choose the Line option and set the Spacing and Angle to your taste. Store your new texture in the current Paper library by naming it in the Save As field and clicking the OK button. Choose your new paper in the Papers palette, and then choose Effects, Surface Control, Apply Screen, Using Paper to get a two- or three-color effect with rough (aliased) lines. Or try Effects, Surface Control, Express Texture, Using Paper to get a broader range of values and smoother, anti-aliased lines. You can also apply screens using Painter's Distress feature. See "Distressing a Photo" on page 261.

Posterizing an image. Painter lets you limit the number of colors in your image for a posterized effect. This is a great way to unify photos shot under a variety of conditions. At the bottom of the Layers palette, click the plug icon to open the Dynamic Plugins menu, and select Posterize. Click Apply and enter the number of levels. Because the Posterize plug-in layer is dynamic, you can experiment, and preview it on your image until it's the way you like it.

You can also get creative posterization effects by making or loading a Color Set (see "Capturing a Color Set" in Chapter 2) and selecting Effects, Tonal Control, Posterize Using Color Set.

Embossing and debossing. To emboss an image, raising its light areas, choose File, Clone; then Select All and press the Delete/Backspace key, leaving a blank cloned image. Now choose Effects, Surface Control, Apply Surface Texture, and choose 3D Brush Strokes from the Using pop-up menu. To raise the dark areas instead of the light, click the Inverted box, or change the Using menu choice to Original Luminance. Images with a lot of contrast give the best results, and busy images work better if less important areas are first selected and softened using Effects, Focus, Soften.

Simulating Motion

Overview *Open a color photo and copy to a layer; apply Motion Blur to the copy; add a layer mask to the layer; paint with a brush to erase areas of the layer mask and reveal the original photo.*

PORTRAIT OF MIKE CASEY BY CHER THREINEN-PENDARVIS

The original photo

Applying Motion Blur to the layer

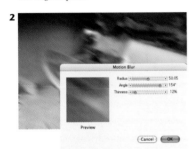

Painting the layer mask to hide a portion of the blurred layer

Adjusting the opacity of the blurred layer

CREATING A SENSE OF MOVEMENT for a subject *after* the film is out of the camera is easy with Painter's layers and Motion Blur command. We blurred a layer, and then used a layer mask to hide some areas to reveal the untouched image underneath. The benefits of this method over applying effects to selections are that you can control the amount of the effect by adjusting opacity of the layers; you can simultaneously add effects other than a blur (such as lighting and texture); and you are altering a copy while leaving the original intact, and this makes it easy to correct errors.

1 Copying the image. Open a color photo and choose Select, All (Ctrl/⌘-A). Using the Layer Adjuster tool, Alt/Option-click on the image. This creates a layer that's an exact copy of the original image.

2 Blurring the layer. Select the layer by clicking on its name in the Layers palette and choose Effects, Focus, Motion Blur. To get a dramatic blur on our 1200-pixel-wide image, we set Radius to about 50.05, Angle to 154° (to complement the direction the table was moving) and Thinness to 12%. Experiment with different Angle settings for your particular image.

3 Painting on the mask. To allow parts of the original image to show through, target the layer in the Layers palette and add a layer mask by clicking the Create Layer Mask button on the Layers palette. Click on the layer mask to target it—you'll see a dark outline around it when it is active. Use a brush to paint on the layer mask. In the Brush Selector Bar, choose the Digital Airbrush (Airbrushes) and choose black in the Colors palette. As you paint the layer mask in the area you wish to hide, the underlying image will appear. If you want to restore an area of the blurred layer, choose white in the Colors palette and paint on that area of the layer mask. For an illusion of speed we hid the frontal blur on the table and laptop, leaving trails of motion blur behind them.

4 Adjusting the opacity. To reduce the blur we clicked on the layer (instead of the mask) and made it slightly transparent by lowering the Opacity of the layer in the Layers palette to 90%. 🖌

Selective Coloring

Overview *Open a color photo and copy it to a layer; desaturate the layer; paint with a brush to erase areas of the layer mask and reveal the underlying color photo.*

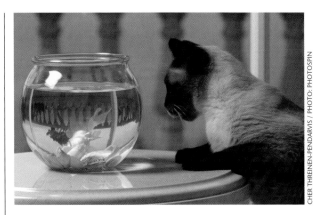

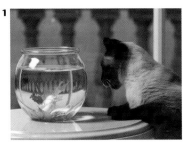

The color photo

Using the Adjust Color dialog box to desaturate the layer to black-and-white

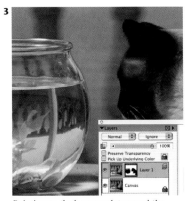

Painting on the layer mask to reveal the color image underneath

IF YOU WANT TO FOCUS ATTENTION on a particular element in a color photo, you can turn the photo into a black-and-white image and then selectively add color back into it for emphasis. Here's a way to use Painter's layers and brushes to "paint" color on an image.

1 Copying the image. Open a color photo and choose Select, All (Ctrl/⌘-A). Press the Alt/Option key and choose Select, Float. This creates a layer with an exact copy of the original image, in register with the original.

2 Desaturating the layer. Now use the layer to make the image appear black-and-white: Choose Effects, Tonal Control, Adjust Colors, Using Uniform Color, drag the Saturation slider all the way to the left and click OK.

3 Revealing color in the underlying image. To allow parts of the color image to show through, use a brush to hide portions of the "black-and-white" layer. Target the layer in the Layers palette and add a layer mask by clicking the Create Layer Mask button on the Layers palette. Click on the layer mask thumbnail to target it—you'll see a dark outline around it when it is active. In the Brush Selector Bar, choose a Fine Tip Soft Air variant of Airbrushes and choose black in the Colors palette. (To view the layer imagery while editing the layer mask, keep the layer mask eye icon shut.) As you paint with black on the layer mask to hide that area of the mask, the color will appear. If you want to turn a color area back to gray, choose white from the Colors palette and paint on the area.

Creating a Sepia-Tone Photo

Overview *Use gradient features to tint a color or black-and-white image; adjust the image's contrast and saturation.*

1a

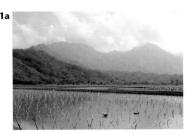

The original photo

1b

Choosing Express in Image

2a

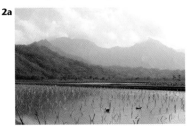

Applying the Sepia Browns gradient

2b

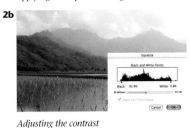

Adjusting the contrast

3

Neutralizing and warming up the browns

CHER THREINEN-PENDARVIS

TYPICALLY FOUND IN IMAGES CREATED at the turn of the last century, sepia-tones get their reddish-brown color cast in the darkroom when the photographer immerses a developed print in a special toner bath. You can use Painter's gradation and tonal control features to quickly turn color or grayscale images into sepia-tones.

1 Tinting the image. Open a grayscale or color photo. In the Gradients palette (Window, Library Palettes, Show Gradients), select the Sepia Browns gradient from the picker. Choose Express in Image from the triangle pop-up menu at the right end of the Gradients section bar. (Read more about gradients in Chapter 2.) Click OK in the dialog box to tint your image with shades of brown. (You can also use a similar procedure to turn a color image into shades of gray, but make sure the back and front Color rectangles in the Colors palette are black and white, respectively, and choose Two-Point in the Gradients palette.)

2 Adjusting the white and black points. If you're working with an image that has poor contrast, you can adjust the white and black points by choosing Effects, Tonal Control, Equalize (Ctrl/⌘-E). When the dialog box appears, the image will be automatically adjusted so that its lightest tones are pure white and its darkest ones are pure black. The automated contrast was too dramatic for our taste, so we lightened the image by moving the Brightness slider to the left.

3 Desaturating the image. We wanted to emulate the mild tinting effect usually used for traditional sepia-tones, so we desaturated the image using Effects, Tonal Control, Adjust Colors, dragging the Saturation slider to the left to –21. Set the Hue Shift at 0% and experiment with the Saturation slider until you see the effect you want in the Preview window. We also adjusted the Hue a slight amount (to 2%) to warm up the browns in the image.

Matching Color Schemes

Overview *Open a black-and-white photo and a brown-toned photo; use the Match Palette dialog box to apply the brown color scheme to the black-and-white photo.*

1a

The brown-toned photo of Bryn

1b

The black-and-white photo of the German doll store window

2

The Match Palette dialog box with settings

CHER THREINEN-PENDARVIS

THE HELPFUL NEW MATCH PALETTE EFFECT (Effects, Tonal Control, Match Palette) is a great tool for applying a consistent color theme to a series of photos. It allows you to match color schemes between two open images, applying the Color and Brightness from a source image to a destination image. Using the Match Palette dialog box, we colored a black-and-white portrait with brown tones from another photo.

1 Preparing the images. To begin, open two images: a brown-toned photo such as the one on the facing page (for the source) and a black-and-white photo (the destination). If you do not have a black-and-white image, you can make a color image into a black-and-white: Choose Effects, Tonal Control, Adjust Colors and move the Saturation slider all the way to the left.

2 Matching color. Click on the image that you want to adjust (in our case, the black-and-white image) and then choose Effects, Tonal Control, Match Palette. In the dialog box, set the Source pop-up menu to the image with the brown color scheme. To give the destination image the maximum color from the Source, set Amount at 100% and Color at 100%. Adjust the Brightness and Variance sliders to your taste. *W*

Making a Selective Correction

Overview *Use a dynamic layer to adjust the brightness and contrast of an image; convert the dynamic layer to an image layer; make a selection; use the selection to remove a portion of the layer.*

The original photograph

Making a Brightness and Contrast dynamic layer

Increasing the Brightness by moving the lower slider to the right

HERE'S A USEFUL IMAGE-EDITING TECHNIQUE that combines a dynamic layer Brightness-and-Contrast adjustment and a selection. Using a dynamic layer has the advantage of being able to make a correction and dynamically preview the changes on the image without harming the image. To enhance the focal point of this image—shining more light onto the faces—we selectively lightened the shaded window area.

1 Editing brightness and contrast with a dynamic layer.
Open a grayscale or color photo. To make a Brightness and Contrast dynamic layer for your image, click the Dynamic Plug-ins button at the bottom of the Layers palette and from the pop-up menu, choose Brightness and Contrast. A Brightness and Contrast dynamic layer will cover your entire image. (Turn to "Using Dynamic Layers" on page 209 in Chapter 6 to read about the basics of using dynamic layers.)

When the dialog box appears, adjust the sliders and preview the correction in your image. To see more detail on the faces, we moved the Brightness (lower) slider to the right, making the image lighter. We also slightly increased the contrast by moving the Contrast slider (upper) to the right.

We only wanted the Brightness-and-Contrast adjustment to affect the shaded area within the window, so we planned to make a mask and load a selection that we could use to isolate a portion of the layer. To use a selection on a dynamic layer, the layer must first be converted to an image layer. When you've finished making adjustments, convert the dynamic layer to an image layer as follows: Click the right triangle on the Layers palette bar to open the pop-up menu and choose Convert to Default Layer. Next, hide the layer temporarily: In the Layers palette, click the layer's eye icon shut; then click on the Canvas layer's name.

The active selection around the window

Selecting the mask to view it as a red overlay

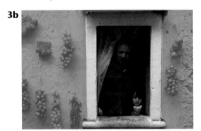

Viewing the mask as a red overlay before editing and feathering

The completed mask

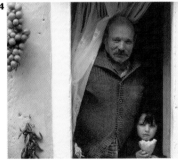

Detail from the final corrected image with more detail in the shaded areas

2 Making a selection and saving it as a mask. In our example, when we were satisfied with the Brightness-and-Contrast adjustment in the window area, the blue wall was too light and flat. In preparation for using only the window area of the adjusted layer, we made a selection of the window area on the image canvas, and saved it as a mask. In the Toolbox, choose the Pen tool or Lasso and make a selection. (We drew a shape with the Pen tool and converted it to a selection using Shapes, Convert to Selection.) When you've completed the selection, choose Select, Save Selection to save it into the Channels palette. (For more information about using the Pen tool to create paths with which you can make selections, turn to the beginning of Chapter 5, "Selections, Shapes and Masks" and to "Working with Bézier Paths and Selections" on page 187.

3 Editing and feathering the mask. To get a clear view of the mask as we edited and feathered it, we worked back and forth between viewing it as a red overlay (on the image) and as a black-and-white mask. We used the Digital Airbrush variant of the Airbrushes and white paint to spray soft edges along the top of the window and added a 3-pixel feather to the entire mask to give it a soft transparent edge. If your mask needs editing, select its name in the Channels palette. To view your mask as a red overlay, click both the mask eye icon and the RGB eye icon open. To view the mask in black-and-white, click the RGB eye icon closed. With the mask active you can give it a soft edge by applying feathering as follows: Click the right triangle on the Channels palette bar to open the menu and choose Feather. Type a feather width in the field and click OK. Now shut the mask eye icon and click on RGB in the Channels palette to prepare for the next step.

4 Using the selection to edit the layer. In our example, we used the selection to remove the area on the Brightness-and-Contrast layer outside the window. Now that your mask is complete, load the selection from the mask, as follows: In the Layers palette, click on the Brightness-and-Contrast layer name to select it, and also open its eye icon to display the layer. Now choose Select, Load Selection and choose the mask that you saved (Alpha 1) to isolate the area on the layer. To remove the unwanted portion of the layer, choose Select, Invert and press the Backspace/Delete key.

USING SELECTIONS WITH LAYERS

You can have several masks saved in the Channels palette and choose any one of them to load as a selection to then isolate paint or effects on any image layer. Choose Select, Load Selection and pick the selection you need from the menu. In the Layers palette, click on the name of the layer with which you want to work.

Hand-Tinting a Photo

Overview *Retouch a black-and-white photo; color the image using Tinting brushes and several layers set to Gel Composite Method.*

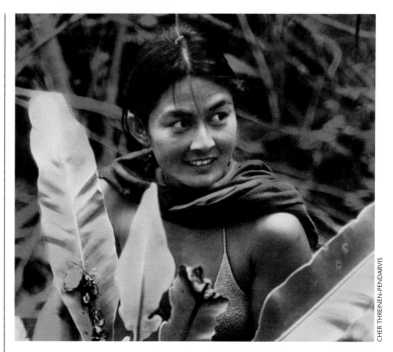

CHER THREINEN-PENDARVIS

1

Using Equalize to adjust the tonal range of the black-and-white photo

2

Repairing scratches with the Soft Cloner variant of Cloners

3a

The new layer in the Layers palette, with Composite Method set to Gel

HAND-TINTING IS A GREAT WAY to give an old-fashioned look to a black-and-white print. It also gives the sensitive artist plenty of opportunity to add depth to an image using hues, tints and shades. For this example, *Rell with Bird's Nest Fern,* we hand-colored a portrait of Hawaiian friend Rell Sunn using Painter Tinting brushes, applying transparent color to layers above the image, so we would not disturb the existing photo.

1 Equalizing the image. To preserve shadow detail during tinting, choose a light image without solid shadows, or correct the tonal range after scanning as described below. Because we no longer had the 35mm slide, we scanned an 8 x 10-inch print at 100%, 150 pixels per inch. The print was slightly overexposed, so we darkened it, taking care to preserve detail in the shadows. If your image needs tonal correction, select Effects, Tonal Control, Equalize (Ctrl/⌘-E). Your image will be automatically adjusted when the dialog box appears. For a more subtle result, experiment with spreading the triangular sliders on the histogram, or move them closer together for more contrast. Use the Brightness slider to make the gray tones brighter or darker overall.

2 Retouching scratches. To touch up scratches, use the Magnifier tool to enlarge the area that needs retouching. Now choose the Soft Cloner variant of Cloners in the Brush Selector Bar. Establish a clone source by Alt/Option-clicking on your image near the area that needs touch-up, then begin painting. A crosshair cursor shows the origin of your sampling. If necessary, re-establish a clone source as you work by Alt/Option-clicking again.

3b

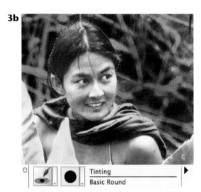

Coloring the "background" layer with the Basic Round variant of the Tinting brush

4a

Flat, transparent washes on the "clothing" and "skin and hair" layers

4b

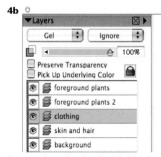

The Layers palette showing the "clothing" layer selected

5a

Bringing out highlights on the shirt using the Soft Eraser variant of Tinting

3 Making a new layer and coloring the background. Create a new layer by clicking the New Layer button on the bottom of the Layers palette. So the paint will appear transparent, in the Layers palette, set the layer's Composite Method to Gel. Also, disable Preserve Transparency (so you can add pixels to the layer) and turn off Pick Up Underlying Color, so the Tinting brushes will not pick up gray from the Canvas as you paint. Choose a color in the Colors palette and the Basic Round variant of the Tinting brush from the Brush Selector Bar. Begin to brush color onto your image. If the color looks too strong, reduce the opacity of the Basic Round variant using the Opacity slider in the Property Bar. For grainier brushstrokes, try the Soft Grainy Round variant.

4 Coloring elements on separate layers. It's often helpful to color areas of the image (such as the skin, clothing and background) on separate layers to make it easy to edit a specific element. Add more layers as needed by clicking the New Layer button on the Layers palette. Remember to set each new layer to Gel Composite Method before you start to paint. We added new layers for each of these elements: the skin and hair, clothing, and the foreground plants.

5 Emphasizing the area of interest. After you've painted color washes, look at the overall balance and color density of your image. Add more or brighter color to the areas that you want to emphasize and apply less saturated colors to make other areas appear to recede. For detail work, reduce the size of the Basic Round variant using the Size slider on the Property Bar. To remove color from oversaturated areas or to clean up edges, use the Soft Eraser variant of Tinting, adjusting its Opacity setting in the Property Bar as you work. The Blender and Softener variants are useful for making color or value transitions smoother.

We used the Blender variant to smooth the brush work in the face and shirt, by softly brushing over the areas using a low-opacity version of the brush.

Saving the image. If your coloring extends for more than one work session, save your image in RIFF format to preserve the layers set to Gel Composite Method. If you'd like import your image

5b

We used the Blender variant of Tinting to smooth areas in the face and shirt.

into Adobe Photoshop, you'll want to flatten a copy of the image first, because Gel method is not available in Photoshop and the color on your tinted layers may change if you open the layered file in Photoshop. Choose File, Clone to quickly make a flattened copy; then save the image as a TIFF file.

Cloning, Painting and Blending a Photo

Overview *Adjust the color and contrast; simplify details and give the photo a soft vignette; use Dodge and Burn tools to enhance highlights and shadows; add expressive brushwork; restore important details with a Soft Cloner brush.*

CHER THREINEN-PENDARVIS

1

The original photo of Michael and Bryn

2

Applying the Sketchbook Scheme and Increase Contrast in the Underpainting palette

PAINTERLY CLONING IS A GREAT WAY to add natural atmosphere to photos and the new Photo-Painting system in Painter 11 makes the process fun and efficient. To create *Portrait of Bryn and Michael*, we began by opening a photo and cloning it. Then we enhanced the clone by warming up its color and adding contrast. To prepare it for painting we used the Smart Blur feature to simplify the photo and then we used Blenders, RealBristle Brushes and Cloners to paint expressive brushwork.

1 Opening palettes, choosing a photo and cloning. To open the Auto-Painting System palettes, from the Window menu choose Show Underpainting. Choose File, Open, then navigate to choose your photo and click Open. To preserve your original photo, make a clone by choosing File, Clone. If the background in your photo is busy, consider selecting it and using Effects, Focus, Soften to blur details. (For information about making selections, see Chapter 5.)

2 Warming up color and adding contrast. Our original photo was taken on a gray January day. We warmed up our clone's color using a Color Scheme chosen from the Underpainting palette. In the Underpainting palette, click the Color Scheme pop-up menu and choose a scheme that suits your image. We used "Sketchbook Scheme." If your image needs adjusting, make a choice from the Photo Enhance pop-up menu. The image will update with a live preview. Our photo also had fairly flat contrast due to the soft natural light, so we bumped up the contrast using the Increase Contrast choice. When you are happy with the look, click the

COLOR SCHEMES

The Color Scheme pop-up menu on the Underpainting palette allows you to access a color scheme from any image that's open in Painter, and apply it to the image you're working on.

3a

Portrait Color: The photo with warmer palette and increased contrast

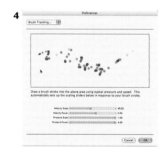

3b

Portrait Color Soft Edge: Detail of the image with Smart Blur applied

4

Setting Brush Tracking

5

Portrait Paint: Sculpting the sleeve with the Real Tapered Flat and Real Blender Tapered variants of RealBristle. The hair was painted with the Real Blender Tapered variant.

Apply button and then save the clone with a descriptive name. We named our file "Portrait Color."

3 Simplifying the image and adding a vignette. A photograph in focus has fine details—for instance, individual strands of hair, or tiny highlights on foliage. An expressive painting, however, usually does not have the same fine detail overall. To simplify the photograph, creating broader patches of color as in a painting, we recommend using the Smart Blur option on the Underpainting palette. Adjust the Smart Blur slider to your liking (we used 50%.)

Next, we added a vignette to focus more attention on the subjects' faces. To give your image a soft edge, choose an edge style from the Edge Effect pop-up menu near the bottom of the Underpainting palette. (We used a Circular Vignette.) The edge effect will update as you change the settings. When the image is as you like it, click the Apply button to accept the settings. Save the file with a descriptive name, we named our file "Portrait Color Soft Edge." This file and the "Portrait Color" file from step 2 will be used as the Clone Source for most of the photo-painting process.

4 Setting Brush Tracking. Before beginning to paint, it's a good idea to set up Brush Tracking, because the RealBristle Brushes used in this technique perform more naturally with Brush Tracking set to match your own stroke pressure and speed. With Brush Tracking you can customize how Painter interprets the input from your stylus. You'll notice the more sensitive control of the RealBristle Brushes, especially with brushes such as the Real Tapered Flat, Real Tapered Bristle, Real Round and Real Fan Soft variants. Choose one of these variants then choose Edit (Win) or Corel Painter 11 (Mac), Preferences, Brush Tracking, make a representative brushstroke in the window and then OK.

5 Cloning and painting. Next, we cloned the "Portrait Color Soft Edge" file from step 3. (To clone your image from step 3, choose File, Clone, and then give the clone a descriptive name. We named ours "Portrait Paint."). Next, we chose Coarse Cotton Canvas in the Paper Selector and the Real Tapered Flat variant of RealBristle Brushes from the Brush Selector Bar. Before beginning to paint, we turned on the Clone Color option in the Colors palette (by clicking its rubber stamp icon) to sample color from the original image. When we wanted to move paint on the image without applying as much color, we switched to the Real Blender Tapered variant of RealBristle. To paint the brighter highlights on the clothing, eyes, chins and lips, we turned off Clone Color and used the Dropper tool to sample color from the image. As we applied the brushwork, we followed the contours of the forms. As we worked, we sized the brushes using the Size slider on the Property Bar. We used larger brushes while painting loose strokes behind the subjects and smaller brushes to paint the details on the faces and clothing. To give the girl's lips more color, we used the Saturation Add variant of the Photo brush.

6a

*Portrait Paint: Using the Just Add Water
variant of Blenders to paint the skin.*

6b

*Portrait Paint: Using the Saturation Add
brush to touch up the lips*

7a ▼ Restoration ⊠

⦿ Soft Edge Cloner brush

● Hard Edge Cloner brush

Brush Size: ◄ △ ► 53.9

*You can use the Brush Size slider on the
Restoration palette to change brush size*

7b

*Portrait Paint Restore: Using the Soft Cloner
to restore the eyes*

8

*Portrait Paint Texture: The subtle texture on
the hat and cheek bone*

6 Blending. In areas where we wanted smoother brushwork, for instance, on the faces and skin, we subtly used the Just Add Water variant of Blenders. We also used this brush to expressively paint over the background. The Just Add Water variant of Blenders uses the Soft Cover submethod and doesn't show paper texture; it's the smoothest of the blending brushes. For a more subtle smearing effect, you may want to reduce the Opacity in the Property Bar. To make more expressive strokes, with the brush size changing as you vary pressure on the stylus, choose Window, Brush Controls, Show Size, and in the Size section, move the Min Size slider to about 15%. Now, paint strokes on your clone. We painted energetic, smeary strokes along the edges of the painting and on the clothing in the foreground; then we smeared the background into more abstract shapes. Change the brush as you work (we varied the Size between 10 and 30 pixels). For a varied blending effect, lower the Opacity to between 30% and 40% using the sliders in the Property Bar.

7 Partially restoring from the original. We recommend saving a new version of your file prior to restoring areas. Again, save it with a descriptive name. We named our file "Portrait Paint Restore." Under the File menu, set the Clone Source to the "Portrait Color Soft Edge" image from step 3. If the Restoration palette is not open, choose Window, Show Restoration.

To bring the subjects' eyes and lips back in subtle focus, we used the file saved prior to using the Smart Blur as our Clone Source. Open the file from step 2 (in our case "Portrait Color") and with your "Portrait Paint Restore" file active, designate the "Portrait Color" file as your clone source (File, Clone Source, Portrait Color.)

With your "Portrait Paint Restore" file active, click the Soft Cloner brush button on the Restoration palette, and with a very low opacity (5%), brush lightly to bring detail back into some of the painted or blurred areas of your image. Experiment with the Opacity slider in the Property Bar until you find a setting that suits your drawing style and pressure. Remember to do the restoration process subtly, and preserve your painted brushwork. Save your image.

8 Adding texture. After we finished painting, we added relief and texture to the brushwork. We recommend saving another version of your file before beginning the texturing process. Give the file a descriptive name. We named ours "Portrait Paint Texture."

To add texture to your image that will subtly enhance your brushwork, choose Effects, Surface Control, Apply Surface Texture, Using Image Luminance. For a natural look, set the Amount slider to around 5–10% and set the Shine to 0%, (for a matte look rather than a glossy look). Click the Light Direction button that complements your image (we chose the 11 o'clock Light Direction button and left the other lighting settings at their defaults). 🖌

Creating a Photo-Painting

Overview *Open a retouched photo in Painter; paint a loose abstract background; clone and paint the image with brushes; add surface texture.*

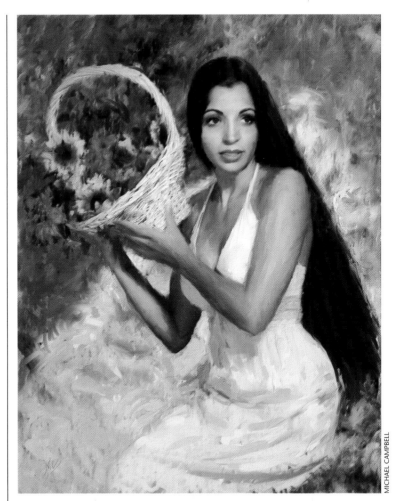

MICHAEL CAMPBELL

The original photo shot by Campbell

The clone filled with a tan color (left) and the loose brush work painted over the tan fill (right)

FOR *PORTRAIT OF PATRICE*, Michael Campbell combined photography with painting. Campbell is a professional photographer who specializes in portraits. He began the work by choosing a photo from a shoot and retouching it using Photoshop, and then saving it as an RGB TIFF file. In Painter, he used cloning and paint applied with various brushes to combine the photograph with expressive brush work and texture.

1 Opening a photo and making a clone. To begin the image, Campbell opened his photo in Painter. The file was approximately 10 x 14 inches, at 150 pixels per inch. He made a clone of the image by choosing File, Clone. (Campbell left the original photo open so that he could sample color from it later using the Dropper, or clone from it later using the Cloners brushes.) He saved the cloned image, giving it the name *Step 1* to keep versions of his image organized.

2 Building a painted background. For a colored background that would provide a base for more tightly rendered brushstrokes,

3

Loosely cloning the photo into the painted background

4a

Building the forms and colors

4b

Using smaller brushes to refine the forms and background

Campbell used the Dropper tool to sample a light tan color from the original photo. Then he filled the clone canvas with the color by choosing Effects, Fill (Ctrl/⌘-F), choosing Current Color and clicking OK. Next, he applied loose brush work to this background using various Oils brushes (for instance, the Opaque Round variant of Oils), applying colors that he had sampled from the photo with the Dropper. At this point, he had not cloned imagery from the photo yet. He saved and named the painted background image *Step 2*.

3 Beginning to clone in the photo. Next, Campbell added more loose brushstrokes to his image using a large cloning brush based on the Camel Oil Cloner variant of Cloners. (During this step in his process, he doesn't like to use Painter's Tracing Paper function much, because he feels that it hides the look and color of his brushstrokes).

4 Building form and color. As Campbell continued to paint the figure and basket, his brushstrokes followed the contours of the forms as they do when he uses conventional oil paints. While he worked, he often changed the Size of the brush using the Size slider popped out of the Property Bar. Sometimes he turned off the Clone Color button in the Colors palette and painted freehand to retain a loose painterly feeling in the image. He saved this version of the image as *Step 3*.

5

The final painted stage is shown in this detail.

5 Refining the painting. Campbell wanted to create a looser painted look in the clothing, flower basket and background, and more realistic detail in the model's face. To paint the dress, flowers and basket, he used a small version of the Camel Oil Cloner variant. He softly refined the detailed parts of the face, especially the eyes and mouth. In areas where he wanted even more realism, he switched to a small Soft Cloner variant of the Cloners and with the original photo as the clone source, he carefully restored the model's eyes, nose and lips. When Campbell was pleased with this stage, he saved it and named this version of the image *Step 4*.

6a

The complete painted and cloned image before texture was added

6b

Detail of the face showing the Surface Texture applied to the paint

6c

Detail of the image showing the second Surface Texture application using the canvas texture

6 Applying two kinds of texture. Next, Campbell added three-dimensional highlights and shadows to his brushstrokes by choosing Effects, Surface Control, Apply Surface Texture, Using Image Luminance, with subtle Amount and Shine settings of approximately 30%, leaving other settings at their defaults. He named this textured image *Step 5*.

He wanted to try a canvas-like texture, so he opened his "Step 4" image, and chose File, Clone again. With this image active, he chose Effects, Surface Control, Apply Surface Texture, this time Using Paper. He chose the Raw Silk texture from the Painter 7 texture library, loaded from the Painter 11 CD-ROM. He named the clone with the canvas texture *Step 6*.

7 Cloning imagery from different versions. To hide the canvas in some areas as if it were thick paint covering up the canvas of a real painting, Campbell used various sizes of the Camel Oil Cloner variant to clone imagery from the *Step 5* clone into the *Step 6* clone. (To designate another image as a clone source, open it; then choose File, Clone Source and select its name in the menu.) After he was satisfied with the look of his image, he saved it as *Step 7*, and as an RGB TIFF file for printing on a high-resolution inkjet printer using archival inks. The final image can be seen on page 257. 🖌

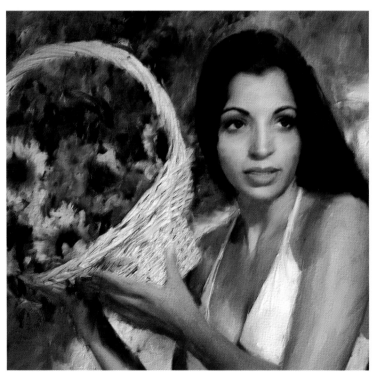

Detail of the final image showing areas of the first Apply Surface Texture application that accentuated the brushstrokes ("Step 5") cloned into the "Step 6" clone that included the Apply Surface Texture application Using Paper

Melting with Watercolor

Overview *Posterize the image to create flat areas of color; build a soft border; lift the Canvas to a Watercolor layer; apply effects; enhance the image using a Composite Method.*

1

The color photograph

2

The posterized photo with soft edge added

3a

The Watercolor Layer set to Screen

3b

The photograph melted into watercolor

WITH PAINTER'S WATERCOLOR LAYERS, a photograph on the Canvas layer can be melted into a watercolor painting.

1 Choosing an image. For the best results, open an image with good value contrast and color. Our image was 1200 x 900 pixels.

2 Posterizing and making a layer. To build flat areas of bright color that will aid in simulating watercolor paint, choose Effects, Tonal Control, Posterize. Choose a setting that complements your photo. (We chose 12.) Now give your image a soft vignette. (For information about building a vignette, see page 182 in Chapter 5.) Next, put a copy of the Canvas on a new layer by choosing Select, All, pressing Alt/Option and then choosing Select, Float. Hide this layer by toggling its eye icon closed in the Layers palette.

3 Creating a watercolor effect. Now, select the Canvas, and from the pop-up menu on the Layers palette, choose Lift Canvas to Watercolor Layer. Choose a texture in the Paper Selector. (We chose French Watercolor Paper.) Now choose a Watercolor brush whose characteristics you'd like to apply to your image when you "wet" the Watercolor layer. We used the Diffuse Grainy Camel variant of Watercolor.

To melt the image with watercolor, choose Wet Entire Watercolor Layer from the pop-up menu on the Layers palette. In the Layers palette, when the animated water drop next to the Watercolor layer name stops dripping, the watercolor effect is complete.

We wanted a brighter, high-key look, so we dragged the posterized photo layer under the Watercolor Layer and then opened its eye icon. Because the default Composite Method of the Watercolor Layer is Gel, the image looked dark. To lighten it, we changed the Composite Method for the Watercolor Layer to Screen in the Layers palette. Then we lowered its opacity to 80%.

Distressing a Photo

Overview *Open a photo; copy the image to a new layer; use Distress to make it black-and-white and texturize it; combine the layer and the canvas using a transparent Composite Method.*

1a

The original photo of the Mercury Temple

1b

Increasing the Contrast of the paper texture

2

Applying the Distress effect

3

The image showing the layer set to Screen Composite Method before reducing Opacity

CHER THREINEN-PENDARVIS

BY DEFAULT, THE DISTRESS FILTER IN PAINTER adds texture and changes a color image to black-and-white. In this example, we used custom settings to apply the filter to a layer and then set its Composite Method to Screen, so the effect would combine with the colored photo beneath it.

1 Choosing a photo and a texture. Open a photo with good contrast and color. A bold image with a strong focal point will respond best to this technique. Choose a high-contrast texture that will complement your photo. We opened the Papers palette (Window, Library Palettes, Papers) and chose Worn Pavement from the Papers picker menu. To achieve a more dramatic texture in the final image we increased the contrast to 190%.

2 Making a layer and applying the effect. The Distress process is easier to control when the filter is applied to a copy of the image on a layer, and then the filtered and original versions are combined. To put a duplicate of the image onto a layer in the Layers palette, choose Select All (Ctrl/⌘-A); then press the Alt/Option key and choose Select, Float.

With the layer active, access the Distress dialog box by choosing Effects, Surface Control, Distress. Leave the Using menu set to Grain. Experiment with the settings in the dialog box to suit your taste. We increased the Edge Size to 20.32 to bring out the highlights; lowered the Edge Amount to 33% to darken the shadows; reduced Smoothing to 1.00 so the filter would not "round" the edges and reduced Threshold to 44% to lighten the image. When you've achieved a texture with the amount of white you want, click OK.

3 Blending the treated layer with the original photo. In the Layers palette, to drop out the black areas of the layer to reveal the photo underneath, change the Composite Method to Screen. For a more subtle effect, we also lowered the opacity of the layer to 60% using the Opacity slider in the Layers palette. 🖌

Creating a Woodcut from a Photo

Overview *Open a photo and clean up the background; copy the Canvas to make a new layer; create a color woodcut plate on the Canvas; create a black woodcut plate on the new layer; retouch the black plate; add clouds and texture.*

JOHN DERRY

The original digital photo of the pagoda

2a [toolbar: Tolerance: 11 | ☑ Anti-Alias ☐ Contiguous]

Setting the Tolerance for the Magic Wand in the Property Bar

WITH PAINTER'S WOODCUT FILTER you can start with a photo and achieve a look similar to a conventional wood block print. You can simply use the color arrived at by the Woodcut filter defaults, or you can enjoy complete control over choosing the colors.

The traditional wood block printing process involves simplification of detail in the lines and color areas. Inspired by Japanese wood block prints from the 1800s, John Derry created *Pagoda*, which is based on one of his own digital photos. Painter's Woodcut filter helped him to reduce the number of colors in the image and to fine-tune the colors for the final artwork.

1 Choosing a photo. Open a photo with good contrast and color. A bold image with a strong focal point will work best for this effect.

2 Cleaning up the sky. To focus more attention on the pagoda, Derry simplified the sky by selecting it and applying a blue fill. Choose the Magic Wand in the Toolbox and click in the sky. Adjust the Tolerance in the Property Bar until most of the sky

2b

The Image viewed with the mask eye icon open (left), and the active selection with the blue fill applied (right)

3

The visibility of Layer 1 is turned off and the Canvas is selected.

4a

Increasing the Color Edge to make simpler, smoother shapes (left) and brightening the gold color (right)

4b

The color woodcut plate

is selected; at this point, edges are most important, since you can clean up any small internal "debris" by painting on the mask later. Save the selection as a mask in the Channels palette by choosing Select, Save Selection. In the Channels palette, open the eye icon to the left of the mask's name. Choose *black* in the Colors palette and paint on the mask where you need to *add* more mask; use *white* to *remove* areas of the mask (for instance, to remove debris). To use the mask to isolate the sky, choose Select, Load Selection. (See Chapter 5 to read more about working with masks and selections.) Next, fill the selection with blue by choosing Select, Fill with Current Color.

3 Setting up layers. The Woodcut process is easier to control when the color elements are on a separate layer from the black elements. Derry started his layering by making a duplicate of the original image. To put a duplicate of the image canvas onto a layer, choose Select, All (Ctrl/⌘-A), press the Alt/Option key and choose Select, Float. In the Layers palette, turn the new layer's visibility off by toggling shut the eye icon to the left of its name.

4 Cutting the color "wood block." In the Layers palette, click the canvas name to activate it for the colors. To access the Woodcut dialog box, choose Effects, Surface Control, Woodcut. When the dialog box appears, disable the Output Black check box. The options for Black Output will now be grayed out. In the lower portion of the window, accept the default number of colors (16), and smooth out the edges of the color blocks by adjusting the Color Edge slider to the right. (Derry set it at approximately 11.46.)

When the edges were as he liked them, Derry fine-tuned a few of the colors. For instance, he chose a tan color swatch (at the bottom of the dialog box) and made the color brighter. Click on a color square to select it; a red outline will appear around it. Now that it's selected, you can choose a new color in the Colors palette and the swatch will change to the new color. To sample a color directly from the image Preview window, press the Ctrl/⌘ key and click on the Preview. To change the color, choose a new color in the Colors palette.

To see other areas of your image in the Preview window, drag with the grabber hand cursor to move around the image preview. When you're satisfied with the colors, click OK to accept.

5a

Setting the Composite Method for Layer 1 to Multiply

5b

To achieve more detailed black edges, the Black Edge slider was adjusted to the left.

6a

The black plate (shown with the Canvas hidden) with black in the sky (left), and with the sky retouched (right)

6b

The in-progress woodcut with both color and black plates in place

5 Cutting the black plate.

To begin making the black plate, target Layer 1 by clicking on its name in the Layers palette and open its eye icon. At the top of the Layers palette, set its Composite Method to Multiply so the white that will be generated on the layer by the Woodcut effect will disappear. Now, choose Effects, Surface Control, Woodcut and turn on Output Black and turn off Color Output in the dialog box. For more detailed edges, adjust the Black Edge slider to the left. (Derry set it to approximately 25.75.)

6 Cleaning up the black plate.
The settings that worked well for the detail in the pagoda left too much black in the sky. Using the Scratchboard Tool variant of Pens and white paint, Derry removed the black by painting white over the sky. He chose the Scratchboard Tool because it paints with a crisp edge. An Eraser variant would have produced a softer edge.

7 Adding clouds and texture.
Next, Derry painted simple cloud shapes on a new layer using a large Scratchboard Tool and white paint. (To add a new layer, click the New Layer button near the bottom of the Layers palette.) Increase the size of the Scratchboard Tool using the Size slider in the Property Bar (Derry adjusted his to about 25.4). Paint loose brushstrokes that complement your composition. Then he dragged the layer below the black plate layer in the Layers palette so the black would appear to be "printed" on top.

7

The clouds and texture have been added.

For added realism, Derry completed the woodcut by adding a subtle paper texture to the colored layer. To add texture, click on the colored layer in the Layers palette. Select Basic Paper in the Paper Selector; then choose Effects, Surface Control, Dye Concentration, Using Paper. In the dialog box, try moving the Maximum slider to the right until a subtle paper texture effect is visible. Adjust the settings to your taste and click OK. 🖌

Auto-Painting with Custom Strokes

***Overview** Build a custom stroke preset for Auto-Painting; use the Auto-Painting system to create a painting from a photograph.*

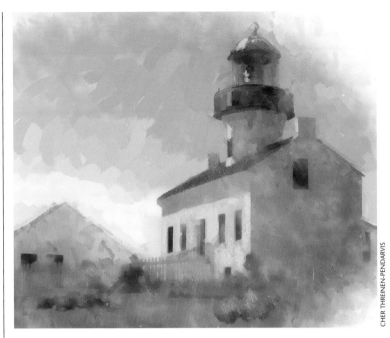

CHER THREINEN-PENDARVIS

The original photo

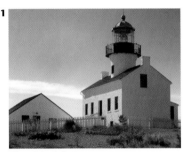

The Underpainting palette with settings

AUTO-PAINTING ALLOWS YOU TO transform photographs into paintings by applying automatic strokes that incorporate stroke style, pressure and direction. The Auto-Painting system includes three palettes: Underpainting, Auto-Painting and Restoration. Using sliders in the Auto-Painting palette, you can adjust Pressure, Length, Rotation, and Brush Size to get the brushstrokes you desire. For even more creative freedom you can record your own strokes and use them with the Auto-Painting features.

1 Choosing a photo and opening palettes. Open a photograph that has a strong center of interest and good contrast. Choose File, Open, navigate to choose your photo and click Open. To open the Auto-Painting system palettes, from the Window menu choose Show Underpainting.

2 Simplifying for an underpainting. To make a clone image with a white Canvas for your painting, click the Quick Clone button on the Underpainting palette, and save your clone file with a descriptive name.

To make the source image we would use in steps 4 and 5, we used the Underpainting palette controls to increase the Brightness, Contrast and Saturation; we also used the Smart Blur control to simplify the details in the photograph. So that you can easily use these settings on other images, click the + option to save them as a custom preset. (We named our preset +10 B, +10 C, +40 Sat, SB 75.) Click Apply to accept the settings and make the adjustments to your image. Now that your underpainting is complete, save your file and give it a descriptive name. We named our file "Lighthouse Underpainting."

2b

The original photo of the lighthouse

The photo with underpainting

3a

Choosing Record Stroke from the Brush Selector Bar menu

3b

The curved stroke painted with the Variable Oil Pastel 30 variant

4a

The Variable Oil Pastel 30 is chosen in the Brush Selector Bar (top). Clone Color can be enabled in the Colors palette by clicking the Rubber Stamp icon.

3 Recording a custom stroke to use with Auto-Painting.
Painter allows you to record a brushstroke and play it back, using any of three methods: Playback, Auto Playback or Auto-Painting. Playback repeats the brushstroke each time you click with your stylus or mouse. Auto Playback repeats the stroke until you turn it off by clicking in the image or by choosing Auto Playback again. Auto-Painting uses recorded strokes to clone a photograph to create a painted look. You can save recorded strokes as presets to use with the Auto-Painting features

When we paint from scratch using conventional pastels, we often use a loose cross-hatching technique to block in basic color shapes and values. You can record a stroke and play it back using Auto-Painting to simulate this hatching process. Begin by choosing the Variable Oil Pastel variant of Oil Pastels, and then paint a short diagonal stroke with a slight curve. In the brushstroke illustration, notice that we varied the stylus pressure when making our stroke, using lighter pressure for the lower part of the stroke to make it partially transparent. (The transparency will help with the paint interaction later.) When you have practiced the stroke and are ready to record it, choose Record Stroke from the pop-up menu on the Brush Selector Bar. (The Record Stroke, Delete Stroke and Save Stroke commands can also be accessed from the tiny arrow to the right of the Stroke menu on the Auto-Painting palette). Draw the stroke. Then to try out the recorded stroke, choose Playback Stroke from the pop-up menu on the Brush Selector Bar, and click to place a stroke and then disable Playback Stroke by choosing it again. Next, save your stroke by choosing Save Stroke from the pop-up menu on the Brush Selector Bar, and when the Save Stroke dialog box appears, name your stroke. (We named our stroke Soft Diagonal.)

4 Roughing in strokes using Auto-Painting. For artists who like to paint freehand, Auto-Painting can be a useful, quick method for roughing in basic colors and values to get you started. For those who are not practiced with painting by hand, Auto-Painting can create a painted look. Multiple applications using larger brushes first, and then applications using smaller brushes can build a painting without much freehand brushwork.

To set up your file for Auto-Painting, select your underpainting file and then click the Quick Clone button on the Underpainting palette. So that you can see the strokes as they appear on the empty canvas, turn Tracing Paper off by pressing Ctrl/⌘-T. If the Auto-Painting palette is not open, choose Window, Show Auto-Painting.

Now choose the brush that you want to use for Auto-Painting. You can use the same brush that you used when recording the stroke, or a different one. We chose a Variable Oil Pastel, because it performs like a soft oil pastel that smears subtly in a painterly way, and it incorporates Color Variability that adds interest and expression to the image, making it look hand-painted. (Color Variability allows the Hue, Saturation and Value to vary with each stroke,

The Auto-Painting palette shows the custom stroke chosen and its settings.

Lighthouse Rough: Auto-Painting with the basic shapes and colors

Lighthouse Medium: Auto-Painting with smaller brush size and more detail

The painting with restoration and more loose brushwork applied

within the range of settings that have been saved with the brush.) In the Colors palette, enable Clone Color for the Variable Oil Pastel. The custom stroke you saved will appear in the pop-up menu on the Auto-Painting palette; choose it. For the rough stage, we used these settings: Randomness, 95% (applies strokes randomly for a natural look); Pressure, 90% (the amount of pressure applied); Length, 50% (the length of the strokes), Rotation, 180° (the rotation of the brush-strokes); and Brush Size 75% (percentage of the actual brush size chosen). When the sliders are set, click the Play button (the small arrow) near the bottom of the Auto-Painting palette. You can click the Stop button or click in the image to stop the Auto-Painting process. Click the Play button again if you want to add more strokes. When the rough painting is complete, save your file, giving it a descriptive name. We named ours "Lighthouse Rough."

5 Refining with finer strokes. After the rough stage was complete, we added smaller brushstrokes. To begin this stage, make a clone of your rough file by choosing File, Clone and naming this image with a descriptive name. We named ours "Lighthouse Medium." Next, change the clone source for your new image by choosing File, Clone Source, and from the list choose your Underpainting file. Set up the Auto-Painting palette to use a smaller brush size and to make shorter, less random strokes, using these settings: Randomness, 50%; Pressure, 85%; Length, 77%, Rotation, 180°; and Brush Size 50%. With the sliders set, click the Play button, and watch Painter add strokes to your image.

6 Refining with Restoration. You can use any of Painter's brushes, as well as the Restoration palette and Cloning brushes to restore detail to your image. Make a clone of your recent image stage (File, Clone), and save it with a descriptive name (we named ours "Lighthouse Fine.") Choose File, Clone Source, and select your Underpainting image from the list of files.

With your new image active, if you'd like to retain a loose sketchy look as we did, we recommend using a Square Hard Pastel (Pastels) to complement the Variable Pastel strokes. You can use this brush to paint a few crisper edges to subtly strengthen the focal point—we touched up the lighthouse tower, roof and wall highlights in our image. When you want to pick up color from the Clone Source, enable the Clone Color button on the Colors palette to turn the brush into a cloner. You can also sample color from the painting using the Dropper tool. We added a few subtle strokes to the foreground plants, to the building on the left, and we painted some light-colored strokes in the upper-right and lower-right corners. If you want to use crisper edges or other imagery from your Underpainting file, you can click the Soft Cloner button on the Restoration palette and use this brush. But keep in mind that if you restore too much detail, your image will look like a photograph again. 🖌

Making a Custom Solarization

Overview *Use Express Texture on positive and negative clones of an image; merge the images by filling with a Clone Source.*

CHER THREINEN-PENDARVIS

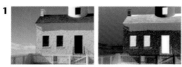

The original image after equalizing (left), and the negative clone

Creating black-and-white positive (left) and negative versions of the clones using Express Texture

Merging the positive and negative images

Adjusting the image's brightness and contrast

IN THE DARKROOM, SOLARIZATION OCCURS when a negative or print is exposed to a flash of light during the development process, partially reversing the photo's tonal range. To achieve this effect digitally, we tested other image-processing programs and filters, and found that we got the most control and detail using Painter's Express Texture feature. This technique gives you a lot of control over the image's value contrast and it frequently creates a glowing edge-line effect where contrasting elements meet.

1 Making positive and negative clones. Open an image with good value contrast; then choose Effects, Tonal Control, Equalize (Ctrl/⌘-E) to increase its tonal range. Choose File, Clone twice. Make one of the clones into a color negative by selecting Effects, Tonal Control, Negative.

2 Making black-and-white separations. Use Painter's Express Texture feature to convert both clones to black-and-white: Choose Effects, Surface Control, Express Texture, and select Image Luminance from the pop-up menu. Experiment with the sliders and click OK. Repeat the process for the second clone. We set Gray Threshold to 85%, Grain to 85% and Contrast to 113%. These settings helped emphasize the gradient effect in the sky and on the building.

3 Merging the two exposures. Choose File, Clone Source and choose the positive clone. Now fill the negative image with a percentage of the positive (the "flash of light"): With the negative window active, choose Edit, Fill, Clone Source. Set the Opacity slider between 20% and 60%, depending on the tones in your image.

4 Pumping up the tonal range. To achieve a broader tonal range while maintaining a silvery solarized look, we selected Effects, Tonal Control, Brightness/Contrast. We increased the contrast (the top slider) and decreased the brightness. 🖌

■ Artist **Fay Sirkis** created the engaging portrait *Ashlie*, using a photograph captured by the late **Don Blair** and sensitive Painter brush work. Sirkis has a background in traditional painting and uses this experience to create paintings from photographs. "I am inspired by the fact that I can turn cherished photos into timeless portrait paintings, thereby helping people keep their special memories alive," says Sirkis.

Sirkis wanted to paint the young teen using high to medium key colors with a dramatic background. To begin, she opened the image in Photoshop and adjusted the Curves and the Hue and Saturation to obtain the skin tones that she desired for her painting. In Painter, she used cloning and paint applied with various brushes on layers.

She opened the photo in Painter and chose File, Clone to clone the photo. She left the original photo open and selected the clone image. Next, she added a new transparent layer to the clone image, and then she enabled Pick Up Underlying Color in the Layers palette.

She painted using a soft brush, the Digital Airbrush variant of Airbrushes and a hard-edge brush, the 2B variant of Pencils. First, she chose the Digital Airbrush and enabled Clone Color in the Colors palette, and then she painted on the layer, right over the photo on the Canvas below. She used a very small brush to outline the image, and then she added broader strokes. As she painted colors for the portrait onto the layer, she turned Clone on and off as she worked. She alternately added color with

the Airbrush, and then blended it with the Smudge and Grainy Water variants of Blenders.

For the background, Sirkis painted deeper tones using the Palette Knives, and she also used the Palette Knife to define crisper edges on the girl, making the portrait seem three-dimensional. Finally, she added the smaller details on the sweatshirt seams and hood strings with a tiny 2B Pencil brush.

When the painted layer was complete, Sirkis merged it with the Canvas by choosing Drop from the Layers palette pop-up menu. The photo acted as a foundation for her brushstrokes, and the painted brush work blended with the photograph perfectly so that no details were lost.

■ Artist **Donal Jolley** usually begins his paintings by shooting reference photos. He usually roughs in color using the Oils brushes, the Sargent Brush variant of Artists and then uses Palette Knife variants for more detailed brushwork.

Jolley began *Capitol* by taking a photograph of the Georgia Capitol on a summer evening. He opened the photo in Painter and made a clone of it by choosing File, Clone. He saved the clone image by choosing File, Save As, giving it a new name. Jolley kept the original photo open. He loosely painted over the entire clone image using the Sargent Brush variant of Artists. Next, he brushed more color onto the background—modulating subtle tonal differences—using Smeary variants of Oils, for example, the Round Camelhair. When he wanted to paint with color from the original image, he enabled Clone Color in the Colors palette for the brush. To sample color from the painting, he turned off Clone Color in the Colors palette and used the Dropper tool to pick up color from

the image. When the larger forms were in place, Jolley used a small Round Camelhair brush to paint the details on the building. Then, he used the Smeary Palette Knife variant of Palette Knives to push and pull color, sizing the brush and changing the Opacity as he worked. This brushwork is most noticeable in the clouds and sky.

When the painting was nearly complete, Jolley added a new layer and painted final details using a small Tapered Conte Crayon variant.

■ *American Rose-Eyed Glasses* is an illustration by designer and illustrator **Donal Jolley**. The image is based on a composite of a photograph Jolley captured of a young woman and an American flag illustration that he created in Adobe Illustrator and then distressed in Photoshop.

Jolley began by drawing the American flag using Illustrator, and then he distressed it in Photoshop. Next, he opened the portrait photo in Photoshop and created a mask to drop out the background behind the subject's head. After increasing the color saturation, he saved the file in Photoshop format for opening in Painter. Working in

Painter, he cloned the image by choosing File, Clone and then saved the clone with a new name. Using smeary brushes (for instance, the Round Camelhair variant of Oils) and the Sargent variant of Artists, Jolley painted over the entire photograph, directly on the Canvas layer. When he wanted to paint with color from the Clone Source, he enabled the Clone Color option in the Colors palette. When the Canvas was completely covered with brushwork, he turned off the Clone Color option and continued using the Round Camelhair brush to further refine the portrait. To blend and pull color, Jolley used the Blenders and

Palette Knives variants, for example, the Smeary Palette Knife. Next, he used the Fairy Dust variant of the F/X brush to blend areas. When the brushwork was nearly complete, he added another new layer and painted more detailed, tighter brushstrokes using the Smeary Palette Knife. Then he saved the layered file in PSD format.

Next, working in Photoshop, he selected the portrait and put it on a layer. Then he positioned the American flag behind the portrait. To complete the image, Jolley made final adjustments to the color.

■ An internationally acclaimed studio portraitist, **Phillip Stewart Charis** has created elegant and timeless likenesses of celebrities, individuals and families for more than three decades. Known for his life-sized portraits, which are printed and then mounted on canvas, Charis has drawn inspiration from artists such as John Singer Sargent, Raphael and Rembrandt. The portrait *Pretty Little Girl* was photographed in his studio in Southern California. Then, a transparency was scanned, saved as an RGB TIFF file and opened in Painter. To protect the figure while he worked on the background, Charis made a mask.

Then, using expressive brush work, he painted over the image background with the Sable Chisel Tip Water variant of Brushes (loaded from the Painter 5.5 Brushes library from the Brushes folder on the Painter 11 CD-ROM). To smooth some areas, he painted finer strokes with a low-opacity Just Add Water variant of Blenders. He used the brushes not to apply color, but to blend and smear pixels in the image in a painterly way.

For the figure and clothing, Charis used smaller versions of the same two brushes. When brushing over the face and hair, he carefully painted with a small brush to preserve the important details. "The photographer must seek out the personality of the sitter, which lies beneath a veil that subtly alters the surface of the face. Piercing that veil to reveal the subject's character is something that, after the posing is taken care of, can only be done for a fraction of a second," says Charis.

■ For *Bottles*, artist **Richard Noble** was inspired by an arrangement in the window of an antique store in Idaho. He was interested in capturing the luminescent colors and shapes of the bottles contrasted with the rugged, rusty plates. Noble began by taking a reference photo of the window. Later, back at his studio, he opened the photo, made a clone by choosing File, Clone and saved the file with a descriptive name. Working on the clone image, Noble painted base colors directly over the photograph using the Round Camelhair variant of Oils.

In his composition, Noble plays the warm colors of the rusty license plates and wood against the cool colors of the bottles and glass. The careful use of color and detail leads the viewer's eye around the canvas.

When the basic colors were established, Noble wanted to enhance the reflection effect on the dusty glass window, so he used the Lasso tool to make a freehand selection of areas of the window and then lightened them to brighten the appearance of the reflection and to help define the image. Noble worked over the painting

using the Round Camelhair brush, which allowed him to smear paint as he applied fresh color, reconstructing details of the bottles and wood, one by one.

After the composition and rough painting was established, he refined details using a smaller Round Camelhair brush. He also used the Artist Pastel Chalk variant of Pastels to draw back into the painting and a small Just Add Water variant of Blenders to smooth areas. This brushwork is most noticeable on the license plates and in the details of the highlights on the bottles.

■ When artist **Larry Lourcey** shot reference photos for *Bluebonnets,* he was inspired to create an image with an Impressionist look. He designed the scene for his composition, seating his wife Heather in the middle of a field of bluebonnets. The clusters of flowers and foliage and the weave in the hat and basket reminded Lourcey of Impressionist brushstrokes.

Back at his studio, Lourcey picked one of the photos from the shoot, and opened it in Painter. Lourcey chose File, Quick Clone, to clone the image, delete the contents of the clone Canvas and enable Tracing Paper. He left his original image open (to paint with color from the Clone Source) and he targeted the clone. In the Brush Selector Bar, he chose the Impressionist variant of the Artists brush. To paint with color from the clone source, he enabled Clone Color for the brush in the Colors palette. Then he painted broad, expressive brushstrokes to bring elements of the photograph into the clone Canvas toggling Tracing Paper on and off as he worked (Ctrl/⌘-T). As he painted, Lourcey changed the Size and Opacity of the Impressionist brush. When he wanted to paint with color from his working image, he disabled the Clone Color button on the Colors palette, and used the Dropper tool to sample color from the painting. To paint small details in the center of interest (for instance, on the figure, hat and basket), he sized the Impressionist brush to about 5–10 pixels and painted smaller, curved strokes.

■ Artist **Ad Van Bokhoven** works both traditionally and digitally. To create *Madrid Opera House*, he used Painter to produce brushstrokes and a style similar to that he achieves with traditional acrylics and oil paint. Van Bokhoven was inspired by the beautiful lighting and the fall colors in the foliage. He shot digital photographs to use for reference.

Later, back at his studio, he selected one of his photos and opened it in Painter. He chose File, Quick Clone to clone the image, deleted the contents of the clone Canvas and enabled Tracing Paper. He left his original image open (to paint with color from the Clone Source), targeted the clone and chose a custom Oils brush, and then he enabled Clone Color in the Colors palette. He painted broad brushstrokes to bring elements of the photo into the clone Canvas. When he wanted to see his brushstrokes without the Tracing Paper overlay, he toggled Tracing Paper on and off as he painted (Ctrl/⌘-T).

So that he could apply paint and blend it as he worked, he painted directly on the Canvas, without the use of layers. To mix and pull color, he used modified Blenders brushes, similar to the Round Blender Brush and the Grainy Blender variants. Van Bokhoven's expressive brushwork suggested the shapes of the architecture and foliage, without adding fine details.

Finally, to add a subtle canvas texture to his image, Van Bokhoven chose Coarse Cotton Canvas in the Paper Selector and then chose Effects, Surface Control, Apply Surface Texture Using Paper with subtle settings. To avoid a "filtered" look, he painted back into areas of his image with a Blenders brush. Then, he used a custom Oils brush to paint loose leaf shapes on the foreground grass and trees.

■ Photographer and artist **Marilyn Sholin** was commissioned to create *Remember When Your Brother Was Your Best Friend*. The painting is part of Sholin's *Remember When* series, which is devoted to precious childhood memories.

Sholin began by shooting photographs of the children at a Key Biscayne beach (Florida) at sunrise, using her Hasselblad 500C with a 150 mm lens and Kodak 400NC film. She captured the exquisite light of the early morning, and the warm relationship that the twins shared. After the film was processed, she ordered a high-resolution scan of the negative, and then she enhanced the saturation of the photo using Photoshop.

Sholin opened the edited photograph in Painter and cloned it by choosing File, Clone. Then, she deleted the contents of the clone image by choosing Select, All (Ctrl/⌘-A) and then pressing Backspace/Delete. She saved the clone image by choosing File, Save As, and gave it a new name. Sholin kept the original photo open and enabled Tracing Paper in the clone by pressing Ctrl/⌘-T. Working in the clone, she used Cloners brushes to paint the image into the clone Canvas.

After establishing the image in the clone, she toggled Tracing Paper off and on as she worked. To enhance the mood in the painting, she added warmer, soft colors by

using a variety of Acrylics brushes. Then, to smooth and blend areas, she used the Wet Sponge variant of Sponges and various Blenders brushes. As she worked, Sholin was careful to retain the highlights and the contrast in her portrait. Next, she added details to the children's eyes and faces.

At last, to give the image an irregular border, Sholin extended the size of the Canvas by choosing Canvas, Canvas Size, and then she added more width and height. Then, she used the Acrylics, Blenders and Sponges to paint around the border to create a soft edge. When her image was complete, Sholin printed it on Red River Lux Art watercolor paper.

■ An internationally acclaimed portrait photographer and artist, **Helen Yancy** has been honored by the Professional Photographers of America, the British Institute of Professional Photography, the United Nations and other organizations. For more than forty years, Yancy has created exquisite images that portray people with sensitivity and realism. Working with Painter has helped Yancy to break down creative boundaries and to enjoy great artistic freedom.

"From a lovely red rose in a glass on my kitchen counter and a session with a lovely young woman, *Heart of the Rose* was created," says Yancy. The portrait session was shot with a Canon 5D Mark II camera, Profoto lights with a softbox and reflector on a dark background. Yancy selected a photograph from the shoot and then used Photoshop to retouch and enhance the face. She opened the photograph of the red rose and composited the two images in Photoshop to place Lacey as if she was sitting in the heart of the rose. She cropped the image, flattened the layers, and saved the composite as a new file in PSD format.

Then, Yancy opened the rough composition in Painter, made a clone copy by choosing File, Clone and saved the clone with a new name. She likes working on layers because she can hide or show them as she paints. She added a new layer above the photo composite on the Canvas and turned on Pick Up Underlying Color in the Layers palette. On the first layer, she painted the background and the rose using extremes of contrast and color to amplify highlights and depth. Highlights on the reds were painted with yellow-oranges and Yancy added leaves and stems using a variety of greens. She used the Captured Bristle variant of Acrylics to lay down paint and the Grainy Water variant of Blenders to smooth areas. Next, Yancy added a new layer for the flesh tones. She used Captured Bristle to sculpt the dimensionality of the face. When the face was modeled, she added a new layer for the hair and applied exaggerated colors in both highlights and shadows, this time blending with the Grainy Water brush at 100% opacity to retain definition in the hair. She painted the gown on the same layer, using subtle blending to retain the smooth look of the satiny material.

■ "Although the program is called Paint-
er," says renowned photographer **Pedro
Meyer**, "it's important not to exclude pho-
tography from its repertoire, given that
the program can also be used effectively in
that medium." Meyer's keen photograph-
ic eye—and a Nikon digital camera—cap-
tured the initial photo for the image above
in Glendale, California. "One of the aspects
that I do find intriguing with the tools
that we have at hand today, is that we

can explore after the image is taken, what
works to our best advantage in making the
image more effective," says Meyer.

Meyer had taken the photograph straight.
To create an impression of dynamic
motion, he tilted it slightly, and then used
focus and blur effects (for instance, Cam-
era Motion Blur) to help the viewer con-
centrate on the most significant areas in
the image. The stores in the background
were not as important as the single figure,

so Meyer turned them into more general
texture elements. Meyer says, "Before dig-
ital photography it was very hard to make
credible images which had these traits, for
instance, the special focus and blur effects
which are used in *Glendale*. It was quite
complicated and time-consuming. These
days, almost all it takes is the imagina-
tion to use the tools in ways that are more
about the ideas than about showing off the
virtues of the tools themselves."

■ Artist **John Derry** created the photo-painting *KD House*. He began by using his Canon 5D digital camera to shoot a photograph of the Kappa Delta House at the University of Nebraska.

Later, back at his studio, he opened the photo in Painter and added a new layer by clicking the New Layer button on the Layers palette. So that he could pull color from the Canvas below onto his working layer, he enabled Pick Up Underlying Color on the Layers palette. Derry used the Auto-Painting features in Painter to simplify the photographic imagery. To reduce the photographic detail, he used the Smart Blur slider on the Underpainting palette. To apply rough brushwork, he used controls on the Auto-Painting palette including a custom stroke, chosen from the Stroke

pop-up menu. He also adjusted the Randomness and Brush Size sliders.

When he was satisfied with the underpainting, he added a new layer for his hand-blended brushwork, and then he turned on the Pick Up Underlying Color check box for the new layer. Working on the new layer, Derry used the Grainy Blender variant of Artists' Oils to add smeary, blended strokes over the entire image. The brush smeared color, but did not apply color, due to its low Resaturation setting in the Well section of Brush Controls. Next, he added a another new layer and painted finely colored details using small Artists' Oils brushes including a favorite custom brush, John's Schmear. He sampled color from his image with the Dropper tool as he worked. These brushstrokes are most visible in the foliage

in the foreground of the image. To blend areas, he used a modified Blenders brush to add a few more loose strokes to the foliage in the foreground without the need to mix or adjust color.

For the final application of color, Derry used Painter's Mixer palette to mix several accent colors, and then he applied them to the image with various brushes, including a custom Artists' Oils brush. As a last step, he added a hand-painted varnish to the painting using a brush similar to the Clear Varnish variant of Impasto. Derry used the adjustable lighting controls located in the Impasto dialog under the Canvas menu to create the illusion of a raised three-dimensional surface on the painting.

EXPLORING SPECIAL EFFECTS

An innovative artist, Laurence Gartel combines drawing and painting with special effects such as Mosaic tiles and Apply Surface Texture, in Person Pill #1. *To view more of Gartel's work, turn to the gallery at the end of this chapter.*

INTRODUCTION

PAINTER'S SPECIAL EFFECTS ARE SO NUMEROUS and complex that an entire book could be written about them alone. Because they're so powerful, there's much less need for third-party filters than with Photoshop or other image processors. But with that power comes complexity; some of these effects have evolved into "programs within the program." This chapter focuses on five of Painter's most frequently used "mini-programs"—Apply Surface Texture, Apply Lighting, Patterns, Glass Distortion and Mosaics. It also covers several special-effects dynamic layers—including Bevel World, Burn, Tear and Liquid Metal—and a handful of other exciting effects.

ADDING EFFECTS WITH SURFACE TEXTURE

One of the most frequent "haunts" of Painter artists is the Effects, Surface Control, Apply Surface Texture dialog box. You'll find it used in a number of places throughout this book. The Apply Surface Texture dialog box contains intricate, powerful controls, allowing you to apply paper textures to images, build realistic highlights and shadows for masked elements, and more. First, the Softness slider (located under the Using pop-up menu) lets you create soft transitions, such as smoothing the edge of a mask or softening a texture application. Adding Softness can also increase the 3D effect produced when you apply Surface Texture Using Mask (when working with an image that contains a mask). And with the Reflection slider (bottom Appearance of Depth slider), you can create a reflection in your artwork based on another image or the current pattern.

Another very important Surface Texture control is the preview sphere, located below the image Preview. Think of the sphere displayed as a dome supporting lights above your image. Although the preview sphere seems to show a spotlight effect, any lights you set are applied evenly across the surface of your image. Experiment

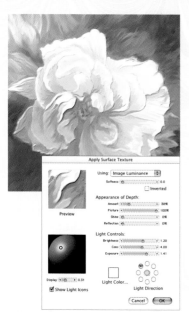

Creating textured, dimensional brushstrokes with Apply Surface Texture Using Image Luminance

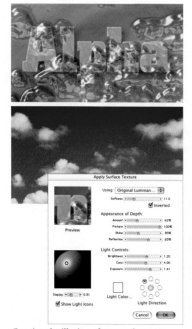

Creating the illusion of type under water (top), with Apply Surface Texture using Original Luminance and a reflection map. We applied the reflection using a clone source image of a cloudy sky (tinted red to match the color in the type by using Effects, Tonal Control, Adjust Color).

with adding more lights by clicking on the sphere. Adjust an individual light by selecting it and changing its color, and adjusting its Brightness and Conc (Concentration). Use the Exposure slider to control ambient light in the environment.

You can get some interesting effects by changing your color choices for the lights. For instance, if the area to be lit contains a lot of blue, you can add more color complexity by lighting with its complement, an orange-hued light.

Applying a reflection map. Reflections can add interest to shiny type and to other surfaces like glass or metal objects in your illustrations. The Reflection slider allows you to apply an image that you designate as a clone source to your illustration as a reflection. Open an image and make a selection or mask for the area where you'll apply the reflection. You can use a pattern as a source for a reflection map or you can open an image the same size as your working file (the current Pattern is applied automatically if you don't choose another image as clone source). (Turn to "Making an Environment Map" and "Applying an Environment Map," later in this chapter, to read about how Michelle Lill builds custom-made reflection maps and applies them to her images. And for more inspiration, check out Michelle Lill's E-Maps folder on the *Painter 11 Wow!* CD-ROM, and in Painter 11's application folder, Extras, Patterns for more Pattern libraries.)

Creating 3D effects. You can use Apply Surface Texture to enhance the surface of your image and give dimension to your brushstrokes. Image Luminance, in the Using pop-up menu, adds depth to brushstrokes by making the light areas appear to recede or "deboss" slightly. If you want to bring the light areas forward, check the Invert box. Experiment with the sliders to get the effect you desire. You can get a stronger 3D effect by clicking to add a second light (a bounce or a fill light) to the preview sphere with a lower Brightness or a higher Concentration (Conc) setting.

RETURN TO DEFAULT SETTINGS

Painter remembers the last settings you choose in effects dialog boxes such as Effects, Surface Control, Apply Surface Texture and Color Overlay. This is helpful when designing scripts (see "Automating Movie Effects" in Chapter 11). To revert to Painter's default settings, save your image and quit Painter to clear the program's Temp file settings.

REFLECTING ANOTHER IMAGE

To use a separate image as a reflection map, bend it using Effects, Surface Control, Quick Warp to achieve a spherical or rippled look. (Quick Warp is applied to the entire image, not just to selections or to a single layer.) Open the reflection image and designate it as the clone source (File, Clone Source). Then (in the original image, not the map image) choose Effects, Surface Control, Apply Surface Texture Using Original Luminance to apply the effect to an entire image. To see the reflection, move the Reflection slider to the right, or distort the reflection effect by moving the Softness slider to the right. Experiment with the other settings.

In Still Life, *Chelsea Sammel created drama in her image using Effects, Surface Control, Apply Lighting. Then she painted over some areas with Brushes variants. She finished the image with an application of Apply Surface Texture Using Paper and a rough paper texture.*

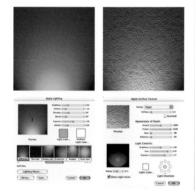

When you use Surface Texture together with Apply Lighting, you'll get more dramatic results if you choose similar lighting directions for both commands.

SOFT LIGHTING TRANSITIONS

If you're using Apply Lighting on a selection, you'll get a softer transition between lighted and unlighted areas if you use Select, Feather (with a high Feather setting) on your selections before you apply the light.

MOVING LIGHTS

To access the Lighting Mover in Painter, so you can copy lights from the Painter Settings file into a new custom library, choose Effects, Surface Control, Apply Lighting. To load the new library, click the Library button in the Apply Lighting dialog box.

Combining Surface Texture with other effects. Apply Surface Texture works especially well when combined with other Painter tools. "Creating an Impressionist Look," on page 293, uses a Glass Distortion dynamic layer and Surface Texture to add paint-like texture to a photo. "Draping a Weave," on page 301, uses a powerful Glass Distortion displacement in combination with Surface Texture to achieve the look of draped fabric. And Steve Campbell used Surface Texture and Apply Lighting together to add gradations to textured areas while creating the illustration "Coffeehouse" on page 313 in the gallery.

ADDING DIMENSION WITH LIGHTING

Painter's *Help* gives a good description of how to adjust the controls under Effects, Surface Control, Apply Lighting. Here are some tips and practical uses for the tool.

Applying Lighting to unify an image. Like most of the Surface Control effects, applying lighting across a composite image can help to unify the piece. (If the lighting effect is too dramatic, try using Edit, Fade immediately afterward to reduce it.)

Preventing hot spots. You can avoid "burnout" of lit areas by increasing the Elevation of the light, reducing the light's Exposure or Brightness, or giving the light a pastel or gray color.

Lighting within selections or layers. Add instant dimension to a selection or a layer by applying lighting within it.

Creating subtle gradient effects. To achieve colored gradient effects in an image, some artists prefer lighting with colored lights instead of filling with a gradient; they prefer the Apply Lighting command's smooth luminosity shifts over the more "mechanical" result usually achieved when using gradations.

Painting back into lit areas. For artists who want to achieve a more painterly effect, the Apply Lighting command can look a bit artificial. In creating *Still Life* (left), Chelsea Sammel used Apply Lighting and then she broke up the lit area with brushstrokes, sampling color from the image as she worked.

Creating softly lit backgrounds. On a white background, start with the Splashy Colors light effect. Increase the Brightness and Elevation and reduce the Distance on both colored lights until they form very soft-edged tinted circles on the background. Click in the Preview to add another light or two and change their colors. Move the lights around until the color, value and composition are working. Save and name your settings and click OK to apply the effect. Repeat this process two or three times, returning each time to your saved effect and making minor adjustments in light color, light position and other settings.

Grunion Run *is an illustration for a calendar designed and illustrated by Kathleen Blavatt. She used several special-effects brushes to paint the image. Beginning with a black-and-white pen drawing, she modeled the hills using the Pixel Dust variant of Pens (loaded from the Ver 5 Brushes library in the Painter 11 application folder, Extras, Brushes). She added sparkling texture to the sky using the Fairy Dust variant of the F-X brush. Blavatt painted the water with the Piano Keys variant of the F-X brush. She added textured brushstrokes to the sun's head using the Grain Emboss variant of Impasto.*

EXPLORING PATTERNS

On the Patterns palette, there are commands that let you make seamless wrap-around pattern tiles. (To access the menu, click the right triangle on the Patterns palette.) Once a pattern has been defined and is in the Patterns section, it becomes the default Clone Source when no other clone source is designated. You can apply a pattern to an existing image, selection or layer with Cloning brushes, with the Paint Bucket tool (by choosing Fill with: Clone Source in the Property Bar), with any of the special effects features that use a clone source (such as Original Luminance or 3D Brushstrokes), or by choosing to fill with a pattern or clone source (Ctrl/⌘-F). (The Fill dialog box shows a Pattern button if no clone source image is designated; if a clone source *is* available, a Clone Source button appears.) Use the pattern feature to create screen design backgrounds, textile design, wallpaper—anywhere you need repeating images. (For step-by-step techniques, see "Creating a Seamless Pattern" and "Applying Patterns" later in this chapter.)

Capturing a Pattern. To make and store a pattern image in the Patterns section, select an area of your document with the Rectangular Selection tool (or press Ctrl/⌘-A to select the entire image) and on the Patterns palette, click the right triangle and choose Capture Pattern. To offset your pattern use the Horizontal and Vertical Shift options and the Bias slider to control the amount of the offset. Experiment with these settings to get nonaligned patterns—for example, to create a brick wall look, wallpaper or fabric.

Using Pattern wrap-around. Painter creates a wrap-around for the pattern tile you create. Here's a great way to see it work. Select a pattern in the Patterns palette. From the pop-up menu on the right side of the Patterns palette, choose Check Out Pattern; a pattern tile image will appear. Choose the Image Hose category in the Brush Selector Bar. Select an Image Hose nozzle from the Toolbox's Nozzles section. Begin spraying across your image and beyond its edge. Notice how the hose images "wrap around" the edges of the pattern tile (so that when the pattern is captured and an area is filled with these pattern tiles, the edges will match seamlessly).

Making a Fractal Pattern. Choosing Make Fractal Pattern from the Patterns palette menu automatically creates a pattern as a new file when you click OK in the Make Fractal Pattern dialog box. Some of the textures you can create with Make Fractal Pattern make very cool paper textures: Select the area of the fractal pattern that you

The evolution of a fractal pattern. The original pattern was made by choosing Make Fractal Pattern from the Patterns section menu (top left), and then a hard edge was added with Effects, Surface Control, Express Texture Using Image Luminance (top right). We loaded the Earthen gradient from the Painter 6 Gradients library in the Gradients folder in the Extras folder inside the Painter 11 application folder, and applied it via Express in Image—chosen by clicking the right triangle on the Gradients section bar (lower left). To change the color, we adjusted the Bias to 46% in the Express in Image dialog box (lower right).

want for your texture (or choose Select, All) and on the Papers palette, click the right triangle and choose Capture Paper.

Enhancing Fractal Patterns. You can add any special effect to fractal (or regular) patterns and they still remain patterns. Here are two creative applications of fractal patterns.

To create a hard-edged fractal pattern with wild color, make a Fractal Pattern, setting Power to –150%, Feature Size to 75% (for a relatively coarse pattern) and Softness to 0. Click OK. Select Effects, Surface Control, Express Texture Using Image Luminance. Adjust the Gray Threshold and Grain sliders to about 80%, and set the Contrast slider at 200% for a contrasty effect. Click OK. Now color the pattern by choosing the Spectrum gradation from the Gradients palette and clicking the right triangle of the Gradients palette and choosing Express in Image. Experiment with shifting the distribution of color in the image by dragging the Bias slider. Choose Select, All and capture the pattern.

To make an abstract topographical map image with color and relief, create a new pattern using Fractal Pattern's default settings: Power, –150%; Feature Size, 100%; Softness, 0%; Angle, 0°; Thinness, 100%; and Channel, Height As Luminance, click OK. Give the image a "topographical" look by choosing Effects, Surface Control, Apply Surface Texture, Using Image Luminance (Amount, 200%; Picture, 100%; Shine, 0% and Reflection, 0%). Tint the image with Express in Image and the Earthen gradation, loaded from the Painter 6 Gradients library, in the Painter 11 application folder, Extras, Gradients folder. Now, add a little relief by applying a second pass of Apply Surface Texture, Using Image Luminance (Amount, 100%; Picture, 100% and Shine, 0%). To add a swirl to your "map" choose

After creating this topographic map using Make Fractal Pattern, we added clouds for more atmosphere by copying our original Fractal pattern file and pasting it into the map image as a layer. We changed the Composite Method in the Layers palette to Screen to apply only the light parts of the clouds to the topographic map image. Then we adjusted the Opacity slider for the clouds layer to 90%.

CREATING REPEATING TEXTURES WITH MAKE PAPER

Using the Make Paper dialog box, accessed by clicking the right triangle on the Papers palette, you can make seamless repeating textures to apply to your images. For the image below, Corinne Okada created her own repeating texture that resembled a grid of pixels to represent the digital output process. She created the grid of beveled squares with Make Paper using the Square Pattern, then chose her new paper from the list on the Papers palette and applied the texture to the central portion of her image using Effects, Surface Control, Color Overlay.

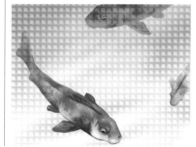

Left: Detail from a package design created by Corinne Okada for The Digital Pond. Above: Okada's settings for the grid of beveled squares.

Conventional diffuser screens attach to the camera lens, breaking up or softening the image as it refracts through the screen. Painter's Glass Distortion effects work the same way but with more variety. To make a Glass Distortion layer, select Glass Distortion from the Dynamic Plug-ins menu at the bottom of the Layers palette. Choose Paper from the Using menu and experiment with refracting your image through different textures chosen in the Papers palette. On this photo, we used a custom line texture built with the Make Paper feature on the Papers palette. In the Make Paper dialog box, we set Line Spacing at 10.55 and Angle at 45°.

Effects, Surface Control, Quick Warp and click the Swirl button. Experiment with different Angle Factor settings in the dialog box.

CREATING EFFECTS WITH GLASS DISTORTION

Try using another image as a "refractor" for your main image. With Painter's Glass Distortion features you can superimpose glass bas-relief effects (using a paper texture or another image). You can apply the procedure directly to your image by choosing Effects, Focus, Glass Distortion. Or you can use a Glass Distortion layer, which lets you preview the effects on a copy of your image without changing the original image; however, the Effects, Focus, Glass Distortion command features a dialog box with more controls. (To learn more about using Effects, Glass Distortion turn to "Diving into Distortion" and "Draping a Weave" later in this chapter. To read about using a Glass Distortion layer, turn to "Creating an Impressionist Look.")

WORKING WITH MOSAICS

Tile mosaics became a popular medium at about 200–300 B.C. in the Roman Empire, Greece, Africa and Asia; floors and walls of many buildings were decorated with mosaics made of small pieces of glass, stones or shells. They were most often built to celebrate a historic event or for religious purposes.

Inspiration for mosaics. You can build mosaics using Painter's Mosaic brush and dialog box in any of three ways: by drawing them from scratch, by basing them on a line drawing that you've scanned, or by creating a clone-based mosaic using an existing piece of art or a photo. Keep in mind that because of the nature of

To change the hue of an image, use Effects, Tonal Control, Adjust Color and then drag the Hue Shift slider. Use Uniform Color to shift the hue of the entire image, or use Image Luminance to change color properties only in the lighter (but not white) areas.

Highpass (under Effects, Esoterica) acts like a color filter. It looks for smooth transitions in dark areas (as in a sky or shadowed background) and replaces them with abrupt edges or halo effects. Keep the Radius slider to the left for a more pronounced halo effect. To further enhance Highpass, try using Effects, Tonal Control, Equalize.

PHOTO: CHER THREINEN-PENDARVIS

The initial, unaltered photograph

Adjust Colors, Uniform Color: Hue Shift, –44%; Value, 25%

Adjust Colors, Image Luminance: Hue Shift, 20%; Value, 25%

Highpass: Amount, 26.05

To create Pencil and Brush, artist John Derry built a mosaic in Painter beginning with white grout.

A colored pen-and-ink sketch was used as reference for this mosaic. Top: The cloned sketch (with Tracing Paper turned on) shows the mosaic in progress with recently applied tiles. Bottom: The same stage with Tracing Paper turned off. Click Tracing Paper on and off without closing the Make Mosaic dialog box by using the check box.

The default grout color is white, shown here (left) in the Colors dialog box. Dragging the Lightness slider to the bottom darkens the color of the grout. The Colors dialog is accessed by clicking on the Grout Color button in the Mosaic dialog box.

the Mosaic tool, your decorative design or photo reference should have a strong compositional focal point. If you want to use a photo that has a busy background, consider simplifying it first by desaturating or blurring. (For tips on neutralizing busy backgrounds, see "Creating a Shallow Depth of Field" on page 243.)

Laying down tiles. Here's a way to try out Painter's Mosaics. Open a new blank file, or a reference on which to base your mosaic. Visualize the forms in your design before you begin laying down the tiles, and rotate your page by dragging with the Rotate Page tool (nested with the Grabber tool in the Toolbox) to accommodate your drawing style so you'll be able to make smooth, controlled strokes to describe the forms.

Open the Colors palette by choosing Window, Color palettes, Show Colors. (If the Colors palette is *not* open, you cannot open it while the Mosaic dialog box is open.) Then choose Canvas, Make Mosaic to open the Make Mosaic dialog box. Opening the dialog box will turn the background of the currently active image white, the default grout color. To change the grout color in the Colors dialog box, click in the Grout box, and choose a new color. Then choose a contrasting color in the Colors palette to paint some tiles. Switch colors again and continue to make tiles. Once you have tiles in place, you can sample color from an existing tile by pressing the Alt/Option key as you click on it. You can undo an action without closing the Mosaic dialog box by pressing Ctrl/⌘-Z. To erase a tile, click the Remove Tiles button and stroke with the Mosaic brush over the tile. While working on a mosaic, save it in RIFF format to preserve the resolution-independent nature of the mosaic. (Because mosaic tiles are mathematically described, a mosaic can be resized without loss of quality.) See the *Painter 11 Help* for an in-depth explanation of Painter's mosaic-building tools.

SPECIAL EFFECTS USING DYNAMIC LAYERS

Painter features seven kinds of dynamic layers (plug-ins) that allow you to create exciting special effects quickly. They are Glass Distortion, Kaleidoscope, Liquid Lens, Burn, Tear, Bevel World and Liquid Metal. In the paragraphs below, we focus on special-effects applications for several of these plug-ins. (To read more about working with plug-in layers turn to the introduction of Chapter 6; see Chapter 6 to see how dynamic layers apply to image correction and photography. Turn to "Creating an Impressionist Look" later in this chapter to read about using the Glass Distortion dynamic layer in combination with Apply Surface Texture. And the *Painter 11 Help* contains good descriptions of each of these dynamic layers.)

Painting with metal and water. Painter's versatile Liquid Metal dynamic layer allows you to paint with bas relief and give it the look of chrome, steel, ice, water and other materials. The Liquid Metal layer works in an existing file to make a layer on which you create the metal. To make a dynamic layer, open an image, click

Hiroshi Yoshii painted Bird *with Painter's Liquid Metal. He used colored environment maps and multiple Liquid Metal layers to sculpt the bird's outline and body.*

©CDM-F.LLI MAGRO (ITALY)

Athos Boncompagni used the Liquid Metal Brush tool to draw trees and falling stars for this wrapping paper design.

BURNED AND TEXTURED

By checking the Use Paper Texture box in the Burn Options dialog box you can apply the current Paper texture to the burned edge of a layer.

the Dynamic Plug-ins icon at the bottom of the Layers palette and choose Liquid Metal from the menu. To paint with chrome, select the Brush in the Liquid Metal dialog box and choose Chrome 1 or Chrome 2 from the Map menu. Drag in the image with the Brush. For thin lines, try a Size of 8.0 and a Volume of 25%. For thick lines, increase Size to 50 and set Volume over 100%.

If you'd like to paint with bubbles or water drops that reflect your image, begin by making a clone of the image (File, Clone). On the clone, make a Liquid Metal layer. From the Map menu choose Clone Source, choose the Circle or Brush and drag to paint on the layer. For fairly flat drops use an Amount of 0.5 to 1.5. For the look of 3D water drops on a camera lens, move the Amount slider to between 3.0 and 4.0. For bubbles use an Amount of 5.0.

You can color the objects on a Liquid Metal layer based on a clone source (as above) or on the current pattern. Begin by making a Liquid Metal layer. In the Liquid Metal dialog box, choose Clone Source from the Map menu. Select a pattern in the Patterns palette or open an image and define it as the clone source (File, Clone Source). Now use the Circle or Brush tool to apply metal to the layer.

Tearing, burning and beveling. The Tear, Burn and Bevel World layers require a selected "source image layer" to perform their effects. To Tear or Burn an image's edges, begin by opening a file. You can select a layer in the image and apply the plug-in to it or you can reduce the image canvas to accommodate the torn or burned edge to come: Choose Edit, Transform, Scale—we scaled our image at 80%. The Scale command will automatically create a selection, and to float it to a layer, choose Layer, New Layer, and when the dialog box appears, click Commit. With the layer still selected, click the Dynamic Plug-ins icon at the bottom of the Layers palette and choose the Tear or Burn plug-in from the menu. To change the color of the torn (or burned) edge, click in the Color box and choose a new color. Bevel World allows you to create complex bev-

To design this striking beveled button Michelle Lill captured a custom-made environment map as a pattern, and applied it to the button graphic using the Reflection slider in the Bevel World dialog box. To learn more about reflection maps, turn to "Making an Environment Map" and "Applying an Environment Map," later in this chapter.

els quickly. You can apply a bevel to a "source layer" in an image or make a unique beveled frame for an image. Open an image you'd like to frame, choose Select, All and choose Bevel World from the Dynamic Plug-ins menu on the Layers section. Choose your settings and click OK. To read more about Bevel World, turn to "Creating Beveled Chrome," in Chapter 9 on page 332.

Creating a Seamless Pattern

Overview *Set up and capture a basic pattern layout; check this pattern out of the library; add more elements, shifting the pattern as needed; capture the final pattern; save it in a pattern library.*

CAROL BENIOFF

1

Benioff's three silhouette drawings of cats used to build the pattern tile

1b

The final arrangement of the three cat silhouettes used in the basic pattern tile

PAINTER'S AMAZING PATTERN-GENERATION TOOLS MAKE IT easy to build even a complex pattern tile. You can capture a very basic layout for your tile into a Patterns library and then "check it out" of the library to add complex elements. The new elements will automatically wrap from one edge of the pattern to the opposite edge as you paint, to make a pattern that tiles seamlessly! *Cat Trio* is a pattern created by Carol Benioff. See "Applying Patterns" on page 290 to see how Benioff used this and other patterns.

1 Setting up your pattern layout. To start the pattern files, choose File, New and in the New dialog box, set up a small image. Benioff's image was 600 x 600 pixels.

First, Benioff created a new layer by choosing New Layer from the Layers menu and made a quick outline sketch of a cat silhouette using the Real Variable Width Pen variant of Pens. She repeated this process twice to complete the outlines of the cats. Benioff then filled the outlines with the same solid red hue using the Paint Bucket. She cleaned up the edges, alternating between the Eraser and the Real Variable Width Pen variant of Pens. Next, Benioff arranged and scaled the three cat silhouettes until she was happy with the arrangement. She then flattened the image by choosing Drop All from the menu on the right side of the Layers palette.

Use Painter's brushes to draw your own pattern layout.

2 Capturing a pattern. With your basic pattern layout complete, capture the layout as a pattern tile as follows: Choose Window, Library Palettes, Patterns to open the Patterns palette. From the Patterns palette menu, choose Capture Pattern. In the Capture Pattern dialog box, set up any Horizontal or Vertical Shift that you want for your pattern and watch how your element repeats as you

2

Setting up the Vertical Shift in the Capture Pattern dialog box

3a

Choosing Check Out Pattern from the Patterns palette

3b

Pressing Shift-spacebar and dragging in the image to shift the pattern

4

Saving the completed pattern using the Capture Pattern dialog box

5

Dragging and dropping the new patterns into the newly created Benioff_Patterns library

experiment with the Bias slider. Benioff chose a Vertical Shift and set the Bias slider to 56%. Name your pattern and click OK to accept. The working pattern will be saved to the current Patterns library.

3 Embellishing the tile. To access Painter's automatic seamless tiling feature for developing the pattern tile, make sure that your new pattern is selected in the Patterns library and choose Check Out Pattern from the Patterns palette pop-up menu. A new Painter window will open with the pattern tile in it.

By working in this "checked-out" pattern window, you'll be able to embellish your tile without having to do a lot of retouching on the edges. Notice that you can shift the pattern tile and view the repeating element: If you press the spacebar and Shift key, the cursor will change to a hand, and you can drag in the image window to shift the pattern so you can see the offset that you built in step 2.

Now, you can paint to embellish your basic layout, turning it into your final pattern tile. Benioff used the Flat Color variant of Pens to draw the large and small circles in various hues. Because of Painter's seamless wrap-around feature for checked-out patterns, her brushstrokes automatically wrapped around, and there were no obvious edges as the pattern repeated.

As you paint, shift the pattern continually (with the Shift key and spacebar) to check the design and make sure that it's balanced. Benioff's last step was to use the Paint Bucket to fill the background with the current color, a light yellow-green hue.

4 Capturing the final pattern. When your pattern is complete, add the final tile image to the Patterns library: Choose Capture Pattern from the Patterns palette pop-up menu. In the Capture Pattern dialog box, leave the Shift and Bias settings as they are, give the pattern a new name (Benioff named hers "Cat Trio Green BG") and click OK.

5 Saving your pattern in a library. Continue to make more patterns if you like, following the instructions in steps 1 through 4. Then, store your new pattern(s) in a library for safekeeping: From the Patterns palette pop-up menu, choose Pattern Mover. When the dialog box appears, the currently loaded pattern library, with the pattern(s) you created, will appear on the left side of the Pattern Mover dialog box. To create a new library, click the New button, and then name and save the new empty pattern library. To copy an item from the current pattern library, click on the pattern thumbnail and drag and drop it into the new library. If you leave all of your custom patterns in the default Painter Patterns library, the library can become very large, taking up a lot of disk space. So after you've copied your new patterns to the new library, it's a good idea to delete the original(s) from the default library: For each one, click on the pattern swatch and then click the Delete button. 𝕎

Applying Patterns

Overview *Make selections based on a reference image, place each selection on its own layer and fill it with patterns; add corresponding solid-filled layers; adjust the Composite Method and transparency of each layer.*

Four drawings used to create 4 of the 6 patterns used in the final image.

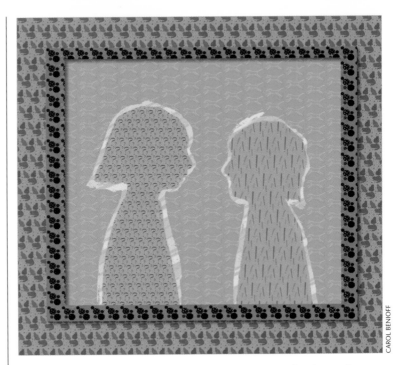

CAROL BENIOFF

YOU CAN APPLY A PATTERN TO AN EXISTING IMAGE, selection or layer with Cloning brushes, with the Paint Bucket tool (by choosing Fill With: Source Image in the Property Bar), with any of the special effects features that use a clone source (such as Original Luminance or 3D Brushstrokes) or by choosing Edit, Fill, Fill with Pattern (Ctrl/⌘-F). Carol Benioff built the framed image above, *Conversing,* using a reference monoprint titled *Conversation 6,* filling selections based on the shapes in the reference image with a variety of illustrated patterns she created for this image.

1 Making the patterns. Benioff used a variety of brushes and methods to create the six patterns that are used in this image. For this project you can create your own patterns or use Carol Benioff's pattern library that is located on the *Painter 11 Wow!* CD-ROM. To create the Circles & Circles pattern used in the inner frame, Benioff began by filling a circular selection with black. Then, she added solid colored spots to the black. She duplicated the spotted circle, changed its size, position and color, captured it as a pattern and then enhanced it using Painter's pattern generation tools. Benioff drew the stripes for the MultiStripes pattern with the Felt Art Marker variant of the Art Pen Brushes and then added additional color with the Paint Bucket. Benioff used the Real Soft Pastel variant of Pastels to draw the question mark and exclamation mark patterns. To embellish this final pattern, she used a variety of paper textures and colors. You can create your own patterns, store them in a pattern library and then use them to create your own image. (See "Creating a Seamless Pattern on page 288 for more information.)

Selecting the Horses + pattern and sizing it down to 9 percent.

2c

The Horses + pattern layer is set to Color.

2d

The frame patterns with the drop shadow applied to inner frame's fill.

3

Using the Paint Bucket to fill the left figure selection with the Questions2 pattern

4

Filling outlines with the MultiStripes pattern.

2 Using a reference image, selecting and filling. Benioff began by opening a reference image. Using the Magic Wand tool with the Tolerance set to 24, she clicked on the background mauve color. She cleaned up the selection using the Polygon Selection tool while holding down the Shift key to add to the selection, or the Option/Alt key to subtract from the selection.

Next, she created a new layer by selecting New Layer from the Layers menu. With the selection active, she filled the selection with a solid color. Then, she duplicated this layer (Layers, Duplicate Layer) and chose Reselect from the Select menu. Benioff chose the Paint Bucket tool and set the Fill pop-up menu to Source Image and the Tolerance to 8 in the Property Bar, and then she filled this selection with the Horses + pattern. Next, to create a unique mix of colors between the solid and pattern layers for the background, she set the Composite Method for the Horses + pattern layer to Color in the Layers palette.

Benioff repeated the process for the outer frame of this image using one variation. After she filled the outer frame with the Cat Trio Green BG pattern, she set the Opacity to 65%, prior to setting the Composite Method to Multiply.

To build the inner frame, Benioff created a new selection using the Rectangular Selection tool and then created two layers using the same selection. She filled the first layer with a solid color, filled the second layer with the Circles pattern and set the Composite Method for both layers to Multiply in the Layers palette. To set the inner frame away from the image and its outer frame, Benioff added a drop shadow. She selected the inner frame layer filled with the solid color and chose Effects, Objects, Create Drop Shadow; adjusted the offset, opacity, radius and angle settings to create the desired drop shadow effect and then clicked OK.

3 Filling the figures. Next, Benioff added more interest to the figures. She selected the left figure in her reference image and cleaned up the selection using the same method described in step 2. Then, she created a new layer (Layers, New Layer), filled the selection with a solid color, duplicated this layer (Layers, Duplicate Layer), and activated the same selection by choosing Select, Reselect. She filled the second selection with the Questions pattern, with its size set to 10% in the Patterns palette, and set the Composite Method for this Layer to Multiply. She repeated this same process for the figure on the right, but filled the pattern layer with the Exclamations pattern.

4 Filling the border around the figures. The last shapes Benioff filled were the rough-edged borders around each figure. She used the same method she described in step 3, but this time she used the MultiStripes pattern for both figures. Again, she set the Composite Method for the Pattern layer to Multiply, which makes the white background of the pattern transparent, while at the same time mixing the color of the pattern with the solid color layer that was filled using the same selection. 🖌

Diving into Distortion

Overview *Use Glass Distortion to displace an image using a clone source; then combine a dramatic distortion with a subtle one to create a water-stained effect.*

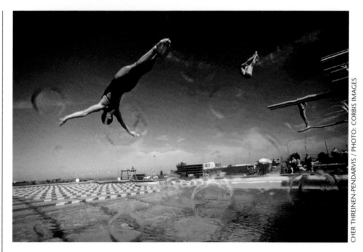

CHER THREINEN-PENDARVIS / PHOTO: CORBIS IMAGES

The original photograph

The water image displacement map

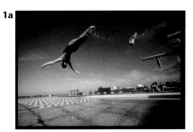

Settings for the subtle distortion

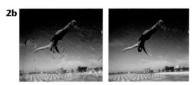

The Extreme clone (left), and the Subtle clone (right)

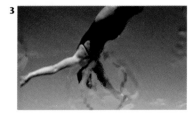

Cloning in a dramatic water drop

PAINTER'S GLASS DISTORTION can move pixels in an image based on the luminosity of another image. We used it here to simulate water drops on a camera lens.

1 Choosing images and making clones. Choose an image for a displacement map (the water drops in this case) that has good contrast; both crisp and soft-focus images can give good results. Because you'll be applying the displacement map image to the original image as a clone source, you'll need to size the map image to the same pixel dimensions as the image you want to distort. (Our images were 883 x 589 pixels.) Make two clones of the image you want to distort by choosing File, Clone (twice). Save the clones, naming them Extreme and Subtle; then size and position them on your screen so that you can see both of them.

2 Applying the distortion. Open the displacement map image. Now, click on the Extreme clone, and designate the displacement image as the clone source (File, Clone Source). With the Extreme clone active, choose Effects, Focus, Glass Distortion, Using Original Luminance, and choose the Refraction Map model. (Refraction works well for glass effects; it creates an effect similar to an optical lens bending light.) Our settings were Softness, 2.3 (to smooth the distortion); Amount, 1.35; Variance, 6.00. We left Direction at 0, because it has no effect when using a Refraction map, and clicked OK. Click on the Subtle clone, and apply Glass Distortion with subtler settings. (Our settings were Softness 15.0; Amount, 0.07; and Variance, 1.00.) We wanted the diving board to curve, while preserving smoothness in the image.

3 Restoring from the Extreme clone. We added several dramatic water drops from the Extreme clone to enhance the composition of the Subtle image. Click on the Subtle clone to make it active and choose the Extreme clone as clone source. Use the Soft variant of the Cloners brush to clone dramatic effects from the Extreme clone into your Subtle image.

Creating an Impressionist Look

Overview *Combine Glass Distortion and Surface Texture special effects to transform a photo into a painting, creating brushstrokes and building up paint.*

The original photograph

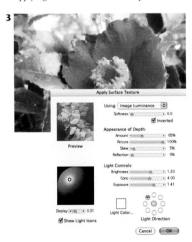

Applying Glass Distortion to the photo

Adding highlights and shadows to the distorted image with Apply Surface Texture

BY COMBINING TWO POWERFUL EFFECTS, Glass Distortion and Apply Surface Texture, you can create an Impressionist look with textured highlights and shadows—turning a photo into a painting. This effect can be applied to an entire image, a selection or a layer, giving you much more flexibility than you would have in the darkroom working with diffuser screens and masks.

1 Choosing an image. Choose an image with a strong focal point and good highlights and shadows. You can achieve good results with either crisp or soft-focus images.

2 Initiating strokes. Choose a coarse paper texture—large organic textures with a broad tonal range help to emulate the look of paint on canvas. We chose River Map from the Branched Textures library (located in the Paper Textures folder on the Painter 11 CD-ROM). Then we used the Paper Scale slider on the Papers palette to scale it to 70% to complement our 1200-pixel-wide image. To diffuse or break up the image into paint-like strokes on paper, apply the Glass Distortion dynamic layer: In the Layers palette, click the Dynamic Plug-ins button and choose Glass Distortion from the pop-up menu. In the Using menu select Paper. Choose subtle settings—our settings were Amount, 0.72; Variance, 1.00; and Softness, 2.7. Click OK to apply your settings.

3 Adding texture and shadows. To add realistic relief, choose Effects, Surface Control, Apply Surface Texture. (If the Commit dialog box appears asking you if you'd like to convert the dynamic layer to an image layer, choose Commit.) In the Using menu choose Image Luminance. Use subtle-to-moderate Surface Texture settings to avoid a harsh look and to preserve the original image. We used Amount, 65%; Picture, 100%; Shine, 5%; Softness, 0 and Reflection, 0. (To raise the highlights, we turned on the Inverted check box.) Choose a light direction that complements the light in your photograph, and click OK.

Making an Environment Map

Overview Choose a file and resize it; make a selection; use Quick Warp to bend the image into an environment; capture it as a pattern.

MICHELLE LILL

1a

Michelle Lill's original photo

1b

Making a square selection on the image

2

Applying the Quick Warp Sphere option

3

Naming the water map in the Capture Pattern dialog box

YOU CAN USE PAINTER'S QUICK WARP FEATURE to bend any image into a useful environment map, an image that shows an environment as if it were seen through a fish-eye lens or reflected in a shiny metal sphere. Multimedia designer Michelle Lill creates her own environment maps—like the one above on the left—and uses the maps to enhance images by applying them as she did in the image on the right.

1 Opening an image and making a selection. Open the image that you want to use as the basis for your reflection map. To conserve disk space and optimize performance, Lill recommends that a reflection map image be a square that is 256 pixels or fewer. Using the Rectangle Selection tool, make a 256-pixel-square selection (holding down the Shift key as you drag to constrain the selection to a square), as you check the Width in the Info palette. If you need to move or scale the selection, use the Selection Adjuster tool. (Turn to "Transforming Selections" in the beginning of Chapter 5 for more about manipulating selections.) Copy the selected area (Edit, Copy), and paste it into a new file by choosing Edit, Paste into New Image.

2 Bending the image. To get the "fish-eye lens" effect that adds realism to the map (since most surfaces that reflect their environment are not flat), Lill chose Effects, Surface, Control, Quick Warp and selected the Sphere option. She used the default settings of Power 2.0 and Angle Factor 2.0. The effect was applied to the entire canvas.

3 Saving the image as a pattern. To save the map into the current Pattern library, capture it as a pattern: With the environment map image open, select all, click the right triangle on the Patterns palette bar and choose Capture Pattern from the menu. Name the map when prompted and click OK. The environment map is now a permanent member of the library. Now you can use the map to enhance special effects—as Lill did in her water illustration above. To read a step-by-step description of how Lill used a custom environment map to enhance an image, see "Applying an Environment Map" on the next page. 🐾

Applying an Environment Map

Overview *Open a file and set type shapes; convert the shapes into a layer; add an environment map, dimension and a soft drop shadow to the type; add a border to the image.*

1a

Choosing a font and size in the Text palette

1b

The text set on a layer over the image

1c

The selected Text layer in the Layers palette

2

Choosing Lill's custom-made environment map in the Patterns palette

MICHELLE LILL

TO CREATE THE TITLE DESIGN *RED ROCK*, designer Michelle Lill used a custom-made environment map in combination with one of Painter's most powerful and versatile tools, Apply Surface Texture.

1 Opening an image and setting the type. For this example, Lill began by setting 60-point VAG Rounded Bold text on top of a photo. Begin by opening a background image (Lill's image was 889 pixels wide). Select the Text tool and choose a font in the Property Bar. For the best results, choose a bold font with a broad stroke and rounded corners. Position the cursor in your image and type the text.

When you're finished setting the text, select the Layer Adjuster tool and drag to reposition the text layer to your taste. (To read more about using Painter's text features see Chapter 9, "Working with Type in Painter.")

2 Selecting the reflection map. Load the Reflection Map pattern from Painter 8's Patterns by clicking on the right triangle of the Pattern Selector, choose Open Library, navigate to the Painter 11 application folder, Extras, Patterns. Lill used her own pattern, made from the same Red Rock photo she used for the background. (To read about how to make your own environment map, check out Michelle Lill's method in "Making an Environment Map," on the facing page.)

PROPERTY BAR TEXT CONTROLS

You can format your type without opening the Text palette. As soon as you select the Text tool, most of the controls you will need to format your text will be available in the Property Bar.

Michele Lill's Red Rock environment map

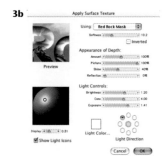

Settings for the second Apply Surface Texture application showing dimension on the type

Setting up an automatic drop shadow

The Red Rock image with the drop shadow applied to the text layer

3 Adding reflection and dimension to the type. To achieve a strong reflection in the type and a realistic 3D look, Lill used two applications of Apply Surface Texture. First select the text layer in the Layers palette to make it active. Then click on the right arrow of the Layers palette and select Convert to Default Layer from the menu. Next, choose Select, Load Selection and load the transparency mask for the text layer. Then choose Effects, Surface Control, Apply Surface Texture. To reflect the environment map onto your type, use these settings: In the Using menu choose the text mask to restrict the reflection to the type. (Lill's mask is named Red Rock Mask) Move the Reflection slider to 100% (so the environment map shows up) and move the Softness slider to the right (to scale the reflection map). Adjust the other settings to suit your image. The Apply Surface Texture dialog box is interactive, so you can scale your pattern while viewing the reflection map in the Preview window. When the reflection looks good, click OK in the Apply Surface Texture dialog box. Lill's Apply Surface Texture settings for the first application are as follows: Softness 40.0; Amount 200%; Picture 100%; Shine 40%; and Reflection 100%.

Now add a realistic 3D look to the text by choosing Apply Surface Texture a second time. This time, check the Inverted box (to add a second light source); decrease the Reflection slider to 0% by moving it all the way to the left; and decrease the Softness to about 10. Lill's second Surface Texture application settings are as follows: Using, Red Rock Mask; Softness, 10.0; Amount, 100%; Picture, 100%; Shine, 40%; and Reflection, 0%. Click OK. The image with Apply Surface Texture can be seen at the beginning of this story.

4 Adding a shadow and a soft black border. Next, Lill added a black drop shadow to her text, adding to the 3D look and giving her image more contrast. To generate the shadow, she chose Effects, Objects, Create Drop Shadow. In the dialog box, she specified settings for the X and Y coordinates to fit her image, increased the Opacity of the shadow to 80%, left the other settings at their defaults and checked the Collapse to One Layer box to combine the text and shadow.

Then, to finish the image with a more graphic look that would complement the shadow, Lill added a softly feathered black border to her image. To create her border effect, begin by choosing Select, All. Then from the Select menu choose Select, Modify, Contract. In the Contract Selection dialog box, type in 12 pixels. Now choose Select, Feather and set the feather to 24 pixels. Finally, Lill filled the selected, feathered edge with black. Begin by choosing black in the Colors palette. Choose the Paint Bucket, and in the Property Bar make these choices: Click the Fill Image button, and from the Fill menu choose Current Color. Click inside the active selection with the Paint Bucket tool. ⚜

Building a Terrain Map

Overview Create a terrain map from elevation data; make a custom gradient; color the map; use Apply Surface Texture to give it realistic dimension.

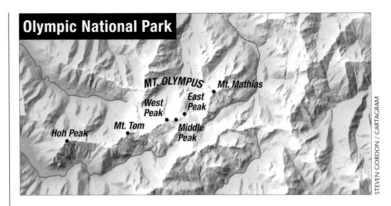

Olympic National Park

STEVEN GORDON / CARTAGRAM

The grayscale image representing elevation

2a

Building a custom gradient for the map

2b

The map with the custom gradient applied using Express in Image

3

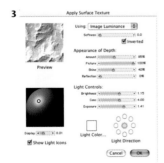

Gordon's settings in Apply Surface Texture, used to produce the terrain map

TO CREATE THIS REALISTIC MAP of Mount Olympus, Washington, Steven Gordon built a color terrain background from real data. As principal cartographer and owner of Cartagram, Gordon produces custom maps for electronic and print publication, specializing in tourism maps with relief renderings of the terrain.

1 Making a grayscale-to-height image. To begin the map, Gordon downloaded a digital elevation model (DEM) file from the USGS (www.usgs.gov). He processed it using a shareware DEM reader he found by searching for the keyword "DEM" in an Internet search engine. The resulting PICT image contained grayscale values mapped to elevation values, which Gordon could then use in building the image.

2 Coloring the image. Gordon opened the grayscale PICT file in Painter and built a custom gradient to color the map. To make your own gradation, open the Colors and the Gradients palettes; in the Gradients palette choose the Two-Point gradation. Now open the Edit Gradient dialog box by clicking the right triangle on the Gradients palette bar and choosing Edit Gradient. Using the dialog box, you can create a new gradation with color control points representing elevation zones (as Gordon did). Add control points to the center of the gradient by clicking in the Gradient bar. Click each control point and then click in the Colors palette to choose a color for that point. Gordon's gradation progressed from dark blue-green valleys to white mountain crests. When the gradient looks good, click OK and then save it by choosing Save Gradient from the Gradients palette's menu. Apply the gradient to your image by choosing Express in Image from the Gradients section's menu.

3 Building Terrain. To add realistic relief to your map, choose Effects, Surface Control, Apply Surface Texture, Using Image Luminance. Click the Inverted box to make the light areas in the map "popup." To blur undesirable detail, move the Softness slider to the right. Adjust the Amount to build dimension and shadow. Gordon decreased the Amount to 85% to keep the shadows from being too dark and prominent. He used the default 11:00 light direction setting and left the Shine at the default 40%. 🖌

Creating a Circular Panorama

Overview *Shoot a series of photos for a panorama and stitch them together; capture a pattern; use a Pattern Pen to stroke a circular selection; touch up areas and add clouds to the sky.*

1a

The original photographs

1b

Arranging the horizon of the photographs

1c

The completed linear panorama

2a

The flipped linear panorama

WITH THE GROWING POPULARITY of digital photography, it's become easier to create panoramic imagery. By combining a linear photographic panorama with the Pattern Pen, you can create a very unique variation—the circular panorama.

John Derry has been passionate about photography for more than 30 years. He enjoys creating panoramas; however, he wanted to give some of his imagery a new twist, as shown here in *Bonfante Gardens*. After a lot of experimentation, he discovered how to create a circular panorama using the Pattern Pen in Painter.

1 Creating a panorama. A digital panorama is created by stitching together several photos that have been carefully shot as a set of overlapping images. Stitching refers to the process of matching up image elements in the overlapping areas of the adjacent photos. Derry manually stitched the images together in Painter, with each photo element on an individual layer. He used layer masks, cloning and Airbrushes to match up the edges. When it was complete, he flattened the file. For more information about layers and layer masks, see Chapter 6, "Using Layers."

2 Converting a panorama to a pattern. When the panorama is ready, you can capture it into the Pattern library so that it can be used by the Pattern Pens. (A Pattern Pen uses the Current Pattern as its media.) Open the Patterns palette by choosing Window, Library Palettes, Show Patterns. Now, make a selection around your image

2b

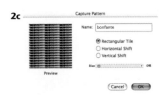

Capturing the original panorama into the Patterns palette

2c

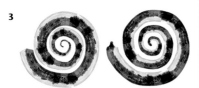

Naming the panorama pattern and using the default settings

3

Test strokes painted with the Pattern Pen, using the original panorama pattern (left) and the flipped image (right)

4a

The Drawing Mode buttons with the Draw Anywhere button being selected

4b

The stroked circular selection painted with a 500-pixel Pattern Pen, using the original panorama pattern (left) and the flipped image (right)

by choosing Select, All and then choosing Capture Pattern from the pop-up menu on the Patterns palette. Give your new pattern a name and accept the default settings. The selected image will appear in the current Patterns library.

Derry also created a second version of his linear panorama with the sky at the bottom so that he could try them both out with the Pattern Pen and then decide which image worked the best. To flip your panoramic image, choose Select, All and then Select, Float to put it on a layer. Then, choose Edit, Flip Vertical. Now, make a selection around the panorama (Select, All), choose Capture Pattern from the pop-up menu on the Patterns palette and name the pattern. The new pattern will appear in the current Patterns library as before.

3 Making practice strokes. With both versions of the panorama captured as patterns, you are now ready to test the patterns using the Pattern Pen. Open a large, new file about 3000 pixels x 3000 pixels. Select the Pattern Pens category and then choose the Pattern Pen variant. Draw a few practice strokes with both versions of the pattern image.

4 Stroking a circular selection with the Pattern Pen. Next, open a new 3000 x 3000 pixel image. In this step you will create the circular selection that the Pattern Pen will follow when you use the Stroke Selection feature. Select the Oval Selection tool in the Toolbox and press Shift, and then draw a circular selection. (Derry made the circle about one third of the width of the image.) Now, use the Oval Selection tool to reposition the active selection into the center of your image. (For more information about selections, see Chapter 5.)

Before stroking the selection with the Pattern Pen, you must first set the Drawing Mode (the buttons at the bottom-left corner of the Painter image window) to Draw Anywhere, because the Draw Inside mode will automatically be chosen when you make a selection, and it will constrain the media to the inside of the selection. Draw Anywhere will allow the media to be painted on both sides of the selection border. Now choose Select, Stroke Selection, and marvel as the linear panorama flows from the Pattern Pen in a continuously repeating stroke.

The final size of the circular panorama is controlled by a combination of the circular selection's diameter and the current size of the Pattern Pen. The goal is to make adjustments until the linear

PANORAMA PATTERN SIZE

Depending on the intended form of output, a captured panorama can be either a small or large file. (Derry's linear panorama image measured 3486 x 600 pixels.) If the panorama is large, it is best kept in its own Patterns library rather than in the default Patterns library. You can use the Pattern Mover to create a new Patterns library. (To learn more about using libraries and movers, see Chapter 1.)

5

Using the Soft Cloner variant of Cloners to complete the unfinished area

6a

The airbrushed sky added to the center

6b

The clouds added to the sky

7

The final rotated image with the soft edge

panorama is wrapped around the circle with the two ends slightly overlapped. You will need to experiment to find the desired settings.

If the linear panorama imagery repeats, try increasing the size of the Pattern Pen using the Size slider in the Property Bar. It's a good idea to adjust the size value in regular increments. Derry started with a 500-pixel brush. When he needed to adjust the brush up or down in size, he did so using increments of 50 pixels. For instance, his resized brush increments varied like this: 1050, 1100, 1150 pixels and so on.

You might also want to adjust the size of your selection. By doing this in regular increments, you can estimate your additional adjustments more accurately. Open the Info window (Window, Show Info) and select the Selection Adjuster tool (Toolbox). Hold down the Shift key and click and drag on one of the corner handles outside of the selection to adjust the selection's size. Watch the Info palette, noting the numeric Width and Height readout as you adjust the selection. Derry repeated the Stroke Selection and Undo commands (using a combination of brush and selection sizing adjustments) until he arrived at the result he desired.

5 Hiding the flaws. When the linear panorama is correctly wrapped into a circle, there will be a flaw where the two ends meet. This flaw can be repaired in a variety of ways. You can use Painter's cloning features to clone bits of imagery over the flaw. You can also use the Lasso tool to draw a freehand selection around a bit of imagery and then copy and paste it into an area to cover the flaw.

6 Painting the sky. To complete your circular panorama, you'll need to paint over the blank area inside. Derry created a layer, sampled a blue color in the sky with the Dropper tool and then used a large airbrush to feather in a completed sky area. To complete the effect, he painted a few faint clouds.

7 Making final adjustments. Take a good look at your final circular panorama and decide whether there is a subject element that you'd like to position at the bottom of the composition. Derry wanted to position the tower element at the bottom. Use the Rotate Page tool (located in the Toolbox under the Grabber hand) to preview the various degrees of image rotation. Then, for the actual rotation, use the Oval Selection tool to select the panorama and copy the image. Choose Edit, Paste in Place to put the copy of the panorama on a new layer and then choose Edit, Free Transform. Press the Ctrl/⌘ key and drag a corner handle to rotate the layer and then choose Commit Transform. Finally, drop the layer by choosing Drop from the Layers palette menu. To add a soft edge treatment to your image as Derry did, use the Magic Wand (Toolbox) to select the white background, and then choose Select, Feather (using about 30 pixels). Finally, press the Backspace/Delete key to clear the area and leave a soft edge.

Draping a Weave

Overview *Paint a grayscale file that will be your source image; fill a clone of that file with a weave; use a combination of Glass Distortion and Surface Texture to wrap the weave around the source image.*

CHER THREINEN-PENDARVIS

The grayscale form file with strong values

YOU CAN USE PAINTER'S WEAVES, located in the Weaves palette, to fill any selection or document, using either the Fill command or the Paint Bucket tool. Weaves can be used in fashion design and they make good backgrounds for scenes, but their flat look can be a drawback. To create the appearance of fabric—to hang behind a still life, for instance—we added dimension to a weave by "draping" it over a painted form using a powerful Glass Distortion displacement effect along with Apply Surface Texture.

WEAVES IN THE TOOLBOX

You can access Weaves in the Weave Selector on the bottom right of the Toolbox. By clicking on the right arrow to open the menu, you can choose to open another library, edit a weave, or launch the Weaves palette from the menu.

1 Making the form file. Think of the form file as a kind of mold—or fashion designer's dress form—over which you'll drape your fabric. Create a grayscale form file that has strong value contrast and smooth dark-to-light transitions. As a reference for our 500-pixel-square form file, we draped fabric over a chair and sketched it in Painter, and then cleaned up the sketch with the Digital Airbrush variant of Airbrushes. Since any hard edges in the form file would make a noticeable break in the weave's pattern, we softened the image with Effects, Focus, Super Soften. We used a 7-pixel Super Soften setting on our file.

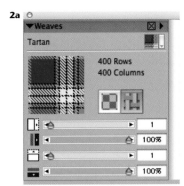

The Pastel Plaid in the Weaves palette

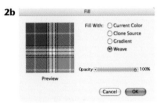

Filling the clone with the weave

Applying Glass Distortion to the weave

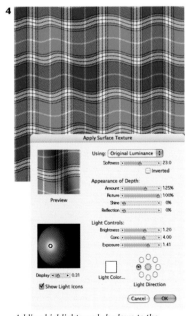

Adding highlights and shadows to the distorted image using Surface Texture

If you don't want to paint the form file, here's a fast, but less "organic" way to create it. Open the Make Paper dialog box by clicking the Paper Selector on the Toolbox and then choosing Make Paper from the pop-up menu (to the right of the paper list). In the Make Paper dialog box, choose Line from the pop-up menu. Use a high spacing setting to make vertical lines and set Angle at 90°. In the Save As field, type a name for the new paper. Choose your new paper in the Paper Selector and then choose black in the Colors palette. To apply the new paper, choose Effects, Surface Control, Color Overlay, Using Paper, at 100% Opacity and then click the Hiding Power button. To blur the image, use Super Soften as described above.

2 Making a clone and filling it with a weave. Choose File, Clone to make a duplicate of the form file with identical dimensions. Now choose a weave from the Weave Selector. (We chose the Pastel Plaid weave.) Fill the clone file with your weave (Ctrl/⌘-F; Weave, 100%).

3 Initiating the distortion. Here's where the movement begins. Choose Effects, Focus, Glass Distortion, Using Original Luminance. Now let Painter know the direction that you want the fabric to go when it overlies the form file. When a clone image is displaced by Glass Distortion using Original Luminance, the distance each pixel moves is based on the luminance of each pixel in the source file. We chose Vector Displacement to move pixels in a specific direction, and used the Amount slider to get a moderate "ripple" effect in the Preview (we chose 1.57), leaving Variance at 1.00. To establish the direction (and make the light areas move up and to the right, and dark areas move down and to the left—based on the form file), we moved the Direction slider to 90°. We added a Softness of 20.2 to smooth any rough edges that might be caused by the distortion of the weave. Experiment with your settings; the Softness, Amount and Direction may change based on the size of your file. For a clean image, choose Good from the Quality menu.

4 Adding highlights and shadows. Using Apply Surface Texture adds to the illusion of folded fabric by contributing highlights and shadows based on the form file. Choose Effects, Surface Control, Apply Surface Texture, Using Original Luminance. Experiment with your settings—paying special attention to how the lighting controls affect the look—and click OK. We set Softness to 23.0 (to smooth the image and slightly increase the depth of the folds), Amount to 125%, Picture to 100% (to make the image lighter while maintaining weaving detail), and Shine to 0% and then chose the 9 o'clock Light Direction button. 🖌

Creating Art for Glass Sculpture

Overview *Draw freeform images to capture as paper textures; use the custom textures to build background surfaces and to add texture to motifs; add embossing and texture effects; transfer the final images onto a glass block.*

MARY ANN ROLFE

FOR HER GLASS SCULPTURE *Petroglyphs,* Mary Ann Rolfe developed iconic southwestern images using texture, dimension and lighting effects in Painter. She used Painter to create the images and to preview them prior to output. She superimposed five panels in Painter: two background panels and three motif panels with figures. Then, she output the images and transferred them onto the glass using techniques that she teaches in her Digital Stretch workshops (www.digitalstretch.com). All of the panels combine to emphasize the transparency and depth of the glass.

Getting organized. Rolfe enjoys the freeform, playful aspect of her digital art. She also carefully documents her processes as she works, which takes discipline but serves her well. On her computer, she creates a project folder to save all the Painter files that she uses to create a piece. Careful organization allows her to re-create all or part of these effects on future works.

Before beginning to draw the pieces featured here, Rolfe created a custom color set from an earlier image so that she could incorporate its color scheme. (To read about color sets, see Chapter 2.)

1 Drawing patterns and capturing paper textures. First, Rolfe needed to create the textures that she would use to create the water-like background image, and to texturize the three overlaid motifs. She created a new file that measured 6 x 6 inches at 200 ppi. Keeping her strokes loose, she used the Flat Color variant of Pens to draw multiple patterns. Then, she captured each pattern as a paper texture. To build a paper texture, use the Rectangular Marquee tool to make a selection around an image, leaving plenty of white space around it. Click the triangle on the right side of the Paper Selector (in the Toolbox) and choose Launch Palette to open the Papers palette. Now, choose Capture Paper from the pop-up menu on the Papers palette. (Rolfe used the default Crossfade setting of 16. Crossfade blurs the transition between the tiles of the captured paper texture.) Save and name your paper. Rolfe saved all of her textures into her own paper library. (For more information on working with paper libraries, turn to pages 17 through 19 in Chapter 1.)

Three-quarter view of the final sculpture

1

Drawn patterns that were captured and turned into paper textures

2

Detail of Background2 after Rolfe used the Apply Surface Texture effect using Image Luminance

3a

Rolfe started with a basic shape for each of the three motifs and she colored them.

3b

She added paper textures to the figure using Apply Surface texture.

3c

She applied Surface Texture to the figure using Image Luminance.

2 Embossing the background. For the background panel, Rolfe created an empty new file, *Background2*. She used a two-point color gradient that had a diagonal axis and filled the entire Canvas. (See Chapter 2 for more information about using gradients.) To add interest to the color transitions in the gradient, she used the Turbulence variant of the Distortion brushes. Next, to apply an emboss effect using the lights and darks of her image, she chose Effects, Surface Control, Apply Surface Texture and chose Image Luminance from the Using pop-up menu.

To soften the edges of the background, Rolfe began by adding space around the outside of the image. She selected the entire Canvas (Select, All), chose Edit, Transform, Scale, scaled the image to 96% and chose Edit, Transform, Commit Transformation. Then, she blended the colors into the white of the Canvas using the Oily Blender variant of the Blenders.

Next, Rolfe built up textured layers of color using the Square Chalk variant of Chalks. She picked colors from her custom color set and papers from her custom library of paper textures. As she worked, she changed the opacity and grain settings of the Square Chalk (using the sliders in the Property Bar) to vary the amount of texture and color that she applied with each stroke. To add dimension and an embossed effect to the brush work, she chose Effects, Surface Control, Apply Surface Texture, Using Image Luminance. She set Softness to 0% and under Appearance of Depth, she set the Amount to 28%.

3 Developing the motifs. Rolfe opened a black-and-white figure motif and added colors using the Oils Pastel variant of Pastels. To create your own motif, open a new image and add an empty new layer by clicking the New Layer button on the Layers palette. Choose the Flat Color variant of Pens and draw a motif or figure. When your motif is complete, turn on Preserve Transparency in the Layers palette. Preserve Transparency will protect the pixels outside the motif from new paint. Now, you can add color using the Oil Pastel variant of Oil Pastels.

Next, Rolfe added custom paper textures to selected areas of her motif. She used the Magic Wand tool to select a colored area of the motif; then she chose Effects, Apply Surface Texture, Using Paper and applied a custom paper texture. She repeated this step multiple times to add a variety of textures to her motif. Then, to add more depth to the texture, she chose Effects, Surface Control, Apply Surface Texture, this time using Image Luminance. She experimented with the Softness and Amount sliders to achieve the desired depth and roundness. Then, she added a drop shadow for more depth (Effects, Objects, Create Drop Shadow) and accepted the default settings.

4 Building the panels. Next, Rolfe created three beveled panels that would appear behind the figures. She selected the Canvas layer in the Layers palette and filled the canvas with the same style of

4a

The completed Canvas layer for one of the three motifs

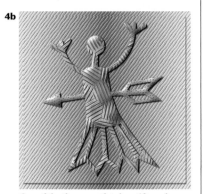

4b

One of the three completed motif panels

5a

Starry Sky paper in the Papers palette

5b

Front Layer image with gradient fill and Apply Surface Texture using Starry Sky paper

5c

Front Layer with Bevel World effect applied

gradient that she had used in step 3. To add texture to the gradient fill on the Canvas, first choose a paper texture from the Paper Selector in the Toolbox. Choose Effects, Surface Control, Apply Surface Texture and then select Paper from the Using pop-up menu. Adjust the controls for Softness, Amount, Shine, and Reflection in the Apply Surface Texture dialog box to achieve the look you desire and then click OK. To create the illusion of a raised panel to go behind your motif (as Rolfe did), select the entire image (Select, All), and make an exact copy of the Canvas layer by pressing Alt/Option and choosing Select, Float. Click on the new layer in the Layers palette to select it and reduce its size to 90% by choosing Edit, Transform, Scale and then Edit, Transform, Commit Transformation. To add the drop shadow to the new layer choose Effects, Objects, Create Drop Shadow and use the default settings. When Rolfe had completed all these steps, she dropped all of the layers and saved her file.

5 Adding dimension to the background. The last panel Rolfe created was the top portion of the background that would fit behind the three motif panels and in front of Background2. Create a new file with the same dimensions as Background2. (Rolfe named hers *Front Layer*.) Fill the canvas with the same type of gradient you used in step 3, but pick two different colors. Next choose Effects, Surface Control, Apply Surface Texture, Using Paper. Choose a coarse texture such as Worn Pavement or Handmade Paper. To give the image a beveled edge, choose Select, All, click the Dynamic Plug-ins button on the Layers palette and then chose Bevel World. Adjust the Bevel Width and the lighting direction. When you have the settings as you like them, click OK.

6 Visualizing and printing. To help visualize how the elements would look together on the glass, Rolfe created a new file that contained a copy of each of the panels on its own layer. To build a layered file like Rolfe's, open each image and choose Select, All and then copy and paste each image into the new file. Rolfe reduced the opacity of each layer in the Layers palette so that she could see through each image to preview how it would look after it was embedded in the glass.

Rolfe printed the three motif panels using Painter and her Epson 2000P printer onto Epson Enhanced Matte paper. She also used the Epson 2000P to output the two other panels onto a specialty paper that she uses in her unique transfer process. When the prints were complete, she was ready to assemble and apply the images onto her digital glass sculpture titled *Petroglyphs*.

6

Details of a motif transferred onto the glass

Creating a Color-Adjustable Leaf Brush

Overview *Paint a background, tree and branches; draw leaf elements using values of gray; capture them as an Image Hose Nozzle; load the Nozzle and adjust it; decorate the tree with colored leaves.*

JOHN DERRY

1a

Painting the sky using an Artists' Oils brush

1b

The completed landscape background

THE IMAGE HOSE IS A UNIQUE BRUSH that uses multiple elements as its medium. Small painted elements or masked photographic elements can easily be captured into an Image Hose Nozzle file. John Derry and Mark Zimmer invented the Image Hose. They received a patent for it, and the Image Hose made its debut appearance in Painter 3. As Painter has evolved, Nozzle files have become easier to build.

Many kinds of illustrations employ similar visual elements. Illustrating a tree, for example, can require the rendering of many small leaves. When painted using conventional media, the leaf elements must be individually created, and this can be a tedious, time-consuming process. For the fanciful illustration *Tree*, John Derry created a set of leaves and then used them to quickly decorate the branches of the tree. He was also able to use the Nozzle that he had built on future illustrations.

1 Setting the stage. Derry wanted to create a stylized illustration of a tree in a landscape. He painted the background using two layers, and he used a modified Clumpy Brush variant (Artists' Oils) to paint the grass and sky.

Open a new 1200 x 1000 pixel file, and choose a bright blue color in the Colors palette. Now, choose the Clumpy Brush variant of the Artists' Oils. Add a new layer to your image by clicking the New Layer button on the Layers palette. Use quick, loose brushstrokes to paint the sky. As you work, vary the value of the color by choosing

2

The painted tree trunk and branches

3a

The painted leaves

3b

Grouping the selected layers

3c

Choosing the Make Nozzle from Group command

3d

The Nozzle file created by the Make Nozzle from Group command

subtly lighter or darker values in the Colors palette. When the sky is as you like it, add a new layer, choose a green color and then paint the grass using loose strokes. To suggest the shadow patterns on the grass, vary the value of the color as you did for the sky.

2 Painting a bare tree. With the background finished, Derry used the Scratchboard Tool variant of Pens to draw the tree's trunk and branches. Then, he painted the bark and the shadows.

Next, add a new layer for the tree. Choose a rich brown color, and use the Scratchboard Tool variant of Pens to paint the trunk and branches. When you have completed the base color for the tree, enable the Preserve Transparency check box in the Layers palette so that the new paint that you apply will appear only within the existing tree shape. Use varied brown colors to paint the bark and shadows on the trunk and branches.

3 Creating the leaf nozzle. Now that the stage was set, Derry was ready to build the leaf Nozzle. He began the Nozzle by creating six leaf elements that would form a layer group that could be incorporated into an Image Hose Nozzle. To match the brush work on the tree, he used the Scratchboard Tool to illustrate the leaves, with each leaf on its own layer. Derry drew the leaf elements using values of gray, rather than color, so that later he could take advantage of the Image Hose feature that allows you to add variable color to the Nozzle elements.

Begin by opening a new file (Derry's measured 500 x 500 pixels). Add a new layer for your first leaf. Disable Preserve Transparency in the Layers palette and then use the Scratchboard Tool to paint the leaf with values of gray. Repeat the process of adding a new layer and then painting each leaf on its own layer. When the leaf layers are complete, Shift-select them in the Layers palette and group them using the Group command found in the Layers palette pop-up menu. Next, convert the layer group into a Nozzle. Click the Nozzle Selector on the Toolbox, and from the pop-up menu choose Make Nozzle from Group. This command organizes the layer group into a grid that can be used by the Image Hose to read the individual elements. Save the Nozzle file in RIFF format. Now you are ready to load your new nozzle into the Image Hose.

4 Loading and adjusting the Image Hose. To load the newly created leaf nozzle into the Image Hose, click the Nozzle Selector on the Toolbox, choose Load Nozzle from the pop-up menu and navigate to where you saved the file. Now, select the Image Hose in the Brush Selector Bar and choose the Spray-Size-P Angle-D variant. This variant uses pressure (P) to vary the Nozzle's element size and the direction the stroke is painted to express the angle (A) of the element. When Derry tried out the variant on a test image, he found that the leaf elements were incorrectly angled for the tree. He corrected this by experimenting with the Angle of the brush using

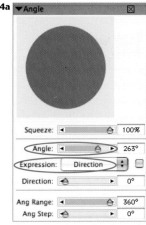

Adjusting the Angle in the Angle palette. The Expression menu is set to Direction.

The leaves pointing outward

Adjusting the Grain slider in the Property Bar

The dark green color chosen as the Additional Color and the dark green leaves

The lighter green color chosen as the Additional Color and the light green leaves

Painting the shaded leaves

the Angle section of Brush Controls. When he arrived at a setting that he liked, the pointed ends of the leaves were positioned away from the brushstroke direction as it was drawn. This enabled drawing the leaves from the outer periphery into central areas of the tree, with the leaves pointing outward. Open the Angle section of Brush Controls (Window, Brush Controls, Show Angle) and experiment with the Angle slider.

5 Controlling the nozzle color. Because Derry chose to create the leaf elements using values of gray, he could mix any color with his Nozzle elements. He used the Grain slider in the Property Bar to mix color with the luminosity of his nozzle elements. Click on the Additional Color (back color square) in the Colors palette and choose a dark green hue. In the Property Bar, experiment with the Grain Setting (Derry used 39%).

6 Painting the leaves. When he painted the leaves, Derry wanted to create highlights and shadows in areas of the leaves. To accomplish this, he painted the leaves on three separate layers, using a variety of greens that would simulate the variations in highlights and shadows.

Paint each series of leaves on its own layer so that you will be able to adjust their opacity or make tonal adjustments later. Add a new layer for the shadowed lower leaves. Choose a dark yellow-green in the Colors palette and spray these leaves onto the layer. When you have the lower leaves as you like them, follow the same process. Use a new layer and lighter greens to build each of the remaining levels of tone.

With the three leaf layers painted, Derry was now ready to make final adjustments. He selected the top leaf layer and adjusted its tonal values using the Effects, Tonal Control, Brightness/Contrast command. The final image on page 306 shows his hand-rendered illustration. He dramatically reduced the tedious process of leaf creation by using the Image Hose.

> **COLORING NOZZLE ELEMENTS**
>
> The Image Hose uses the Grain slider in the Property Bar to control the opacity of the current Additional Color (back color square in the Colors palette) within the Nozzle elements as they are painted. If you create the elements for a Nozzle using values of gray, you can apply any color to the Nozzle elements. Using the minimum Grain setting (0%), the Nozzle elements are completely filled with the Additional Color. Using a percentage of the color (Grain slider) will allow you to retain the luminosity of the leaves. As you increase the value, the Additional Color is blended with the color of the Nozzle elements.

The leaves painted and adjusted

■ Artist **Susan Thompson** created *Pettus Home*, a mosaic portrait of the historic Pettus family home, in Elm Hill, Norwich, England. Originally, she was commissioned to create an enlarged, hand-colored version of a pencil drawing of the home, which dated back to the 1500s. The client provided colored photographs of the street for her to use for reference. Thompson colored the image in Photoshop using several tinted layers.

A year later, Thompson decided to use the *Pettus Home* image as a reference for a mosaic that she created in Painter. To begin the mosaic, she opened the final colored *Pettus Home* image, and then she created a clone (File, Clone). She chose Canvas, Make Mosaic, enabled the Use Tracing Paper button and then clicked the Apply Tiles button. She applied tiles along the

most important shapes first, following the design of the composition; for instance, the perimeters of the building, the flow of the street and the perimeter of the entire image. Then she applied tiles to the interior areas. To build perspective, she used larger tiles in the foreground of the street and then gradually reduced the size of the tiles as the street receded into the distance. Thompson made notes of the tile sizes and other details so that she could return to certain areas, if needed. When she was happy with the mosaic, she gave the tiles three-dimensional highlights and shadows by choosing Effects, Surface Control, Apply Surface Texture. The mosaic, which contains more than 77,000 tiles, took a few months for Thompson to complete. Her delighted client purchased the mosaic rendition, as well.

■ Illustrator **Philip Howe** was commissioned by the Harvey and Daughters agency to create this richly textured photo-collage painting for H & S Bakery. The completed illustration was used for a trade show mural that was more than 18 feet wide.

First, Howe built a photographic composite using several photos that his team had shot of the breads. Then, he tightly rendered the stands, windows, walls, floor, oven and other elements to give the illustration the look of an old world bakery. At this point, Howe's client decided that he wanted more of a painted look, so Howe used Painter to create the illusion of a painting.

He made a clone of the photo-illustration by choosing File, Clone. To create brush-stroke effects, he used a smeary custom cloning brush (similar to the Oil Brush Cloner variant of the Cloners) to paint over every inch of the image, building expressive brush work. Then, he enhanced the brush work using special effects.

Howe began the process of building relief on the image with distortion. He applied Effects, Focus, Glass Distortion Using Image Luminance and the Refraction Map Type. Then, to give the relief highlights and shadows, he applied Effects, Surface Control, Apply Surface Texture, Using Image Luminance.

The combination of powerful effects created a heavy-looking texture, which he wanted to subdue in a few areas. Howe saved the painted, textured image as a Photoshop file. Then, he copied and pasted the image as a layer over the tightly rendered photo-illustration. He added a layer mask to the texture layer (click the Create Layer Mask button on the Layers palette), and he softly airbrushed areas with black paint to hide portions of the texture layer so that the breads would appear more photographic, because they were revealed through the texture layer.

■ **Michael Bast** creates illustrations for commercial products and packaging. To begin this package illustration, Bast drew a sketch using pencils and paper, and then he scanned the drawing. He opened the sketch in Painter and cut it to a layer by choosing Select, All and Select, Float.

Before Bast began to paint his illustration, he used the Oval Shape tool to draw circular shapes for the body of the snowman, using the sketch as a guide. Then, he converted each circular shape into a selection by choosing Shapes, Convert to Selection, and he saved each selection as an alpha channel by choosing Select, Save Selection.

To paint the sky, he targeted the Canvas and applied a two-point gradient using cool, light-to-medium blues by choosing Edit, Fill, Fill with Gradient. Then, he used the Digital Airbrush variant of Airbrushes to paint wispy white clouds.

Bast planned to paint the popcorn snowman and fields using the Image Hose, so he created a custom popcorn Image Hose. To begin, he photographed individual popcorn kernels, and when the photos were ready, he opened them in Painter. He selected each kernel in its source file, copied each silhouetted image and then pasted it into his working file as a layer. Next, he arranged the popcorn image layers into a pleasing order in the Layers palette and grouped them by Shift-selecting them and choosing Layers, Group. He clicked the

Nozzle Selector on the Toolbox, and from the pop-up menu he chose Make Nozzle from Group. He sprayed varied sizes of the popcorn onto the image, using smaller kernels to suggest distance and keeping larger kernels for the foreground. To paint the snowman, he loaded each circular selection and loosely used it to constrain the spray. For more information about using the Image Hose, see "Creating a Color-Adjustable Leaf Brush" on page 306. As a last touch, Bast created a deeper illusion of space by adding a new layer and using the Digital Airbrush to paint a soft-edged, pink gradient behind the snowman.

■ Inspired by the music of the late, great Ray Charles, **Jeremy Sutton** created the expressive portrait *Ray*. "I have always been deeply moved by his music. There is something so raw and honest in his songs, so moving," says Sutton.

Sutton began by searching for a photograph of Ray Charles. Eventually, he found a photo, taken by Ira Schwartz, that captured the exuberance of Charles's personality and his joy of life. Sutton purchased the rights from the Associated Press to do a derivative work based on the photograph.

He cropped and resized the photograph to the resolution and size that he wanted to use for a printed image (40 x 40 inches at 150 dpi). Then, he made a clone of the photo by choosing File, Clone. Next,

he chose the Big Wet Luscious variant of the New Paint Tools library (located in the Brushes folder within the Extras folder on the Painter 11 CD-ROM) and painted a loose, colorful painting that he refers to as his "muck-up" stage. Then, he saved two copies of the painting so that he could apply a different set of effects to each. For the first copy, he applied a Zoom Blur that emanated from the center by choosing Effects, Focus, Zoom Blur. With the second copy, he created a woodcut version by choosing Effects, Surface Control, Woodcut. Then, he pasted both of the variations into the original photograph as layers, with the Woodcut version on top. To blend the information on the layers, he adjusted the Composite Methods, setting the Woodcut layer to Overlay and the Zoom Blur layer

to Magic Combine. When he was satisfied with the image, he flattened it and then used Canvas, Canvas Size to add a white border around the image. For the explosive effect with paint emanating out from the center, he used the Smear variant of Blenders and the Big Wet Luscious brush to add diffused brush work.

Finally, Sutton printed the image using an Epson 9600 on Epson PremierArt Water Resistant Canvas with Epson UltraChrome inks. To protect the ink, he sprayed several coatings of Krylon Acrylic Crystal Clear protective non-yellowing finish, and then he stretched the canvas on stretcher bars. As a final touch, Sutton added accents of acrylic paint and gels.

■ An innovative artist, **Steve Campbell** began *Coffeehouse* by sketching a cafe scene using conventional pencils and paper. The color theme was inspired by the work of traditional artist Yoshiro Tachibana.

When his sketch was complete, Campbell scanned the drawing and opened it in Painter. He cleaned up the drawing using a low-opacity Eraser variant, and then he smudged areas using the Just Add Water variant of Blenders. Next, he brushed on translucent color using the Diffuse Bristle variant of Watercolor. To complete the underpainting, he added opaque paint using the Square Chalk variant of Chalk.

So that he could limit paint as he refined the image, he isolated the figures and

areas of the background by making hand-drawn selections using the Lasso tool and then floating the elements to layers. (Alt/Option-click on an active selection with the Layer Adjuster tool to copy it to a layer.)

Campbell used numerous custom textures during the development of the piece, including textures from the *Painter 11 Wow!* CD-ROM. For instance, the texture on the table in front of the Bird Girl (left foreground) was created from a scan of a checkered Japanese paper, and another was built using a scan of a musical notation by Beethoven.

To model the foreground figures and other areas, he used the Square Chalk and then blended areas with the Just Add Water variant of Blenders.

To add to the rich texture, Campbell used pieces of manipulated photographs. He pasted bits of his own photos into the working image, for instance, a shot taken at Golden Gate Park, a crowd scene and another of a sax player. Then, to give the photos an aged, textured look, he chose Effects, Surface Control, Distress. To subdue the images and merge them with the composition, he adjusted the opacity and the Composite Method for the photo layers.

As a last step, Campbell set type on paths in Adobe Illustrator and then he pasted the text into his Painter image as layers. He adjusted the opacity and Composite Method for each layer to blend the text phrases with the image.

■ **Mary Beth Novak** creates textile designs that are used in a variety of products—from bedsheets to bath accessories. From concept to production art, Novak uses Painter 11, Adobe Photoshop and Macromedia FreeHand. Using Painter gives her greater flexibility and the ability to create hand-drawn textured looks in her textile designs.

Incorporating Painter into her process has pushed her textile designs to a whole new level. Novak says, "I use a lot of the different brushes, and I use the Distress feature all the time to give things a hand-drawn look. Painter has really gotten us to a whole new plane with our prints at *Room Creative*. Usually, I am able to get a more hand-done look than if we had painted all the layers on paper and scanned them in."

For the *Umbria* bedding print (above), Novak sketched the flowers and leaves in pen and ink and then scanned her sketches at the scale they would be in the final print. To begin building the flower element in Painter, Novak opened the flower scan (shown at the right, top) in Painter. She selected the white background, and then inverted the selection. Novak copied and pasted the selected flower onto a new layer, leaving the original scan intact. To constrain her brush strokes to the shape of the flower, she checked the Preserve Transparency button in the Layers palette.

Then, using the Magic Wand tool she selected some of the interior shapes of the flower. With the selection active, she painted into the selected area with the Spatter Water Variant of the Digital Watercolor brushes.

Novak then distressed the selected area of the flower layer by choosing Effects, Surface Control, Distress. In the Using pop-up menu, she selected Paper, and then she chose a custom paper that looked like an irregular water texture. The Distress effect converted the selected areas of the image into black and white. She alternatively selected the black areas of the pen sketch and applied variations of the Distressed Effect to this portion of the image as well. She continued selecting portions of the flower, painting and distressing the image till she was satisfied with the result. She duplicated the original scanned flower again, and repeated this process, creating another variation of the flower image (two distressed examples are pictured bottom right). Novak used this same technique on the scanned image of her leaf sketch.

The colors Novak used in the Painter file were for visual reference only. Textiles are printed with 6 to 12 custom spot colors (Pantone textile colors), each of which can be mixed by overprinting to make other colors. At this point, Novak saved the layered Painter file in Photoshop format,

opened the image in Photoshop and saved each layer as a separate TIFF file. Using FreeHand, she imported each of the files (as layers) into one FreeHand file so that she could reassemble the leaves and flowers in the correct order and then color them using the Pantone textile colors that she had selected to use in the design so the colors would blend as she planned.

The ability to pull out elements, scale, rotate and change colors easily is essential to Novak's creative process. To complete the *Umbria* bedding print, Novak combined the multiple variations of the flowers and leaves in FreeHand. She created her final pattern for printing as a 25¼" repeat design in FreeHand.

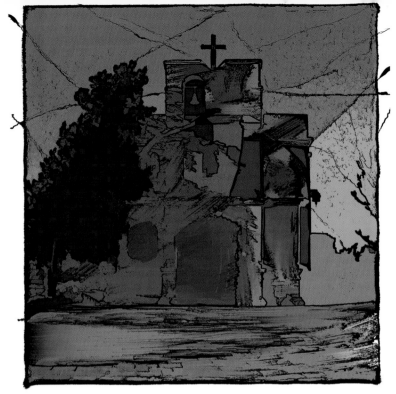

■ **Mary Ann Rolfe** worked quickly and freely to create her loosely rendered, stylized image ***Oquitoa Mission***. Her goal was to stretch herself to achieve a more painterly style than a previous rendition of the same subject. Rolfe began *Oquitoa Mission* by opening her original photograph of the mission in Painter, and cropping it to the final size she envisioned for her fine art print.

Next, she put a copy of the image on a new layer by choosing Select, All, Edit, Copy and then Edit, Paste In Place. To remove detail from the layer, she applied the buZZ.Pro 2 filter Simplify technique. (buZZ.Pro 2 is a third-party plug-in). Then she added loosely drawn strokes to this layer using one of her customized Pens variants. Rolfe then selected and copied the contents of her modified layer and again chose Paste In Place to create the second layer. To create the dark outlines, Rolfe applied the buZZ.Pro 2 filter Sketch technique to the second layer. Then to remove excess detail from this sketch she used the Eraser tool from the Toolbox. (This image is shown on the top right.) In the Layers palette she set its Composite Method to Multiply, which made the white on the layer transparent, and made the darker colors blend, rather than replace the color on the underlying layers. Rolfe then dropped all the layers to the canvas (Layers, Drop All). She wanted to add further interest to the black lines In her image, so she chose File, Quick Clone. The default setting for

Quick Clone creates a duplicate file of the image file, but with an empty canvas and Tracing Paper turned on. With the Clone image active, she used a custom Pens variant to loosely trace the main outlines of the image. To create textured, irregular lines, she used a variety of paper textures (from the Paper Selector in the Toolbox) as she sketched. The more heavily textured papers produced greater irregularity in the lines. Next, Rolfe painted broad strokes of color using the Coarse Mop Brush and Dry Brush variants of Digital Watercolor. (This image is on the right, and is second from the top.) As a last step, Rolfe individually selected areas of her image Using the Magic Wand tool. Ensuring that she would be using the current image colors she chose File, Clone Source and checked to make sure her current image filename was selected. Using various brushes emulating textured paint such as the Sargent Brush and Wet Acrylic she loosely painted back into the selected areas. On the Colors palette, Rolfe clicked the Clone Color button. Then she selected other portions of this image and repeated this painting process. To add additional depth and texture to the entire image, she chose Effects, Surface Control, Apply Surface Texture, and in the Using menu she chose Image Luminance. She decreased the Amount slider, and left the other settings at their defaults. She also experimented with different colorations for the image using Effects/Tonal Control. (See the two variations on the center and the bottom right.)

■ *The Cowboy* is one in a series of thirteen illustrations featuring a cowboy theme created by **Keith MacLelland**. "The focus of the series is on the cowboy image, myth and iconography. This painting is a response to the desire to be a cowboy in spirit and combines toy objects, sketches and photographs from my collections," says MacLelland. Using toy cowboys from the 1950s that were designed for children, he juxtaposes the toys and the idea of playing cowboy as a kid, but with adult masculine themes. The bright color palette in the illustration alludes to the fantasy and depicts this cowboy as more of a fictitious character.

MacLelland used Painter's Text tool to build a subliminal background behind the cowboy figure. He chose the Text tool and the Tombstone font, and then he typed a prayer written by Roy Rogers onto a text layer. When the text was complete, he converted the text layer to an image layer by choosing Convert to Default Layer from the pop-up menu on the Layers palette. Then, he duplicated the layer several times, shifting it a little each time to build a wallpaper effect. Next, he merged all of these layers into one layer by Shift-selecting them in the Layers palette and then choosing Layers, Group Layers and then Layers, Collapse Layers. MacLelland drew the other typography in source files and then copied and pasted the elements into his working file and arranged them with the Layer Adjuster tool. The cowboy on horseback was based on an original photograph by MacLelland. To simplify the photo into flat patches of color, he posterized it by choosing Effects, Tonal Control, Posterize and set the number of levels to 5. Then, he edited the color. Using the Magic Wand tool, he selected areas of color and then in the Property Bar, he set the Paint Bucket to Fill With Current Color. He used the Paint Bucket to drop in bright complementary colors.

For the cowboy on the right, MacLelland drew an outlined silhouette for the cowboy, and then he set the Composite Method for this layer to Colorize. As a last step, MacLelland added the star elements. He created them in a source file, and copied and pasted them into his working image. He duplicated them, positioned them with the Layer Adjuster tool. To blend them with the image, he set their Composite Method to Colorize in the Layers palette.

■ *The Refined Henchman* is an illustration from **Chet Phillips'** portfolio. He began by drawing a detailed black-and-white illustration with the Scratchboard Tool variant of Pens. Then, he cut the black-and-white drawing to a separate layer by choosing Select, All, and Select, Float. So the white areas of the layer would appear to be transparent, he set the layer to the Gel Composite Method, chosen from the Composite Method menu in the Layers palette.

In preparation for painting, Phillips built masks for the monkey, wings, stained-glass window and masonry and saved each one as an alpha channel in the Channels palette. Next, Phillips created a colored, textured surface for his painting. He selected the Canvas in the Layers palette and chose Edit, Fill, Fill With Current Color, using a creamy yellow color. To build texture for the masonry, Phillips loaded the masonry selection by choosing Select, Load Selection, and then he applied a subtle paper texture. He chose a light brown color in the Colors palette and chose Effects, Surface Control, Color Overlay, Using Paper and the Hiding Power option, with a very low opacity setting. Then, he painted over the masonry with Chalk and Pastels variants using several sizes.

For the stained glass window, Phillips loaded its selection and used saturated, jewel-toned colors to paint the glass. To give the glass realistic three-dimensional texture, Phillips used the Taffy paper texture loaded from the Nature texture library in the Extras folder on the Painter 11 CD-ROM. After selecting the Taffy texture, he chose Effects, Surface Control, Apply Surface Texture, using Paper with subtle settings.

Phillips wanted a richly textured look on the monkey and masonry, so he painted varied colors using a modified Artists Pastel Chalk variant of Pastels. To achieve the interesting randomness to the texture, Phillips adjusted the randomness of the brushstroke grain. In the Random section of Brush Controls: he toggled the Random Brush Stroke Grain on and off as he worked. This technique is most noticeable in the monkey's fur and in the transitions between the light and dark values on the masonry. To read more about his "woodcut" technique, turn to "Coloring a Woodcut" in Chapter 2.

■ Filmmaker, painter and printmaker **Elizabeth Sher** traveled to the Crusaders Palace in Rhodes, Greece, where she saw a mosaic of the Medusa. Inspired, she created *Me Dusa,* an installation piece that she exhibited at the Oliver Art Center, C.C.A., in Oakland, California. Sher has used Painter in her teaching at C.C.A. and in her own work since Painter 4.

Sher began by scanning a photograph of the Medusa mosaic and a 4 x 6-inch portrait of herself, using the same scale and resolution. She opened the scan of the portrait in Photoshop and used the Quick Mask function to isolate her face from the rest of the photograph. Then, Sher opened the scan of Medusa in Painter, and she created a Color Set from the image. She chose Create Color Set from Image in the pop-up menu on the Color Set palette. Next, Sher opened and made a Clone (File, Clone) of her face image. Then, she chose Canvas, Make Mosaic and enabled the Use Tracing Paper button to keep the image of her face visible. She selected a tan grout color to blend with the face tiles. Then she mapped the size, shape and tone of the tiles to the contours of her face as she carefully built the mosaic.

With the face mosaic completed, Sher copied and pasted it as a layer over the Medusa mosaic photograph. She reduced the opacity of the layer in the Layers palette so that she could see underneath it to align the two images. When the alignment was complete, Sher used a variety of brushes to add translucent glazes of color to integrate the two images. To smooth out the rough transitions, she used a variety of the Blenders brushes.

The circle image was printed with an Iris printer onto treated canvas at the Lightroom in Berkeley, California. Sher cut and mounted the printed piece onto cotton canvas, and then she painted the marble floor with acrylic paints to complement the 4 x 6-foot canvas. The final piece was shown on the floor with rocks and sand covering parts of the image, as a re-enactment of the uncovering of the mosaics in Petra, Jordan.

■ *Leviticus, I Love You* is a children's book by **Mary Minette Meyer** and **Beth Prince** of RainboWindow. The illustrations above show two spreads from the book that were conceptualized by the mother and daughter team and painted by Beth Prince. "Since these are illustrations for a children's book, we decided not to over-think each page, but to color within and outside of the lines, using different brushes to achieve the look we desired," says Prince.

As they began each spread, Meyer drew sketches using conventional pencils and paper, and Prince scanned them for import into Painter. Next, the women assembled large rocks in their photo studio and shot photographs of the rocks using even

lighting. After that, Prince used Painter's paper texture creation features to capture textures from the photos of the rocks. For more information about capturing and working with your own paper textures, see "Applying Paper Textures" on page 112.

As inspiration for the lobsters and other characters, the team shot photographs to use for reference. Then, they drew and painted the mother and child lobsters and other animals in different poses, as well as several arrangements of rocks, using primarily Watercolor brushes. For instance, Prince used the Simple Round Wash variant of Watercolor to lay in base colors on the herring. When she wanted to paint with more texture on the lobsters and seafloor, she used the Diffuse Grainy Camel. Prince

also employed Painter's special effects to add richness and texture to the scene elements. For instance, she applied three-dimensional texture to the rocks by choosing Effects, Surface Control, Apply Surface Texture, Using Paper. After creating all of the characters and scene elements in Painter, she printed the illustrations and cut them out by hand in order to physically place them into scenes.

"Once the author and I agreed upon how a page would look," says Prince, "I used Photoshop to assemble the elements in each scene using layers." To complete the illustrations, Prince added layer effects such as the drop shadows, and she also set the text for each spread using Photoshop.

■ "I am interested in how we can connect with the world beyond our own individuality—how we can connect with the past and with each other living in the present," says artist **Cynthia Beth Rubin**. *Senegal Textures* was created by Rubin based on photographs that she had taken while visiting Africa.

Although she does most of her compositing in Photoshop, Rubin uses Painter extensively to bring out textures in her images and to enhance the color and lighting. When an image is complete, she saves a copy of the image as a TIFF file and opens it in Photoshop for printing.

She printed *Senegal Textures* in two sizes, one large (about 22 x 36 inches) and the other small (on 13 x 19-inch paper). The large print was done on a Roland HiFi Jet printer with pigmented inks in the Faculty Research Lab at the Rhode Island School of Design. For the Roland print, Rubin set up the image with an Adobe RGB color profile embedded in Photoshop on a Macintosh, and then ported it over to the ripping PC for the Roland. The Roland color choice software does the final color conversion from RGB to CMYK. After running a few tests at 20% size, she subtly color corrected the image. For the smaller print, Rubin

used her studio Epson 1280 printer, using Jon Cone's system (inkjetmall.com). She bought paper, inks and color profiles from him, and followed his instructions. Again, she printed out of Photoshop.

In *Senegal Textures*, Rubin captures the grass houses that are still in use, playing the architecture against the textural illusions in the fabric of the clothes that are still worn by so many in Senegal. To add highlights and shadows to the foliage and the homes, making them look more three dimensional, she used the versatile Apply Surface Texture feature.

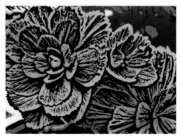

■ To create a series of prints for cards and calendars, artist **Anne Syer** transformed several of her close-up flower photographs using the Woodcut feature in Painter. The large image shows Syer's *Pink Perfect Woodcut;* the smaller images are from her *Begonia Woodcut* series.

Syer began each image by opening a digital photograph she had shot of a flower. She selected Effects, Surface Control, Woodcut. In the Woodcut dialog box, she set the Black Edge slider to about 9%, set the number of colors (N Colors) to about 14 and kept the Heaviness at 50%. The

Black Edge setting brought out the detail and delicate texture of the begonia petals in the black portion of the effect. The limited number of colors posterized the colors in the images.

To clean up some of the lines and to add detail to the black areas, Syer used the Opaque Round variant of Oils. For more depth in the color areas, she added a new Watercolor layer by clicking the New Watercolor Layer button on the Layers palette, and then she painted washes of similar hues using the Simple Round Wash and Wet Flat variants of Watercolor. After Syer

completed her washes, she merged the Watercolor layer with the Canvas by choosing Drop from the Layers palette pop-up menu.

To add more rich color to her image, Syer selected solid areas of color using the Magic Wand and Lasso tools. Then, she applied a custom linear gradient that she had built using two colors from the image. (For information about making a custom gradient, see Chapter 2.) She repeated this process several times until she achieved the harmonious colors.

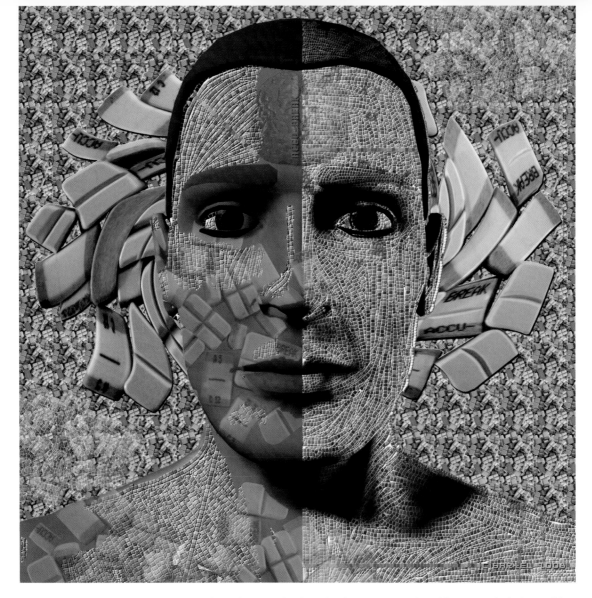

■ *Person Pill #4* is a member of a series of images and one-of-a-kind Iris prints created by renowned artist and photographer **Laurence Gartel**. The series of Iris prints was purchased by Scripps Research for their collection. "The images were inspired by a friend and colleague who is a medical doctor who invented a pill that adjusts the patient's dosage," says Gartel. "His invention inspired this body of work."

Gartel began *Person Pill #4* by modeling the head and shoulders using the 3D program Poser. When he was happy with the composition, he saved the file in TIFF format so that he could work on it in Painter. Next, Gartel opened the file in Painter and used the Mosaic tool to add color and a variety of tiled textures to the image. To

begin the mosaic, he chose File, Clone and made a clone copy of the image, and then he saved the clone with a new name. Working in the clone file, he chose Canvas, Make Mosaic and in the Mosaic dialog box, he turned on the Use Tracing Paper button and then clicked the Apply Tiles button. So that he could lay down tiles using the color from the original image, or the Clone Source, he turned on the Clone Color button on the Colors palette. First, Gartel applied tiles along the perimeter of the larger shapes—for instance, the outline of the head and shoulders. Then, he added tiles to outer edges of the image. When all of the edges were established, he carefully applied tiles to the interior of the figure and to the background. To suggest motion

and to add interest to the background, he created a curved design using larger tiles. When Gartel was happy with the mosaic design, he clicked OK to exit the Mosaic dialog box.

To achieve the repeated pattern of smaller tiles in the background, Gartel opened a small new image, and laid colored tiles into the image and then captured it as a pattern. Then, he selected the remaining background area and filled it with the pattern of small tiles. Finally, he added three-dimensional highlights and shadows to the tiles by choosing Effects, Surface Control, Apply Surface Texture, Using Image Luminance, with subtle settings.

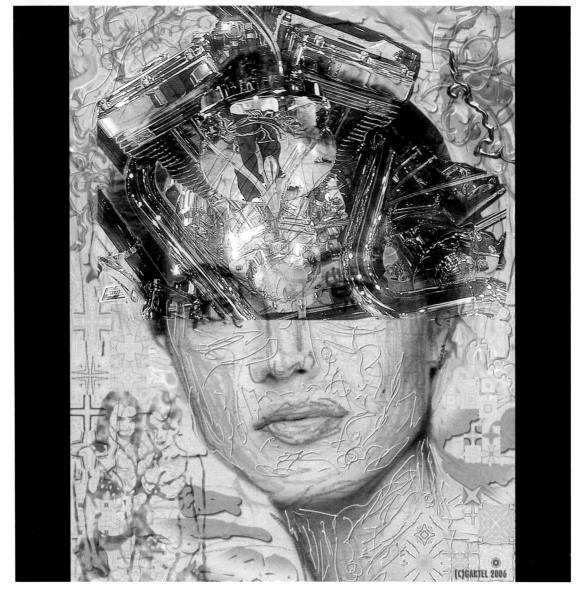

(C)GARTEL 2006

■ To create the surreal photo-collage *Motorhead*, **Laurence Gartel** began by scanning each of the source photos into Photoshop, where he made selections to isolate the subjects from their backgrounds. He opened a large new blank file, copied each component image and pasted it onto its own layer in the composite. He used several machine elements to assemble the motor on the woman's head. He used the Move tool to position elements until the composition seemed balanced. When the photo-collage elements were in place, he saved the image as a Photoshop file. Then, he opened the working composite in Painter.

To create a flashy surreal look, Gartel added several Liquid Metal layers by clicking the Dynamic Plug-ins button at the bottom of the Layers palette and choosing Liquid Metal from the menu. He used the Brush tool in the Liquid Metal dialog box to paint three-dimensional chrome brushstrokes of different thicknesses on the woman's face and neck. To reposition the chrome and metal elements, he used the Liquid Metal Selection tool (arrow). He applied Standard Metal and Chrome using the pop-up Map menu in the dialog box. The "live" nature of the Liquid Metal dynamic layers allowed Gartel to finesse the Liquid Metal until he was satisfied with the effect. When these elements were complete, he converted the dynamic layers into image layers by choosing Convert To Default Layer from the Layers pop-up menu.

Gartel also created many of the supporting elements with Liquid Metal. To create the transparent figures in the lower left, Gartel added a new Liquid Ink layer, and painted the figures using Standard Metal. To achieve a glassy transparent look, he adjusted the Refraction slider. For the background behind the woman's head, he used the Liquid Metal brush on yet another layer to draw curved shapes that frame the head. To complete the image, Gartel painted accents on the face using the Impasto brushes, including the Smeary Round variant. He also adjusted the Opacity and Composite Method in the Layers palette for a few of the layers (for instance, the light blue and gray Liquid Metal drawings on either side of the woman's head).

WORKING
WITH TYPE
IN PAINTER

When creating The Abducted Airstream, *Chet Phillips used Painter's text layers to build elements for his illustration. You can see more of Phillip's work in the gallery at the end of this chapter, and in Chapter 6.*

INTRODUCTION

PAINTER IS A POWERFUL TOOL FOR DESIGNING creative display type and for special effects. With Painter you can set type and put an image inside it; add texture to type; rotate type, stretch it and paint on it; fill and stroke type for a neon look; add type with special effects to your illustration (for a book cover design, for example); and create three-dimensional chrome type for a logo. You can set text on a path, fill the type with a color, add a shadow and much more. This typography primer will help you get the most out Painter's type tools.

A TYPOGRAPHY PRIMER

Painter is not recommended for setting large amounts of text—it's a good idea to leave this task to your favorite page layout program, such as InDesign or QuarkXPress. Instead, we'll focus on type as a design element using display type, because this is where Painter's tools shine. Display type is generally set in sizes 14-point or larger; it's usually used for feature headlines in magazines, for book covers, for posters and billboards and for Web page headers, to name a few applications.

Fonts and font families. A *font* is a complete set of characters in one size and one typeface. The characters usually include uppercase and lowercase letters, numbers, punctuation and special characters. A *font family* is all of the sizes and style variations of a typeface (for instance, Roman and italic styles in light, medium and bold weights).

Serif and sans serif. One way typefaces differ from one another is in the presence or absence of *serifs,* the small cross-strokes on the ends of the strokes that make up the letters. Serif faces were the first typefaces designed for printing. The serifs help our eyes to recognize the shape of a letter sooner and to track horizontally from one letter

The letter "E," showing the City font family, which includes upper- and lowercase City Light and City Light Italic, City Medium and City Medium Italic and City Bold and City Bold Italic

Serif fonts have small cross-strokes at the ends of the strokes. The letter "G" is shown here in a serif font, Goudy (left), and a sans serif font, Stone Sans Semibold (right).

The letter "T," demonstrating examples of several type classes. From left to right, top row: Black Letter, Fette Fraktur; Roman, Century Old Style; Slab Serif, City Bold. Bottom row: Script, Reporter Two; Sans Serif, Stone Sans; and Novelty, Arnold Böcklin.

to the next across a page, which makes these faces typically easier to read than sans serif faces.

The term *sans serif* refers to type without serifs. Usually sans serif fonts have a consistent stroke weight. Because of this quality, they can be ideal for display type because they look good in larger sizes and are good candidates for graphic treatments such as beveling and edge texture application. A sans serif font with very broad strokes has plenty of weight to work with when you apply special effects!

Classes of fonts. Fonts can be further grouped into several classes: Black Letter, Roman, Slab Serif, Sans Serif, Script and Novelty. *Black Letter* type resembles the style of hand-lettering that was popular during the time of Gutenberg's first printing press in 1436; Fette Fraktur is an example. These faces are usually used for an old-fashioned, formal look. Many typefaces fall into the *Roman* classification, including Old Style (for instance, Caslon and Century Old Style), Transitionals (Times Roman), and Modern (Palatino). The Old Style fonts have angled serifs, while the Modern Roman faces have straight vertical or horizontal serifs. *Slab Serifs* are also known as Egyptians, and they are characterized by even stroke weights and square serifs (examples are City Bold and Stymie). *Sans Serif*, mentioned earlier, is also considered a classification of type. Examples are Helvetica, Franklin Gothic, Futura and Stone Sans.

Designs for *Script* type were originally inspired by penmanship. Script fonts with dramatic thick-and-thin strokes (such as Linoscript) are often not good candidates for special effects because many techniques involve blurring of the edges or beveling, which can destroy the thin

HELPFUL FONT UTILITIES

Painter reads all of the open fonts when it starts up. If you're a designer with hundreds of fonts on your computer, consider organizing your fonts with a utility (such as Suitcase or FontAgent Pro) that enables you to turn them on and off for a faster startup.

USE EVEN STROKE WEIGHT

Many serif and script fonts have interesting thick and thin strokes. But for type manipulation, choose a font that has strokes with even thickness, rather than dramatic differences in stroke weight, unless your goal is to have the thin strokes disappear when softened or textured.

We set type using two script fonts, Linoscript (top) and Monoline Script. Our example shows the original typeset word above the type with textured edges. As you can see, the Monoline type kept its integrity of design through the special-effects application because of its thick, even stroke weight, while the thick-and-thin Linoscript did not.

Each typeface has its own aesthetic and emotional feel, as shown in this example. With Painter's text you can easily set type in different faces and colors. Shown here, from left to right are Fenice Ultra, Brush Script, Vag Rounded Black and City Medium. In this example, each letter was set on a separate layer so the different fonts could be applied.

Jeff Hull created The Crossing Guard *storyboard for a Miramax Films movie title and trailer. He began with a black background and set individual letterform shapes in Painter using Mason from the Emigré font library. After converting the shapes to layers, he filled them with color and erased portions of the letters by painting the layer masks with white paint. He also used Edit, Transform, Scale on the layers to vary the size of the elements.*

strokes. If you'd like to try special effects and still preserve the script typeface, find a font with thick strokes, such as Kaufmann Bold, Monoline Script or Reporter Two.

Finally, the *Novelty* category is diverse and graphic. These faces are often used to communicate emotion in special projects like poster designs (Arnold Böcklin and Stencil are examples).

Legibility. Have you ever driven past two billboards and noticed that one was easy to read as you drove by, and the other was not? The easier-to-read one was more *legible* than the other. When it's easy to recognize the words so you can absorb their meaning quickly, the type is legible. Legibility was important when you drove by the billboard, or when you were able to efficiently scan the headlines on the front page of a newspaper this morning.

When you set type in Painter, choose fonts carefully if you intend to manipulate them with special effects. Are you using the typeface simply as an element in a collage, where the letters are employed for graphic purposes only and content is not

as important? Or do you plan to set an important, legible headline and enhance it with beveling? If the latter is the case, make sure to choose a font with strong enough strokes to withstand the bevel effects, such as a bold sans serif face. Turn to "Creating Beveled Chrome" on page 336 for a step-by-step example of a three-dimensional chrome effect applied to sans serif type with Painter's Bevel World plug-in.

DESIGNING WITH PAINTER'S TYPE TOOLS

Each type element that you design has its own purpose: a Web page header, a food advertisement in a magazine, a billboard, the headline for a feature story in a magazine or a signage design. Know your client and research the style aesthetics needed for the design. This knowledge will help you choose the tools to use for the project.

Painter's Text is editable, which means you can easily change the size, color, font or content of the text, until you decide to convert the text layer into an image layer so you can paint on it or add special effects, or convert it to shapes so you can edit the outlines or do hand-kerning of the individual letters. Painter can display TrueType, Adobe Type 1 (If the printer font is installed) and OpenType fonts. Each text layer can display a single font.

Setting text in your image. Begin by choosing the Text tool in the Toolbox. Using controls in the Property Bar, you can specify a

This Frutiger Black text was set using the Text tool from the Toolbox. It shows the bounding box around the selected type and the insertion point crosshair.

When the Text tool is clicked in the image window, a new Text layer represented by a "T" icon is generated in the Layers palette.

The Text palette contains controls for specifying the appearance of the type, including putting type on a curve and specifying an angled blur for a shadow.

font and the size, alignment, color, opacity and shadow attributes. Click the cursor anywhere on the image and enter your text. The type will be displayed on a special new Text layer in your image. Using controls in the Text palette (Window, Text), you can also add a shadow and apply a curve style to the baseline of the type. Any changes that you make will be applied to the entire text layer.

In the Property Bar or Text palette: To specify the size, adjust the Point Size slider or click on the number to the right of the slider and enter a numerical value. Adjust the Tracking slider in the Text palette to globally change the spacing between the letters. To specify the alignment of the text, click the Align Left, Align Center or Align Right icon.

If you'd like to set more than one line of text, press the Return key (without moving the cursor), and Painter will begin a new line of type. To remove the last letter you typed, leave the cursor where it is and press the Backspace/Delete key. To adjust the spacing between multiple baselines of the Text, adjust the Leading slider, or enter a numerical value.

TEXT LAYER TO IMAGE LAYER

To convert a text layer to an image layer, choose Convert to Default Layer from the menu on the right side of the Layers palette. The text will be converted to a pixel-based layer so that you can paint on it or apply effects; the text layer's name will be preserved in the Layers palette.

Applying a new color. The current color chosen in the Colors palette will automatically be applied to the text as you set it. If you'd like to change the color of the text, make sure that the Text Attributes button is chosen in the Text palette. Choose a new color in the Colors palette and the text will update to display the new color.

Adding a shadow. When you'd like to add a shadow to your type, click the External Shadow or Inside Shadow icon on the left side of the Property Bar or in the Text palette. By default, a black shadow will be applied and the Shadow Attributes button will automatically be chosen. To adjust the opacity or the softness of a shadow, use the Opacity and Blur sliders. To blur the shadow more on one edge than on the opposite edge, enable the Directional Blur check box and adjust the Directional Blur slider. For a colored shadow, choose a new color in the Colors palette.

SPECIFYING TEXT ATTRIBUTES USING THE PROPERTY BAR

When the Text tool is chosen in the Toolbox, you can specify a font as well as the point size, alignment, color, opacity, shadow and a Composite Method in the Property Bar.

Choosing 100-point Helvetica Black in the Property Bar

This type was set along a path using the Curve Perpendicular style.

Setting type on a curve. The Text controls in Painter include the capability to create a Bézier path for the type baseline right in the Text palette. (The Curve Style controls are in the Text palette underneath the sliders, as shown in the illustration on page 334.) To begin, enter your type on the image. To place the type on a curve, click on a non-straight Curve Style icon. The first icon is Curve Flat, which will not create a curve. The other three icons will generate a curved baseline and allow you to edit the baseline using Bézier curves: the Curve Ribbon style specifies that the vertical strokes of the type will be straight up, and Curve Perpendicular places each character perpendicular to the curve, without distorting the letters. The fourth option, Curve Stretch, distorts the shape of individual letters to fit the space created by the bend of a curve. Use the Centering slider on the Text palette to move the type along the baseline curve. See "Setting Text on a Curve" on page 330 for a step-by-step description of the process.

Converting Text to Shapes.
After you set type with Painter's Text tool, you can convert each letter that you set to an individual vector object on its own layer by choosing Convert Text to Shapes from the triangle pop-up menu on the right side of the Layers palette. Shapes have certain advantages over type: They have editable Bézier curve outlines and unique transparency capabilities. You can stroke and fill them, and then change fill and stroke. As with type, you can rotate them without loss of quality. Because each letter is a separate element, it's easy to do custom kerning of the individual letterforms, which isn't possible with text.

The Curve Ribbon style chosen in the Text palette allowed us to rotate this text set in the Bauer Bodoni Italic font around a path. We set text and clicked the Curve Ribbon button to place the text on the curve. Then we used the Add Point tool to add an anchor point near the center of the path and used the Shape Selection tool to manipulate the path.

We created this clear, embossed look by setting text in the Machine Bold font, converting it to a default layer, and then using Apply Surface Texture and Composite Methods.

PHOTO: CORBIS IMAGES

To create this painted text, we began by setting type in the Sand font and converted it into an image layer by choosing Convert to Default Layer from the menu on the right side of the Layers palette bar. The Opaque Round variant of Oils was used to add colored brushstrokes.

PHOTO: CORBIS IMAGES

To make the type break up into sharp ice shards, we set type on a Text layer using Futura Extra Bold, and then painted on the type with the Shattered variant of the F-X brush, clicking the Commit button when the warning dialog box appeared.

Convert text to shapes when setting small amounts of type, when you want to pay special attention to spacing between individual letters, or when you want to edit the outline shape of the letters. Also, shapes are useful when you want to make a quick selection or mask from type (Shapes, Convert to Selection)—for instance, when you want to put an image inside of the type. (For more information about shapes, turn to "Working with Shapes," in the beginning of Chapter 6.)

When to convert text to pixels. If you'd like to paint on type, add special effects such as Apply Surface Texture or manipulate a layer mask on the type layer to erode the edges of the type, you'll need to convert the text layer to an image layer. To convert a text layer to an image layer, choose Convert to Default Layer from the triangle pop-up menu on the right side of the Layers palette. If you attempt to paint on a text layer without converting it, a Commit dialog box will appear, asking if you would like to convert the text layer to an image layer. Click Commit to convert it. 🖐

WAVE
WAVE

This text was set in Meta Bold. The original text had "uneven" letterspacing (top), so it was converted to individual shapes and kerned to tighten the spacing and to make it more consistent (bottom).

Setting Text on a Curve

Overview *Set the text; choose a Curve Style; use the Shape Selection tool to finesse the length and shape of the path; adjust the text on the path.*

1a

We set type using the Sand font and used the Tracking slider to tighten letterspacing.

1b

Choosing the Curve Stretch style

2a

Using the Shape Selection tool to pull an end point and lengthen the curve

2b

With two more points added, the curve is taking shape.

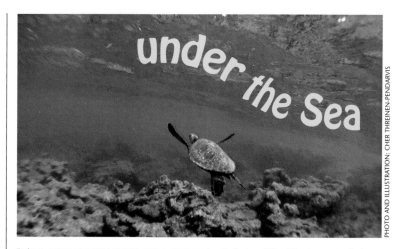

IT'S A SNAP TO SET TEXT ON A CURVE in Painter. The Text controls in Painter enable you to create a Bézier path for the type baseline right in the image window. Here's a quick method, applied to a comp for an advertising layout:

1 Setting the type and applying it to a curve. For this technique you can begin with a new blank image, or start with a photo, as we did. Choose the Text tool in the Toolbox and open the Text palette by choosing Window, Show Text. Choose a font and size and set your type. We chose the typeface Hobo Std Medium, because its shape and playful feel would work well with the Curve Stretch curve style we planned to use.

Click on the Curve Stretch button in the Text palette (the button farthest to the right in Curve Styles), and you'll see the text curving around the baseline of a newly generated path in your image. The Curve Stretch curve style distorts the letters to fit the spaces in the curve. The slight distortion adds to the ripply underwater effect. To reposition the text layer on the image, use the Layer Adjuster tool.

2 Adjusting the path. To change the shape of the path, choose the Shape Selection tool in the Toolbox (it's the hollow arrow), select the text layer in the Layers palette and click on an end point. Pull on the end point to lengthen the path. To change the shape of the curve, drag a control handle in the direction that you want the curve to go. As you manipulate the path, aim for gentle curves so the type will flow smoothly.

To add more anchor points (for instance, to make a gentle wavy line, like we did), choose the Add Point tool (it's nested under the Shape Selection tool in the Toolbox) and click the baseline curve. To remove a point, choose the Remove Point tool (it's also nested under the Shape Selection tool in the Toolbox) and click the anchor point. Use the control handles on each anchor point to finesse the curve. To adjust the position of the text on the path, use the Centering slider in the Text palette. We set Centering at 4%. 🐾

A Spattery Graffiti Glow

Overview *Use the Text tool to set text over a background; convert the text to an image layer, then to selections; stroke the selections using the Draw Outside mode to spatter the background outside the type.*

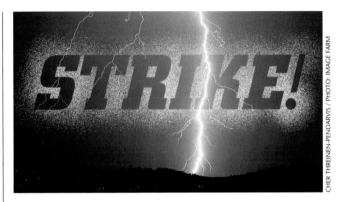

WITH THE HELP OF PAINTER'S TEXT LAYERS, selections and Draw modes, you can stroke around the edges of type with an Airbrush to create this fast, fun title solution.

1 Choosing an image and setting type. Open an image to use as a background; our photo was 864 x 612 pixels. Choose the Text tool in the Toolbox, and then select a font and size in the Property Bar. (We chose 200-point Berthold City Bold Italic.) Click in the image and begin typing. If the Layers palette is open, you'll see a text layer appear when you begin typing. To adjust the spacing between the letters, open the Text palette (Window, Text) and adjust the Tracking slider.

2 Converting the text to selections. To achieve the result at the top of this page, it's necessary to convert the text to an image layer, then to selections. Select the text layer in the Layers palette, click the right triangle on the Layers palette bar and choose Convert to Default Layer from the menu. Now reduce the opacity of the layer to 0% using the Opacity slider in the Layers palette and choose Drop and Select from the menu on the right side of the Layers palette bar. The layer will disappear from the list in the Layers palette and will reappear as animated marquees. To prepare the selection for stroking, choose Select, Transform Selection.

3 Stroking outside of the selection. With the help of Painter's nifty Drawing Modes in the bottom left of the image window, we used a brush to stroke around the edge of the selection. The Drawing Modes allow you to use a selection just as you would a traditional airbrush frisket, to paint inside or outside of the selection. From the Drawing Modes pop-up in the bottom-left corner of the image window, choose the Draw Outside (center) icon. In the Brush Selector Bar choose the Pixel Spray variant of Airbrushes. (We increased the size of the brush to 60 pixels, using the Size slider on the Property Bar.) Choose white in the Colors palette; then choose Select, Stroke Selection and watch as Painter gives your type a fine-grained, spattery glow. Try stroking your selection with other Airbrushes such as the Coarse Spray or the Variable Spatter variant.

The text set in City Bold Italic

The selection marquee created from the layer

3a

Choosing the Pixel Spray variant of the Airbrushes in the Brush Selector Bar

3b

Selecting the Draw Outside mode and stroking outside the active selection

Creating Beveled Chrome

Overview *Open a file and apply lighting to build a background; set text; convert the text to shapes and then to a layer; bevel the forms and apply a reflection; add a shadow.*

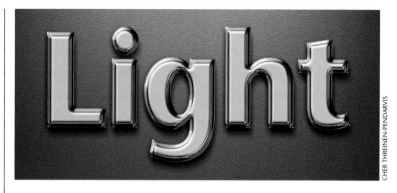

CHER THREINEN-PENDARVIS

1a
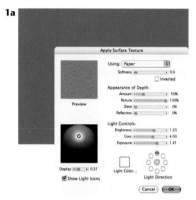
Applying a stucco texture to the background

1b

Creating an overhead spotlight based on the Drama light

2

The selected type and the background with lighting after the spacing was adjusted between the letters

PAINTER'S BEVEL WORLD DYNAMIC LAYER allows you to try an endless variety of custom bevels on a selected layer quickly, without time-consuming masks and channels. To create this three-dimensional chrome title, we applied effects that included custom lighting, a complex bevel with a reflection map and a shadow.

1 Creating a textured background with lighting. Begin by creating a new file with a medium blue background (our file was 1000 x 700 pixels). To add a stucco texture to the background, choose Worn Pavement in the Paper Selector and then choose Effects, Surface Control, Apply Surface Texture. Set Amount to 50%, Shine to 0% and click the 12 o'clock light direction button. Leave the other settings at their defaults.

To add depth to the background, we applied overhead lighting that would complement the bright, shiny chrome to come. Choose Effects, Surface Control, Apply Lighting and in the dialog box, click on the Drama choice. To shine the light from overhead, click the small circle and drag it so that it points upward. Increase Brightness to 0.60 and decrease the Distance to 1.31. To save your new light, click the Save button and name it when the Save Lighting dialog box appears.

2 Setting the type and adjusting the tracking. Now that the backdrop is finished, you're ready to create the type. Choose a color that contrasts with the background in the Colors palette. This will automatically fill the text with color as you type. The contrasting color will make it easier for you to see your type as you adjust the spacing between individual letters. Select the Text tool in the Toolbox and in the Property Bar, choose a font and size. Click in the image with the Text tool and enter the type. We set 100-point type using Stone Sans Bold. (If you don't have the typeface we used, choose a bold font with broad strokes to accommodate the beveling effect to come.) So that you can tighten the spacing between the individual letters, open the Text palette by choosing Window, Show Text and move the Tracking slider to the left to decrease it.

3 Beveling the type. With the layer still selected, click the Dynamic Plug-ins button at the bottom of the Layers palette and

3a

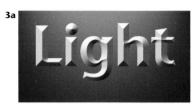

The rough bevel generated by the Bevel World layer default settings

3b

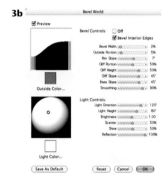

Our settings in the Bevel World dialog box

4

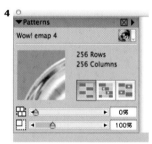

We used "Wow! emap 4" from the Wow! Patterns on the Painter 11 Wow! *CD-ROM*

5

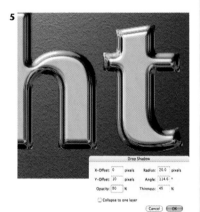

The Drop Shadow dialog box with settings for casting the shadow directly below the chrome type

choose Bevel World from the menu. When the Commit dialog appears, click Commit to convert the Text layer to a default layer. To build a 3D effect with a smooth stamped shape that would show off the reflection map we planned to add, we used these settings: Bevel Width slider to 2% (for narrower sides and a broader top); Outside Portion, 5% (for a small bevel outside of the original pixels on the layer); Rim Slope, –3° (for a recessed top); Cliff Portion, 50% (the vertical distance between the base and rim); Cliff Height, 50% (the height of the sides); Cliff Slope, 45° (the angle for the middle of the bevel); Base Slope, 35° (the angle of the outermost portion); and Smoothing, 80% (to smooth any ridges, while retaining the tooled shapes). Ignore the outside color, because it will disappear when the reflection is applied. Leave the dialog box open.

4 Achieving the chrome effect. The secret to achieving this chrome effect is choosing a bright, shiny environment map in the Pattern Selector, and then going back to the Reflections slider in the lower part of the Bevel World dialog box. We chose an environment map that included shiny metal reflections and bright colors. To apply the reflection map that we used, you'll need to load the "Wow emap" library. Locate it in the Wow! Patterns folder on the *Painter 11 Wow!* CD-ROM and copy it into the Painter 11 application folder. To load this library, click the Pattern Selector on the Toolbox and choose Open Library from the triangle menu. Navigate to the "Wow emap" library in the Painter application folder, select it and click Open. Back in the Pattern Selector, choose "Wow! emap 4" from the triangle menu. Now move the Reflection slider in the Bevel World dialog box to the far right (we used 100%). Your type will magically change to bright shiny chrome! Click OK to close the Bevel World dialog box.

5 Adding a shadow. To increase the depth of our image, we added a drop shadow using Painter's automatic drop shadow feature. To build your shadow, select the beveled layer and choose Effects, Objects, Create Drop Shadow. In the dialog box, we set X-Offset to 0 pixels, Y-Offset to 20 pixels and increased the Opacity to 80%. For a softer shadow, we set Radius to 20.0 pixels, and we left the Angle (114.6°) and Thinness (45%) at their defaults. (A low Thinness setting creates a streaked look similar to a motion blur.) 🐾

HAND-KERNING TYPE

If you can't achieve the results you desire using the Tracking slider, you can *hand-kern* the spacing of individual letters by converting them to shapes. Select the text and then choose Convert Text to Shapes from the pop-up menu on the Layers palette. Painter will convert the text layer to letterform shapes and group them. To hand-kern the letters, in the Layers palette, open the arrow to the left of the group of shapes. Click on a letter's name in the Layers palette and use the arrow keys on your keyboard to adjust the spacing between the letters. Make sure to leave room between the letters to allow for the bevel to be extended outside of each letter.

Painting with Ice

Overview *Set Text to use as a template for "hand-lettering"; paint icy script on a Liquid Metal plug-in layer; composite a copy of the layer to enhance the design.*

CHER THREINEN-PENDARVIS / PHOTO: CORBIS IMAGES

YOU CAN CREATE TEXT EFFECTS QUICKLY with dynamic layers. To begin this cover comp for an online travel agency catalog, we set type on a Text layer. Using this text as a template, we "hand-painted" new 3D letters onto a Liquid Metal dynamic layer using a tablet and stylus. Then we applied special settings to give the liquid letters a clear, frozen look.

1 Choosing an image. We began by selecting a photo that measured 768 x 512 pixels. Although the final art used online would be smaller, we preferred to work at a larger size so we could zoom in and finesse the details, and then reduce the size later. We chose a photo with a Mediterranean theme and refreshing colors that would complement the "ice" or "glass" title.

The original photograph

2 Setting Dynamic Text. To make it easier for you to see the type over the image, choose a contrasting color in the Colors palette to automatically fill the text with color as you type. Select the Text tool in the Toolbox. In the Property Bar, choose a font and size and set the type directly on the image. (We set our text using the Reporter Two font.) Open the Text palette by choosing Window, Show Text, and adjust the spacing between the letters, using the Tracking slider in the Text palette. To interactively resize the type, use the Size slider in the Property Bar or Text palette. To use the Layer Adjuster tool to resize the type, position it over a corner of the text, and when the arrow cursor appears, drag on the text. Drag the text with the Layer Adjuster to reposition it in your image.

The Text palette with settings for our title, including the tighter Tracking

3 Drawing with crystal-clear ice. Using the text as a template, we drew new letters using a Liquid Metal plug-in layer. Set up your Liquid Metal layer as follows: Open the Layers palette, click the Dynamic Plug-ins button at the bottom of the Layers palette and choose Liquid Metal. Painter will generate an empty, transparent Liquid Metal dynamic layer, and the Liquid Metal dialog box will appear. With the title as an underlay, we used a stylus to

The image with the Text set and in position

The settings in the Liquid Metal dialog box for the icy look

Beginning to hand-letter the Liquid Metal type using the dynamic text as a template

The underlying template layer is visible through the "ice."

The icy type with text layer removed

Detail of the icy type showing the underlying layer's Composite Method set to Darken

trace the text with the Liquid Metal brush tool. To begin, move the Refraction slider all the way to the right (so you can paint with crystal-clear ice). Choose the Brush tool in the Liquid Metal dialog box and carefully paint your title.

Adjust the Amount, Smooth, Size and Volume settings to your liking. To select all of the Liquid Metal so that you can apply new settings, choose the Liquid Metal Selector (arrow) and drag a marquee around what you've painted. Our settings were Amount, 1.1; Smooth, 90%; Size, 16.3; Volume, 97%; Spacing, .331; Map, Standard Metal, with Surface Tension checked. We reduced the Refraction setting to 90%, because it helped the type stand out from the photo.

After completing your letters, click OK to close the Liquid Metal dialog box. Then delete the Text layer you used as a template: Select its name in the Layers palette and click the Delete (Trash can) button.

A Liquid Metal dynamic layer is *live*, which means you can continue to finesse the dialog box settings. To keep a layer dynamic, do not "commit" the layer (change it into an image layer), and make sure to save the file in RIFF format. For more information about dynamic layers, turn to Chapter 6, "Using Layers."

4 Compositing a second layer. As you can see in your image, Painter's Liquid Metal dynamic layer "refracts" an underlying image. To give the ice more texture and make it look shinier, we set up another layer between our ice layer and the image beneath. To begin, make a copy of the Liquid Metal layer (Alt/Option-click with the Layer Adjuster tool in the image). To enhance the copy of the Liquid Metal layer using tonal effects, choose Effects, Tonal Control, Brightness/Contrast and slightly increase the contrast. When the Commit dialog box appears, asking if you'd like to convert the dynamic layer an image layer, click Commit. To add more texture and bring out the highlights in the icy type, we changed the underlying layer's Composite Method in the Layers palette to Darken.

So many options! When you have the underlying layer in place, experiment with changing the Composite Method in the Layers section to different settings. We experimented with Gel (left), and Pseudocolor (right). Control the effect with the layer's Opacity slider.

■ With *The Boxers*, artist **Susan LeVan** depicts figures in a dynamic relationship, by incorporating typography with expressive brushwork. In this work, she also explored working with thicker line weights and with colored lines merged with black lines.

For this portfolio piece, LeVan used a palette composed primarily of reds, oranges, browns and golds, accented by greens and blues. To begin, she opened a new file and filled the Canvas with a neutral gray. She brushed over the surface using the Square Chalk variant of Chalk and a reddish-gold color. Then, she added a new layer and used the Round Tip Pen and Scratchboard Tool variants of Pens to draw the figures and mat.

Next, LeVan randomly set the type and symbols using the Text tool. After arranging the text elements with the Layer Adjuster tool, she Shift-selected all of the text layers in the Layers palette and grouped them by choosing Layers, Group Layers. She merged the text layers by choosing Layers, Collapse Layers. When the Commit dialog box appeared, she clicked the Commit All button to accept. Then, she blended the text layer with her image by setting the Composite Method to Colorize and merged the layer with

the Canvas by choosing Layers, Drop. To add more color and richness to the image, LeVan painted textured strokes using the Square Chalk. Next, she added a new layer and drew large, squiggly brown lines with the Dry Ink variant of Sumi-e. For this layer, she set the Composite Method to Gel and then dropped the layer to the Canvas.

To complete her illustration, LeVan used the Magic Wand tool to select the area around the figures, and then she used the Square Chalk to paint loose, white brushstrokes. For more information about LeVan's collage painting technique, see "Selecting, Layering and Collaging" on page 191.

■ Artist **Chet Phillips** created *Bowling Alley Cats* for a personal gallery show. Phillips began by making a detailed drawing using the Scratchboard Tool variant of Pens and black color. To draw the straight lines for the signs, he employed the Straight Lines Stroke option in the Property Bar. When the line drawing was complete, he lifted it to a layer by choosing Select, All and Select, Float. Before deselecting the layer, he set the Composite Method to Gel in the Layers palette so the white areas of the layer would appear transparent.

In preparation for painting the scene, Phillips used the Lasso tool and Polygon Lasso tool to draw selections so he could isolate areas of his image, for instance the sky and the elements of the signs. With the selection active, he used the Digital Airbrush variant of Airbrushes in various sizes and opacities to paint within the selection.

To create the type for the signs, Phillips used the Text tool. For instance, for the Bowling sign, he chose the Text tool and Frutiger 95 Ultra Black font, set the word vertically and then clicked the Align Center option in the Property Bar to center the letters. Next, he converted the text layer to an image layer by choosing Convert to Default Layer in the pop-up menu on the Layers palette. So that he could add a dotted texture inside the type, Phillips created a selection based on the layer transparency by choosing Select, Load Selection and choosing Layer Transparency in the Load From pop-up menu. Then, he saved the selection as an alpha channel for use later by choosing Select, Save Selection. To paint the neon bulbs, Phillips used the Scratchboard Tool variant of Pens to draw a dotted pattern, which he captured as a pattern and saved in his Patterns library. (See "Creating a Seamless Pattern" on page 288 for detailed information about making and saving patterns.) With his new pattern and the selection loaded, he filled the selection by choosing Edit, Fill, Fill With Pattern. For the Alley Cats text, Phillips used a similar method to paint the light bulbs.

When the text and coloring was complete, Phillips merged the layers by choosing Layers, Drop All. To see more of Phillips's work, turn to "Coloring a Woodcut" in Chapter 2 and the gallery in Chapter 8.

10

USING
PAINTER
WITH
PHOTOSHOP

When creating Temperance, *Pamela Wells used Painter and Photoshop. To see the complete image, turn to page 351.*

complete image, turn to page 351.

MASK MAXIMUMS

A Painter file can contain up to 32 masks in the Channels palette, plus one layer mask for each layer. Photoshop 7 maximum is 24 channels in an RGB file, but three of the channels are taken up by the Red, Green and Blue color channels (leaving room for 21 masks). If you attempt to open a file with 32 masks in Photoshop 7, you will be greeted by a polite dialog box asking if you would like to discard the extra channels (numbers higher than 21 will be discarded). In Photoshop CS and higher the maximum number is 53 channels, in addition to the RGB channels.

INTRODUCTION

IT'S EASY TO MOVE FILES back and forth between Painter 11 and Photoshop. And Painter's fantastic natural-media brushes can give Photoshop images warmth, a multitude of textures, and fabulous special effects! In addition to the work showcased in this chapter, several of the other artists whose work appears in this book have used both Painter and Photoshop in the development of their images. If you're an avid Photoshop user and would like to see more examples of how others have combined the use of the two programs, check out the work of these artists for inspiration: Jeff Burke, John Dismukes, Donal Jolley and Pamela Wells. The index in the back of the book lists page references for each of them.

PHOTOSHOP TO PAINTER

Here are some pointers for importing Photoshop files into Painter 11:

- Although Painter 11 will open CMYK files, keeping files in RGB color mode when porting files from Photoshop to Painter will make the best color translation, because RGB is Painter's native color model.

- Painter can open Photoshop format files saved in RGB, CMYK and Grayscale modes.

- Photoshop can save a layered TIFF file, but Painter does not support layered TIFF files. Painter will flatten a layered TIFF image on opening.

- A Photoshop document made up of transparent layers only—that is, without a Background layer—will open in Painter as layers over a white-filled background in the Canvas layer.

- Painter can recognize most of Photoshop's blending modes when compositing the layers (some exceptions are Color Dodge, Color

Marc Brown used Illustrator, Photoshop and Painter when building Iron Casters, *a detail of which is shown here. See the entire image on page 344.*

See the entire image on page 344.

DYNAMIC LAYERS

When a Painter file that includes a Dynamic Layer such as Liquid Metal is opened in Photoshop, the layer is preserved but the dynamic capabilities are lost. To retain the dynamic properties for further editing in Painter, save a copy of your file with live dynamic layers in RIFF format.

A PATH TO PHOTOSHOP

You can store path information with a selection in Painter for import to Photoshop, and it will appear in the Photoshop Paths palette. When you make a selection with Painter's Lasso or Rectangular or Oval Selection tool, or set text and convert it to shapes and then to a selection in Painter (by choosing Convert Text to Shapes from the triangle pop-out menu on the Layers palette and then choosing Shapes, Convert to Selection), path information is automatically stored in the file. Then if you save the Painter file in Photoshop format, these kinds of outlines will appear in Photoshop's Paths palette. If you save a selection as a mask in the Painter's Channels palette you can build path information back into the file: Choose Select, Load Selection to create a selection based on the mask; then convert this mask-based selection to outline information using Select, Transform Selection. (Painter's Transform Selection command adds vector information to the selection border.)

Burn, Vivid Light, Linear Light, Pin Light and Exclusion). Painter converts blending modes that it doesn't recognize to the Default Compositing method.

- Layer sets created in Photoshop will be recognized by Painter.

- Photoshop layer masks translate consistently into layer masks in Painter. They will be listed in the Layers palette, as they are in Photoshop. To view a layer mask in black and white, in the Layers palette, select the layer, click the layer mask thumbnail and in the Channels palette, open its eye icon.

- A live layer style will disappear from the layer when the file is opened in Painter. You can try this work-around in Photoshop: Convert a "styled" layer to a series of rasterized layers (Layer, Layer Style, Create Layers) before attempting to open it in Painter. But this may not work either, since the conversion often involves a clipping path group, and clipping groups don't translate to Painter.

- Photoshop Alpha Channel masks are recognized by Painter 11. The channels will appear in Painter's Channels palette.

- Photoshop type layers will be rasterized by Painter; and shape layers, layer clipping paths and clipping groups will not translate.

PAINTER TO PHOTOSHOP

Here are some pointers for importing Painter 11 files into Photoshop:

- To preserve image layers when moving an image from Painter 11 into Photoshop, save your file in Photoshop format. Photoshop will open the file and translate the layers with their names and the layer hierarchy intact. (Photoshop rasterizes any dynamic layers such as Text, Liquid Metal and Watercolor, as well as Shape layers.)

- If a Painter file contains layers that extend beyond Painter's live image area, and that document is opened in Photoshop, the areas outside of the live area are retained.

- Many of the Photoshop Blending modes are available in Painter where they are called Composite Methods. Some modes/methods have different names in the two programs: Photoshop converts Magic Combine to Lighten mode, Gel to Darken mode, Colorize to Color mode and Shadow Map to Multiply. When Photoshop encounters a Painter-native Composite Method it can't convert (such as Pseudocolor or Reverse Out), it converts that layer to Normal.

- To preserve the alpha channels (masks) in Painter's Channels palette and use them in Photoshop as channels, save a Painter file in Photoshop format. When you open the file in Photoshop, the named masks will automatically appear in the Channels palette.

Compositing, Painting and Effects

Overview *Scan a drawing and a sheet of paper and composite the scans; add color and texture with brushes; add a colored lighting effect; open the image in Photoshop and convert it to CMYK.*

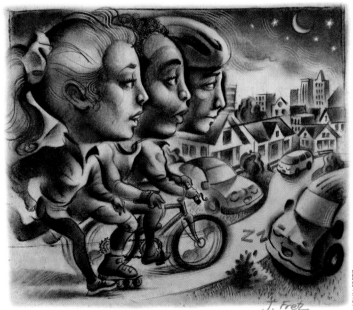

JOHN FRETZ

1a

The sheet of speckled Oatmeal paper

1b

The pencil-and-charcoal drawing on paper

2

Compositing the scans of the Oatmeal paper and the sketch

JOHN FRETZ COMBINED TRADITIONAL DRAWING materials and digital ones in Photoshop and Painter to build the composite illustration *AM Exercise* for an American Lung Association calendar.

1 Drawing and scanning. As a basis for his illustration, Fretz drew a black-and-white study using pencil and charcoal on a rough newsprint paper. Then he used a flatbed scanner to scan the drawing and a sheet of Oatmeal paper into Photoshop using RGB mode.

2 Compositing the scans. Fretz built the image in Photoshop because he was more familiar with Photoshop's compositing procedures. (His compositing process, which follows, can be accomplished almost identically in Painter.) Fretz copied the drawing and pasted it as a new layer on top of the Oatmeal paper background. To make the white background of the drawing transparent, he applied Multiply blending mode to the drawing layer using the triangle pop-up menu on the Layers palette.

For the soft, irregular edge on the background layer, Fretz first used the Lasso to draw a selection around the perimeter of the image. He reversed the selection by choosing Select, Inverse and feathered it 30 pixels (Select, Feather); then he filled the border area with 100% white. He saved the file in Photoshop format to preserve the layers for import into Painter.

3 Modifying brushes. At this point, Fretz opened the composite drawing in Painter, where he planned to add color and texture. Before beginning to paint, he made two custom Soft Charcoal brushes. The first, for adding soft values, used the Soft Cover subcategory; the second, for subtly darkening color, used the Grainy Soft Buildup subcategory and a low opacity. To make Fretz's "darkener,"

3

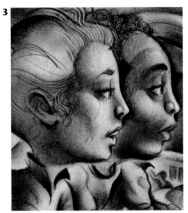

Building up color on the faces using the custom Soft Charcoal brushes

4

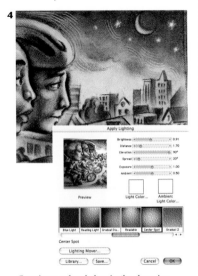

Creating a colored glow in the sky using Apply Lighting

5

Painting details on the foreground

in the Brush Selector Bar, choose the Soft Charcoal variant of Charcoal. In the General section of the Brush Controls palette, change the method to Buildup and the subcategory to Grainy Soft Buildup. A lower opacity will give you more control when building up color, so in the Property Bar, change the Opacity to about 15%. Save your new variant by choosing Save Variant from the Brush Selector Bar's triangle menu. Name it and click OK.

Adding color and texture in Painter. Fretz chose Basic Paper texture in the Paper Selector. To enlarge the texture to complement the grain of the Oatmeal paper background, he used the Scale slider on the Papers palette (Window, Library Palettes, Papers). He brushed color onto his drawing using two grain-sensitive brushes, the Large Chalk and Square Chalk variants of Chalk, and used his custom Charcoals to deepen color saturation in some areas. Choose a Chalk brush and begin painting color onto your image background; switch to the custom Soft Charcoal variant using Grainy Soft Buildup to darken color. To change the brush size and the opacity while you work, use the Size and Opacity sliders in the Property Bar.

4 Emphasizing the sky with lighting. For a warm glow in the sky that faded across the people's faces, Fretz applied a colored lighting effect within a soft-edged selection. Begin by choosing the Lasso tool and making a loose freehand selection. Now give the selection a soft edge by applying a feather: Choose Select, Feather, type in a feather width and click OK. Now apply the lighting effect to make the sky glow as Fretz did: Choose Effects, Surface Control, Apply Lighting. In the Lighting dialog box, choose the Center Spot light. To give the light a colored tint, click on the Light Color box to open the Select Light Color dialog box. Then choose a color by clicking on it in the Colors palette. (If the circle is black, move the slider up to the top.) Click OK. To move the spotlight to a new location in the Preview window, drag the large end of the light indicator. To save the custom light, click the Save button and name the light when prompted; then click OK to apply the light to your image, and deselect (Ctrl/⌘-D).

5 Painting final details. To make the layer and image canvas into one surface on which he could paint details, Fretz merged all the layers. (Click the right triangle on the Layers palette bar to open the menu and choose Drop All.) Then he chose the Scratchboard Rake variant of Pens, and modified it by reducing the number of bristles. To build a similar brush, open the Rake section of the Brush Controls palette. Reduce the number of Bristles to 5. Fretz added finishing strokes in various colors to several places in the foreground, the grass and highlights on the cars. He also used a smaller brush and more subtle colors to add textured strokes to areas of the background.

Fretz saved a copy of the image as a TIFF file. He opened the file in Photoshop and converted it to CMYK for use in the calendar. 🐾

Illustrating with Soft Pastel

Overview *Shoot photos; build a rough composite in Photoshop to use for reference; paint with Pastels in Painter.*

Four of the reference photos

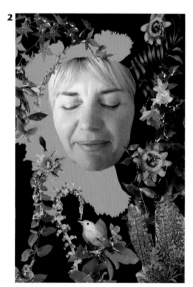

The composite image

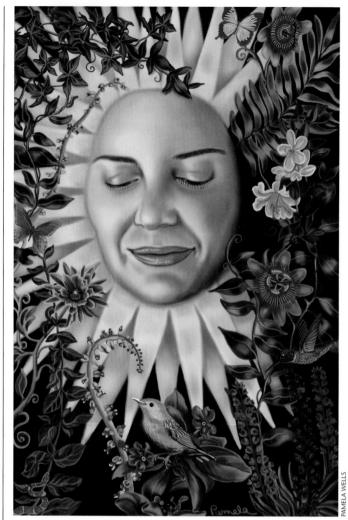

PAMELA WELLS USED PHOTOSHOP AND PAINTER to create *Sun,* which is a member in her series of works inspired by Tarot cards. "The Sun card represents happiness, contentment and joyful living," says Wells. She built a composite to use for reference, and then working in Painter, she created a colorful illustration that has the look of blended pastel.

1 Shooting photos. Wells set up her model, the flowers and other elements using a white background; then, she photographed them with a digital camera.

2 Building a composite. To begin the illustration, Wells built a composite that included several elements. She made masks for the images in Photoshop using the Lasso tool, and then she dragged and dropped the elements into a composite file. Wells could have brought a layered Photoshop file into Painter with layers, but she wanted a flat document with all of the elements merged together.

3a

Using the Soft Pastel to paint color over the simple pencil outline

3b

Achieving a soft, blended pastel look. The Paint Bucket fills can be seen on two flowers.

4

Building color and tones on the foliage and flowers

3 Tracing, sketching and coloring. Wells opened the flat composite file in Painter, and then she made a clone copy of the image to use as a guide while she created the sketch.

Open your reference image and choose File, Quick Clone. The default Quick Clone feature is set up for tracing. It creates a clone copy of your image, removes the contents of the clone copy document and then turns on Tracing Paper. Save your clone image and give it a descriptive name. Leave your original open. (For more information about cloning, see "Cloning, Tracing and Painting" in Chapter 3.) To sketch as Wells did, choose the Soft Pastel Pencil variant of Pastels and draw a black-and-white sketch on the Canvas of the blank clone image. Make sure to create solid lines so that you can use the Paint Bucket to fill areas with base colors, in preparation for modeling the forms.

When her sketch was complete, Wells used the Paint Bucket to fill areas of the sun with a yellow-gold color directly over the drawing on the Canvas. Then, using the Soft Pastel variant of Pastels, she began to develop the forms. As she worked, she mixed color using the Colors palette, occasionally sampling colors from her reference collage using the Dropper tool. Wells works completely on the Canvas without the use of layers. She likes the paint interaction that is possible when working on the Canvas because it is more similar to traditional painting, working on a conventional surface. When the sun's basic forms were blocked in, she used the Paint Bucket to fill a few of the flowers with their base colors.

Choose the Paint Bucket (Toolbox) and fill an area of your drawing with its base color in preparation for painting. Then, use Soft Pastel (Pastels) to build the highlights and shadows. As you work, vary the appearance of the grain by adjusting the Grain slider in the Property Bar. For a grainier look, move the Grain slider to the left, and for a smoother look, move the Grain slider to the right. For a softer look similar to blended traditional pastels, continue to work over areas with the Soft Pastel until they are smooth. (For more information about the Grain slider and grain penetration, see the "Grain Penetration" tip on page 54.)

4 Modeling the forms. When she had most of the color for her composition laid in, Wells began to gradually develop more three-dimensional form and color on the flowers and other elements in her composition. Carefully observe your reference, and then use the Soft Pastel to refine the forms in your composition.

Wells recommends cloning or painting directly over photo references *only* to gain practice with how to develop color and anatomy. After creating a drawing, she prefers to work from scratch, referring to the reference, rather than cloning in color from her reference. As she models the forms, she leaves the reference composite open on the screen to the left of her working painting so that she can refer to it. For Wells this approach is less confining than cloning (or continuing to trace over a photo).

■ Designer/illustrator **Marc Brown** was commissioned by Angie Lee, art director at Grindstone Graphics, to create *Museum Store* (above). He created *Iron Casters* (right) for Amanda Wilson, art director at The Evans Group Advertising. Brown employed similar techniques to create both illustrations. He started with a loose pencil drawing, and then scanned the drawing and placed it into Adobe Illustrator as a template. In Illustrator he drew the elements on individual layers and filled them with flat color. To rasterize the image, he copied each Illustrator layer and pasted it into Photoshop as a layer. (This process can also be accomplished in Painter by drawing shapes and filling them with color, or by importing Illustrator art into Painter. See Chapters 5 and 6 for more information about using and importing shapes.) At this point, Brown opened the layered file in Painter. He used Airbrushes and Chalk variants to add colored details to the faces and clothing, blending color with Blenders variants. After he had completed the composite, he merged the layers by choosing Drop All from the menu on the right side of the Layers palette bar. To finish, he broke up some of the smooth edges by painting them with the Just Add Water variant of Blenders.

■ Color and vibrant energy radiates in *Into the Light*. "This image was a visual response to the question, 'what is the creative process?'" says artist **Ileana Frometa Grillo.** "The woman moves toward the light, bringing forth the richness and power of the creative inspirations that can only be accessed in moments of introspection and sitting quietly in the dark. My goal is to portray the opposites not as polarities, but as dynamic, interdependent and ever-changing aspects of the same. To me, art is one manifestation of this wonderful dance of 'opposites.'"

Ileana began the image by shooting photos on location. Back at her studio, Grillo made a pencil drawing to work out the composition. After scanning the drawing into Photoshop, she created collage elements from her photographs. Next, she opened the composite in Painter and added brushwork to areas using the Chalk variants. To soften areas, she used the Blenders brushes. The blended pastel brushwork is most noticeable in the woman's skin and hair. For more texture in a few of the blended areas, she brushed lightly with a small Soft Chalk, which was based on the Large Chalk variant of Chalk.

When partners **Jeff Burke** and **Lorraine Triolo** were commissioned to create the new *Acapulco Restaurants menu cover*, several people played important roles: Photography and imaging, Jeffrey Burke; food and prop styling, Lorraine Triolo; art direction, Jeff Burke and Bob Marriott; Design Firm, Marriott & Assay; and client, Acapulco Restaurants.

To begin the menu cover, Burke built a composite that included several images of food and live models, shot in the studio against a white cove background. To add to the atmosphere, he incorporated a sky image from a recent Caribbean vacation, as well as an outdoor fountain photographed with a point-and-shoot digital camera. He made masks for several of the images in Photoshop using the Lasso and Pen tools and dragged and dropped elements into a composite file. After several preliminary compositions and the client sign-off on a final arrangement, he flattened the file and saved it in TIFF format. (Burke could have brought the file into Painter with layers, but he wanted a flat document with all of the elements merged together so that he could use Painter's brushes to paint over the entire image, completely integrating the elements.)

Burke opened the file in Painter, cloned it, and used the Big Grain Rough texture (loaded from the Painter 6 Textures library on the Painter 11 CD-ROM) and a pressure-sensitive tablet and stylus. He smudged the edges of some of the elements and added colored brush work to some areas using an Oil Pastel variant of Oil Pastels. By selectively blending areas in the image with the Just Add Water variant of Blenders, and leaving other edges in focus, Burke created a dynamic feeling of movement in the illustration. For instance, in the server's skirt and blouse, the leading and trailing edges are blurred with soft diagonal brush work, but the sash and ruffle are sharper. To lead the eye to the food tray, Burke airbrushed a glow under the tray and along the sleeve of the blouse. Because the food was the focal point of the composition, Burke avoided adding brush work here. To balance the design, he left the faces of the mariachis in clearer focus than most of the other elements. It was easy to restore the focus where it was needed by designating the original file as the clone source (File, Clone Source) and using the Soft Cloner.

Finally, Burke airbrushed highlight hints on the image on a separate layer (for editing flexibility), using the Digital Airbrush to "blow out" the highlights, while keeping the look natural.

■ **Athos Boncompagni** created this topographic map of *Italy* for the educational publisher *Klett* in Stüttgart, Germany. Boncompagni began by creating a tight pencil drawing with pencil-and-paper. He scanned the illustration and opened the file in Painter. First, he made selections for the country of Italy, the outer regions and the water and saved each one as an alpha channel in the Channels palette. Then, he loaded each selection in turn and he began to lay in basic colors using a variety of Digital Watercolor brushes. For example, he used the Broad Water Brush for larger areas and the Simple Water Brush to paint details. When the underpainting was in place, he modeled the topography using Pastels and Chalk brushes, blending some areas using the Grainy Water variant of Blenders. In areas where he wanted more texture, he used the Square Chalk variant of Chalk. While painting the map, he saved the master working file in RIFF format to preserve the wet watercolor paint, in case he wanted to edit the painting later.

After painting the physical aspects of the land, Boncompagni enhanced the color in the image using two Surface Control features. First, he applied paper texture using the Effects, Surface Control, Adjust Dye Concentration dialog using subtle settings. Then he applied colored texture using the Color Overlay dialog, which is also located under the Surface Control menu.

When the topography was as he liked it, Boncompagni used the Pen tool to draw colored lines of different weights for the rivers, roads and the colored outlines around the land masses. To denote the cities, he used the Oval Shape tool, with the Shape Preferences set to Fill on Draw and with an appropriate red color chosen in the Colors palette. As he drew each small round shape, it automatically filled with red. Boncompagni settled on three main sizes for the red city dots so that he could draw them once, then copy them and position them. When all of the elements were in place, he saved the working RIFF file.

For import into Photoshop, he saved a copy of his master file in PSD format, where he planned to create the type. Using the Type tool in Photoshop, he set the city names on individual layers. To finish, he made a few minor color adjustments to the land areas using Hue/Saturation adjustment layers.

■ **Delro Rosco** creates illustrations for product packaging and print advertising. Rosco created *Almond Sunset* as feature art on the packaging for a new line of dessert teas by Celestial Seasonings.

Rosco began by drawing several sketches of the composition using conventional pencil on tissue paper. When the final design was chosen, he scanned the sketch into Photoshop and saved it as a TIFF file. Opening the sketch in Painter, Rosco put the sketch on a layer by choosing Select, All and then Select, Float. He built selections and masks to limit the "paint" (just as he uses friskets with conventional airbrush). When the masks were complete, he lowered the opacity for the sketch layer using the slider on the Layers palette. Then, he laid in base colors using the Digital Airbrush variant of Airbrushes. To create more depth and interest, he varied the opacity of the airbrush as he worked, using the Opacity slider in the Property Bar. When the basic colors were established, Rosco used Painter's Watercolor layers and brushes to paint glazes.

When creating the almonds, orange slices and other floating elements, Rosco found the copying, pasting and layer features helpful. He created all of the elements on individual layers. For instance, he painted one almond and then selected it, copied it and pasted it back into the image as a new layer. He positioned the layer and dropped it by choosing Drop from the Layers palette menu. Then, he added more brushstrokes to blend the almond with the painting.

To build the textured watercolor look on the sky, Rosco began by applying a blue gradient to a selected area of the Canvas by choosing Edit, Fill, Fill With Gradient. Then, he chose Lift Canvas to Watercolor Layer from the pop-up menu on the Layers palette and selected a Watercolor brush in the Brush Selector Bar—for example, the Wash Camel variant of Watercolor. Next, he chose Wet Entire Watercolor Layer to add watercolor paint texture to the layer. As it turned out, the watercolor effect was a bit too strong, so Rosco added a new layer to his image, loaded the selection for the sky and filled it with the blue gradient. Then, he reduced the opacity of both layers to combine the effects.

Rosco added final details to the painting using the Opaque Round variant of Oils, again varying the opacity to simulate transparent and opaque painting with conventional watercolor and gouache.

He saved his working file in RIFF format to preserve the wet watercolor paint and then saved a copy of the final file in PSD format for import into Photoshop. In Photoshop, he converted the illustration to CMYK and then made a few minor color adjustments using an adjustment layer.

■ **Phillip Straub** is the Senior Concept Artist at Electronic Arts, and he illustrates children's books. He is the co-author of two books, *d'artiste* and *Otherworlds*.

For *Cohabitation,* Straub was inspired to create a unique, futuristic city. He began the image by making sketches to work out the composition. In Painter, he used the Pastels brushes to rough in the color scheme. Then, he used the Thick Oil Bristle variant of Oils to add more color and to move paint around on the Canvas.

The brush work with the Thick Oil Bristle is most evident on the sky and on the large building that overshadows the city in the distance. Straub painted without using masks, because he wanted to avoid a mechanical look. When working in Painter, he emulates his favorite traditional painting practices.

To create the spaceship in the foreground, Straub added a new layer and then worked on that layer with Pastels brushes to build its design. When he was satisfied with the

basic forms for the spaceship, he dropped the layer by choosing Drop from the Layers palette menu. Then, working on the Canvas, he continued to model the spaceship using the Pastels and Thick Oil Bristle brushes.

Finally, Straub opened the painting in Photoshop, where he added fine details with the program's brushes. For instance, he painted the tiny people and added details to the piping around the building in the foreground.

■ The works of artist **Pamela Wells**, which focus on feminine archetypes, are sold in commercial and fine-art markets. The illustrations on these pages are members of Wells' *Affirmations for the Everyday Goddess* series. "*Strength* is about how to wisely use life-force energy to create and direct your good work in the world," says Wells.

Wells began *Strength* by shooting photos of a model to use for references. Wells opened the photos in Photoshop and built a rough collage to use for inspiration while working in Painter. She drew a tight line drawing using the 2B Pencil variant of Pencils and a neutral color. Because she wanted to begin the coloring of the sketch by

filling areas with flat color, she made sure to create solid lines to enclose the areas she wanted to fill. She could then apply color fills to the woman and clothing, for example, using the Paint Bucket from the Toolbox. To model the forms of the figure and her clothing, Wells carefully painted over the filled areas using the Soft Charcoal variant of Charcoal to apply layers of color. To blend areas, she laid subtly different colors over existing ones. For instance, to render the skin, she brushed the areas with a light tan color, covered them with a darker orange and then finally, with a peachy red. For the animals and the foliage, she used

more contrasting values and a tiny Soft Charcoal variant.

Next, Wells created the light coming from the background. The woman and the cats were on their own layer in the foreground, and the background was on the Canvas. Before merging the layer with the Canvas, she painted the light on the Canvas using the Soft Pastel variant of Pastels. Then, she softened the trees and light by painting with the Just Add Water variant of Blenders. When she finished painting the illustration, Wells saved it as a TIFF file and opened it in Photoshop, where she applied a few color and brightness adjustments.

■ "*Temperance* is about how to translate inner knowledge and wisdom into action into the physical world," says artist **Pamela Wells**. "The affirmation for this painting is 'Lord, make me an instrument of Thy peace.'"

Wells began the image by shooting photos to use for reference. She opened the photos in Photoshop and made a collage; then she merged the layers and saved the file in TIFF format. Wells opened the flattened collage file in Painter and cloned it by choosing File, Clone. She wanted to use Tracing Paper so that she could see her reference as she sketched, so she deleted the contents of the clone by choosing Select, All and then pressing the Backspace/Delete

key. Then, she pressed Ctrl/⌘-T to turn on Tracing Paper. She drew a detailed line sketch with the 2B Pencil variant of Pencils. Wells created solid lines that would completely enclose areas in the drawing because she wanted to use the Paint Bucket to fill the areas with flat color. She began the coloring process by applying colored fills to the figure, clothing and other elements. Then, using the Soft Pastel variant of Pastels, she painted over the filled areas to sculpt the forms. Wells brushed subtly different colors over existing colors. To render the fabric, she painted light-gold base colors and then painted shadows using a darker gold. For the texture on the background landscape, she sampled color from

the image using the Dropper tool, and then adjusted the color in the Colors palette to a lighter value and used small Pastels variants to add grainy textures. To give the angel a luminous glow, Wells used a lighting effect. She made a loose selection around the angel and gave it a soft edge by feathering it. Then, she chose Effects, Surface Control, Apply Lighting, using a custom light similar to the Warm Globe. After the lighting was applied, Wells painted back into her image to blend the lit area with her brushwork. When the illustration was complete, Wells saved it as a TIFF file and opened the image in Photoshop, where she applied color and tonal adjustments.

■ Artist and designer **Ted Larson** created the images on these pages to illustrate scenes in the Holy Bible. They are used as both large-format digital prints and PowerPoint-ready digital slides for seminary and church presentation aids.

"*Gabriel and Daniel* is an emotion-driven piece based on a passage from Chapter 8 in the Book of Daniel. During his years of service to the various monarchs of Babylon, Daniel was shown several visually rich symbolic prophecies of events to come. The image illustrates a personal visitation by the angel Gabriel to convey one such message. I wanted to make the smile of Gabriel slightly reminiscent of Leonardo DaVinci's angels. The hand of Daniel is stretched out in faith and awe," says Larson.

To begin *Gabriel and Daniel,* Larson sketched with pencil-and-paper to establish a composition. With his concept in mind, he shot digital photos of the brickwork and

of friends at his studio dressed in a simple robed costumes. He photographed several large wings at a local museum and modeled 3D wings based on these reference photos. Then, he used a 3D program to model the background scene.

Later, working in Photoshop, Larson assembled a gray-toned composite image with layers. He opened each source image and copied and pasted it into his composite image as a layer, and repositioned elements to create a balanced composition. Once the grayscale "underpainting" was completed, he opened it in Painter. Larson preferred to begin coloring the image with a warm sepia color, so he used Painter's Express in Image command to apply a Sepia gradient to the image. (See "Creating a Sepia-Tone Photo" on page 248 for information about this process.)

Next, he added an empty new layer for the coloring. To make the layer like a

transparent color overlay on top of the sepia image on the Canvas, he set the Composite Method of the layer to Color. He began blocking in color with large Digital Watercolor brushes, including the Broad Water Brush and Simple Water Brush. Then, he used various Charcoal and Oil brushes to paint sfumato-style smoky shadows. For the fully lit areas on his subjects, he employed Pastels brushes.

To complete the work, Larson brushed subtle colored tints over the image using Digital Watercolor brushes. For the background wall, he used gray-violet colors and warmer yellow-grays on the figures and foreground steps. For the focal point around the head, waist and sash, he painted with soft yellow-golds. For additional depth to the color in his image, Larson added a new layer and painted with a small Digital Airbrush variant of Airbrushes.

■ **Ted Larson** created *The Rider Among the Myrtles*, an illustration from the small Book of Zechariah. Larson describes the inspirational story: "Zechariah was a Jewish prophet who brought hope and encouragement to Israelites as they finished rebuilding their temple destroyed by the Babylonians. It also foretold the coming of a messianic leader many believed to be Jesus. The picture of the rider depicts the first of several symbolic night visions in which the prophet Zechariah was shown a supernatural rider among a number of horses at the bottom of a ravine. Myrtle and olive trees were symbolic of the nation of Israel. The ravine is a picture of a very low point in their history. The various colors of the horses shown have symbolic meaning described in a later Chapter depicting messengers sent out to the distant nations via the four cardinal directions—North, East, West and South. The rider in red is a messenger of justice and hope, One who can right all the wrongs, comfort the oppressed and give hope to the hopeless."

Larson began the picture with background, using Photoshop to layer and edit images of foreground, middle and background elements photographed with his Canon 5D Mark II. He finds using a 50mm lens best for capturing background material. The horses were photographed at a local horse show. He copied and pasted them into the working file, moving them around and scaling them down behind the "hero" red horse. The horses were shot with his 70–200mm lens, which works great for moving distant subjects. Once the horse group was composed, he posed and photographed a friend in costume at an angle to match the red horse using his 85mm lens because it flattens them to a graphic shape. The 50mm lens in the studio tends to distort the perspective of full-figure poses making them difficult to blend in with their surroundings. Larson likes to compose illustration in grayscale in Photoshop. It is a technique he learned in traditional oil painting where a monochromatic undertone was blocked in and color was applied as the final stage.

When the gray-toned composition was ready, he opened it in Painter. To tone the image on the Canvas, Larson used Painter's Express in Image command to apply a Sepia gradient to the image. Then, he added a new layer and painted greens and muted red-browns to arrive at a balanced color scheme. To give contrast suggesting a night mood, he added lights and darks. As a final touch, he used the Glow variant of F/X to create the halo around the rider's head.

ANIMATION
AND FILM
WITH PAINTER

Award-winning film artist Ryan Church created Catamaran City *using Painter's brushes and effects. To see more of Church's work, turn to the gallery at the end of this chapter.*

INTRODUCTION

WHETHER YOU'RE AN ANIMATOR, film artist, designer, or 3D artist, Painter's capabilities offer you dozens of practical techniques. Concept artists appreciate the creative freedom offered by Painter's brushes, textures and effects. If you're producing an animation or making a movie, many of the techniques and effects shown in this book can be applied to frames in a Frame Stack, Painter's native animation format, or to an imported movie clip. Although it isn't a full-featured animation or film-compositing program, Painter is good for making comps so you can preview motion. And Painter gives 3D artists a wide variety of choices for creating natural, organic textures to be used for texture mapping. In addition, the ability to record painting scripts lets you make tutorials to show others how your painting was built and even lets you batch-process a series of images.

WORKING WITH SCRIPTS

Painter's versatile Scripts feature lets you record your work, and then play the process back, either in Painter or as a QuickTime or AVI (video for Windows) movie. But if you use this feature a lot, you'll soon discover its limitations—for example, its inability to record some Painter operations can produce a different effect during playback.

The Scripts palette with a current script chosen in its menu. The most recent current script has a small rectangle to the left of its name.

There are two basic kinds of scripts—Painter's automatically recorded Current Script and scripts that are recorded by enabling the Record feature. Both kinds of scripts are visible in the Scripts palette when you install Painter: The white icon with a date represents the Current Script

A CURRENT SCRIPT PREFERENCE

You can tell Painter how long to save current scripts by specifying the number of days in the Preferences, General dialog box. (The default is one day.) A word of caution: Saving several days of scripts can use a lot of hard disk space!

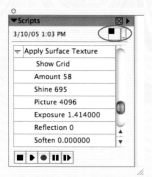

An open Current Script showing the instructions for an application of Apply Surface Texture. The white icon in the picker near the top right of the Scripts palette represents the Current Script. The tiny rectangle identifies the most current script.

You can use these buttons on the front of the Scripts palette to begin recording a single script (center red button) and to stop recording when you're finished (left square button).

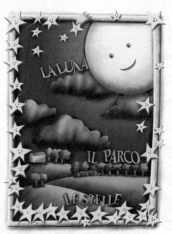

Athos Boncompagni saved a series of scripts when creating La Luna e le Stelle, *and played them back at higher resolution to build a larger image. For more information about using scripts in this way, see the tip "Increasing File Resolution with Scripts," on page 356.*

and the icons with pictures represent scripts that were manually recorded by artists while they worked, to demonstrate various kinds of images that can be created using Painter. If you record your own scripts they will also appear in the Scripts palette.

Understanding the Current Script. The Current Script starts when you launch Painter and closes when you quit the application. While you work, Painter transparently records your actions automatically, saving them as the Current Script in the Painter Script Data file in the Painter application folder. If you have launched and quit Painter several times during a 24-hour day, you'll notice several white icons in the Scripts menu list, with the dates and times for each work session listed in the pop-out resource list menu on the Scripts palette (for instance, "5/22/03 8:07 AM").

Playing back a complete Current Script in which you created and saved more than one image can cause problems. For instance, if you opened a file, added brushstrokes and saved it, playing back the Current Script may result in Painter finding the first file, redrawing your strokes over the image and then resaving over the file. A more practical way to use an automatically recorded script is to open it and copy a specific series of commands from it (a lighting and texture effect, for instance) to paste into a new script, which can then be played back on other images.

Using a portion of a Current Script. To use a portion of a current script, copy specific commands from it and paste them into a new script, begin by opening the Scripts palette (Window, Scripts). Click the right triangle on the Scripts palette bar and from the menu select Open Script. In the dialog box that opens, choose Current Script from the Painter Script Data file list and click Open. The Current Script cannot be edited, but to use only a specific set of instructions from it, you *can* copy them to the clipboard and paste the instructions into a new script. Then you'll be able to use your new script to re-create just that series of actions. To do this, open the Current Script, Shift-select the instructions that you want to use (you may want to start at the bottom of the list, where the most recent instructions are found), choose Copy from the Scripts menu, choose Close Script and then choose New Script from the menu. Type a name for your new script in the Script Name dialog box, and click OK. Now choose Paste from the Scripts menu, and then choose Close Script. To play your new script, select the new script by name from the pop-up list in the Scripts palette and click the Playback button.

Recording a planned script. To record a series of deliberate actions into a script (instead of copying and pasting from the automatically recorded script), click the right triangle on the Scripts palette bar to open the menu and choose Record Script to begin recording, or click the Record button (the red dot) on the Scripts palette. When you've finished working on your image choose

To add lighting and a paper texture to this Mediacom video clip, we played a special effects script (using Effects, Surface Control, Apply Lighting and Apply Surface Texture) on each of the frames.

Stop Recording Script (or click the square Stop button). Painter will prompt you to name your script. The new named script will appear in the pop-up list in the Scripts palette, available for later playback. To play the new script, select it from the list and click the Play (forward arrow) button.

Recording and saving a series of scripts. If you want to record the development of a complex painting (so you can use the script to demonstrate how you created the painting) but you don't want to finish the painting in one sitting, you can record a series of work scripts to be played back. First note the dimensions of your file by choosing Canvas, Resize, and then click OK to close the dialog box. Click the right triangle on the Scripts palette bar, and choose Record Script. Include a number in the name of your script (such as "01") to help you remember the playback order. Then begin your painting. When you want to take a break, stop recording (Scripts palette bar, Stop Recording Script). When you're ready to continue, choose Record Script again and resume working on your image. Record and save as many scripts as you need, giving them the same basic name but numbering them so you can keep track of the order. To play them back, open a new file of the same dimensions as the original, and then choose Playback Script from the menu on the Scripts palette bar. Choose the "01" script, and when it's done playing, choose the next script: It will play back on top of the image created by the first script. Continue playing back scripts in order until the image

QUICKTIME CAN'T CONVERT

Scripts that contain Painter commands that QuickTime cannot convert can't be turned into QuickTime movies. It's not possible to use the Record Frames on Playback function with scripts that contain commands such as File, New or File, Clone (an Illegal Command error message will appear).

INCREASING FILE RESOLUTION WITH SCRIPTS

You can use Painter's Scripts function to record your work at low resolution, and then play it back at a higher resolution. This technique gives you a much crisper result than simply resizing the original image to a new resolution. Here's how to do it: Start by opening the Scripts palette (Window, Show Scripts). Click the right triangle on the Scripts palette bar to open the menu and choose Script Options. In the Script Options dialog box check the Record Initial State box, and then click OK. Open a new file (File, New) and choose Select, All (Ctrl/⌘-A). From the Scripts palette menu, choose Record Script (or press the round red button on the Scripts palette) to begin recording. Then begin painting. When you're finished, from the menu on the Scripts palette bar, choose Stop Recording Script (or click the square black button on the Scripts palette). Open a new document two to four times as large as the original (this technique loses its effectiveness if your new file is much bigger than this). Again press Ctrl/⌘-A to select the entire Canvas. Then choose Playback Script from the menu, or click the black triangle button (to the left of the red button) on the Scripts palette. Painter will replay the script in the larger image, automatically scaling brushes and papers to perfectly fit the new size. A word of caution—scripts can be quirky: Your higher-resolution image may not match the lower-resolution one if you use imported photos, complex selections, shapes or the Image Hose, for instance.

Choosing Script Options from the menu on the right side of the Scripts palette bar

The Frame Stack palette for Donal Jolley's animation Rattlesnake *showing the movement in frames 13–14.*

When you're turning a script into a frame stack by checking the Save Frames on Playback box (accessed by clicking the right triangle on the Scripts palette bar and choosing Script Options), a long script may result in a huge frame stack. There is currently no way to preview the number of frames that will be created when you enter an interval number in the dialog box, so you need to make sure you have plenty of hard disk space available.

To record the painting process of Mill Valley *(720 x 540 pixels, painted with Pastels and Blenders brushes), we made a movie using Save Frames on Playback and an interval of 10. The resulting movie was 110.6 MB with 120 frames.*

is completed. (You can also record a script so that it can be played back on a canvas of a different size; see the tip below.)

Automating a series of operations. Recording a series of actions can save you a lot of time when you need to apply the same effect to several images. Test a combination of operations (such as a series of choices from the Effects menu) until you get something you like. Choose Record Script from the menu on the Scripts palette bar (accessed by the right triangle), and repeat the series of choices that produces the effect you want. After you've stopped recording and have saved your script, you can apply the operations to a selection, a layer or a still image by selecting your script in the Scripts palette and clicking the forward arrow button on the front of the palette.

You can also apply your script to a Frame Stack. Turn to "Automating Movie Effects" later in this chapter for a detailed explanation of this technique.

Saving a script as a movie. This is a great option if you'd like to "play back" a painting for someone who does not have Painter. QuickTime movies can be played on Macintosh and PC/Windows computers with a freeware QuickTime projector such as Movie Player. First you'll record your work as a script, then you'll play it back on a new file, and then you'll save it as a QuickTime/AVI movie.

Begin by clicking the right triangle on the Scripts palette bar and choosing Script Options. In the Script Options dialog box, turn on Record Initial State (otherwise Painter will play back the first few commands or brushstrokes of your script using whatever colors, brushes and textures are active, instead of the ones you actually used during the recording of the script). Check Save Frames on Playback. You can leave the time interval Painter uses to grab frames from your script at 10, the default, but you may want to experiment with lower settings instead, to get a smoother playback result.

Next, open a new file of the dimensions you want for your eventual movie file. Click the right triangle on the Scripts palette bar, choose Record Script from the menu, and make your drawing. When you've finished, from the same menu, choose Stop Recording Script; name your script and click OK to save it. Now Painter

To save a script as a movie, check Save Frames on Playback in the Script Options dialog box (chosen by clicking the right triangle on the Scripts palette bar and choosing Script Options). Painter will grab a part of your script as a frame at the interval (tenths of a second) that you set. A lower setting in the interval box (such as 1 or 2) results in smoother playback than the default setting of 10, but file sizes for lower settings are larger because more frames are created. For instance, a short script with an interval setting of 1 resulted in a 4.2 MB Frame Stack; the same script recorded with an interval of 10 produced a 1.4 MB file.

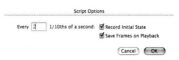

A storyboard frame from the MGM movie Stargate. *Peter Mitchell Rubin used Painter to build digital storyboard illustrations for the movie, saving them as numbered PICT files and animating them with Adobe Premiere.*

140 141

Frame 141 of 243

Playback: [◀ ———————— ▶] 25 FPS

To change the continents from brown to green in this Cascom video clip, we recorded a script while performing the New from Color Range procedure and Color Overlay tinting process on one frame, and then stopped recording and saved our script. After undoing the effects applied to the first frame, we chose Movie, Apply Script to Movie and took a break while Painter completed the masking and tinting process on all 243 frames. Above: The Frame Stack palette shows frame 140 with the operations applied, and frame 141 as yet untouched.

will convert the script to a movie. First, watch your recorded script played back as a Painter Frame Stack by opening a new file (same dimensions) and choosing Playback Script from the menu, choosing your script from the list and clicking the Playback button. Painter will prompt you to enter a name for your new movie file. Name it, click Save and then specify the number of layers of Onion Skin and color depth by clicking on the appropriate buttons. (For most uses, select 2 Layers of Onion Skin and 24-bit color with 8-bit alpha.) Click OK, and your script will unfold as a Frame Stack. When it's finished playing, save it in QuickTime/AVI movie format by choosing Save As, Save Movie as QuickTime. The QuickTime/AVI file will be smaller than a Frame Stack (if you use a Compressor choice in the Compression Settings dialog box) and will play back more smoothly. (Because most compression degrades quality, compress only once—when you've completed the project. Film artist Dewey Reid suggests using Animation or None as the Compressor setting.) To read more about preserving image quality when working with movies, turn to "Importing and Exporting," on page 360.

Making movies using multiple scripts. You can save a series of successive scripts, and then play back the scripts as frame stacks and save them as QuickTime movies without compression to preserve quality. Then you can open the movies in a program such as Adobe Premiere or Adobe After Effects and composite the movies into a single movie.

ANIMATING WITH FRAME STACKS

If you open a QuickTime or AVI movie in Painter, it will be converted to a Frame Stack, Painter's native movie format. Frame Stacks are based on the way conventional animators work: Each frame is analogous to an individual transparent acetate cel. You can navigate to any frame within a stack and paint on it or apply effects to it with any of Painter's tools (see "Animating an Illustration" on page 363).

Artists accustomed to specialized animation and video programs such as Adobe After Effects and Adobe Premiere will notice the limitations of the Frame Stack feature (there are no precise timing or compositing controls, for instance). If you use one of these

A frame from an animation based on a video clip. We began by using Painter's Watercolor brushes to illustrate the frames, which created a Watercolor Layer. Because a Watercolor Layer sits on top of the entire Frame Stack, we copied the layer to the clipboard, and then dropped it to the Canvas when we had finished painting the frame. We advanced to the next frame and pasted in the copied watercolor and added new brushstrokes, repeating this copying, dropping, pasting and painting process until the frames were complete. As a final touch, we applied an effects script (with Apply Surface Texture, Using Paper) to complete the piece.

programs, you will probably want to work out timing and compositing in the specialized program, and then import your document into Painter to give it an effects treatment.

When you open a QuickTime or AVI video clip in Painter or start a brand-new movie, you'll specify the number of frames and color bit depth to be used in the Frame Stack. You will be asked to name and save your movie. At this point the stack is saved to your hard disk. A Frame Stack will usually take up many more megabytes on your hard disk than it did as a movie (depending on the kind of movie compression used), so have plenty of space available. Each time you advance a frame in the stack, Painter automatically saves any changes you have made to the movie. When you choose Save As, Painter will ask you to name the movie again. This is not a redundant Save command, but an opportunity to convert the file to another format: Save Current Frame as Image, Save Movie as QuickTime or AVI format, or Save Movie as Numbered Files (to create a sequence of frames to edit in another program such as Adobe Premiere).

USING A VIDEO CLIP REFERENCE

Painter's cloning function allows you to link two movies—a video clip and a blank movie of the same pixel dimensions—and use the video as a reference on which to base an animation. Open a video clip that you want to use as a reference (File, Open), and then make a blank movie (File, New Movie) of the same pixel dimensions as your video clip. (The second movie doesn't need to have the same number of frames.) Under File, Clone Source, select the video clip. In the blank movie frame, turn on Tracing Paper (Ctrl/⌘-T). Using the clone source as a guide, choose a brush and paint on the frame. To use the Frame Stacks palette to advance one frame in the original, click the appropriate icon (circled in the palette shown below), or press Page Up on your keyboard. Do the same to advance the clone one frame. Use Movie, Go to Frame to move to a specific frame in either the clone or original. You can also apply special effects such as Effects, Surface Control, Apply Surface Texture and Color Overlay, or Effects, Focus, Glass Distortion (all using Original Luminance), to your new movie using the clone source.

We opened a video clip (shown here in the Frame Stack palette) and a new Frame Stack, both using two layers of Onion Skin to show the position of the diver in both frames. Click on the circled button to advance one frame in the Frame Stacks palette.

Frames 1 and 2 of the Diver video clip (top row), and corresponding frames in the animation (bottom row), painted with the Sharp Chalk variant of Chalk. Tracing paper is active on the bottom-right image.

Creating animated comps. Painter provides a good way to visualize a rough animation. An animatic (a comp of an animation, consisting of keyframe illustrations with movement applied) can be comprised of images drawn in Painter, scanned elements, or numbered PICT files created in Painter, Photoshop or even object-oriented programs that can export PICT files (such as Illustrator). (See "Making an Animated Comp" on page 366, featuring Dewey Reid's illustrations in a demonstration of an animatic technique.) You can also alter individual frames in a movie with Painter's effects or brushes. For a demonstration of frame-by-frame painting, see "Animating an Illustration" on page 363.

Rotoscoping movies. There are numerous ways to rotoscope (paint or apply special effects to movie frames) in Painter. Many of the techniques in this book can be used for rotoscoping—brush work, masking, tonal adjustment or filters, or Effects, Surface Control, Apply Lighting and Apply Surface Texture, or Effects, Focus, Glass Distortion, for example.

Basing an animation on a movie. You can use Painter's Tracing Paper to trace images from a source movie to a clone to create an animation. This feature lets you shoot video and use it as a reference on which to base a path of motion. This process is described in the tip "Using a Video Clip Reference" on page 359.

IMPORTING AND EXPORTING

With a little planning and understanding of file formats, still and animated files can easily be imported into Painter and exported out of Painter to other programs.

Preserving image quality. Because compression can degrade the quality of image files, when you obtain source files to bring into Painter, choose uncompressed animation and video clips. And because quality deteriorates each time you compress (the degree of degradation depends on the compression choice), save your working files without compression until your project is complete. If you plan to composite Painter movies in another application, such as Adobe Premiere, After Effects or Final Cut, save them without compression. For an in-depth explanation of compressors for QuickTime or for AVI, see the *Painter 11 Help.*

Importing multimedia files into Painter. Painter can accept QuickTime and AVI movies from any source, as well as still image PICT files and numbered PICT files exported from PostScript drawing programs, Photoshop and Premiere. To number your PICT files so that they're read in the correct order by Painter, you must use the same number of digits for all the files, and you must number them sequentially, such as "File 000," "File 001," "File 002" and so on. With all files in a single folder, choose File, Open and check the Open Numbered Files option. Select the first numbered file in

Jon Lee of Fox Television used Painter's brushes and effects to progressively modify the logo for the comedy Martin, *creating numbered PICT files for an animated sequence. The modified files were animated on a Quantel HAL.*

your sequence and, when prompted, select the last file. Painter will assemble the files into a Frame Stack.

You can create a mask in a Painter movie and use it in your Frame Stack, or export it within a QuickTime movie to another program such as Premiere or After Effects. To make a movie with a mask, choose File, New, click the Movie button and enter the number of frames desired and click OK. In the New Frame Stack dialog box, choose one of the options with a mask: for instance, 24-bit color with 8-bit Alpha. (You can also make a Frame Stack from a sequence of numbered PICT files in which each file includes its own mask.) To export the movie from Painter as a QuickTime movie and include the mask, choose Save As and select the Save Movie as QuickTime option. When the Compression Settings dialog box appears, in the Compressor section, choose Animation or None from the top pop-up menu to make the mask option available, and then choose Millions of Colors+ in the lower pop-up menu. Click OK.

Highly saturated colors can smear when output to video. Choose Effects, Tonal Control, Video Legal Colors to make the colors in your file compatible with NTSC or PAL video color. In the Preview, press and release the grabber to toggle between the RGB and Video Legal Colors previews; click OK to convert the colors in your file.

Exporting Painter images to film editing applications.
Since most animation work is created to be viewed on monitors and the standard monitor resolution is 72 ppi, set up your Frame Stacks and still image files using that resolution. Most files that use film editing have a 4 x 3 aspect ratio: 160 x 120, 240 x 180, 320 x 240 or 640 x 480 pixels. Television also has a 4 x 3 aspect ratio, but for digital television the pixels are slightly taller than they are wide. Artists and designers who create animation for broadcast usually prepare their files at "D-1 size," 720 x 486 pixels. Digital television uses a ".9" pixel (90% the width of standard square pixels). The narrower pixel causes circles and other objects to be stretched vertically. To create a file for D-1 maintaining the height-to-width ratio (to preserve circles), begin with a 720 x 540-pixel image. When the image is complete, scale it non-proportionally to 720 x 486. This will "crush" the image slightly as it appears on your computer screen, but when it's transferred to digital television it will be in the correct proportions.

QuickTime movie files can be exported from Painter and opened in film editing programs such as Premiere and After Effects. If you're using one of these programs to create an 8-bit color production, you'll save processing time if you start with an 8-bit Frame Stack in Painter: Choose the 8-bit Color System Palette option in the New Frame Stack dialog box (after choosing File, New and naming your movie). If you don't set up your file as 8-bit in Painter, you should consider using Photoshop or Equilibrium DeBabelizer—both offer excellent color-conversion control.

We used a modified photo to create this repeating pattern. To generate seamless, tiled textures for 3D, use any of the commands in the menu of the Patterns palette. Turn to "Exploring Patterns" on page 283 in the beginning of Chapter 8 and to "Creating a Seamless Pattern" on page 288 for more about working with patterns.

Some experienced artists prefer to export their Painter images as PICT files rather than as movies because they can easily remove frames from the sequence if they choose. To export Painter still images to applications such as Premiere and After Effects, or to other platforms, save them as single PICT images or as a series of numbered PICT files. You can include a single mask in a Painter PICT file that can be used in compositing in Premiere or After Effects. See "Animating a Logo," on page 368, for a demonstration of exporting Painter images to another platform.

You can also import Painter-created QuickTime movies and still PICT images into Adobe Director. A QuickTime movie comes in as a single linked Cast Member in the Cast Window, which means it will be stored outside the Director file, keeping file size manageable. 🐾

CREATING TEXTURE MAPS FOR 3D RENDERING

A *texture map*—a flat image applied to the surface of a 3D object—can greatly enhance the realism of rendering in 3D programs such as Bryce, Maya, LightWave 3D, 3ds Max and Strata Studio Pro. Many kinds of images can be used for mapping—scanned photographs, logo artwork or painted textures, for example. 3D artists especially like Painter's capability to imitate colorful, natural textures (such as painted wood grain or foliage). There are several kinds of texture maps: A *color texture map* is an image that's used to apply color to a 3D rendering of an object. Other types of mapping affect other qualities of the surface; for instance, a *bump map* (a two-dimensional representation of an uneven surface), a *transpar-*

ency map (used to define areas of an image that are transparent, such as glass panes in a window) and a *reflectance map* (used to define matte and shiny areas on an object's surface). If you're developing more than one of these texture maps to the same 3D object, you can keep them in register by using Save As or making clones of the same "master" Painter image to keep file dimensions the same. Remember to save your surface maps in PICT or TIFF format so the 3D program will be able to recognize them.

These floating globes were rendered by John Odam in Strata Studio Pro. He created a texture map in Painter using the Wriggle texture from the Wild Textures 2 library (located on the Painter 11 Application folder, in the Extras folder, Paper Textures folder) and applied the texture to the objects as follows: color map (A), bump map (B), reflectance map (C) and transparency map (D). The Studio Pro document size was 416 x 416 pixels; the texture map size was 256 x 256 pixels.

Animating an Illustration

Overview *Create an illustration; open a new movie document; paste the drawing into the movie and onto each frame as a layer; copy an area you want to animate; position it and drop it as a layer into a precise position; advance to a new frame and repeat the pasting, moving and copying process; use brushes to paint on individual frames.*

DONAL JOLLEY

1a

Jolley's finished Painter illustration

1b

Making a selection of the tail and rattle

1c

The Layers palette showing the Tail layer selected

CREATING AN ANIMATION—whether you use Painter or draw on traditional acetate cels—is labor-intensive because of the sheer number of frames required to get smooth motion. But working digitally does have advantages. You can save a lot of time by copying and pasting a single illustration onto multiple frames. Corrections to digital art are easier to make than with conventional methods and, thanks to the Frame Stacks player, you can see results immediately.

To begin Rattle Envy, Donal Jolley painted and animated a comical snake with Painter's brushes. Once the basic animation was complete, Jolley composited some extra layers at a reduced opacity to add the feeling of movement, further enhancing the effect with painted speed blurs.

1 Planning the animation and illustrating. Create an illustration in Painter, choosing a file size no more than a few inches square at 72 ppi (Jolley's illustration was 3 x 3 inches at 72 ppi). Use Painter's brushes to paint just the essential image; you'll be adding the details to each individual frame later. To keep the animation process simple, choose a subject that you won't need to redraw in every frame, such as a character winking an eye. Jolley sketched a whimsical rattlesnake, and then copied the tail area, eyebrows and tongue elements to separate layers so that he could transform them later to create motion in the animation.

After sketching the snake using the Scratchboard Tool variant of Pens, Jolley added color and modeled forms using the Digital Airbrush variant of Airbrushes and the Square Chalk variant of Chalk. Then he added more linework and shadows using the Colored Pencil variant of Colored Pencils and blended color with the Grainy Water variant of Blenders.

He carefully selected each of the areas he planned to animate—three elements in the illustration—the tail area, the eyebrows and the tongue—and pasted copies of them on separate layers as described below. In addition, he created a layer with a copy of only the stationary parts of the snake's body without the tail, eyebrows and tongue, so when he rocked the tail back and forth or moved the parts, the area underneath it would be white.

When you've finished your illustration, make a selection around an area that you want to animate (Jolley used the Lasso tool), press Alt/Option and choose Select, Float to place a copy of it on a new layer. Repeat for any other parts that you want to animate. Also

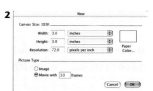

2

Beginning a new Frame Stack, 3 x 3 inches, 72 ppi, with 33 frames

3

Pasting the base illustration into the movie

4a

Clicking the Rewind button to return to Frame 1

4b

Frame 3 with Tracing Paper/Onion Skin (three layers) turned on

4c

The red marker shows that Frame 4 is active.

prepare a layer that includes everything that will not be animated. Now, click on the non-animated layer's name in the Layers section and choose Select, All, and copy it to the clipboard (Ctrl/⌘-Shift-C). It's now ready to be pasted into a movie. Leave the original illustration file open so you can copy elements from it into your movie.

2 Starting a new Frame Stack. To open a new movie file, choose File, New. Choose a small size so Painter will play the movie quickly; then click the Movie Picture Type, and enter enough frames to give you a smooth animation. Jolley created a 3 x 3-inch movie at 72 ppi (that matched the dimensions and resolution of his illustration), with 33 frames to start, though he added more frames as he needed them using Movie, Add Frames, so that his finished animation was 38 frames. Click OK; name and save your movie, and in the New Frame Stack dialog box, choose Jolley's options: three layers of Onion Skin (so you can see three frames back into the stack) and full 24-bit color with an 8-bit alpha.

3 Pasting the illustration into the Frame Stack. Paste the non-animated part of your illustration from the clipboard into the movie file by choosing Edit, Paste in Place. It will come in as a layer. Now use the arrow keys on your keyboard to move it into position. Copy it in its new position, then drop it to the Canvas by choosing Drop from the triangle menu on the right side of the Layers palette. Because a layer sits on top of the entire frame stack, make sure that you've dropped it before you begin the next step. To advance the frame stack one frame, click the Step Forward icon on the Frame Stacks palette (or press the Page Up key on your keyboard). Paste the copied base illustration into a new frame in the same position (press Ctrl/⌘-Shift-V) and drop, repeating the paste and drop sequence for each frame of the movie.

4 Creating movement by offsetting layers. Then, to return to the first frame in the stack, click the Rewind button. Back in your original illustration file, choose the Layer Adjuster tool and select the layer for a part that you want to animate by clicking on its layer name in the Layers palette, and choose Ctrl/⌘-C to copy it. Now activate your frame stack file and choose Ctrl/⌘-Shift-V to paste it into exact position.

The frame stack palette, showing movement in Frames 30–32

5

Frame 29 shows a copy of the tail layer pasted in, rotated and at 58% opacity

6a

Frame 32 showing the Gritty Charcoal smudges and a low-opacity layer

6b

Frame 30 showing a speed blur painted with the Grainy Water variant

So that he would have an unmanipulated copy that he could use later, Jolley made a copy of the pasted tail area layer by Alt/ Option-clicking on it in the image window with the Layer Adjuster tool. Then he hid the copy by shutting the eye icon to the left of its name in the Layers palette.

With the original tail section layer selected, he chose Edit, Free Transform and used the feature to rotate the tail. When you choose Free Transform, an eight-handled bounding box will appear. Now choose the Transform tool and select the Rotate button in the Property Bar. Rotate the layer. Select the Move button in the Property Bar to position the layer and then select the Commit Transform button in the Property Bar to complete the transformation. To bring the layer in its new position into the next frame, store a copy of the layer in the clipboard by pressing Ctrl/⌘-C. Then choose Drop from the triangle menu on the right side of the Layers palette to drop the layer onto the current frame, and go to the next frame by pressing Page Up on your keyboard. Paste the copied illustration again (Ctrl/⌘-V), and use the Layer Adjuster tool to reposition the element in the frame; then drop it.

As you work, look at the Frame Stacks palette to check your progress. You can view previous frames "ghosted" in your main image— much like an animator's light box—by choosing Canvas, Tracing Paper (Ctrl/⌘-T). The number of previous frames displayed is determined by the number of Onion Skin layers you chose when you opened the movie. To change the number of layers, close the file, reopen it, and choose a new number of layers. Use Ctrl/⌘-T to turn the Onion Skin view on and off as you work. Click the Play button to play the animation, and take note of the areas that need to be smoother.

5 Making the animation smoother. After playing the animation, Jolley wanted to make the transition between some of the frames smoother and slower. So he used the tail area layer copy that he had hidden in the Layers palette (in step 4) as a basis to add several more low-opacity layers to a few of the frames. Then he replayed the animation again to check its smoothness. To blur a few of the edges, he used the Just Add Water variant of Blenders on some of the frames.

6 Adding more motion with brushstrokes. Now that he liked the way the animation played, Jolley added to the feeling of motion by painting more noticeable brushstrokes on the tail area. Using the Gritty Charcoal variant of Charcoal, he painted darker smudges on the tail—altering it slightly in each frame. He also added speed blurs by smearing the edges of the snake's tail and the rattle using the Grainy Water variant of Blenders. When the Frame Stack was completed, Jolley saved it as a QuickTime movie. (Turn to "Importing and Exporting" on page 360.) 🖌

Making an Animated Comp

Overview *Set up a layered illustration file; record the movement of a layer using scripts; play the script back into a movie.*

DEWEY REID

1

Reid's original street scene illustration

2a

The topmost layer (with the Canvas hidden) showing the dropped-out area that will reveal the background scene underneath

2b

The Dino character showing the painted mask (left), and with the background dropped out (right)

TO VISUALIZE MOTION in the early stages of creating an animation, Dewey Reid often makes an animated comp (a conceptual illustration with a moving element). Adding motion is a great way to help a client visualize a concept, and it's more exciting than viewing a series of still images. Reid's storyboard, above, shows frames from a movie created by recording a script of a moving layer.

Using scripts and the Record Frames on Playback feature, you can record a layer's movement. When you play the script back, Painter will generate a Frame Stack with the appropriate number of frames, saving you the tedious work of pasting in and moving the character in each frame. After you've made your Frame Stack, convert it into a QuickTime movie (or AVI/VFW on the PC) for easier and faster playback using a freeware utility like Movie Player.

1 Beginning with an illustration. Begin with an image at the size you want your final movie to be. Reid started with a 300 x 173-pixel street scene illustration from his archives.

2 Setting up a layered file. Like conventional animation where characters are drawn on layers of acetate, this animation technique works best when all elements in the image are on separate layers. You may want to create masks for the various elements in separate documents, and then copy and paste them into your main image. (For more about layers and masking, turn to Chapter 6.)

Reid envisioned three "layers" for this comp: a background image (the street scene) in the bottom layer, a copy of the street scene with a portion of the scene removed in the top layer, and a dinosaur positioned between the two street scenes that would move from left to right across the "opening" in the top layer. Reid made a duplicate layer from the Canvas by selecting all and Alt/Option-clicking on the image with the Layer Adjuster tool. To make it easier to see the top layer as you work, hide the Canvas layer by clicking its eye icon shut in the Layers palette. Select the top layer. To erase an area of the layer, choose a Pointed Eraser 7 variant of the Erasers for most of the editing; for removing small areas, you may want to try the

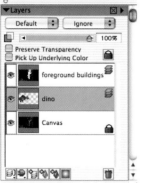

The Dino layer, selected in the Layers palette and in starting position, ready to be moved by the arrow keys

3

Setting up the Script Options to Save Frames on Playback

4

Selecting the Dino script in the Scripts palette

5

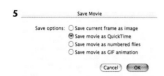

Choosing the QuickTime button in the Save Movie dialog box

1-Pixel Eraser variant. To see the background layer again, click open the eye icon for the Canvas in the Layers palette. You'll see a complete background image, since the lower layer shows through the hole in the top layer.

In a separate file, Reid painted a mask to isolate Dino the dinosaur from the background and turned the mask into a selection by choosing Select, Load Selection. He copied Dino to the clipboard and pasted him into the street scene RIFF file. (An easy way to add a character is to drag an item from the Image Portfolio palette into your image—like the strawberry, the pumpkin or the lollipop, for example.) In the Layers palette, Reid dragged Dino down to a position between the two street scene layers. Using the Layer Adjuster and the arrow keys, Reid positioned the dinosaur so that only the red nose was visible behind the left front building, establishing Dino's starting position in the animation.

3 Recording the script. Click the right triangle on the Scripts palette to open the menu and choose Script Options; check Record Initial State, check Save Frames on Playback and enter a number for Every ¹⁄₁₀ths of a second (Reid chose 5), and click OK. Select the layer that will be moving by clicking on its name in the Layers palette (for Reid, the Dino Layer). Choose Record Script from the menu on the Scripts palette bar (or click the round red button on the front of the Scripts palette). Then hold down an arrow key to move the layer smoothly in the RIFF file. When you have completed the path of motion, choose Stop Recording Script from the Scripts palette menu (or click the Square button) and name the script. Return the character to its starting position by pressing Ctrl/⌘-Z.

4 Playing back the script into the movie. From the pop-up menu on the Scripts palette, choose Playback Script, choose your script from the list in the Apply Script to Movie dialog box and click Playback. When prompted, name your movie a different name than the RIFF file. Click the Save button and Painter will convert your RIFF image to a movie (leaving the original RIFF intact) and will add the movie frames needed. As the movie is generated, you will see the frames accumulating in the Frame Stacks palette. When Painter finishes generating the Frame Stack, turn off visibility for the layers that are above the Canvas by clicking their eye icons in the Layers palette. (If you don't hide the layers, you won't be able to see your movie, which is recorded on the Canvas.) Finally, press the Play button on the Frame Stacks palette to play your movie!

5 Converting the Frame Stack to QuickTime or AVI. To play the movie without having Painter loaded, convert the Frame Stack to QuickTime or AVI format: Choose File, Save As, and when the dialog box appears, choose Save Movie as QT/AVI. Give your movie a new name (such as "Dino movie.qtime"), click Save and in the Compression Settings dialog box, choose from the top pop-up menu (Reid recommends Animation or None).

Animating a Logo

Overview *Make a clone of existing artwork and modify it with Painter's brushes and effects; save it, make another clone and alter the new clone; continue to progressively make and alter clones, restoring the image when needed by pasting a copy of the original logo from the clipboard.*

1

Starting with the existing Martin logo

2a

Lee began manipulating the logo by selecting and scaling a portion of the cloned image (left). Then he selected and inverted a portion of the next clone in the sequence (right).

"IMPROVISATIONAL, FRESH, SPONTANEOUS, and very flexible!" says Jon Lee, Director of Art and Design for Fox Television, when describing his artistic experience with Painter. For the Fox TV program *Martin,* Lee built an animated title sequence like a painting, saving frames at different stages of development. He created a wild, hand-done, organic look to express the comedic street sensibility of the TV show.

Lee created a series of 35 keyframes in Painter (keyframes are the frames that establish essential positions in an animated sequence), eight of which are shown above. When he finished, he moved them from his Macintosh to a lightning-fast Quantel HAL system, where he added dissolves to blend one frame into the next. (Dissolves can also be achieved on the Macintosh desktop in Adobe After Effects or Adobe Premiere.)

1 Beginning with existing art. Lee began by opening the existing *Martin* logo in Painter. He copied and pasted it into a new file measuring 720 x 486 pixels (the aspect ratio of the Quantel HAL) with a black background, and then merged the layers by clicking

2b

Adding colored boxes to Frame 05 with the Rectangular Selection tool and the Effects, Fill command

2c

Using Distorto variants (Distortion) to pull paint onto the background in Frame 07

2d

A motion blur effect applied in 14 (left), and then cloned and filtered in Frame 15

3a

Adding hand lettering and colored brush strokes to a clone of Frame 15 in Frame 16

3b

Restoring readability with a layer in Frame 17

the right triangle on the Layers palette bar, and choosing Drop from the menu.

Choose an image that you want to manipulate in your animated sequence and open it in Painter. Save your file in PICT format, naming it "01." In order for a numbered sequence of files to automatically play in numerical order, the files must be named using the same number of digits, such as 01, 02 . . . 10, 11 and so on.

2 Manipulating progressive clones. After planning how many keyframes you'll need and how the artwork will progress through the frames, begin your manipulation. Clone the first document (File, Clone) and use Painter's tools and special effects on your clone. If you don't like the result of a brushstroke or applied effect, undo it and try something else. When you're satisfied with the result, save the file, name it "02," and make another clone from it. The new clone will become the next canvas for your experimentation. Working quickly and intuitively, Lee treated the logo with a wide variety of brushes, filters and effects from the Effects, Surface Control menu, saving progressive versions in a numbered sequence.

3 Restoring the logo. After a few progressively altered clones, your image may become unrecognizable. To restore the original to some degree, go to your original file, select all and copy, and then paste it into your current clone. Adjust the Opacity using the slider in the Layers palette and drop the layer by choosing Drop from the triangle menu on the right side of the Layers palette bar. Lee used this technique to periodically restore the readability of the type, working the original logo back into the progressive image.

Outputting the Painter files. When Lee was finished with the series of PICT frames, he used Electric Image Projector (a subprogram within Electric Image) to automatically shuttle the files over to the Quantel HAL platform for compositing and output to Beta videotape for broadcast. The workstation is set up with the Quantel HAL and Mac systems side-by-side; they're connected with an Intelligent Resources card that helps convert the digital imagery from one platform to another. Part of the translation process involved converting RGB color to the NTSC video color system for television.

On the HAL, Lee "stretched" the 35 original frames to 90 frames; the HAL added the appropriate number of frames to achieve the dissolves between each pair of keyframes, keeping the animation even and smooth. To create a 10-second title sequence at 30 frames per second, Lee needed 300 frames total. He made a loop of the 90-frame sequence and let it cycle until it filled the necessary frame count. ✍

Automating Movie Effects

Overview *Open a video clip; test a series of effects on a single frame; undo the effects; repeat the effects while recording a script; apply the script to the entire clip.*

CTP / VIDEO: MEDIACOM

1

Frame 1 of the original video clip

2

The Apply Surface Texture and Apply Lighting settings chosen for the movie

3

Choosing Movie, Set Grain Position to create a "live" texture on the movie

4a

The Stop button (left) and the Record button (center)

4b

Detail of effects on Frames 35 and 50

WITH PAINTER'S SCRIPTS FEATURE, you can automate any series of recorded effects and apply them to each frame of an entire movie.

1 Starting with a video clip. Tests will be processed faster if you begin with a small video clip like the one we used—320 x 240 pixels with 67 frames. When you open a video clip (a QuickTime or AVI movie), Painter converts it to a Frame Stack. (When you save the Stack, give it a new name so the original clip isn't replaced.)

2 Testing a series of effects on a frame. Before you test a sequence of effects on a single frame, open General Preferences (Ctrl/⌘-K) and set up multiple Undos so that you can return the clip to its original state. Enter a number of Undos that exceeds the number of effects you plan to use. Choose a rough paper texture (we chose Thick Paint from the Painted Effects 3 library on the *Painter 11 Wow!* CD-ROM) and apply it to Frame 1 in your movie with Effects, Surface Control, Apply Surface Texture, Using Paper (we settled on Amount 22%, Picture 90% and Shine 12%). Next, we added a look of cloud-filtered sunlight by choosing Effects, Surface Control, Apply Lighting. We customized the Slide Lighting, named it "sunlight," and saved it. (See Chapter 8 for more about lighting techniques.) When you've finished testing, undo the effects you applied to Frame 1. (Painter will remember the last settings you used in the dialog boxes.)

> ### HI-RES MOVIE EFFECTS
> If you want to apply effects to a broadcast-quality (640 x 480 pixels) video, use an editing program (such as Final Cut) to create a low-resolution version on which to test a combination of effects. Because it takes a higher setting to get results in a larger file, plan to adjust the settings before treating the larger file.

3 Moving paper grain in the movie. To add subtle interest to your movie, you can change paper grain position on a frame-by-frame basis by choosing Movie, Set Grain Position. We chose the Grain Moves Linearly button and a 2-pixel horizontal movement.

4 Recording and playing back the session on the movie. Begin recording the effects by clicking the Record button in the Scripts palette; then repeat your sequence of effects. When you're finished, click the Stop button. Give your script a descriptive name, and undo your effects again. To apply your script to the movie, choose Movie, Apply Script to Movie. When the dialog box appears, find your new Script in the list, click the Playback button and watch as Painter applies the recorded series of effects to each frame. 🐾

■ **Dewey Reid** of Reid Creative, illustrated the 30-second animation *Yuri the Yak* for *Sesame Street*, a production of Children's Television Workshop. In the story segment, Yuri travels the countryside eating yellow yams and yogurt, and teaching the letter "Y." Reid stresses the importance of preproduction planning in animation. He created the *Yuri the Yak* animation with a total of only 35 drawings (it could have taken hundreds). His background in conventional animation helped him determine which drawings to make, and which to generate by tweening in an animation program, saving time and a lot of work. Reid used Painter to create individual parts of the Yak, such as the head, body and arms. He opened the illustrations in Photoshop and created a mask for each image, and then saved the illustrations as PICT files in a numbered sequence. (He prefers using PICT files rather than QuickTime movies, since PICT files allow higher quality. Also, a sequence of PICT files allows for more flexibility—it's easier to remove a frame or two, if necessary.) He imported the masked files into Adobe After Effects, created animation cycles for each of the Yak parts, and then joined animation cycles together. A virtuoso with effects, Reid completed his artistic vision by adding subtle lighting and texture. He opened the animation in Painter as a Frame Stack. After recording a script of Effects, Surface Control, Apply Lighting and Apply Surface Texture, he chose Movie, Apply Script to Movie to add the effects to the frames.

■ *Snuffy 1 and 2* are two compositional layout illustrations by **Cindy Reid** of Reid Creative for a proposed *Sesame Street* production of Children's Television Workshop. The animation was conceived to accompany the children's song "I Wish I Were Small." In Frame 1, Snuffy (who is normally mammoth-size) becomes small enough to fit into a bird's nest; in Frame 2, small enough to fit in a buttercup. To create both frames Reid shot photos of a bird's nest, a bee, the sky and clouds, foliage and buttercup flowers for "scrap." She scanned the photos into Photoshop and pasted the images onto layers to build two composite files. When the elements were in place, she opened the layered composite file in Painter, where she added painterly brush work to each layer using the Grainy Water variant of Blenders. She added details using a small Sharp Chalk variant (Chalk). When the brush work was complete, she flattened the image by choosing Drop All from the Layers palette bar menu.

■ Art director and animator **John Ryan** employs an expressive approach when creating his animations. Ryan is co-owner of the Dagnabit! animation studio with Joyce Ryan and Robert Pope.

Black & Decker commissioned Dagnabit! to create *Mo Skeeter*, a thirty-second animation spot for their Mosquito Halo product.

Ryan produced all of the original drawings for the Mo Skeeter character using a conventional 4B Derwent sketching pencil on animation bond paper. Then, he scanned the drawings in sequence into Softimage Toonz ink and paint software. Working in Toonz, he cleaned up the images and built mattes (alpha channels), which would help later with compositing the critter into the background scene. Then, Ryan saved the files as a series of sequentially numbered Targa files, and he opened the numbered files in Painter as a Frame Stack.

Using the Soft Camel variant of Watercolor, he added color to the mosquito. As he worked, Ryan paid careful attention to the Grain setting in the Property Bar and the Paper Scale slider in the Papers palette because these settings influence the texture of the brush work. "I'll change the grain size or type of paper every few frames to mimic what would happen if I was actually painting on different sheets of paper and photographing them under a camera," says Ryan. While building the animation, he switched between French Watercolor Paper, Italian Watercolor Paper and Hot Press papers.

Ryan usually keeps a small version of the finished character design to use for reference, to keep the transparency densities in check. He also usually works through the Frame Stack, painting one color at a time whenever possible. Because he created mattes earlier to constrain the paint, he was free to make expressive brushstrokes without worrying about staying within the lines.

■ "I always pepper each painting with several different brushes to keep things alive," says **John Ryan**, who created the illustrations for this 120-second spot for Equifax.

Ryan began the work by drawing with conventional pencil-and-paper on bond paper. Next, he scanned the drawings in sequence into Softimage Toonz ink and paint software, and exported them as a series of numbered Targa files so he could work on them in sequence in Painter.

Working in Painter, he worked on the individual frames, using several Watercolor brushes, including the Wash Camel and Soft Camel variants of Watercolor on Watercolor layers. He chose to paint on the individual frames, instead of using framestacks for this piece, because Watercolor layers can be challenging to combine with framestacks. He painted quickly, and after applying a series of washes, he dropped the layer by choosing Drop from the pop-up menu on the Layers palette. For the next stage of washes, he added a new Watercolor layer and continued to refine his painting.

When the washes were as he liked them, he applied a variety of textures to the images, using the Apply Surface Texture, Using Paper feature and subtle settings.

While building the animation frames, he switched between using Italian Watercolor, French Watercolor and Artists Rough Paper. "If I change texture and size of grain periodically throughout the painting process, it keeps the texture from fighting with the lively quality of the washes of color," says Ryan.

■ An innovative storyboard artist, **Peter Mitchell Rubin** used a variety of Painter's brushes and compositing controls to create the storyboards for the MGM movie *Stargate.* The Giza, Egypt, sequence is shown here. Rubin outputs his illustrations from Painter as numbered PICT files, and then animates them in Adobe Premiere. Rubin's love of drawing shows in his storyboards. He works very quickly, in gray, at 72 ppi. His document size depends on the amount of detail needed, but is usually under 600 pixels wide. The aspect ratio depends upon how the film will be shot. Rubin organizes the thousands of drawings that he creates for a film in folders according to scene. He sets up QuicKeys macros to automate actions wherever possible, automating the processing of all the files in a folder. When Rubin adds other elements to an image, he pastes the element, drops it, and then paints into it to merge it seamlessly into the composition. He also uses Painter's Cloners brushes. For example, he created the texture in Frame 15 (left column, third frame down from top) by photographing the actual set sculpture used in the movie, scanning it and cloning the scan into his drawing.

■ Award-winning concept artist **Ryan Church** creates cinematic environments. He is the Concept Supervisor for *Star Wars III* and a senior art director at Industrial Light and Magic.

Before designing a two-dimensional concept for a scene, Church meets with the director to review the script, and then he does research for the elements he needs. When creating the scenes, he takes advantage of his background in conventional design and painting, and the flexibility of working on the computer with Painter and a Wacom tablet.

Church created *Pirate Catamaran* for his portfolio. He began by making rough sketches in Painter using Pens variants that included the Croquil Pen and Scratchboard Tool. When the elements were as he liked them, he added a new transparent layer and then created a tighter line drawing.

European master artists such as Da Vinci, Michelangelo and Velasquez often worked over a midtone background because it made developing the highlights and shadows easier, and it helped them to create drama. With a similar goal in mind, Church selected the image Canvas and then applied a midtone brown by choosing Effects, Surface Control, Color Overlay, Using Uniform Color and Dye Concentration.

Then, Church developed the ship, water and clouds using translucent brushes that included the Detail Airbrush variant of Airbrushes. When the basic values were laid in, he painted opaque color on areas (including the gold sky) using a modified Square Chalk (Chalk). He increased the Grain setting in the Property Bar so that the brush would cover more grain and thus paint smoother strokes. Then, he smoothed areas of the water and sky using Blenders variants. His expressive blending is most noticeable on

the clouds and in water splashing the front of the boat. For more drama in the sky, Church added richer gold and rust colors with the Square Chalk and then smudged areas using the Diffuse Blur (Blenders).

At this point, he copied the Canvas onto itself by choosing Edit, Copy and then Edit, Paste in Place. Working on the layer, he used the Glow variant of F-X to add light to the windows and to the brightest sunlit areas on the clouds. To refine forms, Church painted translucent strokes on the sails and a few other areas with the Wash variant of Digital Watercolor. Then, he dropped the layer to the Canvas.

For the details, Church added a new, empty layer and then used the Detail Airbrush to refine areas and to paint a few orange accents on the boat. Finally, he deepened the shadows in areas that needed more contrast.

■ Artist and multimedia designer **Ted Larson** created the images on these pages for *The Book of Exodus*, an educational CD-ROM about the Holy Bible.

Larson began *The Burning Bush* by sketching with pen-and-ink on paper to establish a composition. Then, he used Poser and Cinema 4D to design a balanced composition before shooting photos of the model and burning bush. To build the burning bush, Larson photographed a simple wood fire at night, then cut out and pieced together several layers to get the final shape of the fire surrounding the bush. He created the wood limbs of the bush and the desert foreground using Cinema 4D. Next, he created a costume for the model and photographed him against a green screen background.

After the photos and supporting elements were ready, Larson began the compositing process. He opened the individual gray-toned elements in Photoshop and copied and pasted them into a working Photoshop file. Then, he used Photoshop to layer the wood branches behind the fire elements and arranged the robed figure of Moses and the flaming bush as foreground elements. The absence of color is a classic art technique called grisaille. In terms of digital picture making, working in monochrome makes it easier to blend all the elements of a composition that are layered in Photoshop.

Larson wanted a warm, earthy palette for his image, so he gave it a warm sepia base color using Painter's Express in Image command to apply a Sepia gradient to his image. (See "Creating a Sepia-Tone Photo" on page 248 for information about this process. To learn about gradients, see Chapter 2.)

After the image was sepia-toned, Larson clicked the New Layer button on the Layers palette to make a new empty layer for the coloring. To make the layer like a transparent color overlay on top of the sepia image, he set the Composite Method of the layer to Color. Larson wanted to convey a warm Rembrandt-like look, so he chose deep monochromatic earth tones that included golds, rusts and browns to make Moses and the fire a focal point and the main sources of light. To convey the heat of the flame and smoke, Larson applied warm colors using low-opacity Airbrushes, including the Digital Airbrush. Then, he brushed colored transparent washes over his image using Digital Watercolor brushes. Next, he brightened areas of the flame with the Fire and Glow variants of the F-X brush. Larson also used the Glow brush to enhance the lighting around the burning bush and figure of Moses.

■ **Ted Larson** created *The Demise
of Pharoah's Army* for an educational
CD-ROM about the Holy Bible. "In the
Book of Exodus, the Lord told Moses to
part the waters of the Red Sea so the peo-
ple of Israel could pass through in safe-
ty, which they did. The Egyptians pursued
the Israelites and all of Pharoah's army fol-
lowed them into the sea. The water flowed
back and covered the chariots and horse-
men. The entire army had followed the
Israelites into the sea, and not one of them
survived," says Larson.

First, Larson sketched with pen-and-ink
on paper to establish a composition. With
his concept in mind, he created all of the
individual elements as source files that
would be arranged into his composition.
For example, he shot digital photos of the
water on location and of horses, chari-
ots and riders. He hiked to a waterfall and

captured photos to represent the cascad-
ing flood of water from the Red Sea, shot
pictures of Andalusian horses at a local
show and photographed friends in robed
costumes. The chariots were modeled in
Rhino, a 3D program. When the photos
and other elements were ready, he used
Photoshop to mask important items so that
he could easily copy them into a layered
composite file in Painter.

Working in Painter, Larson assembled all of
the elements into a gray-toned compos-
ite image. He opened each source image
and copied and pasted it into his compos-
ite image as a layer, and repositioned ele-
ments to create a balanced composition.
Larson saved the layered image, and then
he duplicated the file and flattened the
copy of the image by choosing Drop All
from the Layers palette menu. Larson pre-
ferred to begin coloring the image with

a warm sepia color, so he used Painter's
Express in Image command to apply a
Sepia gradient to the image.

Next, he clicked the New Layer button on
the Layers palette to make a new emp-
ty layer for the coloring. To make the lay-
er like a transparent color overlay on top
of the sepia image, he set the Composite
Method of the layer to Gel. Larson brushed
subtle colored tints over the image using
Digital Watercolor brushes including the
Simple Water and Spatter Water variants of
Digital Watercolor, using low opacity set-
tings. Then, to intensify the color on the
layer, he used Effects, Tonal Control, Adjust
Colors. He also used Chalk, Charcoal and
Pastels brushes for modeling of the figures
and details. To add depth to the color in
his image, Larson added a new layer and
painted with a small Digital Airbrush vari-
ant of Airbrushes.

12

PRINTING
OPTIONS

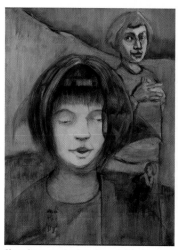

Shoreline, *a mixed media painting by Carol Benioff. Benioff printed the base image on an Iris printer, and then mounted the print on a panel. After painting it with a protective coating of clear shellac, she collaged photos and drawings, overpainting with oil paint and pencil.*

INTRODUCTION

HOW WILL YOU PRESENT YOUR PAINTER ARTWORK to the world? Will it be as a limited-edition digital painting, printed on archival paper by a print studio or service bureau, and then matted, framed and hung on a gallery wall? Or as an illustration in a magazine, where it's part of a page layout that's output direct-to-plate, to be printed on an offset press? Or as a desktop color print? For each of these and other output options, there are things you can do to prepare your Painter file so the output process runs smoothly. We hope the tips that follow will help you as you plan your own project.

COLOR FOR COMMERCIAL PRINTING

Most types of printing involve the use of four-color process, or CMYK (cyan, magenta, yellow, black) inks and dyes. Painter's native color mode is RGB (red, green, blue), which has a larger color gamut (range of colors) than the CMYK color model. (An illustration that compares RGB and CMYK color gamuts is on page 8 in Chapter 1.) Although Painter doesn't let you specify CMYK color mixes as Adobe Photoshop and some other programs do, it does allow you to soft proof your image as CMYK. Select Canvas, Color Proofing Settings, and then choose the CMYK profile in the Simulate Device pop-up menu and choose the Rendering Intent setting desired. Turn the Color Proofing Mode on by choosing Canvas, Color Proofing Mode.

Which RGB Color Space to use in Painter 11. Painter's default RGB color space is sRGB. If your image is going be converted to CMYK for offset printing, the preferred RGB color space is Adobe RGB. In 8-bit mode, they both display 16.7 million colors. But Adobe RGB has a wider gamut of colors that are more evenly spaced within the RGB spectrum. (Note that for the web, sRGB is the preferred RGB

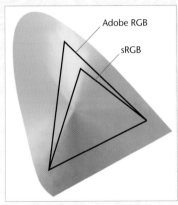

The difference in color gamut between Adobe RGB and sRGB.

The default color profile in Painter 11 is sRGB IEC61966-2-1 noBPC ICC. Save your file in PSD format and check the Embed Profile checkbox. Open the Painter PSD file in Photoshop, choose Edit, Assign Profile and then select Painter's default RGB color profile. The colors will then view the same when moving from Painter to Photoshop.

The default Color Management Settings for Painter 11.

LINE SCREEN AND RESOLUTION

When you're preparing files to be printed on an offset press, use a factor of 1.5 to 2 times the line screen. For example, to accommodate a 150-line screen, set up your file with the dimensions you need at a resolution of 225 to 300 ppi.

color space.) When working on an image that will be printed on an offset press, set your RGB color space to Adobe RGB by choosing Canvas, Color Management Settings, Default RGB Profile and selecting Adobe RGB in the pop-up menu.

Choosing the correct rendering intent. Rendering Intent effects how the color management engine converts colors between color spaces. *Perceptual Intent* preserves the perceived relationship between the whites and blacks in the image with the least amount of clipping. *Relative Colorimetric* moves the white point of the image to relatively match the white of the destination color space, but scales the black absolutely to match the maximum black of the destination color space. (In Photoshop there is the option "Use Black Point Compensation," which gives a good black to use along with the Relative Colorimetric. With this option checked, black in the image is mapped relative to the black in the destination color space, rather than clipped.) Absolute Colorimetric does not allow any remapping of colors. Any colors that are out of range in the image, will be clipped in the destination color space. The best rendering intent to use when converting your image to CMYK from Adobe RGB is Relative Colorimetric with Black Point Compensation activated.

Making CMYK conversions in another program. To convert your finished images to CMYK, open the image in Photoshop or Equilibrium DeBabelizer. These programs provide a selection

PHOTOSHOP TO PAINTER

To ensure consistent viewing of a Photoshop file with an embedded color profile in Painter; set up your Color Management Settings to use the embedded profile of any image that you open. Go to Canvas, Color Management Settings, RGB Images, select Use embedded profile from the drop-down menu. For CYMK images, select Use embedded profile from the Convert CYMK Images drop-down menu. Then, Painter 11 will use the embedded CYMK color profile in the image to convert it to the RGB profile you have chosen in the Color Management Settings.

SOFT PROOFING CMYK

You can soft proof a CMYK conversion of your RGB image on screen in Painter 11. To select the destination CMYK profile and rendering intent for your image, choose Canvas, Color Proof Settings.

Choosing settings for soft proofing an image as it would look printed on a U. S. sheetfed press on uncoated paper.

To turn on and off Color Proofing Mode, choose Canvas, and select Color Proofing Mode.

Laurence Gartel appreciates the vibrant color of Iris printmaking and has printed his Pills *series on a renovated Iris printer. See examples of his* Pills *series on page 322 in the Chapter 8 gallery.*

Bonny Lhotka created the digital file for Day Job *in Painter, by painting with brushes and using layers to composite several source files. Before printing the digital image, Lhotka prepared a one-of-a-kind surface using gold- and ochre-colored acrylics. She painted an abstract design on a nonporous surface to create a monotype that she could transfer to a piece of rag paper using a large roller. After drying and coating the surface of the monoprint with inkjet receiver to help it absorb the ink, she printed the image on top of it using an Encad NovaJet 3. A photograph of the final print is shown above.*

of profiles and settings that allow you to control the conversion between RGB and CYMK color spaces. (A word of caution: There are many variables besides the RGB-to-CMYK conversion that will affect how your image will look—for instance, the color cast of your particular monitor and the color of the paper.) There are several good resources that give detailed explanations of color conversion using Photoshop, including the *Adobe Photoshop User Guide, The Photoshop CS3/CS4 Wow! Book* and *Real World Print Production with Adobe Creative Suite Applications* (these last two are from Peachpit Press). Check with your printer to work out a conversion method.

FINE ART PRINTING AT A SERVICE BUREAU

Many artists prefer to choose a service bureau or master printer who specializes in output for fine art printmaking. Rather than attempt to print an edition in their studio, they rely on fine art service bureaus for high-quality equipment. The expertise needed for a fine art print studio differs greatly from that of a commercial service bureau accustomed to making film and proofs for offset printing. Choose a printer who has experience working with artists and who understands archival and editioning issues. (See Appendix B for a list of service bureaus that specialize in working with artists.)

Large-format inkjet printers. The Iris printer has played an important part in the history of digital printmaking because of its capability of producing images with luminous color and no visible dot, which made the output desirable for fine art printmaking. Unfortunately, Iris printers are no longer being manufactured and parts are difficult to obtain. Cone Editions (Cone Editions still maintains their Iris printer for printing on rag or Japanese papers.) and Nash Editions were among the first printers to pioneer printing techniques using the Iris; they moved back the printing heads, allowing 400-lb. watercolor paper, canvas or metal to be taped onto the drum.

Many more excellent choices are available for the artist who wants to order high-quality archival large-format prints of his or his work from bureaus. Some service bureaus offer prints from the Hewlett-Packard DesignJet 5500uv series using the dye or pigment based UV six-color archival ink set. These 1200 x 600 dpi printers can accept rolled watercolor paper and canvas and can print up to 42 or 60 inches wide. Wilhelm Imaging Research, Inc. reports that the HP DesignJet CP ink systems' UV inks will hold true color for 150+ years. Also available is the HP Z3200, a 1200 by 2400 dpi printer, (24" or 44" wide) using 12-color HP Vivera pigment inks, with a permanence rating from Wilhelm Imaging Research of 200 years plus.

High-quality prints from large-format Epson printers are also available from some service bureaus. The Epson 7900 (24 inches wide) and the 9900 (44 inches wide) are 2880 x 1440 dpi inkjet printers that use 11-color Ultra-Chrome HDR pigment inks. The

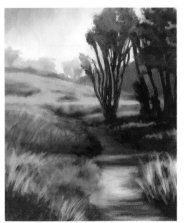

To check color and detail before printing on an Epson 4800 with the Epson Ultrachrome inkset, Cher Threinen-Pendarvis proofed Path to Water, North *as an 8 x 10-inch Fujix Pictrography print. (Fujix Pictrography prints are described in "Outputting to a Digital Positive" on this page.) The final print was made at 15 x 17 inches on Hahnemuhle Watercolor Paper and framed with UV-protective glass.*

A LENTICULAR SERVICE

Some service bureaus specialize in making lenticular signs. (A lenticular is an image that uses a lens to produce stereo 3D or video-motion-like effects as a transition is made from one image to another.) These companies (for instance, Durst Dice America, www.durstdice.com and Lenticular Development, www.lenticulardevelopment.com) can print a lenticular using an artist's files. They also offer proprietary software and training in the process.

Epson 7880 (24 inches wide) and 9880 (44 inches wide) are 2880 x 1440 dpi that also uses eight-color Ultra-Chrome K3™ Vivid Magenta pigment inks. They're capable of producing prints on a wide variety of media, including paper, canvas and posterboard with a thickness of up to 1.5 mm.

Large, high-quality prints from Roland printers are also available at service bureaus. The Roland Hi-Fi Jet Pro II–FJ-540 has a resolution of 1440 dpi, uses an eight-color dye based archival ink set, and can accommodate media widths to 54 inches.

Outputting to a digital positive. Major advances have been made in the area of direct digital photographic prints. In general, the two printing methods discussed below use a laser to image the digital file onto a photographic substrate.

The Cymbolic Sciences LightJet 5000 also uses a laser, imaging the digital file to large-format archival photo paper and creating a continuous-tone print without visible dots, as large as 48 x 96 inches. Because the LightJet 5000 uses 36-bit RGB color, the broad color gamut in these prints is comparable to that in photographic "R" prints. To prepare Painter files for the LightJet 5000, set up your file at its final output size, using a resolution of 150–200 ppi and save it as an uncompressed RGB TIFF file. The LightJet's software incorporates an interpolation algorithm that makes it possible to increase the resolution of the image while retaining its sharpness. Artist and photographer Phillip Charris often outputs his Painter-enhanced photographs using a LightJet 5000, and then carefully strips the print from its backing paper and mounts it on canvas.

Another recommended photo-slick, archival printmaking method is the Durst Lambda system. (Using a laser, it images to archival photo media, such as paper, color negative media or color reversal media.) It's also a 36-bit RGB system. The Durst Lambda 76 can print seamless 32-inch-wide images up to 164 feet long. Durst Lambda prints are reported to be lightfast for a minimum of 50 years. Some artists strip the prints, mount them on canvas, and then finish them with glazes of UV-protectant varnish (such as Golden Varnish, described on page 383) to protect the print from humidity and to add a hand-finished look.

PHOTOGRAPHIC IMAGING OPTIONS

Many new technologies are available for Painter output at graphic arts service bureaus and photo labs that use digital equipment.

Imaging to transparencies using a film recorder. Small- and large-format film recorders are used to image digital files such as Painter artwork to transparencies ranging from 35mm to 16 x 20 inches. For output via a film recorder, images should be in landscape orientation (horizontal) to take advantage of the width of the film.

To avoid *pixelation* (a jaggy, stair-step look caused by lack of sufficient resolution) on transparencies generated by a service bureau's

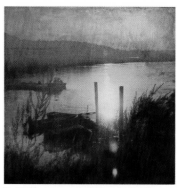

Red Water is a part of the series Fragile Beauty *by Dorothy Simpson Krause. The collage was based on a photograph Krause took near her home. Using an Epson 9600, Krause printed onto Oce FCPLS4 clear film using Ultra Chrome ink. After coating a linen canvas with rabbit-skin glue and letting it set like gelatin, she transferred the image to the surface like a monoprint. To see another image in the series, turn to page 394 in the gallery.*

To see another image in the series, turn to page 394 in the gallery.

INCREASING LONGEVITY

A few fine art printers (notably, Cone Editions and Nash Editions) have developed their own silkscreened coatings to protect Iris prints from fading. The coating merges with the ink on the substrate and doesn't change the appearance of the print. (Some of the ink sets developed for inkjet printers use water-soluble inks. Keep the print dry unless you purposely want to spot or mix the color with water.)

film recorder, here are some guidelines from Chrome Digital in San Diego for creating or sizing your files. Most professional-quality 35 mm film recorders (such as the Solitaire 16 series) use a minimum resolution of 4000 lines; for this resolution, your image should be 4096 x 2732 pixels (about 32 MB). The minimum resolution for 4 x 5-inch transparencies is 8000 lines, requiring an 8192 x 5464-pixel (approximately 165 MB) file. For even more crispness, devices such as the Solitaire 16XPS will image at a resolution of 16000 lines (a 16384 x 10928-pixel file, of approximately 512 MB). Two powerful film recorders used to create 4 x 5-inch, 8 x 10-inch and larger-format transparencies are the LVT (from Light Valve Technology, a subsidiary of Kodak) and the LightJet 2080 (from Cymbolic Sciences, Inc.). Plan to create huge images (up to 15000 x 18000 pixels and approximately 800 MB) to take full advantage of the resolution capabilities of these machines.

Printing your images as Fujichrome. For fine art images, Fujichrome prints made from transparencies offer excellent detail and saturated color, and can be ordered with a high gloss. Prints can be made from 35 mm slides or 4 x 5-inch transparencies. To print to the maximum size of 20 x 24 inches, a 4 x 5 transparency is recommended. The permanency of the Fuji print is 40–50 years, and this can be extended by adding a lamination with an ultraviolet inhibitor. Diane Fenster, a noted fine artist and photographer, has produced much of her digital work as large-format Fujichrome prints.

FINE ART PRINTING IN THE STUDIO

Today, many exciting alternatives are available for artists who want to proof their images, or make fine art prints in their own studio using archival ink sets and papers.

Printing digital images with desktop printers. Desktop inkjet printers can deliver color managed, full color gamut color prints with a little effort. The three main players HP, Canon and Epson offer affordable good quality printers for under $1,000. HP printers (such as the Photosmart Pro B8850 or B9180), Canon printers (such as the Canon PIXMA Pro 9000 Mark II or 9500 Mark II) and Epson printers (Epson Stylus Photo R1900 or R2400) all print up to 13 x 19 inches on a variety of paper weights and finishes. All use archival pigmented ink sets of 8 to 12 cartridges, with one using dye inks (Canon PIXMA Pro 9000 Mark II). Each maker has its own line of enhanced archival papers that have been formulated to give the widest gamut of colors along with the greatest longevity. Some of the printers can handle paper weights up to 1.5mm. Prints made with the pigment based inks will accept any form of other water-based media without smearing or running.

New inks and substrates for desktop art prints. With the increased interest in desktop art-making, new inks and papers keep coming out. Henry Wilhelm has done important research regarding

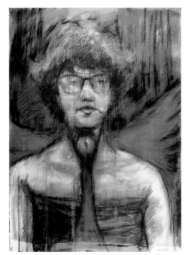

To create this Self-Portrait, *a layered digital print, Carol Benioff combined the same image printed twice. First she photographed a mixed media drawing. Then she opened the image in Photoshop and printed it using an Epson 4000 on to rag paper. Benioff then took a piece of sheer silk organza and taped it to the feeder sheet of paper. Then she printed this same image on the silk. She removed the printed piece of silk from the feeder sheet. As the last step, Benioff used PVA size to laminate the two printed images together. The silk layer gives dimension and shimmer to the final printed image.*

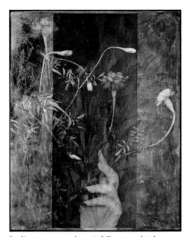

Indigo, *an experimental Fresco print by Bonny Lhotka. To view more of her work, turn to pages 386 and 395.*

the longevity of different ink and substrate combinations. A comparison of color gamut and longevity with the different inks is available through Wilhelm Imaging Research, Inc., on the Web at www.wilhelm-research.com.

New inkjet printers, ink and papers continue to become available. For information about Hewlett-Packard printers, check out www.hp.com; for information about Canon products, visit its company web site at www.canon.com; for information about Epson products, go to their web site at www.epson.com. Also, InkJet Mall (a sister company of Cone Editions) is another good resource for information, inks and their own special formulated black and white and color inks; it's found on the Web at www.inkjetmall.com. Another company that offers archival inksets for desktop printers is Media Street, offering Generations Inks, among many other products, found on the Web at www.mediastreet.com.

Several traditional art papers are now manufactured for digital printmaking—for instance, Inova Fine Art Paper, Moab Entrada Papers, Somerset Enhanced, Concorde Rag, Hahnemuhle's German Etching, William Turner or Photo Rag. These papers are available at Bytes 2 print at www.bytes2print.com or at Cone Editions's InkJet Mall. Now there are many brands of inkjet canvases (Fredix Canvas, Hahnemuhle, and inkAID, to name a few). The canvas comes both in rolls and as sheets. The canvases can be found at BookSmartStudio at www.booksmartstudio.com. Many of the papers and canvases can also be found at traditional art supplies outlets.

Inkjet receivers and protective coatings. To seal custom substrates (like handmade papers), so the ink will hold better, paint thin rabbit skin glue onto the substrate with a brush and dry it thoroughly. Then make your print.

You can treat prints yourself so the color will last much longer. Several protective coatings are available at your local art supply store, from Daniel Smith via mail order, or from Media Street on the Web at www.mediastreet.com. One of our favorites is Golden MSA Varnish with UVLS (soluble with mineral spirits). Use a protective respirator and gloves for the process because the fumes from this coating are *very* toxic. To minimize contact with dangerous airborne particles, dilute the varnish and apply it with a brush. Golden Varnish is also available in a spray can, as is Krylon UV Protectant spray. Make sure to use a protective respirator when using the spray varnishes.

Caring for prints. After a UV-protective coating has been applied, treat your print as you would a watercolor and avoid displaying it in direct sunlight. Frame it using UV-resistant glazing

Bonny Lhotka creates a flexible waterproof decal using artist gloss acrylic medium and inkAID™ White Matte Precoat, which will be removed from a polypropylene carrier sheet printed on the Encad 880 with GO pigment inks. Other printers like the Epson 7500, 7600, 9500, 9600, 10600, Roland and Mutoh, can be used for this process if the polypropylene plate is thin enough. The decal can be glued to canvas, paper or wood using acrylic gel medium. The surface can be sealed with acrylic medium.

(glass or Plexiglas) and preserve air space between the surface of the print and the glazing.

EXPERIMENTAL PRINTMAKING

In today's world of experimental printmaking, anything goes if it works with your vision of the image you're printing. For instance, many different substrates can be used successfully with inkjet printers; among the favorites are archival-quality papers with a high cotton content. Browse your local art store for Saunders handmade watercolor paper, Arches hot-press and cold-press watercolor paper, Rives BFK printmaking papers and Canson drawing and charcoal papers. You can hand-feed these papers into a studio desktop printer, or request that a fine art print studio create an archival digital print with paper that you supply. Fine art print studios often keep special papers in stock—Cone Editions, for instance, has hundreds of fine art papers on hand. Some print studios also print on canvas, film or metal.

Mixing media. Prints from an inkjet printer can be modified with traditional tools and fine art printing processes, such as embossing, intaglio and silkscreen. If you plan to hand-work an inkjet print with media such as pastels, pencils or oil paint, make the print on rag paper with enough body to hold together when you apply the traditional media to the print. Arches 140-pound watercolor paper and Rives heavyweight printmaking paper are good choices.

Overprinting a digital file onto a monotype. To create a surface that she would later use for printing *Day Job* (shown on page 383), Bonny Lhotka created a one-of-a-kind monotype "plate" by applying acrylic paint onto prepared acetate. She laid a piece of rag paper onto the "plate" and used a custom-made 40-lb. roller to transfer the painted image onto the paper. After transferring, she lifted the paper off the "plate" and allowed it to dry. Then she used a Novajet inkjet printer to overprint the digital file on top of the monoprint. She believes that the overprinting process produces a broader range

DIGITAL PRINT AND MONOTYPE

Master printer David Salgado has developed a process that combines monotypes with archival digital prints, using the 39 x 52-inch Mailänder flatbed hand-fed offset press at Trillium Graphics. After a mylar-coated aluminum plate is painted with lithography inks, the plate is mounted on the press and the press roller pulls ink from the plate to transfer to the archival digital print. Depending on the image, seven to ten prints can be pulled in what is known as an *edition variée*. Some artists use an archival digital print as a starting point, while others use cutout pieces of the print as elements in collage work, after which the collage is run through the press. Salgado feels they've just begun to discover the possibilities for this technique. Trillium has printed editions of artwork that have combined archival digital printing, silkscreen, monotype and lithography in edition numbers of 50 and more.

Carol Benioff's monoprint Conversation 2 *began with her photographing two different drawings and her collection of wish bones with a digital SLR camera. She then opened the images in Photoshop, combined the three files into one image, keeping each on its own layer. When she was happy with the composition, she printed the image on Japanese paper using the Epson 4000 printer. Benioff then created a stencil of the two foreground figures. She attached with masking tape the cut-out portion of the stencil to her Plexiglas printing plate. She then rolled up multiple earthtones on a Plexiglas plate, wiping away portions to form the background texture. Then she placed the print on top of the inked Plexiglas plate and ran them through her etching press. She removed the stencil from the plate, cleaned the plate and then attached the half of the stencil with the two figures cut out. Next, Benioff rolled multiple colors of ink over the plate to add the hair color, skin tones and the greens for the dresses. After using rages and brushes to blend the tones of the inks, she placed the paper on the plate and ran them through the press to create the final monoprint.*

of color than is possible if the entire image is composed and printed digitally. The result is a print with more depth.

FINE ART EDITIONS FROM DIGITAL FILES

Some artists scan finished, traditionally created artwork and then print it on an Iris or another high-quality printer (such as an Epson 7900 or a HP Z3200). This process is actually *replicating* an original piece of work. However, when artwork *originates* as a digital file—using a program such as Painter—and is then output to a high-quality printer using an archival inkset, that print itself becomes an original. (Think of your Painter image as a kind of "digital printing plate" stored in your computer.)

Advantages of digital editions. Printing a digital edition has advantages over traditional, limited-run printing methods. Any number of multiple originals can be made from a digital file without loss of quality: The "digital plate" won't deteriorate. Also, the set-up charge for the digital process is usually much less than when an edition is printed conventionally. And while an edition printed with traditional methods needs to be printed all at once, with digital editions, an artist may request prints from the fine art service bureau as needed.

Planning an edition. An edition should be carefully tracked and controlled, just as it would be if printed with traditional methods. It's wise to make a contract between the master printer and artist, stating the type of edition, the number of prints in the edition and that no more prints will be made. When an original is sold, the artist should give the buyer a certificate of authenticity that contains the name of the artist and the print, the date sold, the edition size, the print number, the number of artist proofs, the substrate, and any details of hand-working done on the print. Once the edition is complete, the artist should destroy the digital file, just as the screen would be destroyed after a silkscreen edition.

INKJET PRINT OR GICLÉE?

Some businesses in the fine art printmaking community have adopted the name Giclée (which can be loosely defined as *spray*) when referring to a fine art print made on a high-quality inkjet. Many artists who create their work digitally prefer to leave the Giclée term to the traditional fine art reproduction industry that originated it, thinking that it's important to maintain the distinction between an original print made from a digital painting or collage and a traditional reproduction. This is because each direct digital print has its own unique value and, in fact, is not a reproduction.

CERTIFICATE OF AUTHEN
Title **Swimmers 2**
ImageSize **12 x 18"** Edition # **2/50**
Edition Size **50** Artist Proofs **5**
Date Created **July 1, 1995** Date Purchased **July 14,**
Art Media **Iris print on Rives BFK**
Uniqueness of this Print **This print is hand-worked with pa**
Artist
The above information contains all the information pertaining to this Edition. As or watercolor, do not display this artwork in direct sunlight. Frame it under UPS pl

Detail of a sample certificate of authenticity. You'll find a PDF of this sample certificate on the Painter Wow! *CD-ROM.*

Constructing a Lenticular Work

Overview *Build textured elements and layer them into a collage; set up multiple versions of the file for the lenticular; print the images on an inkjet printer; glaze the wood mat and embellish its surface.*

BONNY LHOTKA

The handmade paper, the letterpress type block with the radio tower image and the tray filled with "lava"

The lava and paper elements with the Apply Surface Texture emboss added

An impression of the photo of sand and foam was embossed into the working image.

"A LENTICULAR IMAGE SUSPENDS TIME, SPACE and movement. It adds a level of ambiguity that engages the viewer's attention," says artist Bonny Lhotka. (A lenticular image is actually several images sliced into strips and alternated. A plastic sheet with a series of parallel lens strips, or lenticules, embossed into one surface is applied over the assemblage, so the different images are seen one at a time, as a viewer moves past the artwork.) To create *Ancient Echo*, Lhotka scanned elements, applied textural effects and then composited the source files into a collage. To build the lenticular, she created eleven variations of the file. As a viewer walks past *Ancient Echo*, the central portion of the image turns to black. At the same time, the background rotates through a rainbow of color shifts and the lower portion appears to recede. You may want to loosely follow Lhotka's process and also experiment with your own effects.

1 Preparing the source images. Lhotka chose squares of painted handmade paper from an earlier project, and a letterpress type block with a radio tower image. For one of the background layers, she built a surface using modeling paste and painted it with acrylics to look like lava. Lhotka scanned and touched up the source images. She created the rings in Painter and colored them with a gradient. To give the rings wire-like dimension, she used Glass Distortion.

2 Adding texture to elements. Lhotka likes to emulate the look of handmade paper, using Painter's Apply Surface Texture feature. For this work, she embossed several elements (including the lava and paper elements) by choosing Effects, Surface Control, Apply Surface Texture Using Image Luminance and subtle settings.

The composite in progress

Printing the images

6a

Preparing the transfer board

6b

Mixing the gel and applying it to the board

Preparing to transfer the mat print

8

Burning the mat surface to crackle the glaze

3 Giving the colored fields texture. She wanted to add texture to more colored areas in the image. So she opened an original photo of beach sand and used Apply Surface Texture, Using Original Luminance to emboss the pattern of the foam and sand into her image. To ensure that the emboss effect will apply to your entire image, choose as your clone source an image with the same pixel dimensions as your working file. Make the image that you want to emboss active, target a layer you want to emboss and designate the clone source by choosing File, Clone Source. Choose Effects, Surface Control, Apply Surface Texture, Using Original Luminance.

4 Assembling the composite. After all the elements were embossed with Apply Surface Texture, Lhotka copied and pasted the elements into Photoshop, where she completed the composite. After the image was finished, she created 11 different color variations of the central portion of the file, which would become the lenticular.

5 Processing and printing the lenticular. For the next step, Lhotka used SuperFlip software. Using a sophisticated mathematical formula, the software sliced the images into linear strips and reassembled them according to the specifications for the lenticular that Lhotka had chosen. When the assemblage was complete, Lhotka printed it on a Roland HiFi. The six-color printer uses a CMYKOG archival pigment set with saturated colors. After the interlaced image was printed, it was aligned with the lens.

6 Setting up a gel transfer for the glaze. When building the fine art mat for the lenticular, Lhotka chose Baltic birch. As she planned to pour liquid onto the wood, to prevent the wood from bowing, she temporarily attached a one-by-three-foot board to the back of the birch mat. To hold the liquid, she placed duct tape around the sides to make a tray. Then she made a gel: She dissolved rabbit skin glue in water, warmed it, and allowed it to return to room temperature, and then added powdered pearlescent pigment to it. She used a strainer to remove undissolved colorant and large bubbles, and then poured the mixture onto the wood.

7 Printing the image for the mat. Lhotka printed the image for the mat on Rexam white film. After printing, she transferred it to the gel on the wood. Placing the printed film on the gel caused the image to transfer immediately without pressure. When the gel dried, the image was permanently bonded into the wood.

8 Embellishing the surface of the mat. To give the glaze a crackled effect, Lhotka used a torch to burn the surface of the mat after it was dry. This caused the glue to bubble, creating a crackled glaze surface. The completed presentation of *Ancient Echo* measures 34 x 28 inches; the 28 x 22-inch center of the image with the 3D animated lenticular sits inside a ½-inch recession on the glazed mat board.

Making a Color Managed Art Print

Overview *Scan a gouache painting and small drawings; create a composite file in Photoshop; use an off-the-shelf ICC profile for printing using Epson's UltraChrome inks on Epson's Smooth Fine Art paper; overprint etching on the digital print.*

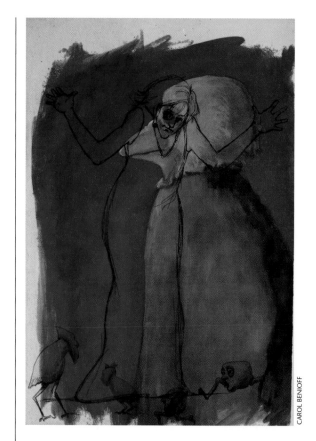

CAROL BENIOFF

Selecting the white point, gamma and ambient lighting in MonacoOPTIX by X-rite.

Final measurements for Black Luminance and White Luminance prior to creating monitor profile

WHEN PRINTING ON DIFFERENT PAPERS or using different inks, accurate printing profiles, or custom printing profiles, allow you to obtain more accurate color. Artist Carol Benioff has developed a useful color management system that includes monitor calibration and using Epson's own printing profiles, or custom ICC profiles. For the mixed media print *Nocturnal Questions*, Benioff combined one etching, a gouache painting, and four small drawings to create the final image. She printed the layered composite file of the gouache painting and four drawings on her Epson 4000 printer using Ultra-Chrome inks on a roll of Epson's Smooth Fine Art paper. Then, Benioff soaked the digital print in water to soften the paper and blotted the excess water. After inking up the etching plate, she placed the plate on the press bed, overlaid the damp print and then ran the paper through the press to create the final mixed media print.

COLOR MANAGEMENT

Color management is part science and part art. Some factors can be measured; some are subjective. CMM or Color Management Modules (ColorSync on the Macintosh, ICM on Windows) perform the calculations between the color profiles (the numerical description of the color) of your devices, such as your monitor and printer. For more information check out *Real World Color Management* by Bruce Fraser, Chris Murphy and Fred Bunting, published by Peachpit Press.

2c

Benioff's custom color setup in Photoshop CS3

3a

Choosing Leave as is (don't color manage) in the Missing Profile dialog in Photoshop

3b

Target file provided by Chromix, which Benioff printed on Lana Gravure paper

4

To preview the custom print ICC profile, Benioff used Photoshop custom soft proof setup. Preview is on (top), and off (bottom).

1 Managing color. To ensure that her monitor displays colors accurately, Benioff calibrated her monitor using MonacoOPTIX from X-rite, which includes both software and a sensor. (The calibration sets the white point, the black point, the color temperature and the dynamic range, or gamma of each monitor and then generates an ICC profile based on the calibration.) To enable Color Management in Photoshop CS3, choose Photoshop, Colors Settings, and in Photoshop CS4, choose Edit, Color Settings, More Options. Then, select one of the preset color management settings or create your own custom settings. Make sure to use the Color Management Policies to display a warning dialog box when you open the file with no embedded color profile or when the file has a color profile different from your own color working space.

3 Using ICC print profiles. Because Benioff was going to print on an Epson paper, she was able to use the ICC print profile for the Smooth Fine Art paper for the Epson 4000. For other work, she often prints on regular fine art paper such as Lana Gravure. In order to achieve color-accurate prints, Benioff purchased custom ICC print profiles from Chromix. Chromix is a third-party company that specializes in color management and custom profiles, and that provides a downloadable profiling application called Chromix Color-Valet Client, that walks you through all the steps and provides the profile target files needed (www.chromix.com). Open the profile target file provided in Photoshop. In the Missing Profile dialog box, select Leave as is (don't color manage). Print the file on the paper you wish to profile using non-color–managed settings. Make a note of the print settings, including the resolution, rendering intent and media type chosen. (The Media Type setting tells the printer how much ink to put down, not the color mix.) Make sure to use these same settings when printing with the custom profile. Next, inspect the printout to make sure you have a clean print and that all parts of the file have printed. Benioff sent the print to Chromix, and the company sent her a custom profile via e-mail. In OS X for all users, load the custom ICC profile into Library, ColorSync, Profiles; for a single user, choose User, Library, ColorSync, Profiles. In Windows, choose Program Files, Common Files, Adobe, Color, Profiles.

4 Making a soft proof. In Photoshop, Benioff chose View, Proof Setup and Custom, and then she selected her printing profile: Pro4000 Smooth Fine Art.icc. For Rendering Intent she chose Relative Colorimetric (this adjusts the white point in the image, relative to the ICC profile chosen). Benioff did not check Simulate Paper White. She found that it does not correctly simulate the way inkjet ink sits on her paper. Next, she chose Proof Colors from the View menu to view the results. The "soft" (onscreen) proof is only an approximation. Benioff recommends keeping in mind these critical factors: the effects of your lighting, ambient light and angle of viewing on your perception of the color.

Print with Preview dialog box for Photoshop CS3 using the Epson ICC print profile

5b

The Epson 4000 Print dialog boxes for Printer and Print Presets (top), Print Settings (middle) and Color Management (bottom)

5c

Detail of the archival print on Epson Smooth Fine Art paper

5 Printing from the desktop. Benioff opened her final image in Photoshop. In Photoshop's Print dialog box, she chose Page Setup, and then chose the paper dimensions and orientation for the Smooth Fine Art paper roll. Choosing Color Management in the right drop-down menu, she then chose Photoshop Manages Color in the Color Handling the drop-down menu. For Print Profile she selected the Epson ICC profile Pro4000 Fine Art.icc, the Rendering Intent as Relative Colorimetric, with Black Point compensation on. Next she selected Print, which opened the Epson Print Driver settings dialog box, and she chose her print preset of SmoothFineRoll. The settings in this preset are the following: under Print Settings pick Smooth Fine Art Paper (The Media Type setting tells the printer how much ink to put down. For glossy surfaces, the printer puts down less ink; for smooth soft papers, it puts down more ink), select Advance Settings and choose Print Quality Super fine - 1400 dpi, High Speed, Finest Detail. In the Color Management section of the Epson 4000 Print dialog box, select No Color Adjustment. If you were to enable Color Management (at the printer driver level), there would be two layers of color management (one in Photoshop's Print settings and a second one in the printer driver settings), which would distort the colors in the print.

If you are using a custom ICC printing profile, the procedure is the same; in Photoshop's Print dialog box under Print Profile, select your custom profile, and select the same Rendering Intent and Print Settings as used when printing the target file.

Remember that each paper absorbs ink from your printer differently, just like any other painting or drawing medium. Using color management will allow you to view and print your images on a variety of papers with consistent color acuity. 🖌

HOW DOES A PROFILE WORK?

An ICC color profile is a look-up table of color values that control a device such as a monitor, printer, scanner, or digital camera and its associated CIELAB color value. (CIELAB is the agreed-upon color values for device-independent color, created by the International Consortium on Color, or ICC.) The ICC color profile describes in numbers a particular device's color behavior. The profile for your monitor speaks to the profile for your printer through your computer's CMM (Color Management Module). On the Macintosh the CMM is ColorSync; on a PC it is called ICM or Image Color Management. There are different flavors of CMM; for instance, Apple, Adobe, Heidelberg, Agfa and Kodak. Make sure to select one of these on the OS level to make sure the color management calculations for all applications will be consistent for device-independent color. Color management makes it possible for your monitor and printer to speak the same color language.

■ **Carol Benioff** layered multiple print-making, painting and drawing techniques in her piece titled *Singular Notion*.

Benioff began by making a ghost print from an earlier monoprint. (A ghost is a second print from a monoprint plate, as shown above.) She chose a watercolor study and shot a digital photo, then opened the photograph, shown above center, in Photoshop and printed it with her Epson 4000 onto Japanese printmaking paper using a custom print profile.

She used the photo of the same watercolor as the basis of the lithography plate. She opened the image in Photoshop, converted it to grayscale, removed some of the shadows and adjusted its tones. Benioff then printed this image using a black-and-white laser printer and printing onto a polyester

lithography plate, which is shown on the above right. Polyester plates can be imaged using a laser printer, a photo copier or drawn on by hand with a ballpoint pen.

For the final print, Benioff rolled up the lithography plate and printed the small image multiple times onto small sheets of translucent Japanese silk tissue. After the prints dried, she took the lithography

prints and the digital print and arranged them over the ghost monoprint. Then, she brushed a thin layer of PVA Size over the prints to glue them together.

When the glue was dry, she applied thin washes of watercolor and drew fine colored pencil lines on the final print to enhance the ghost image and to help synthesize the layers of images.

■ Artist **Mary Ann Rolfe** was commissioned to create these two translucent window panels for the home of Kris and Hans Campestrini. Rolfe built each panel with a front and back layer with different imagery on each panel. The layering of the imagery adds depth and movement to the panels. Rolfe developed her images in Painter and transferred the images to translucent panels using her unique transfer process.

To build the color scheme for this project, Rolfe took digital photographs of the interior of the Campestrini's home. She opened several of the photographs in Painter, cut and pasted elements from each of the

photographs into a new file, and saved the new file. Rolfe built a custom color set from the new composite image that matched the color scheme of her client's home. Rolfe loves Painter's capability to easily generate custom color sets that she can use when painting a commission.

Working in Painter, Rolfe opened the scans of the motif drawings that she planned to incorporate into the panels. She painted on top of the scanned drawings with variants of the Oil Pastels using the colors from the custom color set. To add depth, Rolfe applied surface texture by choosing Effects, Surface Control, Apply Surface

Texture and a shadow by choosing Effects, Objects, Create Drop Shadow. For more detailed information about Rolfe's process, see "Creating Art for Glass Sculpture" in Chapter 8. For the final piece, Rolfe arranged the painted motifs in two new Painter files, and then filled the background with custom Gradient fills using her custom Color Set.

To complete the window panels, Rolfe used an Epson 2000P to print the two panels onto a speciality paper that she uses in her unique transfer process. For more information about her printing process visit Rolfe's Web site at www.digitalstretch.com.

■ **Elizabeth Sher's** book *Nuggets* is based on drawings made during her residency at New Pacific Studio in New Zealand, combined with text gleaned from local news items, podcasts of the PBS programs *Fresh Air* and *This American Life*, and quotations from the book *The Conversations: Interviews With Sixteen Contemporary Artists* by Richard Whittaker.

The corresponding "nugget" for the forest image is from the is from Whittaker's interview with Iren Pijoan, included in his book *The Conversations*. The text reads, "The mind is like a still forest pond. If you

sit there quietly, all manner of strange and beautiful animals will show themselves."

Sher began the image above by photographing the two small sculptures, a girl on a swing and a ceramic horse. Next, she opened a new file in Painter, and with each element on its own layer, she painted the pond and the multiple groups of green stripes using Digital Watercolor brushes. Using the Sumi-e brushes, Sher painted the eels in the pond.

To continue assembling the collage, Sher opened her photograph of the two sculptures and copied them onto the bottom

layer of the image. Then, she created drop shadows for the two sculptures. To add cohesive lighting to the layers, she used Painter's Apply Lighting effect on each of the layers in the image.

All 25 double-sided pages of this book were printed on Moab Entrada Rag paper on an Epson 4800 printer. The book was assembled and bound by the bookbinder John De Merritt of Emeryville, California. The book opens vertically on one side and horizontally from the other. The title is embossed with gold lettering. Sher produced an edition of four books.

■ With her series *Fragile Beauty*, fine artist **Dorothy Simpson Krause** transports us to treasured places where the impact of human existence has been kept at bay.

For the digital collage *Reflections*, a member of the *Fragile Beauty* series, Krause began by taking a digital photograph of a pond near her home. Then, using her computer, she combined the photograph with a scan of a landscape painting that she had painted using conventional oil paint. Krause planned to print *Reflections* on aluminum. So she prepared a sheet of aluminum for printing by painting it with one coat of inkAID adhesive and two coats of inkAID clear gloss precoat. (The applications of inkAID allow the printing inks to adhere to the metal substrate.) When the coating was complete, Krause printed the image onto the precoated aluminum using an Epson 9600 with the Epson Ultra-Chrome inkset. Reflections is an Edition of four; the final print on aluminum measures 24 x 24 inches.

■ *Weiman Canal* is a member of Digital Atelier artist **Bonny Lhotka's** Reflective Visions series.

Lhotka created *Weiman Canal* using digital photographs and scans of found objects. Then, she placed the digital file with the found objects over the photograph of the surface image. She lightened areas of the digital file and removed portions of the image so that the bright aluminum substrate she planned to use would blend into the image. Water and other luminous imagery look particularly beautiful when printed on aluminum.

Lhotka printed *Weiman Canal* using an Epson 9600 inkjet printer on simple aluminum flashing, which can be purchased at a hardware store. To prepare the substrate, she used Soft Scrub cleanser to remove the non-corrosive coating and tri-sodium phosphate to degrease the metal. Then, she roughed up the surface using 40-grit sandpaper. Next, she applied a layer of DASS inkjet precoat, which enables the ink to adhere to the metal.

After drying, the print can be treated with a UV protective coating such as Krylon Crystal Clear spray or Golden's MSA Varnish.

■ Digital Atelier artist **Karin Schminke** celebrates an interplay of shape and texture that is inspired by the natural world in her series *Form Inform. Joy,* an image from her series, is shown above.

Schminke began *Joy* by creating a watercolor painting and colored-pencil drawings using conventional materials. When the painting and drawings were complete, she scanned them on a Microtek flatbed scanner. She opened a new file, and then copied and pasted the scans into the working file to build a layered collage.

Using an Epson Stylus Pro 9600 printer with Ultrachrome inks, she printed her layered image onto a black rag paper, Arches by Magic, which is precoated for inkjet printing. So that she could paint with conventional acrylics on her print, she applied inkAID Semi Gloss precoat. Then, she dried the surface.

She assembled a second combination of drawings to add another layer of imagery to her print. Schminke fed the precoated print into the Epson Stylus 9600 and printed it using the second combination of drawn forms.

■ For *Night Highway 4,* artist **Helen Golden** achieves intriguing abstract color spaces and textures. "There was a time when I frequently found myself riding in a car on the highway at night and I became fascinated with the visual richness of the various light sources," Golden says.

To capture the transient information she saw, Golden used a small digital camera that she set to make a long exposure. As she took the pictures, she wiggled and waved the camera. Back at the studio, she chose a photograph and opened it in Photoshop, where she extracted hidden details using the Photoshop plug-in LucisArt. As she explored a direction for the composition, she used Painter, Photoshop and LucisArt.

She copied the extracted elements to layers and composited them using several blending modes, including Multiply, Exclusion, Difference, Soft Light and Color. Next, she opened her Photoshop file in Painter and used Effects, Surface Control, Apply Surface Texture, using Image Luminance to add dimension and texture to the shapes.

Golden printed *Night Highway* as an edition of 50 prints using a Hewlett-Packard DesignJet Z3100PS printer with Vivera inks onto HP Canvas. After printing, the canvas print was attached to stretcher bars and the work was coated with a UV filtering varnish for protection.

■ "For someone like me, who has both a painting studio and a digital studio, drawing with line is one of the options that bridges the gaps between media," says artist **James Faure Walker**. "What excites me is the continuing convergence of painting, photography and digital media."

Via Dora was inspired by a small villa in Croatia, hidden away on the coast. Walker shot photos of the gardens and projected them onto conventional canvas. He transcribed the pattern in paint and then scanned the canvas to bring the imagery back into the digital process so he could continue working on the image in Painter.

Walker used a variety of Painter brushes and media during the process, including hand-drawn patterns applied with the Pattern Pen brush and brushwork drawn with Sumi-e brushes. For more contrast, and as a final touch, the white form floating in the center was copied from another painting and pasted into *Via Dora*.

Walker printed *Via Dora* using an Epson Stylus Pro 4000 using Epson Smooth Fine Art paper.

■ *Take Me There* was created by **James Faure Walker** and was inspired by his interest in astronomy and the modernist painter Wassily Kandinsky.

Walker began by using the Oval Shape tool to draw an image of circles in Painter. As he worked, he projected the image onto canvas on his painting wall. He moved and resized the arrangement of circles and drew directly onto the eight-foot–wide projected image using a simple network of lines and a custom Pattern Pen brush. When the image was as he liked it, he copied and reduced it in size by about 20%

and repeated it, overlaying the original circle design. Pieces of masking tape, drill holes and scraps of paint were attached to the wall, as it was one of his painting walls. Walker incorporated inspiration from tape and scraps of paint on the wall into his painting. He photographed the projected image to capture the elements on the wall and then opened this image in Painter. Working in Painter, he experimented with the motifs, turning and resizing them. Then, he overlaid this image as a layer on top of the painting using the Difference Composite Method in the Layers palette.

Walker uses Painter to paint digitally every day and also uses conventional paint every day. He enjoys exploring brushmarks, shapes and effects for hours on end.

Walker printed *Take Me There* in his studio on an Epson Stylus Pro 4000 using the Ultrachrome ink set on top of Epson Smooth Fine Art paper. For exhibitions at museums and commissions, he worked with the London Print Studio fine art atelier to order large fine art prints of the image.

PHOTO: LIBBY BLUNTZER

PHOTO: LIBBY BLUNTZER

■ With a background as a psychiatric counselor and as an experimental artist, **Kramer Mitchell** is interested in the field of art therapy, in which art techniques are used to work toward healing and personal development.

"Painter, Photoshop and my Epson 2200 printer with its archival inks have allowed me to bring my various interests together in this latest form of experimental art," says Mitchell.

Historically, dolls have been used for healing, prayer, magic, fertility, as fetishes, for personal development and more. By drawing from the rich history of dolls, Mitchell found a vehicle to express her artistic passion.

For *Untitled Frac Talisman Doll 1* (above left), Mitchell began by creating a fractal fabric pattern in Painter. (For detailed information about creating patterns, see Chapter 8.) Then, she sketched the design for the doll. After printing the design, she traced it on the back side of the fractal fabric. Then, she cut it out, sewed it by hand, stuffed it with polyfill and embellished it with beaded embroidery.

To begin *Untitled Art Doll* (above right), Mitchell painted the head and face using a variety of the Artists' Oils brushes. Then, she sketched a design for the body of the doll. She resized the head and face in Painter and printed it onto a fabric sheet

that had an adhesive backing. When the design for the body shape was complete, she printed it and then traced it onto a piece of interesting fabric. She cut out the doll, sewed it on her sewing machine and then stuffed it. As a final touch, she added the nose bead and emu feather.

To print her fabric designs, Mitchell used an Epson 2200 and specially prepared materials that she purchased at craft stores and quilting shops. Mitchell also recommends the Dharma Trading Company as an excellent resource for specially prepared materials. Find them on the Web at www.dharmatrading.com.

■ *Cottonwoods* by **Richard Noble** is the first collage in a series in which he incorporates Painter brushwork with the paper, pen-and-ink and masking tape.

To prepare for the works, Noble gathered sketchbook paper, a brown paper bag, blue construction paper, tracing paper, masking tape, pastels, acrylics and pencils. Then he took reference photos of the cottonwood trees along Idaho rivers in the fall season. He captured the trees from different angles, shooting both distance and close up shots of the trees and their leaves.

Next, Noble created a composition using several of the photos and printed it on paper using his Epson 4800. He taped the print to the window (as a makeshift light

table), taped tracing paper to the print and traced the images. Using pencil, he transferred parts of the image from the tracing paper to the papers he was planing to use in each section—the sketchbook paper, brown paper bag and sheet of construction paper. When the sketches had been transferred onto each paper he worked with paint and pencils on the paper.

Then he recomposed the collage by lining up the individual paper pieces and taping them together with masking tape. Once the assembly was complete, he was ready to go back into the world of virtual paint. He placed the collage in the scanner and scanned it at a high resolution to capture all the details of the paper and the edges.

Next Noble resized the original digital photo composition to line up with the scan of the conventional collage. Then he opened both the collage and original composition in Painter and used the original photo composition as a clone source with the scan as the destination (File, Clone Source). As a final step, Noble used Painter's brushes to paint detail and texture to unify the composition. When he had completed the collage, it was difficult to identify which pencil lines and brushstrokes were created with conventional art tools and which were created with Painter. Noble printed *Cottonwoods* using his 8-color Epson 4800 printer and Epson Ultrachrome inks on archival paper.

Appendix A
Vendor Information

IMAGE COLLECTIONS

These vendors provided photos or video clips from their collections for the Painter 11 Wow! *CD-ROM in the back of this book.*

Artbeats, Inc.
Myrtle Creek, OR
800-444-9392
541-863-4547 fax
www.artbeats.com

Corbis Images
Bellevue, WA
800-260-0444
301-342-1501 fax
www.corbis.com

Digital Wisdom, Inc.
Tappahannock, VA
800-800-8560
www.digiwis.com

Image Farm, Inc.
Toronto, ON, Canada
800-438-3276
416-504-4163 fax
www.imagefarm.com

Mediacom
Richmond, VA
804-560-9200
804-560-4370 fax

Getty Images / PhotoDisc
Seattle, WA
800-462-4379
www.gettyimages.com
www.photodisc.com

PhotoSpin
100 Oceangate Blvd.
Suite 1200
Long Beach, CA 90802
888-246-1313
www.photospin.com

Visual Concept Entertainment
661-299-5605
http://www.vce.com

HARDWARE

Apple Computer, Inc.
877-412-7753

Color Vision / *Color Management*
www.colorvision.com

Epson America / *Desktop color printers*
Torrance, CA
800-289-3776
800-873-7766
www.epson.com

Encad, Inc. / *Desktop color printers*
www.encadstore.com

Hewlett-Packard / *Desktop color printers*
San Diego, CA
800-752-0900
www.hp.com

Wacom Technology Corporation
Drawing tablets, Cintiq Interactive Pen Display
Vancouver, WA
800-922-6613
360-896-9833
sales@wacom.com

SOFTWARE

Adobe Systems / *Illustrator, InDesign, Photoshop*
San Jose, CA
800-833-6687

Auto F/X / *Photographic Edges / Lighting Effects*
Birmingham, AL
205-980-0056
205-980-1121 fax
www.autofx.com

Corel / *Corel Painter, Painter Essentials, CorelDraw*
Ottawa, ON, Canada
877-534-4278
www.corel.com

INKS AND SUBSTRATES

Charrette Corporation /
Substrates and Inks
www.charrette.com
www.pitman.com

Digital Art Supplies / *Substrates and Inks*
877-534-4278
www.digitalartsupplies.com

Epson / *Substrates and Inks*
www.epson.com

Hewlett-Packard / *Substrates and Inks*
www.hp.com

ilab Corporation, Inc. / *Inks for Epson, Iris and Novaget*
Atkinson, NH
603-362-4190
603-362-4191 fax
www.ilabcorp.com

InkjetMall / *Substrates and Inks*
Bradford, VT
802-222-4415
802-222-3334 fax

Luminos Photo Corporation / LumiJet
Inks for Epson and other printers
Yonkers, NY
inkjetart.com

Media Street / *Substrates and Inks*
www.mediastreet.com

MIS Associates, Inc / *Substrates and Inks*
248-690-7612
248-690-7618 fax
www.inksupply.com

Wilhelm Imaging Research, Inc. / *Ink and paper longevity information*
Grinnell, IA
515-236-4222 fax
www.wilhelm-research.com

Appendix B
Fine Art Output Suppliers

These bureaus specialize in making large-format prints for fine artists. More are listed on the Painter 11 Wow! CD-ROM.

Cone Editions Press / *Fine Art Prints*
East Topsham, VT
802-439-5751
www.cone-editions.com

Chrome Digital / *Fujix Pictrography prints; film recorder output*
858-452-1588

Durst USA / *Lenticular prints*
Tuxedo, NY
914-351-2677

Lenticular Products / *Lenticular prints*
www.lenticulardevelopement.com

Trillium Press / *Fine art prints; monotypes; silk screen*
Brisbane, CA
415-468-8166
415-468-0721 fax

Appendix C
Reference Materials

Here's a sampling of recommended references for both traditional and digital art forms.

ART BOOKS

Art Through the Ages
Fifth Edition
Revised by Horst de la Croix and Richard G. Tansey
Harcourt, Brace and World, Inc.
New York, Chicago, San Francisco, and Atlanta

The Art of Color
Johannes Itten
Van Nostrand Reinhold
New York

Drawing Lessons from the Great Masters
Robert Beverly Hale
Watson-Guptill Publications
New York

Mainstreams of Modern Art
John Canaday
Holt, Reinhart and Winston
New York

Printmaking
Gabor Peterdi
The Macmillan Company
New York
Collier-Macmillan Ltd.
London

The Natural Way to Draw
Kimon Nicolaïdes
Houghton Mifflin Company
Boston

The Photographer's Handbook
John Hedgecoe
Alfred A. Knopf
New York

TypeWise
Kit Hinrichs with Delphine Hirasura
North Light Books
Cincinnati, Ohio

COMPUTER IMAGERY BOOKS

Digital Character Design and Painting
Don Seegmiller
Charles River Media
Hingham, MA

The Illustrator CS Wow! Book
Sharon Steuer
Peachpit Press
Berkeley, CA

The Photoshop and Painter Artist Tablet Book
Creative Techniques in Digital Painting
Cher Threinen-Pendarvis
Peachpit Press
Berkeley, CA

Beyond Digital Photography
Creating Fine Art with Photoshop and Painter
Cher Threinen-Pendarvis and Donal Jolley
Peachpit Press
Berkeley, CA

The Photoshop CS/CS2 Wow! Book
Linnea Dayton and Cristen Gillespie
Peachpit Press
Berkeley, CA

Real World Color Management
Bruce Fraser, Fred Bunting and Chris Murphy
Peachpit Press
Berkeley, CA

PUBLICATIONS

Communication Arts
Menlo Park, CA
www.commarts.com

How
Design Ideas at Work
New York, NY
www.howdesign.com

Graphis
New York, NY
www.graphis.com

Official Corel® Painter™ Magazine
Bournemouth, UK
Tel: +44 (0) 1202 586200
www.paintermagazine.co.uk

Print
New York, NY
www.printmag.com

Appendix D
Contributing
Artists

Nick Anderson
Houston, TX
www.chron.com/nick

Ben Barbante
San Francisco, CA
415-657-9844

Michael Bast
Brookfield, IL
708-485-4853
michael.bast@sbc.global.net

Carol Benioff
Oakland, CA
510-533-9987
carol@carolbenioff.com
www.carolbenioff.com

Richard Biever
Evansville, IN
812-437-9308

Kathleen Blavatt
San Diego, CA
619-222-0057

Ray Blavatt
San Diego, CA
619-222-0057

Athos Boncompagni
Arezzo, Italy
+39 0575 299177
athos@athosboncompagni.com
www.athosboncompagni.com

Martha Jane Bradford
Brookline, MA
martha@marthavista.com
www.marthavista.com

Jinny Brown
Cupertino, CA
jinbrown@pixelallery.com
www.pixelalley.com

Marc Brown
Denver, CO

Jeff Burke
Culver City, CA
310-837-9900

Michael Campbell
San Diego, CA
858-578-8252
www.michaelcampbell.com

Steve Campbell
415-668-5826
steve_campbell@mindspring.com

Karen Carr
www.karencarr.com

Phillip Charris
San Juan Capistrano, CA
949-496-3330

Ryan Church
www.ryanchurch.com

James D'Avanzo
(11/2/73–5/28/96)
Family of James D'Avanzo
Fairfield, CT
203-255-6822

Linda Davick
Knoxville, TN
615-546-1020

Michela Del Degan
40131 Bologna, Italy
+31-339-58-99-741
mdegan@infinito.it
www.micheladeldegan.com

John Derry
Omaha, NE
derry@pixlart.com

Matt Dineen
Santa Cruz, CA

John Dismukes
949-888-9911
www.dismukes.com

Mary Envall
Vista, CA
760-727-8995

John Fretz
Seattle, WA
206-623-1931

Laurence Gartel
Boca Raton, FL
561-477-1100
gartel@comcast.net
gartel@aol.com

Brian Gartside
beeegeee@clearnet.nz
www.gartside.info

Helen Golden
Palo Alto, CA
650-494-3461
hsgolden@aol.com

Steven Gordon
Madison, AL
256-772-0022
StevenGordon@cartagram.com

Ileana Frometa Grillo
949-494-3454
ileana@ileanaspage.com
www.ileanaspage.com

Bill Hall
www.billhall.com

Kathy Hammon
bouchedoree@wanadoo.fr

Fiona Hawthorne
+44 (0)20-8968-8889
fionahawthorne@beeb.net

Philip Howe
Snohomish, WA
425-385-8426
www.philiphowe.com

Geoff Hull
Studio City, CA
818-761-6019

Donal Jolley
c/o Studio 3, John's Creek, GA
770-751-0553
www.donaljolley.com

Andrew Jones
ajones@spectrum.net
www.androidjones.com
www.conceptart.org

Ron Kempke
217-278-7441

Rick Kirkman
Glendale, AZ
623-334-9199

Dorothy Simpson Krause
781-837-1682
www.dotkrause.com

Terrie LaBarbera
Reston, VA
portraits@tlbtlb.com
www.tlbtlb.com

Ted Larson
Seattle, WA
206-524-7640
theoson@earthlink.net
http://home.earthlink.net/
~theoson/index.html

John Lee
Los Angeles, CA
213-467-9317

LeVan/Barbee
LeVan/Barbee studio
Kingston, WA
lvbwa@comcast.net

Bonny Lhotka
Bonny@Lhotka.com
www.Lhotka.com
www.inkAID.com

Michele Lill
Valparaiso, IN
lill@netnitco.net

Larry Lourcey
Plano, TX
972-596-8888
larry@lourceyphoto.com
www.lourceyphoto.com

Keith MacLelland
617-953-9550
keith@yourillustrator.com
www.yourillustrator.com

Janet Martini
San Diego, CA
619-283-7895

Craig McClain
La Mesa, CA
619-469-9599

Pedro Meyer
Coyoacan, Mexico D.F., Mexico
011-525-55-54-39-96
011-525-55-54-37-30
pedro@zonezero.com
www.zonezero.com

Judy Miller
Fall River, NS, Canada
902-861-1193

Kramer Mitchell
rhebam@dishmail.net

Brian Moose
Capitola, CA
831-425-1672

Wendy Morris
wendydraw@aol.com

Richard Noble
Eagle, ID
208-429-1802
rnoble@mac.com
www.nobledesign.com

Mary Beth Novak
Room Creative
Berkeley, CA
510-848-1557
www.roomcreative.com

John Odam
Del Mar, CA
858-259-8230

Dennis Orlando
215-355-1613
215-355-6924 fax
dennisorlando@comcast.net
www.dennisorlando.com

Chet Phillips
214-987-4344
chet@chetart.com
www.chetart.com

David Purnell
c/o New York West
Lonsdale, MN
507-744-5408
SkyOtter@aol.com

Arena Reed
617-945-2754
arena@visualarena.com
www.visualarena.com

Mike Reed
Minneapolis, MN 55403
612-374-3164
www.mikereedillustration.com

Cindy Reid
cindy@reidcreative.com

Dewey Reid
dewey@reidcreative.com

Mary Ann Rolfe
520-399-2133
Green Valley, AZ
mrolfe1@cox.net
www.digitalstretch.com

Delro Rosco
Eva Beach, HI
delrorosco.com
delro.rosco@hawaiiantel.net

Cynthia Beth Rubin
New Haven, CT
info@crubin.net
http://crubin.net

Peter Mitchell Rubin
c/o Production Arts Limited
310-915-5610

John Ryan
Atlanta, GA
john@dagnabit.tv
www.dagnabit.tv.

Joyce Ryan
Atlanta, GA
joyceryan@comcast.net

Steve Rys
Trevor, WI
262-862-7090
steve@rysdesign.com
www.rysdesign.com

Chelsea Sammel
Oakland, CA
510-628-8474

Karin Schminke
Karin@schminke.com
www.schminke.com

Don Seegmiller
www.seegmillerart.com

Elizabeth Sher
510-528-8004
liziv@ivstudios.com
www.ivstudios.com

Marilyn Sholin
sparkle1@aol.com
www.marilynsholin.com

Fay Sirkis
fay@faysartstudio.com
faysartstudio.com

Jan Smart
jansmart@jansmart.net
www.jansmart.net

Nancy Stahl
nancy@nancystahl.com
www.nancystahl.com

Sharon Steuer
www.ssteuer.com

Don Stewart
336-854-2769
www.donstewart.com

Phillip Straub
straubart@aol.com
www.phillipstraub.com

Jeremy Sutton
415-626-3871
jeremy@.paintercreativity.com
www.paintercreativity.com

Anne Syer
Davis,CA
530-758-1949

S. Swaminathan
Capitola, CA
408-722-3301

Tom Tilney
tomt@belgiandiamonds.com
www.belgiandiamonds.com

Susan Thompson
Lindsay, CA
susan@sx70.com
www.sx70.com

Thomas Threinen
twmt@cox.net
www.tomthreinen.com

Jean-Luc Touillon
jtouillon@free.fr

Lorraine Triolo
Culver City, CA
310-837-9900

Ad Van Bokhoven
Holland
info@advanbokhoven.nl
www.advanbokhoven.nl

Stanley Vealé
bettyheadz@yahoo.com

Pamela Wells
Cardiff, CA
artmagic1@cox.net
www.artmagic.com

James Faure Walker
London, UK
james@faurewalker.demon.uk

Helen Yancy
helen@helenyancystudio.com
www.helenyancystudio.com

Hiroshi Yoshii
Tokyo, Japan
tel/fax 81-3-5491-5337
hiroshi@yoshii.com

Index

A

B

P